Anne W. Thomas

San Francisco

Spring - 1979

Painting Materials
A Short Encyclopaedia

by Rutherford J. Gettens

Head Curator, Freer Gallery Laboratory
Freer Gallery of Art
Washington, D.C.

and George L. Stout

Director, Isabella Stewart Gardner Museum
Boston, Massachusetts

Dover Publications, Inc., New York

Standard Book Number: 486-21597-0
Library of Congress Catalog Card Number: 65-26655

Manufactured in the United States of America
Dover Publications, Inc.
180 Varick Street
New York, N.Y. 10014

PREFACE TO THE DOVER EDITION

This brief encyclopedia of the materials and processes of painting has been out of print for more than a decade, and so the authors are pleased that continued interest in the work warrants its republication. Although the book was designed as a reference work for museum curators and conservators, and not as a guide for practicing artists, it is gratifying to learn that many painters have found it valuable.

Since 1943, the year in which this work was first published, there has been a rapid growth in studies of the materials of ancient and modern art all over the world. The field of art technology, in particular, has been very actively cultivated. Industrial chemistry has introduced new products for the artist as well as for the conservator. In addition, much fresh information about old and new materials has become available. The extent of this knowledge can be observed in some six-thousand abstracts of articles and books published in *IIC Abstracts* (Technical Literature on Archaeology and the Fine Arts) and in its forerunner, *Abstracts of Technical Studies in Art and Archaeology*, 1943-52 (Freer Gallery of Art Occasional Paper, Vol. II, No. 2, 1955).

The most lively technological growth has occurred in the development of synthetic resins and plastics, which were just coming into prominence in the early forties. To the vinyl, acrylic and alkyd resins, which long ago proved their worth, have been added the epoxy and polyester resins which have found multiple uses as adhesives, coatings, and mounting media. The polyethylene or "Polythene" synthetics, hardly known in 1940, have today become commonplace, even in the household. Also, in recent years much has been learned about natural resins, such as mastic and dammar, which for centuries were used in spirit varnishes for paintings. Natural drying oils have been re-examined and new theories of drying have been proposed.

Significant growth has taken place, too, in our knowledge of pigments. For example, in the original edition of this book, green earth was treated as if it were employed only in the paintings of Europe. Since then, however, good natural resources have been located in North America, and this pigment is now known to have been used by American Indians. Lead-tin yellow (a pigment omitted from the present work) has been discovered in many European paintings, even

prior to 1650. (It is difficult to understand why such a beautiful and permanent pigment fell into disuse.) Also, much has been learned about Maya blue, its composition and wide use in Meso-America. The date of the earliest use of Prussian blue has been pre-dated; we now know that it was employed by the American painter John Smibert in the 1740's. Knowledge of the use of saffron and verdigris in early paintings has been extended by research carried on at the Doerner Institute in Munich. It has been found that the blue pigment, smalt, was used widely several centuries earlier than was formerly known. Finally, a new class of permanent red and purple organic pigments called "quinacridones" has become available.

Furthermore, there have also been improvements in the design and construction of such materials as supports for easel paintings and canvas stretchers. In addition, our knowledge of the distribution of wood species in European panel paintings has been increased by Mme. Marette's *Connaissance des primitifs par l'étude du bois* (Paris, 1961).

And so it goes. The reader should be aware that this is not a revised edition of *Painting Materials,* that no attempt has been made to insert the wealth of information about recent knowledge and improvements in the field, some of which have been briefly cited above. The only major change in this edition is in the Table of Physical Properties of Pigments (p. 147), which has been revised to classify pigments according to color groups and which now includes five new pigments. It is hoped that someday a thoroughly updated and enlarged edition can be prepared, one that will be broad enough in scope to include all art materials. However, since this possibility is at present little more than a fond hope, it is felt that a reissue of the original work will make available once again a great deal of useful information about the large majority of the materials and processes of painting in use today.

Washington, D.C., and Boston, Mass.
September, 1965 R. J. GETTENS AND G. L. STOUT

PREFACE TO THE ORIGINAL EDITION

This was not started as a book. It was begun as a series of notes and was published as separate sections in *Technical Studies in the Field of the Fine Arts* from 1936 until 1941. At the start those data were assembled about which little information was available, particularly those on supports and mediums. As more were put together and a book was suggested, a question came up about discarding the sectional arrangement and putting all of the entries in a single alphabetical sequence. In the end it was decided to keep the five sections intact and to print them as they are. The grouping is, perhaps, slightly awkward and is certainly unusual in any volume that calls itself an 'encyclopaedia,' but that word seems open to some variety of definition, and practically there appeared to be good reasons for leaving the data arranged as they were.

Chief among those reasons is that custom has made such an arrangement habitual. Painters and all workers in the materials of paint have grown familiar with handbooks and texts in which pigments, mediums, and the others are treated separately. Individual names are apt to be unknown and information about a general kind of material can probably be got more handily when that kind is segregated. Time and trial will show whether or not a change might have been better and whether or not it should be considered at some later date.

Those who have occasion to use this book will find it uneven as to quantities of information set down. That is because so much study has been made of certain kinds, and so little of others. Pigments, for example, have been explored by painters since the beginning of the art and by scientists for many generations. Solvents, on the contrary, are most of them new things, recent developments in industry and in the painting trade. Their utility is limited and knowledge about them is only beginning to work its way into the arts. The section on tools and equipment has only a small amount of previously published reference data. Much of it, in contrast to other sections, is assembled directly from sources. Headings or titles of the sections may need some explanation. The word, support, as defined in a publication on museum records by a committee of the American Association of Museums (*Technical Studies*, III [1935], p. 204) means 'the physical structure which holds or carries the ground or paint film.' This would

include panels, canvas, paper, and even the masonry of walls. The word, inert, is still strange to the artist-painter but has a common application in industrial painting to materials mixed with a medium, as is a pigment, but which, unlike pigments, have little or no tinting or hiding power.

In a broad sense, these data were put together for workers in the art of painting, for all who do work in the art—painters, teachers of painting, students, museum curators and conservators, paint chemists, and analysts. There is much that will concern the museum worker and the paint analyst more than others—distinctions among chemical and physical properties, problems of conservation, and history of materials. These details, however, may be of some interest to painters, and surely they will have a value for students and teachers. Because this encyclopaedia is for those who work in the arts, the information has been made selective rather than exhaustive. Many more materials could have been listed if the aim had been to produce a thorough, scientific compilation. As it is, most artists will find here facts about materials that are not familiar to them and that they may never use. Yet each entry may have its practical worth in the problem of some painter or worker with paint at some time in his professional life. It is only hoped that omissions are not too many. Facts about materials have to be put in the terms in which such facts have their most exact meaning. Often that requires using the terms of chemistry and physics, and for the artist who finds these baffling a short glossary has been added for the purpose of defining some of them.

Recent years have seen an increase in demand on the part of painters for more information about materials they use, and as this demand can be satisfied the art will be enriched. With a wider range of technical means, a wider scope of expression will become possible. Many excellent publications have led in that direction. This one is added not to take the place of any others but to take a somewhat different place and one that has not been filled.

Much of the work of collecting this information was made possible by grants for research by the Carnegie Corporation. Revision of the periodical publication has been done through a gift from Robert Treat Paine II. This aid is gratefully acknowledged.

Cambridge, Massachusetts
November 4, 1941

INTRODUCTION

The Department of Conservation of the Fogg Museum of Art has for many years made a study of the materials and processes of painting. These studies have included the fields of chemistry, microscopy, physics, and the use of infra-red and ultra-violet rays. Also special investigation has been made of the use of the x-ray in the examination of paintings and to a lesser extent of sculpture and bronze. All these methods of research have been useful in dealing with problems of restoration and of conservation and in the detection of forgeries.

We feel that such research is valuable in many ways: in the historical examination of the processes and materials of the past; in the study and detection of forgeries in the present; and in the inquiry into the scientific care and restoration of works of art.

Finally it is important for the creative artists of today, who must understand sound processes and know how to choose permanent materials if their work is to endure. The various scientific approaches supply information and data bearing on all of these fields.

Mr George L. Stout has for many years been the head of the Department of Conservation, and associated with him has been Mr Rutherford J. Gettens, chemist and Fellow for Technical Research in the Fogg Art Museum. Mr Stout has been the editor of *Technical Studies in the Field of the Fine Arts*. He and Mr Gettens have both written many articles in this magazine embodying the results of their work.

It is encouraging to see that so many artists are beginning to take a real interest in technical problems. We feel that there is a need for a book which will co-ordinate in easily available form a large amount of knowledge and research in methods of painting. This field is attracting increasing attention among the art lovers of the world, and it is hoped that the growing number of inquiring minds which are eager for information will find this encyclopaedia valuable.

EDWARD W. FORBES

TABLE OF CONTENTS

MEDIUMS, ADHESIVES, AND FILM SUBSTANCES

Acrylic Resins (see also **Synthetic Resins**). The polyacrylic resins have been recently developed. Neher has outlined the history of the work on this class of compounds and he credits their industrial development to Otto Röhm of Darmstadt. Chemically, they are closely related to the vinyl resins (see **Vinyl Resins**), for they have a $CH_2 = CH$—group in common. Although solid polymers can be made from acrylic acid, $CH_2 = CH \cdot COOH$, and from methacrylic acid, $CH_2:C(CH_3)COOH$, it has been found that the esters of these acids lend themselves better to the formation of useful resins. Most useful is that made by the polymerization of methyl methacrylate, $CH_2:C(CH_3)COOCH_3$, often referred to as methacrylate resin.

Methyl methacrylate monomer is a volatile liquid of low viscosity which boils at 100.3° C. Polymerization is autocatalytic and is easily effected by light, heat, and oxygen. The polymer is a hard, strong resin which has the clarity of glass. It is a linear polymer and is thermoplastic, although its softening temperature is high (125° C.). Now it is used chiefly as a plastic for clear or light-colored, molded articles. For these it is more suitable than polyvinyl acetate, because it is harder, is less rubbery, and has little cold flow. It can be worked well mechanically. The solid resin is so clear that printed matter can be read through masses of it several inches thick with perfect visibility. It is insoluble in water, alcohols, and petroleum hydrocarbons (Anonymous, 'Methacrylate Resins,' p. 1163), and is soluble in esters, in ketones, in aromatic and in chlorinated hydrocarbons. Lacquers and protective coatings may be made by dissolving the clear resin in these solvents singly or in combination. In general, the solubility is lower than that of polyvinyl acetate. The acrylic resins are characterized by their strong adhesion to most surfaces, and advantage may be taken of their thermoplastic properties to effect good adhesion. Ultra-violet transmissibility and stability to light are high. The refractive index is 1.482 to 1.521. Polymerized methyl methacrylate is supplied as a molding powder and in made-up forms under the trade name, 'Lucite.'

In addition to methyl methacrylate, other methacrylic ester polymers are available, including ethyl, n-propyl, isobutyl, and n-butyl. These have become commercially important as materials for protective coatings and lacquers. Strain, Kennelly and Dittmar supply data on their physical properties, solubilities, and compatibilities with resins and plastics. As the molecular weight of the esterified alcohol radical increases, the polymers become softer and more plastic. Film-forming and adhesive properties, as well as solubility and compatibility, also change markedly along the series from methyl esters to the higher esters. The higher esters become increasingly more miscible with aliphatic type solvents, the butyl and isobutyl esters being soluble in petroleum solvents. Strain presents data which show wide variations in viscosities of methyl methacrylate polymers made from different solvents in the same concentrations. Toluene gives lower viscosity for the polymer than any other single solvent tested.

3

It has been suggested ('Methacrylate Resins,' p. 1163) that the monomeric ester, since it has such low viscosity and can be polymerized so easily, may be used as an impregnating agent which can be polymerized *in situ*. Porous, fibrous, and cellular materials, which are ordinarily difficult to impregnate because of the viscosity of the organic solutions of the polymers, may be treated for protection and stiffening in this way. It is also reported (*ibid.*) that 'monomeric methyl methacrylate has been used to protect wood to give a final product containing as much as 60 per cent by weight of resin.'

Albumen (see **Egg White**).

Alkyd Resins (see also **Synthetic Resins**). The alkyd resins are obtained by the elimination of water from polyhydric alcohols (glycol and glycerol) with dibasic acids (phthalic, etc.). These resins have been prepared from a number of different ingredients leading to widely differing properties. There are many so-called 'alkyd resins.' Combined with drying oils, they are now much used in the industrial preparation of paints, lacquers, and enamels which are durable and flexible and do not yellow. Some of the resins are thermosetting and are used for making molded articles. The alkyd resins are the most important of the synthetic resins in the industrial paint and lacquer field today. Incorporation of alkyd resins in cellulose nitrate and cellulose ester coatings has helped to overcome some of the disadvantages of the latter.

Amber (see also **Resins**). The name 'amber' in early times was given to many hard resins. It is, properly, a fossil resin found chiefly on the shores of the Baltic Sea but also in Denmark, Sweden, Norway, France, and along the coast of England. A dark variety has been found near Catania, Sicily. Aristotle was the first to record that amber was not a mineral but a fossil tree resin. It is mostly known in its natural state as jewelry. Beads of it have been found in early English graves and good specimens are still highly valued for ornamental purposes. It has been used, also, as a varnish ingredient, undoubtedly when adulterated with other hard resins.

The chief distinguishing feature of true amber is its yield of succinic acid when heated, and the name, 'succinite,' is now commonly used in scientific writings to denote the real Prussian amber. There are several ways to distinguish between amber and copal with which it is often confused or adulterated. One is the presence of succinic acid in the distillate of amber; another is the insolubility of amber in cajuput oil which completely dissolves copal; amber, when heated quickly, splits up and then fuses into a viscous liquid, the drops of which rebound when falling on a cold surface; copal resin does not have this characteristic.

Amber is practically insoluble in ordinary resin solvents. When made into a varnish, it is melted or distilled and the residue is dissolved in amber oil, oil of turpentine, or a fatty oil. It makes a very dark, slow-drying varnish, unsuitable for paintings, and there is doubt that it was ever employed alone for this purpose.

Animal Waxes (see also **Waxes** and **Vegetable Waxes**). These are obtained from a great variety of sources and have little in common, except their absence of glycerides. Small deposits may be found in many parts of animals and are

also present in the cell contents of their tissues. Hydrocarbons do not seem to be of so frequent occurrence as in the vegetable kingdom; among the alcohols there are cholesterol and allied substances, which replace the phytosterols of the plants, and higher aliphatic alcohols containing, as a rule, fewer carbon atoms than the aliphatic plant alcohols. They have, in fact, the same carbon content (16, 18, 20) as the most common fatty acids (Hilditch, p. 127).

Balsam (see also **Resins**). This general term has been used to designate the resinous exudate from trees of the order *Coniferae*. It is also spoken of as oleo-resin, turpentine, or gemme. The flow of balsam is quite profuse from shallow incisions, except for larch balsam, and for that the heart of the tree is pierced. The composition of balsams varies with the habitat of the tree. Those containing the largest amount of essential oil come from trees growing in sandy soil near the sea. Balsam is a soft, semi-liquid consisting of terpenes associated with bodies of resinous character. By distillation, turpentine and the residue, colophony, are obtained. The balsams most used in varnishes or as paint mediums are Venice' turpentine, Strasbourg turpentine, Canada balsam, and copaiba balsam. Balsams flow easily on a surface and give a lustrous, pleasing quality when first applied. Unless a harder resin is mixed with them, however, they deteriorate easily.

Beeswax (see also **Waxes**) is produced by the common bee, *Apis mellifica*, and also by some allied species. It is not collected by the bee, but is the secretion of organs situated on the underside of the abdomen of the neuter or working bees, and is used by them in forming the cells of the honeycomb. They are said to consume about ten pounds of honey in order to secrete one pound of wax. The wax may be obtained by melting the combs in hot water and by straining to free it from impurities, or by pressure extraction. A further yield may be obtained by the use of volatile solvents. The industry is carried on in many parts of the world and, naturally, the waxes from widely different localities vary considerably in texture, color, and, to some extent, in chemical composition. The color ranges from light yellow to dark, greenish brown. Those of light color are used directly in many cases but the darker colored varieties are more frequently bleached. This may be done by treatment with bleaching earths or charcoal, or by chemical means such as simple exposure to light and air, or by treatment with ozonized air or hydrogen peroxide; the use of oxidizing acids such as chromic acid tends to cause deterioration. Beeswax is fairly brittle, but is plastic when warm; bleached beeswax, ' white wax,' is heavier, more brittle, and has a smoother fracture. Like other waxes, beeswax is somewhat complex in composition and contains about 10 per cent of hydrocarbons in addition to alcohols, acids, and esters. It consists principally of melissyl (myricyl) palmitate ($C_{15}H_{31}COOC_{30}H_{61}$) and there are also present small proportions of a number of other alcohols and acids, including ceryl and melissyl alcohols, palmitic, cerotic, melissic, and probably other higher fatty acids. Beeswax is very likely to be adulterated. In some districts it is the custom to place artificial combs in the hives. These are frequently composed of paraffin wax or stearic acid, or a mixture of the two, and

the resulting wax will thus be largely adulterated. Besides its use in the arts (see **Waxes, history in painting**), and it has doubtless been the principal wax used by painters, beeswax is mainly used in candle manufacture and in the preparation of wax polishes.

Benzoin (see also **Resins**) is a dark, resinous substance obtained from trees (*Styrax Benzoin* and other species) growing in Siam and in Sumatra. Siamese benzoin has a characteristic odor which results partly from the presence of 1 per cent vanillin. It has frequently been used as a plasticizer for varnishes and lacquers. It was imported into Europe at an early period, but Merrifield (I, cclx) says that it does not appear to have been used as an ingredient in varnish until the middle of the XVI century when it became a spirit varnish, but did not figure in the preparation of oil varnishes. It is mentioned in various mediaeval MSS.

Binding Medium (see **Medium**).

Bitumen Waxes form a link between the vegetable waxes and the mineral waxes. In this respect they resemble lignite and peat, the parent substances which are bodies intermediate between vegetable and mineral in character (see also **Waxes** and **Montan Wax**).

Blown Oil. The usual procedure for preparing blown oil is to pass an air current through the oil (see **Oils and Fats**), at about 120° C., in the presence of traces of cobalt driers. Blown linseed oil is used somewhat instead of stand or polymerized oils which are more expensive to manufacture. By prolonged blowing, drying oils yield jelly-like or even solid, elastic masses. Fatty oils belonging to the class of semi-drying oils lend themselves especially to the manufacture of blown oils. Rape oil and cotton-seed oil are blown in order that the products may be mixed with mineral oils to produce specific lubricants, while other blown oils find various technical applications.

Boiled Oil is linseed or other drying oil which has been heated with the addition of lead, manganese, or cobalt oxides, or other suitable siccative compounds of those elements. Formerly it was usual to heat the oil at 260° to 290° C., to add a metallic oxide, and to continue heating for a few hours until a homogeneous solution was obtained. The modern practice is to operate at lower temperatures (130° to 150° C.) and to employ ' soluble driers ' such as the metallic resinates or linoleates. If the oil is blown with air, the driers may be incorporated at temperatures as low as 100° C., for slight oxidation of the oil facilitates dispersion of the driers. These are probably colloidally dispersed, not truly dissolved. Boiled oils have the property of absorbing oxygen from the air at a much more rapid rate than does raw linseed oil, and the time required for the formation of a skin is thereby much shortened (see **Oils, drying process**). They are used largely for industrial paints, varnishes, and enamels, and for waterproofing, for electrical insulation, and for patent leather. Doerner (pp. 105–106) says that commercial boiled oil is not of much use for artistic purposes because it dries with a sleek, greasy sheen and easily forms a skin.

Bone Glue is impure gelatin prepared from bones (see also **Gelatin** and **Glue**).

Canada Balsam (see also **Balsam**) is derived from a fir (*Abies balsamea* Mill.) which grows widely in the eastern United States and Canada. It is obtained from small blisters in the bark and only a small amount can be collected at a time. The balsam is relatively pure and is valuable for its transparency and its high refractive index (1.5194 to 1.5213 at 20° C.). It was introduced into Europe in the XVIII century.

Candelilla Wax (see also **Waxes**) is obtained from the stem of the leafless Mexican plant, *Pedilanthus pavinia*, and from other Mexican genera of the *Euphorbiaceae*. It is a brownish, brittle mass which may be bleached. Although of a lower melting point than carnauba wax, it finds application in similar industries.

Candlenut Oil is obtained from the seeds of *Aleurites moluccana*, a tree covering large areas in the western tropics. For use in paints and varnishes, it is recommended by some and condemned by others. It is closely related to tung oil.

Carnauba Wax (see also **Waxes**) is obtained from the Brazilian palm, *Corypha cerifera* (the carnauba tree), on the leaves of which it forms a deposit. The young leaves are cut and dried and the wax powder is scraped off and melted in boiling water. It is bleached with fuller's earth or charcoal or by a chemical oxidant such as chromic acid. It is a yellowish, hard, brittle material of exceptionally high melting point (83° to 86° C.) which increases somewhat with age. The major component of the wax is melissyl (myricyl) cerotate ($C_{25}H_{51}COOC_{30}H_{61}$) with minor amounts of hydrocarbons, wax alcohols, and higher fatty acids. Owing to its hardness and high melting point, it takes a fine, hard gloss when rubbed. It has been recommended (Rosen, p. 115) as a coating material for paintings, when mixed with other waxes.

Casein (see also **Casein Tempera**), usually referred to as a glue, is an organic compound belonging to the class known as proteins, the most complex compounds with which chemists have to deal. Furthermore, it belongs to one of the more complex subdivisions, the phosphoproteins. It consists of carbon, hydrogen, oxygen, nitrogen, sulphur, and phosphorus, and, although it has been the subject of many investigations, a great deal of information is still lacking with regard to the amino-acids of which it is composed. Like all proteins, it is amphoteric, *i.e.*, it functions both as an acid and as a base. It has, however, decided acid properties and exists in milk as calcium caseinate. Casein is prepared from skimmed milk by heating it at 34.5° to 35° C. and adding hydrochloric acid till the mixture reaches a pH of 4.8. It is then allowed to settle and, after separation from the supernatant liquid, is washed with hydrochloric acid, also with a pH of 4.8. Casein so prepared is technically pure, and is a snow-white, slightly hygroscopic powder with a specific gravity of 1.259. It reacts as a weak acid, is insoluble in water, alcohol, and other neutral organic solvents, and is soluble in the carbonates and hydroxides of the alkali and alkaline earth metals and in ammonia.

The curd of milk with nearly any alkali like borax, trisodium phosphate, or sodium carbonate, will yield an adhesive. If the alkali is lime, the adhesive is highly water-resistant. Nowadays hydrated lime (calcium hydroxide) may be more convenient to use than quicklime. Sutermeister (c. VII) discusses the theory and practice of casein glue formulation and says (p. 190) that a casein glue capable of giving excellent dry strength and water-resistance may be prepared from 100 grams of casein, 300 grams of water, and 16 grams of calcium hydroxide. The casein must be finely ground and must be allowed to soak thoroughly before the lime is added in order that solution may take place as readily as possible. Since the working life of such a glue is limited to 10 to 45 minutes, it must be used immediately. Prepared casein glues are now on the market, which have only to be mixed with water.

Casein yields one of the strongest glues known and has been used for centuries by joiners and cabinet makers. It has served extensively as a binding medium for cold-water house paints, and, to a limited extent, for pictorial painting, both as a binding medium and in the preparation of grounds. Craftsmen of ancient Egypt, Greece, Rome, and China are considered to have used it. Without doubt it was a joining adhesive in the cabinet work of the Middle Ages. MSS of the time give directions for preparing an adhesive out of lime and cheese, very similar to an adhesive that is now used for putting together the wooden parts of an aeroplane. (A large part of the casein used as a glue today is consumed by the woodworking industries.) Ancient Hebrew texts mention the use of curd (casein) in house painting and decoration. Michelangelo is said to have used a combination of sour milk, oil, and pigments to produce highlight effects on walls (Sutermeister, p. 105). The material used in the many well preserved XVIII century ceiling paintings in upper Bavarian and Tyrolean peasant houses is lime-casein. It is little used as a painting medium by modern artists, except, possibly, for mural decorating. The casein film is hard, brittle, and insoluble, and lends itself poorly to handling and to correction.

Casein Tempera (see also **Casein**). This medium, made from skim milk and lime, has been used since very early times. It has great adhesive power and has long served as a joining glue, as well as for painting on walls. Unless properly thinned, lime casein is not considered to be suitable for easel painting. It is occasionally used, at present, to make oil color short, and has even been added as a medium with oil colors. With the addition of one fifth of its volume of slaked lime, casein becomes liquid, is easily emulsified, and can be thinned with water. Three to five parts of water, or more, can be added, and the emulsion should be freshly made before it is used. Lime-casein sets quickly and becomes very hard.

For easel painting, Doerner (p. 218) recommends powdered casein which is insoluble in water but is soluble in ammonia. Forty grams of casein are mixed with a small amount of water, and then 250 cc. of warm water are added. After the lumps have been pressed out, 10 grams of ammonium carbonate, dissolved in a few drops of water, are added. The solution is ready for use after the carbonic

acid has escaped through effervescence. Ammonia casein may be kept in a corked bottle and diluted in water before it is used. The adhesive power, though not so great as that of lime-casein, is good. It has the additional advantage that its solvent is harmless. Commercial caseins are often prepared with potash or soda, and, as these lyes destroy certain colors, the litmus test (red litmus should not turn blue) can be applied. It is difficult to keep casein colors in tubes without their hardening and crumbling. Glycerine may be added, but, although this keeps the paint moist, it destroys the insolubility of casein in water. A great difficulty with this medium, besides its brittleness in the film, is its tendency to encourage mold growth.

Castor Oil (see also **Non-Drying Oils**) is an oil from the seeds of *Ricinus communis* which is grown in India and in most hot countries. It is the heaviest of all the fatty oils, is almost colorless, and is very viscous. Chemically, it is quite different from the other fatty oils (see **Oils and Fats**), consisting largely of the glyceride of ricinoleic acid ($C_{18}H_{34}O_3$); a small quantity of hydroxystearic acid and stearic acid also occurs. It is largely used as a plasticizer and in practice is distinguished from many oils by its ready solubility in alcohol.

Celluloid (see also **Cellulose Nitrate**) is a pyroxylin plastic that is plasticized with camphor. In time the camphor disappears and the film becomes brittle. Celluloid lacquers have been extensively used during the past fifty years in restoring and repairing objects of art. Celluloid clippings could easily be dissolved in acetone or in some solvent mixture.

Cellulose Acetate (see also **Cellulose Coatings** and **Cellulose Nitrate**). Cellulose acetate is a white, bulky solid that now finds extensive use as a coating and lacquer material and as a molding compound. Compared with cellulose nitrate, it has some advantages and some disadvantages. Although acetylated carbohydrates were known as early as 1865, it was not until 1910–1911 that mention of products which were like those now called 'lacquers' and which contained cellulose acetate, began to appear in the patent literature. Cellulose acetate is prepared from some form of cellulose, like cotton linters or paper, with a mixture of glacial acetic acid, acetic anhydride, and concentrated sulphuric acid. The product is an ester of cellulose (which may be considered to be a polyhydric alcohol) and acetic acid. Cellulose acetates of widely different properties may be made. The low-viscosity acetates are best for lacquers. The chief difficulty in the way of the commercial development of cellulose acetate has been its limited solubility. It is dissolved by fewer organic solvents than cellulose nitrate, and these few are strong—acetone, diacetone alcohol, ethylene dichloride, and the glycol ether acetates. Even with such solvents, the dilute solutions of cellulose acetate are viscous. In general, the lacquers have too low solids content for wide commercial application. Hofmann and Reid have made an exhaustive study of the solubility of cellulose acetate in single solvents and in solvent mixtures, and, on the basis of their experimental data, have been able to work out some very satisfactory lacquer formulas. There has been difficulty from the tendency of cellu-

lose acetate lacquers to blush in humid weather because of the rapid evaporation of such solvents as acetone and methyl acetate, but it is now possible, by proper choice of high-boiling solvents, to prepare lacquers with a high degree of blush resistance.

Most cellulose nitrate plasticizers are incompatible with cellulose acetate and it is hard to prepare a satisfactory plasticizer. Moreover, few natural resins are compatible with it and that has prevented the development of a cellulose acetate lacquer with good adhesion. Recently, however, it has been found that some of the alkyd synthetic resins (glycol phthalate) may be used with cellulose acetate in the combined rôle of resin and plasticizer. Cellulose acetate is superior to cellulose nitrate in that it does not yellow or become so much degraded in sunlight. It is chemically more stable and, also, the solid cellulose acetate is nearly non-inflammable, in contrast with cellulose nitrate. Hill and Weber have recently made a study of the comparative stability of cellulose nitrate and cellulose acetate motion picture films. From their oven-aging tests they found that cellulose acetate retains its flexibility and weight much better than cellulose nitrate. On artificial aging, cellulose acetate remains neutral but cellulose nitrate increases greatly in acidity. They conclude that a cellulose acetate film appears to be a stable substance.

As an impregnating material, cellulose acetate has little value because solutions are too viscous and have too low solids content. Advantage may be taken, however, of this high viscosity in impregnating and stiffening old fabrics, because the cellulose acetate does not appreciably penetrate and darken. This is important in the conservation of old textiles. Plenderleith (p. 12) suggests that a 1 per cent solution of cellulose acetate in acetone, applied in several coats, be used for strengthening brittle fabrics. He also recommends it (p. 19) as a cement for repairing old ivories. A film of cellulose acetate may be used in place of glue for the sizing of artists' canvas. It has long been used as a 'dope' for aeroplane wing fabrics. Care must be taken in the application of cellulose acetate—and, for that matter, of almost any cellulose ester coating—not to have solutions that are too thick or viscous, especially on smooth surfaces. Such coatings have poor adherence and are liable to peel. It has been observed that films of cellulose acetate applied as a thick lacquer to a smooth paper base can be stripped as intact films from the paper without any difficulty. The incorporation of synthetic resins with the film helps to alleviate this shortcoming.

Cellulose Coatings (see also **Cellulose Acetate** and **Cellulose Nitrate**). Several plastic and coating materials are derived from cellulose which is the principal carbohydrate constituent of many woody plants and vegetable fibres. Cotton fibre and delignified wood are the most important raw materials for the production of these derivatives, many of which are esters. The cellulose coating materials are colloidal in nature. They may be dispersed in organic solvents and in this way used as lacquers. Wilson says (p. 11): ' For practical purposes cellulose may be

considered as a complex alcohol, with three hydroxyl groups for each unit molecule. These alcoholic radicals can be esterified by acids and the acetic and nitric acid esters have tremendous importance in industry.' These cellulosic coating materials can not properly be called 'synthetic resins,' although they may be used for lacquers and molding compounds in a similar way. The raw, modified cellulose materials are, for the most part, light-colored or white, powdery or flaky materials that do not have a resinous lustre or fracture. Moreover, they are natural products prepared by dissimilar chemical processes. Cellulose acetate and cellulose nitrate are frequently classified as 'plastics.'

In recent years there have been developed some new cellulose materials which are similar to cellulose acetate and which are said to be superior in many respects. Among these is cellulose acetobutyrate, which is more highly miscible with resins and plasticizers than is cellulose acetate. Lacquers can be made from it which are tough, flexible, and resistant even to out-of-door weathering. Cellulose acetobutyrate is a white, flaky material; it gives a colorless film which transmits all visible and ultra-violet light in the solar spectrum and does not yellow or discolor. The refractive index of the pure film is 1.47 at 25° C. Another derivative is ethyl cellulose, a cellulose ether, which is softer and more extensible than the cellulose esters and, hence, requires little or no plasticizer. Benzyl cellulose is another cellulose ester, suitable for lacquer formulation.

Cellulose Nitrate (see also **Cellulose Coatings** and **Cellulose Acetate**). Cellulose nitrate, also known as gun cotton or pyroxylin, has been known for nearly one hundred years. (Wilson [p. 11] says that the cellulose nitrates are broadly and incorrectly termed ' nitrocelluloses.') It was not until after 1920, however, that its manufacture became important through the demands of the wood- and metal-finishing industries. It is made by treating cotton linters or high-grade tissue paper with a mixture of concentrated sulphuric and nitric acids, which is partially diluted with water. Dry cellulose nitrate is a voluminous, white or faintly yellow solid which is readily flammable and deflagrates if brought near a naked flame. For shipping purposes it is usually moistened with alcohol or some other organic liquid. It is sold on the basis of its viscosity in standard solution; for example, a specification that the cellulose nitrate is ' R. S. one half second cotton ' indicates that when it is made up in a standard solution (regular solvents), one half second is the time required for a standard steel ball to fall through ten inches of the solution contained in a one-inch-diameter, vertical column at 25° C. (A. S. T. M. method). One half second cotton is used extensively for preparing lacquers, but cellulose nitrate is prepared commercially with a viscosity as high as 200 seconds.

The best solvents for cellulose nitrate are the organic esters, ethyl acetate, butyl acetate, amyl acetate, and ketones, like acetone and diacetone alcohol. Paraffin hydrocarbons, coal-tar hydrocarbons, and even the lower alcohols have little or no solvent effect, although these solvents may be used as diluents along

with the esters and ketones. In recent years the glycol ethers have become important cellulose nitrate solvents. Solutions of pyroxylin in simple solvent mixtures do not make very good surface coatings. Well compounded cellulose nitrate lacquers are complex in composition. Pure cellulose nitrate solution, like pharmaceutical collodion, dries out to a brittle film which shrinks as it hardens. For this reason it is necessary to incorporate with the solution liquid or plastic materials which are retained in the film and keep it flexible. Camphor and castor oil have long been used with cellulose nitrate. The former, however, is readily lost from the film since its vapor pressure (for this purpose) is high. Castor oil has a tendency to develop rancidity and an unpleasant odor on standing, and it makes the film too soft if used in slight excess. In recent years synthetic plasticizers, like the triphenyl or tricresyl phosphates or dibutyl phthalate, have come into favor.

In addition to plasticizers, nearly all pyroxylin lacquers contain certain amounts of resin, either natural or synthetic. Resins increase the body of the film, enhance the gloss (where this is desirable), and improve the adhesion, particularly to metal and to glass. Dewaxed dammar is used where a pale lacquer is required. Shellac, copal, elemi, mastic, sandarac, the phenolic and the vinyl resins, and others are compatible with cellulose nitrate. Besides the solvents used for taking the cellulose nitrate into solution, it is usually necessary to add small quantities of solvents which have a higher boiling point. Such solvents are known as ' blush resistants.' If the main solvent or solvents evaporate too rapidly, they may chill the surface to which a lacquer is applied and cause water to condense in the film; this, in turn, causes the film to turn white (blush or bloom). Small amounts of such solvents as diacetone alcohol, the glycol ethers, and the lactates are commonly used for this purpose. These high-boiling solvents also improve the brushing and spraying qualities.

Cellulose nitrate has two main shortcomings. In the first place, it is not stable to light, particularly strong sunlight. Devore, Pfund, and Cofman say (p. 1836):

> The action of sunlight or ultra-violet light on an unpigmented nitrocellulose film is accompanied by a variety of phenomena in addition to the gaseous decomposition. The film becomes acid, its brittleness increases, its tensile strength decreases, and after prolonged exposure the film becomes yellow. The viscosity of a solution prepared by redissolving an irradiated film is lower than that of the solution from which the film was cast.

In their experimental work they found that there is a sharp peak in the curve indicating a strong maximum of decomposition per unit energy in the region represented by lines near 3130 Å. Gloor found that sunlight not only subjects a film of nitrocellulose lacquer to stresses incidental to normal temperature change, but that it also promotes photochemical changes in the film itself. His data indicate that the principal effect of ultra-violet light is a pronounced local denitration and degradation, while the effect of heat is the same but more general. The second

shortcoming of cellulose nitrate, the inadequacy of plasticizing materials now available for it, has already been touched upon. Loss of plasticizers, however, may not be secondary to the effects of light and heat. Camphor and such plasticizers escape eventually because of their inherent vapor pressures. The incorporation of natural and synthetic resins tends to lessen some of these shortcomings. The high flammability of cellulose nitrate compositions is well known. There is much greater danger attendant upon application of the lacquer than there is from any possibility that the dried film will ignite.

Cellulose nitrate, particularly in the form of a celluloid lacquer, has played some part in the restoration of museum objects in the last quarter century, principally as an adhesive and as an impregnating agent (see Lucas, *Antiques*, etc., index). In the *Third Report of the British Museum on the Cleaning and Restoration of Museum Exhibits* (p. 20) is a record of the employment of a celluloid varnish for coating baked clay tablets prior to washing them in distilled water. Plenderleith (p. 15) says that a celluloid lacquer is useful for coating the powdery surface of decayed wood; advantage is taken of the great contraction of the celluloid to re-enforce the surface.

Cement. Frequently adhesives, and film materials generally, are referred to by this name if they are used for the purpose of joining objects or parts of objects. For such a purpose, a number of types of film material may be used (see **Glue, Resins,** and **Synthetic Resins**).

Ceresin (see also **Waxes** and **Ozokerite**) is obtained from Galician ' earth wax,' ozokerite. It is harder than paraffin, is dazzling white in appearance, inodorous, and transparent at the edges. It consists of a mixture of hydrocarbons and differs from paraffin wax in being plastic and non-crystalline in character (Fryer and Weston, p. 208). The melting point varies between 65° and 80° C. It is not attacked by acids, either cold or hot, or by alkalis, which do not saponify a trace of it. It is entirely volatilized at a high temperature without alteration. It is employed as a substitute for beeswax which it resembles in plasticity. It is often adulterated with paraffin wax, many so-called ' ceresins ' being, in fact, entirely paraffin.

Cherry Gum (see also **Gums**) is from the cherry, mahaleb-cherry, apricot, and plum trees. It swells in water, and about 10 per cent is enough to form a thick substance. The solution is pressed through a cloth. It may be emulsified with fatty oils and balsams. It gives great transparency to color, but is inclined to chip easily if used alone or if applied in thin glazes. When added to an egg or casein emulsion, it is said (Doerner, pp. 223-224) to give a brilliant, enamel-like effect. It is mentioned as a painting medium in some treatises, particularly of northern origin, and probably had occasional use as late as the XIX century.

Chinese Insect Wax (see also **Waxes**) is the deposit of an insect, *Coccus ceriferus*, which is a parasite on certain Asiatic trees. The wax is obtained by placing the larvae of the insect on certain selected trees up which it creeps, and

on the twigs and leaves of which the wax is deposited. Wax is removed first by scraping, and finally by skimming water in which the scraped leaves and branches are boiled. Insect wax is pale-colored and resembles spermaceti but has a more fibrous structure and is more opaque. Chemically, it consists largely of ceryl cerotate ($C_{25}H_{51}COOC_{26}H_{53}$) together with other wax esters and a small proportion of hydrocarbons. It contains very little free fatty acid. It is employed in the East for much the same purpose as beeswax, but it is not largely exported.

Chinese Wood Oil (see **Tung Oil**).

Collagen (see also **Gelatin** and **Glue**) is the organic material which largely comprises the bones, the tendons, the cartilage, and the skin of animals. There is no tissue which consists exclusively of collagen and it is invariably associated with other protein material such as keratin, elastin, mucin, chondrin, etc., in addition to other non-protein organic material and inorganic salts. When collagen is heated in water to 80° or 90° C., it is slowly converted into the protein, gelatin.

Collodion (see also **Cellulose Nitrate**). It is said (Wilson, p. 140) that pharmaceutical collodion still consists of 8 ounces of pyroxylin dissolved in 3 parts ether and 1 part alcohol. Proprietary substitutes are made up in amyl and butyl acetate solutions and give a better product. As a plasticizer for flexible collodion, 3 ounces of camphor and 2 ounces of castor oil are used.

Colophony (see also **Balsam** and **Resins**), or rosin, is the residue which remains after spirits of turpentine has been distilled off from the balsam or crude turpentine produced by various species of pine. A large amount of colophony comes from the long-leaf pine of the southern United States, and, in France, from the *Pinus maritima*. The proportion of colophony to turpentine seems to be related to the condition of the trees' habitat. The usual ratio is about three to one. There is a larger amount of essential oil in the balsam from trees near the coast. After distillation, the residue, which is rather dark, must be purified. Colophony has a low melting point (100° to 130° C.) and is very soluble. It facilitates the running of harder resins, and is supposed to improve the flowing qualities of a varnish. In industry it is often used as a clarifier for dammar and other natural resin varnishes (see **Dammar**). Its acid value is between 165 and 175, which corresponds to about 89 to 97 per cent of abietic acid. Being so strongly acidic, it probably acts by combining with basic substances which would otherwise be precipitated.

As a varnish resin, colophony has many defects. The pale color and brilliant gloss evident when it is freshly applied disappear rapidly on exposure. The film becomes permanently whitened by the action of water and is easily destroyed by abrasion. The introduction of Chinese wood oil to rosin varnish has materially raised its value for industrial use. Colophony retards the gelation of the oil, and the rapid drying and hard film of the oil reduce the weakness of the resin. A synthetic resin called ' ester gum,' made by esterifying colophony with glycerine, is now widely used in the varnish industry. From ancient recipes for oil varnishes

requiring a large amount of *pica greca*, with or without the addition of a soft resin, it is known that colophony was used in Italy as early as the IX century.

Congo Copal (see also **Copal** and **Resins**) is derived from the tree, *Copaifera Demeusi* Harms., in the Belgian Congo. It is found as a fossil resin in deposits from six inches to three feet underground, although some is still obtained by tapping the trees. It is considered the standard fossil resin. Except for colophony and shellac, Congo copal and resins from the Dutch East Indies constitute the bulk of natural resins in present-day manufacture of varnishes for general use. Like all the copals, it has no definite melting point but is fused at from 180° to 200° C. It must be heated before it will dissolve in oil, thus forming an oil varnish, and this process makes the resin darker. It has probably not been much employed as a picture varnish.

Copaiba (**Copaiva**) **Balsam** (see also **Balsam** and **Resins**) is an oleo-resin obtained from the tree, *Copaifera landsdorfii*, in South America. It is a deep brown, viscous liquid with a peculiarly fruity odor and a high content of essential oil. It is soluble in fatty and essential oils as well as in alcohol. It was formerly much esteemed by restorers. Max von Pettenkofer (see Doerner, p. 125) used this balsam in the so-called ' Pettenkofer treatment ' for the brittle, dried-out ' linoxyn ' skin of old oil paint. When combined with ammonia, it is less harmful to a paint film than is a strong alkali solution (see **Varnish**). Helmut Ruhemann (' A Record of Restoration,' *Technical Studies*, III [1934], p. 7) mentions using it to make a mixture of petroleum spirit and ethyl alcohol in the process of removing surface varnish from a Flemish painting.

Copal (see also **Resins**) is the general name given to a large variety of hard resins. They are obtained as fossils and are also taken directly from living trees. The fossil resin, found three or four feet underground, is the harder kind and is the most valuable and widely used of all the resins. The copals vary much in their origin, in their degrees of hardness, and in their solubility. They are products, also, of many different species and even genera of tree. It appears, from the researches of Tschirch and his associates, that copals consist of ' resenes,' neutral compounds containing oxygen, and of resin acids. The oxidation of these resenes by contact with the air, and the resultant increase in the acid number and decrease in iodine absorption, have been illustrated by experiment. The finer the particles of the resin and the more porous they are, the higher will be their acid number.

There is a wide range in the solubility and fusibility of copals according to their origin and age. The melting points vary from 180° to 340° C. For conversion into a soluble form, they are heated at a temperature of 200° to 220° C. for several days, or are distilled dry, at a temperature of 380° to 400° C., or until 25 per cent of copal oil has passed over. The benefits from the increased solubility by distillation are counteracted by the color which darkens in proportion to the temperature or time of heating.

As the term ' copal ' is so commonly used for a variety of resins, tests have been made to distinguish the true or fossil copal from such resins as dammar, colophony, and Kauri and Manilla copals. True copal is insoluble in an 80 per cent solution of chloral hydrate, but the other resins are partially or completely soluble. The hard and soft varieties may be distinguished by treating a sample with boiling water. After standing for half an hour, the hard copal remains unchanged, whereas the soft copal becomes milky and opaque. The hardest copal resin is Zanzibar; Sierra Leone and Kauri are of medium hardness; Manilla is a soft copal.

Congo copal is the chief copal resin used in general commercial varnish manufacture today. It is practically the standard fossil resin. Copals appear in the market in a variety of forms and colors. They may be had in large lumps or pea-size ' tears,' and they range from an almost colorless, transparent mass to a bright, yellow-brown. They have a conchoidal fracture.

Copal resins make a thick, hard, dark, oil varnish. From varnish recipes of the Middle Ages, it may be assumed that amber was often confused with copal. The trade in copal probably began in the X century with the Arabs, but it is mentioned only infrequently until the latter part of the XVIII century. It has been used chiefly as a furniture and coach varnish. The old coach painters apparently executed their designs in bright oil colors, freely mixed with turpentine. This was coated with several layers of a spirit varnish, well rubbed down, and over that was spread a copal oil varnish. Because of its tendency to become yellow and dark, however, and because of the difficulty of dissolving and removing it, copal varnish is not practical or useful as a varnish for paintings.

Crude Turpentine (see **Balsam** and **Turpentine**). This is another term for the balsam in its natural state as it exudes from the pine tree. More commonly, that is called ' turpentine,' ' balsam,' or ' oleo-resin.' The last two names are preferable, for the common use of ' turpentine ' applies to ' spirits of turpentine.'

Dammar (see also **Resins** and **Varnish**) is derived from a certain family of trees (*Dipterocarpáceae*) growing in the Malay States and in the East Indies. The principal trees that supply the dammar resin of the varnish maker are of the genus *Shorea* or *Hopea*. From incisions the resin oozes readily in a soft, viscous state, with a highly aromatic odor which it loses on hardening. 'Dammar Mata Kuching,' from Malaya, is known as 'cat's eye resin,' and is of a very high quality. It is used for incense in the Orient, but appears in the European market in transparent, brittle, odorless lumps for the manufacture of a spirit varnish. Its distinguishing characteristic is that it is completely soluble in coal-tar hydrocarbons and in turpentine, and is only partially soluble in alcohol. It is light in color, lustrous, and adherent. The film is soft, however, is less durable than that made from copal resin, and has a tendency to remain slightly tacky. Its paleness and the ease with which it may be used have caused it to be very popular, and it is regarded by some as the best varnish for pictures (see Maximilian Toch,

' Dammar as a Picture Varnish,' *Technical Studies*, II [1934], pp. 149 ff.). The proportions sometimes given are, 1 part of resin to 3 parts of turpentine. Sabin (p. 135) suggests 5 or 6 pounds of dammar resin dissolved in 1 gallon of turpentine, and allowed to settle for sixty days. In tempera emulsions, 1 part of resin is dissolved in 2 parts of oil of turpentine. Two per cent dammar in petroleum spirit may be used as a pastel fixative.

Often the varnish is cloudy, probably owing to the presence of retained moisture. According to Barry (p. 94), cloudiness does not necessarily mean reduction in durability. If the resin is ' run ' before it is dissolved in the turpentine, a clear varnish results, but it is naturally darker. It can also be cleared by adding rosin, though this detracts from its quality. There is recent evidence that dammar varnish is very resistant to blooming, even in a moisture-laden atmosphere. It is used to some extent with nitrocellulose in making clear lacquers. Reid and Hofmann (p. 498) have given a formula for dewaxing dammar resin for commercial purposes. The resin solution obtained is clear and not milky. Their formula is:

> Dissolve 80 pounds of Batavia dammar in a mixture composed of 20 pounds of ethyl acetate and 40 pounds of petroleum distillate having a boiling range, 80–180° C. When completely dissolved (in a mixer equipped with a mechanical agitator), add 100 pounds of denatured alcohol, agitate for a time, and then allow to settle overnight. The waxy precipitate forms a cake in the bottom of the vessel, and when the clear supernatant solution has been drawn off, the wax cake is removed. This wax has not yet found any special use and is generally burned.

Dammar is mainly composed of dammarolic acid ($C_{54}H_{77}O_3(COOH)_2$) and two resenes. Its melting point is from 100° to 150° C.; its specific gravity, 1.062; and its acid number, 18 to 16.

Dextrin (see also **Starches**) is commonly prepared from starch by heating the dry material at 200° to 250° C. It is less commonly prepared by moistening starch with dilute nitric or hydrochloric acid and heating it, when air-dried, to about 110° C. Dextrin, as prepared, is a mixture of soluble starch, at least three varieties of true dextrin, and sugar (maltose and dextrose). It dissolves in water and yields a syrupy solution with strong adhesive properties. With iodine it gives a color which varies from red to violet. Its discovery is said to have followed the observation that starch, which had been roasted during a fire in a Manchester warehouse, yielded a sticky, gummy solution when wetted with water.

Distemper (see also **Tempera**) is a term common in the painting trades, particularly in England, and indicates a paint made with a glutinous medium. It is ordinarily used on walls or in scene painting.

Dragon's Blood (see also **Resins**) was known by this name in mediaeval times when it was used as a pigment in manuscript illumination. ' Leave it alone,' says Cennini, 'for it is not of a condition to do you much honor' (Thompson, *The Materials of Medieval Painting*, p. 124). It seems to have been used for medicinal

purposes, being mentioned in this connection by writers from Dioscorides to the XVI century. In the XVIII century the Italian violin makers used it as an ingredient in their varnishes. Today it is used to some extent in colored spirit varnishes and for lacquering metals. Laurie (*Materials of the Painter's Craft*, p. 203) quotes an auripetrum recipe, a yellow varnish for coating tin foil, which calls for an ' oil varnish coloured by saffron, aloes, the inner bark of black plum or dragon's blood ' (St Audemar MS., Merrifield, I, 115). These substances are all easily dissolved in hot pine balsam, which can then be diluted with boiled oil and turpentine.

Dragon's blood comes from a species of rattan palm, *Calamus draco*, which grows in Further India and in the Eastern Archipelago. The variety from Sumatra, which appears in commerce in the form of eighth-inch sticks wrapped in fibre, is considered the best. On the surface, the resin appears brown but it gives a red, lustrous fracture and a light red powder. It is soluble in alcohol, in ether, and in fixed and volatile oils, and, if heated, it gives off benzoic acid. An inferior resin comes in lump form from Socotra and is the product of the tree, *Dracaena cinnabari*.

Drier (see **Siccative** and **Oils, drying process**).

Drying Oils are oils (see **Oils and Fats**) which have the property of forming a solid, elastic substance when exposed to the air in thin layers (see **Oils, oxidation**). This ' drying ' power decreases as the iodine absorption diminishes, *i.e.*, it is proportional to the total amount of unsaturated fatty acids present. The iodine values of these oils (see **Linseed Oil, Walnut Oil, Poppy-Seed Oil, Tung Oil, Soya Bean Oil, Perilla Oil, Sunflower Oil, Hempseed Oil, Candlenut Oil,** and **Safflower Oil**) range from about 200 to 120. They find their chief use in commerce as the vehicles for pigments in paints and in varnishes.

Egg Tempera (see also **Egg Yolk** and **Egg White**). The whole egg, the yolk, or the white may be used as a tempera medium. Doerner (p. 213) gives a recipe for using a whole egg, which requires with it an equal measure of oil, or stand oil, or oil varnish, and two measures of water added separately with thorough shaking. According to him, the freshness of the egg is important for the quality and the permanence of the emulsion. He says that pigments containing sulphur, such as cadmium, vermilion, and artificial ultramarine, when used with an egg emulsion, may decompose by combining with the nitrogen and sulphur compounds in the egg to form hydrogen sulphide, and he finds that the addition of vinegar or phenol is inadvisable because they discolor some pigments, and he prefers a drop of oil of cloves or small amounts of alcohol.

Among many other present-day recipes for egg tempera is that of Kurt Wehlte in *Ei-Tempera und ihre Anwendungsarten* (Dresden: Herrmann Neisch, 1931), pp. 28–29. He requires: 1 part of whole egg, ⅜ part of linseed oil varnish, ⅜ part of dammar resin in turpentine, and 1 part of water. For a somewhat different tempera, he suggests substituting oil for the amount of resin in this one. These are

complicated emulsions, possibly with oil as the continuous phase (see **Emulsions**). A more simple medium which makes use of the whole egg is that described by Cennino Cennini, c. LXXII (Thompson, *The Craftsman's Handbook*, p. 51). He speaks of a tempera for wall painting, made of the white and yolk of an egg into which are put some cuttings of young shoots of a fig tree. These are beaten well together. A very rare form of egg tempera was developed by the Indians of Canada (see Douglas Leechman, ' Native Paints of the Canadian West Coast,' *Technical Studies*, V [1937], pp. 206–207). They used, among other mediums, eggs from various species of salmon, sometimes taken fresh, sometimes dried, and sometimes worked up by being chewed in the mouth together with a piece of red cedar bark.

The egg tempera which is traditional and reflects the practice of many centuries is that made simply with yolk of egg. It is described by Thompson in *The Practice of Tempera Painting* (p. 96):

> Take a raw fresh hen's egg, and crack it on the side of a bowl. Lift off half of the shell, keeping the yolk in the lower half, and letting the white run into the bowl. Pass the yolk back and forth from one half shell to the other several times without breaking it, so as to get rid of as much of the white as possible; and pinch off between the shells the little white knots which adhere to the yolk. Put the yolk into a cup, and break it, stirring up with it one or two tablespoonfuls of cold water. It does not much matter how much water you add; a little more or less makes no difference. You will probably develop a preference for a thick egg mixture or a thin one as you get used to it, and either is all right. The main point of adding the water is to cut the greasiness of the yolk a little, and make it fairly liquid. Pour it into a four-ounce, glass-stoppered, wide-mouthed bottle.

He recommends adding to this two or three drops of vinegar or 3 per cent acetic acid as a preservative and to make the medium less greasy. Into the egg yolk as prepared, the colors are mixed. They have already been ground in water and about equal parts of pigment paste and prepared yolk are put together, proportions being adjusted to the needs of each pigment, and the whole thinned out with water.

White of egg or glair has probably been most used as a medium for illuminating books, and for powdered or 'shell' gold, and for bole. The traditional use of it is described particularly in two MSS. One of these is in Naples, Biblioteca Nazionale *MS. XII.E* 27; it is translated with notes by Thompson and Hamilton, *De Arte Illuminandi* (New Haven: Yale University Press, 1933). The other is published also by Thompson, ' The *De Clarea* of the So-Called " Anonymus Bernensis," ' *Technical Studies*, I (1932), pp. 8–19, and 69–81. The former is of the XIV century and the *De Clarea* is described by this translator (p. 11) as ' a fragmentary extract from a lost work of the second half of the eleventh century.' There is little to be added to that treatise so far as preparation of the glair is concerned. The author distinguishes two kinds—one made by beating and the other by pressing. The latter sort is squeezed through cloth and is contaminated in the process. The

beaten glair is better. The white is separated from the yolk and is thoroughly beaten in a platter with a wooden whisk until it sticks to the platter even when that is turned bottom-side up. Then the platter with the froth is left in a cool place, tilted slightly, until the glair liquid has settled out. With this the colors are tempered. Of this medium Thompson says (*The Materials of Medieval Painting*, pp. 55–56):

> It is a delicate binder, very modest and retiring and inconspicuous; and it preserves the individual quality of a pigment beautifully. . . . Glair is rather weak and brittle, especially when newly made, and partly for this reason (which militated against its use in strong concentrations), partly because it was not dense enough to bring out the full quality of some pigments, it was often supplemented in book painting by gum arabic.

Egg White (see also **Egg Tempera** and **Egg Yolk**) contains in quite different amounts the same substances found in the yolk. Church (p. 72) gives the percentage proportions of these as follows:

> Water.................................. 84.8
> Albumen, vitellin, etc..................... 12.0
> Fat or oil.............................. 0.2
> Lecithin............................... trace
> Mineral matter......................... 0.7
> Other substances....................... 2.3

The albumen is the adhesive substance of egg white and is complex, containing, besides carbon, hydrogen, nitrogen, and oxygen, about 1.6 per cent of sulphur. As a pure film it is clear and brittle and is readily dissolved by water. Church has suggested (p. 73) that if paintings in tempera, before they are quite dry, were heated to 70° or 75° C. the albumen would be changed to an insoluble form, or that treatment with tannin would serve the same purpose. Egg white as a medium is called also by its other name, 'glair.'

Egg Yolk (see also **Egg Tempera** and **Egg White**) is an oily emulsion in which the oil particles are suspended in a solution of albumen. Its average composition is given by Church (p. 72) in percentage proportions:

> Water.................................. 51.5
> Albumen, vitellin, etc..................... 15.0
> Fat or oil.............................. 22.0
> Lecithin............................... 9.0
> Mineral matter......................... 1.0
> Other substances....................... 1.5

The lecithin is a fatty substance to which has been given the empirical formula, $C_{42}H_{84}NPO_9$, but it differs from most fats (see **Oils and Fats**) in containing nitrogen and phosphorus and in being very hygroscopic. It evidently acts as an emulsi-

fying agent. When egg yolk is used as a painting medium, it dries to a strong film, first by evaporation of the water and then by a slow hardening of the oil which remains suspended in the albuminous matrix. This oil content is greater than that of the albumen and, in consequence, the ultimate film is very little affected by water.

Elemi. This is a generic term applied to a large number of resins obtained from trees of the *Burseraceae* family. Manilla elemi, or ' soft elemi,' the only kind that has been closely examined, comes from a species of *Canarium, C. commune* growing in the Philippines. Other varieties come from South America, Africa, and the East and West Indies. American or West Indian, Yucatan elemi, is generally found in commerce. Manilla elemi is a soft, semi-crystalline, yellow resin, with a fennel-like odor. It is usually viscous like a balsam, but may be quite hard. The true elemis have comparatively low acid and saponification values, and one per cent of ash is the highest limit for a good sample. All varieties are easily soluble; ether, alcohol, chloroform, carbon disulphide, and benzol are effective solvents, benzine and petroleum ether being less so. Elemi is used chiefly to modify the consistency of varnish. It is not employed as a paint medium, and, when added to recently ground colors, gives them the appearance of being covered with frost. Since the so-called ' Dutch Process ' of relining pictures on canvas came into practice early in the XX century, gum elemi has been used in this process as an addition to waxes, its effect being to increase the tackiness of the wax. It is included in a number of formulas given by Plenderleith and Cursiter (pp. 92 and 93).

Emulsions (see also **Egg Yolk, Oils and Fats, Oils, history in painting,** and **Waxes, history in painting**). An emulsion consists of drops of one liquid suspended in another liquid. In most cases there is an actual film around the globules which keeps them from coalescing. With any pair of non-miscible liquids, such as oil and water, there may be two kinds of emulsions, one with drops of oil suspended in water and one with drops of water suspended in oil. The necessary conditions for forming a stable emulsion are that the drops shall be so small that they will stay suspended and that there shall be a sufficiently viscous or plastic film around each to keep the drops from coalescing. An emulsifying agent is a substance which goes into the interface and produces a film having satisfactory physical properties. According to Bancroft's theory, an oil-in-water emulsion is formed if the emulsifying agent at the interface is chiefly in the water phase, and a water-in-oil emulsion is formed if the emulsifying agent at the interface is chiefly in the oil phase. For example, sodium and potassium oleates are water-soluble colloids, and they are excellent for emulsifying oils in water. The gums are also water-soluble colloids and certain ones are much used in pharmaceutical work for emulsifying oils in water. Calcium and magnesium oleates form colloidal solutions in oil and can, therefore, be used to emulsify water in oil; rosin and the resinates behave in the same way. Since sodium oleate emulsifies oil in water and calcium oleate emulsifies water in oil, a mixture will behave according to the relative amounts of

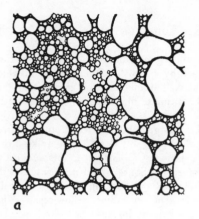
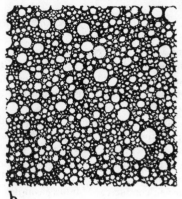

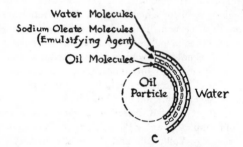

Water Molecules
Sodium Oleate Molecules
(Emulsifying Agent)
Oil Molecules
Oil
Particle
Water

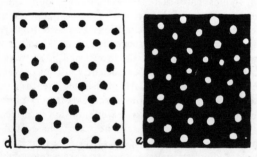

An emulsion of oil and water, made mechanically by stirring, has a pattern approximately like that in *a*; and a similar emulsion, made by an electric mixer, is indicated at *b*. These, as magnified to about 150 diameters, are taken from photomicrographs in *Paints, Varnishes, Lacquers and Colors*, 9th ed. (Washington, D. C.: Institute of Paint and Varnish Research, 1939), by H. A. Gardner, figure 350, page 202. At *c* is illustrated the action of an emulsifying agent in dispersing oil particles in a continuous phase of water. This is taken from a diagram, figure 128, page 327, in *Colloid Chemistry* (Boston: Houghton Mifflin Co., 1939), by Robert J. Hartman. At *d* is diagrammed an oil-in-water emulsion; and at *e* a water-in-oil emulsion. Both are adapted from Hartman, figure 127, page 326.

each present. There will be some ratio of calcium to sodium at which the two oleates will practically balance each other and the slightest relative change will change the type of emulsion. Although most emulsions are made with gelatinous colloids as emulsifying agents, theoretically, this is not necessary. Anything that will go into the interface and make it sufficiently viscous will give the same result. If enough of a fine powder is put into the interface, a plastic mass is formed there which will stabilize the emulsion. It is not always easy to tell by inspection whether water is the external phase or the internal phase in a given emulsion. One way is to examine the emulsion under a microscope while a little water or a little oil is being added. The one that is the external phase will mix readily with the emulsion and the other will not. If the emulsion is not deeply colored, its type may be recognized by means of a few minute crystals of a fat-soluble dye, such as Sudan III or Scarlet R, which are dropped on the surface and give a spreading color to a water-in-oil emulsion but not to an oil-in-water type.

It is not possible to say to what extent emulsions have been used as mediums in painting. Berger interpreted the description of Punic wax given by Pliny (XXI, 49) and by Dioscorides (II, 105) as an emulsion. His theory, however, has been overwhelmingly refuted by the studies of Eibner, Laurie, Schmid, and others. Modern attempts to explain the Flemish method of the XV century, particularly that of the Van Eycks, have brought about, among others, the view that both oil and tempera were used. There is a further difference of opinion, however, as to whether the medium was an emulsion of the two or whether the two were used either alternately or in juxtaposition to produce a final result. Maroger has strongly argued for emulsion as the explanation. It is, of course, possible to emulsify either wax or oil, and many experiments have been made in recent times with both emulsions as painting mediums.

Encaustic (see also **Waxes**) was a method of painting with wax common in ancient times. The word refers, literally, to the process of melting or burning the color into the surface on which it was applied.

Fatty Acids are the organic, aliphatic acids which are combined with glycerine to form fats and oils (see **Oils and Fats**). In most fats and oils there is a small per cent of uncombined, free fatty acid.

Fish Glue is impure gelatin prepared from fish heads, bones, and skins. The pure gelatin from fish bladders is known as isinglass (see also **Gelatin, Glue,** and **Isinglass**). Glue made from the skins is clearest and best. Usually, fish glue is marketed in liquid form but it can sometimes be obtained in the form of cakes or broken sheets which are hygroscopic and readily soluble in water. As a liquid it contains a preservative and sometimes an essential oil like wintergreen or cinnamon to mask the odor. This glue is inferior to animal glues as an adhesive and is more easily spoiled by bacterial decomposition. Alexander says (p. 218) that the joint strength of a common commercial fish glue was only 260 pounds per square inch, but, according to the Forest Products Laboratory (*Technical Note*, F-2), high-grade skin glue should average 1,700 to 1,800 pounds.

Fish Oil shows wide variation. The oil and the films made from it have bad odors and the films suffer from non-uniformity. Although it is ordinarily called a non-drying oil, it will dry when boiled with a siccative. Doerner (p. 114) says that, in spite of all efforts at prevention, it occurs here and there in artists' colors.

Fixative. Any film material, which can be dissolved in low concentration and low viscosity, may be sprayed upon drawings or pastels for the purpose of holding the pigment granules in place. Such a sprayed film, or material capable of being sprayed, is called a ' fixative.' As fixatives are commonly used, however, they include only the natural resins such as mastic, dammar, and bleached shellac (see also **Resins**).

Flour Paste (see also **Starches**). Since flour consists of a mixture of gluten and starch, flour pastes differ materially in their working properties from starch pastes, and pastes made from different varieties of flour also differ among themselves. Wheat flour and rye flour are the ones most commonly used, but rice flour is often made into paste and some mixtures contain corn, barley, or buckwheat. Besides the simple preparation of paste by cooking flour in water, there are other methods which result in a partial breaking down of the flour molecules by means of fermentation or heat. For example, in one process mentioned by Alexander (Walton, p. 177) flour and water are mixed to form a dough which is fermented at 110° F. and then is cooked, dried, and pulverized. The powder may be kept indefinitely without deterioration and be used for a paste when desired. Fermenting pastes of flour are known to be used for mounting in Japan. In another process flour is heated under steam pressure with about five times its weight of water and, when partly cooled, has a quantity of raw flour added. Dextrin may be used in place of the cooked flour.

For certain purposes, the flour can often be advantageously combined with other materials. For securing paper, leather, etc., to metals, Alexander (*loc. cit.*) gives the following directions. Ten pounds of animal glue are melted in 3 gallons of water at a moderate heat. Twenty pounds of rye flour are then mixed with 4½ gallons of cold water and 8 pounds of acetic acid are added; the whole is poured into the melted glue and boiled. Doerner (p. 226) says that many tempera recipes used in commercial art are based on rye-paste emulsion, which, for such a purpose, is combined with a glue solution and boiled linseed oil. He gives a trade recipe which has been found useful by different artists in the painting of large, decorative surfaces: Rye flour, 125 g., is mixed with 50 cc. warm water and to this are added 100 cc. of cold water. After these are thoroughly mixed, 300 cc. of boiling water are put in and then 125 cc. of boiled linseed oil. This is followed by 100 cc. of cold water and 125 cc. of boiled linseed oil. The whole mixture is then given an optional thinning with water.

Formogelatin (see **Gelatin**). When gelatin solutions, especially concentrated solutions or those containing free alkali, are treated with formaldehyde, the gelatin is converted, upon drying, into an insoluble substance known as formogelatin,

which seems to be a compound of formaldehyde with gelatin. The formogelatin is decomposed by repeated washing with boiling water, by heating to 110° C., and by cold 15 per cent hydrochloric acid. Although formogelatin is nearly insoluble and swells much less in water than does untreated gelatin, it is not, strictly speaking, a very water-resistant adhesive. Bogue (p. 319) says that joints made from it fail to retain their strength when subjected to drastic treatment with either cold or hot water. Casein and blood albumin glues are much more highly water-resistant.

Gelatin (see also **Glue** and **Tempera**) belongs to the complicated class of organic compounds known as proteins and is composed of carbon, hydrogen, oxygen, and nitrogen. Its exact composition is not known but, like all proteins, it is made up of large molecules of high molecular weight. Though an animal product, it is not itself found in the animal organism, except under pathological conditions. The parent substance of gelatin is collagen, of which the organic material of the bones, the tendons, the cartilage, and the skin is largely comprised. Gelatin is slowly formed from collagen by heating that in water to 80° or 90° C. It is a nearly colorless, transparent, amorphous substance. In its normal, dry state, in which it still retains 15 to 18 per cent of water, it is flexible and horny, and has a slight yellow cast. Precipitated from alcohol or from salts, it is pure white and nearly water-free.

Gelatin is a typical colloid of the emulsoid type, and the viscosity of its solutions is high and variable with slight alterations in temperature, concentration, hydrogen-ion concentration, etc. It swells to many times its normal volume when immersed in cold water or in dilute acids or alkalis; a slightly acid solution is the most favorable for maximum swelling. Above 35° C., the swollen jelly goes readily into solution. A firm jelly is formed when a solution containing 1 or more per cent of gelatin is allowed to stand at 10° C. Gelatin, either pure or in the impure form known as glue, is used extensively as an adhesive.

Glair (see also **Tempera** and **Egg Tempera**) is the white of egg (see **Egg White**) and is a term now largely employed with reference to the painting medium prepared from this substance.

Glaze. When the quantity of medium is so great in relation to the quantity of pigment that light is refracted through the film produced by the mixture of these two and is reflected from the surface beneath it, such a film is commonly called a ' glaze.' The term has no precise meaning but usually indicates a coating in which there is some pigment content. Its main characteristic is transparency. When the pigment used is opaque and pale, films of this general type are called ' scumbles.'

Glue (see also **Gelatin** and **Tempera**) is an adhesive consisting largely of gelatin, but the collagen from which gelatin or glue is prepared is invariably associated with other protein material such as keratin, elastin, mucin, chondrin, etc., in addition to non-protein, organic material and inorganic salts which may or may not remain in the glue. Glue and gelatin merge into one another by im-

perceptible degrees. The difference is one of purity: the more impure form is termed ' glue ' and is used only as an adhesive; the purer form, termed ' gelatin ' or 'size,' is used when an especially fine adhesive or a medium is required, and it has other uses—in foods, in photography, etc. Generally, it is customary to use the word ' size ' to indicate a nearly pure gelatin. Glue is an organic, colloidal substance of varying appearance, chemical constitution, and physical properties. It occurs in commerce in a wide variety of forms and colors. The colors range through all shades of white, yellow, and brown and glue may be transparent, translucent, or opaque. Gelatinous or glue-forming tissues occur in the bones, skins, and intestines of all animals. These agglutinating materials are removed by extraction with hot water, and the solution, on evaporation and cooling, yields a jelly-like substance—gelatin or glue. Glue is prepared from fish bones, skins, or bladders which give impure forms of bone gelatin, skin gelatin, and isinglass. Parchment size is made from parchment waste.

When glue is soaked for some time in cold water, it softens and swells without dissolving, and, when again dried, should resume its original properties. When gently heated, it dissolves entirely in water, forming a thick, syrupy liquid with a characteristic but not disagreeable odor. Remelted glue is not so strong as that which is freshly prepared; and newly manufactured glue is inferior to a glue which has been in stock for some time. Glue loses strength continuously under the action of heat, and it is better to heat successive small amounts rather than to have a large lot cooking for a relatively long period. All glue solutions putrefy with time and lose their adhesive power. The following table (*cf.*, *Encyclopedia Britannica*, 11th ed., p. 143) shows the holding power of glued joints with various kinds of wood:

WOOD	POUNDS PER SQUARE INCH	
	With grain	Against grain
Beech	852	434.5
Maple	484	346
Oak	704	302
Fir	605	152

The word ' glue ' has been extended to many other substances that are not glue at all. Solutions of gums, dextrins, converted starches, etc., are often called glues, generally modified by the adjective, ' vegetable.' Silicate of soda is called ' mineral glue '; solutions of rubber, asphaltum, and the like, in benzene or naphtha, are called ' marine glue '; and those of casein are called ' casein glue.'

Glue is used extensively in painting grounds. Gesso is a thick, white, water paint, with chalk or gypsum as the inert material, and glue or gelatin as the binding medium. In mediaeval painting, size was sometimes used as a medium in books, especially for blues which often had to be laid quite thickly, and it was important to have a strong binding medium which would not be too brittle when

used in quantity. Doerner (p. 303) says that glue-color painting is very useful for decorative work. Glue-color is easily soluble in water, but spraying it with a 4 per cent formalin solution will render it less soluble (see **Formogelatin**). Wax soap is often applied for the same purpose. For use in painting, glue can be emulsified alone or it can be used as an addition to egg and gum tempera.

Among the stone carvings of the ancient city of Thebes, at the time of Thothmes III, the Pharaoh of Exodus, on a stone at least 3,300 years old, there is a representation of the process of gluing a thin piece to a yellow plank of sycamore. A glue pot and brush are shown, together with a chunk of glue that has a characteristic concave fracture. Such a piece of glue, which had originally been rectangular but had dried, was found in the tomb of Queen Hatshepsut (XVIII dynasty). Glue is mentioned in the *Bible* in Ecclesiastes, XXII, 7: ' He that teacheth a fool is like one that glueth a potsherd together.' Pliny refers to it with gums, milk, eggs, and wax, as a vehicle for the paints of the ancient Egyptians. During the Middle Ages glue was used extensively, and old MSS give directions for its preparation. In the MS. of Jehan le Begue (Merrifield, I, 148) is given a detailed recipe for the preparation of glue from the skin of an ox or cow. It is described as a mordant for powdered tin. In the Bolognese MS. (Merrifield, II, 466) it is mentioned in connection with gilding. Cennino Cennini (see Thompson, *The Craftsman's Handbook*, p. 67) gives recipes for its preparation and speaks of a glue which is made of the clippings of the muzzles of goats, feet sinews, and many clippings of skins.

The earliest practical manufacture of glue that can be directly traced from the present day was in Holland at the time of William III. It was evidently made there in 1690, and shortly after was introduced into England and established as one of the permanent industries by about 1700. In France, the industry started in the vicinity of Lyons, and for many years these factories were the most important of their kind in Europe.

Glycerides are esters of glycerol. Oils and fats are glycerine esters of the fatty acids, *i.e.*, they are glycerides (see **Oils and Fats**).

Glycerine, or **Glycerol,** is the trihydroxy alcohol ($C_3H_5(OH)_3$) which is combined with various fatty acids to form oils and fats, 1 molecule of glycerine being combined with 3 molecules of fatty acid to form 1 molecule of an oil or fat (see **Oils and Fats**). Free glycerine, or glycerol, is a syrupy, hygroscopic liquid used as a plasticizer for aqueous mediums (see also **Gum Arabic**).

Gouache (see also **Gums**) is actually a water color or a gum tempera and the word is used more to describe the opacity obtained with such paints than to define any particular difference of original material. Like water color, it is ordinarily applied on a paper support, but less thinly than water color and with mixed tints of white and color rather than with transparencies of color.

Gum Arabic (see also **Gums** and **Tempera**) is produced by several species of *Acacia* growing in Africa, India, and Australia. The gum from *Acacia arabica*

Willd. is inferior to that produced by *Acacia Senegal*, and is little used for artistic purposes. The good gum is variously known as Kordofan, picked Turkey, white Senaar, and Senegal gum. The tree, called by the natives, 'hashab,' grows chiefly in the Sudan and Senegal, sometimes attaining a height of twenty feet. The gum exudes naturally and is slightly darker and less valuable than is that from the cultivated trees. Gum arabic—Kordofan or Senegal—appears on the market in the form of rounded 'tears,' either colorless or slightly yellow. The lumps are brittle and break with a vitreous fracture, exposing a transparent interior, colorless in the finer grades. Senegal gum, which Church (p. 79) considers the only sort that ought to be employed in painting, should leave no appreciable residue when dissolved in cold water. It should be clear, giving no color with tincture of iodine. If a reddish purple color results, the gum has probably been adulterated with dextrin.

To prepare gum arabic for use, according to Church (p. 80), it is finely powdered and slowly stirred into boiling, distilled water, the proportions being one measure of the powdered gum to two of water. The solution should stand for at least a day, and then be decanted from any sediment into a wide-mouthed bottle covered with a glass cap. The addition of a lump of camphor, a few drops of eugenol, or β-naphthol, makes an effective preservative. Gum solutions may be emulsified by a fatty oil (see **Emulsions**), and a small amount of glycerine (not more than 5 per cent) may be added to the emulsion to eliminate brittleness. Gum emulsions are sometimes used in the manufacture of water colors.

Gum Tragacanth (see also **Gums**) is produced by leguminous shrubs belonging to the genus *Astragalus*. It consists of a small quantity of gum soluble in water, a little starch and cellulose, and a large proportion of a mucilaginous substance which swells in cold water but does not dissolve. This latter constituent is a complex compound of carbon, hydrogen, and oxygen, called 'bassorin.' Gum tragacanth contains 12 to 15 per cent of water, and leaves 2 to 3 per cent of ash when burned. It may be prepared for use by placing some finely powdered gum in a bottle, wetting it with alcohol, and then adding the required amount of water, with shaking at intervals. Only 2 or 3 per cent of the gum makes a thick solution. Unlike gum arabic, which dissolves in water, gum tragacanth swells, forming a mucilaginous mass which must be strained through a cloth. A uniform consistency is difficult to obtain. Gum tragacanth may be used as a medium for painting on linen. It must be applied thinly and the painting left unvarnished for some time. Its principal use, however, is as a binder in the manufacture of pastel crayons.

Gums (see also **Tempera**). A group of non-crystalline, structureless materials, occurring widely in plants, composed mainly of carbon, hydrogen, and oxygen, and forming viscous solutions or mucilages, is given this general name. Their chief characteristic is that they dissolve in water, forming a clear solution, or swell when they are soaked in water. This differentiates them from resins which are sometimes misleadingly called by the same name. Gums differ, also, from gelatins,

glues, and proteins, which form similar mucilaginous solutions, in that the latter are definitely nitrogenous bodies, while the gums contain practically no nitrogen. They are insoluble in alcohol, do not melt but char on heating, and do not give off a nitrogenous odor. The one chiefly used for a painting medium is gum arabic; gum tragacanth and cherry gum are of less importance.

With the exception of gum arabic, the chemistry of plant gums has not been very thoroughly studied. The plant gums are salts of complex, organic acids, usually with calcium, magnesium, and potassium. The complex acids are built up of sugar units in combination with the acidic part of the molecule. C. L. Butler and L. H. Cretcher (' The Composition of Gum Arabic,' *Journal of the American Chemical Society*, LI [1929], pp. 1519–1525) have identified rhamnose, *d*-galactose, and *l*-arabinose in the sugar fraction of the hydrolysis product of gum arabic. Calcium, which is the principal metal of this gum, is present as the salt of aldo-bionic acid. The solution of gum arabic may be precipitated by basic lead acetate, and it is thickened or rendered turbid by the addition of solutions of borates, ferric salts, or alkaline silicates. Mixtures of copper sulphate and sodium hydroxide, and of neutral ferric chloride and alcohol are valuable confirmatory tests. Gum arabic yields about 3 per cent ash, consisting of calcium, magnesium, and potassium carbonates. The percentage of moisture varies with the different varieties of the gum. Senegal gum contains more moisture (16.1 per cent) than the Sudan gums, which may make it a superior product, although the Sudan gums are lighter in color.

As sizing materials and as tempera mediums, gums have probably been used for a long time. In chapter XXVII of the *Schedula diversarum artium* of Theophilus, early XII century, there is an account of the use of gum in place of sun-dried oil (see Laurie, *Materials of the Painter's Craft*, p. 164). Jehan le Begue (Merrifield, I, 284) describes the preparation of a rose color in which powdered *brixillium* is ground with a gum water made of two thirds gum arabic and one third clear water. And there is good evidence that long before this it had been a medium common in the practice of classical painting.

Hempseed Oil. Hemp (*Cannabis sativa*) is cultivated in Western Europe, in North America, and in Japan. The oil from its seed is greenish in color and is slow-drying; it also wrinkles badly and has a somewhat greasy texture.

Honey (see also **Tempera**) has been used from early times as an addition to water-soluble mediums, such as gum arabic or size or glair, and as late as the XIX century was a common ingredient in moist water colors. By retaining a certain amount of water, it had the effect of keeping these materials from becoming brittle through extreme dryness. It is made up of two sugars, dextrose and levulose, with other compounds, and about 20 per cent of water. Church (pp. 82–83) recommends that a solution of levulose be prepared from pure honey and used instead of the more complex substance. In modern practice, small quantities of glycerine take the place of honey in aqueous mediums.

Hydrolyzed Oils are oils or fats (see **Oils and Fats**) which have been split up by the action of water under suitable conditions, glycerine and fatty acids being formed in the process.

Isinglass is a very pure fish gelatin (see also **Gelatin** and **Fish Glue**). It is yielded by the sounds (swim bladders) of a limited number of fish, chiefly the sturgeon, which, for centuries, has been the main source of the celebrated Russian isinglass. North American isinglass comes mainly from the hake, but some is obtained from the cod. It is nearly pure collagen. Alexander says (p. 221) that, when soaked in cold water, it swells greatly without losing its organized, fibrous, thread-like structure, but that boiling converts it into gelatin which, probably because of the ease of its formation, yields a very strong jelly. It was formerly used as an adhesive much more generally than it is at present. Thin, transparent sheets of the mineral, mica, are often wrongly called ' isinglass.'

Japan Wax is prepared from the berries of various species of the sumach tree (*Rhus*) which is cultivated in Japan and China for the lacquer it yields. The wax is a by-product. The berries yield 15 to 25 per cent of wax which occurs on them as a greenish coating. They are gathered and stored until ' ripe,' and are then crushed and the kernels are separated. The remaining crude wax is pressed in wedge presses and is purified by remelting and sun-bleaching, the wax being kept moist during the process. It is pale yellow or light brown in color with a pronounced and characteristic odor. It acquires a white, powdery surface. Its melting point varies from 48° to 55° C., that usually found being 53°; the wax solidifies again at about 41°, and, when recently solidified, melts at 42° and only slowly regains its original melting point. Its iodine value is low; Fryer and Weston (p. 156) give the average value of 6. It is readily soluble in benzene and petroleum ether, and is sparingly soluble in cold ether; it is insoluble in cold alcohol, but dissolves on warming and separates again on cooling. It is of hard and brittle consistency with a conchoidal fracture. Physically, it resembles bleached beeswax. Since it is similar to the waxes in physical properties, it is called a wax, and some writers classify it with them. From a chemical standpoint, however, the term ' wax ' is, of course, a misnomer for it, as it consists largely of palmitin and free palmitic acid together with a small proportion (less than 1 per cent) of dibasic acids (*e.g.*, japanic acid, $C_{22}H_{42}O_2$), and probably some soluble acids. (See also **Oils and Fats**.)

Kauri (see also **Copal**). The tree which produces this resin is a conifer, *Agathis australis*, growing to an immense height and age on the north island of New Zealand. It is easily ' run ' and combined with oil, and the better grades make a very good varnish for industrial purposes. It is believed by some to be inferior in hardness and durability to Sierra Leone or Zanzibar copal varnishes. On the other hand, certain investigations on 'blooming' tend to show that varnishes correctly made from Kauri do not bloom in the most humid atmosphere.

Lac (see also **Resins** and **Shellac**). This resin is not a natural exudate from a tree but is produced by an insect belonging to the *Coccidae* or scale insect family, *Tacchardia lacca*. Like the cochineal insect, these produce a red dye which was formerly valued both in India and in Europe. The tree, *Butea frondosa* Roxb., which is still one of the most important hosts, is referred to in Sanskrit writings as 'Lakshatarn, the tree which nourishes a hundred thousand insects,' and in the writings of Ælian, about 250 A.D., there is reference to the insect yielding a red coloring matter. Mention of the use of lac in varnish is made in the 'Ami-Akbari,' 1590 A.D., which tells of the decorating of the imperial palace. The dye was used in Spain and in Provence as early as 1220, and is mentioned in recipes for rose-colored lake. The Paduan MS. (Merrifield, II, 688) speaks of the colorless resin left after the extraction of the dye, but apparently its use as a varnish ingredient was unknown in Europe until the XVI century.

The insect attaches itself to various trees of the acacia family (particularly *Ficus religiosa* Linn.) for feeding and breeding. Both hard- and soft-woods may act as hosts, but generally soft, non-resinous trees are preferred. The insects fasten themselves to twigs and branches and produce a scaly covering consisting of an amber-like material which is the basis of shellac varnish. The secretion forms a kind of cocoon, and as the separate exudations coalesce, a continuous layer is deposited over the twig. This resinous secretion is collected in June and November and is dried and ground. It is then washed free of coloring matter and is filtered and dried quickly, for it grows dark on exposure. The lac is graded as to size and the largest particles, ' seed-lac,' go to make the best grade of shellac varnish (see **Shellac**). Lac, dyed yellow, is used in the East Indies for ornaments. It is an important ingredient in sealing-wax. At present, the largest portion of the total lac production is taken by the electrical and gramophone industries.

Lacquer (see also **Resins**) is a broadly used term. It has been applied to paints or varnishes that dry with a high gloss. It has been applied, also, to coatings made from shellac. In modern commercial usage it indicates a coating material that dries by evaporation of the solvent. Coatings made from synthetic resins and cellulose derivatives are commonly known in the trade as lacquers. Such coatings are usually clear but they may be pigmented or dyed.

More strictly, and in the fine arts, ' lacquer ' is used for a natural resinous exudation from the tree, *Rhus Vernicifera* DC. In China, where the art of lac-quering originated, the tree is called *Tsichou* (varnish tree) and in Japan, where the art was imported and reached its highest development, it is known as *Urushi No-Ki*. There are other lacquers from Burma, Indo-China, and Formosa. These are like the Chinese and Japanese variety, though Burmese lacquer dries more slowly and is said to be free from the irritating effect on the skin, which is the European worker's objection to the Japanese product. The tree, indigenous to China and cultivated in Japan at least since the VI century, is tapped when about ten years old, horizontal incisions being made in the bark. The resin is a

milky liquid which rapidly thickens and darkens on exposure to air. It can be kept in closed containers without change for a considerable length of time. On standing, it separates into two layers, the top, of superior quality, being filtered, slightly heated, and thinned before it is used.

Secrecy surrounded the methods of making and working lacquer, and it is only recently that its composition and the art of its manufacture and application have been generally known and studied. When used as a furniture varnish, it can be applied in extremely thin coats. It has the unique quality of attaining extreme hardness in the presence of moisture. It does not become brittle, and can be highly polished. It affords permanent protection as it is unaffected by acids, alkalis, alcohol, or heat up to about 160° C. It may be dried either in a moist chamber at temperatures below 20° C., which takes several days, or at 100° to 200° C., which takes only a few hours. Moisture and temperature are both important. In drying at low temperatures, evaporation is increased with the amount of moisture present. The loss of weight from evaporation occurs before the film begins to set, and then an increase in weight, from oxidation, is noticed. As moisture accelerates the drying process, it has been suggested that it acts as an oxygen carrier and also provides a suitable medium for the action of the oxidase enzyme, ' laccase.' At a temperature above 63° C., laccase ceases to be active, and the drying occurs by oxidation. When lacquer is mixed with Chinese wood oil (80 per cent lacquer to 20 per cent bodied oil) it dries more slowly than lacquer alone, but is satisfactory, for the oil gives the mixture a high gloss, and the lacquer prevents the oil from forming a wrinkled film.

According to the findings of Majima and Tahara (see Barry, pp. 141–142), lacquer contains 90 per cent urushiol and 10 per cent hydro-urushiol. Chinese lacquer was found by Majima to have a lower percentage, possibly because of inferior methods of cultivation or of climatic differences. Yoshida lists the composition as follows:

Urushic acid	85.15 per cent
Gum.........................	3.15 " "
Nitrogenous matter.............	2.28 " "
Volatile and water.............	9.42 " "

Its density is 1.002. Tschirch, in his investigations, found that an oily, non-volatile substance, which was soluble in petroleum ether, was responsible for the skin poisoning which affects lacquer workers.

Lanolin (see **Wool Wax**).

Linoxyn (see also **Oils and Fats**) is oxidized linseed oil. This comprises a colloidal system which is by no means a simple mixture of organic compounds. In its simplest terms it must be looked upon as a conglomerate of unsaturated glycerides which have partially or completely undergone addition of a molecule of oxygen at each double bond, together with the unsaturated glycerides which

have not added oxygen, any saturated glycerides originally present in the oil, and small amounts of other compounds formed by slight decomposition and further oxidation of the first oxygen-addition product. At present, it is widely held that linoxyn consists, physically, of a continuous lattice-work of oxidized glyceride molecules enclosing the liquid (unchanged) glycerides, the whole forming a perfectly homogeneous, solid jelly (Hilditch, p. 391).

Linseed Oil, the most important of the vegetable drying oils, is obtained from the seeds of the flax (*Linum usitatissimum*), the same plant that furnishes linen fibre. The content of oil varies with the source and the season. An average is 35 to 40 per cent. The oil is obtained almost entirely by expression rather than by solvents, for the oil cake is of great value in cattle-feeding. Cold expression yields the better oil. This is edible, has a pleasant flavor, and a bright, golden yellow color. Most of the oil in commerce, however, is hot-pressed. This method yields a light brown oil which is slightly turbid, owing to albuminous and extractive substances and to moisture. Artists' oils are generally obtained by cold expression. Linseed oil may be refined chemically, by washing, or by simply allowing impurities to settle. The three standard methods of chemical refining are: (1) with concentrated sulphuric acid, (2) with alkali (sodium hydroxide or carbonate), and (3) with brine (see **Oils, refining**). The alkali refined oils are more desirable and more expensive. If an oil is used as a grinding medium, free fatty acid should be present, for the neutral oils wet pigments with difficulty (see **Oils, relation to pigments**). Artists' oils are usually bleached by exposure to sunlight. Doerner (p. 101) objects to bleaching, for he says that it does not last and that it is better if the inevitable yellow tone is taken into account from the outset. Further bleaching can be obtained by chemical means.

Linseed oil has a faint but distinctive odor. Its iodine value (see **Oils and Fats**) varies from 170 to 195, being highest in Baltic oil which is from the purest seeds. The iodine number in this is the highest of those of known fatty oils, except perilla. The chemical composition of linseed oil, like that of the other vegetable drying oils, is not fully established. It is essentially composed of mixed triglycerides of linolenic, linoleic, oleic, and stearic acids with small amounts of other acids, *e.g.*, palmitic. It also contains approximately 1 to 1.5 per cent of materials classified as unsaponifiable matter. Proportions of the four main types of acids vary according to origin and to conditions of growth. Long (' Drying Oils ') gives the following percentages in North American and South American seeds: saturated acids (stearic and palmitic), 4.8 to 9.0 per cent; oleic, 13.2 to 16.0 per cent; linoleic, 37.9 to 45.0 per cent; linolenic, 36.4 to 40.3 per cent; unsaponifiable matter, 1.05 to 1.4 per cent. Linseed oil is the one commonly used for grinding oil colors, as an additional painting medium, and as an ingredient in emulsions and in varnishes.

Manilla (see also **Copal**). This name came into use because the Philippines was the first principal region to ship copal resin to the European varnish manu-

facturers. Now only a small amount is collected in these islands. The bulk of it comes from the Dutch East Indies, more than 75 per cent being estimated as shipped from Macassar. It passes through many hands before its final shipment, and it is probably adulterated to a considerable degree. This would account for the many different properties ascribed by authorities to Manilla copal and the difficulties in tracing a sample's origin. The wide varieties of commercial grades come from the tree, *Agathis alba* (Lam.) Foxw., growing to a height of two hundred feet, nearly that of the Kauri pine of New Zealand. Manilla is a soft copal, and makes a less durable varnish than the hard varieties.

Mastic (see also **Resins** and **Varnish**) is a resin used chiefly in varnishes for oil paintings. It comes from the tree, *Pistacia Lentiscus*, which grows in the Greek Archipelago. It is also found in Portugal, Morocco, and the Canary Islands, but, since the days of Dioscorides, commercial production has been almost exclusively confined to the island of Chios. The trees are small and the resin, contained in the bark rather than in the wood, is collected from numerous vertical incisions. Mastic appears commercially in small, pea-like, transparent 'tears,' of a pale straw color. It is very fragile, and has an aromatic odor. Its melting point is very low (95° C.), its specific gravity is 1.074, and, besides resinous constituents, it has a small quantity of essential oil and moisture. It is almost entirely soluble in alcohol, ether, chloroform, and ethereal oils, but the greater part is insoluble in petroleum spirit.

Mastic, as well as dammar, may be used as a varnish ingredient, for certain purposes as a paint medium, and as an addition to oil colors. The varnish produced with mastic is light-colored, glossy, and elastic. It yellows with age, becomes fragile and fissured, and blooms readily in a moist atmosphere. From old recipes it seems probable that the varnish most widely used from the IX till the late XV century was made by dissolving mastic, or both mastic and sandarac, in linseed oil, often with the addition of a considerable quantity of *pica greca*, or colophony. Today mastic is primarily used in spirit varnishes. A mastic-turpentine solution is most common because it does not dissolve dry paint. To increase its elasticity, elemi resin, linseed oil, or Venice turpentine is sometimes added (see **Megilp**). Doerner (p. 130) recommends the following proportions: for a picture varnish and painting medium, 1 part of mastic is dissolved in 3 parts rectified or doubly rectified oil of turpentine. For a tempera emulsion, the proportions are 1 : 2. The commercial mastic varnishes are usually prepared by dissolving the resin in hot oil of turpentine. They are sticky and very yellow, characteristics which, according to Doerner, come from the method of preparation as well as from the probable use of inferior resin. He maintains that cold-prepared varnishes are almost colorless and remain so. Mastic and sandarac are easily confused. Mastic, however, softens when chewed, whereas sandarac powders. The colors, also, are different, sandarac becoming darker and redder with age.

Mat Varnish (see also **Resins** and **Waxes**) is usually prepared by adding white, purified beeswax, dissolved in turpentine, in the proportions of 1 : 3, to mastic or dammar resin.

Medium is the word usually applied to the binding material or vehicle that holds together pigment particles in paint. The relation of the quantities of these two principal ingredients of the paint film has been studied, particularly with regard to oils (see **Oils, relation to pigments**). Frequently the word is mistakenly used to name a fluid which has no film-forming properties but is added actually as a diluent. Examples of this are turpentine, commonly used with oil, or water used with tempera.

Megilp (see also **Mastic**) is a paint medium made by dissolving mastic resin in turpentine, with the addition of linseed oil. This medium, which is gelatinous in consistency, has been used by artists on account of its excellent working qualities. It gives an enamel-like effect but becomes brittle and yellow with age.

Methacrylate Resins (see **Acrylic Resins**).

Mineral Oils are not oils at all in the sense that artists' oils are (see **Oils and Fats**). They are hydrocarbons (compounds of carbon and hydrogen) obtained in the distillation of petroleum. They are not used in painting, except rarely as plasticizers for some resins.

Mineral Waxes are all unsaponifiable on treatment with caustic alkalis; they contain no alcohols, but consist entirely of hydrocarbons. They occur in the earth's crust and may be divided into (1) those obtained by distillation—paraffin wax from petroleum and shale, and (2) those obtained by direct mining—ozokerite. (See also **Waxes**.)

Montan Wax (see also **Waxes**) is obtained from lignite or peat by extraction with petroleum ether or similar solvents. It is a material of high but variable melting point and is largely used for the same purposes as carnauba wax. Samples from different sources show different composition, but all contain esters of montanic acid ($C_{27}H_{55}COOH$) and, also, the free acid. The alcoholic components have not as yet been clearly characterized; there is always a certain amount of hydrocarbon also present.

Mordant is the adhesive film which, in a tacky state, is used to catch and hold gold leaf laid over it. Concerning the origin of mordant gilding, Thompson (*The Materials of Medieval Painting*, p. 202) says:

> Quite early in the Middle Ages, certainly before the twelfth century (when documentary evidence first begins to be common), someone found that if he made a mark with gum or glair on parchment, and clapped a bit of gold leaf on it before the mark was dry, the gold would stick, and when it was dry it could be burnished bright. From this it followed that he could write a letter with some sticky material and put leaf on it and burnish it, and get something like the effect produced by writing with gold ink.

The gum or glair would make a water mordant. Frequently with them an inert material, like bole or slaked plaster of Paris, was added to give bulk. Later, mixtures of oil and resin with pigment were used for the same purpose (see Thompson, *op. cit.*, pp. 226–228).

Non-Drying Oils (see also **Oils and Fats**). Vegetable, non-drying oils are characterized by the preponderance of glycerides of acids absorbing two atoms of iodine to the practical exclusion of glycerides of acids absorbing 4 or 6 atoms of iodine. The iodine numbers range from about 100 to 80. These oils thicken at elevated temperatures but they do not dry to a skin, even on long exposure. Fryer and Weston (pp. 135–143) list the following oils as non-drying: ravison oil, rape oil, mustard oil, jamba oil, the kernel oils, almond oil, arachis oil, rice oil, olive oil, and castor oil.

Oils and Fats. Oils and fats belong to the class of chemical compounds known as esters. They are essentially the glycerol esters of aliphatic acids (see **Fatty Acids**) and, to a large extent, acids of the eighteen carbon series. Fats and oils, however, being natural products, contain varying amounts of impurities, substances that occur in the seeds along with the fats; small amounts of these are squeezed out or extracted along with the fat or oil. Most of such impurities are, of course, removed during the refining process (see **Oils, refining**), but small quantities are retained. The impurities are called 'unsaponifiable matter.' Most important are phytosterol ($C_{27}H_{45}OH$) and its isomer, cholesterol. The former occurs in all oils and fats of vegetable origin; the latter is characteristic of all oils and fats of animal origin. Chemically, there is no distinction between oils and fats but, popularly, the term 'oil' is used to denote the substances that are liquid at ordinary temperatures and the term 'fat' is used to denote those that are semisolid or solid, and typically greasy to the touch.

When oils and fats are treated with steam under pressure, they split up, glycerine and a mixture of fatty acids are produced, and the elements of water are absorbed. This process of splitting and absorption of water is termed 'hydrolysis' (see also **Hydrolyzed Oils**). There are five principal series of fatty acids:

1. The stearic acid series, all saturated.
2. The oleic acid series, one double bond.
3. The linoleic acid series, two double bonds.
4. The linolenic acid series, three double bonds.
5. The clupanodonic acid series, more than three double bonds.

Practically, the saturated fatty acids are distinguished from the unsaturated by the fact that the unsaturated acids can combine directly with iodine while the saturated can not. One molecule of an unsaturated fatty acid is able to combine directly with 2, 4, 6 or more atoms of iodine according as it contains 1, 2, 3 or more double linkages. As oils and fats differ chiefly in the amount of unsaturated fatty acids which they yield, the most discriminative results are obtained by a determination of this figure. The iodine value or number is usually the percentage

of iodine chloride, calculated as iodine, which is capable of being absorbed by the substance.

The principal acids occurring in fats and oils are:

NAME	FORMULA	DOUBLE BONDS	OCCURRENCE
Palmitic	$C_{16}H_{32}O_2$	0	Widely distributed; probably the most abundant of the natural fatty acids.
Stearic	$C_{18}H_{36}O_2$	0	Widely distributed but not present in large amounts in most fats and oils.
Oleic	$C_{18}H_{34}O_2$	1	Present in most fats and oils.
Linoleic	$C_{18}H_{32}O_2$	2	Present in most fats and oils.
Eleostearic	$C_{18}H_{32}O_2$	2	Present mainly in tung oil.
Linolenic	$C_{18}H_{30}O_2$	3	Present mainly in linseed and perilla oil.

The saturated and unsaturated fatty acids consist of long chains of carbon atoms strung together with an acidic or carboxyl ($-COOH$) group at one end of the molecule. In nearly all cases each carbon atom is attached only to two other carbon atoms, the remaining valences being satisfied by hydrogen atoms or left in some cases unsatisfied (ethylenic linkage or double bond). The majority of the fatty acids are thus ' straight-chain,' aliphatic compounds; either branched-chain or closed-chain fatty acids are exceptional. Another curious and striking feature of the natural fatty acids is that, almost, and perhaps entirely, without exception, they contain an even number of carbon atoms. Since one molecule of glycerine is combined with three molecules of fatty acid, either simple triglycerides, where all the fatty acid radicals are alike, or mixed triglycerides, consisting of two or three different fatty acid constituents, are possible. It is unusual to find any simple triglyceride in a vegetable oil unless a considerable excess of one fatty acid is present. Various mixed triglycerides, dilinoleo-linolenin, oleo-linoleo-linolenin, etc., have been obtained from linseed oil but there is no evidence of the presence of simple glycerides such as triolein. In the case of tung oil, which contains 75 to 85 per cent of eleostearic acid, the triglyceride of this acid can be separated, the remaining acids presumably being present in the form of mixed glycerides.

The accompanying table gives the source and some of the more important analytical characteristics of the principal drying oils. The specific gravity is the ratio of the mass (weight) of the oil to the mass of an equal volume of water at 4° C. The oils are all lighter than water; their specific gravities do not vary widely. The refractive power of oils varies more and is chiefly governed by the proportion and degree of unsaturated matter present. Both the saponification number and the acid number depend on the amount of acid present; the saponification number is a measure of the amount of combined acid, i.e., glyceride, and the acid number is a measure of the amount of free acid. Numerically, the saponification number is the number of milligrams of caustic alkali (KOH) required to saponify (see

Saponified Oils) one gram of the fatty material; and the acid number is the number of milligrams of caustic alkali required exactly to neutralize the free acidity of 1 gram of the material. The meaning of the iodine number is explained above.

Oils, drying process. Drying oils (see **Oils and Fats**) are suitable vehicles for pigments and for mixture with resins because of two distinct processes which occur in them when they are exposed to heat or to the action of atmospheric oxygen: (1) A thickening occurs, and, in certain cases, the oil becomes a jelly (gelation). This is undoubtedly from some kind of association or polymerization of the molecules, and takes place when the oil is heated for a time at a temperature of about 250° C. (See **Polymerized Oil.**) (2) When a drying oil is exposed to air it becomes a solid, rubbery mass or, if exposed in thin layers, it becomes a clear, hard solid. There are two principal processes recognized in this ' drying ' of an oil, namely, oxidation and subsequent polymerization of the oxidation product to form aggregates of high molecular weight. The oxidation is effected by the addition of oxygen to the unsaturated glycerides without any great amount of molecular disruption. The ' drying ' of oils is imperfectly understood. For linseed oil, there exists the largest amount of experimental data, but the process for all ' drying ' oils is essentially the same.

When exposed to air, linseed oil absorbs oxygen, first slowly, then, for a time, more rapidly. After that, the rate progressively diminishes as the process nears completion. At ordinary temperatures the period of induction is from one to three days, and the process is complete in about twenty to thirty days; at 100° C. the whole process occupies only six or seven hours and the induction period is less than half an hour. If a small percentage (about 0.1 to 0.3 per cent as metal) of certain salts such as lead, manganese, or cobalt linoleates or resinates (abietates) are present in the linseed oil, the oxidation period is greatly shortened; this is mainly because the induction period is eliminated and oxygen absorption sets in immediately at its maximum rate. The weight increase of the oil film on ' drying ' is from oxygen absorption less the diminution resulting from the escape of volatile products of decomposition. The true oxygen absorption is about 28.7 per cent of the original weight of the oil and the primary process is one of addition of a molecule of oxygen at each ethylenic linkage or double bond. In the case of trilinolein, the first product of the action is apparently a substance of the formula,

$$(CH_3(CH_2)_4 \cdot \overset{\lceil O-O \rceil}{CH \cdot CH} \cdot CH_2 \cdot \overset{\lceil O-O \rceil}{CH \cdot CH} \cdot (CH_2)_7 COO)_3 C_3 H_5.$$

Trilinolenin yields a similar triperoxidic compound:

$$(CH_3 \cdot CH_2 \cdot \overset{\lceil O-O \rceil}{CH \cdot CH} \cdot CH_2 \cdot \overset{\lceil O-O \rceil}{CH \cdot CH} \cdot CH_2 \cdot \overset{\lceil O-O \rceil}{CH \cdot CH} \cdot (CH_2)_7 COO)_3 C_3 H_5.$$

These compounds may be further oxidized and break down into carbon dioxide, acetic acid, acrolein, and non-volatile oxidation products of lower molecular

SOURCE AND AVERAGE ANALYTICAL CHARACTERISTICS OF THE PRINCIPAL DRYING OILS

Oil	Source	Per cent of oil content	Specific gravity at 15°C.	Refractive index	Saponification number	Acid number	Iodine number	Per cent of non-saponifiable matter
Candlenut	*Aleurites moluccana*	—	0.925	1.470/40°	193	2	164	0.5–1.0
Hempseed	*Cannabis sativa*	—	0.927	1.474/40°	191	0.45	148	1.08
Linseed	*Linum usitatissimum*	35–40	0.932–0.941	1.484/15°	190–195	1–8	170–195	0.5–1.0
Perilla	*Perilla ocimoides*	36	0.937	1.487/40°	193	4.3	190–205	—
Poppy-seed	*Papaver somniferum*	45	0.924–0.926	1.477/15°	190–195	1–10	140–158	0.5
Soya bean	*Glycine hispidu*	18	0.924–0.926	1.468/40°	190–192	0–5	126–135	0.5
Sunflower	*Helianthus annuus*	50	0.924–0.926	1.473/25°	188–193	6–12	125–140	0.3–0.5
Tung	*Aleurites cordata*	50	0.936–0.943	1.522/15°	191–196	0–12	160–175	0.5–1.0
Walnut	*Juglans regia*	63–65	0.924–0.927	1.480/15°	190–197	2.5	140–150	0.5–1.0

THE DRYING CURVES OF LINSEED OIL

The weight increase of drying linseed oil, as a result of combination with oxygen is shown graphically. In these curves which have been adapted from A. Eibner, *Über Fette Öle*, p. 30, table 1, per cent increase in weight is plotted against drying time in days. Curve *a* shows it for linseed oil, cold-pressed and prepared as a film in the dark and weighed in red light. Curve *b* is for the same oil prepared and dried in diffuse daylight. 1 = point of initial set; 2 = tacky stage; 3 = tack-free dryness.

weight. In no case, however, is the proportion of non-volatile products very large, and undoubtedly the constituent to which a paint film owes its peculiar tenacity and transparency is the addition product of the unsaturated glyceride with oxygen.

Chemically, there seems little doubt that the initial product is of the nature of an organic peroxide; on the other hand, it seems that the peroxide is only a transitional phase and does not exist to any degree in the final product. Many schemes have been put forward in an effort to account for what takes place after the initial formation of the peroxide. Although there is little or no experimental evidence for the opinion, the most likely explanation is that rearrangement to a hydroxyketone takes place, followed by subsequent polymerization:

$$-CH-CH- \overset{\lceil O-O \rceil}{\longrightarrow} -C(OH)=C(OH)- \longrightarrow -CHOH-CO-.$$

Studies on the mechanism of the formation of synthetic resins have recently offered a new approach to the drying phenomenon in oils and natural resins. Bradley maintains, from theoretical considerations, that the drying of oils is but a typical manifestation of a more general phenomenon which consists of the transformation of an organic substance from an essentially linear structure to the so-called three-dimensional polymeric form (see **Synthetic Resins**). He has shown that the oxygen convertibility of drying oils is closely related to their heat convertibility and that convertibility, in general, is governed by the specific nature and number of the reactive or functional groups of the oil molecules. The function of the catalyst (*i.e.*, lead, manganese, or cobalt linoleates—or resinates) is not thoroughly understood either. It can be assumed that the metallic driers and the initial peroxide product, in the absence of the driers, are both simple oxygen carriers or catalysts for the reaction. It can also be assumed that the ' induction period,' in the absence of a drier, represents the time taken to produce sufficient ' peroxide '-product in equilibrium with the rest of the system to act as the oxidation catalyst. Long and his associates have found that little oxidation takes place in a linseed oil film after it has set to a hard gel. The ultimate failure of these films is not caused by continued oxidation; aging consists of a gradual transition of polar liquid phase to solid phase of substantially the same ultimate analysis. Embrittlement and failure of drying oil films is essentially a matter of reduction of the percentage of liquid phase to low values.

Clewell has recently found that linseed oil surfaces, both dry and liquid, can be studied by electron diffraction. He has followed polymerized oil through different stages of drying and finds that the surface structure of a wet film is completely amorphous. As the oil absorbs oxygen in the drying process, a gradual orientation of carbon chain molecules, normal to the film surface, occurs. Complete orientation does not exist until the film has completely dried. Alignment

is better explained on the basis of a three-dimensional polymerization than by the simple splitting off of fatty acids.

The oxidized product from linseed oil is known as linoxyn, and this refers more often than not to the final material obtained. That must be looked upon as a conglomerate of unsaturated glycerides which have partially or completely undergone addition of a molecule of oxygen at each double bond, the unsaturated glycerides which have not been attacked, any saturated glycerides originally present in the oil, and perhaps a small amount of other compounds formed by slight decomposition and further oxidation of the first oxygen-addition product. Oxidized linseed oil, or linoxyn, has certain physico-chemical resemblances to the typical colloid gelatin. For example, the viscosity relationships of linoxyn and of gelatin are qualitatively similar and both materials swell when treated with suitable liquids, water in the case of gelatin and hydrocarbon solvents in the case of linoxyn. It is supposed that linoxyn consists physically of a solid lattice-work of oxidized glyceride molecules enclosing the liquid (unchanged) glycerides, the whole forming a perfectly homogeneous, solid jelly. Most drying oils other than linseed oil do not give so satisfactory a film on exposure to air; linseed oil itself, if intensively oxidized, becomes thick and finally crumbles into soft fragments. In these cases, separation of the colloidal solid phase from the homogeneous medium has taken place, and, instead of a clear, solid film or jelly, a more or less coagulated and heterogeneous system of colloidal solid interspersed with clear jelly is produced.

The utility of the oxidized products from various fatty oils differs widely and bears little relationship to the original state of unsaturation of the oil. Linseed oil is the most suitable vehicle for paints; perilla oil is more unsaturated but gives an irregular film; tung oil is equally unsaturated but has more tendency to separate in the heterogeneous phase, so that the films produced are frequently dull or mat. Soya bean oil, safflower oil, sunflower-seed oil, and other oils of fairly high iodine numbers and pronounced drying properties do not yield such satisfactory films as linseed oil; the products tend to be softer and more gummy. Fish oils oxidize very readily but the products also tend to be gummy. These variations are doubtless conditioned to a large extent by the general type of unsaturation present. Thus, in oils of the poppy-seed class, there is little linolenic acid present, but there is an abundance of linoleic acid; tung oil contains a linoleic acid (eleostearic acid) structurally different from the ordinary variety; the fish oils contain only traces of linolenic acid, as a rule, but do contain fair quantities of oleic and linoleic acids and marked amounts of unsaturated acids with twenty and twenty-two carbon atoms and the equivalent of four or five ethylenic linkages. On the other hand, perilla oil contains more linolenic acid than linseed oil and yet does not give so satisfactory a product. The most abundant constituent of linseed oil is believed to be dilinoleo-linolenin (Hilditch, pp. 388–396):

$$(CH_3 \cdot (CH_2)_4 \cdot CH = CH \cdot CH_2 \cdot CH = CH \cdot (CH_2)_7 \cdot COO)_2$$
$$C_3H_5.$$
$$CH_3 \cdot CH_2 \cdot CH = CH \cdot CH_2 \cdot CH = CH \cdot CH_2 \cdot CH = CH(CH_2)_7COO$$

Oils, history in painting (see also **Resins, history in painting**). A great amount has been written on this subject but many problems still remain obscure, and many questions are still unanswered. For poverty of evidence to the contrary, oil painting is considered to belong to relatively modern times. Oil has never played an extensive rôle in Oriental art, but, before it can be eliminated entirely from the ancient art of the East, further study must be undertaken.

Whenever the early classical writers on history or medicine speak of oils, it is always with reference to their medicinal, cosmetic, or culinary uses. Dioscorides, who is supposed to have lived in the age of Augustus, mentions two drying oils, walnut oil and poppy oil; the use of bruised linseed is recommended medicinally by Hippocrates and other Greek writers on medicine; the medicinal oils enumerated by Pliny include walnut oil; he also speaks of the juice of linseed; Galen, writing in the II century, speaks of the drying properties of linseed and hempseed oils and he also mentions specifically the expression of walnut oil. The first mention of a drying oil in connection with works of art is by Aetius, a medical writer of the V and the beginning of the VI century. He describes the preparation of walnut oil and says that it is used by gilders and encaustic painters to preserve their work owing to its property of drying. He mentions linseed oil on the same page in connection with its medicinal uses, yet he speaks of nut oil as though it were the only one employed in the arts. Leonardo, writing a thousand years after Aetius, recommends nut oil, thickened in the sun, as a varnish.

The first descriptions of the preparation of an oil varnish, by dissolving resins in a drying oil, are found in the Lucca MS., supposed to be of the VIII century, and in the *Mappae Clavicula*, of doubtful though early date (see Berger and Merrifield). It is not until the time of Theophilus, XII century, and of the MS. of Eraclius, supposed to be of about the same date, that the use of a drying oil as a paint medium is described. The earliest writers who distinctly mention the admixture of solid colors with oil for the purpose of painting are thus Eraclius, Theophilus, Peter de St Audemar, and the unknown author of a similar treatise preserved in the British Museum (see Merrifield). It has been supposed that both Eraclius and Theophilus were of some country north of the Alps, but there is ample evidence that oil painting of a limited kind was practiced in Italy at an early period. Lorenzo Ghiberti says that Giotto occasionally painted in oil. Again, according to a document found by Vernazza in the archives of Turin, a Florentine painter, named Giorgio d'Aquila, contemporary with Giotto, was employed in 1325, by the Duke of Savoy, to paint a chapel at Pinarolo. The artist was furnished with a large quantity of nut oil for the purpose, but the oil, from some cause or other, did not answer his purpose, and was sent to the ducal kitchen (Eastlake, I, 46). In England early documents relate to the use of oil in art. By 1239 it is mentioned

in connection with painting. Similar notices appear in account rolls belonging to the reign of Edward I (1274–1295), and in others dated 1307 (Edward II). Another series exists in the records of Ely Cathedral, from 1325 to 1351, and a great number of the same kind are preserved in accounts belonging to the reign of Edward III, with regard to the decoration of St Stephen's chapel (1352 to 1358). From a study of such evidence, Eastlake concludes that oil painting was employed in Germany, France, Italy, and England, during the XIV century, if not before. He says, however (I, 58), that proofs of its having been employed for pictures, in the modern sense of the term, are less distinct, and are not numerous.

On the subject of the early use of oil in painting, Thompson (*The Materials of Medieval Painting*, pp. 65–67) says:

> Without entering upon the controversial questions of "oil painting" as it is generally understood, some mention must be made of the uses of drying oils in medieval painting. Long before the elaboration of the developed techniques of fifteenth- and sixteenth-century oil painting, oils were used in connection with painting in other media. Transparent colours are much more transparent and rich in oil than in water colour or egg tempera, and a certain amount of oil glazing was certainly used along with tempera painting from quite early times. We do not know accurately how much it was used, and we are not always sure of being able to recognize it in paintings now. One connection in which oil media were quite regularly employed was the glazing of metal surfaces, particularly red over gold (as may be seen in the Paolo Uccello Battlepiece in the National Gallery), and over silver and tin as well, and green too over these metals. We know that from remote ages oil and varnish glazes of yellow colour were applied to tin to make it look like gold, to silver, also, and even to gold itself, to make it look more like gold. Medieval examples of glazes of this sort are known, though they are not common until the Renaissance. The inside of the dome in the central panel of Giovanni Bellini's Frari Altarpiece was gilded, and then shaded down with rich, warm oil glazes; and this technical device, which is quite common in Renaissance painting, especially in sixteenth-century Germany, must look back to the ancient tradition of gold-coloured lacquering in oil varnishes on metal.
>
> How far oil glazes were used over tempera painting, and how far tempera painting glazed with oil media was repainted in tempera colours, and what the materials of these combined operations may have been, are questions still to be settled. A vast amount of evidence will have to be weighed and sifted laboriously before any attempt to solve these problems can be regarded as in any degree authoritative. The modern tendency is to regard the development of oil techniques as an evolution of manipulative methods primarily, rather than a sudden adoption of new materials. We may be quite sure that the "Secret of the Van Eycks" was not merely something which could be kept in a bottle; but we cannot pretend to adequate knowledge of the physical elements of Flemish, or, for that matter, of any fifteenth-century oil painting, at the present time.

This agrees with the earlier comment of Eastlake (I, 88) that in about 1400 the practice of oil painting had been confirmed by the habit of at least two centuries.

He points out its inconvenience, as compared with tempera, for works that required careful design, precision, and completeness, and assumes that the Van Eycks (traditionally credited with the discovery of oil painting) had aimed to overcome the stigma attached to it as a process fit only for ordinary purposes and mechanical decorations.

Laurie thinks that stand oil (see **Polymerized Oil**) was known and used at the time of the Van Eycks (see ' Notes on the Medium of Flemish Painters '). Maroger and Ruhrmann (Walther Ruhrmann, ' Das Bindemittel der alten Meister,' *Technische Mitteilungen für Malerei*, L [1934], pp. 43–47, 52–56, 60–67, 74–76, 81–84) have both written recently on the Van Eyck medium and both explain it as an emulsion.

Whatever may have been the particular developments of the XV century in the use of oil as a painting medium, it is apparent that during the XVI and XVII centuries it became the prevalent film material. Then and for some time later it was ground with pigment in the painter's workshop. During the XIX century various means were devised for storing this paint. Bags of skin or small bladders had already served as containers. Rigid metal tubes with pistons were occasionally employed for this purpose and then these gave place to the collapsible tube in which artists' oil paint is now sold.

Oils, refining. In the commercial manufacture and refining of oils from seeds, the first process is to clean the seeds themselves, and, with modern devices for this purpose, foreign material can be reduced to a few tenths of one per cent. The seed is then ground and expressed, either hot or cold, or the oil is extracted by suitable solvents. Such oil is always more or less impure and must be further refined. The impurities present consist of suspended matter, including mucilage, albumenoid matter, and resinous bodies, which may be dispersed as relatively coarse matter or in exceedingly fine suspensions of colloidally dispersed material. The impurities also include natural coloring matter, free fatty acids produced by hydrolysis, and semi-volatile compounds dissolved in the oil and giving it odor and taste. There are three principal methods of refining linseed oil: (1) with con- centrated sulphuric acid, (2) with alkali (sodium carbonate or caustic soda), and (3) with brine. In the first, the oil is agitated in lead-lined tanks with approxi- mately two per cent of sulphuric acid. The acid dehydrates and coagulates the albuminous and carbohydrate material which settles out and allows the clear oil to be drawn off, washed, and dried. The acid value of oil refined in this way is higher than the acid value of the original oils. This is desirable in those that are to be used for grinding certain pigments, for the free fatty acids facilitate wetting. In the second process the oil is agitated with a hot, aqueous solution of sodium hydroxide or sodium carbonate. The soap formed by the action of the alkali and the coagulated albuminous and carbohydrate material settles out and the clear oil is then washed and filtered with the aid of fuller's earth. If the oil is for paints or varnishes, only enough alkali is used to neutralize most of the free acidity, about 0.3 to 0.5 per cent of free fatty acid being left. The alkali process is the

most costly but yields a product of superior clarity and color. In the third method, oil is boiled in tanks containing strong brine with a 10 per cent solution of crude aluminum sulphate or with a 10 per cent solution of sulphuric acid, and then is allowed to settle. The settled oil is treated with dry fuller's earth which adsorbs any remaining mucilage and also bleaches the oil to some extent. Besides these methods industrially used, there is an old workshop practice, still somewhat followed, of washing oil with water. The two fluids are shaken together and when the water, and any water-soluble impurities it carries, has settled out, it is drained off. Frequently, also, the whole container, after shaking, is put in a freezing temperature and when the water part is frozen, the oil is poured off. Laurie (*The Painter's Methods and Materials*, p. 128) describes some of these methods in detail:

> Linseed oil is prepared by grinding, heating and pressing the seeds of the common cultivated flax. As it comes from the press it requires to be refined. This can be done in various ways. The oldest and the most satisfactory manner for artists' purposes is to expose it to light and air in covered glass vessels. A variation of this method is to float it on salt water, introducing as well a certain amount of sand. Large glass flasks are filled one-third of salt water, one-third of oil, and are then loosely corked and placed outside. Every day for the first two or three weeks the contents are vigorously shaken up. The oil is then left for a few weeks to clarify and bleach. By this process mucilaginous and albumenoid substances are removed from the oil, and the final product, pale and clear, dries quite quickly enough. . . . The same result is obtained on a large scale by the addition of a small quantity of sulphuric acid, which chars and removes impurities, and subsequent washing.

Linseed oil can also be bleached by the action of ozonized air. The bleached oils are almost colorless, but a certain amount of oxygen is inevitably absorbed by the glycerides during the oxidation of the non-fatty coloring matter to color-less derivatives. Linseed oil which has received one or the other of the foregoing treatments may be designated as refined, pale, or bleached linseed oil, but in the paint and varnish trades these oils which have not been further treated (see **Polymerized, Boiled**, and **Blown Oils**) are frequently classed as raw linseed oil, in spite of any preliminary refining.

Oils, relation to pigments. The oil required to give a stiff paste with a pigment, *i.e.*, when each pigment particle is thoroughly wetted by the liquid, is known as the oil absorption of the pigment and its numerical value is given by the volume of a standard oil (linseed) required for 100 grams of pigment. There are differences of opinion on this subject. Thorpe and Whitely (II, 103) say: 'The oil required to give a stiff paste with a pigment depends chiefly on the specific gravity of the pigment and, also, on its physical condition, *e.g.*, the shape and size of its particles.' According to Gardner and Levy (p. 531), ' The amount of oil required for pigment saturation or wetting is directly proportional to the specific surface of the pigment mass existing at the point of saturation. As the specific surface of the mass is relative to its degree of particle subdivision or fineness, it also measures to a

great extent the fineness of the pigment. The oil absorption factor being relative to the surface conditions of the pigment is independent of its chemical composition or specific gravity.' Williamson observes: ' The fact that no simple relationship exists between oil absorption and consistency is explained as follows: Two factors which act in opposition to each other—*i.e.*, degree of wetting and soap formation—control the values obtained from oil-absorption measurements, whereas the consistency of the ground pastes is controlled by soap formation alone.' By empirical methods Wolff and his collaborators have derived a mathematical expression for the consistency of a paint as a function of pigment concentration, and from this they calculate the critical oil content of paints. They have found that this critical point indicates the pigment-fixed binder ratio which yields the optimum paint properties from the point of view of drying, water resistance, etc. Elm ('Fundamental Studies of Paints') has studied experimentally the relationship which exists between the critical point of a paint as determined according to Wolff's method and the durability of the same system on exterior exposure. Results showed that the critical point falls within the range of pigment concentrations yielding good durability, and the conclusion that paint durability is a function of paint consistency seems justified. There are other factors besides pigment-vehicle ratio which affect the durability of a paint. J. Schmidt says that for each pigment there is an optimum acid value for the oil used in grinding and that this affects working quality and permanence.

Oils, yellowing. All fatty oils (see **Oils and Fats**) have a tendency to yellow with time; darkness and dampness increase this tendency and it is also accelerated by certain pigments. It varies with different oils and somewhat, also, with the particular sample and the treatment it has received. Poppy and walnut oil have, in general, less tendency to yellow than has linseed oil. Cold-pressed linseed oil yellows more than oil that has been thickened in the sun, but stand oil (see **Polymerized Oil**) is superior to both. Impurities may tend to increase yellowing, but complete removal of them does not remove the tendency, for pure, synthetic trilinolenic glyceride turns color badly. Furthermore, the yellowing of an oil is independent of the free acid content. Various vegetable oils turn yellow, to some extent, according to degree of unsaturation. Other things being equal, the least unsaturated oil, that is, the oil with the lowest iodine number, has the best color retention. Polymerization of oils reduces their iodine numbers and makes them less susceptible to yellowing. This is especially true if they are heated in an inert atmosphere, such as nitrogen or carbon dioxide, so as to prevent the formation of oxidation products. The nature of the chemical change that causes yellowing is not known. It is well known, however, that drying oils yellow more readily in the dark than when exposed to light. In fact, films that have become badly yellowed after storage in the dark may be partially bleached when exposed to the light. Werthan, Elm, and Wien (p. 775) found that white linseed oil paints yellowed more in red light than in blue light and, hence, wave-length of light seems to be a factor.

Oleo-Resin is a natural combination of resinous substances and essential oils occurring in or exuding from plants. It is usually a soft semi-liquid in which the resin is in solution in the essential oil. Deitrich (p. 9) classifies oleo-resins into four sub-groups: (a) the varnish group, derived mostly from plants of the *Anacardiaceae* family; (b) the copaiba group, sweet-smelling resins similar to the balsams; (c) the turpentine group, derived from *Coniferae* which comprise soft resins; and (d) the elemi group, which are soft resins containing above 10 per cent of ethereal oil. Among the oleo-resins most common in pictorial painting are Venice turpentine and copaiba, both used in the older practice of picture restoration and in the compounding of some surface films. The term, oleo-resin, has been used occasionally to define mixtures of drying oil and resin, but the definition given here is the one common in standard works on the technology of resins. (See **Balsam**.)

Ozokerite (see also **Waxes**). The origin of ozokerite is still, like that of petroleum, a matter of controversy. It is regarded by some as an intermediate product between natural fat and petroleum, but the more common view is that it is an oxidation and condensation product of petroleum. It is a variable substance. It may be quite soft or as hard as gypsum. In color, it varies from a light yellow to a dark, greenish brown. The refined product is known as ceresin.

Paraffin Wax (see also **Waxes** and **Mineral Waxes**) is obtained chiefly in the distillation of shale oil, lignite, and American and East Indian petroleum. It is a mixture of saturated hydrocarbons of the C_nH_{2n+2} series. Its melting point has the wide range, from 35 to 75° C.; it is available on the market in samples melting at 48 to 50°, 50 to 52°, 52 to 54°, 54 to 56°, 56 to 58°, 58 to 60°, and 60 to 62° C. The higher the melting point the harder, the heavier, and the less crystalline is the material. The softer varieties contain not only lower members of the usual constituents but also more or less of the liquid members which have not been removed during the process of manufacture. Commercial paraffin wax is a white to bluish white, translucent material of lamino-crystalline structure. It is an extremely indifferent substance, being attacked only slowly by the strongest reagents. It is freely soluble in mineral oils, ether, and benzene, but is only sparingly soluble in hot alcohol. Because of its inert nature, it finds many applications in the arts and industry.

Parchment Size (see also **Glue** and **Tempera**) is a nearly pure gelatin made from parchment waste. Its preparation is simple: cuttings are soaked in water until they are soft, and then are heated for 1½ to 2 hours in a double boiler with enough fresh water to cover them. When the size has been taken into solution, the waste is strained off and the liquor is allowed to cool to a gel or is used while warm. The jelly that forms can be sliced and allowed to dry. The finished product may be kept indefinitely and used as desired.

Paste (see **Starch** and **Flour Paste**).

Pastel (see also **Gums**). This kind of painting material is a chalk or crayon made from pigments and fillers held together in stick form by a weak gum medium, usually gum tragacanth.

Perilla Oil is obtained from the seeds of the *Perilla ocimoides*, an annual plant, occurring in China, Japan, and the East Indies; it is of the mint family, and is closely related to the highly colored *Coleus* seen in gardens. In appearance and odor, perilla resembles linseed oil. It is highly unsaturated and is characterized by its iodine number (190 to 205) which is the highest in any of the known oils. It dries quickly but gives a dried film which is somewhat marred by irregular markings and spots. During the last few years perilla oil has become of industrial importance.

Phenol-Formaldehyde Resins (see also **Synthetic Resins**). Although the phenol-formaldehyde resins (bakelite) are much used commercially, because of their yellow to deep brown color they have found little application in the treatment of works of art. Certain of the phenolic resins are soluble in oil and can be added in oil varnishes. Stamm and Seborg have recently described how the shrinkage and swelling of wood may be lessened by impregnating it with a phenol-formaldehyde mixture and condensing the mixture directly in the cell structure.

Pitch is a term which is often improperly applied to the resin or crude turpentine that exudes from pine and fir trees. It may mean the residuum from the distillation of turpentine (see **Turpentine** and **Colophony**), or it may mean asphalt or bitumen. More broadly, pitch is any tenacious, resinous substance, black or dark brown in color, which is hard when cold and is a thick, viscid, semi-liquid substance when heated.

Plasticizers are non-volatile, or little volatile, liquids or solids that are incorporated, usually in small amounts, in a lacquer or varnish and are retained in the film after escape of volatile solvents for the purpose of keeping the film adhesive, elastic, and flexible. A plasticizer is a necessary component of most cellulosic coatings (see **Cellulose Acetate** and **Cellulose Nitrate**). Although such natural products as camphor and castor oil have been used for this purpose, the modern trend is toward ' chemical ' plasticizers which are usually high-boiling esters like dibutyl phthalate and tributyl phosphate. Some of the synthetic resins serve as plasticizers for cellulose coatings. (See also p. 199.)

Polymerized Oil or **Stand Oil** (see also **Polymerized Resins**). If air is excluded, most oils can be heated to a temperature of about 250° C. without undergoing any appreciable chemical change. Some oils (*e.g.*, linseed oil) become pale in consequence of the destruction of the dissolved coloring matter. When heated above 250°, and up to 300° C., most drying oils (see **Oils and Fats**) undergo a change which is essentially one of polymerization. The iodine number falls rapidly, *i.e.*, a certain number of the ethylenic linkages become saturated, not by the addition of hydrogen or oxygen but by polymerization. When the iodine number has fallen to about 100 (' thin stand oil '), the density has increased from about 0.935 to 0.966 and the oil has become somewhat more viscous. On further heating at the same temperature, the iodine number falls lower, though more slowly, the viscosity increases rapidly, and the oil becomes very thick but remains clear. In

certain cases (as in tung oil and safflower oil) the oil is converted into a gelatinous or rubber-like material. The effect of heat is thus to diminish the iodine number (unsaturation) and to increase the viscosity, but in the absence of air there is no oxidation. Typical figures for various commercial polymerized oils are given by Leeds as follows (see Hilditch, p. 400):

	PER CENT LOSS ON THICKENING	SPECIFIC GRAVITY 15° C.	IODINE NUMBER	SAPONIFICA- TION NUMBER
Raw oil	—	0.9321	169	194.8
Thin oil	3	0.9661	100	196.9
Middle oil	6	0.9721	91	197.5
Strong oil	12	0.9741	86	190.9

Such polymerized oils are often known as ' lithographic varnishes.' Not much is known of the nature of the constituents of the polymerized oils. There is a little loss of volatile products of decomposition but the chemical structure remains essentially the same. During the heating polymerization takes place—molecules of linseed oil unite to form larger molecules, and these larger molecules are less liable to the chemical changes that produce yellowing, cracking, and disintegration. Such oils dry more slowly but the resulting film is much more durable than the film of raw or boiled or blown oil, and white lead ground in stand oil yellows very slightly. From the physical standpoint, mainly in view of the observed viscosity relationships, it is now thought that, like the oxidation product (linoxyn), the fully polymerized glyceride must be a solid, colloidal structure and that the thickened or stand oils are systems in which the colloidal polymerides are dispersed in the unchanged portion of the fatty oil.

Polymerized Resins (see **Synthetic Resins** and **Polymerized Oils**). Polymerized resins are synthetic resins that are formed from simple, monomeric compounds by the chemical process of polymerization. Bender, Wakefield, and Hoffman say (p. 125): ' Polymerization is the term we use to denote change of a substance without loss or gain of material, but generally with a transfer of energy to a less fusible, less chemically active form of higher average molecular weight.' The vinyl, acrylic, and styrene artificial resins are formed by this process. An example will serve to explain it. The unsaturated, organic compound, styrene, has the simple formula, $CH = CH_2$. Styrene is a clear, sweet-smelling liquid that boils at

$$\overset{|}{C_6H_5}$$

146° C. and has a molecular weight of 104. In this form it is known as the ' monomer.' Under suitable conditions, however, as when warmed or when a catalyst is added, or even when allowed to stand for a long time, the monomeric units combine to form solid polystyrene which may consist of thousands of monomeric units and have a molecular weight estimated to be in the hundreds of thousands (Ellis, ' Tailoring the Long Molecule,' p. 1135). These polymeric molecules are

often termed 'macromolecules.' From the work of Staudinger and co-workers, it is generally agreed that the formation of polystyrene from monomeric styrene may be represented thus (Ellis, *loc. cit.*):

$$n\begin{pmatrix} CH = CH_2 \\ | \\ C_6H_5 \end{pmatrix} \rightarrow \text{---} CH - CH_2 - CH - CH_2 - CH - CH_2 - CH - CH_2 \text{---}$$
$$\qquad\qquad\qquad C_6H_5 \qquad C_6H_5 \qquad C_6H_5 \qquad C_6H_5$$

This type of polymer is known as a linear polymer. Ellis (*loc. cit.*) says about it: 'The long chain of polystyrene is, in effect, a single molecule and the properties of various polymeric styrenes are a function of the size. Relatively short chains dissolve readily (in solvents) to yield solutions of low viscosity; this low viscosity is not affected by heat.' Under certain conditions of polymerization, however, the polymer may form in branched chains or in three-dimensional molecules. The molecular polymeric structure can be built up to a compact and complex structure in which the linear chains are fused together at certain points with the formation of a network design. Such polymers of styrene swell and dissolve little in organic solvents. The linear molecule, as compared with the three-dimensional structure, tends to be soluble in all stages of polymerization. For this reason, resins built from linear macromolecules are more suitable for making lacquers than are those built from three-dimensional molecules. Ellis (*loc. cit.*, p. 1131) also says:

> Whatever cohesion there is between the chains of the linear polymer in the formation of micelles is accomplished by means of secondary valence forces yielding micelles considered to be elongated. In solution the solvents force themselves between the linear chains and solubility results. . . . The thread molecules may be in random arrangement in solution but they never lose their identity as such.

It is supposed that polymerization plays an important part in the natural formation of such plant products as cellulose and rubber. Carothers ('Polymers and Polyfunctionality,' p. 41) has said: 'The most important peculiarity of high polymers is that they alone among organic materials manifest to a significant degree such mechanical properties as strength, elasticity, toughness, pliability, and hardness.'

Polyvinyl Acetate (see **Vinyl Resins**).
Polyvinyl Alcohol (see **Vinyl Resins**).
Polyvinyl Chloracetate (see **Vinyl Resins**).
Polyvinyl Chloride (see **Vinyl Resins**).
Poppy-Seed Oil is obtained from the seeds of the opium poppy (*Papaver somniferum*) which is grown largely in India, Russia, France, and Asia Minor. The seeds contain 45 to 50 per cent of oil. The cold-drawn oil is pale straw or light golden yellow in color and is the 'white poppy-seed oil' of commerce; the hot-pressed oil is reddish in color. It can be sun-bleached to a nearly water-clear

oil, but Doerner (p. 109) recommends using it in its natural state, for he says that the bleaching does not last. Poppy oil has been known from classical times (see **Oils, history in painting**), but it was not until the XVII century that it came, in Holland, into general use for painting. It is used today in the preparation of tube paints, especially with the light pigments, because of its pale color. Some authorities (*e.g.*, Eibner) object to its use because of numerous disadvantages, chiefly, poor drying. Owing to its high linoleic acid content (its iodine number is in the neighborhood of 150), thin layers of poppy-seed oil dry, but, linolenic acid being absent or present only in small amount, the film formed melts at about 100° C., and is softer and more soluble in ether than is a linseed oil film. It does not yellow much on aging but has a tendency, especially in a closed space, to resoften (' synaeresis '). Poppy oil has a greater tendency to crack than has linseed oil, especially if it is not thoroughly dried or if it is too quickly painted over. Its properties as a paint oil are improved by polymerization.

Protective Varnish (see also **Resins** and **Waxes**). The problem of coating a paint film in order to seal it from destructive agencies of all kinds is one that has challenged painters, restorers, and technologists for many centuries. In spite of innumerable studies and experiments, no single solution has been found, and, in view of the diversity of paint materials, it is doubtful if any one film substance could be expected to provide safely for the covering of all pictures. The difficulty is to find a film material which is highly impermeable, enduring in itself, harmless in application to paint, capable of safe removal from paint, and possessed of such optical properties that it does not distort the subtle tone relations of a pictorial design.

Permeability to moisture has been studied experimentally by Gettens and Bigelow with concluding evidence in favor of waxes, natural soft resins being next the waxes in having this property. A comparison of these results with other properties of a series of film materials used for pictures was recently made by Stout and Cross. Their observations tended to support a practical suggestion made by Helmut Ruhemann (see Stout and Cross, p. 249) that a thin coating of resin followed by a coating of wax be taken as an effective means of protection for the usual type of European painting. It is an old rule, and one supported by theoretical studies, that a resinous film should not be put over paint until the paint has had many months in which to become thoroughly dry.

Pyroxylin (see **Cellulose Nitrate**).

Resins (see also **Synthetic Resins**) are secretions or excretions of certain plants. Most of them are the products of living trees, but some copals are from trees long dead, and amber is from a plant known only as a fossil. According to researches by Tschirch, Stock and others (I, 93), nearly all resins and balsams are formed in special secretory glands. The resin may exude naturally to some extent onto the surface of the bark, but it is generally collected by wounding the tree. The trunk is ' tapped '—small incisions, either vertical slashes or triangular

TABULAR COMPARISON OF SOME NATURAL RESINS

	SOLUBILITY															PHYSICAL AND CHEMICAL CHARACTERISTICS			
	Acetone	Ethyl alcohol	Amyl alcohol	Benzene (benzol)	Benzine (petroleum naphtha)	Butyl alcohol (butanol)	Cellosolve	Carbon tetra-chloride	Diacetone alcohol	Ether (diethyl ether)	Ethyl acetate	Ethylene dichloride	Methyl alcohol (methanol)	Turpentine	Toluene (toluol)	Melting point °C.	Refractive index	Acid number	Saponification number
Amber	I	SS	SS	SS	SS	—	—	—	—	SS	—	—	SS	PS	—	250–325	1.546	15–35	115
Canada balsam	PS	PS	S	S	AS	S	S	S	—	S	S	—	PS	S	S	—	1.530	81–86	89–95
Colophony (rosin)	S	S	S	S	AS	—	—	S	S	S	S	S	S	S	S	120–150	1.525	150–180	150–200
Copaiba balsam (Para)	—	AS	—	S	AS	—	—	—	—	S	AS	—	AS	S	—	—	1.500	75–100	80–100
Copals:																			
Congo	PS	PS	PS	PS	PS	—	—	PS	S	PS	—	PSH	PS	PS	I	180–200	1.545	122.5	132.4
Manilla	S	PS	AS	PS	SS	PS	—	PS-I	S	PS	PS	S	I	PS	I	120–190	1.544	128	178
Sierra Leone	AS	PS	AS	PS	—	—	—	PS	—	PS	—	—	PS	SS	S	130–200	—	109–114	146–150
Elemi	PS	S	AS	S	PS	S	S	PS	I	PS	AS	S	PS	PS	S	77–121	1.515	17.8–25	25–50
Dammar (Batavia)	AS	AS	S-PS	S	AS	I	PS-I	S	I	AS-S	PS-I	S	PS	AS	PS	80–150	1.536	18–60	20–65
Mastic	I-PS	PS	S	I	I	S	SS	PS-S	S	S	PS-S	S	PS	PS	S	95–120	1.545	50–71	82–92
Sandarac	I-PS	S	S	I	I	S	S	PS-I	S	S	S-PS	PS	S	PS	I	135–150	1.516	140–155	143
Shellac	I-PS	S	S	S	I	S	S	PS-I	S	I	I	I-SSH	S	SS-PS	I	115–120		48–64	194–213

The symbols of solubility are as follows: S = soluble; AS = almost soluble; PS = partly soluble; PSH = partly soluble hot; I = insoluble. The resins and solvents listed are selected because relatively full information is available about them. The table is not complete and can not be entirely accurate; since the natural resins are not pure substances and, hence, are not easily reproducible, authorities commonly disagree on their properties. The solubility table has been compiled from several sources, but, chiefly, from A. Tschirch and E. Stock, *Die Harze*, I, 110. The data are based upon the crude resin and not upon applied thin films.

holes, are cut in the bark. In some cases the incisions pierce to the heart of the tree. At first, the flow of resin is very small, giving at most, a ' tear,' as in mastic and sandarac. In the conifers, producing colophony and turpentine, however, the injury seems to stimulate the growth of the canals and resin flows profusely at certain seasons.

Resins are considerably modified on exposure to air and light so that the collected product rapidly changes in consistency and color from its natural state within the tree. Handling and adulteration often change it still more; a wide variety of resins, though all from the same species of tree, may be found on the market. Much early research on the properties of resins has had to be discarded because the samples could not be accurately traced. This difficulty of obtaining pure, more or less uniform, samples still presents a problem to investigators and accounts for differences in many of their results. Several general characteristics are found in resins as a whole: they exhibit an amorphous structure, rarely crystalline but often glassy; they soften with heat, and finally melt to a more or less sticky fluid; they burn with a smoky flame. All resins are insoluble in water, but generally they can be fairly easily dissolved in alcohol, ether, and carbon disulphide. Unlike fats and oils, they do not leave a greasy mark on paper, and they are resistant to reagents and to decay.

Resins form the basis of all natural varnishes. They may be used in the raw state fresh from the tree, or in mixtures (see **Varnish**). With the exception o amber, the fossil and hard resins called by the generic name ' copal ' come from Africa, South America, New Zealand, and the East Indies. Amber is found chiefly on the shores of the Baltic Sea, and in northern Europe. These hard resins are combined with a drying oil to make oil varnishes, and are extremely strong, resistant, and usually dark in color. From the East Indies and the eastern and southern shores of the Mediterranean Sea, come the soft resins, dammar, mastic, and sandarac. These are the spirit-varnish resins, the resin or a combination of resins being dissolved usually in turpentine, and they constitute the most generally used picture varnishes. The balsams or oleo-resins come from coniferous trees widely distributed throughout Europe and America. Lacquer is the exudate of a tree indigenous to China and Japan. Shellac, the most common resin in commercial varnishes for woodwork, is not a product of a particular tree, but is the excretion of an insect feeding and breeding on a variety of trees in India, Siam, and Burma.

Chemically, the natural resins differ from one another very widely, and inquiry has not been carried far enough yet to make possible a satisfactory arrangement of the resins from a chemical viewpoint. Barry (p. 25) classifies the essential constituents as:

1. Aromatic acids.
2. Aliphatic acids.
3. Resinols and resino-tannols. (Alcoholic Constituents.)
4. Resin acids. (Acidic Constituents.)
5. Resenes.
6. Essential oils.

Aliphatic and aromatic acids, aside from the characteristic resin acids, are not common. Acids of the benzoic and cinnamic acid series occur in a few resins but mainly in those that are of minor importance commercially; succinic acid, which occurs in amber, seems to be the only aliphatic acid found. The resin acids may occur free or combined with resinous bodies which Tschirch divides into two groups: the resino-tannols, which give the tannin reaction, and the resinols, which do not. The acids which have been most investigated are abietic acid, $C_{20}H_{30}O_2$, and its congeners. The resenes are inert substances and are very resistant to chemical reagents. They appear to be of an aromatic nature. In some cases, the oxygen content is so small that they might be hydrocarbons of high molecular weight. Contrary to expectation, their chemical inactivity seems to have no direct relation to the hardness and durability of varnish films. Zanzibar copal, for instance, a very hard resin, has 10 per cent resene; dammar, of medium hardness, has 60 per cent; and colophony, a very soft resin, also has 10 per cent. Two investigators, Haber and Von Weiman (see Barry, p. 29), agree that, as the resenes interfere with crystallization, they tend to keep the resins in an amorphous condition.

The amount of essential oil in resin varies. The considerable amount present in the fresh exudation from the tree either evaporates or changes chemically on exposure to air. Thus, the balsams are practically solutions of resin in essential oil, the elemis and soft copals contain sufficient oil to make a pasty consistency, and most of the fossil resins contain only an extremely small amount. Following is an arrangement of some of the natural resins according to hardness.

COPALS—OIL VARNISH RESINS

Hard	Medium	Soft
Zanzibar	Sierra Leone	Manilla
	Kauri	

SPIRIT VARNISH RESINS

Dammar	Sandarac
Shellac	Colophony
Mastic	

Resins do not have definite melting points because the fusing is a continuous process and may extend over a considerable range of temperature. Hard resins, particularly, have a long transition stage, the ' upper melting point ' being reached

as the resin decomposes and an oil distills off. As samples of the same variety of resin may give different results, the melting point can not be used to identify a particular resin.

When exposed to ultra-violet light, resins tend to decompose and to yellow. Generally, the natural gums and resins are said to be less sensitive to ultra-violet rays and to be more transparent, especially in the shorter wave-lengths, than are synthetic resins. The relatively transparent resins remain stable under ultra-violet radiation, Kauri being found the most stable.

From x-ray diffraction studies resins have been found to be amorphous and to give patterns that are similar to those obtained from liquids. The intermolecular spaces are larger in the soft resins than in the hard ones. It is possible that the hardness of resins like Zanzibar copal and Congo copal depends upon the strength of the forces preventing the larger particles from becoming scattered. This theory would also explain the wide variations in solubility of different resins. Kauri, for instance, easily dissolves in drying oils, and shows a weak inner ring which contracts and becomes diffuse when the resin has been melted; Zanzibar copal, which is soluble only with difficulty, shows a sharply defined, inner halo.

The solubility of a particular resin varies with its age and with its handling after collection. In general, the hard resins are most difficult to dissolve. No resins are soluble in water. All may be classified according to solubility: those which are completely soluble in one or more organic liquids, and those which are partially or completely insoluble. The balsam resins, such as colophony, are entirely soluble in alcohol. The soft resins, such as dammar, mastic, and sandarac, are more or less readily dissolved in alcohol; but the fossil resins, amber and copal, are soluble only with difficulty, though more readily so if they are first melted. Prolonged contact of the resin with the solvent results in a dispersion rather than in a true solution. Some of the hard resins, however, may be completely dissolved in alcohol on standing for several weeks. It does not necessarily follow that, upon evaporation of a dissolved resin, a satisfactory varnish film results. Often an uneven and opaque mass is obtained, as many resins are precipitated when a certain concentration is reached.

There appears to be little available information concerning the autoxidation of resins. No doubt oxidation plays an important part in the drying and hardening of oleo-resins and balsams, and autoxidation may take place, to a limited extent, in the drying of soft resins. Tschirch and co-workers (I, 309) have found that when such resins as colophony, mastic, and sandarac are powdered and exposed freely to the air there is a definite amount of oxygen absorption which is accompanied by a lessened solubility of the resins in petroleum ether. The aging, embrittlement, and final destruction of soft resin films, however, do not appear to be caused primarily by autoxidation but rather to be the result of molecular re-arrangement and association and loss of volatile essential oil. Tschirch and Stock (loc. cit., pp. 315–317) report that many of the resins which have been found

with mummies in various Egyptian and Carthaginian sarcophagi are little altered with respect to chemical or physical behavior. Oxidation, although it may play some part in the formation of fossil resins, does not seem to be an important factor in ultimate disintegration.

Resins, history in painting. Either as natural exudates from the tree or as fossils mixed with an oil, resins have been used from very ancient times. Laurie (*Materials of the Painter's Craft*, p. 27) examined a fragment of a coffin of the XIX Egyptian dynasty, and found a reddish varnish which dissolved easily in alcohol, leaving the gesso and the black painting beneath unaffected. It was too transparent to have been a mixture with beeswax, and, as alcohol and petroleum were unknown at the time of its application, it seems likely to have been a natural, semi-liquid resin laid on while warm. A solution of resin in oil is said to have been found in specimens taken from the temple of Jupiter Ammon. As the Egyptians were unacquainted with linseed oil, the conclusion is that this was oil of cedar which was used also for embalming. Mummy cases of the first millennium B.C., examined by Tschirch (see Barry, p. 1), revealed the use of mastic, storax, and Aleppo resin; sandarac was found in Carthaginian varnishes of the same period. According to Lucas (*Antiques: Their Restoration and Preservation*, p. 56), the black, varnish-like coating on many wooden funerary objects from ancient Egypt, wrongly termed bitumen, pitch, or tar, is a black resin possibly such as is found and used in India, China, and Japan today. It was applied directly to the wood. It dissolves in alcohol and acetone, and, sprayed with these, it will soften and re-adhere. Laurie thinks that the use of varnish in Egypt was limited in time to the XIX and XX dynasties (1300 B.C.), being abandoned shortly after. Two embalming resins, used by the Incas of South America and examined by Reutter (see Barry, p. 1), appear to contain, among other things, Tolu and Peru balsam. Phoenician mummies show the use of amber.

In China, as early as the Chou dynasty (1169 to 255 B.C.), lacquer, a natural resin from a living tree, was in use as a carriage varnish. Covers for jars, coated with red lacquer and belonging to the Han dynasty (266 B.C. to 250 A.D.) have been found. The art of applying and carving lacquer reached its height in China technically in the Ming dynasty (1368 to 1644 A.D.). The Japanese learned the husbandry of the lacquer tree and the use of the resin from the Chinese. The earliest specimens of lacquer work in Japan are of the VI century, although it is mentioned in records which date two centuries earlier. The process of working lacquer was kept a carefully guarded secret, and it is only recently that investigators have examined the constituents of lacquer and the methods by which it was employed (see **Lacquer**).

Sabin (p. 437) refers to Gulick and Timbs who, writing in 1859, were of the opinion that varnishes composed of resins dissolved in oil must have been used in Persia, India, and China before the height of Greek art, and they concluded that the Greeks, also, must have been acquainted with the varnish process. It is

a natural inference, for pitch and crude varnish were used in ship-building, and the Egyptians used pure resins. The only historical reference, however, is made by Pliny (John, p. 36), who, in speaking of Apelles, tells how that artist covered his pictures with a layer of ' atramentum.' This was evidently some kind of a varnishing process; the layer was said to be so transparent that, while it did not affect the colors and served to protect them from dust, it was invisible, except under close examination. According to Pliny, no one was able to imitate this process. It is hard to understand why there were difficulties, for, from Pliny's intimations, it can be assumed that the varnish was a semi-liquid resin, dissolved in a little fluid bitumen. He lists resins obtained from many varieties of pine and others from Syria and Africa, such as mastic and terebinth; but, although resins dissolved in olive oil were used pharmaceutically, there is no mention of a varnish being prepared in this way. Varnishes that can be applied with a brush require the use of a thinner or of a solvent. The solvent power of turpentine was known as early as 460 B.C. and was referred to by Pliny, but apparently spirits of turpentine, or other volatile thinners, were not employed in the manufacture of varnish.

Historical records about resins and their use in varnish making up to the XVIII century are largely recipes and statements of early writers. These have to do with oil varnishes, but it is often impossible to know the exact nature of the resin called for. The term, ' amber,' was used to cover a great variety of hard resins, and it referred often to their color regardless of their origin. In the same way, ' mastic ' and ' sandarac ' are used indiscriminately, and other resins are called by names which are difficult to identify today. Many of the varnish recipes given in the Lucca MS. in the VIII century and those given during the following centuries, however, may be interpreted in the light of present knowledge about the resins probably available at those times. Both mastic and sandarac were used and many pine balsams were known. Of the hard resins, amber was certainly obtainable at an early date, and African copals probably could be found in the markets. Barry (p. 44) quotes Fr. Stuhlman (*Deutsch Ost. Afrika*) as believing that the trade in copals began as early as the X century when Arabs exchanged it with the Indians for cotton fabric. From isolated statements it appears to have been used in the XVI century, but it is not mentioned to any extent until the latter half of the XVIII century. The Lucca MS. (Berger, III, 15) describes the preparation of a varnish by dissolving resin in linseed oil, and one recipe, *de lucide ad lucidas,* calls for amber, mastic, three kinds of turpentine, resin, galbanum, myrrh, two gums, a little linseed oil, and *florae puppli*. This would make an extremely stiff varnish which, while still hot, would have to be rubbed onto the picture. Here there is confusion again about the term, amber. True amber could only have been dissolved by first fusing the turpentines and by adding the amber before the oil. Several recipes call for a hard resin, and, although this is called ' glassa ' or ' karabe,' and has, therefore, been assumed to be amber,

it is more likely to have been a hard copal, possibly indistinguishable from amber even to the varnish makers. Large quantities of balsams were sometimes used, as is shown by a recipe consisting of 3 parts Venice turpentine, 3 parts oil, and 1 part mastic.

Theophilus, in the early XII century (*Schedula diversarum artium*) (see Berger, III, 57), describes the process of varnish making. According to him, the resin was melted to a clear liquid and was then poured into hot oil. The solution was beaten and stirred until a drop, after cooling, remained clear and was of the desired consistency. These same principles are followed today in the manufacture of oil varnishes. Laurie (*Materials of the Painter's Craft*, p. 287) is of the opinion that the common varnish used from the IX till late in the XV century consisted of a fairly soluble resin, either sandarac or mastic, or both, dissolved in linseed oil and having *pica greca*, which is now called 'colophony,' added in considerable quantities. In the early XVII century, oil gives way as a constituent, and spirit varnishes, that is, resins dissolved not in oil but in turpentine or natural naphtha, and later in alcohol, are mentioned. They originated, apparently, in Italy, and a recipe is given in a treatise supposedly published about 1740 (Barry, p. 4), for an oil varnish thinned with turpentine.

In the five centuries between Theophilus and Alberti there developed an appreciation of the different varieties of resins. Matthioli, in his commentary on Dioscorides published in 1544, makes the observation (Barry, p. 5): '. . . the juniper produces a resin similar to mastic called (though improperly) sandarac. With this resin and linseed oil is prepared liquid varnish, which is used for giving lustre to pictures, and varnishing iron.' Pine balsams are frequently mentioned, and probably the Flemish painters used balsam more than the painters of Italy where the climate was much drier. De Mayerne (Berger, IV, 185, 259, and 269), writing in the XVII century, gives recipes used by Flemish painters and speaks of Venice turpentine as a suitable substance for the preparation of varnishes, advising that it should be dissolved in spirits of turpentine, with the occasional addition of sandarac or mastic or a few drops of oil to give it toughness. Early Flemish paintings have been supposed to owe their durability to the fact that the vehicle was an oil varnish which fixed the painting without the need of a further coating. Records of the methods of the Van Eycks (XV century) and their followers are so scanty that it is impossible to speak with certainty of the ingredients they used. Many authorities on this period affirm that the vehicle was oleo-resinous. Laurie considers it improbable that amber varnish was seriously employed in painting, although Rembrandt is said, by his contemporaries, to have used it. It is likely that the so-called amber varnish purchased in shops was not made from the fossil resin, for true amber yields a dark, runny varnish which dries badly.

Modern literature on resins and their use in painting may be said to start with Watin, who published *The Art of the Painter, Gilder and Varnisher* in 1778.

He describes amber and copal varnishes and the use of turpentine as a thinner (pp. 221, 240, and 259). In giving the proportions of oil to resin, he comments on the varying effect which different proportions had on the hardness and rate of drying of the varnish (pp. 232 and 237). In the last century there has been much investigation, notably by Tschirch and his co-workers, into the nature of specific resins.

Rosin (see also **Colophony** and **Balsam**) is the residue left after spirits of turpentine has been distilled off from the balsam collected from pine trees. Rosin is a resin. The similarity of the two words has caused much confusion, and it is preferable to call rosin by its other name, colophony.

Rubber, chlorinated. Chlorinated rubber is an odorless, non-inflammable, yellow-to-white solid; it is soluble in the coal-tar (toluene) and chlorinated aliphatic hydrocarbons (ethylene dichloride), and in these solvents it may be applied as a coating. Ellis (*Chemistry of Synthetic Resins*, p. 116) says that the film is hard, tough, glossy, and translucent with a light yellow color, and that it exhibits a high resistance to the action of acids, alkalis, and oxidizing agents. Where decorative or protective coatings are to be exposed to a very unfavorable environment, such as smoke, salt spray, and fumes, or extreme weathering, the use of chlorinated rubber as a medium or surface film might be considered.

Safflower Oil occurs in the seeds of the *Carthamus tinctorius* to the extent of 30 to 32 per cent. It is a relatively slow-drying oil with an iodine number of 130 to 147. Polymerized safflower oil (see **Polymerized Oils**) is prepared by heating the oil to about 250° C., a treatment which turns it into a jelly-like mass. In India this has been prepared by natives for many centuries and is known as ' Roghan ' or ' Afridi wax.' (See also **Oils and Fats**.)

Sandarac (see also **Resins**) is produced by a coniferous plant, *Callitris quadrivalvis*, which grows in Africa on the Mediterranean coast and also in Australia. It now comes chiefly from Algiers, but in ancient times it was apparently exported in considerable quantities from Benghazi, then known as Berenice. (See **Varnish**.) The resin first called ' sandarac ' was probably juniper resin, having a dull reddish color and yielding a dark brown varnish. The term was given, also, to a variety of red pigments. The present sandarac resin occurs in somewhat elongated, pale yellow lumps, being dusty on the surface and crumbling into reddish powder when chewed. It is soft and brittle and similar to mastic. Its melting point is 135° to 145° C. and its specific gravity, 1.078 to 1.088. It is soluble in alcohol and in ether, but is only partially soluble in chloroform, oil of turpentine, and petroleum ether. Like the hard resins, it is readily soluble in hot turpentine, if it is first fused; if it is gradually heated with turpentine, it will soften into a stringy mass without dissolving. With alcohol or turpentine, sandarac gives a white, hard, spirit varnish, the resulting film being harder than a mastic film. With age, however, it becomes darker and redder. Sandarac varnish is used particularly for coating metals, as it gives a lustre when applied thinly. Its

tendency to brittleness may be reduced by the addition of Venice turpentine, elemi, and other substances. It has been observed that films from its alcohol solution develop fine, hair-like cracks which give the surface a silky sheen.

Sandarac was commonly used as a varnish ingredient in the Middle Ages. A recipe is quoted by Laurie (*Materials of the Painter's Craft*, p. 286) in which sandarac and *pica greca* (colophony) are added to an almost equal amount of oil. This would make an extremely thick varnish, and one that could be used only if rubbed on while hot or if thinned in some way. In many of these old recipes the proportion of resin to oil is very high, indicating the use of a soft resin.

Saponified Oils are oils or fats (see **Oils and Fats**) which have been split up by the action of an alkali, glycerine and a soap being formed in the process:

$$(C_{15}H_{31}COO)_3C_3H_5 + 3NaOH = 3C_{15}H_{31}COONa + C_3H_5(OH)_3$$

| tripalmitin | sodium hydroxide | soap | glycerine |

Sarcocolla is a resin from *Penaea sarcocolla*, an African *Penaeaceae*.

Semi-Drying Oils (see also **Oils and Fats**). Vegetable semi-drying oils are those containing notable proportions of glycerides of acids which absorb 4 atoms of iodine, and only small amounts (if any) of glycerides of acids absorbing 6 atoms of iodine. These oils have iodine numbers ranging from about 120 to 100. They are characterized by the fact that they form a skin when exposed to the air at somewhat elevated temperatures. Some very slow-drying oils may be classed by one writer as drying oils and by another as semi-drying oils. Those classed as vegetable semi-drying oils by Fryer and Weston (pp. 126–132) are maize oil, kapok oil, cotton-seed oil, sesame oil, croton oil, and curcas oil. The semi-drying oils lend themselves especially to the preparation of blown oils.

Shellac is the resinous secretion of the lac insect (see also **Lac** and **Resins**). After the crude lac is gathered from the tree, it is crushed and graded and the largest particles, called ' seed-lac,' are selected for making the best grade of shellac varnishes. The lac is heated, squeezed through a cotton bag, and worked into a plastic mass ready for stretching. It is stretched, either on rollers or by hand, into a thin sheet about four feet square. The sheet is slowly cooled and is broken into the flake-like pieces which appear on the market. Shellac comes almost entirely from India, although it is also produced in small quantities in Burma, Indo-China, and Siam. Its constitution has been investigated, but results vary because the origin of samples is often indefinite or unknown. Tschirch and Farner (see Barry, p. 258) give the following data on a sample of unknown origin.

Resin	74.5 per cent
Coloring matter	6.5 " "
Wax	6.0 " "
Moisture	3.5 " "
Residue	9.5 " "

They found it to consist largely of esters of an acid to which they assigned the formula, $CH_3CH_2CH_2(CHOH)(CH_2)_7CHOH \cdot COOH$, *i.e.*, dihydroxyficocerylic acid. The melting point is between 77° and 82° C. Gardner and Whitmore have experimented with shellac in different organic solvents. They conclude that hydroxyl, carboxyl, and carbonyl groups are probably present.

Shellac is a spirit-varnish resin. When it is commercially prepared, 5 to 7 pounds are dissolved in 1 gallon of alcohol. Often, oleo-resins are added to increase the elasticity. Sandarac, mastic, and Manilla copal are sometimes mixed with it, and dragon's blood or gamboge is occasionally put in for coloring. Shellac varnish gives a smooth finish and takes a high polish. The film is tough but not completely water-resistant. It is used as a primer for wood because it prevents any resin escaping and affecting the paint film and because it is impervious to the solvents ordinarily used for fresh oil paint. In restoration, it is sometimes applied as a weak priming over filling gesso in the losses of a paint film, for it has the property of being wetted with water and so will take an aqueous medium. Its color and slow solubility keep it from being much employed in connection with paint.

Shellac Wax (see also **Waxes**). The wax content of shellac generally varies between 3½ and 6 per cent. Pure shellac wax is of a light, rich, yellow color and resembles carnauba in strength and hardness. Its melting point lies between 78° and 82° C.; its mean iodine number is 9.2. It is marketed in small quantities, and is usually derived from bleaching processes of the resin (see **Shellac**). In such processes, it has been subjected to saponification by alkalis with detriment to its color, melting point, and hardness.

Siccative or **Drier**. Any metallic salts or solutions of them which are added to drying oils for the purpose of accelerating the rate of drying or oxidation go under this name. Usually they are derived from lead, cobalt, or manganese (see **Oils, drying process**).

Sierra Leone Copal (see also **Copal** and **Resins**). This resin is obtained by tapping the tree, *Copaifera guibourtiana*, which grows in the British colony in Africa. The quality is more uniform than that of many copals. Tapping is permitted every three years, and the resin is collected five or six months after the incisions are made. It is brittle, hard (next in hardness to Zanzibar copal), has a light yellow color, and produces a pale, durable, and elastic varnish. Formerly, a fossil variety was found, but now Sierra Leone resin comes from the living tree.

Silica (see **Water-Glass**).

Silicon Ester, which is usually tetraethyl silicate, is a clear, fluid, organic compound of silicon. It has been used slightly as a medium for painting. When exposed to the air in thin films, this ester hydrolyzes with the formation of colloidal, hydrated silica that is the film material. It is a modern development and is still in the experimental stage. It is related to water-glass.

Size (see also **Gelatin, Glue,** and **Parchment Size**) is a term frequently applied to gelatin or to very pure glue. Herringham, in ' Notes on Mediaeval Methods ' in her translation of the *Book of the Art of Cennino Cennini* (p. 243) says that, except in English, there are not distinct words for size and glue, and the word, ' glue,' is constantly used in translating where ' size ' would be more nearly correct. Church (p. 63) maintains that the term, ' size,' should be synonymous with ' gelatin' derived from skins and bones. It should not be used for ordinary glue, especially that from cartilages and sinews, which contains chondrin. It has been a custom, however, to use the term more broadly for various materials, like starches, gums, and albumen, that are used to stiffen fabrics and to give a smooth surface to writing paper. In paper manufacture, much ' rosin size ' is used for that purpose. In its broadest sense, the term, ' size,' is used to mean any material that fills or dresses a porous surface. Glue size is frequently used in preparing wood surfaces for painting. Thompson (*The Practice of Tempera Painting*, pp. 18–20) gives directions for the making and application of gelatin size in the preparation of a panel for tempera painting.

Skin Glue is impure gelatin prepared from the skins of animals (see also **Gelatin** and **Glue**).

Soap is any metallic salt of a fatty acid. Ordinary soap is the sodium salt but soaps can also be formed by lead, manganese, cobalt, and other compounds combining with fats and oils. When a fat or oil combines with a metallic hydroxide to form a soap, glycerine is set free. (See **Saponified Oils** and p. 200.)

Sodium Silicate (see **Water-Glass**).

Soya Bean Oil. The soya bean (*Glycine hispida* and varieties) is native to China, Manchuria, and Japan, and the plant is being cultivated in other countries. The seeds contain about 18 per cent of oil. A typical analysis of soya bean oil gives 14 per cent of palmitic acid, 26 per cent of oleic acid, 57 per cent of linoleic acid, and 3 per cent of linolenic acid. It is a slow-drying oil (its iodine number is in the neighborhood of 130), and it forms a soft and not very durable film. It is used in some tube colors to meet the demands of the painter for more slow-drying colors. (See also **Oils and Fats.**)

Spermaceti (see also **Waxes**) is obtained as a solid precipitate from the head oil of the sperm and bottlenose whales (*Physeter* and *Hyperoodon*). It occurs in glistening, white, crystalline masses and is very brittle.

Spirits of Turpentine (see **Turpentine**) is the distillate of crude turpentine or balsam. The balsam collected from conifers is allowed to settle and spirits of turpentine is distilled off, leaving the residue, colophony or rosin. The word, ' turpentine,' is now commonly used instead of the longer term.

Spirit Varnish, a resin dissolved in a volatile solvent (see **Varnish**).

Stand Oil. According to J. G. Bearn (*The Chemistry of Paints, Pigments and Varnishes* [London: Ernest Benn, Ltd, 1923], p. 226), ' stand oil' is derived from the German word, *Standöle*. This gets its name from the fact that, on standing,

the mucilage coagulates and separates out from drying oils. (See **Oils and Fats** and **Polymerized Oil.**)

Starches (see also **Dextrin** and **Flour Paste**) are carbohydrates occurring in plants and synthesized by them from carbon dioxide and water by means of energy derived from sunlight and absorbed by chlorophyll, their green coloring matter. This process is known as photosynthesis. Starch occurs as white granules in nearly all plants, the granules from different plants differing in size and shape. Because of the difference, a microscopic examination will reveal the source of the starch. The size ranges from a diameter of 1μ ($\mu = 1/1000$ millimeter) or less to one of 150μ, and, although in some starches the granules are nearly all large (*e.g.*, canna), and in some nearly all small (*e.g.*, rice), there are starches consisting of both large and small granules. The granules of most starches exhibit diversity of form. They are classified by Eynon and Lane as round, lenticular, elliptical, oval or ovate, truncated, and polygonal. The percentage of starch present varies from plant to plant. Rice is about 75 per cent starch; corn, 50 per cent; and potatoes, 20 per cent. Starch is composed of carbon, hydrogen, and oxygen and has the empirical formula, $(C_6H_{10}O_5)_n$, where the exact value of 'n' is unknown. It is prepared commercially from potatoes, corn, rice, etc., by the simple, mechanical process of grinding and washing. When a suspension of impure starch in water is allowed to settle slowly, the impurities settle out first and can be removed. It is almost insoluble in cold water but, when a suspension in water is heated, the granules swell and form a viscous solution which sets to a jelly on cooling. If sufficiently diluted, it will remain liquid at room temperatures. Dextrin is prepared by heating dry starch at 200° to 250° C. On hydrolysis in the presence of dilute hydrochloric acid, starch is converted to the sugar, dextrose $(C_6H_{12}O_6)$; in the presence of the enzyme, diastase, it is converted to the sugar, maltose $(C_{12}H_{22}O_{11})$. A characteristic and delicate test for starch is the deep blue color which it gives with iodine.

For the preparation of starch paste the starch from rice, wheat, corn, potatoes, or arrowroot may be employed. It is mixed with enough cold water to make a creamy liquid which is then poured into the requisite amount of boiling water. Starch, being free from nitrogen and sulphur, has no effect on pigments but it holds poorly on fat grounds and is, therefore, not to be recommended in connection with oil colors. Ordinary starch paste is too viscous to be very suitable as a binding material for pigments.

Since paste contains a very large percentage of water, it tends to soften or to 'wet up' the material to which it is applied, and to shrink or swell cloth or paper. The moist, organic film encourages mold growth, and the changing moisture content of the atmosphere makes for instability. These disadvantages can, however, be largely eliminated by proper handling. The paste films become brittle with age, probably from a gradual loss of moisture and from development of mold and micro-organisms. An added hygroscopic material would be advantageous if it did not increase the tendency to mold growth. Stout and Horwitz say:

The aqueous adhesives have not proved themselves inferior. . . . They need further and more exact investigation, but evidently if their flexibility can be somewhat increased and if their composition can include a permanently effective fungicide, the traditional use they have had with paper can be confidently kept in the future.

Soluble starch can be prepared from starch by treating it with a dilute acid under controlled conditions. It can be prepared, also, by treating starch with various oxidizing agents, with glycerine, with enzymes, or with an alkali. According to the conditions, starch may be modified or converted so as to give all degrees of viscosity or adhesiveness. The mildest treatments give rise to soluble starch; more complete conversion results in dextrin or sugar (maltose or dextrose). After the process is completed, the product should be washed and the excess acid or alkali should be neutralized. The preparations obtained by various methods are mixtures, in different proportions, of products of the more or less complete disaggregation of starch. The product dissolves to a clear solution in hot water and a 2 per cent solution will remain clear or only faintly opalescent for some days. Soluble starch can be used in the preliminary priming of canvas instead of animal size. According to Church (p. 95), it is also admirably fitted as a binding material in water color painting, for the various preparations of soluble starch become, to a high degree, insoluble in cold water after they have dried.

The preparation of starch from cereal grains dates back to antiquity. A description is given by Cato, c 170 B.C., in his treatise on Roman agriculture (see Walton, p. 236). According to Pliny, the process of extracting starch from grain was discovered by the inhabitants of the island of Chios. Its history in Egypt dates from very early times. Walton (p. 235) says, ' Strips of Egyptian papyrus, some specimens of which date back to about 3500 B.C., were cemented together with a starchy adhesive.' There is, however, doubt as to whether starch was used in the preparation of papyrus. Partington (p. 206) records an observation by Schubart to the effect that no binder was necessary, the juice of the plant being sufficient, although a paste from the sifted crumbs of sour bread, or flour with hot water and vinegar might have been used. It has been reported that a Chinese document, of the year 312 A.D., was sized with starch. Paste made from the flour of grain is the traditional adhesive for joining pieces of paper. Cennino Cennini (Thompson, *The Craftsman's Handbook*, p. 65) gives directions for its preparation and such directions were probably a matter of common knowledge throughout the Middle Ages and the Renaissance.

Stereochromy (see **Water-Glass**).

Strasbourg Turpentine (see also **Balsam** and **Oleo-Resin**) comes largely from the conifer, *Abies excelsa* link., which grows in the Vosges Mountains. It is a balsam easily obtained from blisters in the bark, and it is partially clarified by sedimentation before being filtered. It differs from Venice turpentine in that it is coagulated by magnesia and has less color. It is much more expensive, however,

and on this account Venice turpentine has almost completely replaced it in commerce. Neither of these oleo-resins is easily obtainable, particularly in an unadulterated state.

Strasbourg turpentine was largely used in the XVI century. According to Church (p. 65), it is undoubtedly the *olio d'Abezzo* mentioned by early Italian writers. The best quality is said to come from *Abies pectinata* DC., a silver fir growing on the Italian side of the Tyrolese Alps. Dissolved in a terpene, this oleo-resin was used as a varnish for pictures in tempera and oil, affording special protection to verdigris and to some other easily decomposed pigments. Strasbourg turpentine contains about 57 per cent of resinous acids (different from those in Venice turpentine), 28 per cent of terpenes, and 13 per cent of resins.

Styrene Resins (see also **Synthetic Resins** and **Polymerized Resins**). A clear, colorless resin may be made by polymerizing styrene or phenyl ethylene ($C_6H_5CH = CH_2$). Ellis ('The Newer Chemistry of Coatings,' p. 129) says that it is one of the most promising of the plastic materials suitable for coatings. The solid resin is colorless, like glass, and it is very tough. It is insoluble in alcohol, acetone, petroleum hydrocarbons, and the glycol ethers, but it is soluble in coal-tar hydrocarbons, chlorinated hydrocarbons, esters, and turpentine. It is also reported that polystyrene lacquers are quick-drying and that, even when baked for a long time, the films do not become insoluble. The resin is thermoplastic and softens above 150° C. It may be plasticized with dibutyl phthalate or with triphenyl phosphate. The refractive index is 1.50 to 1.75 (Ellis, *Chemistry of Synthetic Resins*, p. 236).

Sunflower Oil is obtained from the common sunflower (*Helianthus annuus*), cultivated in Russia, China, Hungary, and India for food. The seeds contain about 50 per cent of a pale yellow, very fluid, slow-drying oil with a pleasant flavor. It is used in the preparation of oil varnish. It is said to be used in Russia for grinding colors (Doerner, p. 113). It has an iodine number of about 130 and pronounced drying properties, but does not yield such a satisfactory film as linseed oil; there is a tendency to produce softer, gummier products. (See also **Oils and Fats.**)

Sun-Thickened Oil (see also **Blown Oil, Boiled Oil, Oils and Fats,** and **Polymerized Oil**) is oil which has been exposed to the action of light and air in shallow containers. During exposure it is stirred from time to time to prevent the formation of a skin. It thickens in a few days and, when it has acquired the consistency of honey, it is ready for use. It dries with a gloss and has been used for centuries as a painting medium and with resin as a varnish. It has already absorbed some oxygen and dries more quickly than ordinary linseed oil. The old masters further accelerated drying by putting the oil in leaden vessels. It is probable that no polymerization takes place on such exposure (Laurie, 'Notes on the Medium of Flemish Painters,' p. 125), and sun-thickened oil is more like a blown oil than a stand oil.

Surface Film (see also **Resins** and **Synthetic Resins**) is sometimes used as a slightly more general definition than ' varnish ' of the layer or layers of film material applied over a completed painting (see also **Protective Varnish**).

Synthetic Resins. These are complex, amorphous, organic, semi-solids or solids that are made by chemical reactions from a variety of raw materials. They approximate the natural resins in many physical properties: lustre, fracture, comparative brittleness at ordinary temperatures, insolubility in water, and fusibility and plasticity when heated or exposed to heat and pressure. They commonly differ from the natural resins in chemical constitution and in their behavior to chemical reagents (see Ellis, *Synthetic Resins and Their Plastics*, p. 13). Most of the synthetic resins that have been developed for commercial purposes are prepared from unsaturated, organic compounds by the chemical process known as ' polymerization ' (see **Polymerized Resins**) or from oxygen-containing compounds (particularly hydroxy) by condensation (Ellis, *op. cit.*, p. 27). Some resins are produced by the combined effect of both polymerization and condensation. In both these processes, simple and usually liquid substances are changed into solid but generally plastic substances that are useful for molding or for the preparation of paints, varnishes, and lacquers. The polyvinyl resins (see **Vinyl Resins**), the acrylic resins (see **Acrylic Resins**), the styrene resins (see **Styrene Resins**) and some of the alkyd resins (see **Alkyd Resins**) are good examples of linear or additive polymer resins that dissolve in organic solvents and, hence, have become commercially practicable for the preparation of colorless lacquers and varnishes.

Many of the most important synthetic resins, historically and commercially, are prepared by a chemical process known as condensation. This is similar to polymerization, except that the primary reaction of simple molecules to form macromolecules is accompanied by dehydration, and the condensed product is not a multiple of the molecular weight of the simple starting substance (or monomer). Condensations may also take place between unlike molecules. In the formation of some resinous substances, both polymerization and condensation are supposed to take place and this process is known as ' polymerization condensation ' or ' multicondensation.' Although in some cases linear molecules are supposed to be formed in the early stages of condensation, the products usually end as three-dimensional molecules and, hence, are usually infusible and insoluble in organic solvents. The condensation resins are of minor importance in the preparation of paints, varnishes, and lacquers, but are of major importance in the preparation of molding compounds. The most important are made from formaldehyde and phenolic compounds. Bakelite is a typical example. Certain of the phenolic resins are soluble in oil and can be used to make oil varnishes directly (Ellis, *op. cit.*, p. 1141), but most of these products are dark in color. Light-colored resins from the condensation of urea and formaldehyde are of commercial importance in the preparation of molding compounds and coating compositions.

The manufacture of resins by the synthesis of macromolecules through the processes of polymerization and condensation is not far removed from the processes that nature uses in building up resins, drying oils, cellulose, rubber, and proteins. Carothers (' Polymers and Polyfunctionality ') has touched upon the rôle of polymerization in the growth of living organisms. He says (p. 42): ' Reactions of polymerization appear to be uniquely adapted to the chemistry of vital growth because they are the only reactions that are capable of indefinite structural propagation in space.'

The synthetic resins formed by polymerization and condensation appear to have very good chemical stability. In the process of their formation, all unsaturated groups are stabilized by the formation of cross linkages. Many of them are stable, even to strong acids, bases, and oxidizing agents. Among the cellulose derivatives only cellulose nitrate is known to be unstable and to have poor aging qualities (see **Cellulose Nitrate**). Cellulose acetate, on the other hand, appears to have very good chemical stability (see **Cellulose Acetate**). The permanence of artificial coating materials is usually considered from two points of view: first, the tendency to turn yellow, and, secondly, the tendency to become brittle with age. The first of these seems to be associated with ultra-violet light absorption and the second is attended by complete loss of solvent and plasticizer. The synthetic resins proper—the vinyl, alkyd, and the methacrylate resins—appear to be inherently more plastic than the cellulose derivatives. In the technical literature there has been found no mention of continued polymerization as a factor that might cause the embrittlement of polymer resins.

Synthetic Resins, physical properties. The usefulness of the synthetic resins depends upon various physical properties like hardness, clarity, transparency to ultra-violet light, adhesiveness, refractive index, moisture permeability, and thermal behavior. Although hardness is not a primary requisite for protective coatings on works of art, in special cases it may be a desirable property. Kline and Axilrod have recently made a study of the hardness of clear, synthetic plastics in connection with their use in aircraft windshields. In their tabulated results on scratch resistance, an acrylate resin led the list. The vinyl and styrene resins and cellulose acetate and nitrate gave intermediate results, and were much alike. Vicker's indentation-hardness tests placed these materials in different order. Here a styrene resin led the list and the other synthetic resins were less easily indented than cellulose derivatives. Synthetic resins and natural resins, like many other substances, owe their exceptional physical properties of strength, elasticity, hardness, and plasticity to their peculiar molecular structure.

Cellulose plastic coatings and synthetic resins, in this order, have high moisture permeability as compared with coatings made from natural resins and waxes. A study made by Gettens and Bigelow on the moisture permeability of an extensive list of materials that have been suggested or used for protective coatings allows the comparison of the moisture permeability of synthetic resins and plastics

with natural resin and wax coatings. Recent studies of moisture permeability of coatings usually have been limited to coatings for special purposes, or to the effect of adding various resins or plasticizers to certain types of coating bases. The methods of measuring permeability of industrial products have not been standardized, and so it is impossible to compare the values obtained. Natural and synthetic resins, when added to cellulosic coatings, usually reduce moisture permeability, but the addition of liquid plasticizers increases it. There are many other influences on permeability. Within limits it is held to be inversely proportional to film thickness, and conditions under which films are applied and dried no doubt affect it. Solvents retained in the film, as well as liquid plasticizers that are hygroscopic, appreciably increase moisture permeability. The age of a lacquer film, up to the point where it begins to break down as a result of natural causes, would be expected to have an effect on moisture permeability. Wray and Van Vorst have found that the moisture permeability of cellulose nitrate and vinyl resin lacquers decreases with age. Their findings were based on measurements carried out over a period of one year. Kline, who has recently made a study (p. 236) of synthetic resin finishes for aircraft, believes that water vapor is absorbed and transmitted through the films by a process of chemical diffusion. He found that an aircraft finish made with a cellulose nitrate base is very permeable to water vapor. He also found (p. 244): ' The additional protection afforded by the thin film of wax (carnauba) against passage of moisture was found to be considerable, being in some cases equivalent to doubling the thickness of the original film.' It seems that the use of wax coatings may help to overcome one of the inherent disadvantages of synthetic resin coatings, namely, a high moisture permeability. Where lacquer films with high moisture impedance are required, the use of chlorinated rubber coatings (see **Rubber, chlorinated**) may be considered.

Other than that furnished by the study of Gettens and Bigelow, it has been impossible to find data by which the moisture permeability of a large number of synthetic resins may be directly compared. The Hercules Powder Company, in a booklet entitled *Ethyl Cellulose*, furnishes the following comparative figures for moisture permeability of some plastic materials. These data are in terms of a K value which represents the grams of water permeated per hour/sq. cm./cm. thickness of film by a modified Gardner method.

Cellulose acetate	$5.0-7.0 \times 10^{-6}$
Ethyl cellulose	2.72×10^{-6}
Cellulose nitrate	1.68×10^{-6}
Benzyl cellulose	1.12×10^{-6}
Tornesit (chlorinated rubber)	0.80×10^{-6}

In the selection of protective coatings for special purposes, it is sometimes necessary to take into account the refractive index of the coating base. Coatings with high index of refraction sometimes cause changes in value of colors and a

general darkening of surfaces. Among the synthetic resins, there is a wide choice in respect to refractive index. Polymerized vinyl acetate and cellulose acetate have very low refractive properties. If in viscous solution so that they will not penetrate deeply, they may be used to coat paper, textiles, and granular surfaces so that very little darkening or change in value results. The refractive indices of several clear, synthetic resins and cellulose derivatives are given in the table below. These data have been collected from various sources: manufacturer's bulletins and journal articles.

SYNTHETIC RESINS, INDICES OF REFRACTION

Polyvinyl acetate	$n = 1.46-1.47$
Cellulose acetobutyrate	1.47
Ethyl cellulose	1.47
Cellulose acetate	1.48
Cellulose acetate—plasticized	1.48-1.51
Cellulose nitrate—plasticized	1.45-1.50
Cellulose nitrate	1.51
Polymethacrylate	1.48-1.52
Polyvinylchloracetate	1.53
Glycerol phthalate	1.56-1.58
Polystyrene	1.50-1.75

Conspicuous among the properties of many of the synthetic resins is their behavior when subjected to heat and pressure. On the basis of their response to heat, they may be divided into two main classes: (a) those that are ' thermoplastic,' and (b) those that are ' thermosetting.' For molding purposes, the powdered or granulated resin is placed in a form and when this is heated (usually with pressure) the resin fuses and flows; when the mold is cooled, it sets to a hard, solid substance. A thermoplastic resin is permanently plastic when repeatedly heated and cooled. The thermoplastic resins are, for the most part, linear polymers like the polyvinyl, polystyrene, polymethacrylate, and alkyd resins. On the other hand, certain of the synthetic resins, when heated and formed in a mold, set to hard and permanently infusible compounds. These are called ' thermosetting resins.' The resins that belong to this class are three-dimensional polymers, or condensates, and the phenol-formaldehyde resins are good examples. Houwink has discussed the colloidal structure of linear and three-dimensional polymers in their various stages of formation, and he has made a comparison between the thermoplastic and thermosetting resins on the basis of their intermolecular bonds.

Tempera (see also **Egg Tempera**). The meanings of the word, ' tempera,' as used to define a painting medium, have been many and have changed from time to time in the history of the art. As late as the XV century this term probably included all mediums but, with the gradual prevalence of oil, its limits were narrowed until it has often meant only a medium prepared from egg. A broader definition which allows it to include albuminous, gelatinous, and colloidal mate-

rials is also in use. For specification this requires a second term, and the whole would be, for example, ' glue tempera,' ' gum tempera,' or ' egg tempera.'

If glues and gums as well as egg are to be considered as tempera mediums, the history of this general group would go along with the history of all painting until the late Middle Ages. Then, although oil came to displace the aqueous materials in some degree, it did not crowd them out of use altogether. Before the advent of oil, wax was about the only other medium as such, and fresco gave a place to a crystalline binder for purposes of wall painting. It can still be said, however, that the greater part of pictorial painting, the world over, has been done with tempera —with some kind of aqueous medium.

Recently, studies have shown results which indicate that the fresco method was used in India as early as the XI or XII century A.D. (see S. Paramasivan, ' The Mural Paintings in the Brihadisvara Temple at Tanjore—An Investigation into the Method,' *Technical Studies*, V [1937], pp. 221–240), but glue was the general medium, it appears, for panel pictures and illuminations, and also for painting on walls. In a treatise compiled by Someśvara of the XII century and containing material corresponding to that of the VII century, a glue made from buffalo skin is spoken of as ' the adamantine medium ' and is said to be ' universally approved for painting ' (see Ananda K. Coomaraswamy, ' The Technique and Theory of Indian Painting,' *Technical Studies*, III [1934], pp. 60–61). Glue has been the traditional medium also for the painting of China and Japan. Even for walls, there seems little doubt that pigments were mixed into a thin size. The nature of the size probably differed from place to place, and included any of the animal tissues from which it can be made.

With the exception of the salmon egg medium of the Canadian West Coast Indians (see **Egg Tempera**), there is little to suggest that egg was used much outside of Europe. Laurie (*Materials of the Painter's Craft*, pp. 20–21) considers it quite probable that egg, both the white and the yolk, was used as a medium in Egypt, but reports one analysis of paint from a tomb of the XIX dynasty in which the medium was found to be gum. Lucas (*Antiques: Their Restoration and Preservation*, p. 140) says that all Egyptian mural paintings are in tempera, but does not distinguish the particular kind. In his *Ancient Egyptian Materials* (p. 149), he had already said that if egg white were ever used, it must have been at a late period, because the domestic fowl was not indigenous but was an importation.

The complete disappearance of the easel painting and practically of the wall painting of classical Greece has made the inquiry into the medium of that art depend on a few isolated references by classical writers. Certainly it appears that more than one tempera was familiar to them. Laurie (*Materials of the Painter's Craft*, p. 67) makes the following translation of a passage in Pliny (XXXV, 26):

Painters put on *sandyx* as a ground colour; thereafter, laying on *purpurissum* with egg, they produce the brilliance of vermilion. If they prefer to produce the brilliance

of purple, they put on *caeruleum* as the ground colour, and then lay on *purpurissum* with egg.

The translator, (*op. cit.*, pp. 68–69) says that gum, egg, and glue were all at the command of the classical painter and refers, also, to a mention, in a papyrus of Thebes, of a medium made of egg and gum to which was added bile, to make the color flow easily.

The mixture of egg white and gum was evidently common at later times. Cennino Cennini (*c* 1400) speaks of it (Thompson, *The Craftsman's Handbook*, p. 102) as a medium for ' mosaic gold ' and it appears in the Naples MS. of the late XIV century (Thompson and Hamilton). Occasional strange mixtures of tempera for paint are found in treatises on materials that reflect medieval practice. Among these are two in the MSS of Jehan le Begue. One (Merrifield, I, 306) is made of lime, ashes, wax, fish glue, and mastic. Another (Merrifield, I, 316) is made of pieces of flesh boiled in water with the root of the plant called,' *stipatum*.' Gums and glues (including size) must have been used extensively in European tempera besides their employment in illumination. Gums, particularly, are often mentioned in the Strasbourg MS. (Berger, III, 155 ff.). Yet it is probable that egg was the common tempera of European paint during the Middle Ages and the early Renaissance. It also, either as glair or whole egg, is frequently mentioned in the Strasbourg MS., a document of the XV century and definitely northern in origin, and it is clearly the main tempera medium treated by Cennino Cennini, the chief recorder of Italian practice. For panel painting this writer prescribes the yolk alone (Thompson, *The Craftsman's Handbook*, p. 91):' . . . you must always temper your colors with yolk of egg, and get them tempered thoroughly—always as much yolk as the color you are tempering.'

Analysis of paint from a portrait by Holbein (unpublished report by Ruther-ford J. Gettens) indicated that the medium was tempera. It is probable, however, that egg tempera did not long survive in general practice after the XVI century. By certain slight changes the transparent inks and thin gum temperas used in connection with writing, drawing, and illuminating were ultimately worked into a standard paint having a medium of gum with additions of hygroscopic materials. This paint, called ' water color,' is very common in present-day practice and is used thinly on a support of paper (see **Gums**).

Tung Oil, also called ' Chinese wood oil,' is obtained from the seeds of *Aleurites cordata*, *A. fordii*, and *A. montana*, contained in a nut, and growing in China and surrounding countries. A similar tree is native to Japan and yields Japanese tung oil which varies slightly from the Chinese oil and is not so satisfactory. The seeds contain about 50 per cent of oil. The native method for separating it is very crude. The seeds are roasted over a naked flame and are ground between stones before expression. Wooden presses are used. The cold-pressed oil is light in color and is mainly exported; the hot-pressed oil has a very dark color. The former is

called ' white tung oil ' and the latter, ' black tung oil.' An experimental cultiva-
tion of *Aleurites fordii* in Florida has succeeded, and oil is now being produced
there on a commercial scale. The Florida kernels yield a high quality, very pale oil,
of low acid value (0.3 to 1.4) which is free from the unpleasant odor associated
with the Chinese oil. Tung oil contains a large proportion (75 to 85 per cent) of
eleostearic acid ($C_{18}H_{32}O_2$), a stereo-isomeride of linoleic acid. This acid contains
two unsaturated double bonds and gives the oil its drying property. The rest is
largely olein with some saturated acid. Its average iodine value is 165. Its specific
gravity (about 0.941) is high, and it has, also, a high refractive index (1.522 at
15° C.). Tung oil appears to dry in about two days in moist air, but the resulting
film is always wrinkled or cracked and uneven. In dry air about fourteen to
twenty-one days are required and a smooth, coherent film is obtained. In either
case it takes twenty-one to thirty days for the full gain in weight (12.9 to 13.3
per cent). From this it appears that tung oil is really a slow-drying oil, and that
the rapid rate of drying in moist air is not ' drying ' in the usual sense (*i.e.*,
oxidation and polymerization), but is a colloidal change in which moisture acts
as the coagulant (W. Schmidt, ' Zum Trockenvergang des Chinesischen Holzöl's,'
Farben-Zeitung, XXIX [1924], pp. 1261–1262). A characteristic property of tung
oil is that it forms a jelly on being heated. If it is ' bodied ' or polymerized (see
Polymerized Oils) by heating at 270° to 290° C. until it thickens, it will dry to a
smooth, glossy film which is highly resistant to the action of water. It is not much
used by artists, although it has various favorable qualities. It is as unsaturated
as linseed oil, but has considerably more tendency to gelatinize or separate in the
heterogeneous phase, so that the films produced are frequently dull or mat. It
also yellows badly and may cause skin diseases. (See also **Oils and Fats**.)

Turpentine (see also **Balsam** and **Oleo-Resin**) is a semi-liquid, natural exudate,
containing terpenes associated with bodies of resinous character, from pine trees
widely distributed throughout the world. The raw or crude product from the tree
is also called balsam, or oleo-resin, and the word, ' turpentine,' is commonly used
for the spirits of turpentine, the distillate of the crude balsam. The residue, after
distillation, is colophony or rosin.

Turpentine is commonly used as a thinner or diluent for oil paints and var-
nishes. There is no indication that it was employed in this way by the ancients,
although its solvent power was known and referred to by Pliny. Turpentine and
alcohol are now the usual solvents for spirit-varnish resins. It appears that spirit
varnishes were introduced into Italy in the XVI century and were widely used
by the Flemish painters in the XVII century. At that time, also, turpentine was
used to dissolve verdigris and to prepare lake color (see **Resins, history in painting**).

Varnish (see also **Resins, Oils and Fats**, and **Waxes**). A picture varnish is the
protective coating, usually with a resin content, laid over a paint film. The use of
such a coating was probably introduced at a remote time in the history of the art
for the purpose of protecting water-soluble mediums and fugitive pigments and,

also, to give a uniform surface to the work. As the variety of resins increased, during antiquity, and as the differences among them were recognized, it became necessary to make distinctions. At one time amber and other hard resins had been called '*berenice*.' By the XIV century Italian writers referred to resin as *vernix* and to the varnish as *vernice liquida*. It has been suggested that the origin of the name is based on the story of Queen Berenice of Cyrene whose golden, or amber-colored hair was accepted by Venus as a thank offering for the safe return of the Queen's husband, and was transformed by the goddess into what is now known as the Milky Way. Laurie offers a less romantic suggestion: that the name came from that of sandarac resin which was formerly called '*berenice*,' being exported from Berenice on the African coast. In any event, the name, varnish, came from such a word.

There are two kinds of varnish in common use: the simplest consists of a solution of a resin in a volatile solvent; the second is made of a resin dissolved in a drying oil to which a thinner is generally added. The spirit varnishes are of a soft resin, such as mastic or sandarac, dissolved in turpentine or in alcohol; they are brittle and not very durable. An oil varnish in modern manufacture is made by heating a hard resin, such as a copal, and then dissolving it in linseed oil, with or without tung oil. The harder the resin, the higher is the temperature to which it must be heated. The mixture is thinned with turpentine or with alcohol. Lead and manganese compounds are often incorporated in the oil before or after the addition of the thinner. Such a varnish is apt to be too dark and too insoluble for use with pictures. Spirit varnishes, being readily soluble in alcohol, are easily removed from the surface of a painting. Oil varnishes require special methods, depending on the nature of the resin and on the properties of the ingredients.

Vegetable Oils are oils occurring in the vegetable kingdom (see **Oils and Fats**).

Vegetable Waxes (see also **Waxes** and **Animal Waxes**). These make up a large class, in which the typical member is carnauba wax. The only other commercially important member is candelilla. Vegetable waxes are generally found in or upon the outer skin of leaves, stems, flowers, and fruit, and, also, to some extent, in the tissues. They contain, as a rule, hydrocarbons of the paraffin series, C_nH_{2n+2}, where 'n' ranges frequently from about 30 to 60, alcohols of the phytosterol series, either free or combined with fatty acids, and the higher aliphatic alcohols of the type of ceryl alcohol, or those of higher carbon content, again either free or in combination with fatty acids (see Hilditch, p. 127).

Vehicle is a traditional term used interchangeably with ' medium ' as a name for the film-forming or binding material of paint (see also **Medium**).

Venice Turpentine (see also **Balsam**). This balsam is produced by the European larch, *Larix decidua*, and is collected chiefly in the Tyrol. It is a viscous, sticky substance with a characteristic pinaceous odor. It consists of about 63 per cent of resinous acids, 20 per cent of terpenes, and 14 per cent of resins; it is free from crystals of abietic acid which discolor the common turpentines. Unlike

that of pines, the larch balsam is secreted in the heart of the tree. Therefore, for tapping, a hole must be bored deep into the tree near the base. There are many old recipes naming Venice turpentine as a varnish ingredient. De Mayerne, XVII century (Berger, IV, 185, 259, and 269), gives several which call for Venice turpentine. In one, admixture with sandarac resin is mentioned. Doerner (p. 125) recommends it as a '. . . non-yellowing painting medium where an enamel-like effect of the colors is desirable.' It must be sparingly used, however, especially with dark, slow-drying colors, or it will dry poorly and give an unpleasant gloss. It is not recommended as a finishing varnish.

Vinyl Acetate (see **Vinyl Resins**).

Vinyl Ester (see **Vinyl Resins**).

Vinyl Resins (see also **Synthetic Resins**). The so-called vinyl resins may be considered as the polymerized derivatives of vinyl alcohol, $CH_2 = CHOH$. Although polymerized vinyl alcohol has been produced commercially and is a water-soluble, film-forming substance, it is not so important as the polyvinyl chlorides or acetates, particularly the latter. Although the vinyl halides have been known for about one hundred years, it is said that the acetate was first discovered by Klatte in 1912 (German patent, no. 281,687). Since about 1930 the vinyl resins have acquired a considerable industrial importance because certain ones can produce protective coatings which are colorless when applied and which are free from after-yellowing. It is claimed (Ellis, *Chemistry of Synthetic Resins*, p. 1025) that coatings of the acetates and chloracetates are transparent to ultraviolet light. Their acid number is usually rated as zero. They are used in the preparation of thermoplastic molding compounds as well as in coatings. Vinyl acetate is synthesized from acetylene and acetic acid; some mercury salt (as mercurous sulphate) is employed as a catalyst. The monomer is a mobile, colorless, ethereal-smelling liquid, which boils at 73° C. Polymers of varying viscosity can be made, depending upon the concentration of the catalyst. Polyvinyl acetate now comes on the market in coarse, granular form (shavings). Since it has a high cold-flow it is difficult, in warm weather, to keep it from caking; hence, it should be packed in small containers, and stored at as low a temperature as possible.

The vinyl acetate resin is a colorless solid, horny, and a little rubbery, but not brittle. It is soluble in alcohols, ketones, esters, and chlorinated and aromatic hydrocarbons, but is insoluble in aliphatic hydrocarbons (petroleum naphthas) and water. It softens at 30° to 40° C.; it has outstanding light and heat stability. According to Curme and Douglas (p. 1124), it has a relatively high water absorption—3 to 5 per cent in 16 hours at 60° C. Coatings may be made by dissolving the solid vinyl acetate resin in various combinations of organic solvents mentioned above. Since the vinyl polymer resins have a high solubility in some of the solvents, it is possible to prepare lacquers that have a high solids content. Although polyvinyl acetate resin is insoluble in water, it does swell when immersed in it and becomes leathery and pliable when a large amount of water has been ab-

sorbed. The surface, however, is unaffected after drying. The dried film is quite permeable to water vapor. The water absorption (A.S.T.M.) is given as 2 per cent in 144 hours. A noticeable property of polymerized vinyl acetate resin is its low refractive index, 1.4665. This property makes it valuable as a fixative for granular surfaces, since it does not cause so much darkening as do films with higher refractive index. Polymerized vinyl acetate can now be obtained in different viscosities. Where penetration is desired, a low-viscosity resin should be used. Since films of vinyl acetate are naturally quite flexible, it is not necessary to incorporate plasticizers except for special purposes. If necessary, any of the common plasticizers, like the phthalates, abietates, or glycollates can be used; in general, much less plasticizer is required to impart a definite degree of flexibility to these films than is required for cellulose nitrate. Vinyl acetate polymers have conspicuous adhesive properties when used with a wide variety of materials —cloth, paper, porcelain, metal, stone, leather, and wood.

Polyvinyl chloride is an odorless, chemically inert, and difficultly thermoplastic, synthetic resin. It has a more limited solubility than do the polyvinyl acetates. It is partially soluble in acetone, but is insoluble in most ketones, is resistant to acids, alcohols, and water, and is soluble in dioxan, ethylene dichloride, and chlorobenzene. The refractive index at 20° C. is 1.544. The heat and light stability of this resin is poor (see Curme and Douglas, p. 1124). It is brittle; hence, when used industrially, it is always plasticized.

A synthetic resin that is in many respects superior to straight polyvinyl acetate or polyvinyl chloride is one that is produced by the co-polymerization of the two. This is not just a physical mixture but is a product formed by simultaneous polymerization of the monomers. Those now in commercial production contain 65 to 80 per cent vinyl chloride. The polyvinyl chloride in the co-polymer may be regarded as being internally plasticized by polyvinyl acetate. Curme and Douglas (loc. cit.) have described many of the properties and uses of these vinyl co-polymers. They are colorless, tasteless, odorless, non-toxic, and permanently thermoplastic compounds. Their chief advantage over the polyvinyl acetates lies in the fact that they are not swelled by water. Moreover, they are stable to alcohol and to petroleum naphthas. They are soluble only in ketones and related compounds, esters, and chlorinated compounds, but they only swell and dissolve slightly in aromatic hydrocarbons. Heat and light stability are not quite so good as in straight polyvinyl acetate, but are much better than in the chloride. The vinyl acetate-chloride co-polymer darkens on prolonged exposure to heat or direct sunlight, but may be improved by the use of small amounts, usually 1 or 2 per cent, of stabilizers such as the commonly used lead pigments or lead stearate, lead oleate, or slaked lime. The co-polymers are marketed as white, fluffy powders which may be dissolved in mixtures of the solvents mentioned above, and the solutions can be diluted with cheap aromatic hydrocarbons like toluene. The refractive index of the vinyl co-polymer is 1.53.

A useful synthetic resin can be made by replacing part of the acetate groups of polyvinyl acetate by acetaldehyde. It is known as polyvinyl acetal. Elliot (*loc. cit.*) describes it and says that protective films made from it have greater toughness, hardness, and adherence than polyvinyl acetate, but that resistance to weathering is not so good. Woodbury has described the use of this resin in an anthropological museum for impregnating decayed and brittle bone specimens. The polyvinyl acetals so far produced have a pale straw color in solution.

Polyvinyl alcohol is of some interest because it is soluble in water to the extent of forming a 20 per cent solution, but it is insoluble in most organic solvents. In water the polyvinyl alcohol behaves as a reversible colloid. Solutions are similar to those of dextrin, albumen, and gum arabic. Its film-forming properties seem to be as good as those of the polyvinyl esters. It can be used as a water-color medium, and, in aqueous solutions, as a sizing agent for fabrics (see Ellis, *Chemistry of Synthetic Resins*, p. 1058).

Because of their recent development, the vinyl resins have had a small place in painting. Herbert E. Ives and W. J. Clarke, however (' The Use of Polymerized Vinyl Acetate as an Artist's Medium,' *Technical Studies*, IV [1935], pp. 36–41), have suggested in detail the way to use polyvinyl acetate as a medium; Stout and Gettens have described its use, also, for the treatment and transfer of Oriental wall paintings.

Viscose (see also **Cellulose Coatings**). Viscose is a regenerated cellulose now widely used in the making of rayon and transparent wrapping films (cellophane). It is made by treating sulphite wood-pulp, first with sodium hydroxide and then with carbon disulphide. The product, cellulose xanthate (a yellow solid), is a definite though unstable compound, is soluble in caustic soda (viscose proper), and from this caustic solution cellulose can be precipitated rapidly by an acid in a setting bath. By forcing the viscose through spinnerets directly into the acid bath, viscose rayon threads are formed. Transparent films (cellophane) are made by extruding a viscose solution into a long, narrow slit in a setting bath. After passing through baths to neutralize the acid, it passes through a glycerine solution from which it takes up 17 per cent. The process is continuous and a sheet of any length can be produced. Riegel says (p. 347) that cellophane is made moisture-proof and waterproof by passing the sheet, after the glycerine bath, through a dilute lacquer solution with rather volatile solvents such as ethyl acetate; after passing through driers, the lacquer, with the proper amount of plasticizer, remains as a coating.

This regenerated cellulose is not soluble in organic solvents. Wire netting and fabrics, however, can be impregnated by precipitating the viscose directly upon them. Heaton (p. 426) says that it has been suggested that the glue sizing of artists' canvas be replaced by a viscose sizing since a canvas treated this way would be less likely to mold. For application, the canvas is first impregnated

with a solution of viscose, then immersed in an acid bath, when the fabric becomes cemented together with regenerated cellulose.

Walnut Oil is expressed from the nuts of the walnut tree (*Juglans regia*) which contain about 65 per cent. The best is from cold expression which yields a pale-colored oil with an agreeable taste and the odor of walnuts. The hot-pressed oil is greenish in color and has an acrid taste. It may also be separated by boiling the kernels in water, a process recommended by Leonardo da Vinci. Nut oil has an iodine number of 140 to 150 and dries more slowly than linseed oil but does not turn yellow so readily. Laurie (*The Painter's Methods and Materials*, p. 133) says that it dries very slowly, but, if exposed to light or air over water, it can be obtained very pale in color and will then dry quite as quickly as the linseed oil prepared for painters' use. It is said to have less tendency to crack than linseed oil. As early as the V century it was recommended by Aetius for varnishing wax pictures and gilt surfaces. Its use was formerly more widespread than it is today. It is recommended for all light pigments in the treatises on painting by Leonardo da Vinci, Vasari, Borghini, Lornazzo, Armenini, Bisagno, Volpato, and others. It is said to have fallen into disuse because it easily becomes rancid, and manufactured tube colors ground in it are difficult to keep in storage for any length of time. (See also **Oils and Fats**.)

Water Color. The modern term is used to describe a standard preparation of pigment ground in water-soluble gums, usually from *Acacia Senegal* or from *Acacia arabica* Willd. (see **Gums**). The typical water color painting is executed with this paint thinly on a support of paper.

Water-Glass is a thick, syrupy, clear liquid, an aqueous solution of potassium or sodium silicate. It differs from ordinary insoluble glass in that it contains no calcium, barium, or aluminum. Water-glass serves as an inorganic binding medium because, on evaporation of water, it leaves an amorphous, coherent film. By virtue of its strong alkalinity, water-glass can be used only with a limited number of pigments. Church (p. 85) says that as early as 1648 a silicate of potash, called ' fluid silica,' was made but that the commercial production of these salts dates from 1825. Water-glass is used for mineral painting or so-called stereochromy (see Wolfgangmüller, ' Erfahrungen mit Keim'scher Mineralfarbe " A," ' *Technische Mitteilungen für Malerei*, XLVIII [1932], pp. 124–126, 134–135). In the practice of painting, water-glass is ordinarily used as a fixative for colors that are put on merely with water. Potassium silicate appears to be preferable to sodium silicate for this purpose. It is only useful on plaster supports, since a chemical combination of the alkali silicate with lime of the plaster is essential to the formation of a durable film. Laurie (*The Painter's Methods and Materials*, p. 215) says that certain murals in the House of Lords which were executed in this medium have suffered from disintegration. Water-glass is used extensively as an adhesive.

Waxes. The composition of these substances is more varied than is that of the oils and, at present, has been less investigated. Like most natural products, they are mixtures of several components, and the isolation of these is a difficult and lengthy task which has been attempted by comparatively few. The chief proximate components are: (1) esters of the fatty acids with alcohols containing a high number of carbon atoms; (2) free fatty acids; (3) free alcohols containing a high number of carbon atoms; and (4) hydrocarbons. They can be divided as animal, vegetable, bitumen, and mineral waxes. The following table gives the chief analytical characteristics of the principal animal and vegetable waxes and of montan wax. (For a discussion of the meaning of these characteristics, see **Oils and Fats.**)

The waxes are esters of monohydric alcohols whereas oils are esters of a tri-hydric alcohol. The protective strength of most waxes against permeation of moisture has given them an extensive use in the modern treatment of paintings, though they are little used as a medium. Gettens and Bigelow, in a series of tests of the moisture permeability of coatings, gave beeswax and ceresin a rating of 4 (average permeability in milligrams lost per day). Commercial mastic had a rating of 35, dammar had 24, and the ratings for oils ran from 250 to 527. For application over a normal and firm paint film with a thin film of varnish—thoroughly dry—Rosen (p. 115) recommends beeswax, 1 part, carnauba, 2 parts, ceresin, 2 parts, as a surface coating for paintings. Wax adhesives have been found to possess certain very decided advantages over the traditional glue mixture as well as over synthetic materials for the purpose of lining canvases. Plenderleith and Cursiter subjected a wax-lined painting, in which a well known recipe was employed (equal parts of beeswax and resin with a small quantity of Venice turpentine) as the cementing material, to a series of extreme tests of endurance, and found that the wax proved remarkably unaffected by such drastic treatment. Fink (' The Care and Treatment of Outdoor Bronze Statues,' *Technical Studies*, II [1933], p. 34) has found paraffin to be the best protective coating which can be applied to outdoor bronze statues. Wax has also proved itself suitable for impregnating objects made of wood.

Waxes, history in painting. The art of using colors prepared with wax began in antiquity. The term, ' encaustic,' which has long been applied to this method, strictly means, ' burning in,' an expression which is scarcely applicable to the mere melting of wax colors. According to Pliny, the process was not originally restricted to painting but included other processes in which melted wax was used. Lucas (*Ancient Egyptian Materials and Industries*, pp. 280–281) says that the only wax known to have been used in ancient Egypt was beeswax. It figured in mummification, served as an adhesive, as a luting material on the covers of alabaster vases, as a paint vehicle, as a fixing substance in the curls and plaits of wigs, and had a place in the making of magical figures, in ship-building, and in other crafts. Eleven specimens of beeswax from mummies examined by Lucas had melting points

PROPERTIES OF COMMON WAXES

Wax	Source	Specific gravity 15°/15° C.	Refractive index	Setting point °C.	Melting point °C.	Saponi-fication number	Iodine number	Acid number	Per cent of alcohols and hydrocarbons
Beeswax	*Apis mellifica*	0.962–0.966	1.440/75°	60°–63°	63°–70°	88–97	8–11	16–21	52–56
Chinese insect wax	*Coccus ceriferus*	0.970	—	80°–81°	80°–83°	80–93	1–2	1–1.5	49–50
Candelilla wax	*Pedilanthus pavonis*	0.950–0.990	1.456/71°	63°–68°	67°–70°	50–65	15–20	12–20	65–75
Carnauba wax	*Corypha cerifera*	0.990–0.999	1.472/40°	80°–87°	83°–86°	79–88	13–13.5	0.4–7.0	54–55
Montan wax	Lignite and peat	—	—	—	76°–130°	74–127	16–20	30–70	c 50

ranging from 63° to 70° C. and five specimens from wigs varied from 60° to 63° C. The melting point of modern beeswax is from about 60.5° to 64.25° C. These specimens, although light-colored and somewhat friable on the surface, had apparently not undergone any considerable change. Partington (p. 140) has this to say about Egyptian practice:

> The process of encaustic painting (with a wax medium) was not in use in ancient Egypt but appeared in the Ptolemaic Period for painting on wood, although Herodotus says Amasis (559–525) sent a portrait of himself to Cyrene. The encaustic paintings on wood on mummy cases are Greek and Roman. The encaustic technique may have originated in Egypt; preparations of wax for preserving paintings are said to go back to the XVIII dyn., and the names of most of the encaustic painters of antiquity appear to be Alexandrian or Egyptian. The first literary mention is after Alexander: a reference in a supposed ode of Anacreon (c. 550 B.C.) is of doubtful date. Eusebius (264–340) calls the process κηρόχυτος γραφή ("drawing in liquid wax"): it continued in use till the Middle Ages, but had declined after the 9th century A.D. The pigments (now in the British Museum) found at Hawara by Petrie are really water colors, but it is probable that they would be similar to the pigments used by the encaustic painter. The process, according to Petrie, was as follows. The colours were ground in the wax, previously bleached by heating it to its boiling-point, and fused in the sun in hot weather or in a hot-water bath, which is mentioned by Theophrastos. The portrait was made on a wood panel, previously primed with distemper, the wax colour being put on from a pot with a lancet-shaped spatula or (more probably) with a brush, pressed out at the end of the stroke.

This makes a description that fits with the appearance of the small mummy portraits which, as a group, have taken their name from the Fayûm district of Egypt. In Greece, it is said, pictures in wax commanded large prices in ancient times: 60 talents (about $85,000) was offered for one and 7,000,000 sesterses (about $400,000) was paid for another (Schmid, ' La Reconstitution du Procédé à l'Encaustique,' p. 37).

Since the IX century A.D., wax has not been much used as a painting medium. Eastlake (I, 156) speaks of its prevalence in the first centuries of the Christian era when it appears to have superseded all other processes, except mosaic. The Lucca MS. (VIII century) has more about mosaic than about wax painting, but says that colors mixed with wax were used on walls and on wood. It is scarcely alluded to in the treatises of the XII, XIII, and XIV centuries.

There has been argument about the type of wax used in ancient times as a medium for painting. Some reports have attempted to show that the wax was applied in an emulsified or a saponified state with water, and Berger has taken the recipe for Punic wax as given by Pliny (XXI, 49) and by Dioscorides (II, 105) to be proof that the medium was an emulsion. Studies by Eibner, Laurie, Schmid, and others have, however, made this supposition very doubtful. It is barely

possible, also, that oils and resins were added to the wax. One such combination, called *Zopissa*, a mixture of wax and balsam, was familiar in ancient industry. Laurie (*Greek and Roman Methods of Painting*, Cambridge [1910], p. 65[n]) argues, however, that fatty acids detected by analysis in some ancient wax could have been caused by oxidation, and considers the medium of encaustic painting to be wax alone. This is probably the general opinion. The melting point has sometimes been found to be high in specimens from Fayûm portraits and there remains a possibility that some other medium was added.

Although wax serves very little now as a painting medium, it finds many other applications in the arts. Because of its easy solubility in weak solvents and because of its protective strength and its permanence, its use as a surface coating for pictures has increased in recent years and it is much used in restoration (see **Waxes**).

Wood Oil (see **Tung Oil**).

Wool Wax (see also **Waxes**) is the natural grease from the fleece of sheep. It is a pale yellow, translucent substance with a distinctive odor and an unctuous consistency. Purified, it forms, together with about 25 per cent of water, the lanolin of commerce. Its chemical composition is not fully known. It consists of a mixture of neutral esters and free alcohols, among which occur cholesterol and isocholesterol ($C_{27}H_{45}OH$). Although insoluble in water, it emulsifies it (see **Emulsions**), and it can easily be made to take up 80 per cent of its weight of water. It is used extensively in the treatment of leather, as a rust preventative, and for medicinal purposes.

Zanzibar Copal (see also **Copal** and **Resins**) occurs either as a resin from a living tree, *Trachylobium verrucosum* Oliv. (of the *Papilionaceae* family), as a semifossil in the ground beneath these trees, or as a true fossil deposited by a tree no longer standing. The fossil resin has a brown crust which, when scraped away, exposes a transparent, yellow mass on which are small, round elevations called ' goose skin.' The exudation from the living tree is not so hard as the fossil resin, but has a smooth, glossy surface. Very little of this resin is now actually collected on the island of Zanzibar; it is sent directly from the mainland. It is sometimes also called ' anime.' Zanzibar copal is the hardest of the copal resins, has a very high melting point (240° to 360° C.), and makes a rather dark, oil varnish, used chiefly for industrial purposes.

Zapon, a lacquer or varnish containing highly viscous nitrocellulose (see G. Zeidler and F. Wilborn, ' Application of Zapon Lacquers to Metallic Surfaces,' *Paint and Varnish Production Manager*, XIX [December 1939], pp. 358–363, 373). It is sometimes mentioned in works of Continental origin that deal with restoration of museum materials.

BIBLIOGRAPHY

Jerome Alexander, *Glue and Gelatin* (New York: The Chemical Catalogue Co., 1923).

Ivey Allen Jr, V. E. Meharg, and John H. Schmidt, 'Chemistry of Synthetic Varnish Resins,' *Industrial and Engineering Chemistry*, XXVI (1934), pp. 663-669.

Anonymous, *Cleaning and Restoration of Museum Exhibits, Third Report* (London: H. M. Stationery Office, 1926).

Anonymous, 'Methacrylate Resins,' *Industrial and Engineering Chemistry*, XXVIII (1936), pp. 1160-1163.

Anonymous, *Second Report of the Adhesives Research Committee* (London: H. M. Stationery Office, 1926).

Wilder D. Bancroft, *Applied Colloid Chemistry* (New York: McGraw-Hill Book Co., 1926).

T. Hedley Barry, *Natural Varnish Resins* (London: Ernest Benn, Ltd, 1932).

G. F. Beal, H. V. Anderson, and J. S. Long, 'X-ray Study of Some Natural and Synthetic Varnish Resins,' *Industrial and Engineering Chemistry*, XXIV (1932), pp. 1068 ff.

H. L. Bender, A. F. Wakefield, and H. A. Hoffman, 'Colloidal Developments in Synthetic Resins,' *Chemical Reviews*, XV (1934), pp. 123-137.

Ernst Berger, *Beiträge zur Entwicklungsgeschichte der Maltechnik*, 4 vols (Munich: G. D. W. Callwey, 1901-1912).

K. G. Blaikie and R. N. Crozier, 'Polymerization of Vinyl Acetate,' *Industrial and Engineering Chemistry*, XXVIII (1936), pp. 1155-1159.

R. H. Bogue, *The Chemistry and Technology of Gelatin and Glue* (New York: McGraw-Hill Book Co., 1922).

'Properties and Constitution of Glues and Gelatins,' *Chemical and Metallurgical Engineering*, XXIII (1920), pp. 5-12, 61-66, 105-109, 154-158, 197-201.

T. F. Bradley, 'Drying Oils and Resins; Influence of Molecular Structure upon Oxygen and Heat Convertibility,' *Industrial and Engineering Chemistry*, XXIX (1937), pp. 579-584.

'Drying Oils and Resins; Mechanism of the "Drying" Phenomenon,' *Industrial and Engineering Chemistry*, XXIX (1937), pp. 440-445.

Wallace H. Carothers, 'Polymerization,' *Chemical Reviews*, VIII (1931), pp. 353-426.

'Polymers and Polyfunctionality,' *Transactions of the Faraday Society*, XXXII (1936), pp. 39-53.

A. H. Church, *The Chemistry of Paints and Painting*, 3d ed. (London: Seeley and Co., Ltd, 1901).

D. H. Clewell, 'Drying of Linseed Oil: Electron Diffraction Study,' *Industrial and Engineering Chemistry*, XXIX (1937), pp. 650-653.

C. Coffignier, *Varnishes, Their Chemistry and Manufacture* (London: Scott, Greenwood and Son, 1923).

James B. Conant, *The Chemistry of Organic Compounds* (New York: The Macmillan Co., 1933).

G. O. Curme Jr and S. D. Douglas, 'Resinous Derivatives of Vinyl Alcohol,' *Industrial and Engineering Chemistry*, XXVIII (1936), pp. 1123–1129.

J. O. Cutter, 'The Polymerisation of Drying Oils,' *Journal of the Oil and Colour Chemists' Association*, XIII (1930), pp. 66–83.

H. B. Devore, A. H. Pfund, and V. Cofman, 'A Study of the Action of Light of Different Wave-Lengths on Nitrocellulose,' *Journal of Physical Chemistry*, XXXIII (1929), pp. 1836–1842.

A. De Waele, 'A Consideration of Some Factors Affecting the Oxygen Absorption of Linseed Oil,' *Journal of the Society of Chemical Industry*, XXXIX (1920), pp. 48T–50T.

Karl Dieterich, *The Analysis of Resins, Balsams and Gum Resins*, trans. (London: Scott, Greenwood and Son, 1920).

Max Doerner, *The Materials of the Artist and Their Use in Painting*, trans. (New York: Harcourt, Brace and Co., 1934).

Thomas H. Durrans, *Solvents*, 3d ed. (New York: D. Van Nostrand Co., 1933).

Charles L. Eastlake, *Materials for a History of Oil Painting*, 2 vols (London, 1847-1869. Reprinted by Dover Publications, 1960).

A. Eibner, *Entwicklung und Werkstoffe der Tafelmalerei* (Munich: B. Heller, 1928).
Entwicklung und Werkstoffe der Wandmalerei (Munich: B. Heller, 1926).
Malmaterialienkunde als Grundlage der Maltechnik (Berlin: J. Springer, 1909).
'Das Punische Wachs des Dioskurides und seine neuzeitliche maltechnische Bedeutung,' *Technische Mitteilungen für Malerei*, L (1934), pp. 95–97, 104–107, 111–113.
Über Fette Öle (Munich: B. Heller, 1922).

Roy Elliot, 'Vinyl Acetate Resins,' *Canadian Chemistry and Metallurgy*, XVIII (1934), pp. 173–176.

Carleton Ellis, *The Chemistry of Synthetic Resins*, 2 vols (New York: Reinhold Publishing Corp., 1935).
'The Newer Chemistry of Coatings,' *Industrial and Engineering Chemistry*, XXV (1933), pp. 125–132.
Synthetic Resins and Their Plastics (New York: The Chemical Catalogue Co., 1923).
'Tailoring the Long Molecule,' *Industrial and Engineering Chemistry*, XXVIII (1936), pp. 1130–1144.

A. C. Elm, 'The Drying and Yellowing of Trilinolenic Glyceride,' *Industrial and Engineering Chemistry*, XXIII (1931), pp. 881–896.
'Fundamental Studies of Paints,' *Industrial and Engineering Chemistry*, XXVI (1934), pp. 1245–1250.

Encyclopaedia Britannica, 11th and 14th editions.

Lewis Eynon and J. Henry Lane, *Starch: Its Chemistry, Technology and Uses* (Cambridge: W. Heffer and Sons, Ltd, 1928).

H. Freundlich, 'Der Trocknungsprozess des Leinöles,' *Kolloidchemische Untersuchungen*, no. 45 (1930), pp. 526 ff.

Percival J. Fryer and Frank E. Weston, *Technical Handbook of Oils, Fats and Waxes*. I, *Chemical and General* (Cambridge: University Press, 1920).

D. L. Gamble and G. F. A. Stutz, 'Ultra-Violet Light Transmission Characteristics of Some Synthetic Resins,' *Industrial and Engineering Chemistry*, XXI (1929), pp. 330 ff.

H. A. Gardner and S. A. Levy, 'Pigment and Color Index,' *Circular no. 352*, *American Paint and Varnish Manufacturers Association* (June, 1929).

W. H. Gardner and W. F. Whitmore, 'The Nature and Constitution of Shellac,' *Industrial and Engineering Chemistry*, XXI (1929), pp. 226–229.

Rutherford J. Gettens, 'Polymerized Vinyl Acetate and Related Compounds in the Restoration of Objects of Art,' *Technical Studies*, IV (1935), pp. 15–27.

'Preliminary Report on the Measurement of the Moisture Permeability of Protective Coatings,' *Technical Studies*, I (1932), pp. 63–65.

Rutherford J. Gettens and Elizabeth Bigelow, 'The Moisture Permeability of Protective Coatings,' *Technical Studies*, II (1933), pp. 15–25.

W. E. Gloor, 'Effect of Heat and Light on Nitrocellulose Films,' *Industrial and Engineering Chemistry*, XXIII (1931), pp. 980–982.

Noel Heaton, 'The Permanence of Artists' Materials,' *Journal of the Royal Society of Arts* (London), LXXX (1932), pp. 411–435.

W. O. Hermann and W. Haehnal, 'Über den Poly-vinylalkohol,' *Berichte des Deutschen Chemischen Gesellschaft*, LX (1927), pp. 1658–1663.

Christiana J. Herringham, *The Book of the Art of Cennino Cennini* (London: G. Allen, 1899).

T. P. Hilditch, *The Industrial Chemistry of the Fats and Waxes* (New York: D. Van Nostrand Co., 1927).

J. R. Hill and C. G. Weber, 'Stability of Motion-Picture Films as Determined by Accelerated Aging,' *Journal of Research of the National Bureau of Standards*, XVII (1936), pp. 871–881.

H. E. Hofmann and E. W. Reid, 'Cellulose Acetate Lacquers,' *Industrial and Engineering Chemistry*, XXI (1929), pp. 955–965.

'Formulation of Nitrocellulose Lacquers,' *Industrial and Engineering Chemistry*, XX (1928), pp. 687–693.

R. Houwink, 'Synthetic Resins, their Formation, their Elastic and Plastic Properties, and their Possibilities,' *Journal of the Society of Chemical Industry*, LV (1936), pp. 247–259.

George S. Jamieson, *Vegetable Fats and Oils* (New York: The Chemical Catalogue Co., 1932).

J. F. John, *Die Malerei der Alten* (Berlin, 1836).

R. H. Kienle, 'Observations as to the Formation of Synthetic Resins,' *Industrial and Engineering Chemistry*, XXII (1930), pp. 590–594.

G. M. Kline, 'Permeability to Moisture of Synthetic Resin Finishes for Aircraft,' *Journal of Research of the National Bureau of Standards*, XVIII (1937), pp. 235–249.

G. M. Kline and B. M. Axilrod, 'Method of Testing Plastics,' *Industrial and Engineering Chemistry*, XXVIII (1936), pp. 1170–1173.

A. P. Laurie, *Greek and Roman Methods of Painting* (Cambridge: University Press, 1910).

The Materials of the Painter's Craft (Philadelphia: J. B. Lippincott Co., 1911).

New Light on Old Masters (London: The Sheldon Press, 1935).

'Notes on the Medium of Flemish Painters,' *Technical Studies*, II (1934), pp. 124–128.

The Painter's Methods and Materials (London: Seeley, Service and Co., 1926).

'The Yellowing of Linseed Oil,' *Technical Studies*, IV (1936), p. 145.

J. Lewkowitsch, *Chemical Technology and Analysis of Oils, Fats and Waxes* (London: Macmillan and Co., Ltd, 1913).

J. S. Long, 'Drying Oils,' *Paint and Varnish Lecture Course* (American Paint Journal Co., St Louis), (1933), pp. 36–46.

J. S. Long and W. S. W. McCarter, 'Studies in the Drying Oils, XV: Some Aspects of the Oxidation of Linseed Oil up to Gelation,' *Industrial and Engineering Chemistry*, XXIII (1931), pp. 786–791.

J. S. Long, A. E. Rheineck, and G. L. Ball, 'Studies in the Drying Oils, XVII: Influence of Several Factors on the Mechanism of Drying of Oil Films,' *Industrial and Engineering Chemistry*, XXV (1933), pp. 1086–1091.

A. Lucas, *Ancient Egyptian Materials and Industries*, 2d ed. (London: Edward Arnold and Co., 1934).

Antiques: Their Restoration and Preservation, 2d ed. (London: Edward Arnold and Co., 1932).

E. W. J. Mardles, 'The Dissolution of Substances in Mixed Liquids with Special Reference to Colloids,' *Journal of the Chemical Society*, CXXV (1924), pp. 2224–2259.

'Solvents of Some Cellulose Esters,' *Journal of the Society of Chemical Industry*, XLII (1923), pp. 127–136.

'The Swelling and Dispersion of Some Colloidal Substances in Ether-Alcohol Mixtures,' *Journal of the Chemical Society*, CXXVII (1925), pp. 2940–2945.

Jacques Maroger, 'Essai de Reconstitution de la Matière Picturale de Jean Van Eyck,' *Mouseion*, XIX (1932), pp. 39–46.

J. G. McIntosh, *The Manufacture of Varnishes and Kindred Industries* (London: Scott, Greenwood and Son, 1911).

M. P. Merrifield, *Original Treatises on the Arts of Painting,* 2 vols (London: John Murray, 1849. To be reprinted by Dover Publications in 1966).

R. S. Morrell and W. R. Davis, 'Studies in the Oxidation of Drying Oils and Cognate Subjects,' *Journal of the Society of Chemical Industry*, LV (1936), pp. 237T–246T, 261T–265T, 265T–267T.

R. S. Morrell and S. Marks, 'The Polymerisation of Drying Oils,' *Journal of the Oil and Colour Chemists' Association*, XIII (1930), pp. 84–90.

R. S. Morrell and H. R. Wood, *The Chemistry of Drying Oils* (London: Ernest Benn, Ltd, 1925).

H. T. Neher, 'Acrylic Resins,' *Industrial and Engineering Chemistry*, XXVIII (1936), pp. 267–271.

E. J. Parry, *Gums and Resins* (London: Sir Isaac Pitman and Sons, Ltd, 1918).

J. R. Partington, *Origins and Development of Applied Chemistry* (London: Longmans, Green and Co., 1935).

H. J. Plenderleith, *The Preservation of Antiquities* (London: The Museums Association, 1934).

H. J. Plenderleith and Stanley Cursiter, 'The Problem of Lining Adhesives for Paintings —Wax Adhesives,' *Technical Studies*, III (1934), pp. 90–113.

M. Ranagaswami, 'A Note on the Determination of Melting Point of Resins,' *Journal of the Oil and Colour Chemists' Association*, XIII (1930), pp. 287 ff.

E. W. Reid and H. E. Hofmann, 'Cellosolve and its Derivatives in Nitrocellulose Lacquers,' *Industrial and Engineering Chemistry*, XX (1928), pp. 497–504.

F. H. Rhodes and T. T. Ling, 'The Oxidation of Chinese-Wood Oil,' *Industrial and Engineering Chemistry*, XVII (1925), pp. 508–512.

Samuel Rideal, *Glue and Glue Testing* (London: Scott, Greenwood and Son, 1926).

E. R. Riegel, *Industrial Chemistry* (New York: The Chemical Catalogue Co., 1933).

David Rosen, 'A Wax Formula,' *Technical Studies*, III (1934), pp. 114–115.

A. H. Sabin, *The Industrial and Artistic Technology of Paint and Varnish* (New York: John Wiley and Sons, 1927).

J. Scheiber and K. Sändig, *Artificial Resins* (London: Sir Isaac Pitman and Sons, Ltd, 1931).

Hans Schmid, *Enkaustik und Fresko auf antiker Grundlage* (Munich: G. D. W. Callwey, 1926).

'La Reconstitution du Procédé à l'Encaustique,' *Mouseion*, XXIII–XXIV (1933), pp. 30–49.

Julius Schmidt, 'Zur Kenntnis der Künstlerölfarbe,' *Technische Mitteilungen für Malerei*, LI (1935), pp. 186–188, 192–194, 199–203; LII (1936), pp. 7–8, 16–18, 24–26, 33–36, 39–41, 49–51, 71–74, 79–80, 87–88, 96–98, 103–104, 111–112.

H. Schönfeld, *Chemie und Technologie der Fette und Fettprodukte*, I, *Chemie und Gewinnung der Fette* (Vienna: J. Springer, 1936).

A. Schwarcman, 'Linseed Oil and the Chemical and Colloidal Nature of Films,' *Journal of the Society of Chemical Industry*, LIV (1935), pp. 107 ff.

W. F. Seyer and Kuramitsu Ionouye, 'Paraffin Wax: Tensile Strength and Density at Various Temperatures,' *Industrial and Engineering Chemistry*, XXVII (1935), pp. 567–570.

A. J. Stamm and R. M. Seborg, 'Minimizing Wood Shrinkage and Swelling,' *Industrial and Engineering Chemistry*, XXVIII (1936), pp. 1164–1169.

H. Staudinger, 'The Formation of High Polymers of Unsaturated Substances,' *Transactions of the Faraday Society*, XXXII (1936), pp. 97–121.

H. Staudinger, K. Frey, and W. Starck, 'Hochmolekulare Verbindungen, 9 Mitteilungen: Über Poly-vinylacetat und Poly-vinylalkohol,' *Berichte der Deutschen Chemischen Gesellschaft*, LX (1927), pp. 1782–1792.

J. Vernon Steinle, 'Carnauba Wax, an Expedition to its Source,' *Industrial and Engineering Chemistry*, XXVIII (1936), pp. 1004–1008.

George L. Stout and Harold F. Cross, 'Properties of Surface Films,' *Technical Studies*, V (1937), pp. 241–249.

George L. Stout and Rutherford J. Gettens, 'Transport des Fresques Orientales sur de Nouveaux Supports,' *Mouseion*, XVII–XVIII (1932), pp. 107–112.

George L. Stout and Minna H. Horwitz, 'Experiments with Adhesives for Paper,' *Technical Studies*, III (1934), pp. 38–46.

D. E. Strain, 'Viscosity Variations in Methacrylic Ester Polymer Solutions,' *Industrial and Engineering Chemistry*, XXXII (1940), pp. 540–551.

D. E. Strain, R. G. Kennelly and H. R. Dittmar, 'Methacrylate Resins,' *Industrial and Engineering Chemistry*, XXXI (1939), pp. 382–387.

Edwin Sutermeister, *Casein and Its Industrial Applications* (New York: The Chemical Catalogue Co., 1927).

R. S. Taylor and J. G. Smull, 'Studies in the Drying Oils, XIX: Oxidation of Linseed Oil,' *Industrial and Engineering Chemistry*, XXVIII (1936), pp. 193–195.

Daniel V. Thompson Jr, *Il Libro dell'Arte, The Craftsman's Handbook of Cennino d'Andrea Cennini*, 2 vols (New Haven: Yale University Press, 1932-1933. Reprinted in 1 volume by Dover Publications, 1954).

 The Materials of Medieval Painting (New Haven: Yale University Press, 1936).

 The Practice of Tempera Painting (New Haven: Yale University Press, 1936. Reprinted by Dover Publications, 1962).

Daniel V. Thompson Jr and George Heard Hamilton, *De Arte Illuminandi* (New Haven: Yale University Press, 1933).

Edward Thorpe, *A Dictionary of Applied Chemistry* (London: Longmans, Green and Co., 1922).

J. F. Thorpe and M. A. Whitely, *Supplement to Thorpe's Dictionary of Applied Chemistry* (London: Longmans, Green and Co., 1934).

Maximilian Toch, *Paint, Paintings and Restoration* (New York: D. Van Nostrand Co., 1931).

T. R. Truax, *The Gluing of Wood* (Washington, D. C.: Government Printing Office, 1930).

A. Tschirch and Erich Stock, *Die Harze*, 4 vols (Berlin: Gebrüder Borntraeger, 1933–1936).

Hermann Vollman, 'Zur Kolloidchemie des Leinöls,' *Zeitschrift für Angewandte Chemie*, XXXVIII (1925), pp. 337–339.

Hans Wagner and Georg Fischer, 'Filmbildung aus Emulsionen,' *Kolloid Zeitschrift*, LXXVII (1935), pp. 12–30.

R. Walton, *A Comprehensive Survey of Starch Chemistry* (New York: The Chemical Catalogue Co., 1928).

J. F. Watin, *L'Art du Peintre, Doreur, Vernisseur*, 2d ed. (Liege, 1778).

S. Werthan, A. C. Elm, and R. H. Wien, 'Yellowing of Interior Gloss Paints and Enamels,' *Industrial and Engineering Chemistry*, XXII (1930), pp. 772–784.

R. V. Williamson, 'Relation of Oil Absorption to Consistency of Pigment-Oil Pastes,' *Industrial and Engineering Chemistry*, XXI (1929), pp. 1196–1198.

S. P. Wilson, *Pyroxylin Enamels and Lacquers*, 2d ed. (New York: D. Van Nostrand Co., 1927).

Hans Wolff, 'The Critical Oil Content and the Properties of Paint Films,' *Paint and Varnish Production Manager*, VIII (October, 1932), pp. 5–6; (November, 1932), pp. 8–10.

George Woodbury, 'Note on the Use of Polymerized Vinyl Acetate and Related Compounds in the Preservation and Hardening of Bone,' *American Journal of Physical Anthropology*, XXI (1936), pp. 449–450.

R. I. Wray and A. R. Van Vorst, 'Permeability of Lacquer Films to Moisture,' *Industrial and Engineering Chemistry*, XXVIII (1936), pp. 1268–1269.

H. Yoshida, 'The Chemistry of Lacquer,' *Chemical Society Transactions*, XLIII (1883), pp. 472 ff.

C. D. Young, 'Lacquer,' *Industrial Furnishing*, XII (1928), pp. 30 ff.

Fritz Zimmer, *Nitrocellulose Ester Lacquers*, trans. (New York: D. Van Nostrand Co., 1934).

PIGMENTS AND INERT MATERIALS

PIGMENTS FROM ART MATERIALS

Alizarin (alizarin crimson) (see also **Madder**) is the coloring principle of the madder root and it was first isolated from that source in 1826 by Colin and Robiquet ('Recherches sur la Matière colorante de la Garance,' *Annales de Chimie et de Physique, 2d series,* XXXIV [1827], pp. 225–253). It is 1,2 dihydroxyanthraquinone, and was first synthesized by two German chemists, C. Graebe and C. Lieberman, who reported their discovery in 1868 ('Ueber Alizarin und Anthracen,' *Berichte der Deutschen Chemischen Gesellschaft,* I [1868], pp. 49–51; see also English patent 3850, December, 1868). This is important in the history of organic chemistry, for alizarin was the first of the natural dyestuffs to be made synthetically. Its discovery caused the rapid decline and the almost complete disappearance of the large madder-growing industry in France. The 'alizarin crimson' lake used so extensively in artists' paints is nearly all from this source. It is made with aluminum hydrate which gives a transparent lake; different shades of red can be made with different bases. It is more light-fast than natural madder lake because it contains none of the fugitive purpurin associated with alizarin from that source (see Eibner, *Malmaterialienkunde,* p. 202), and is among the most light-fast of the organic red pigments. Some painters have said, however, that synthetic alizarin does not give the pleasing, saturated, and fiery tone that madder alizarin gives. In ultra-violet light, synthetic alizarin does not give any of the strong fluorescence that is characteristic of madder lake. It may not be permanent when mixed with earth colors like ochre, sienna, and umber (see Toch, *Paints, Painting, and Restoration,* p. 97). Microscopically, alizarin lake is not readily distinguished. Merwin says (p. 517) that the isotropic base with the coloring matter has a variable low refractive index, about 1.70 for red. The color by transmitted light is purplish red. It is soluble and turns purple in dilute sodium hydroxide, but this behavior is hardly characteristic.

Alizarin Crimson (see **Alizarin**).

Aluminum Hydrate (transparent white), or aluminum hydroxide, $Al(OH)_3$, is a light, white material which is prepared by treating a solution of aluminum sulphate with an alkali such as soda ash or potash. The gelatinous aluminum hydroxide, because it adsorbs dyestuffs easily, may be used directly in pulp form as a base in the preparation of transparent lake pigments or it can be dried to a very light, white powder. This is used in paint manufacture, largely as a filler. It is the most common cheapening agent for artists' oil colors and many of them now on the market contain it. Because of its low density and low refractive index, it lacks covering power and lends transparency to colors. It has high oil absorption and, for this reason, tends to increase yellowing in paints. Excess of it sometimes causes a rubbery consistency in prepared paste paints. Aluminum hydrate is difficult to detect in paint films by microscopic methods because of its lack of form and its lack of characteristic optical properties. It appears simply in clots of fine grains showing no birefringence. The hydrate is soluble in acids and alkalis, but is otherwise a stable material. When heated to a high temperature,

it loses its combined water and is changed to aluminum oxide, Al_2O_3, which is of no value for pigment purposes. Alum and similar substances were used as early as classical times as a source of substrates for dye colors (see Bailey II, 233–238).

Aluminum Leaf and **Aluminum Bronze Powder** are made from sheet aluminum by a beating and a stamping process, respectively. The name, 'bronze,' is still retained, no doubt from its association with metal powders made from copper alloys (see **Bronze Powders**). Although aluminum powder was probably available as early as the middle XIX century, it was not until a decade or so after 1886, when aluminum began to be produced in large commercial quantities by the Hall process (see **Aluminum,** section on supports, pp. 221 and 222) that the powder became readily available. It was first used for coating picture frames and radiators. Aluminum powder did not become important as a pigment for commercial paints until after 1920 (see J. D. Edwards, *Aluminum Bronze Powder and Aluminum Paint* [New York: The Chemical Catalogue Co., 1927], pp. 26–29). Its development for outside and for protective painting followed experiments and field tests carried on in the Forest Products Laboratory, Madison, Wisconsin, and by the H. A. Gardner Laboratory in Washington.

When aluminum bronze powder is stirred into a suitable vehicle like oil or varnish, the flakes swirl and some come quickly to the surface layer where they spread out to form an almost continuous film of flat particles. This phenomenon, which is called 'leafing,' is caused by surface tension and is shown only to a marked degree by the polished powder and not by the unpolished powder (see J. D. Edwards, F. C. Frary, and Z. Jeffries, *The Aluminum Industry*, II [New York: McGraw-Hill Book Co., 1930], p. 803). No grinding of the powder and vehicle is necessary. In pyroxylin medium (nitrocellulose) aluminum powder has no leafing properties and does not form a durable film. Because of its leafing properties, it is now finding wide use for moisture- and waterproof paints. For exterior use, long oil spar varnishes are the best vehicle. Experiments at the Forest Products Laboratory show that this coating has outstanding moisture resistance and maintains its moisture-proofing efficiency over relatively long periods of time.

Aluminum bronze leaf in a vehicle has a reflectivity of 60 to 75 per cent for light, but it has low emissivity or radiating power for heat. At 40° C. the emissivity of aluminum paint is only about 20 per cent of that of a 'black body,' which is the theoretically perfect radiating surface (see Edwards, *op. cit.*, pp. 47 and 51).

Microscopically, the particles of aluminum bronze powder are irregular in shape; in reflected light the individual flakes are lined with irregular, dark markings which are the result of having been stamped in contact with other flakes. Although the flakes are very thin (in the order of 1 micron), they are opaque to strong transmitted light.

Aluminum Stearate, $Al(C_{18}H_{35}O_2)_3$, is a soap made by the saponification of tallow and treatment with alum. It is a white powder which forms colloidal solutions or gels with linseed or other oils, turpentine, or mineral spirits. For this reason, it is often used in artists' oil pastes and prepared paints to prevent separation of the oil from the pigment. Small quantities only are desirable because too much of it hinders drying and develops a 'cheesy' film. It is used also as a flatting agent in varnishes and lacquers (Gardner, p. 788). Because of its colloid-forming properties, aluminum stearate is not easily recognized in paints; it has no outstanding optical properties.

Anhydrite is the mineralogical name for native anhydrous calcium sulphate, $CaSO_4$, which is often associated in nature with calcium sulphate dihydrate or gypsum (see **Gypsum**). Although it has no useful setting properties, it occurs occasionally as an impurity in gypsum and plaster of Paris. Sometimes it is observed as a component of the gesso in Italian paintings. Anhydrite is a colorless inert like gypsum, but it differs from that material in the nature of its crystallinity and in its optical properties. It crystallizes in the orthorhombic system, has higher refractive index ($\beta = 1.575$) than gypsum, and is strongly birefracting. Particles of it appear as small, square tablets in gypsum gesso; it is characterized by cleavage in three rectangular directions (Dana, p. 630). The chemical properties are about the same as those of gypsum.

Aniline Pigments (see **Coal-Tar Colors**).

Antimony Oxide, Sb_2O_3, was introduced to the paint trade as a pigment under the trade name, 'Timonox,' in 1920 by the Cookson Lead and Antimony Co., Ltd, of England. It has good hiding power; the refractive index is about 2.20, nearly that of a reduced titanium oxide. Some commercial samples that have been examined (Merwin) were found to contain crystals which correspond to the two known mineral forms of antimony oxide: senarmonite, which is isotropic, and valenitinite, which is orthorhombic. They also contain some octahedral arsenic oxide as impurity. Antimony oxide is an inert substance to vehicles and its oil absorption is low (11.2 grams oil to 100 grams pigment [Gardner-Coleman]). Since it is darkened by hydrogen sulphide, it is usually mixed with zinc oxide, which has preferential absorption for that gas. Antimony oxide has not been mentioned specifically as an artist's pigment, and it has no advantage over other white pigments.

Antimony Vermilion is antimony sulphide, Sb_2S_3; it may be prepared by precipitating antimony chloride with sodium thiosulphate or with hydrogen sulphide, and it may be had in hues varying from orange to deep red. It precipitates in minute isotropic red globules. It was first made by C. Himly in Kiel in 1842 (see Rose, p. 15). Although antimony sulphide figures as a pigment in the rubber industry, it is little used in paint because it is fugitive and not very stable chemically. It is said (Weber, p. 120) to have been used as an adulterant for real

mercury vermilion. It is soluble in alkalis and in strong acids, and turns black on heating (Rose, p. 16).

Antimony Yellow (see **Naples Yellow**).

Antwerp Blue (see **Prussian Blue**).

Armenian Bole (see **Bole**).

Artificial Pigments (see **Synthetic Pigments**).

Arzica (see **Weld**).

Asphaltum (bitumen) is a brownish black, native mixture of hydrocarbons with oxygen, sulphur, and nitrogen, and often occurs as an amorphous, solid or semi-solid liquid in regions of natural oil deposits. It is thought to be formed from the evaporation of the lighter components of the petroleum and from polymerization and partial oxidation of the residue. It is found widely, but that used in European paintings came, perhaps, from the region of the Caucasus or the borders of the Dead Sea. In Mesopotamia and Egypt in very early times it was known and used for various purposes (see Partington, index). Asphaltum has little use now, but is still listed by artists' supply dealers. Not much is known about its preparation, but Church says (p. 235) that the crude asphaltum is usually heated to a fairly high temperature to drive off moisture and volatile materials before it is ground in oil or other mediums. The pigment is partially soluble in oil, like a stain, and gives a semi-transparent, reddish brown film. In the film, it may be occasionally observed microscopically as tiny brown flakes without structure. Only thin grains are transparent brown. It is soluble in turpentine, naphtha, and other organic solvents.

Asphaltum and other similar tarry compounds are among the least desirable pigments known because they never become permanently dry. In thick oil films, they have a tendency to run and to crawl, but, if they are properly prepared, such difficulties may be partially overcome (see Church, p. 236). Doerner says (p. 189) that Rembrandt used asphaltum as a glaze with no harmful effect. It is unaffected by acids and is unsaponifiable; it requires about 150 per cent of oil to grind. Under ordinary circumstances, it is unaffected by light but is faded by strong exposure. It was much favored by the XVIII century English school, with unfortunate consequences; those paintings which contained it have become disfigured because of shrinkage of the paint films and 'alligatoring.' Harder paint films put over it sometimes crack and curl. Neuhaus says (see footnote in his translation of Doerner's *The Materials of the Artist*, p. 89): 'Under high summer temperatures in museums without thermostatic control whole areas of the picture surface have moved and become permanently dislocated. Thus in several warm climatic belts of America it has caused the destruction of many paintings of the Munich school which at one time was passionately fond of asphaltum as a frottie.'

Asphaltum is also sold to the artists' trade under the name 'bitumen.' Both mummy (see **Mummy**) and bistre (see **Bistre**) are similar in color and composition

to asphaltum in that they are tarry, organic substances, but their origin is quite different.

Aureolin (see **Cobalt Yellow**).

Azurite (mountain blue) is a natural blue pigment which is derived from the mineral, azurite, a basic copper carbonate, $2CuCO_3 \cdot Cu(OH)_2$. The mineral occurs in various parts of the world in secondary copper ore deposits where it is frequently associated with malachite, a green basic carbonate of copper (see **Malachite**). Like other mineral pigments, this has been prepared from carefully selected material by grinding, washing, levigation, and flotation (see Thompson, *The Materials of Medieval Painting*, pp. 131–132). It has long since ceased to be of importance in Western painting, and is rarely used today, except perhaps to a limited extent in the East.

Azurite is crystalline and is fairly highly refracting and birefracting. For use as a pigment, it is ground rather coarsely because fine grinding causes it to become pale and weak in tinting strength. Ninety-mesh azurite, however, is deep violet-blue in color. Areas of dark azurite on paintings can often be recognized by their sandy texture and by their thickness. Traditionally, it appears to have been most used in a tempera medium because in oil it would be dark and muddy and would not have the sparkle that it has in tempera. The characteristics of azurite blues in old paintings are well described by Thompson (*loc. cit.*, pp. 132–135). The penetration into azurite paint in European panel paintings of successive layers of oil and varnish films has often caused such areas to become nearly black. If cleaned, the particles are usually revealed unchanged. Although there may be instances where the pigment has turned green (to malachite) by hydration, the more usual cause of the change in color is the optical effect of superimposed layers of discolored varnish. Azurite is blackened by heat and by warm alkalis, and it is soluble in acids, even in acetic acid; but, under ordinary conditions, it appears to be a remarkably stable pigment.

This natural copper carbonate was no doubt the most important blue pigment in European painting from the XV to the middle of the XVII century and in paintings of that period it is found more frequently than ultramarine. De Wild (p. 23) lists nineteen early Dutch and Flemish paintings on which he identified azurite. Europe had various sources of the mineral. There is evidence (see Laurie, *New Light on Old Masters*, p. 42) that Hungary was the principal source in the XVI century, but the pigment disappeared from the painter's palette in the middle XVII century when Hungary was overrun by the Turks. One of the early names for azurite was *azure d' Alemagna*, indicating that it came from Germany. It is the *azurro della magna* of Cennino Cennini, and was known by numerous other names in mediaeval times (see Thompson, 'Trial Index for Mediaeval Craftsmanship,' p. 415, f.n. 4 and 5).

Azurite was the most important blue pigment in the wall paintings of the East. It was employed in the cave temples at Tun Huang in Western China and

was used lavishly in wall paintings of the Sung and Ming dynasties in Central China. With difference in the fineness of grinding, different shades were produced (see Gettens, 'Pigments in a Wall Painting from Central China'). The source of azurite in China is not known, but there are extensive copper deposits in the provinces of Kwei-chou and Yunnan. Uyemura lists azurite among the ancient pigments of Japan. It was known and used in ancient Egypt. Lucas says that it occurs both in Sinai and in the Eastern Desert, and he cites (p. 283) examples of its use in very early dynasties. Strangely enough, it seems not to have been reported among pigments identified in Roman paintings.

Barium White (barytes, blanc fixe, permanent white) is barium sulphate ($BaSO_4$), which may be obtained naturally from the mineral known as barite, barytes, or heavy spar, or it can be made artificially. Barytes is found widely in Europe and in the United States. It can be prepared for use as a filler or extender in paints by the simple process of grinding and settling. Frequently it serves as a base for lake pigments. An extremely inert material, it is quite unaffected by strong chemicals, by heat, and by light. In judicious quantities, it may improve the wearing and weathering qualities of lead and zinc white paints (see Toch, *The Chemistry and Technology of Paints*, pp. 110–114). Barytes is a heavy inert (sp. gr. = 4.3 to 4.6), but it does not have enough hiding power for a pigment because of its transparency and medium refractive index (β = 1.637 [Larsen and Berman]). Barytes has low oil absorption; some colors, which alone have high oil absorption, need much less oil when ground with it (*Colour Index*, p. 303).

Blanc fixe is the name given to the artificial barium sulphate made by precipitation from barium chloride solution with sodium sulphate. It is identical with barytes, except that it is a finely divided powder and has much greater hiding power than the natural material. When co-precipitated with zinc sulphide, lithopone (see **Lithopone**) is formed and, with titanium oxide, titanium barium pigment is formed. Like natural barytes, it is an important lake base. Blanc fixe is not opaque enough to be ground alone with oil for a white paint. As an extender it is sometimes put into artists' flake white and other artists' oil paints. Several grades of both barytes and blanc fixe are available now, but most of them contain 98 per cent or over of $BaSO_4$ (see Gardner, p. 1241). Barium sulphate has been used in connection with paints since about the beginning of the XIX century (see Trillich, II, 45–46).

Barium Yellow (lemon yellow) (see also **Strontium Yellow**) is barium chromate ($BaCrO_4$), which is a pale green-yellow pigment made by mixing solutions of neutral potassium chromate and barium chloride. The pigment formed is deficient in brightness and hiding power. Microscopically, it may sometimes be observed in nearly colorless, birefracting, rhombic plates. Other varieties are so fine that crystal character and optical properties can not readily be observed. Church says (p. 151): 'Of all the chromates which have been used in painting, barium chromate is the most stable. It is nearly insoluble in water but soluble

in dilute alkalis and in dilute mineral acids. It is decomposed by heat at high temperatures but is little affected by light.' It may become slightly greener on exposure to light because of formation of chromic oxide. Although Vauquelin, the discoverer of the metal, chromium (1797), described the preparation of barium chromate as early as 1809, little seems to have been recorded concerning its first use as a pigment. J. D. Smith compared the solubilities of barium and strontium chromates as early as 1836 (see 'On the Separation of Barytes and Strontia,' *Philosophical Magazine, 3d series*, VIII [1936], pp. 259–261). Barium chromates and strontium chromates, which are quite similar, are both frequently sold as 'lemon yellow.'

Barytes (see **Barium White**).

Bentonite is a colloidal clay which consists chiefly of the mineral, montmorillonite, a hydrous aluminum, iron and magnesium silicate. It is of volcanic origin and occurs rather widely. Large quantities are now mined near the Black Hills in Wyoming and South Dakota and, also, in California. The outstanding characteristic of bentonite is its colloidal behavior when mixed with water, in which it swells as much as 22 times its absolute volume and forms a stiff, jelly-like paste which is smooth and soft like soft soap. Best dispersion is obtained by adding the bentonite to the water. It does not swell and form gels if water is added to it. Bentonite is unaffected by acids and alkalis. When heated above 205° C., it begins to lose water and, also, its colloidal properties. Only special forms of bentonite are pure white; it is generally a warm gray because of its iron content. Microscopically, it is characterized only by its very fine grain size. (This information is taken from the data sheets furnished by the American Colloid Company.)

Berlin Blue (see **Prussian Blue**).

Bistre (see also **Asphaltum**) is a brown water color pigment which is derived from the tarry soot of burned, resinous wood and beechwood. It is similar to asphaltum in color and composition. The color varies from saffron yellow to brown-black, depending upon the source and treatment of the raw material. It was sometimes mixed with red ochre to give it a warmer tone (see Meder, p. 68). Church says (p. 234) that the ground raw product is washed with hot water before it is mixed with gum and glycerine in the preparation of water color. The tarry nature of bistre (as with asphaltum) makes it an unsuitable pigment, except perhaps in very thin washes. He also says (p. 234) that exposure to strong sunlight oxidizes the tarry matter of bistre and the residual pigment becomes cooler in hue and paler. Tarry materials of wood origin have probably been used for centuries. Meder says (p. 66) that first literary mention of bistre (*caligo*) was by Jehan le Begue in 1431; it had been used extensively, however, in Italian book illustrations in the XIV century. It was used by Rembrandt for wash drawings. It is still listed by artists' supply dealers, but is little used since it is admitted by them not to be permanent.

Bitumen (see **Asphaltum**).

Black Chalk, a bluish black clay containing carbon. (See also p. 285.)

Black Lead, the material used for 'lead' pencils, has no relation to lead metal, nor is it a lead compound; it is a common term for the mineral, graphite (see **Graphite**), or a mixture of clay and graphite which is more useful for writing purposes. The confusion in terminology arose from the color similarity of graphite and lead for marking purposes.

Blanc Fixe (see **Barium White**).

Blue Bice (see **Blue Verditer**).

Blue Verditer (blue bice) is a name now given to an artificial basic copper carbonate, $2CuCO_3 \cdot Cu(OH)_2$, which is similar in chemical composition to the mineral, azurite. This pale greenish blue pigment is little used today, but can still be obtained from some artists' colormen. Recipes for making artificial copper blues or 'azures' are very old (see Thompson, 'Trial Index for Mediaeval Craftsmanship,' p. 415, f.n. 7). The more practical of these call for the addition of lime or potash and sal ammoniac to a soluble copper salt like blue vitriol (copper sulphate). Microscopically, blue verditer may be seen as tiny, rounded, fibrous aggregates, even in size, highly birefracting, and blue by transmitted light. It is similar in color to finely ground azurite. The artificial copper blues have not been credited with great permanence, and Thompson says (*The Materials of Medieval Painting*, p. 151) that they had a tendency to revert to green through the loss of their ammonia content (see also Bearn, p. 93). According to Laurie (*The Pigments and Mediums of the Old Masters*, p. 43), the manufacture of blue verditer seems to have been carried on in England in large quantities at one time. Thompson states (*loc. cit.*) that 'the artificial blues from copper are probably more significant in medieval painting than all the rest (of the blue pigments) put together.' They were the best cheap substitutes for the more expensive azurite and ultramarine. Laurie (*op. cit.*, p. 122) identified this pigment in various English illuminated manuscripts (*Coram Rege Rolls*) of the early XVII century. He records, in another place (*New Light on Old Masters*, p. 42) that it was used throughout the XVIII century and that the 'Madame de Pompadour' by Boucher, in the National Gallery, Edinburgh, is painted with it.

Bole (Armenian bole, red bole) is the name frequently given in the arts to clay, either white or colored. White bole is about identical with kaolin (see **China Clay**). Red bole is a natural, ferruginous aluminum silicate which was originally found in Armenia but now elsewhere in Europe. It is similar to ochre in composition but is softer and more unctuous, and because it is capable of receiving a high polish, it has served since early mediaeval times as a ground for gilding. It is obtainable today under various names such as 'gilders red clay' or 'red burnish gold size.'

Bone Ash (see **Bone White**).

Bone Black (animal black, drop black) (see also **Carbon Black** and **Ivory Black**) is made by charring animal bones in closed retorts; usually bones from glue stock, boiled to remove fat and glue, are used. Bone black is blue-black in color and is fairly smooth in texture (see Bearn, p. 131). It is denser than carbon or lamp black. It contains about 10 per cent carbon, 84 per cent calcium phosphate, and 6 per cent calcium carbonate. Although the calcium compounds (ash) in it have no color value, they improve the working quality and give a superior black. Microscopically, it is also quite different from lamp black; the particles are coarser and more irregular in shape and size, many of them being transparent and some brown. Merwin, who has described some optical properties of ivory and bone black, says (p. 514): 'In charred bones a small amount of dark carbonaceous matter is held in the most minute subdivision throughout a large amount of calcium phosphate. Grains 5μ in diameter transmit an appreciable brownish color and appear practically homogeneous optically. Their apparent refractive index, when their pores are filled with oil, ranges from about 1.65 to 1.70; thus the desirable characteristics of slight diffusing power and effective absorbing power are combined.' Bone black sold under the name, 'ivory black,' is a favorite among artists today. It works well in water color.

Bone White (bone ash), which is made by calcining animal bones, is composed chiefly of tricalcium phosphate, $Ca_3(PO_4)_2$ (85 to 90 per cent); calcium carbonate and minor constituents make up the rest (see Thorpe). Ash from the bones of different animals varies little in composition. Bone white is a grayish white and slightly gritty powder. In mediaeval times, it was used on paper or parchment to give it tooth or abrasive quality to receive the streak of silver point (Thompson, *The Materials of Medieval Painting*, pp. 94–95).

Brazil-Wood is a natural red dye from the wood of *Caesalpinia braziliensis*. That used in the Middle Ages came from Ceylon. It was known and called 'brazil' many centuries before the discovery of the country, Brazil (Thompson, *The Materials of Medieval Painting*, p. 116). Pernambuco wood, *Caesalpinia crista*, from Jamaica and also from Brazil has about twice as much coloring matter, and various other trees of the family, *Leguminosae*, yield brilliant dyestuffs. The interior of the live wood is light yellow, but changes rapidly to deep red on exposure. Brazil-wood extract is made by boiling the finely chipped wood with water and by concentration of the liquor *in vacuo*. The leuco compound is brazilin, $C_{16}H_{14}O_5$, which forms, on exposure to air, brazilein, $C_{16}H_{12}O_5$, which is deep red to brown in color (*Colour Index*, p. 297).

Brazil-wood lakes, which are prepared with different mordants, vary in color from bright cherry to deep red and are sold under a variety of names. One method formerly used was to extract the chips with hot alum solution, followed by precipitation with lye (Thompson, *The Materials of Medieval Painting*, p. 118; see also Perkin and Everest, pp. 627–628). These lakes are insoluble in water and in alcohol but are partially soluble in alkalis, giving them a brownish red color.

Mineral acids decompose them with a yellow to orange-red solution. They are not stable in strong light. Brazil-wood dyes are said to have been used in great quantities in mediaeval times in dyeing, in painting, and in inks, perhaps more than madder at an early date (Thompson, *loc. cit.*, pp. 120–121), but were later replaced by more brilliant colors.

Bronze Powders are metal flake pigments made commonly from copper-zinc alloys (brass), but for some powders copper-tin alloys (bronze) are also used. The copper-zinc powders go into imitation gold paint. Formerly all metal bronze powders were made by the same method: first rolling or beating into foil or leaf, and then powdering. This method was expensive. Since about 1860 to 1865, they have been made directly from sheet metal, up to one eighth inch thick, in special stamping machines (see Otto Von-Schlenk, 'The Manufacture of Bronze Powder,' *The Metal Industry* [New York], XIV [1917], pp. 77–78, 161–163, 200–203). Numerous shades and colors, ranging from citron yellow to orange, can be made, depending upon alloy composition. The alloy, Cu, 95 : Zn, 5, gives a powder the color of nine-carat gold; 90 : 10 is pale gold; 85 : 15 is yellow gold; 70 : 30 is greenish gold, etc. (see Oliver Smalley, 'The Manufacture of High-Grade Aluminum and Bronze Powders,' *The Metal Industry* [London], XXVII [1925], pp. 1–2).

The flakes of these powders are very thin: in the order of 1/50,000 to 1/100,000 inch (Von-Schlenk, *loc. cit.*, p. 77). In spite of thinness, the flakes are quite opaque when viewed under the microscope; they have fairly regular and uniform dimensions and contain little impurity (see three photomicrographs shown by Smalley, *op. cit.*, XXVII [1925], p. 186).

Bronzing liquids are generally solutions of nitrocellulose in amyl acetate (banana oil) or other organic solvents.

Brown Madder is made by the gentle charring of madder lake or alizarin to give a dull, brownish red color. Although it is not permanent and seems to be an unnecessary color in these days, it is still listed by a few colormen. Paints now sold under this name may be mixtures of pure alizarin with burnt sienna or another similar earth color.

Brown Ochre (see **Ochre**).

Brown Pink (see **Pink**).

Buckthorn Berries (see **Persian Berries Lake**).

Burnt Sienna (see **Sienna**).

Burnt Umber (see **Umber**).

Cadmium Green is not a color produced by any pure cadmium compound but is the name given to a warm green made from a mechanical mixture of transparent oxide of chromium (hydrated green or viridian) with cadmium yellow. That produced by one manufacturer is said to be 93 to 94 per cent hydrated green plus cadmium yellow (Gardner, p. 1349).

Cadmium Orange (see also **Cadmium Yellow**) is one of the color modifications of cadmium sulphide (CdS). Toch (*The Chemistry and Technology of Paints,*

p. 73), in dealing with the preparation says: 'If the solution is made slightly acid a yellow shade is produced and by changing the proportions of acid and adding ammonium sulphide deeper shades may be made up to the deepest orange.' The history of cadmium orange is about the same as that of cadmium yellow.

Cadmium Red (see also **Cadmium Yellow**) is a cadmium sulpho-selenide, CdS(Se), which is prepared by precipitating cadmium sulphate with sodium sulphide and selenium. By adjusting the proportion of sulphur to selenium and by regulating the conditions of precipitation, shades varying from vermilion to deep maroon may be obtained. Cadmium red is now a popular and favorite pigment, and today it has, to a great extent, replaced vermilion on the artist's palette. Microscopically, it may be seen as tiny red globules less than 1 μ in diameter, without appearance of crystallinity, and with very high refractive index. The particles are strongly colored, deep red by transmitted light, and have a characteristic appearance. The various cadmium sulpho-selenides are stable and light-resistant under ordinary conditions. Their history is more recent than that of the straight cadmium sulphides. Although a red-orange cadmium pigment containing selenium was mentioned in a German patent (no. 63558; see Rose, p. 107) in 1892, it seems that the commercial production of cadmium reds did not begin until about 1910 (see Toch, *Paints, Painting and Restoration*, p. 105; also Rose, *loc. cit.*).

Cadmium Red Lithopone (see also **Cadmium Yellow Lithopone**) is a mixture of cadmium sulpho-selenide co-precipitated with barium sulphate. It is made in a way similar to lithopone; in one method the metal, selenium, is dissolved in barium sulphide solution, the two co-precipitated with cadmium sulphate, and the residue, after washing, is calcined (see U. S. patent no. 1,894,931 [1933], to W. J. O'Brien). One manufacturer reports (see Gardner, p. 1274) that the barium sulphate content in a variety of shades ranges from 55.0 to 58.5 per cent. In microscopic appearance, it is very similar to pure cadmium red, except that at high magnification irregular prismatic grains of barium sulphate can also be seen. It is stable under ordinary conditions and is light-fast. It is a strictly modern pigment, having been in use only since 1926 (see H. W. D. Ward, under **Cadmium Yellow Lithopone**).

Cadmium Yellow is cadmium sulphide (CdS) which is prepared by precipitation from an acid solution of a soluble cadmium salt (chloride or sulphate) with hydrogen sulphide gas or an alkali sulphide. The color of the pure cadmium sulphide ranges in hue from lemon yellow to deep orange, depending upon the conditions of precipitation. Cadmium sulphide is found in nature as the mineral, greenockite, but the use of the mineral as a pigment has not been mentioned. E. T. Allen and J. L. Crenshaw ('The Sulphides of Zinc, Cadmium and Mercury; their Crystalline Forms and Genetic Conditions' [Microscopic Study by H. E. Merwin], *American Journal of Science, fourth series*, XXXIV [1912], pp. 341–396), from an extensive study of the crystalline nature of cadmium sulphides

made in different ways have concluded (p. 365), on the basis of microscopic examination, that differences in color are primarily dependent upon the amorphous or crystalline nature of the sulphide and on its state of division. They say further (p. 366) that particles of the orange amorphous cadmium sulphide are in the order of 50 times as great in diameter as the yellow particles (see **Cadmium Orange**). Many of the light or lemon shades of cadmium yellow are really cadmium lithopone (see **Cadmium Yellow Lithopone**) which are co-precipitates with barium sulphate. All of these cadmium yellows are very finely divided and even in particle size and at high magnifications can be observed in tiny globules. Cadmium sulphide has a high refractive index and, hence, good hiding power. It is permanent and fast to light. The modern product, because of freedom from excess free sulphur, is compatible with most other pigments. When strongly heated, cadmium sulphide burns to yellowish brown cadmium oxide. It is insoluble in cold dilute acids and alkalis but readily soluble in concentrated mineral acids with evolution of hydrogen sulphide gas. Although cadmium sulphide was first observed by Stromeyer as early as 1817 and was introduced into oil painting by Melandri in 1829 (Eibner, *Malmaterialienkunde*, p. 128), it did not become commercially available as a pigment until about 1846 (see Weber, p. 29). Laurie (*The Pigments and Mediums of the Old Masters*, p. 16) says that the cadmium yellows were first shown in the 1851 Exhibition. It is now perhaps the most important yellow pigment on the artist's palette and is widely available in numerous shades. It appears that, until recently, the cadmium lithopones (see **Cadmium Yellow Lithopone**) were the only cadmium yellows manufactured in this country, the straight commercial cadmium sulphides being chiefly a German product. Now, however, the latter are beginning to be manufactured here.

Cadmium Yellow Lithopone (see also **Cadmium Yellow**) is a co-precipitated mixture of cadmium sulphide and barium sulphate (from cadmium sulphate and barium sulphide), made in a way similar to zinc lithopone (see **Lithopone**). The precipitate is washed and calcined; it contains about 38 per cent cadmium sulphide and can be produced in a variety of shades ranging from lemon yellow to orange and at a cost considerably less than that for pure cadmium sulphide. It is a very finely divided pigment and its properties are similar to the straight sulphide. When this pigment was first introduced, H. W. D. Ward ('New Cadmium Pigments,' *The Chemical Trade Journal and Chemical Engineer*, LXXX [1927], pp. 59–60) reported that cadmium yellow lithopone had all the fastness to light and heat of the pure sulphide but did not quite equal it in covering power. On a cost basis, however, the ratio was in favor of the 'cadmopone,' as he called it. At the time of his report (January, 1927), he said that this pigment had been on the market three or four months. Until very recently the cadmium lithopones were the only cadmium yellows manufactured in the United States.

Carbon Black (see also **Lamp Black, Ivory Black, Charcoal Black, Vine Black, Graphite**) includes various pigments that are derived from the partial burning

or carbonizing of natural gas, oil, wood, and other organic materials. Almost none of these products is pure carbon, but all contain mineral impurities and hydrocarbons that are tarry in nature. Carbon makes a very stable pigment; it is unaffected by light and air and by hot concentrated acids and alkalis; it can only be destroyed by burning at very high temperatures. As a pigment, it has excellent hiding power in all its forms. Oil paints made from carbon black are sometimes slow-drying; the freer they are from tarry matter, the better they dry (see Bearn, p. 125). The organic black pigments, although they all contain carbon as their essential constituent, vary considerably in shade and strength according to the amount and particle size of the amorphous carbon in them.

Specifically, 'carbon black' is used to designate that produced in America by allowing the smoky flame from natural gas to impinge against cooled, revolving metal drums from which the black is automatically removed by scrapers (see Cabot, p. 13, and Bearn, p. 130). This product is deep brownish black in color, strong tinctorially, and is more granular and harder than lamp black and, unlike the latter, wets well in water.

Carthame (see **Safflower**).

Cassel Earth (see **Van Dyke Brown**).

Celite (see **Diatomaceous Earth**).

Cerulean Blue, which is essentially cobaltous stannate, $CoO \cdot nSnO_2$ (see Church, p. 212), is made by precipitating cobaltous chloride with potassium stannate, thoroughly washing, mixing with pure silica and calcium sulphate, and heating. It is a stable and inert pigment and is not affected by light or by strong chemical agents. Physically, it is finely divided and consists of homogeneous, rounded particles which are isotropic, high in refractive index, and green-blue by transmitted light. It has limited tinting strength, but is the only cobalt blue pigment without violet tint. It was known at the beginning of the XIX century as a blue compound that could be made by heating tin oxide with a cobalt solution, but not until the year 1860 was it introduced under the name, 'coeruleum,' by Messrs G. Rowney and Co., who suggested its use for aquarelle and for oil painting (Rose, p. 289). (The word, *caeruleum*, was used in classical times rather loosely to indicate various blue pigments [see Bailey, I, 234].)

Chalk (whiting, lime white) is one of the many natural forms of calcium carbonate ($CaCO_3$). It occurs widely distributed over the world (see Ladoo, pp. 123–130). The deposits on the English coast and those in northern France, Belgium, Denmark, and other European countries are well known. It is also found in the United States, but not in quality good enough for whiting manufacture. Natural chalk is a soft, white, grayish white, or yellowish (iron oxide) white rock which is largely composed of the remains of minute sea organisms (*Foraminifera*). The crude lump from the quarries is prepared by grinding with water and by levigation to separate the coarser material. A very fine variety prepared in this way is known as 'gilder's whiting.' Chalk is quite homogeneous microscopically;

at high magnifications (400 to 500\times) fossiliferous remains in the shape of tiny, hollow shells can be seen. The material is highly birefracting, the shells being made of tiny calcite crystals with their vertical axes in nearly radial directions; its refractive index, however, is low, and this, in part, explains its poor covering power and its discoloration in oil, although it covers well when used in water paints and in distempers. Mixed with white lead and linseed oil, it makes glazier's putty. As a filler and adulterant, it is put into cheap paints and it serves as a base for lake colors. In northern Europe, particularly in England, France, and the Low Countries, chalk was the inert commonly mixed with glue in the preparation of grounds for painting just as gypsum (gesso) was used in Italy and in the south. De Wild (p. 44) found it in the grounds of thirty-six Dutch and Flemish paintings. Under ordinary circumstances, chalk is stable, but when heated strongly it changes to calcium oxide (lime), and it is decomposed by acids, with effervescence of carbon dioxide gas. Made artificially, it is known as 'precipitated chalk,' and this is whiter and even more homogeneous than the natural material.

There are many other natural forms of calcium carbonate, some of which are useful in painting. One of them, marble, is a familiar crystalline variety of calcium carbonate or limestone. Marble dust has been mixed with lime for the plaster ground of fresco painting and of lime-wax painting. Another, oyster shell white, can be made from the shells of almost any mollusk. It was perhaps usual to burn the shells before powdering them. This white was a pigment in Chinese and Japanese painting (see Uyemura, p. 47), and Thompson says that it appeared also in mediaeval England, chiefly mixed with orpiment. Even calcined egg shells were used as the source of a fine lime white. Coral, the calcareous remains of various marine animals, yields, when ground up, a pale pink powder that the Chinese and Japanese made into paint for certain purposes. Uyemura says it was used as early as the Tempyo period (VIII century) in Japan. Lime white, derived from lime putty, $Ca(OH)_2$, or water-slaked lime, went into Italian fresco painting under the name, *bianco sangiovanni* (Thompson, *The Materials of Medieval Painting*, p. 97). On exposure to air, this was slowly reconverted to calcium carbonate or chalk.

Charcoal Black (see also **Carbon Black**), the residue from the dry distillation of woods, is made by heating the wood in closed chambers or kilns. That which is produced from the willow, bass, beech, maple, or such other even-textured wood is the best. For pigment purposes, the charcoal is ground and well washed to remove potash. It may be used in stick form for sketching purposes and for the preparation of cartoons. Charcoal is light and porous; in part, it retains the fine structure of the wood from which it was made and, for this reason, it is quite characteristic in appearance when viewed microscopically. It may be seen as small, opaque, elongated, and splintery particles. This form of carbon has been used as a pigment since very earliest times. It is gray-black and is weak tinctorially. It is found on the wall paintings at Bāmiyān in Afghanistan (see Gettens).

Laurie says that the cool grays of Frans Hals are a mixture of white lead and charcoal black (*New Light on Old Masters*, p. 127).

China Clay (pipe clay, kaolin, white bole), the natural hydrated silicate of aluminum, $Al_2O_3 \cdot 2SiO_2 \cdot 2H_2O$ (kaolinite), is found in vast beds in many parts of the world and is the essential raw material of the ceramic arts (see Ladoo, pp. 138–161). The term is usually reserved, however, for the nearly pure (iron oxide free) white clay with satin lustre that is used in the manufacture of fine porcelain. Its plastic qualities, when it is mixed and worked with water, are of great importance for ceramic purposes. In European paintings, China clay was, on rare occasions, mixed with glue for a ground or priming material on canvas or panel. Among painters it has been known as 'white bole,' which is closely related to the red bole (see **Bole**) used so commonly as a ground for gilding. The Chinese appear to have used it rather extensively in the priming for clay wall paintings (see Gettens, 'Pigments in a Wall Painting from Central China'). The term, kaolin, is Chinese in origin and is said to be a corruption of *Kauling*, meaning 'high ridge,' the name of a hill near Jauchau Fu, where the material is obtained (see Dana, p. 578). Kaolin is not very characteristic microscopically, although with suitable magnification vermicular crystals can be seen. It is semi-transparent, finely divided, and homogeneous. The refractive index is low ($\beta = 1.565$), and it is only weakly birefracting. It is inert chemically. When heated, it loses water and becomes harder, as in the firing of pottery. It is unaffected by strong acids or alkalis.

Chinese Blue (see **Prussian Blue**).

Chinese Ink (India ink) has been the favorite writing and painting material of the East for centuries. It is lamp black (see **Lamp Black** and **Carbon Black**) which is prepared by the imperfect burning of pine-wood or oil in earthenware lamps. Bearn says (p. 129): 'The soot formed is mixed with fish glue size, scented with musk or camphor and moulded into sticks and dried.' For use, the stick is rubbed with water on a slate-like slab. The modern India ink, waterproof, prepared for draughting, is a proprietary material with a resin in the binding medium.

Chinese Vermilion (see **Vermilion**).

Chinese White (see **Zinc White**).

Chrome Green (cinnabar green) is a name that has come into very common use for a green pigment that is made by mixing Prussian blue (see **Prussian Blue**) and lead chromate (see **Chrome Yellow**). In the 'wet' method of preparation, a slurry of Prussian blue is added to a pulp of barytes, China clay, and chrome yellow, and the whole is stirred until thoroughly mixed (see Bearn, p. 96). The product is a very homogeneous mixture and usually the components can not be distinguished microscopically. In the light and medium varieties, the Prussian blue seems to be smeared thinly and evenly over the yellow grains, but in the darker varieties, separate particles of blue can be seen. Because this green has excellent hiding power and has body and can be produced at low cost, it is the

most important commercial green pigment. Chrome green is not very suitable for an artist's pigment, however, because it is not light-fast. It has a tendency to become blue in strong light because of the darkening of the chrome yellow component. It is sensitive to acids (turns blue) which dissolve the lead chromate, and to alkalis which cause it to turn dark orange because they effect the decomposition of the Prussian blue; it is, therefore, unsuitable for fresco. No date for the introduction of this mixed green can be given. It must have been available and in use shortly after the introduction of chrome yellow in the first quarter of the XIX century.

Chrome Red, a brick-red, crystalline powder, is basic lead chromate, $PbCrO_4 \cdot Pb(OH)_2$. It is made by boiling a strong solution of potassium dichromate with white lead and a small amount of caustic soda (see Bearn, p. 74). Many of the particles of the deeper shades may be seen as perfect rectangular, tabular crystals that are highly birefracting. It is stable under ordinary conditions, but is not widely used as an artist's pigment because it lacks brilliancy and is readily affected by sulphur gases. Chrome red was first mentioned by L. N. Vauquelin, the discoverer of the metal, chromium, in 1809 (*Annales de Chimie*, LXX [1809], p. 91). Little is known about its history as a pigment, but it probably came into use in the early part of the XIX century.

Chrome Yellow, the most important of the commercial yellow pigments, is lead chromate ($PbCrO_4$). It is made by adding a solution of a soluble lead salt (acetate or nitrate) to a solution of an alkali chromate or dichromate. (See Bearn, pp. 65–76, for full details.) Lead chromate is a crystalline material which can vary in shade from lemon yellow to orange, depending upon the particle size which, in turn, depends upon the conditions of precipitation. Lighter shades usually contain lead sulphate, or other insoluble lead salts. The middle hues are neutral lead chromate, and the orange leads are basic lead chromate. The pigment is finely divided, dense, and opaque. At high magnification, its crystalline character can be observed; it consists of small, highly birefracting, monoclinic prisms.

When chemically pure, chrome yellow is fairly permanent to light, but it is frequently observed to darken and become brown on aging (see Weber, p. 40, and Doerner, p. 63). Sometimes, especially when mixed with colors of organic origin, it takes on a green tone (by reduction to chromic oxide). It is most satisfactory when used in oil. In fresco painting, only a basic lead chromate (chrome orange or red) can be used, for yellow chromes are turned by alkali. Much chrome yellow is used with Prussian blue to make chrome green (see **Chrome Green**). As a pigment, it dates from the beginning of the XIX century. L. N. Vauquelin, the discoverer of chromium (1797), described the preparation and properties of lead chromate in his 1809 'Memoir' (*Annales de Chimie*, LXX, pp. 90–91). He mentioned that it could be prepared in different shades, depending on the conditions of precipitation. Chrome yellow did not come into commercial production,

however, before 1818 (De Wild, p. 69). One finds it occasionally on XIX century paintings. Laurie says (*New Light on Old Masters*, p. 44) that Turner used chrome yellow and chrome orange. It is not much used now in painting because more permanent yellows are available.

Chromium Oxide Green, opaque. This is the most stable of the green pigments; it is the anhydrous oxide of chromium (Cr_2O_3), and is made in various ways, usually by calcining a mixture of potassium bichromate with boric acid or sulphur. The product is a dull, opaque green which is irregular and fairly coarse in particle size. This oxide is unaffected by heat, strong acids, and alkalis, and is not faded by light. It is permanent in all painting techniques. The opaque oxide is not so much in use by artists as the transparent oxide (see **Viridian**) because it is dull. Vauquelin, the discoverer of chromium (1797), suggested its use for coloring ceramic glazes in 1809, but it evidently did not appear as an artist's pigment until about 1862 (see Laurie, *New Light on Old Masters*, p. 44).

Chromium Oxide Green, transparent (see **Viridian**).

Chrysocolla was a classical name to indicate various compounds that were useful in the hard soldering of gold (Greek: χρυσός = gold; κολλα = glue), and among these were certain green copper minerals, the basic carbonate, the silicate, etc. Pliny may have meant malachite by it (see Bailey, I, 105–111, and note on p. 205). The name is now used by mineralogists, specifically, for natural copper silicate ($CuSiO_3 \cdot nH_2O$), a mineral fairly common in secondary copper ore deposits. In the natural state, its appearance is similar to malachite, except that the color is somewhat more blue. When ground to a fine powder, it retains its green color quite satisfactorily and may serve for a pigment in a water-soluble medium. When seen microscopically, it is nearly amorphous or cryptocrystalline, and is practically colorless or, at most, only a pale green by transmitted light; particles with a crinkled surface are birefracting. The pigment is stable to light and to ordinary environments but is decomposed by acids and is turned black by heat and warm alkalis. This mineral has had little mention as a painting material. Gettens identified it on wall paintings at Kizil in Chinese Turkestan and described some of its properties. It occurs in Egypt and the Sinai peninsula and has been identified by Spurrell as a pigment on certain Twelfth Dynasty tombs at El-Bersha (see Lucas, p. 288), and at Kahun (see Spurrell, p. 227).

Cinnabar (see **Vermilion**).

Cinnabar Green (see **Chrome Green**).

Clay is any plastic, variously colored earth consisting, essentially, of hydrous aluminum silicate, $H_4Al_2Si_2O_9$, formed by the decomposition of feldspar or other aluminum silicates (see also **Kaolin** and **Bole**). It may contain, also, undecomposed feldspar and quartz and may be colored by iron oxides and other minerals. Clay may be used as a filler in paints or it may be present as a necessary component of earth colors like the ochres, umbers, and green earths.

Coal-Tar Colors are made from the distillation products of coal tar, a by-product of coke and coal gas manufacture, and are compounds which contain chiefly carbon, hydrogen, nitrogen, and sometimes sulphur. Benzene, toluene, anthracene, naphthalene, phenol, and pyridine are all direct coal-tar distillation products. By processes of synthetic organic chemistry, these distillation products may be changed to dye intermediates like aniline, phthalic acid, etc., which, in turn, may be synthesized to color products which are dyes. Since the discovery of the first aniline dyestuff, mauve (see **Mauve**), by William Perkin in England in 1856, many thousands of coal-tar dyes have been prepared. Some have become important in the preparation of lake pigments, being valued for their richness and brilliance in color. Many coal-tar lakes lack permanence and have rightly caused the whole range of lake pigments to be looked upon with suspicion by the artist. In recent decades, however, there has been a very decided improvement in the permanence of coal-tar dyestuffs; like the dyes of natural origin, those in the red region of the spectrum are the more permanent, but there has been a great improvement in the stability of lake pigments for other regions of the spectrum, examples of which are the Hansa yellows and the phthalocyanine blues. For the future, there may be developed organic colors which will rival the inorganic colors in light stability and general permanence.

Cobalt Blue (Thénard's blue) is now the most important of the cobalt pigments. The simplest form is made by calcining a mixture of cobalt oxide and aluminum hydrate to form, in part, cobalt aluminate ($CoO \cdot Al_2O_3$). One modern manufacturer gives the composition as $Co_3O_4 = 32$ per cent and $Al_2O_3 = 68$ per cent (see Gardner, p. 1359). It may be made in other ways: the original Thénard's blue was said to be cobalt phosphate on an aluminum base (see Church, p. 211). The color varies slightly with different methods of manufacture and with the amount of impurities present, but it is usually a pure shade of blue, especially in natural light. Microscopically, the particles are characteristic; they are moderately fine, irregular in size, and rounded; the surface of some of the larger particles has a crusty texture; they are bright blue by transmitted light, and are isotropic; the refractive index is medium, about 1.74 in blue light (Merwin).

Chemically, cobalt blue is very stable; it is insoluble in strong acids and alkalis and is unaffected by sunlight; it can be used in all painting techniques, even for the blue coloring of ceramic glazes, in much the same way as cobalt oxide is used.

Cobalt blue was discovered by Thénard in 1802. De Wild gives a brief account of its history and says (p. 28): 'Since the new pigment satisfied a recognized demand, it was employed everywhere relatively soon after its discovery especially in France, as was natural.' The earliest picture painted in Holland on which it was identified by De Wild (see p. 30) was 1840 and he adds, 'Hence its use did not penetrate into Holland directly after its discovery.' It has been identified on a water color painting by R. P. Bonington, 1801–1828. Since it is one of the

most costly of artists' colors, it is liable to adulteration and to substitution by ultramarine and even blue lakes.

Cobalt Green (Rinmann's green, zinc green) is similar to cobalt blue, except that zinc oxide replaces wholly or partly the aluminum oxide in the latter. In one of the ways of making it, a solution of a cobalt salt is added to a paste of zinc oxide and water; the mass is then dried, calcined, and prepared for pigment purposes by usual methods (see Church, p. 196). In the final product, there is only a small proportion of CoO to ZnO, but the color, which is a bluish green, remains much the same with widely varying proportions of cobalt. This indicates that the two oxides, zinc and cobalt, form a solid solution and not a definite compound like $CoO \cdot Al_2O_3$ (see De Wild, p. 82). Cobalt green is semi-transparent and does not have great hiding power. It is fine and regular in particle size; the grains are rounded and transparent, bright green in transmitted light, and they are highly refracting and birefracting. It is a stable and inert pigment and can be used in mixtures and in different techniques. Although it is soluble in concentrated acids, it is unaffected by alkalis and by moderately high temperatures. Church says (p. 196): 'Cobalt green is, in fact, one of the too-rare pigments which is at once chemically and artistically perfect.' It has not had, however, great favor with artists because in oil it covers only moderately well, is costly, and because its color can so easily be imitated by mixtures. Although it was discovered by Rinmann in 1780 (see Rose, p. 290), it was not until after the middle XIX century, when zinc oxide became available in large quantities, that cobalt green in turn became commercially possible. Laurie (*The Pigments and Mediums of the Old Masters*, p. 16) gives 1835 as the date of the first literary mention of cobalt green as a pigment.

Cobalt Violet has been made in various ways, but the violet cobalt pigment on the market today appears to be either anhydrous cobalt phosphate, $Co_3(PO_4)_2$, or arsenate, $Co_3(AsO_4)_2$, or a mixture of the two. The darker variety is the phosphate. It is made by precipitating a soluble cobalt salt with disodium phosphate, washing, and then strongly heating the precipitate. The color is reddish violet; it is transparent and weak in tinting strength, and this fact, in addition to its high cost, seems to be the reason why it is not more generally used as a pigment. It is stable and unaffected by most chemical reagents and can be used in all techniques. Microscopically, it can be seen to consist of irregular particles and particle clusters which are red-violet in transmitted light, highly refracting, and brilliantly birefracting. Samples from different sources differ quite a little in microscopic character. They are still listed by artists' colormen. The preparation of cobalt phosphate as a pigment was first described by Salvétat ('Matières minérales colorantes vertes et violettes,' *Comptes Rendus des Séances de l'Academie des Sciences*, XLVIII [1859], pp. 295–297).

Cobalt Yellow (aureolin) is a complex, chemical compound, potassium cobaltinitrite, $CoK_3(NO_2)_6 \cdot H_2O$. It is made by precipitating a cobalt salt in acid

solution with a concentrated solution of potassium nitrite (see Bearn, p. 79). The precipitate must be thoroughly washed; otherwise it is not stable. The pigment has a very pure yellow color and a fair hiding power. It is fast to light and air and is stable with other inorganic pigments, but it may accelerate the fading of some organic colors and itself turn brown. It is decomposed by heat, by strong acids and alkalis, and is slightly soluble in cold water. At fairly high magnification, it can be observed to be made up of tiny crystals and crystal clusters which are yellow by transmitted light and appear isotropic in polarized light. The pigment has been used perhaps more in water color than in oil. The compound, potassium cobaltinitrite, was discovered by N. W. Fischer in Breslau in 1848 (see Rose, p. 296). It was first introduced as an artist's pigment in 1861 (Laurie, *New Light on Old Masters*, p. 44). Messrs Winsor and Newton, Ltd, say (1930 catalogue, p. 14, and in a private communication) that it was first introduced by them and was popularized by Aaron Penley, a celebrated water color painter. They also say that they introduced primrose aureolin in 1889. Although available today in water color medium, cobalt yellow does not appear to be widely used as an artist's color, one reason being that it is expensive.

Cochineal (carmine lake, crimson lake) is a natural organic dyestuff that is made from the dried bodies of the female insect, *Coccus cacti*, which lives on various cactus plants in Mexico and in Central and South America. It was first brought to Europe shortly after the discovery of those countries (see Beckmann, I, 396–404). Eibner says (*Entwicklung und Werkstoffe der Wandmalerei*, table, p. 51) that it came in after the conquest of Mexico in 1523 and was first described by Mathioli in 1549. The coloring principle of cochineal extract is carminic acid, $C_{22}H_{20}O_{13}$.

Carmine is an aluminum and calcium salt of carminic acid, and carmine lake is an aluminum or aluminum-tin lake of cochineal extract. Carminic acid, the pure extract of cochineal, gives a scarlet-red solution with water and alcohol, and a violet solution with sodium hydroxide (*Colour Index*, p. 295). Crimson lake is prepared by striking down an infusion of cochineal with a 5 per cent solution of alum and cream of tartar. Purple lake is prepared like carmine lake, with the addition of lime to produce the deep purple tone. Perkin and Everest (pp. 625–627) describe methods for making the various cochineal-carmine lakes.

The cochineal lakes are not permanent to light. They turn brownish (Church, p. 186) and then fade rapidly in strong sunlight, particularly when used in water color. In oil, however, they are fairly stable and were used formerly in the preparation of fine coach colors.

Cologne Earth (see **Van Dyke Brown**).

Color is a term used not only to indicate a certain region of the visible spectrum but also to indicate the substances of pigments and dyes; or, frequently, as a synonym for pigment or paint.

Copper Resinate is a green compound formed by dissolving copper acetate, verdigris, or other copper salt in Venice turpentine, balsam, or similar resinous

solution. It has been suggested by Laurie (*The Pigments and Mediums of the Old Masters*, pp. 35–38) that the transparent green colors of early illuminated manuscripts and of the 'oil' paintings of the early Flemish masters were of this nature. (For more complete discussion, see **Verdigris**.) Paint films colored with copper resinate appear green-stained and do not owe their color to discrete green particles of any crystalline copper mineral or salt.

Coral (see **Chalk**).

Cremnitz White (see **White Lead**).

Diatomaceous Earth (infusorial earth, diatomite, celite) is a hydrous or opalescent form of silica which is composed of the skeletal remains of very minute aquatic organisms known as diatoms or radiolaria (see Ladoo, pp. 190–197). Under the microscope, with fairly high magnification, many varieties of the tiny diatom fossils can be seen. Deposits of this earth are found all over the world. The largest and most extensively worked are in California, but they occur, also, in Germany and in other parts of Europe. It is a light colored, light weight, finely granular, and porous aggregate, insoluble in acids but soluble in alkalis. Diatomaceous earth is widely used as a filter medium and as a bleaching agent for oils, fats, and waxes; also as an inert and as an anti-settling agent in paints. Since it adsorbs dyes, it serves as a base for certain lake colors.

Diatomite (see **Diatomaceous Earth**).

Dragon's Blood is a dark red, resinous exudation from the fruit of the rattan palm, *Calamus draco*, which is indigenous to eastern Asia. The resin which is collected from wounds in the bark, as well as from the fruit, is heated and molded into short sticks which are sent to the market wrapped in palm leaves. The resin is odorless. It is soluble in alcohol and other organic solvents, giving a red solution. Although dragon's blood has been used in the arts as a stain for coloring varnishes, principally varnishes to be used over gold and other metals, it seldom has been used directly as an artist's color. It is fugitive unless locked in a resin film. Little is known about it in painting, but probably it has been used to a slight extent in all periods up to the present. It was known very early in the Near East, having been called '*cinnabaris*' by Pliny (see Bailey, I, 121), who admits confusion with the Greek word, 'cinnabar,' which meant minium or mercuric sulphide. It is he who established the myth that it was a product of the mingling of the blood of those traditional enemies, the dragon and the elephant, in a furious death struggle. Cennino Cennini mentions its use in illuminations but he discredits it (Thompson, *The Craftsman's Handbook*, p. 26). Dragon's blood is no longer listed by artists' colormen.

Dutch Pink (see **Pink**).

Dye is a coloring matter which is used in solution as a stain. It is different from a pigment which is used suspended in a medium for painting (see Hackh). Most of the dyes are complex, organic, chemical compounds and may be derived from natural sources (like madder), but the great bulk is now made synthetically

(see **Coal-Tar Colors**). There are many classes of dyes; classification can be based upon the method of application (acid dyes, basic dyes, mordant dyes, etc.) or upon their structure (azo, triphenylmethane, etc.). They consist in structure of a chromophore (coloring) group and a salt-forming (anchoring) group. Some may be used directly in vehicles for staining but, for pigment purposes, most of them are precipitated or struck on inerts to form lake colors (see **Lake**). Although the pure, solid dyes are frequently crystalline when dissolved in a solvent or paint medium, they are quite without structure and, even under the microscope at high magnification, reveal no discrete particles.

Earth Pigments, broadly speaking, are those which are derived from minerals, ores, and sedimentary deposits of the earth's crust. More specifically, they are those complex mixtures of minerals that comprise the clays, ochres, siennas, and umbers. Carbonaceous pigments, like Van Dyke brown, also belong in this group. Earth pigments were among the earliest employed, and they include many of the highest stability.

Egyptian Blue (blue frit, Pompeian blue). The inorganic blue color most commonly found on wall paintings of Egyptian, Mesopotamian, and Roman times is an artificially made pigment which contains as its essential constituents copper, calcium, and silica. Lucas, who gives a very good summary (pp. 284–285) of the history and occurrence of this blue, says it was made by heating a mixture containing silica, a copper compound (probably generally malachite), calcium carbonate, and natron (natural sodium sesquicarbonate). A. P. Laurie, W. F. P. McLintock, and F. D. Miles ('Egyptian Blue,' *Proceedings of the Royal Society of London, Series A*, LXXXIX [1914], pp. 418–429), who carried out an investigation of methods of preparing it, found that the blue crystalline compound is formed only in the rather narrow temperature range of 800 to 900° C., probably about 830°. Chaptal appears to have been the first to call this material a 'frit' but, although it does contain some glass as impurity, the blue is definitely a crystalline compound. Laurie and co-workers (*loc. cit.*) point out that the Egyptian blue pigment is closely related to the well known blue glaze of Egyptian ceramics; that glaze was applied to a base of carved sandstone at a temperature somewhat lower than that required to form the crystalline blue. There is contemporary mention of this artificial blue which includes descriptions of its method of preparation. It is no doubt the Egyptian *caeruleum* of Pliny (see Bailey, I, 145 and 234). Vitruvius (VII, Chap. XI) describes its manufacture but erroneously states that the method for making it was first discovered in Alexandria.

Egyptian blue which is coarsely crystalline and pure blue in color is similar, in appearance, to finely ground azurite. Unlike azurite, however, it is insoluble in acids, is not affected by light or heat (except at very high temperatures), and by alkalis only on fusion. Many specimens, well over 3000 years old, appear to be little changed by time or environment. The blue is characteristic microscopically; it is birefracting ($\omega = 1.635$), and it is moderately pleochroic, the crystals

varying in color from deep blue to faint lavender. This ancient blue invariably contains some calcite and quartz as impurities. Raehlman (pp. 67–68) has well described, with the aid of color plates, its appearance in a paint film.

The history of Egyptian blue is largely ancient. Spurrell states (p. 227) that it was found as early as the IV Dynasty in Egypt. Laurie ('The Identification of Pigments . . . ,' p. 166) observed it on paintings from the palace at Knossos. Raehlman (*loc. cit.*), Chaptal (*loc. cit.*), and others have found it on Pompeian and other Roman wall paintings. It has further been identified as the dark blue material of a mace head from Nuzi, Iraq (*c* 1500 B.C.); as the material of the blue inlay in ivories from Samaria; and as a blue pigment on Roman wall paintings from Dura-Europos in Syria. Partington has reviewed (pp. 117–119) the history and occurrence of Egyptian blue and he says (p. 118): 'No ancient European people could successfully imitate Egyptian blue and the secret of its manufacture was lost between A.D. 200 and 700.' Lump specimens of Egyptian blue can be seen at the Naples Museum, at the Fogg Art Museum, Cambridge, Mass., and at other places. A modern blue pigment called 'Pompeian blue,' which is entirely similar in chemical composition and in optical properties to the ancient copper-lime-silicate blue but which is purer and finer, is now available from a French source.

Emerald Green (Schweinfurt green, Paris green) is an artificial pigment which was first made at Schweinfurt, Germany, in 1814 (see Rose, p. 140). It is copper aceto-arsenite ($Cu[C_2H_3O_2]_2 \cdot 3Cu[AsO_2]_2$) and can be prepared in several ways, in all of which the important raw materials are copper, acetic acid (or verdigris), white arsenic, and sodium carbonate. These are mixed in hot solution and the precipitate is thoroughly washed and dried (Bearn, pp. 102–104 gives all the details). Emerald green, as the pigment is now called, is bright blue-green in color, is one of the most brilliant of the inorganic colors, and is quite unlike any other green pigment. It has fair hiding power. Some specimens of emerald green are quite characteristic; in these the particles consist of small, rounded grains, uniform in size and, at high magnifications, are seen to be radial in structure. Many particles appear to have a pit or dark spot in the center. The grains are strongly birefracting. The particles in other samples of emerald green, however, are not so characteristic in shape. It does not enjoy popularity as an artist's pigment chiefly because it is blackened by sulphurous air and pigments, and also because it is poisonous and dangerous to handle. (As Paris green, it has long been used as an insecticide.) It is readily decomposed by acids and by warm alkalis, and it is blackened by heat. It is fairly permanent, however, in an oil or varnish medium.

Emerald green has not been identified frequently on paintings. De Wild found it on only one (dating 1860). Occasionally it is seen as the green pigment used for making an imitation patina over repairs on ancient Chinese bronzes.

English Red is a name sometimes used for a light red iron oxide (see **Iron Oxide Red**) formerly natural in origin but now, as a rule, made chemically by heating iron vitriol (ferrous sulphate) with chalk. Artificial English red usually contains gypsum.

English Vermilion (see **Vermilion**).

Eosine is the potassium salt of tetrabromofluorescein, $C_{20}H_6O_5Br_4K_2$, and was first made by Caro in 1871 (*Colour Index*, p. 194). It was formerly used for preparing red inks of a very fine scarlet hue, but is not a fast color; it fades rapidly in sunlight. 'Geranium lake' is the name sometimes given to a brilliant bluish red lake made by precipitating eosine on an aluminum hydrate base.

Extender is an inert (see also **Inert**), colorless or white, and usually transparent body used to diffuse or to dilute colored pigments. Extenders up to certain proportions may increase and improve the wearing qualities of paints. The barium sulphate which is used up to 75 per cent with titanium dioxide may be regarded as an extender. The cost of the mixture is materially less than that of pure titanium dioxide, but there is not a proportionate lessening in hiding and covering power. The same is true of the calcium sulphate which is often present in considerable quantities in artificial iron oxide reds. Some of the insoluble dye pigments or toners have such high tinctorial power that it is more economical and practical to use them with carriers and extenders. When an extender is added to a paint or pigment in such quantity that it lowers the tinting strength, it becomes an adulterant.

Filler is a white, inert, transparent material, low in refractive index, which is used in paste form to fill imperfections in a surface that is being prepared for finishing. Wood filler is a paste made with crystalline silica (silex). It is used to fill the pores or grain of the wood with hard, non-shrinking, transparent material so that varnish coats will go on smoothly and take a fine polish. The word, 'filler,' is sometimes used synonymously with 'extender' (see **Extender**).

Flake White (see **White Lead**).

Flavine Lake (see **Quercitron Lake**).

French Ultramarine (see **Ultramarine Blue, artificial**).

Fuchsin (see **Magenta**).

Fuller's Earth is a hydrous aluminum silicate of variable composition belonging to the clay group of minerals (see Ladoo, pp. 231–240). It occurs in sedimentary deposits in many parts of the world but particularly in Florida and in England. It is white, buff, gray, or olive in tint, and has physical properties about the same as clay, except that it is characterized by a marked ability to absorb basic colors from animal and vegetable oils. It gets its name from its original use which was for fulling or removing grease from cloth.

Gamboge is a yellow gum resin which for centuries has been used as a pigment in the Far East. It is produced by several species of trees of the genus *Garcinia*, indigenous chiefly to India, Ceylon, and Siam. It came to Europe quite

early as an article of commerce, and Church says (p. 153) that it was used by the early Flemish oil painters. It has been principally a water color or a color for spirit varnishes and gold lacquer. Mixed with Prussian blue or indigo, it makes a rich green that was formerly a water color paint (see **Hooker's Green**). It is drawn from trees by means of artificial incisions from which it runs as a yellowish brown, milky juice that hardens in the air (Bearn, p. 172). It is marketed in the form of yellow cakes and lumps which are rather brittle and are often covered with yellow dust. Gamboge, when powdered and ground in oil, has a rich golden hue and in this medium it is fairly permanent. As a water color, it is less permanent and fades rapidly in sunlight; but in manuscript painting where it is well protected it has, in some cases, lasted for centuries.

Gamboge burns with an odor of burning resin. It first turns deep orange or red in dilute caustic soda and then dissolves; since it is a resin, it is partially soluble in alcohol and in some other organic solvents. Microscopically, it is not particularly characteristic; the particles are deep yellow or orange and are fairly transparent by transmitted light.

Gesso (see also **Gypsum**), in its broadest meaning, is any aqueous, white priming or ground material that is used to prepare wooden panels or other supports for painting or gilding. The word is Italian for gypsum. The white ground for an Italian panel painting was usually a mixture of glue and burned gypsum (plaster of Paris). Among the Italian painters, two distinct kinds of gesso were recognized. As described by Cennino Cennini (see Thompson, *The Craftsman's Handbook*, p. 70), *gesso grosso* is the coarser and thicker undercoating for a panel; it was made directly from sifted plaster of Paris and applied with size. *Gesso sottile*, however, was the fine, crystalline gypsum made by soaking plaster of Paris for some weeks in excess water so that it did not set. The residue, after the water was poured off, was made up into small loaves, was dried, and was kept for future use. Mixed with glue size, it served for the final coatings over the foundation of *gesso grosso* (Thompson, *op. cit.*, pp. 71–72). Today the word, gesso, has taken on even wider meaning and may include grounds made from chalk (whiting), zinc oxide, or any other inert white. Among modern sculptors, the word is used for plaster of Paris alone, without glue binder (see Thompson, *op. cit.*, p. xvi).

Gold Leaf and **Gold Powder** have been valued in painting for making backgrounds and details. Because gold is the most malleable of the metals and may be beaten into leaves of extreme thinness, it can be used quite economically even to cover large surfaces. Gold beating is a special craft; the foil is placed between sheets of parchment called 'gold-beater's skin,' and these are stacked, one upon the other, and beaten until the metal seems almost to lose its third dimension. In mediaeval times, gold coins were the direct source of most of the leaf, and its thinness was reckoned in terms of the number of leaves that could be made from a ducat (Thompson, *The Materials of Medieval Painting*, pp. 190–229). The color

depends to a great extent upon purity. When the surface of pure gold leaf is highly burnished or polished, it becomes a very good reflecting surface, less yellow, more dark and metallic.

Gold powder can be made in various ways, but not by direct stamping or rubbing because it is too plastic. One method during the Middle Ages was to make it into an amalgam with mercury and then to drive off the mercury by heat, leaving the gold in powder form. Another was to grind gold leaf in a mortar with honey and then wash away the honey with water. Today there are various electrolytic and reduction methods that serve the purpose equally well. There is evidence that river gold or gold dust was used on certain English manuscripts (Thompson, *loc. cit.*, p. 198). Powdered gold leaf was used in mediaeval times for a writing ink; it was applied mixed with egg white or gum and, when dry, was burnished so that the letters looked as though they were cut from gold leaf. Unburnished, powdered gold was used quite freely in panel paintings where brilliance and luminosity were demanded; it was even mixed with transparent colors; painted hair was sometimes streaked with gold to increase its luminosity.

Chiefly, however, gold was laid as leaf. There were various ways of making the leaf adhere to the surface, but for large areas a bole or fine earth with size was usual. For initial letters and illuminations on manuscripts, an aqueous medium (glair, size, honey, plant juices) was brushed onto the part to be gilded. The film was allowed to dry and was moistened by breathing to make it sticky just before the leaf was laid on. For panel and wall painting, however, oil mordants were more common. These were really thin coatings of an oil varnish on which the gold was laid while they were still tacky. (See also **Bole** and **Mordant**.)

Golden Ochre (see **Ochre**).

Grain Lake (see **Kermes**).

Graphite (see also **Carbon Black**) is a crystalline form of carbon which is widely distributed naturally as a mineral in different parts of the world. The most important modern source is Ceylon; European sources have been Cumberland, Bavaria, and Bohemia, where deposits have been worked for centuries. It has also been made artificially by a furnace process (Acheson process) since about 1891. Graphite has long been used as a writing material and it gets its name appropriately from the Greek, γράφειν (to write). It was early confused with lead which was also used for writing purposes, and hence the names 'black lead' and 'plumbago' are also used for it. For use in lead pencils, it is compressed with very fine clay. Graphite has a greasy texture and is dull gray. Merwin in describing it says (p. 514): 'Microscopic flakes thin enough to transmit grayish light have been prepared. Its refractive index is about 3 and its reflective power high (about 37 per cent).' Graphite is one of the most stable and refractory of materials and would be permanent in any technique. It has been used chiefly as a drawing material, however, and rarely as a pigment (Thompson, *The Materials of Medieval Painting*, p. 88).

Green Earth (terre-verte) has been used in European paintings since before classical times. It occurs rather widely but that which is suitable for a pigment is found only in restricted areas. A good quality (celadonite) is found north of Monte Baldo, near Verona (*terre de Verone;* see Church, p. 190), and also in Germany, France, Cyprus, and Cornwall (see Rose, pp. 205–206). Most of the green earths seem to have originated as marine clays. They are complicated in composition but are made up chiefly of two indefinite but closely related minerals, glauconite and celadonite, which are essentially hydrous iron, magnesium, and aluminum potassium silicates. Green earth varies in composition like so many of the complex silicates (see Clarke, pp. 519–523). Although the color may be caused in part by a small content of iron in the ferrous state, the greater part of the iron is ferric. The shade ranges from a neutral yellow-green to pale greenish gray. The best quality is a neutral sage green. Green earth has a low hiding power, especially in oil, but it works well in tempera. Microscopically, it is characteristic; it consists of coarse, rounded, smoky green particles with many transparent, clear, and angular silica and silicate particles. Quite frequently, scattered bright blue particles may be seen. De Wild states (p. 74) that these blue particles are like cobalt blue; but there is no cobalt present and, unlike cobalt blue, the particles are birefracting. The green is turned red-brown on strong heating; otherwise, it is a very stable pigment, unaffected by light or air or by chemical agencies such as dilute acids or alkális. Church (p. 192) says, however, that some samples of terre-verte are liable to become rusty when brought into contact with lime hydrate in true fresco painting. Although good grades of green earth are still obtainable, it is subject to substitution by mixtures of transparent oxide of chromium (viridian) and red earth pigment. The true green earths, which are supplied by different dealers, usually vary in character and shade because of their many different natural sources.

Green earth was used as a pigment on Roman wall paintings at Pompeii and at Dura-Europos. It was widely used by Italian painters as a foundation for flesh tones, and is the pigment that gives the greenish tone to so many of the abraded Italian panel paintings. De Wild has reported it (p. 75) on three Dutch paintings of the XVII century and on one of the XIX century. The green from the ceiling of Cave 1 at Ajanta (India) was identified as green earth.

Green Lake is no particular compound, but a name to indicate various green organic colors of natural or synthetic origin. Mixtures of Prussian blue with zinc yellow or yellow lakes may be sold under this name.

Guignet's Green (see **Viridian**).

Gypsum (terra alba) (see also **Gesso**) is important among the raw materials that have been used in works of art. It is calcium sulphate dihydrate, $CaSO_4 \cdot 2H_2O$, and, often associated with salt deposits, occurs widely over the world; important workings are found in most of the countries of Europe, in the United States, and in Canada. There are several varieties: selinite is crystalline, transparent, and

foliated; satin spar, a fibrous form with silky lustre; alabaster is fine-grained, massive, and may be nearly pure white or delicately shaded (to be distinguished from Egyptian alabaster, which is a compact, crystalline form of calcium carbonate [see Lucas, pp. 56–57]); ordinary, dull-colored rock gypsum, which is a compact granular form, coarser grained than alabaster, often contains impurities of calcium carbonate, clay, and silica (see Ladoo, pp. 281–299). Gypsum gets its name from the Greek, γύψος, which means, more specifically, the calcined mineral (Dana, p. 634).

The raw, unburned gypsum finds little use in the arts. It was perhaps occasionally ground and used directly with glue in the preparation of gesso grounds for mediaeval and Renaissance panel paintings. Lately it has been recommended by Doerner (p. 14) to be used with zinc white and glue for such purposes. Since raw gypsum itself has no setting properties, it acts solely as an inert, and depends upon the glue for binding. A fine grade of ground native gypsum or alabaster, which may be used for this purpose, is sold today under the name, 'terra alba'; it is ground to 200-mesh screen or finer, is bolted or sized by air separation, and is used principally as a filler in paper and paint. The most important use of gypsum is in the preparation of setting cements and plaster of Paris. Gypsum has some utility as a base for lake pigments; it is a component, also, of certain artificial iron oxide reds, like modern Venetian red (see **Venetian Red**), which are made by calcining green vitriol (ferrous sulphate) with calcium carbonate.

Gypsum is a stable material. The only effect of heat, as mentioned above, is to drive off combined water. It is slightly soluble in water (2.41 grams per liter at 0° C.); for this reason, gypsum plasters sometimes effloresce in damp places. It is fairly soluble in dilute hydrochloric acid. From a saturated aqueous or weak acid solution, it precipitates in characteristic needle-like crystals (monoclinic) which group themselves in sheaf-like bundles about the edge of the test drop. The refractive index of gypsum is low ($\beta = 1.523$); hence, it is not useful in oil. It is weakly birefracting.

Haematite (see also **Iron Oxide Red**) is a hard, compact, and nearly pure natural variety of anhydrous ferric oxide. The hard, specular kind is found in columnar (pencil haematite) and reniform (kidney ore) shapes. Although probably this compact form of haematite was sometimes ground and used for a dark, purple-red pigment, ordinarily it was for the preparation of burnishers for gold leaf (see Thompson, *The Materials of Medieval Painting*, pp. 213–214).

Hansa Yellow, which is among the most permanent of the modern synthetic yellow dyes suitable for making yellow lake pigments, is formed by the coupling of diazotized aromatic amines containing nitro or halogen groups or both, with acetoacetanilide or its simple derivatives. There is a range of these Hansa yellows all of which belong to the class of diazo coloring matters. Those with the designation 5G and 10G are used for the preparation of greenish yellow lakes good in

hiding power, fast to light (see Doerner, pp. 66 and 92), and suitable for artists' purposes.

Harrison Red, which is said to get its name from the artist, Birge Harrison (Weber, p. 62), is a brilliant red lake color or toner which is similar to, if not identical with, **Toluidine Red.** Some other lake colors, however, may be sold under that name.

Hooker's Green is not a single pigment but is a mixture of Prussian blue (see **Prussian Blue**) and gamboge (see **Gamboge**), used for water color, and is called Hooker's green after an artist who is said (Weber, p. 63) to have introduced it. Different hues of green are obtained by varying the proportions of the blue and yellow components. The mixture has the chemical properties of its components; in strong light it is likely to turn blue because of the fading of the gamboge. Microscopically, it may be seen as a distinct physical mixture of blue and yellow particles. For oil colors, other yellows like cadmium yellow or yellow lakes are used with Prussian blue to produce similar hues.

India Ink (see **Chinese Ink**).

Indian Lake (see **Lac**).

Indian Red was formerly a variety of natural iron oxide red (see **Iron Oxide Red**) imported from India. It varied in color from light to deep purple-red and contained, generally, over 90 per cent iron oxide. Although the term still indicates a dark red oxide, it is now used for a pigment artificially made by calcining copperas (ferrous sulphate) which is a waste material in certain industries. The product must be carefully washed to get rid of soluble iron salts. Artificial Indian red is pure, homogeneous, and dense, and has great hiding power. Other names for it are 'rouge,' 'colcothar,' and '*caput mortuum.*'

Indian Yellow (*purrée*) is a yellow organic extract formerly prepared at Monghyr in Bengal from the urine of cows that were fed on the leaves of the mango. Its manufacture is now mercifully prohibited by law. The coloring matter is principally the magnesium or calcium salt of euxanthic acid, $C_{19}H_{16}O_{11}Mg \cdot 5H_2O$ (see C. Graebe, 'Ueber die Euxanthongruppe,' *Annalen der Chemie*, CCLIV [1889], pp. 265–303). The dried extract formerly came on the market in round lumps, brown or dirty green outside and brilliant yellow-green inside. The crude material must be powdered and washed and, when thus purified, it has a deep, rich, translucent, orange color. Microscopically, it may be observed as a yellow crystalline material with weak birefringence. This pigment was used in India in the manufacture of paint and also as an artist's oil and water color because of its fastness to light. Church (pp. 154–156) found that even direct sunlight only bleached it slowly.

Indian yellow is slightly soluble in water, is decomposed by hydrochloric acid with precipitation of white, flaky euxanthic acid. The color which is sold today under this name, however, either in oil or in water color, is a synthetic substitute that may be just as permanent or more permanent than the original Indian yellow.

Indigo (see also **Woad**) is a blue vegetable coloring matter which seems to have been used in the Far East very early for dyeing cloth and for painting. The dye is yielded by different plants of the genus *Indigofera*, among which *I. tinctoria*, probably of Indian origin, was the chief source of the indigo of commerce until the time of the discovery of the process for making synthetic indigo by Baeyer in 1880 (see A. Baeyer, 'Synthese des Isatins und des Indigblaus,' *Berichte der Deutschen Chemischen Gesellschaft*, XI [1878], pp. 1228–1229; 'Ueber die Beziehungen der Zimmtsaüre zu des Indigogruppe,' *ibid.*, XIII [1880], pp. 2254–2263; English patent no. 1177). Indigo was formerly grown all over the world, particularly in India and China, but since 1900 the synthetic product has almost entirely replaced the natural. Bengal indigo was one of the best grades and was used widely in dyeing textiles. In the plant indigo exists as a colorless glucoside called 'indican.' For the preparation of the dye, the freshly cut plants are macerated, packed into large vats, and allowed to ferment; in this process the glucoside is hydrolyzed to indigo and sugar. The dark precipitate is strained, pressed, and dried into cakes (see Perkin and Everest, pp. 475–524). For use as a paint pigment, it is not precipitated with a mordant but is ground directly to a fine powder suitable for mixture with artists' mediums. (For details, see Church, pp. 217–223.) It is still used to a small extent for artists' water color. Cake indigo is a deep violet-blue with a bronze-like lustre. The coloring matter is indigotin, $C_{16}H_{10}N_2O_2$ (*Colour Index*, pp. 279 and 299).

Indigo has fair tinting strength; in thin films it is green and blue by transmitted light. Physically, it is much like Prussian blue but, chemically, it is quite different. In an oil medium, no distinct particles can be seen at ordinary magnification; the dye appears to dissolve in the film and to stain it. De Wild says, however (p. 30), that at a magnification of $1500\times$ intensely blue discrete particles appear. Though it can be worked in oil, it is better in tempera or in water color. Indigo may fade rapidly when thin and exposed to strong sunlight, yet specimens of it are frequently seen where it has lasted for many centuries without apparent change. Locked in tempera beneath varnish films, it is very stable. It is also stable chemically, being insoluble in water, ether, alcohol, lyes, or hydrochloric acid. Nitric acid, however, decomposes it, with the formation of a yellow compound called 'isatin.' It sublimes when heated at 300° C. Indigo is reduced by several reducing agents to soluble indigo white, called 'leuco indigo.' This reduction is an important operation in dyeing. The dye is taken up by the fibres in this reduced soluble form and is then oxidized by the air to the insoluble indigo blue. It is bleached by hypochlorite solutions.

Indigo was known and used as a dye in early Egypt (Lucas, p. 313). It was mentioned by Pliny, who called it '*indicum*' (see Bailey, I, 145, and II, 87 and 89). It has been identified as one of the pigments used for decorating Roman parade shields of c 200 A.D. found at Dura-Europos in Syria, was mentioned as early as the XIII century in European commercial transactions (Church, p. 217),

and was used in Italian painting certainly as early as the XV century and probably even much earlier.

A coloring material much like indigo has been observed in a blue layer beneath an azurite film in a Sienese painting. (See R. J. Gettens, 'Microscopic Examination of Specimens from an Italian Painting,' *Technical Studies*, III [1935], pp. 165–173.) De Wild lists (p. 31) four paintings, three by Frans Hals and all of the XVII century, in which he found indigo. Perkin and Everest say (p. 475):

> Its employment in Europe was very limited until in 1516 when it began to be imported from India by way of the Cape of Good Hope, but its introduction in large quantity did not occur until about 1602. Owing chiefly to the opposition of the growers of woad, its European rival as a dyeware, it met with much opposition, and various laws were enacted both on the Continent and in England prohibiting its use. It was called a 'devilish drug' and was said to be injurious to fabrics. In 1737 its employment was legally permitted in France, and from this period its valuable properties appear to have become gradually recognized throughout Europe.

In the Far East, indigo was used as a pigment as well as for dyeing cloth. It was identified in a blue layer beneath azurite on a Chinese painted clay statue of the T'ang Dynasty from Tun Huang in Central Asia, and also on a wall painting of later date from Kara Khoto in Central Asia.

Inert is the name given to any inactive white pigment which has little or no hiding power or tinting strength when it is used in a paint vehicle. Examples are gypsum, barium sulphate, chalk, etc. These generally have a refractive index below 1.70. They may have a considerable whiteness when used with tempera medium, but in oil they are nearly transparent and give only dull yellow films. Inerts are employed for ground and priming materials (see **Gesso**). They may be used as extenders (see **Extender**) for pigments with high tinctorial power, and they may also be used for the bases, carriers, or substrates of lake pigments (see **Lake**).

Infusorial Earth (see **Diatomaceous Earth**).

Ink is a liquid or viscous material used for writing, printing, lithographing, stamping, and staining. Inks are made from dyes and from pigment suspensions like carbon black. Those used for printing and lithographing are made by grinding pigments in oils and varnishes. Ordinary writing inks are iron gall inks in which the color and stain are formed by the combination of gallotannic acid from oak galls and green vitriol (ferrous sulphate) in the presence of air (see **Iron Gall Ink** and **Chinese Ink**). Both vegetable and aniline dyes are used for special, colored writing inks (see Mitchell).

Inorganic Pigments are those natural pigments prepared from minerals and ores (see **Earth Pigments**) or those synthetically made which are chemically prepared from the metals. The most stable and inert pigments are in this class.

Iris Green is an organic dyestuff of natural origin from the juice of iris flowers. Thompson says (*The Materials of Medieval Painting*, p. 171) that it was used extensively in the XIV and XV centuries, particularly in manuscript painting. The beautiful green color was best developed by mixing with alum.

Iron Gall Ink is made from tannin or gallotannic acid which is derived from oak galls. When this is combined with ferrous sulphate, a colorless compound, ferrous gallotannate, is formed which develops a black color on exposure to air because of oxidation to ferric gallotannate. Because 7 to 10 days are required for complete oxidation, a dye or other provisional coloring matter is added to the ink to give it immediate color. The ink ingredients are suspended in a solution of gum and water (see Thorpe's *Dictionary*, Ink). It is uncertain just when iron gall inks came into use, but apparently it was some time in the Dark Ages or in very early mediaeval times (see Mitchell, p. 11).

Iron Oxide Red (see also **Haematite, Indian Red, Light Red, Mars Colors, Tuscan Red, Venetian Red**). Ferric oxide in both its anhydrous (Fe_2O_3) and hydrous ($Fe_2O_3 \cdot nH_2O$) forms has been used as a coloring material since prehistoric times. It was formerly all derived from natural sources, but at present much that is used is artificial in origin. The extensive deposits of iron oxide which occur all over the earth vary widely in hue, depending upon the degree of hydration and subdivision. The anhydrous oxide is dark purple-red or maroon while the hydrated varieties range from warm red to dull yellow, as in yellow ochre. Iron oxide is a very stable compound; it is unaffected by light and by alkalis; it is soluble only in hot concentrated acids; and the only effect of heat is to darken the lighter colored varieties. Microscopically, it is moderately characteristic. The natural forms are heterogeneous in composition and in particle size; in the darker varieties, elongated and splintery, dark brown, lustrous particles of haematite can be seen. In some varieties, the smaller particles are ruby-red by transmitted light, similar to vermilion, but usually they are opaque and dense. The artificial varieties are finely divided and homogeneous and have no very characteristic optical properties. Distinction is difficult, even microscopically, between the finer grades of natural iron oxide and the artificial varieties.

The iron oxide pigments have had such continuous use in all periods of painting and in all parts of the world that it is unnecessary to go into details concerning their history and occurrence in paintings. Even today they are commercially among the most important pigments. Both the natural and artificial varieties of iron oxide are known by numerous names. Some names show the source; some originally were applied to natural products but are now used for artificial ones; others indicate some very special kind of preparation.

An excellent natural red oxide comes from Ormuz in the Persian Gulf and is sold in large quantities under the name, 'Persian Gulf Oxide.' It contains about 70 per cent of Fe_2O_3 and 25 per cent of silica. The well known Spanish red oxide contains, usually, more than 85 per cent of Fe_2O_3. These crude natural oxides require only grinding and sieving to convert them into pigments. Finer products are obtained by washing and levigation.

Italian Pink (see **Pink**).

Ivory Black, strictly speaking, is made by charring waste cuttings of ivory in closed vessels and then grinding, washing, and drying the black residue. It is the

most intense of all the black pigments (*Colour Index*, p. 314). The term is now commonly used for the black from animal bones (see **Bone Black**).

Kaolin (see **China Clay**).

Kermes (kermes lake, grain lake) is one of the most ancient of the natural dyestuffs. It was derived from the dried bodies of the female insect, *Coccus ilicis*, found on the kermes oak, which was indigenous to many parts of southern Europe (see Beckmann, I, 385–404). It is similar to the New World 'cochineal' in origin, color, and chemical composition. It contains the coloring matter, kermesic acid, $C_{18}H_{12}O_9$ (*Colour Index*, p. 295). Lucas suggests (p. 37) that it was used very early in Egypt for dyeing leather, and, he thinks, with an alum mordant. It was well known to the Romans; Pliny called it *Coccum granum* and praised it highly (see Bailey, I, 33 and 218). Thompson (*The Materials of Medieval Painting*, p. 112) says that the English word for it, 'grain,' comes from the Latin, *grana*, the equivalent of the Greek, κόκκος, which means 'berry.' The ancients mistook the dried red clusters of the dead insect, *Coccus ilicis*, for berries. He goes on to say, however (*loc. cit.*, p. 113), that grain and kermes dyestuffs are not the same, though similar in origin. According to him, the English word, vermilion, comes indirectly from the Latin, *vermiculum*, or 'little worm,' which was descriptive locally of the clusters of dead insects and the berries they caused to grow around them. The word, 'kermes,' is Arabic in origin and is the source of the English word, 'crimson.' Kermes and grain dyes were precipitated with alum to form crimson lakes. Sometimes they were prepared with clippings of cloth that had been dyed with grain. The dye was extracted with alkali and then was precipitated with alum (see Thompson, *loc. cit.*, p. 115). Kermes lakes are not brilliant, and in the Middle Ages they were displaced by the lac lakes from India and, still later, by cochineal lakes from Mexico. They are perhaps of no importance in modern painting.

King's Yellow (see **Orpiment**).

Kremnitz White (see **White Lead**).

Lac, Lac Lake (Indian lake), is a natural organic red dyestuff prepared from the resin-like secretion of the larvae of the lac insect, *Coccus lacca*, which lives on certain trees of the species, *Croton ficus*, in India, Burma, and the Far East. From the lac secretion which also produces the 'seed lac' or 'shellac' of commerce, the red dye is extracted with hot dilute sodium carbonate solution when the shellac is purified. The dye infusion is evaporated and the residue is made into cakes and dried. The lake may be prepared by extracting the dry residue with sodium carbonate, after purification in turpentine or benzene, and by precipitating it with alum. The coloring principle is laccaic acid, $C_{20}H_{14}O_{11}$, or its salts (see A. Dimroth and S. Goldschmidt, 'Über den Farbstoff des Stocklacks,' *Annalen der Chemie*, CCCXCIX [1913], pp. 62–90). It is similar in composition and color to the carmine dyes from cochineal, but the lac dye is somewhat faster if duller in shade. Perkin and Everest (pp. 91–94) say that lac dye is a very ancient dyestuff

and that it was employed in the East many centuries before it was known in Europe. R. Pfister ('Materiaux pour server au classement des Textiles Egyptiens posterieurs a la Conquête Arabe,' *Revue des Arts Asiatiques*, X [1936], pp. 1–16) says that lac dye was brought from India and introduced into the West by the Arabs after their invasion of Egypt and the fall of Alexandria in the VII century.

Lake, as a term, may be applied to any pigment which is made by precipitating an organic coloring matter or dye upon a base or substrate which is usually an insoluble, finely divided, semi-transparent, inorganic inert, such as aluminum hydrate or calcium sulphate. The word is derived from the Italian, *lacca*, which, in turn, seems to be associated with 'lac' from India, the source of a red dye (see **Lac Lake**), as well as ordinary shellac (see Thompson, *The Materials of Medieval Painting*, p. 109). The earliest lakes were made from such natural dyes (see Laurie, *Materials of the Painter's Craft*, pp. 253–278), but now they are prepared in enormous quantities from synthetic dyestuffs. The true lake is a transparent color precipitated on a transparent base like aluminum hydrate, but the word has been extended to include those colors struck on barytes, tin oxide, zinc oxide, and a number of other materials which produce pigments with body and hiding power (see Bearn, p. 133). The same dye often produces different shades and different hues with different bases (see also **Coal-Tar Colors** and **Mordant**).

Lamp Black (see also **Carbon Black**) is nearly pure (over 99 per cent), amorphous carbon which is collected in brick chambers from the condensed smoke of a luminous flame from burning mineral oil, tar, pitch, or resin. It is not quite a true black but is slightly bluish in color, and makes good neutral grays. Microscopically, it is very finely divided, uniform, and homogeneous; in mounting mediums, the particles appear to collect in chains and filaments. It does not wet well with water on account of the slight amount of unburned oil it contains. The preparation of lamp black (*atramentum*) from burning resin and pitch, as well as the preparation of other blacks, is described by Pliny the Elder (see Bailey, II, 87 and 216).

Lapis Lazuli (see **Ultramarine Blue, natural**).

Lemon Yellow (see **Barium Yellow** and **Strontium Yellow**).

Light Red (see **Iron Oxide Red**) is a term sometimes used to indicate a red ochre prepared by calcining yellow ochre; it is a light, warm red, the hue depending upon the degree of calcination. Today the term is also used for a processed blend of ferric oxide and calcium sulphate which is almost identical in composition with Venetian red (see **Venetian Red**).

Lime White (see **Chalk**).

Litharge (see **Massicot**).

Lithol Red or **Lithol Toner** is one of the most important and widely used of the synthetic red dyestuffs in the modern lake pigment industry. It is 1-sulpho-β-naphthalene-azo-β-naphthol, $C_{20}H_{14}N_2O_4S$ (*Colour Index*, p. 43). It is prepared

as a lake by precipitation on barytes or chalk. Lithol red is bluish red with a deep blue-red undertone (see Bearn, p. 144). It does not bleed in oil and has good stability to light and heat. It has not been offered to the artists' trade under this name, but no doubt is found in some cheap red paints as a substitute. It was first made by Julius in 1899.

Lithopone is a co-precipitated pigment which is made by adding zinc sulphate to barium sulphide in solution. The press cake, which is a mixture of zinc sulphide and barium sulphate ($ZnS + BaSO_4$), is dried, calcined at red heat, and quenched, a process necessary to give it useful pigment properties (see Bearn, p. 53). The mixture of the two components, zinc sulphide and barium sulphate (28 : 72), is so intimate that they can hardly be distinguished microscopically. It is very finely divided, opaque, and without distinguishing optical character. It has about the same whiteness but has greater hiding power than zinc white. Lithopone is partially soluble in dilute mineral acids, with the release of hydrogen sulphide from the zinc sulphide component; it is unaffected by alkalis and by heat. This pigment, in the early days of its manufacture, had one serious defect, a tendency to darken (gray or blacken) in strong light but to turn white again in the dark (see Bearn, p. 54). The trouble was traced to various causes, among which were the presence of foreign metallic impurities, but, after years of research, a lithopone is now produced which does not suffer change in light. The so-called 'titanated lithopones,' which contain about 15 per cent titanium oxide (see Gardner, pp. 1230–1232), have hiding power superior to that of straight lithopone.

Lithopone was apparently first produced and patented by John Orr in England about 1874. It is now industrially important and widely used in interior paints, lacquers, and enamels, for it has a combination of exceptional whiteness, brightness, and low cost. It has not been much used as an artist's pigment because, perhaps, of its unfortunate early history. It is used for poster colors and for cheap water colors. One may expect to find it in the priming coats of modern, prepared artists' canvas.

Litmus (archil) is a natural organic red coloring matter that is procured from such lichens as *Lecanora tartarea* or *Roccella tinctoria*. It is extracted from the dry plants by potassium carbonate solution in the presence of air. It is soluble in water and in alcohol, giving a carmine red solution, and in alkalis, giving a bluish violet color. Archil is quite similar to litmus, although obtained from other species of *Roccella* and *Lecanora* (see *Colour Index*, p. 297).

Logwood is the name of a red dye that is extracted from the wood of *Haematoxylon campechianum* which is indigenous to Mexico, Central America, and the West Indies. The interior of the live wood is yellow but changes rapidly to dark brown on exposure to air. The leuco compound, haematoxylin ($C_{16}H_{14}O_6$), changes to red-brown haematein ($C_{16}H_{12}O_6$) on exposure to air. It is extracted by boiling logwood chips in water over steam under pressure. The red-brown haematein crystals are sparingly soluble in water. With sodium hydroxide, there is formed

a purplish blue solution which changes to brown on exposure to air. Brown, reddish brown, black, and blue-black lakes can be prepared from logwood extracts with various mordants. All are insoluble in water and alcohol, are turned bluish violet by alkalis, and are decomposed by mineral acids with the formation of a blood-red solution. Logwood extract (as haematoxylin) is widely used as a biological stain. When treated with bichromate, it was formerly used in the manufacture of writing inks. Extracts were used, also, in dyeing and in the lakes for water colors, but, because they are fugitive in strong light, they have been discarded.

Madder, Madder Lake (see also **Alizarin**), is a natural dyestuff from the root of the herbaceous perennial, *Rubia tinctorium*, which formerly was cultivated extensively in Europe and in Asia Minor. Roots from plants 18 to 28 months old grown in a calcareous soil are best. The coloring matter, which is chiefly alizarin, or 1,2 dihydroxyanthraquinone ($C_{14}H_8O_4$), is extracted from the ground root by fermentation and hydrolysis with dilute sulphuric acid. The madder plant is native to Greece and was used as a source of dye perhaps as early as classical times (Church, p. 171). It is understood to be the *rubia* of Pliny (see Bailey, I, 37) and other classical writers. It has been identified as the source of a pink color on a gypsum base from an Egyptian tomb painting of the Graeco-Roman period. There are specimens of it in the Naples Museum (Lucas, p. 287). Perkin and Everest say (p. 23):

> About the time of the Crusades the cultivation of madder was introduced into Italy and probably also into France. The Moors cultivated it in Spain, and during the sixteenth century it was brought to Holland. Colbert introduced it into Avignon in 1666, Frantzen into Alsace in 1729, but only toward 1760–1790 did it become important. During the wars of the Republic, its cultivation was largely abandoned, and only after 1815 did this again become regular.

Madder lake and rose madder for artists' pigments are prepared from the madder extract by adding alum and precipitating with an alkali (*Colour Index*, p. 296; see also Perkin and Everest, pp. 623–625). Thompson thinks that the madder lakes were less employed in mediaeval painting than were the brazil lakes. He says (*The Materials of Medieval Painting*, pp. 123–124) that pure madders, as they are known now, came into use in the XVII and XVIII centuries and that they were not important in the Middle Ages.

Madder was the source of the dye, Turkey red, formerly used in large quantities in textiles and is still the color for French military cloth (*Colour Index*, p. 296). The cultivation of the madder root and its employment for dyeing and pigment purposes almost ceased shortly after a synthetic method for making alizarin was discovered by the German chemists, Graebe and Lieberman, in 1868 (see **Alizarin**).

The extract from the madder root also contains another natural dye called 'purpurin.' This is closely related chemically to alizarin and is 1,2,4 trihydroxy-anthraquinone, $C_{14}H_8O_5$ (*Colour Index*, p. 251). The presence of purpurin distinguishes natural alizarin from the synthetic product. Pure purpurin gives lakes

which are more orange and red than those of alizarin (Church, p. 173). This accounts for the warm tone of madder lakes as compared with the pure alizarin lakes. Eibner says (*Malmaterialienkunde*, p. 20) that purpurin is not so light-fast as alizarin. He gives chemical methods by which the two may be distinguished (*op. cit.*, p. 203). He says, also ('Les Rayons Ultra-Violet Appliqués à l'Examen des Couleurs et des Agglutinants,' *Mouseion*, XXI–XXII [1933], pp. 32–68), that the presence of purpurin causes madder lake to fluoresce a fiery yellow-red in ultra-violet light whereas synthetic alizarin lakes show only a feeble violet luminescence.

Paint films colored with madder lake are nearly transparent and appear bright red, with a definite violet hue by transmitted light. The base on which the dye is prepared, particularly if it is aluminum hydrate, can seldom be distinguished, even at high magnifications, because it is amorphous and transparent. Madder lake is among the most stable of the natural organic coloring matters. The color is turned purple by dilute sodium hydroxide but is only destroyed by much stronger reagents. Harrison says (p. 231) that natural madder is still used in France on a small scale for the production of fine artists' colors. Their manufacture is carried on by traditional methods. He further says (p. 239) that alizarin lakes now far surpass lakes from the natural madder in purity, brilliance, and range of colors.

Magenta (fuchsin) is a brilliant red-purple organic dye, $C_{20}H_{20}N_3Cl$, of the triphenylmethane group of dyestuffs. It was first prepared by Natanson in 1856 (*Colour Index*, p. 173). It is soluble in alcohol, acetone, and aqueous solutions. Although a fugitive dye, it has been used for water colors and is still listed among them by artists' colormen.

Malachite (mountain green) is perhaps the oldest known bright green pigment. It is the natural (mineral) basic copper carbonate, $CuCO_3 \cdot Cu(OH)_2$, and is similar in chemical composition to the blue basic copper carbonate, azurite (see **Azurite**), except that it contains a greater amount of combined water. Like azurite, it occurs in various parts of the world associated with secondary copper ore deposits. It is prepared as a pigment by careful selection, grinding, and sieving, but today it is seldom used, except perhaps to a small extent in the East.

Malachite is crystalline (monoclinic) and is fairly characteristic microscopically. Particles of some varieties have a clear, faint, bottle-green color by transmitted light, and show high relief, strong birefringence, and pleochroism. Prisms with longitudinal striations are common. Since it is a carbonate, it is decomposed by acids, even acetic acid. It is unaffected by cold dilute sodium hydroxide but blackens when warmed with that reagent and, also, when it is heated alone. In spite of its ready decomposition, it has remained unchanged in many paintings for centuries, just as it has in the earth. It is unaffected by light.

The history of malachite in painting runs closely parallel to that of azurite. It occurs on Sinai and in the eastern desert of Egypt, and was used there for

eye paint as early as predynastic times (see Lucas, p. 287). It was found side by side with azurite in Chinese painting at Tun Huang and other temple sites, and it has perhaps been used in the East continuously to the present day. This copper green is found in all periods of European painting up to about 1800, but at that time it was nearly supplanted by artificial green pigments. It was used much in trees and foliage. Like azurite, it worked better in tempera than in oil. Thompson remarks (*The Materials of Medieval Painting*, pp. 160–162) that malachite, although widely used in the Middle Ages, is mentioned but little in contemporary literature on painting materials whereas azurite is spoken of repeatedly. This pigment is no doubt the *verde azzurro* of Cennino Cennini (see Thompson, *The Craftsman's Handbook*, p. 31).

Manganese Blue is a comparatively new pigment which seems to have been first mentioned in the patent literature about 1935. This green-blue pigment is essentially barium manganate fixed on a barium sulphate base. It is made by calcining mixtures of sodium sulphate, potassium permanganate, and barium nitrate, or their equivalents, to a temperature of 750–800° C. in the presence of air. The blue pigment formed is very inert chemically; it is unchanged by heat and is insoluble in strong acids and alkalis. The pigment is fairly coarse and somewhat irregular in particle size. Many rectangular particles with rounded corners can be observed; they are moderately birefracting. Although weak in tinctorial and in hiding power, this pigment may have special uses because of its chemical stability. So far, it has been used almost exclusively for coloring cement; it should be of interest to fresco painters. (See French patent 778,290, March 13, 1935, to I. G. Farbenindustrie A. G. [*Chemical Abstracts*, XXIX, 1935, 4610³]; French patent 802,687, September 10, 1936, to Wolfgang Mühlberg [*Chemical Abstracts*, XXXI, 1937, 2029⁵]; British patent 465,912, May 19, 1937, to Wolfgang Mühlberg [*Chemical Abstracts*, XXXI, 1937, 8230³]).

Manganese Violet (permanent violet) is said to be manganese ammonium phosphate, $(NH_4)_2Mn_2(P_2O_7)_2$ (Rose, p. 255). In the method of preparation described by Weber (p. 88), manganese dioxide and ammonium phosphate are melted together, with the evolution of ammonia, and the fused violet mass is digested with phosphoric acid and heated until a correct color is produced; the product must be thoroughly washed free from phosphoric acid. Church (p. 225) says that it has a truer violet hue than cobalt violet (cobalt phosphate) which is redder as well as brighter. The pigment is permanent to light and is unaffected by heat, but it is decomposed by strong acids and by alkalis, which makes it unsuited for fresco. It is not much used by artists because it is dull in tone and has poor hiding power (see Doerner, p. 81). The manganese violet described by Merwin (p. 521) was birefracting and belonged, probably, to the orthorhombic system. Little is known apparently about the history of this pigment, except for a statement by Messrs Winsor and Newton in their catalogue (1930 ed., p. 18) that it was first introduced by them in 1890. It is understood, however, to have

been first prepared by E. Leykauf in 1868, and named by him 'Nurnberg violet' (Rose, p. 254).

Mars Colors (Mars yellow, Mars orange, Mars red, Mars violet). The Mars colors, so-called, are artificial ochres which are made by precipitating a mixture of a soluble iron salt (ferrous sulphate) and alum (or aluminum sulphate) with an alkali like lime or potash. The depth of the yellow color of the primary product can be controlled by the proportion of alum used. The product is a mixture of ferric and aluminum hydroxides with gypsum (if lime is the precipitant) and, if simply worked and dried, is Mars yellow. When this Mars yellow is heated, various shades of orange, red, brown, and violet result, depending upon the degree and duration of the heat. The product must be thoroughly washed free from soluble salts to be useful as an artist's pigment. The preparation of artificial iron oxide colors of this nature from iron vitriol was described in the middle XIX century (Rose, p. 222). Although these Mars colors are very homogeneous and fine, they possess no advantage over the natural iron yellows and reds. They are sometimes sold for the natural iron oxides.

Massicot (litharge). Both 'massicot' and 'litharge' are names which have long been used for the yellow monoxide of lead (PbO). Some writers have used them as synonyms but, on better authority, they are separated in meaning to indicate lead monoxides that are derived from different sources and have slightly different properties.

Massicot is understood to be the unfused monoxide of lead that is made by the gentle roasting of white lead. At a temperature of about 300° C., white lead gives off carbon dioxide and water, and the oxide is left as a soft, sulphur-yellow powder. It is not an intense yellow but it has good hiding power and is similar to white lead in pigment properties. Microscopically, it is not characteristic; it appears to be nearly amorphous, but Merwin states (p. 519) that natural massicot occurs in orthorhombic, thin plates or scales. Chemically, it has properties like white lead; it dissolves in nitric and acetic acids, and may even give off carbon dioxide from undecomposed white lead. It melts in strong heat and is changed to litharge or red lead, depending upon the temperature. It is unaffected by strong light but may revert to white lead on long exposure to damp air.

Litharge or 'flake litharge' is the fused and crystalline oxide which is formed from the direct oxidation of molten metallic lead. The molten lead, in reverberatory furnaces, is stirred from time to time to expose fresh surfaces of lead to the oxidizing action of the hot air above (see Bearn, p. 114). A more modern way is to atomize molten lead by whirling propellers and allow it to oxidize in contact with hot air. It has long been a by-product of the refining of silver by the 'cupellation' process. Litharge is more orange in color than massicot, caused by the presence of some red lead (Pb_3O_4). It is not used as a pigment but is extensively employed as a drier in paints and varnishes; it is important as an intermediate step in the preparation of red lead (see **Red Lead**).

Yellow lead monoxide was known, certainly, as early as metallic lead, which has been found in sites that date from predynastic times in Egypt (see Lucas, p. 200). Laurie (*The Pigments and Mediums of the Old Masters*, p. 10) found it on a scribe's palette dating 400 B.C. Davy (p. 105) identified an orange color on a piece of stucco in the ruins near the monument of Caius Cestius as a mixture of massicot and minium. Pliny described the preparation of both litharge (see Bailey, I, 117–119, and II, 73) and massicot (see Bailey, II, 83–85).

Although De Wild (pp. 49-50) lists thirty-nine Dutch and Flemish paintings of the XV to XVII centuries in which he identified massicot, it is probable that the more stable double oxide of lead and tin which is called lead-tin yellow was actually employed. In modern times, massicot is not used as a paint pigment.

Mauve is an artificial organic dyestuff belonging to the azine group of dyes; it is mainly amino-phenylamino-*p*-tolyl ditolazonium sulphate, $C_{27}H_{25}N_4(SO_4)_{1/2}$ (*Colour Index*, p. 211). This was the first dyestuff ever to be made synthetically. It was discovered in England in 1856 by Sir William Perkin, who prepared it by the oxidation of crude aniline with chromic acid. Because aniline was the starting point for this as well as for several others which followed, the term, 'aniline dyes,' came to indicate all those made synthetically, particularly those from chemicals derived from the distillation of coal tar (see also **Coal-Tar Colors**). The term has been carelessly applied to dyes not derived from aniline or related to it. Pure mauve dye comes in the form of reddish violet crystals. When applied, the color is dull violet. It was early patented in England where it was widely used for a time in dyeing cloth. Although it is fugitive, it has been used as an artists' water color to a small extent, and today is still listed by some colormen among water color paints.

Maya Blue is a name here provisionally given to a peculiar blue pigment which is found rather extensively on wall paintings and painted objects from ancient Mayan sites like Chichen Itza in Yucatan and other localities in Central America. It is green-blue, an inorganic pigment, probably natural in origin. Apparently, it owes its color to the iron it contains and not to any copper. In a microscopic study made for the Fogg Museum of a sample from Chichen Itza, it was observed to be of grains that are very small and faintly greenish blue by transmitted light. The mineral is weakly birefracting and has a refractive index between 1.54 and 1.55. It is pleochroic, being blue in one direction and yellow in another. The blue is intimately mixed with calcite. A spectrogram shows the elements, calcium, magnesium, silicon, aluminum, and iron. It is not affected by alkalis and is only taken into solution by hot concentrated acids. This mineral, in its optical and chemical behavior, compares quite well with the rare mineral, aerinite (from Spain), of the chlorite group.

Merwin has described a blue pigment from Chichen Itza (see E. H. Morris, Jean Charlot, and Axtell Morris, 'Temple of the Warriors,' *Carnegie Institution of Washington, Publication no. 406*, I [1931], pp. 355–356), and he says:

The blue paints as contrasted with the others form fairly coherent films. These can be isolated by dissolving away the underlying plaster in dilute acid. Microscopically the blue material consists of indefinite spherulitic aggregates of a birefringent substance resembling the clay mineral beidellite. It stains like beidellite. X-Ray powder photographs, taken by Dr. E. Posnjak, show the blue pigment, beidellite, and a blue chromiferous clay, to be similar. Not enough of the blue clay was available to give decisive tests for chromium, but, like the blue clay, the color is not discharged by boiling nitric acid nor by heating much below redness. The conclusion seems justified that this is an inorganic color.

The green paints are a mixture of the blue and yellow ochre.

The occurrence of this blue mineral or clay may have been very restricted or known only in that single locality, but there its use seems to have been quite general.

Mica. In mineralogy, various micaceous minerals are recognized, but the name most commonly applies to muscovite, or hydrous potassium aluminum silicate, $H_2K Al_3(SiO_4)_3$, which is found in nature in thin laminae with perfect cleavage. It occurs widely in small deposits all over the world. Other names are 'isinglass' or 'Muscovy-glass.' Its widest present use is as an insulating material in the electrical industry. Ground mica is used as a lubricating agent and as a reenforcing pigment in paints. In the Far East it had an occasional place in painted designs where its lustrous surface gave an effect somewhat like that of metal.

Mineral Pigments are those derived from the natural minerals of the earth. Although, broadly speaking, they may include complex mixtures and aggregates, like earths and clays, the term is more properly restricted to those minerals which are, on the whole, definite chemical compounds with characteristic physical form and constant chemical behavior. Pigments derived from azurite, orpiment, and lapis lazuli are examples.

Minium (see **Red Lead**).

Molybdate Orange, a pigment of recent origin, is a mixed crystal compound of lead chromate, lead sulphate, and lead molybdate in the approximate ratio, $7PbCrO_4 \cdot 2PbSO_4 \cdot 1PbMoO_4$. This molybdate-modified lead chromate belongs to the tetragonal system whereas lead chromate alone is usually either rhombic or monoclinic. The particles are small, rounded, and uniform in size, have high index of refraction, and are moderately birefracting. As a pigment, it has high covering power and tinting strength. A. Linz has described ('Molybdenum Orange Pigments,' *Industrial and Engineering Chemistry*, XXXI [1939], pp. 298–306) the conditions of precipitation necessary to produce a pigment having the most desirable properties. Molybdate orange can claim only moderate fastness to light. Mixed crystal pigments of lead chromate and lead molybdate were first described by E. Lederle in a German patent (no. 22F.1.52.30) applied for by the I. G. Farbenindustrie A. G. on August 30, 1930 (see Linz, *loc. cit.*, p. 298; see also German patent 574,379, April 12, 1933, and 574,380, April 13, 1933; also U. S. patent 1,926,447, September 12, 1933). Although molybdenum orange went into

production soon after 1935 for use in printing inks and paints, it is not known that it has been used, as yet, in artists' paints. Because of its brilliant color and other desirable properties, however, it may be expected soon to find use for that purpose.

Monastral Blue (see **Phthalocyanine Blue**).

Mordant is a general term for a fixing agent. It is derived from the Latin, *mordere*, 'to bite.' In dye processes, the term is used to indicate certain chemicals which are used for fixing colors on textiles by adsorption. The more common mordants are the soluble salts of aluminum, chromium, iron, tin, etc., which are precipitated on the fibres along with the dye by an alkali. These mordant salts are particularly necessary for fixing adjective dyestuffs to fibres. Occasionally, the term applies to the base or substrate employed in the preparation of lake pigments from organic dyes (see **Lake**). In the technical language of the fine arts, the term refers to the adhesive film used to fix gold leaf in one type of gilding (see also **Mordant**, p. 35).

Mosaic Gold is artificial tin (stannic) sulphide (SnS_2), and it is made by combining tin with sulphur in various ways (see *Colour Index*, p. 306). This sulphide, which looks like bronzing powder, consists of fine, soft, yellow scales with a golden glint. It was formerly used for gilding purposes as a sort of gold substitute. According to Thompson, who has described the preparation and history of this material (*The Materials of Medieval Painting*, pp. 182–184), it was known in Europe as early as the XIII century. There are many recipes for making it in XIV and XV century texts, and it is found occasionally on mediaeval manuscripts. In the Bolognese MS. (XV century), a whole chapter is given to the preparation of mosaic gold or '*purpurino*' and its use in painting (see Merrifield, II, 458). Stannic sulphide is a fairly stable compound; it is unaffected by light and by mineral acids, but is soluble in sodium hydroxide and in aqua regia.

Mountain Blue (see **Azurite**).

Mountain Green (see **Malachite**).

Mummy. A brown, bituminous pigment was once actually prepared from the bones and bodily remains of Egyptian mummies which had been embalmed with asphaltum (see Church, p. 236, and Eibner, *Malmaterialienkunde*, p. 213). It was claimed that, through time, the asphaltum had lost some of its volatile hydrocarbons, and the powder from the ground-up, embalmed remains was more solid than recent asphaltum and was better suited for a pigment. Apparently, it was once a favorite with some artists. Church says (p. 237) that it was certainly used as an oil paint at least as early as the close of the XVI century. Little is known about its history; it has not been mentioned in reports on the identification of materials in paintings. It is now perhaps unobtainable and is no longer desired in the arts. Some oil paints sold under that name are substitutes which contain bituminous earths like Van Dyke brown. The microscopic character of true mummy has not been described, but probably its properties and behavior are much like those of asphaltum (see **Asphaltum**).

Naples Yellow (antimony yellow) is essentially lead antimoniate ($Pb_3[SbO_4]_2$), which may be considered to be chemically combined lead and antimony oxides. It varies in color from sulphur-yellow to orange-yellow, depending upon the proportion of the two materials. It is made in various ways: from the prolonged roasting of the mixed oxides of lead and antimony, or from salts of those metals, like tartar emetic (potassium antimonyl tartrate) and lead nitrate with sodium chloride (see De Wild, p. 56; also Rose, pp. 306–310). The pigment is homogeneous and finely divided, and it has good hiding power. It resembles massicot in its microscopic character, and De Wild says (p. 57) that no crystalline form can be detected, even at high magnification. Chemically, it is quite stable; it is little affected by alkalis or by dilute and concentrated nitric or hydrochloric acids. It fuses only at a high temperature but turns permanently dark brown. Since it is a lead pigment, it is darkened by hydrogen sulphide; hence, it is more useful in oil than in water color medium.

The history of this pigment is rather obscure. A compound of antimony and lead seems to have been used in Babylonia and Assyria in the production of yellow ceramic glazes (see Partington, pp. 256, 283, and 292). It was found (Partington, p. 292) in cake form among other pigments in Sargon II's palace at Khorsabad. Lucas (p. 125) found lead and antimony in a specimen of Egyptian glass of the XIX Dynasty. Little is known about its early history in Europe. Naples yellow has been vaguely connected by some with the *giallorino* of Cennino Cennini (see Thompson, *The Craftsman's Handbook*, p. 28, and *The Materials of Medieval Painting*, pp. 179–180), but the identity of that yellow is still uncertain. R. Jacobi has reported (' Über den in der Malerei verwendeten gelben Farbstoff der Alten Meister,' *Angewandte Chemie*, LIV [1940], pp. 28–29) on specimens of a yellow pigment used in paintings from the XVIII century, particularly in northern Europe which, on the basis of spectroscopic studies, were found to be a compound of lead and tin oxides. Recipes for the preparation of lead antimoniate, as it is now known, first appeared around the middle of the XVIII century (see Guignet, p. 105, and De Wild, p. 56). Rose says (p. 307) that the first recipes are given by Passeri in 1758. De Wild (p. 58) does not believe that it was used by the old masters. Doerner (p. 62) thinks, however, that it was used by Rubens. Only careful chemical analysis could distinguish it, on paintings, from massicot. Naples yellow is still used as a ceramic pigment, but not much by artists, although it can be got from a few colormen. Several substitutes, which are sold under that name, are mixtures like cadmium yellow, zinc white, Venetian red, etc. The name has come to indicate a shade of yellow rather than a definite chemical compound.

Natural Pigments are those which are mineral, vegetable, or animal in origin. They are the pigments most generally used in the early history of painting. Included are many of great stability and usefulness, like ochres and umbers. Some are of fine quality, like azurite, malachite, and ultramarine. A few of the natural animal and vegetable colors, like indigo and madder lake, are moderately stable, but many, like saffron and carmine, are fugitive. Natural mineral pigments are

often characterized by their coarseness and irregularity in particle size and, also, by the presence of impurities. Coarse and impure mineral pigments can impart certain desirable qualities of texture and of tone to painted surfaces not attainable with artificial, precipitated pigments. The inert pigments, like gypsum, clay, and chalk, are of natural origin and have only to be purified to be used as paint materials.

Ochre (yellow ochre, golden ochre, red ochre, brown ochre). An ochre is a natural earth which consists of silica and clay, and which owes its color to iron oxide in either the anhydrous or hydrous form. Red ochre is colored by anhydrous iron oxide, Fe_2O_3 (see **Iron Oxide Red**), but in yellow ochre the color is caused by the presence of various hydrated forms of iron oxide, chief of which is the mineral, goethite, $Fe_2O_3 \cdot H_2O$. This is seen at high magnifications in strongly birefringent spherulites less than 1μ in diameter. Brown ochre is nearly pure limonite. In addition to iron minerals, yellow ochre may contain impurities of gypsum, magnesium carbonate, etc. There is a wide variation in the iron oxide content, but French ochre, which is one of the best varieties, contains about 20 per cent; it is low in aluminum and high in silica. The best ochre district of France centers about Apt in the Department of Vaucluse in the south (see Ladoo, p. 380). Ochre, however, occurs all over the world and ochre pits are worked in many places. It is prepared for use by selection, grinding, washing, levigation, and drying (see Bearn, p. 60). Since it is a natural product, it is found in a number of shades which vary from dull, pale yellow to reddish brown. Some ochres have good hiding power; others, like the siennas from Italy (see **Sienna**), are especially valued for their transparency. Microscopically, the pigment is heterogeneous in particle size and in composition; it is a mixture of colorless silica and semi-opaque, pale yellow and brown particles which are sensibly isotropic. Like other forms of iron oxide, yellow ochre is permanent in all techniques; it is not affected by dilute acids or alkalis. It turns red (to red ochre) on burning from loss of water of hydration.

Yellow ochre has been universally used as a pigment from earliest history. It was known and used in ancient Egypt, in Roman times, and in the East. It was important in the Middle Ages and in all periods of European painting. De Wild has reported it (p. 53) in twenty specimens from paintings of all periods of Flemish and Dutch art. Yellow ochre is now listed by all artists' supply dealers and is a fairly dependable product. In the recent past, it was occasionally brightened with chrome yellow or by natural or aniline dyes (see Weber, p. 94). Artificial iron yellows or ochres are now common (see **Mars Colors**).

Orange Mineral (see **Red Lead**).

Organic Pigments are those which belong to the organic division of chemical compounds. They are compounds of carbon with hydrogen, oxygen, nitrogen, sulphur, and other elements. They may be derived from vegetable sources or they may be made synthetically. Vegetable coloring matters are those like madder,

saffron, indigo; synthetic or coal-tar colors are those like magenta, alizarin, and toluidine red. Although a few organic pigments are stable and are considered permanent, in general they are fugitive.

Orpiment (King's yellow) was once widely used, particularly in the East, but has now fallen into complete disuse because of its limited supply and because of its poisonous character. It is the yellow sulphide of arsenic, As_2S_3, occurring naturally in many places but not in large quantities. The principal sources in ancient times appear to have been in Hungary, Macedonia, Asia Minor, and perhaps in various parts of Central Asia. There was a large deposit near Jula-merk in Kurdistan (see Dana, p. 358). It is said that some hundreds of tons of orpiment are exported annually from Shih-haung-Ch'ang in Yunnan province in China (see Thorp). The natural product must have been prepared by methods common for other natural pigments. It can also be made artificially by precipitation or sublimation. Orpiment is brilliant, when pure, with a rich, lemon-yellow tone, and fair covering power. Laurie says ('The Identification of Pigments . . . ,' p. 165): 'The brilliant color and tint on a MS. are usually unmistakable.' In old paintings and illuminations, it was rather coarsely ground to preserve its rich yellow color. Microscopically, the larger particles glisten by reflected light and have a waxy-looking surface. It often contains orange-red particles of realgar, to which it is closely related (see **Realgar**). Orpiment is crystalline (monoclinic) and is highly refracting. It sometimes appears to have a fibrous structure. This natural sulphide is stable to light and air. It is not affected by dilute acids and alkalis but only by strong acids. When ignited, it burns to arsenic trioxide. Since it is a sulphide, it is incompatible with copper and with some lead pigments.

Orpiment was known in classical times. It is mentioned by Pliny (see Bailey, I, 101) as occurring in Syria, and as a pigment which can not be used in fresh plaster (*op. cit.*, II, 91). It appears to get its name from a corruption of the Latin, *auripigmentum* (gold color or paint). By Vitruvius it is mentioned (VII, Chap. VII) among the natural colors. Spurrell records it as having occurred in Egyptian paintings at Tell el Armarna of the XVIII Dynasty. Lucas (p. 292) says that the mineral does not occur in Egypt and must have been imported, perhaps from Persia. It has been identified many times in old illuminations. Laurie (*The Pigments and Mediums of the Old Masters*, p. 72) reports a peculiar kind on VIII century Irish manuscripts. He says, also, that it was used on Byzantine and on early Persian pages (see 'The Materials in Persian Miniatures,' pp. 146–147). It has been found, along with realgar, on mud wall paintings from Kara Khoto in Central Asia (XI–XIII centuries). Although it was mentioned by Cennino Cennini (see Thompson, *The Craftsman's Handbook*, p. 28), it does not much appear in easel or monumental painting of the West. De Wild did not find it on any of the Dutch and Flemish paintings he examined, perhaps because it was not necessary when a good grade of lead-tin yellow was available.

Oyster Shell White (see **Chalk**).

Para Red or **Para Toner** was one of the early synthetic diazo dyestuff colors; it is p-nitrobenzene-azo-β-naphthol, $C_{16}H_{11}N_3O_3$, and is derived from the dye intermediate, paranitraniline (*Colour Index*, p. 11). For pigment purposes, the dye is usually precipitated on barytes. It is brilliant in hue, but darkens on exposure to strong light and sometimes becomes brown; it has a tendency to bleed in oil paints. Although Para red was formerly widely used in the manufacture of red paints and enamels, it has been replaced in recent years by the more stable **Lithol Red** and **Toluidine Red**. Para red has perhaps never been offered to the artists' trade under this name, but it has no doubt occurred in pigments as a toner and substitute in cheaper lines of paints. It was first made by Messrs Holliday and Sons in England in 1880 (*Colour Index*, p. 11).

Paris Blue (see **Prussian Blue**).

Paris Green (see **Emerald Green**).

Permanent Blue is a name used by some artists' colormen for ultramarine (see **Ultramarine Blue, artificial**). It is occasionally given to a pale variety of that pigment.

Permanent Green is a name sometimes applied by artists' colormen to mixtures of viridian with a yellow pigment like cadmium yellow or zinc yellow; it may also contain zinc oxide.

Permanent Violet (see **Manganese Violet**).

Permanent White (see **Barium White**).

Persian Berries Lake (yellow berries, buckthorn berries) is a yellow lake made from the dried, unripe berries of various shrubs of the buckthorn family, *Rhamnus*, found in the Near East and now imported from Smyrna and Aleppo (*Colour Index*, p. 293). The berries are also available from European members of the family. The coloring principle is rhamnetin, $C_{16}H_{12}O_7$, which is extracted by boiling water. The lake is made by the addition of alum, followed by soda (*op. cit.*, p. 301; see also Perkin and Everest, p. 628). Other colors are produced with other mordants. It is insoluble in water and in alcohol but is soluble in alkalis, forming a yellowish brown solution; it is decomposed and decolorized by mineral acids, but is moderately stable in light. Colors of this origin were popular in France and in England in the XVIII century (Thompson, *The Materials of Medieval Painting*, p. 187), but are no longer current.

Phosphotungstic Acid Bases are complex compounds of phosphorous pentoxide and tungstic acid combined approximately in the ratio, $1P_2O_5 : 24WO_3$. These bases are now quite extensively employed with organic dyestuffs in making lake pigments and toners of excellent strength and light-fastness. They were developed in Germany, and it appears that first patents were issued to the *Badische Anilin und Soda Fabrik* (see British patent 15,951, 1914; French patent 474,706, 1914; also British patent 216,486, 1924).

Phthalocyanine Blue ('Monastral' blue) or copper phthalocyanine, $C_{32}H_{16}N_8Cu$, is an organic blue dyestuff that was recently developed by chemists

of the Imperial Chemical Industries, Ltd, and was first introduced to the pigment trade under the name, ' Monastral blue,' at an exhibition in London, November 1935. American manufacture and trade introduction under other names followed early in 1936 (see first notice in *Industrial and Engineering Chemistry, News Edition* [January 10, 1936]). The claim was made that it was the most important blue discovery since those of Prussian blue in 1704 and artificial ultramarine blue in 1824, and that in many respects it was superior as a pigment to either of these.

Copper phthalocyanine is prepared by a complex organic synthesis. Phthalic anhydride and urea (or phthalonitrile) are fused together with copper chloride and the product is first washed in dilute caustic soda and then in dilute hydrochloric acid. At this stage it is copper phthalocyanine, but it is not in physical form suitable for pigment. It is conditioned by being dissolved in concentrated sulphuric acid and precipitated again in excess water. After careful washing and filtering, the resulting paste can be used directly in the preparation of lakes by adsorption on aluminum hydrate or it can be dried for incorporation directly into non-aqueous mediums.

M. A. Dahlen of Messrs E. I. duPont de Nemours and Co. (in an article entitled, 'The Phthalocyanines: A New Class of Synthetic Pigments and Dyes,' *Industrial and Engineering Chemistry*, XXXI [1939], pp. 839–847), who has described the properties and uses as well as the method of synthesis of this new class of pigments, says that pure copper phthalocyanine in crystalline form is deep blue with a strong bronze reflection, but the dry, disperse form is bright blue with little or no bronziness. It is insoluble in organic solvents, even at high temperatures, in alkalis and in acids, except concentrated sulphuric and phosphoric acids, and is highly resistant to oxidizing and reducing agencies. Dahlen says that when tested in pigment applications the phthalocyanines as a class have good fastness to light and certain members show outstanding fastness. It is very close to the ideal pure blue, for it absorbs light almost completely in the red and yellow, and reflects only green and blue bands. This makes it the true ' minus red ' so much needed in three-color printing. The color is very strong tinctorially, having about twice the strength of Prussian blue and twenty to forty times that of ultramarine. It was proposed and offered for sale under the trade name, ' Monastral blue,' and other trade names, as an artists' color very shortly after its first commercial introduction in 1936. Other phthalocyanine pigments were shortly introduced and more can be expected because of the current interest in this new chromophore. Among the first of these was chlorinated copper phthalocyanine which yields a green dye and pigment having properties quite similar to those of the blue pigment, including light-fastness. It first became available commercially at about the beginning of 1938. (See Dahlen for extended bibliography on this class of pigments to 1938.)

Pigment is a finely divided coloring material which is suspended in discrete particles in the vehicle in which it is used as a paint (thus being opposed to a dye

[see **Dye**], which is soluble in the vehicle). Pigments are derived from a wide variety of substances, organic and inorganic, natural and artificial. They may be classified according to color, chemical composition, or source.

Pigments, chemical properties. Pigments comprise a wide variety of chemical compounds; hence, they differ greatly in respect to their chemical properties. Among the inorganic coloring materials are the oxides, sulphides, carbonates, chromates, sulphates, phosphates, and silicates of the heavy metals. A very few like Prussian blue and emerald green are complex metallo-organic compounds. Carbon in the form of lamp black or charcoal and the metal pigments like gold and aluminum are the only elements that serve in a relatively pure state. Dye-stuffs are complex organic compounds.

For certain special purposes, a pigment should be as nearly chemically inert as possible and be unaffected even by strong acids, alkalis, and heat. Only very few of the paint pigments, however—carbon black, oxide of chromium, and cobalt blue—are so resistant. A few compounds like the oxides of cobalt, chromium, tin, and iron are so stable at high temperatures that they can serve for coloring ceramic glazes. So far as the demands of ordinary painting are concerned, how-ever, a pigment need only be stable and chemically inert enough to withstand light, air, and moisture or environments in which all three agencies are combined.

Light, especially strong sunlight, is the promoter of certain photochemical reactions which result in dimming some colors, in browning and darkening some, and in producing a distinct color change in others. In the case of organic dye-stuffs, light causes a definite degradation to colorless products, a change called ' fading.' The effect of light is usually accelerated by heat and moisture. The oxidizing action of chromates, with reduction to chromic oxide, is accelerated by light. Red lead in a glue medium has been observed to turn to brown lead dioxide through the combined action of light and moisture. Air is the carrier of moisture and certain obnoxious industrial gases like sulphur dioxide and hydrogen sulphide, and the oxygen which is an important component of it may itself take part in reactions which cause fading or discoloration. Church and others (pp. 334 and 339) showed years ago that fugitive pigments exposed in thin washes to light faded less when moisture is excluded and still less rapidly when both air and moisture (*in vacuo*) were excluded. Many chemical reactions require a certain amount of moisture before they can take place. The exact rôle of moisture is not entirely understood, but it may be considered to act as a catalyst.

Stability and inertness enough to insure complete compatibility with others are among the first requirements of artists' pigments because they are intermixed or intimately juxtaposed much more than are those in house paints. Under certain conditions, it is possible for sulphides to interact with copper and lead pigments and produce black or brown copper and lead sulphides, with resulting discolora-tion. Actual happenings of this phenomenon are rare, particularly when the pigments are used in oil medium, because the oil encloses each particle in an

envelope that protects it from moisture and contact with other particles. Some oxygen-bearing pigments, especially the chromates, seem to have an oxidizing action on certain organic pigments with reduction of themselves to a lower state of oxidation. Yellow lead chromate, for example, is reduced to green chromic oxide. Pale tints made with zinc oxide and lake pigments are known to fade more rapidly in direct sunlight than those made with other white pigments.

The simple oxide pigments, as a rule, are regarded as the most stable, particularly to light, air, and moisture. Stable in this respect are also the sulphates, phosphates, and carbonates. Although some of the most important pigments are sulphides, they may not, as already mentioned, be stable with certain lead and copper compounds. Vermilion, which is mercuric sulphide, is so insoluble, however, that specimens are frequently seen where it has been intimately mixed with white lead for centuries without change or darkening of the white lead. The same is true of ultramarine which is partially a sulphide. It is not safe, however, to mix cadmium sulphide yellow with verdigris or with emerald green.

Chemical properties of pigments may be looked at from the point of view of their behavior to strong chemical reagents. Carbonates, ultramarine, and some oxides and sulphides (zinc and lead oxides and cadmium sulphide, for example) are readily decomposed by acids. Prussian blue is sensitive to alkalis and, hence, can not be used for true fresco.

Pigments themselves may have either acid or alkaline properties. The oxides of the heavy metals, in general, are basic (alkaline)—so basic that they can react with free fatty acids of drying oils to form metallic soaps. Zinc oxide has this tendency and so have some of the lead pigments, and it appears that this is one of the reasons why white lead in oil forms such a compact, elastic, and durable paint film. Titanium oxide, on the other hand, is perfectly inert, does not tend to form a titanium soap, or to react in any way with paint and varnish vehicles.

Pigments, history. Coloring materials from animal, vegetable, and mineral sources to be used for personal adornment, for decorating tools, weapons, and utensils, and for making pictures were sought by man as early as remote prehistoric times. Most easily procurable were vegetable colors, flowers, seeds, berries, nuts, bark, wood, and roots of plants. Most of these were fugitive and they soon faded when exposed to sunlight. There were notable exceptions, however, like the materials obtained from the madder root, the woad plant, or from the lac insect which, under conditions not too unfavorable, sometimes lasted for centuries. Only slightly less available were the colored earths which included the yellow, red, and brown ochres and clays that abound on the earth's surface in sedementary deposits. Carbon black in the form of soot, charcoal, and even charred bones, could have been found about the most primitive hearth. Such coloring materials as these were known and used as early as there are archaeological criteria. Somewhat less readily available than the earths were the colored minerals of the heavy metals, but, even so, such brightly colored minerals as cinnabar, orpiment, realgar,

azurite, malachite, and lapis lazuli were known to the ancients and were used for pigments in very early historic times. Since these minerals were not widely distributed but were almost in the class of semi-precious stones, their earliest use was restricted to the particular regions in which they were found. Long before classical times, however, such minerals became articles of commerce and were transported to regions far beyond their origin. There is archaeological evidence of the use of cinnabar (see **Vermilion**) as a pigment in China as early as the third millenium B.C.; azurite (see Lucas, p. 283) was used in Egypt fully that early.

Artificial pigments came to be made almost with the beginning of written history. There is evidence that the blue artificial pigment, copper calcium silicate, more commonly known as Egyptian blue, was manufactured by 2000 B.C. and perhaps much earlier (see **Egyptian Blue**). The artificial yellow and red oxides of lead, as well as basic lead carbonate, were known in classical times and perhaps much before that. And so was verdigris. There is knowledge of the use of these from archaeological as well as from literary sources. It seems that artificial vermilion was not known in the West that early but it is mentioned in the Arabic alchemical writings of the VIII and IX centuries. It may have been made by the Chinese centuries before.

The archaeological remains of ancient Egypt are rich in information about pigments used for decorative and architectural purposes (see Lucas, pp. 282–292). So are those of classical times, particularly of the later and more far-reaching Roman period. Raehlmann has carefully described his findings made from studies of Pompeian wall paintings, and Laurie (*Greek and Roman Methods of Painting*) has commented generally on literary and archaeological information about painting materials of classical times. The materials employed for pigments remained much the same through the Dark Ages, and information about them comes largely from direct observations on parchment illuminations. On the pages of books, where light and moisture have been excluded, conditions have been nearly ideal for the preservation of painting materials.

Pigments in mediaeval as in earlier times were still important articles of trade and were carried for long distances. In value, some of them were in a class with precious metals and stone and, since they were light and not bulky, they were easily transported. In Byzantine times, ultramarine (see **Ultramarine Blue, natural**) began to be brought to Europe from the region of the headwaters of the Oxus in modern Afghanistan, and for centuries remained the most precious of all artists' colors. Ultramarine was carried north to Chinese Turkestan at the same time, but it was probably only the bright, exotic pigment materials that were carried such distances. The more sombre colors, apparently, were usually obtained nearer at hand and for such colors there are perhaps greater geographical limitations of use. The green earths, the siennas, and the umbers were first used in Italy and adjacent regions because best supplies were found there and still are. In later periods smalt seems to have been favored in the Low Countries because

it was made principally in Germany. The Mayans in Central America used a native earth blue in their paintings, a color that seems not to have been known in any other place in the world.

The mineral pigments on the palette of the European painters of the XV and XVI centuries differed little from those of the classical painters, with the possible exception of the blue glass pigment, smalt, which came into use in Europe in this period. Perhaps, also, some new vegetable colors were added about then. Knowledge of the painting materials of this time begins to be handed down in numerous treatises and manuscript writings. From this period there has come, also, a wealth of objective evidence in the form of actual paintings. Examination of these paintings and the identification of materials in them yields technical information that is often more important than that to be had from literary sources. During these centuries of the late Renaissance, many vegetable pigments continued to be used, particularly for book illumination, and they included coloring materials from safflower, brazil-wood, turnsole, and woad. Later sepia and bistre came into use for water color work on paper.

During all these centuries the pigments employed for painting in the Far East were similar to those of the West. The Chinese had basically the same things to start with as the Europeans. Vermilion was used in China as a pigment as early as the Shang period (1766–1122 B.C.). It is not known when it came to be made artificially, but it was probably the Chinese alchemists who first learned how to make mercuric sulphide by the dry process. The minerals, malachite and azurite, were important in Chinese painting and so were the plain earth colors. The lead pigments, red and white, were used in the T'ang period and perhaps much earlier. Vegetable pigments like indigo, safflower, gamboge, were also known and used. The ways in which pigments were employed differed from practices of the West more than the pigments themselves.

The first years of the XVIII century mark the beginning of modern synthetic pigments. It was in 1704 that Diesbach in Germany discovered how to make the pigment that is still made in large quantities under the name, Prussian blue. It is the first pigment about which there is fairly definite knowledge and written contemporary record of the circumstances surrounding the discovery. From then on, equally definite knowledge of the date of discovery of new pigments is available from published records in scientific journals. Unfortunately, often much less is known about the approximate date of introduction of a new color as an artists' material than about its date of discovery. The middle XVIII century was not productive of new coloring materials, but in the last quarter, beginning with the discovery of copper arsenite by Scheele (see **Scheele's Green**) in 1778, new pigments began to appear in fairly rapid succession. These were the direct outcome of the discovery of several new chemical elements about that time, principally zinc, cobalt, and chromium. Cobalt green first appeared about 1780, zinc oxide in 1782, and cobalt blue in 1802. In 1797 the French chemist, L. N. Vau-

quelin, first announced the discovery of the new metal, chromium. This was an important event in pigment history because from that element, which so appropriately gets its name from the Greek word, χρῶμα, meaning color, are derived more pigments and a greater color range than from any other single element. In his memoir of 1809 (see **Chrome Yellow**), he first described some of these new chromium compounds which later were to become useful as pigments. In the XIX century, nearly every decade was marked by the discovery of some such compound that later became a pigment. Some of them remained useless, scientific curiosities for years before they were finally put into production. Conspicuous developments were the discovery of cadmium yellow by Stromeyer in 1817, of artificial ultramarine by Guimet in 1824, and of viridian in 1838. These increased the color range of the artists' palette and, in some cases, added to its permanence. The artist was now independent of the costly and uncertainly available mineral pigments like genuine ultramarine and azurite.

A new epoch in the history of pigments began in 1856 when William Perkin in England announced the preparation of the first synthetic dyestuff, mauve. Although many of the dyes or so-called ' coal tar ' colors that soon followed were taken up with enthusiasm by artists, they soon received a bad name for lack of permanence. It is only in recent years that synthetic dyestuff lake colors have been prepared which vie with mineral colors in stability and permanence, and even today the number is very limited. The last half of the XIX century was not notable for development of new inorganic pigments. Lithopone was first produced in the 1870's, but did not become general as an artists' pigment. Since the beginning of the XX century, however, there have been some important additions. The first of these, the cadmium reds, that now somewhat displace time-honored vermilion, came along about 1910. They were followed by the titanium oxide pigments about 1920. Most recent additions to the organic pigments are the blue and green copper phthalocyanines, and in the inorganic class are molybdate orange and manganese blue.

Since about 1850 first dissemination of knowledge of new pigments and dyestuffs has come from the patent literature. Dozens of patents on pigments and dyestuffs are now taken out every year, but most of them are concerned with improvements and variations in methods for manufacturing long-established materials. Although artists are still conservative in accepting new painting materials, the interval between discovery of a new color and acceptance for artists' purposes is much shorter than it was formerly. Today the artist has a greater range and variety of durable pigment materials to choose from than at any time in history.

Several attempts have been made to show by graphic methods or in tabular form the history and periods of uses of the principal pigments. Laurie, the first to do this, presented the results of the identification of pigments of illuminated manuscripts of various countries in tabular form so that the data could be readily

compared and referred to (see *The Pigments and Mediums of the Old Masters*, insert after p. 112). Another type of chart (*op. cit.*, p. 136, and *The Analyst*, p. 176) shows by vertical lines the occurrence of pigments in Western paintings from 800 A.D. to 1800. De Wild (see inserted table) made up a chronological chart of pigments based on his investigations of Dutch and Flemish paintings. Although his researches covered paintings of limited geographical origin, his data serve to indicate some of the history of pigments in Europe from the XV to the XX century. Eibner (*Wandmalerei*, pp. 549–554) has prepared perhaps the most comprehensive table on the history of pigments. He uses information from several sources, mainly literary evidence, both classical and contemporary, but, also, to some extent, his own objective findings. Noel Heaton ('The Permanence of Artists' Materials, *Journal of the Royal Society of Arts* [London], LXXX [1932], pp. 415–416) has published a table which lists in chronological order the dates of introduction of the important artists' pigments.

Pigments, physical properties. Pigments are materials which are useful for painting mainly because they have some outstanding physical properties, even when they exist in a fairly minute state of subdivision. Physical properties are those properties inherent in a material itself and which do not involve its relationship or combination with other materials.

Color is the most important physical property of a material in determining its immediate usefulness as a pigment. A material has color because of its selective absorption for the component colors of white light. The color of painting materials can be treated from many points of view. One of these has for its end the comprehension of all possible visual tones within a single system. Morton C. Bradley, Jr ('Systems of Color Classification,' *Technical Studies*, VI [1938], pp. 240–275) has made a brief critical review of that phase of color study. It has to do not with pigments specifically but rather with color as visual tone. In isolated instances a pure material itself may serve as a standard of reference in a system of visual tones. True color characteristics are best established analytically by spectrophotometric measurements. Barnes has recently worked out the descriptions of some fifty artists' pigments and has given curves for them on the basis of light reflectance from the surface for different wave-lengths of incident visible light. Maerz and Paul treat the language of color, its origin, growth, and usage, and by means of color plates showing graduations of hue, purity, and value, they offer a quick and practical method for relating colors with the names by which they are commonly identified. Standards of color for many of the pigments described in these data appear on their plates.

Merwin, in treating optical properties and theory of color of pigments, has shown that the color characteristics, the hue, purity, and brightness of the light diffused, depend upon the color absorption, size, shape, and texture of pigment grains. He describes the optical properties of individual pigment substances in detail. For instance, he says of cobalt blue (p. 520) that grains vary in depth of

color; those most deeply colored have the highest refractive index, which for blue is 1.74, for red a little greater than 1.78, and for green less than 1.73. Grains 10μ in diameter are practically opaque to wave-lengths between 560 and 610mμ whereas wave-lengths in the red longer than 650mμ and in the blue-violet are transmitted freely. Most pigment grains are minute crystals and, since many of these crystals are anisotropic, color absorption and transmission of light are different along different axes.

The colors of different classes of pigments cover unequally well the different regions of the visible spectrum. There are no colors of the short wave-length region among the common earth pigments. There is also a deficiency of bright mineral and inorganic pigment colors in that region. The organic dyestuff colors, however, cover all portions of the spectrum almost equally well.

The refractive index of a pigment, which is the measure of light-bending power of particles as light passes through them, is important because the hiding power of a transparent pigment is proportional to the refractive index of its grains. Titanium dioxide with a refractive index of 2.55 has the greatest whiteness and hiding power of any white pigment. Both white lead and zinc white, with refractive index approximating 2.00, have lower covering power. Merwin says (p. 497) that the amount of light reflected from a unit area of surface of a pigment grain increases with the refractive index. Pigment grains reflect most light when surrounded with air, less light when surrounded with vehicle, and paint reflects in proportion to the difference between the refractive indices of the pigment and the surrounding medium. The higher the refractive index of the pigment and the lower that of the vehicle, the greater the light reflection, and, with white pigments, the greater is the resulting whiteness and hiding power. There is also a close relationship between refractive index and color. Merwin says (p. 501):

> To be most effective as a pigment when used alone, a substance should have a high refractive index for the color which it most freely transmits. In general there are large variations of refractive index near and through a region of color absorption. Refractive index is higher on the long-wave side of such a region than on the short-wave side. For this reason red, orange, and yellow pigments usually have much higher refractive indices than blue and violet pigments. The refractive index of lakes is largely determined by the base, and is always comparatively low. Some pigments so nearly match vehicles in refractive index that they diffuse very little light. They become effective only when mixed with a pigment of high refractive index which will diffuse their color, or when painted in thin films over a surface covered with a strongly diffusing paint. For example, Prussian blue, verdigris, and alizarine lakes.

The refractive indices for many pigments are given in the table of physical properties. Pigments may belong to the isotropic, uniaxial, or biaxial groups of crystals and the n index, the ϵ and ω indices, and the $\alpha, \beta,$ and γ indices are given for members of each group respectively. The indices for many of the mineral pigments and inerts are known accurately to the third decimal place. Indices for many of the precipitated chemical pigments are not known with such accuracy because they are too fine to be measured or do not take definitely crystal forms when pre-

pared. Many of the pigments are not uniform in particle composition; hence, the refractive indices lie over a range of values. The degree of hydration and water inclusion are other factors that determine the light-bending properties. The purely opaque pigments, of course, have no measurable refractive index.

Hiding power is the property of a pigment, when made into a paint, to obscure the surface over which it is applied. In the case of white pigments, the ability to reflect light and to obscure black is the measure of hiding power; in the case of black pigments the opposite is true. As a general rule, hiding power of a pigment is proportional to its refractive index, to fineness of particle size (down to a certain limit), and to depth of color. Usually pigments which are compounds of the heavy metals have the greatest hiding power, but there are exceptions like carbon black and ultramarine. Lake pigments, especially when prepared on an alumina base, are transparent and have very little hiding power.

Size and shape of pigment grains are important for various reasons. Pigments are ordinarily very fine substances. To be useful, they must produce a paint that can be applied evenly and smoothly in a uniform film. This requires fine and uniform particle size. In the production of pigments, that is attained in various ways. Those pigments produced from minerals are simply broken crystal fragments. Their particle size is governed by the ease and kind of fracture and by the amount of grinding, but ordinarily mineral pigments are not very finely ground. Small particles produced in this way have the appearance of broken fragments, the edges are sharp and irregular and usually angular; the shape is, in fact, governed by the cleavage properties of the mineral. Azurite and cinnabar vermilion are examples. Many of the earth pigments of sedimentary origin consist naturally of small, discrete particles which, however, are usually very uneven in size. In preparation for use as pigment, the raw earth must be stirred up in large tanks of water and let stand (levigation) to allow coarser particles to settle away from the finer particles which are held in suspension. The supernatant liquid bearing the finer particles is drawn off, is passed from tank to tank, remaining in each longer than it did in the preceding one, and producing in each successive tank a finer and finer deposit. Particles from this kind of source are usually irregular in shape but are rounded or have rounded edges. They are often quite heterogeneous in composition and color. Examples are green earth and raw sienna. Many of the modern pigments are produced as chemical precipitates by the interaction of salt solutions which make an insoluble substance. Many such precipitates are crystalline in nature and each particle is more or less a small, perfect crystal. Pigments that are pyrogenetic in origin, like ultramarine blue and oxide of chromium, have variable particle characteristics because conditions of formation differ greatly. They are produced by complex chemical reactions that may take place between several substances at high temperatures. Pigments made by the corroding action of chemicals upon metals, like white lead and verdigris, are usually fairly coarsely crystalline. Several important pigments are fume and smoke products and, hence,

are finely divided and uniform in particle size. Zinc oxide and lamp black are examples; particles of the former may be perfectly crystalline, existing as stout prisms. Vermilion, prepared in the dry way, is a sublimation product and each particle is more or less a perfect crystal. Pure dyestuffs and toners often appear as stains without any discontinuity in the film, particularly if they are soluble in the film-forming substance. Lake colors are variable in character, depending upon the base on which they are precipitated. The size of grains is usually expressed in microns (1 micron, μ = 0.001 mm.). Merwin (p. 499, f.n. 1) calls grains very small that are less than 0.8μ in diameter; small, those that are between 0.8 and 2μ; medium, 2 to 5μ; large, 5 to 10μ; and very large, over 10μ. The most effective black and white pigments are those which have an average particle size in the order of 1μ in diameter or slightly less. White pigments, however, with average grain size much below 0.5μ do not have such good hiding power as larger grains, they tend to diffuse blue light more than red, and, when mixed with black, give blue-grays (see Merwin, p. 494). Most colored pigments have grains ranging from 0.5 to 10μ in mean diameter. Prussian blue and indigo are extremely fine-grained, but pigments like emerald green, verdigris, and cobalt blue are comparatively coarse (see Merwin, p. 499, f.n. 2). Pigments in older paintings, in general, are coarse, particularly the mineral pigments. Azurite and smalt had to be used coarsely ground because, when very finely ground, so much white light is reflected from the surfaces of their particles that they become pale and unsuitable as coloring materials. Large particle size and graininess are characteristic of the pigments used in early Chinese paintings. Granular, crystalline pigments give a certain pleasing quality to paint films that can not be had from fine, well-dispersed pigments such as are produced for the modern paint industry. Fine and uniform particle size in modern pigments is also partly the result of modern mechanical methods for grinding dry pigments. Control of particle size of pigments is carried out in preparation or in dry grinding. The grinding of a pigment in a vehicle ordinarily does not reduce particle size but merely effects wetting and dispersion of each individual pigment particle.

Individual pigments vary greatly in density or specific gravity and this variation has to be taken into consideration, both in the preparation and in the practical use of paints. Some pigments, particularly the organic lakes and toners, are light and bulky, and so are a few of the inert materials like aluminum hydrate (sp. gr. = 2.45). Lamp black is one of these very light materials (sp. gr. = 1.77). Many of the pigments, however, are compounds of the heavy metals and, hence, have a high specific gravity. Examples are vermilion (sp. gr. = 8.09) and red lead (sp. gr. = 8.73). Pigments with high specific gravity settle rapidly in liquid paints. In paints that contain mixtures of light and heavy pigments, there are sometimes indications of a slight separation of the light and heavy components when the paint is spread thickly on a horizontal surface. Specific gravity has an important bearing in centrifugal methods for the separation and analysis of paint

PHYSICAL PROPERTIES OF PIGMENTS

OPAQUE WHITE PIGMENTS

Pigment Name and Chemical Composition[1]	Specific Gravity[2]	Particle Characteristics[3]	Refractive Index[4]
Titanium calcium white, TiO_2 (25%) + $CaSO_4$ (75%)	3.10	prism. or ragged gr.	mostly 1.8–2.0 (irr.) (bi.) [M°]
Titanium dioxide (rutile) + $CaSO_4$	3.25	...	Av. 1.98 [TPC]
Titanium barium white, TiO_2 (25%) + $BaSO_4$ (75%)	4.30	min. round. gr.	n_{ZC} 1.7–2.5 [M°]
White lead (basic sulfate) $PbSO_4 \cdot PbO$	6.46	...	Av. 1.93 [TPC]
Lithopone	4.3	...	Av. 1.84 [TPC]
Lithopone (regular), ZnS (28–30%), $BaSO_4$ (72–70%),	4.30	fine comp. gr.	2.3 (ZnS)–1.64 ($BaSO_4$) [M]
Zinc white (ordinary), ZnO	5.65	v. fine cryst. gr.	ϵ2.02, ω2.00 [M]
(acicular), ZnO	...	spicules, fourlets	ϵ2.02, ω2.00 [M°]
White lead (basic carbonate), $2PbCO_3 \cdot Pb(OH)_2$	6.70	v. fine cryst.	ϵ1.94, ω2.09 [M]
Antimony oxide, Sb_2O_3	5.75	v. fine cryst.	valentinite, α2.18, γ and β2.35 [LB, M°] senarmonite, 2.09 (isot.)
Zirconium oxide (baddeleyite). ZrO_2	5.69	...	α2.13, γ2.20, β2.19 [LB], Av. 2.40 [TPC]
Titanium dioxide (anatase), TiO_2	3.9	min. round. gr.	ϵ and ω2.5 (w. bi.) [M°]
(rutile), TiO_2	4.2	round. or prism. gr.	ϵ2.9, ω2.6 [M°]

TRANSPARENT WHITE PIGMENTS†

Pigment Name and Chemical Composition[1]	Specific Gravity[2]	Particle Characteristics[3]	Refractive Index[4]
Diatomaceous earth, SiO_2	2.31	min. fossil forms	n mostly 1.435, some 1.40 [M°]
Aluminum stearate, $Al(C_{18}H_{35}O_2)_3$	0.99	agg. of spher. gr.	1.49 (w. bi.) [W]
Pumice (volcanic glass), Na, K, Al, silicate	...	vesicular vitr. frag.	c 1.50 (isot.) [M°]
Aluminum hydrate, $Al(OH)_3$	2.45	v. fine amorph. part.	n_{ZC} 1.50–1.56 [M°]
Gypsum, $CaSO_4 \cdot 2H_2O$	2.36	fine cryst. gr.	α1.520, γ1.530, β1.523 [LB]

† Also called "Extender" or "Inert" White Pigments.

TRANSPARENT WHITE PIGMENTS† (continued)

	Sp. gr.	Crystal form	Optical constants
Silica (quartz), SiO_2	2.66	cryst. frag.	ϵ1.553, ω1.544 [LB]
(chalcedony), SiO_2	2.6	crypt. agg.	ϵ, ω1.54 [LB, M°]
China clay (kaolinite), $Al_2O_3 \cdot 2SiO_2 \cdot 2H_2O$	2.60	fine, vermicular cryst.	α1.558, β1.565, β1.564 (all \pm .005) [LB, M°]
Talc, $3MgO \cdot 4SiO_2 \cdot H_2O$	2.77	platy frag.	α1.539, γ1.589, β1.589 [LB]
Mica (muscovite), $H_2KAl_3(SiO_4)_3$	2.89	platy frag.	α1.563, γ1.604, β1.599 [LB]
Anhydrite, $CaSO_4$	2.93	cryst. frag.	α1.570, γ1.614, β1.575 [LB]
Chalk (whiting), $CaCO_3$	2.70	hollow spherulites	$\epsilon_{\Sigma c}$ 1.510, $\omega_{\Sigma c}$ 1.645 [M°]
Barytes (barite, nat.), $BaSO_4$	4.45	cryst. frag.	α1.636, γ1.648, β1.637 [LB]
(blanc fixe, art.), $BaSO_4$	4.36	v. fine cryst. agg.	1.62–1.64 [M°]
Barium carbonate, $BaCO_3$ (witherite)	4.3	...	α1.529, γ1.677, β1.676 [LB]

† Also called "Extender" or "Inert" White Pigments.

IRON OXIDE PIGMENTS

	Sp. gr.	Crystal form	Optical constants
Ochre, yellow (goethite), $Fe_2O_3 \cdot H_2O$, clay, etc.	2.9–4.0	irr. spherulites	n_Σ 2.0 (isot. part); $(\alpha, \beta)_\Sigma$ 2.05–2.31; γ_Σ 2.08–2.40 (bi. part) [M°]
Sienna, raw (goethite), $Fe_2O_3 \cdot H_2O$, clay, etc.	3.14	uneven spherulites	1.87–2.17 (mostly 2.06) (isot.) [M°]
Sienna, burnt, Fe_2O_3, clay, etc.	3.56	uneven, round. part.	c1.85 (var.) (isot.) [M]
Umber, raw, $Fe_2O_3 + MnO_2 + H_2O$, clay, etc.	3.20	uneven, round. gr.	mostly 1.87–2.17 [M°]
Umber, burnt, $Fe_2O_3 + MnO_2$, clay, etc.	3.64	uneven, round. gr.	mostly 2.2–2.3 [M°]
Iron oxide red (haematite), Fe_2O_3	5.2	min. cryst.	ϵ_{Li} 2.78, ω_{Li} 3.01 [M]

RED AND ORANGE PIGMENTS

	Sp. gr.	Crystal form	Optical constants
Red lead, Pb_3O_4 (c95%)	8.73	crypt. agg.	2.42_{Li} (w. bi.; pleo.) [M]
°°Realgar, As_2S_2	3.56	cryst. frag.	α_{Li} 2.46, γ_{Li} 2.61, β_{Li} 2.59 [LB]
Molybdate orange, $Pb(Mo,S,Cr,P)O_4$...	min. round. gr.	β_{Li} 2.55 (s. bi.) [M°]
Chrome orange, $PbCrO_4 \cdot Pb(OH)_2$	6.7	tabular cryst.	α2.42, γ2.7+, β2.7 [M°]

Cadmium red lithopone, CdS(Se) + BaSO₄	4.30	min. round. gr.	2.50–2.76 (for CdS(Se)part) (isot.) [M°]
Cadmium red, CdS(Se)	4.5	min. round. gr.	2.64 (bright red)–2.77 (deep red) (isot.) [M°]
Antimony vermilion, Sb_2S_3	…	v. fine red glob.	n_{Li} 2.65 (isot.) [M°]
Vermilion (art.), HgS	8.09	hexagonal gr. and prisms	ϵ_{Li} 3.14, ω_{Li} 2.81 [M]
°°(nat., cinnabar), HgS	8.1	cryst. frag.	ϵ_{Li} 3.146, ω_{Li} 2.819 [LB]
Quinacridone red, $C_{20}H_{12}O_2N_2$ (gamma)	1.5	thin plates	n_{Na} Av. 2.04 [Du P]

YELLOW PIGMENTS

°°Gamboge, organic resin	…	irr. amorph. part.	1.582–1.586 [W]
°°Indian yellow, $C_{19}H_{18}O_{11}Mg \cdot 5H_2O$	…	prisms, plates	1.67 (w. bi.) [M°]
Cobalt yellow, $CoK_3(NO_2)_6 \cdot H_2O$	…	fine dendritic cryst.	1.72–1.76 (isot.) [W]
Zinc yellow, $4ZnO \cdot 4CrO_3 \cdot K_2O \cdot 3H_2O$	3.46	min. spher. gr.	1.84–1.9 (irr.; bi.) [M°]
Strontium yellow, $SrCrO_4$	…	small needles	α, β (or ω) 1.92, γ (or ϵ) 2.01 (∥ext.) [M]
Barium yellow, $BaCrO_4$	4.49	v. fine cryst. gr.	1.94–1.98 (bi.) [M]
°°Naples yellow, $Pb_3(SbO_4)_2$	…	round. gr.	2.01–2.28 (isot.) [M°]
Chrome yellow (med.), $PbCrO_4$	5.96	fine prism. gr.	$\alpha_{620m\mu} < 2.31$, $\gamma_{650m\mu}$ 2.49 [M]
Cadmium yellow lithopone, $CdS + BaSO_4$	4.25	fine comp. gr.	2.39–2.40 (for CdS part) [M°]
Cadmium yellow, CdS	4.35	min. round. gr.	2.35–2.48 (isot.) [M°]
Massicot (litharge), PbO	9.40	min. flakes	α_{Li} 2.51, γ_{Li} 2.71, β_{Li} 2.61 [M]
°°Orpiment, As_2S_3	3.4	min. flakes	α_{Li} 2.4 \pm, γ_{Li} 3.02, β_{Li} 2.81 [LB]

GREEN PIGMENTS

Phthalocyanine green, chloro-copper phthalocyanine	2.1	laths	$n_{580m\mu}$ 1.40 [ACC]
°°Verdigris (copper basic acetate), $Cu(C_2H_3O_2)_2 \cdot 2Cu(OH)_2$	…	cryst. frag.	α1.53, γ1.56 [M]
°°Chrysocolla, $CuSiO_3 \cdot nH_2O$	2.4	crypt. agg.	α1.575, γ1.598, β1.597 [LB]
Green earth (celadonite and glauconite), Fe, Mg, Al, K, hydrosilicate	2.5–2.7	round. irr. gr.	n var. c 1.62, (porous) [M°]
Emerald green (Paris green), $Cu(C_2H_3O_2)_2 \cdot 3Cu(AsO_2)_2$	3.27	spherulites and disks	α_{Σ}1.71, γ_{Σ}1.78 (w. pleo.) [M°]

GREEN PIGMENTS (continued)

Pigment	Density	Crystal description	Optical
°°Malachite, $CuCO_3 \cdot Cu(OH)_2$	4.0	cryst. frag. spher. gr.	α1.655, γ1.909, β1.875 [LB]
Cobalt green, $CoO \cdot nZnO$...		1.94–2.0 (w. bi.) [M°]
Viridian (chromium oxide, transparent), $Cr_2O_3 \cdot 2H_2O$	3.32	spherul. gr.	α, β_Σ 1.82, γ_Σ 2.12 [M°]
Chrome green (med.), $Fe_4[Fe(CN)_6]_3 + PbCrO_4$	4.06	fine green agg.	c 2.4 (cf. Prussian blue and chrome yellow)
Chromium oxide green, opaque, Cr_2O_3	5.10	fine cryst. agg.	n_{Li} 2.5 [M]

BLUE PIGMENTS

Pigment	Density	Crystal description	Optical
Phthalocyanine blue, copper phthalocyanine	1.6	laths	Av. 1.38 [DuP]
Ultramarine blue (art.), $Na_{8-10}Al_6Si_6O_{24}S_{2-4}$	2.34	uniform small round. gr.	n 1.51$_{green}$, 1.63$_{red}$ (isot.) [M]
°°(nat., lazurite), $3Na_2O \cdot 3Al_2O_3 \cdot 6SiO_2 \cdot 2Na_2S$	2.4	angular, broken frag.	1.50± (isot.) [LB]
°°Maya blue, Fe, Mg, Ca, Al, silicate (?)	...	porous irr. agg. splintery, vitr. frag.	β_Σ1.54 (irr.; bi. and pleo.) [M°] 1.49–1.52 [M°]
Smalt, K, Co(Al), silicate (glass)	...	colloidal agg.	1.56$_{460m\mu}$ [M°]
Prussian blue, $Fe_4[Fe(CN)_6]_3$	1.83	cryst. frag.	ϵ1.605, ω1.635 [APL]
°°Egyptian blue, $CaO \cdot CuO \cdot 4SiO_2$...	gr. and stubby prisms	c 1.65 [W]
Manganese blue, $BaMnO_4 + BaSO_4$...	fibrous agg.	α_Σ1.72, γ_Σ slightly > 1.74 [M°]
°°Blue verditer, $2CuCO_3 \cdot Cu(OH)_2$...	round. gr.	n var.; max. c 1.74$_{blue}$ (isot.) [M]
Cobalt blue, $CoO \cdot Al_2O_3$	3.83		
°°Azurite, $2CuCO_3 \cdot Cu(OH)_2$	3.80	cryst. frag.	α1.730, γ1.838, β1.758 [LB]
Cerulean blue, $CoO \cdot nSnO_2$...	round gr.	1.84 (isot.) [M°]

VIOLET PIGMENTS

Ultramarine violet	...	round. gr. (blue, rose and violet)	c 1.56 (isot.) [M°]
Cobalt violet, $Co_3(PO_4)_2$...	round. gr.	ε1.65–1.79 (dull violet), ω1.68–1.81 (salmon) (s. bi.) [M°]
Manganese violet, $(NH_4)_2Mn_2(P_2O_7)_2$...	fine cryst. gr.	α1.67, γ1.75, β1.72 (for violet) [M]
Quinacridone violet, $C_{20}H_{12}O_2N_2$ (beta)	1.5	thin plates	Av. 2.02 [DuP]

BROWN PIGMENTS

Sepia (organic)	...	angular frag.	(opaque) [M°]
Asphaltum (bitumen)	...	irr. amorph. part.	1.64–1.66 [M°]
Van Dyke brown (bituminous earth)	1.66	irr. amorph. part.	1.62–1.69 [M°]

BLACK PIGMENTS

Bone black, C + $Ca_3(PO_4)_2$	2.29	irr. coarse grains	1.65–1.70 (for larger translucent gr.) [M]
Lamp black, C	1.77	min. round. part.	(opaque)
Charcoal black, C	...	irr. splintery part.	(opaque)
Graphite, C	2.36	irr. plates	(opaque) [M]

[1] Abbreviations: art. = artificial; med. = medium; nat. = natural. The chemical formulas are those commonly accepted in chemical and mineralogical literature, but they may not compare exactly with structural formulas based on x-ray diffraction data or even on critical chemical analysis.

[2] The figures for specific gravity of the artificial pigments are mainly from H. A. Gardner, pp. 710–712, and those on the mineral pigments are chiefly from E. S. Larsen and H. Berman.

[3] Symmetry terms (monoclinic, orthorhombic, etc.) are omitted because pigments are so finely divided that it is rare when observations on

crystal symmetry can be made. The term "spherulitic," as used here means aggregates that tend toward radial structure and spherical shape. "Amorphous" describes materials that are microscopically formless but may be truly crystalline on the basis of x-ray diffraction data. Abbreviations: agg. = aggregate(s); amorph. = amorphous; comp. = composite; crypt. = cryptocrystalline; cryst. = crystal(s); frag. = fragment(s); glob. = globule(s); gr. = grain(s); irr. = irregular; min. = minute; part. = particle(s); prism. = prismatic; round. = rounded; spher. = spheroidal; spherul. = spherulitic; var. = variable; v. = very; vitr. = vitreous.

⁴Unless otherwise indicated, all refractive index measurements are by sodium light. Σ is the symbol used by H. E. Merwin to indicate greater or less indefiniteness or irregularity in the case of aggregates, especially in respect to refractive index. Abbreviations: bi. = birefringent; c = $circa$; ext. = extinction; isot. = isotropic; ‖ = parallel; pleo. = pleochroic; s. = strongly; w. = weakly. The letters in brackets refer to the authorities for the refractive index data: M = H. E. Merwin; M° = H. E. Merwin, data by private communication, hitherto unpublished; W = C. D. West, data by private communication, hitherto unpublished; LB = E. S. Larsen and H. Berman; APL = A. P. Laurie and co-authors; ACC = A. C. Cooper, "The refractive index of organic pigments. Its determination and significance," *Journal Oil & Colour Chemists Association*, Vol. 31 (1948), pp. 343–357; TPC = Titanium Pigment Corporation; Du P = E. I. Du Pont de Nemours & Co.

°°Chiefly of historical interest.

materials. Specific gravities of the more important pigments and inerts are listed in the table of physical properties.

The oil absorption of a pigment is the amount of oil that is just required to wet each of the pigment particles and to convert the mass into a mobile paste. Pigments differ greatly in the amount of oil required for this purpose. It is often expressed as the number of grams of oil required to grind 100 grams of pigment into a stiff, putty-like paste that does not ' break ' or separate (see Gardner, pp. 539–560). Oil absorption is no exact physical constant. It varies slightly from lot to lot of pigment, with the kind and condition of the oil used, and with the degree and duration of mixing and rubbing. Some pigments, like basic carbonate white lead, are characterized by low oil absorption, which is generally as low as 9 to 12 per cent by weight of oil, to make it into a workable paste; raw sienna, on the other hand, takes upwards of 50 per cent oil to grind. Pigments with low oil absorption are favored, in general, because paints made from them have less tendency to discolor as a consequence of the yellowing of the oil. Many of the pigments with high specific gravity have low oil absorption. Gardner says (p. 544) that oil absorption is dependent essentially upon the total surface of the pigment, the interfacial tension relations between pigment and vehicle, particle shape, size, and distribution, and the chemical nature of oil and pigment. All these are important factors that have much influence on the plastic and flow properties of oil paints (see also R. Houwink, *Elasticity, Plasticity and Structure of Matter* [Cambridge: University Press, 1937], pp. 311–327).

Pink (Dutch pink, Italian pink, brown pink), in addition to its meaning as a tint of red, is also used for certain yellow lakes prepared from quercitron (see **Quercitron Lake**), or from Persian berries (see **Persian Berries Lake**), or from similar, natural, yellow coloring matters. (The *Shorter Oxford English Dictionary* says that the origin of the word in this connection is obscure.) Brown pink is a deep variety of quercitron lake (Weber, p. 127).

Pipe Clay (see **China Clay**).

Plaster of Paris (see **Gypsum**).

Pompeian Blue (see **Egyptian Blue**).

Pozzuoli Red is a red iron oxide of volcanic origin from Pozzuoli, near Naples.

Prussian Blue (Berlin blue, Paris blue, Antwerp blue, Chinese blue) is the earliest of the modern synthetic colors. It is a complex chemical compound which, technically, is ferric ferrocyanide, $Fe_4(Fe[CN]_6)_3$, or a closely similar compound. It is now commonly made by the action of an oxidizing agent, such as potassium bichromate and sulphuric acid, upon a mixture of copperas (ferrous sulphate), sodium ferrocyanide, and ammonium sulphate, giving a blue with the approximate formula, $Fe(NH_4)Fe(CN)_6$. The pigment which is precipitated from dilute solutions of those salts is a deep blue, finely divided compound which, after it has settled and after the mother liquor is drawn off, is washed, filtered, and dried. (See Bearn, pp. 85–92 for details.) The product is amorphous in colloidal ag-

gregates and so finely divided that it has almost the characteristics of a dye. By control of conditions of precipitation and oxidation, variations in shades and physical characteristics of the blue may be had. (Antwerp blue is a light shade of Prussian blue, made by precipitating zinc along with the iron, or it may contain inerts like gypsum, barytes, etc.) The dry powder or lump form is dark blue, almost blue-black, but some varieties, especially those prepared with bleaching powder as the oxidizing agent, have a reddish, coppery lustre. It is a transparent color but has very high tinting strength. One part of Prussian blue will render 640 parts of white lead perceptibly blue (see *Colour Index*, p. 309). The color by transmitted light is green-blue which is also its color in tint. In an oil film, discrete particles can not be seen, even at high magnification. De Wild has compared its appearance in oil with that of indigo (p. 32). It seems to form thin smears on the surfaces of other pigment grains (see **Chrome Green**).

Prussian blue is fairly permanent to light and air. Laurie mentions (*The Painter's Methods and Materials*, p. 94) a ceiling painted with it in the first part of the XIX century in which the color is still good. It sometimes acquires a peculiar, metallic bronze cast when subject to out-of-door weathering, and sometimes paint films that contain it turn green because of yellowing of the oil. The blue is unaffected by dilute mineral acids, but it is very sensitive to alkalis which cause it to turn brown; for this reason, it can not be used in true fresco. It is soluble in 10 per cent oxalic acid (Bearn, p. 89). It decomposes rapidly on ignition and leaves a residue of ferric oxide.

Huge quantities of Prussian blue are now used in the paint and printing ink trades; the most important commercial green pigment, chrome green (see **Chrome Green**), is made by adding it to chrome yellow.

Prussian blue has a conspicuous place in the history of painting materials because it is the first of the artificial pigments with a known history and an established date of first preparation. Moreover, it is a material so complex in composition and method of manufacture that there is practically no possibility that it was invented independently in other times or places. It was first made in Berlin on or about the year 1704 by Diesbach, a dyer or color maker. Kopp (IV, 369) says that it was first mentioned in an anonymous communication entitled ' *notitia coerulei Berolinensis nuper inventi*,' in a report of the *Miscellanea Berolinensis*, 1710. In that notice the beauty of the color was praised and it was claimed that it was useful as a painting pigment. It was said then to be for sale by the book dealers of the Berlin Academy. In that account there was nothing about the discoverer or the method of preparation. Stahl (Georg Ernst, 1660–1734) gave a more accurate and detailed report of the discovery in his *Experimentes, Observationibus, animadversionibus CCC*, etc. (1731). According to him, it came from an accident which resulted when Diesbach wished to prepare Florentine lake by the precipitation of an extract of cochineal with alum and iron vitriol and a fixed alkali. He asked the well known alchemist, Johann Konrad Dippel (1673–1734), to let him

have for the purpose some of the waste potash over which he had distilled in process of purification some of the animal oil with which he was then working (Dippel's oil—a distillation product of bones and other animal matter which consists chiefly of pyridine and pyridine bases). With this alkali Diesbach got, in place of the expected red pigment, a blue one. He told Dippel, who realized that the formation of the blue color was the result of the action of the spent alkali upon the iron vitriol. Dippel had prepared his animal oil from blood. (The calcination of the blood with alkali had formed potassium ferrocyanide, which was the reagent that had reacted with iron vitriol under oxidizing conditions to form Berlin blue.) Kopp goes on to say that the preparation of Berlin blue was kept secret until the Englishman, Woodward, published it in the *Philosophical Transactions* for 1724. It was soon demonstrated that the blue could be prepared from other animal remains (nitrogenous substances) as well as from blood. (In German, the word, ' *Blutlaugensalz*,' is still in use, however, for potassium ferrocyanide.) Bearn, in his short historical introduction to the preparation of Prussian blue, says (p. 85) that Diesbach communicated his discovery to a French pupil, De Pierre, who later started making this pigment in a small way in Paris; hence, the name, ' Paris blue.' He adds that Wilkinson in London next commenced manufacturing it, and that gradually more and more color firms took up its production. It must have been well known all over Europe by 1750. The earliest painting on which De Wild reports it (p. 33) is one by J. E. La Farque, dated 1770, and it is quite commonly found on late XVIII century and XIX century works.

Pumice (and pumicite) is a light, porous stone or natural vesicular glass of volcanic origin, and consists of silicates of aluminum, sodium, and potassium (see Ladoo, pp. 455–464). Ground pumice is a light gray or warm white, gritty powder. Under the microscope, particles appear like broken glass, with the rounded surfaces of broken bubbles appearing prominently. Much that is produced commercially comes from the Lipari Islands off the coast of Sicily. It is widely employed as an abrasive and polishing agent. It is put in certain types of paint, particularly that for masonry, where its open cellular structure allows air diffusion. Being a volcanic ash, pumicite is a fine powder or dust composed of sharp, angular grains of volcanic glass of about the same composition as pumice. It is used extensively in cleaning powders.

Purrée (see **Indian Yellow**).

Quartz (see **Silica**).

Quercitron Lake (yellow lake, flavine lake) is a yellow coloring matter made from the inner bark of a species of oak, *Quercus tinctoria*, that is indigenous to North America. The coloring principle is quercetin or tetrahydroxyflavonal, $C_{15}H_{10}O_7$. The bark is extracted with water and the lake is made by adding alum and precipitating with chalk (see Perkin and Everest, pp. 628–629). It is soluble in water and in alcohol, but forms a yellowish brown solution with alkalis and is decolorized by mineral acids. Yellow lakes of this nature are rapidly faded by

sunlight but are said to retain their color well in artificial light (*Colour Index*, p. 301).

Raw Sienna (see **Sienna**).

Raw Umber (see **Umber**).

Realgar is the natural orange-red sulphide of arsenic, As_2S_2, and it is closely related chemically and associated in nature with orpiment, the yellow sulphide of arsenic (see **Orpiment**). The two minerals are often found in the same deposits. Although it occurs perhaps as widely in nature as orpiment, realgar appears not to have been used so widely. Like orpiment, it was known in ancient times. All are agreed that the ' *sandarack* ' of Pliny (see Bailey, II, 75–77) is identical with the modern realgar. It was confused by the ancients with red lead because it resembles it in color (see Bailey, II, note on p. 205). It is said to get its name from the Arabic, *Rahj al ghār* (powder of the mine) (see Dana, p. 357). Cennino Cennini mentioned it but did not hold it in favor (Thompson, *The Craftsman's Handbook*, p. 29).

The chemical and physical properties of realgar are similar to those of orpiment. It belongs to the same crystal system (monoclinic), but has slightly lower refractive index. Its color is orange by transmitted light but usually many yellow particles of orpiment can also be seen. It may be made artificially, but the artificial product is not used as a pigment in modern times, being too poisonous for that purpose.

Realgar has not been identified in ancient paintings so frequently as orpiment. It was observed, however, as the pigment in an orange-red area on a fragment of wall painting from Kara Khoto in Central Asia (XI–XII centuries). One may expect to find it, along with orpiment, in Eastern miniatures and illuminated manuscripts.

Red Bole (see **Bole**).

Red Lead (minium, orange mineral). The red tetroxide of lead, Pb_3O_4, is made by heating litharge or white lead for some hours at a temperature of about 480° C. (See Bearn, pp. 114–117, for details.) Care must be taken that the temperature does not get too high or it will be decomposed again into litharge, because the reaction is reversible. Most of that now made commercially is from the direct oxidation of lead through the monoxide stage and the product may contain 3 per cent or more of free litharge. ' Orange mineral,' which is made by the roasting of white lead, has the same composition as red lead, except that it contains less free litharge. There is still some question about the structure of red lead but, for analytical purposes, it is treated as $PbO_2 \cdot 2PbO$, in which the PbO_2 functions as an oxidizing agent.

The pigment is bright scarlet, has good hiding power, and excellent texture. It is finely divided but may be either crystalline or amorphous, depending upon how it is made (see Merwin, p. 518). Microscopically, it is not very characteristic. Some of the particles are transparent and orange-red by transmitted light. The

refractive index is high but it is only slightly birefracting. Chemically, red lead is fairly active. It is turned brown rapidly by nitric or acetic acid, which is the result of the formation of brown lead dioxide; hydrochloric acid turns it white (lead chloride); sulphides and hydrogen sulphide blacken it; it is not affected by dilute alkalis. When exposed to light and air, it is not a particularly stable pigment and has had, for centuries, a poor reputation in that respect. Red lead will turn chocolate brown in color when exposed to either strong or diffuse light over a period of centuries, particularly when it has been applied in a water color or tempera medium. This darkening has been particularly noticeable on the wall paintings of China and Central Asia. Gettens observed the phenomenon on the wall paintings of Kizil in Chinese Turkestan (V–VIII centuries, A.D.), and the strange, chocolate-colored faces on wall paintings at Tun Huang appear to add further evidence. In films prepared from a glue medium, the darkening can be produced artificially by exposure to light and high humidity, and seems to come from the formation of brown lead dioxide. This fault of red lead was mentioned by Cennino Cennini (see Thompson, *The Craftsman's Handbook*, p. 25), who says that it is good for painting on panel, but on the wall ' it soon turns black, on exposure to air and loses its color ' (see Thompson, *loc. cit.*). Red lead in oil, when strongly exposed out-of-doors, may eventually turn pink or white because of the formation of lead carbonate (white lead).

Red lead was a pigment of antiquity and was probably known as early as lead itself. Lucas holds, however (pp. 290 and 308), that it was not used in Egypt until Graeco-Roman times. By early classical writers, it seems to be confused with other reds, particularly cinnabar or mercuric sulphide. Pliny describes it under the name, *secondarium minium* (see Bailey, I, 119, 123, 217, 220–221), but appears to have recognized it as distinct from minium, which was the name he used for cinnabar or mercuric sulphide. The name, minium, came to be applied to red lead, rather than to cinnabar, at some time in the Middle Ages.

Red lead is often found as a pigment on objects that date from antiquity. Davy (p. 101) identified it as the orange-red on a vase at the Baths of Titus. Laurie (' The Materials in Persian Miniatures ') says it was a favorite with the Byzantine and Persian illuminators. Thompson (*The Materials of Medieval Painting*, p. 101) records that orange lead was common all through the Middle Ages in manuscript embellishments and in painting, but that it was not used on walls and not much on panels. This is in agreement with the negative findings for red lead by De Wild on the Dutch and Flemish paintings he examined. It has been identified, however, as a pigment on one of the panels of the Monte Oliveto altarpiece, by Spinello Aretino (XIV century) in the Fogg Art Museum. It was widely used on wall paintings in China and Central Asia, as has already been indicated. In spite of its bright color and good covering power, artists do not much use it now, although it is still obtainable in water color form. Commercially, however, it is

important, being used extensively as an anti-corrosive pigment for iron, and familiar in the priming coats used for structural steel and for iron fences.

Red Ochre (see also **Iron Oxide Red**) is an earthy variety of iron oxide which contains more or less clay and silica and is one of the most important of the natural pigments. The best contains as high as 95 per cent of ferric oxide. It has been widely used. It was the red paint of the American Indian and the *sinopis* or *sinopia* of classical antiquity (see Thompson, *The Materials of Medieval Painting*, p. 98).

Rhodamine (Rhodamine toner) is one of the stable, synthetic, organic dye-stuffs used for making red lake pigments. Rhodamine 6G, discovered by Bernthsen in 1892, is the ethyl ester of diethyldiamino-*o*-carboxy-phenyl-xanthenyl chloride, $C_{26}H_{26}N_2O_3Cl$ (*Colour Index*, p. 190).

Rinnman's Green (see **Cobalt Green**).

Safflower (carthame) is a natural organic red coloring matter which is pre-pared from the dried petals of the Dyer's Thistle, *Carthamus tinctorius*, which is cultivated in the East, in Egypt, and in southern Europe. The red coloring matter is carthamin, or carthaminic acid, $C_{25}H_{24}O_{12}$. This is extracted by steeping the dry petals in cold dilute sodium carbonate solution. Safflower extract is only slightly soluble in water and alcohol. The dye is an orange solution with alkalis and is turned dull red by dilute sulphuric acid. It was once used widely in the East as a dye and for the manufacture of pigments and cosmetics.

Saffron is the golden yellow coloring matter that is extracted from the dried stigmas of the crocus flower, particularly *Crocus sativus*. It has long been a flavor-ing for food and was formerly used in painting, especially for illuminating and embellishing the pages of books. The color was put directly into a medium without a mordant. Jehan le Begue (Merrifield, I, 128) and other writers of his period speak of adding it to green, particularly copper green, to make a warmer tone. Saffron is mentioned by Theophilus (p. 41) and by Le Begue (*op. cit.*, p. 158) for *auri-petrum*, a transparent yellow coating over tin foil to make it look like gold. Beck-man has given a whole chapter to saffron (I, 175–180), and believes it originally was brought from the Levant into Spain and Europe by the Arabs.

Sap Green is a natural organic dyestuff derived from the ripened berries of several varieties of the buckthorn, *Rhamnus*. The juice of the berries may be used directly or may be precipitated with alum. In early times it was not dried but was sold in bladders as a dense syrup (Thompson, *The Materials of Medieval Painting*, pp. 169–171). Although a most fugitive substance, it is still used in water color. On the old illuminated manuscripts, it has often survived because of ideal condi-tions. Oil paints now sold under this name usually contain coal tar lakes.

Scheele's Green, an acid copper arsenite, $CuHAsO_3$, was the first artificial green pigment in which copper and arsenic were the essential constituents. It was first prepared by the eminent Swedish chemist, Carl Wilhelm Scheele, in 1778. Methods of preparation varied in details, but it was usually made by dissolving

white arsenic (As_2O_3) in a solution of soda ash or potash and adding the hot
arsenite solution to a solution of copper sulphate. The precipitate needed only
washing and drying. De Wild says (p. 79) that the pigment consists of small and
large, irregular-shaped, green flakes which are only slightly transparent. Since
Scheele's green is inferior as a pigment, it was soon displaced by the superior
copper aceto-arsenite (see **Emerald Green**) when that was introduced in 1814. It
is blackened by lead and is decomposed by acids. Yellowish green when made, it
fades rapidly and is blackened by sulphur-bearing air and sulphide pigments. It
is very poisonous. Although it has not been reported in the examination of paint-
ings, one may expect to find it in works of the late XVIII and early XIX centuries.

Schweinfurt Green (see **Emerald Green**).

Sepia is the black or dark brown secretion from the 'ink bag' of the common
cuttle-fish or squid (*Sepia officinalis*), and also from other species of the *Cephalo-
poda*. Although it has come from cuttle-fish of the English Channel and the
Mediterranean, most modern sepia is from Ceylon. The dark ink has very high
tinctorial power, the secretion from one cuttle-fish being able to turn a thousand
gallons of water opaque in a few seconds (see Mitchell, p. 19). For sepia prepara-
tion the ink sacs are removed from the cuttle-fish, dried, pulverized, and boiled
with lye solution. The extract, which is soluble in the lye, is precipitated out with
hydrochloric acid, is washed, and is dried at a low temperature; it is ground very
finely with gum arabic and is made into cakes or prepared in tubes for use in water
color.

Sepia is a complex nitrogenous organic compound with characteristic fishy
odor. It is in the nature of an organic acid (see Mitchell, pp. 22–25); it is soluble
in alkalis and is reprecipitated by acids. It is insoluble in water, alcohol, ether,
and similar organic solvents; it is decolorized by nitric acid and by chlorine
water. Under ordinary conditions, sepia is fairly permanent, but in strong sunlight,
especially in thin washes, it is quite fugitive. It is relatively opaque to infra-red
rays. The color of sepia, when recently applied, is warm black but it gradually be-
comes reddish brown, the color commonly associated with the name. Under the
microscope, its appearance is similar to bone black and it may be observed in
irregular, fairly coarse particles, most of which are opaque, although there are
many that are semi-transparent yellow-brown. Oil paints sold under the name,
'sepia,' are mixtures of such pigments as burnt umber, Van Dyke brown, and
lamp black.

Although there is reason to believe that sepia was known and used as early as
classical times, particularly as an ink for writing purposes (see Mitchell, p. 8), it
was not until the latter part of the XVIII century that it became popular in Eu-
rope for ink drawings and for water color painting. Meder (pp. 69–70) refers to
Hebenstreit (*Encyklopädie der Aesthetik*) as authority that sepia was introduced
as a color by Professor Seydelmann of Dresden some time after 1778. Until about

the end of the XVIII century, only bistre and India ink were used for washes (see Meder, p. 70). The comparatively late use of sepia makes possible a distinction between late XVIII century sepia additions to earlier bistre drawings.

Sienna (raw sienna, burnt sienna). Raw sienna is a special kind of yellow ochre which gets its name from the well known Tuscan city near which one of the best grades of it has long been found; it is still produced there and is shipped from Leghorn. Good commercial grades are also found in the Hartz Mountains, Germany, and in America. Like ochre, sienna is hydrated ferric oxide (goethite, $Fe_2O_3 \cdot H_2O$) with alumina and silica, but it has a little deeper tint than yellow ochre, is a little warmer, and is considerably more transparent. A good sienna should contain at least 50 per cent of iron oxide (Fe_2O_3); some of the best contain 70 per cent or over. It generally has a small amount of manganese dioxide (0.6 to 1.5 per cent). Raw sienna is prepared for commerce by processes similar to those used with the ochres, and the physical and chemical properties are like those of the other hydrous iron oxides. Microscopically, the pigment is quite heterogeneous; it is a mixture of transparent, colorless, yellow and brown-red particles, along with opaque brown particles and a few scattered pink ones. The transparent grains are highly birefracting, but the brownish material is quite isotropic. This latter material is a darkened variety of goethite (see **Ochre**), occurring in fairly large spherules.

Burnt sienna is prepared by calcining raw sienna; in the process, the raw sienna undergoes a considerable change in hue and depth of color. In going from the ferric hydrate of the raw earth to ferric oxide, it turns to a warm, reddish brown. Microscopically, it becomes more even in color and the grains are reddish brown by transmitted light. Merwin says (p. 578) that it shows no evidence of crystallinity, is not birefracting, and the grains have variable, moderate refractive index.

By artists, sienna has been used as a glaze because of its transparency. For the same reason, both raw and burnt sienna are used in wood finishing for stains and for graining work. In the microscopic and chemical examination of paintings the siennas are usually not reported under that name but are grouped under the ochres or native iron oxide pigments. Often distinction among earth colors is difficult, because the differences are of degree and not of kind. The siennas have been available in all periods of European painting and have been used in all processes.

Silex (see **Silica**).

Silica (quartz, silex) is silicon dioxide which occurs in clear, crystalline form as quartz or rock crystal. It is common in other less pure forms as quartzite, sandstone, sand, and in crystalline grains or masses in granite (see Ladoo, pp. 521–526). It is widely distributed, being one of the most abundant constituents of the earth's crust. Finely ground and sieved quartz (silex), with oil or varnish, serves as a primer for filling the grain of wood before staining and varnishing. Tripoli (not to be confused with tripolite which is the same as diatomaceous earth) is an amor-

phous or cryptocrystalline (chalcedonic) form of silica also used for wood fillers and in paints (see Ladoo, pp. 641–651). Diatomaceous earth (see **Diatomaceous Earth**) is a fossil form of silica. Silicic acid or precipitated silica, $SiO_2 \cdot nH_2O$, prepared by the action of an acid on an alkali silicate, is a pure white, amorphous powder which has special uses as a filler and extender. Silica in all its forms is extremely inert. It is unaffected by heat and is insoluble in strong acids (except hydrofluoric), but it is slowly attacked by strong alkalis. Quartz, or crystalline silica, can be recognized by its optical properties. It has medium refractive index ($\omega = 1.544$), and is only moderately birefracting. Particles of quartz are often seen as an impurity in mineral pigments and other natural products. Sand particles are usually rounded and frosty in appearance as a result of the wearing action of wind and wave.

Silver Leaf and **Silver Powder** were used occasionally in mediaeval paintings, but their very great tendency to tarnish and to blacken limited their effectiveness. This fault was known very early and Cennino Cennini warns against silver for that reason (see Thompson, *The Craftsman's Handbook*, p. 60). Laurie speaks of Byzantine manuscripts (*The Pigments and Mediums of the Old Masters*, pp. 78–79) where not only the silver but the mordant also has become black and appears to have stained through the manuscript page. There seems to be no connection between the discolorations of the two. When protected with a good varnish coating, however, this metal may retain its lustre for years. Silver leaf was used for rendering armor in battle scenes and pageants (Thompson, *The Materials of Medieval Painting*, p. 190). In some early paintings, it was used for a background like gold leaf. Methods of application were much the same as those for gold.

Smalt was the earliest of the cobalt pigments. It is artificial, in the nature of glass, a potash silicate strongly colored with cobalt oxide and reduced to a powder. The origin is obscure. For years there has been much debate concerning whether or not cobalt was used by the Egyptians and by other peoples of classical times to color glass. Marie Farnsworth and P. D. Ritchie have shown recently (' Spectroscopic Studies on Ancient Glass,' *Technical Studies*, VI [1938], pp. 155–173) that cobalt was definitely present along with copper in much Egyptian blue glass, but only in amounts of the order of 0.1 to 0.2 per cent. They assume that the cobalt may have been used intentionally with full knowledge of its properties for that purpose. There is no evidence as yet, however, that any powdered cobalt glass was ever used as a painter's pigment in ancient times. When cobalt was first employed in Europe for glass making is not known, but probably the Venetian glass makers knew of its properties. B. Neuman (' Antike Glazer,' *Zeitschrift für Angewandte Chemie*, XXXVIII [1925], p. 863) remarks that it was first used by them in 1443, but he does not give his source of information. According to Laurie (*The Pigments and Mediums of the Old Masters*, pp. 12–16), the word, *smalto*, was used as early as 1492, and a glass pigment under the name, *azzurro di smalto*, was described in 1584. About the middle of the XV century, certain

cobalt minerals such as cobaltite ($CoAsS$) and smaltite ($CoAs_2$) were discovered on the borders of Saxony and Bohemia. At the time, the nature of these minerals was not known and, since they gave the miners a certain amount of trouble, they were called ' cobalt ' for spirits or ' kobolds ' which were thought to haunt the mines. The Bohemian glass makers soon found, however, that these strange minerals had the property of coloring glass blue. Beckman, who treats the early history of smalt (I, 478–487) relates (p. 483) that information about the early discovery has come through a certain Christian Lehmann (d. 1688) who wrote an historical work on the mines in Misnia. Lehmann said that the color mills, at the time when he wrote, were about a hundred years old, and Beckman, therefore, places the invention at about 1540–1560. Lehmann added that smalt was discovered by Christian Schurer (or Christoph Schürer [see Rose, p. 277]), a glass maker of Platten in Bohemia, who found that when cobalt mineral was added to a molten, vitreous mass, he obtained a fine blue glass. At first, he prepared it only for the use of potters, but in the course of time it was carried as an article of merchandise to Nuremberg and thence to Holland. Later it came to be manufactured in Holland and in better quality than that previously prepared by the Saxons.

As has been said, smalt was first prepared by roasting native cobalt minerals like cobaltite and smaltite to form cobaltous oxide, CoO. ' Zaffer,' it is called by Beckman. Rose mentions (p. 278) that Biringuccio, in his *Pyrotechnia* (1540), calls it by that name. The oxide was then added to a mass of molten glass and, when thoroughly combined, the molten mass was poured into cold water to break it into fine particles. It was further ground and then washed and allowed to settle. The finer particles, which settled last, gave only a pale blue pigment, but the coarser particles gave a deep, rich, purple-blue. Smalt may contain in 100 parts, 65 to 71 parts of silica (SiO_2), 16 to 21 of potash (K_2O), and 6 to 7 parts of cobalt oxide (CoO), as well as some alumina (see Church, p. 224). In an analysis given by Bearn (p. 92), the cobalt oxide content is much lower, only 0.8 per cent. Farnsworth and Ritchie say (*loc. cit.*, p. 160) that in a modern cobalt glass, a strong blue is imparted by 0.15 per cent of cobalt oxide and a quite perceptible blue by 0.006 per cent. Blue glasses, however, with such low cobalt content, when ground to a powder, have little or no color.

Smalt, since it is a glass and is transparent, has very poor hiding power and, for this reason, it has had to be used very coarsely ground. This has led to certain difficulties: a tendency to settle in the paint film; poor spreading qualities, and a tendency to streak down the surface of a painting. Various tricks were employed by early painters to overcome this fault (see De Wild, p. 25).

Smalt can usually be recognized easily by its microscopic appearance. The glassy character and conchoidal fracture are seen even at low magnifications. Quite characteristic are particles with square and angular corners and others with thin, flat edges; some are shaped like sharp splinters; tiny air bubbles in the

particles are common. Like all true glasses, the pigment is isotropic; the refractive index is low. Large particles are purple-blue by transmitted light, but small particles are clear blue. Smalt, like other glasses, is ordinarily considered to be quite stable. It is commonly seen on pictures two or three centuries old, without sign of alteration. While most samples are insoluble, even in strong acids, a few have been seen which are quite readily soluble, even in dilute hydrochloric acid. Church says (p. 224) that it is gradually altered by moisture and by carbonic acid of the air, becoming paler and grayer, and Doerner also speaks (p. 80) of this tendency. These unstable pigments may be high in potash and not true glasses.

In Europe smalt seems to have had its beginnings as a pigment certainly as early as the late XVI century. In the early XVII century it came into general use in oil painting. There is evidence, however, that smalt was known in Asia even earlier than in Europe. It has been identified on Chinese wall paintings: one from Kara Khoto in Central Asia and dated perhaps as early as the XI–XIII centuries; another, a ' Seated Buddha ' of the Ming Dynasty (Fogg Museum, no. 1933.190). Farnsworth and Ritchie say (*loc. cit.*, p. 160): ' Some of the finest blue underglazes in Chinese blue-and-white pottery, occurring about the middle of the Ming Dynasty, were made by means of cobalt ores imported from some Islamic area west of China, and are always described as ' Mohammedan blue.'

The use of smalt as an artist's pigment was discontinued around the beginning of the XIX century. This was because of its shortcomings as mentioned above, and also because its place was taken by the more satisfactory cobalt aluminate (cobalt blue) and by artificial ultramarine. It is still available, however, and is used to some extent by sign-painters for strewing on a background for gold lettering. Smalt is quite frequently found on old paintings. It was identified on a portrait by Hans Holbein the Younger (1497–1543) of Sir William Butts, and this indicates that it was known before the time which Beckman suggests for its discovery (1540–1560). Sixteen specimens of blue pigment were identified as smalt by De Wild on XVII and XVIII century paintings, one by Rubens, dated 1620, being the earliest. Laurie records (*New Light on Old Masters*, p. 126) that Teniers used smalt in his skies and that Velasquez (*op. cit.*, p. 129) used a mixture of smalt and azurite in the green drapery of the Rokeby ' Venus.'

Soapstone (see **Talc**).

Steatite (see **Talc**).

Strontium Yellow (lemon yellow) (see also **Barium Yellow**) is strontium chromate, $SrCrO_4$. It is prepared much like barium yellow except that strontium chloride replaces barium chloride. The finely divided, crystalline precipitate that is formed must be thoroughly washed to be useful for pigment purposes. It is a little deeper and brighter in lemon hue and has greater hiding power than barium chromate. It takes the form of blades or needles which are pale yellow by transmitted light and are strongly birefracting. Strontium chromate is slightly soluble in water and soluble in alkalis, in dilute mineral acids and in acetic acid; it some-

times takes on a greenish tone (reduction to chromic oxide) when exposed to strong sunlight (see Eibner, *Malmaterialienkunde*, p. 165). Like barium chromate, this alkaline earth chromate is also sold as 'lemon yellow.'

Synthetic Pigments are those made by processes of chemical synthesis from chemical elements or compounds. They may be inorganic, compounds of the metals, or they may be organic, complex compounds of carbon, like the dyestuffs of coal-tar origin. Some synthetic or artificial pigments, like Egyptian blue, white lead, and verdigris, have been known since classical times or earlier.

Talc (soapstone, steatite) is a natural hydrous magnesium silicate, $3MgO \cdot 4SiO_2 \cdot H_2O$, and is found as a soft stone. It is smooth and unctuous to the touch because the cleavage is highly perfect and it powders to form thin, laminar particles. It has properties like those of China clay, and in the arts is used for similar purposes. Talc is white to grayish white in color. It is very inert and is used commonly as a filler in paints and paper, in colored crayons, and for dusting. Steatite or soapstone, which is a massive variety of talc, serves as a sculptor's medium and for certain ornamental purposes. A fibrous form of talc from New York State called 'asbestine' is widely used in outside paint films to increase strength and weathering properties; it contains about 92 per cent magnesium silicate (Gardner, p. 1250).

Terra Alba (see **Gypsum**).

Terre-Verte (see **Green Earth**).

Thénard's Blue (see **Cobalt Blue**).

Tin Leaf and, to a smaller extent, **Tin Powder** were very early used to embellish paintings. The metal was used in its own right or for imitating silver, or it was lacquered yellow to imitate gold. Tin, which was one of the metals known to the ancients, is soft and malleable; hence, it is easily beaten into leaf or foil. It is superior to silver in that it does not tarnish and blacken with time. Mediaeval recipes for the use of tin in imitation of gold are numerous. With a yellow varnish to give it a golden glint, it was named ' *auripetrum*.' Many of the recipes for this call for saffron (see **Saffron**) or other transparent yellow or red vegetable coloring matters. Theophilus (pp. 31–33) tells how to beat out the tin foil on an anvil, how to polish it, how to ornament letters and pictures in books with it (p. 41), and how to imitate gold by coating it with glair mixed with saffron. Jehan Le Begue (see Merrifield, I, 304) mentions that tin was used in powder form as well as foil. Laurie says (*Materials of the Painter's Craft*, p. 203) that the famous Spanish leather hangings were decorated with tin foil to give both the silver and the gold effects. Much of the brassy gilding observed so frequently on Russian icons is probably tin foil coated with yellow varnish. Thick tin foil has occasionally been put on the backs of panel paintings and varnished over to make the wood impervious to moisture and to prevent warping.

Titanium Dioxide (titanium white, ' titanox '), TiO_2, is the whitest and has the greatest hiding power of any of the white pigments. The principal titanium ore,

ilmenite (originally menachanite), was first described by an Englishman, the Rev. William Gregor, as early as 1791, but the element was named ' titanium ' by the German chemist, Klaproth, in 1795 (see Weeks, pp. 142–146). Attempts were made to develop it for pigment purposes early in this century (Rose, pp. 357–359), but not until about 1916–1919, however, were certain companies in Norway and America (see Toch, *Chemistry and Technology of Paints*, p. 48; also Trillich, III, 52) able to overcome difficulties in the purification and manufacture of the oxide and to put it on the market in regular production. The native oxide of titanium, rutile, occurs in nature, but the titanated iron ore or ilmenite ($FeTiO_3$), found in large deposits on the west coast of Norway, today supplies the titanium of commerce.

For the preparation of this pigment, the ilmenite ore is digested with concentrated sulphuric acid, and the coagulated mass of iron and titanium sulphate which is formed is dissolved in water and then heated to boiling to precipitate the titanium as metatitanic acid and separate it from the iron. The precipitate is neutralized with barium carbonate and is then calcined. Commercially, only a small amount of titanium dioxide is used, pure, as a pigment for white paints. Most of it is sold as a composite in which it is precipitated on a base of barium or calcium sulphate. Barium base titanium oxide is usually about 30 per cent titanium oxide and 70 per cent barium sulphate. In the preparation of this composite, the titanium sulphate is mixed with blanc fixe (artificial barium sulphate), and the mass is boiled to precipitate titanium hydrate (metatitanic acid) upon the blanc fixe.

Both the pure titanium and the barium base titanium oxides are microcrystalline and fine in texture. The high refractive index ($\omega = 2.5$–2.6) and, hence, the great hiding power, is the outstanding characteristic of titanium dioxide. Bearn (p. 58) says that, bulk for bulk, paints made with pure titanium white have nearly twice the opacity or obscuring power of paint made with pure white lead. The pigment is used extensively in inside white enamels and also as a ceramic white.

Titanium dioxide is a very stable substance; it is unaffected by heat, by dilute acids and alkalis, and by light and air. As a pigment, it is non-reactive with drying oils and is a poor drier; hence, it gives soft paint films unless much zinc oxide or drier is added. The oil absorption of pure titanium dioxide is fairly high, 23 to 25 per cent, but that of the barium base pigment is lower, 17 to 18 per cent (see Gardner, pp. 1228–1229). Titanium oxide was suggested as an artist's pigment very soon after it came into commercial production, and, for some years, titanium barium pigments have been supplied under special names by various artists' supply houses. One can not expect to find it used, however, on paintings that were done much earlier than 1920.

Titanium White (see **Titanium Dioxide**).
Titanox (see **Titanium Dioxide**).

Toluidine Red (toluidine toner) is a synthetic, yellowish red, organic dyestuff, o-nitro-p-toluene-azo-β-naphthol, $C_{17}H_{13}N_3O_3$ (*Colour Index*, p. 16). It is one of the most permanent of its kind and, hence, is now used widely for outside purposes where a permanent, bright red paint is demanded; it will stand strong sunlight for some months without fading. It is unaltered by heat up to 150° C. and by alkalis, is insoluble in water but soluble in boiling alcohol. Toluidine red was first made by the Badische Company in Germany, the patents being dated 1905. Although it has not been offered to the artists' trade under this name, it may occasionally be found in cheaper artists' colors as a toner or as a substitute.

Toner is a term used in the heavy paint industry to indicate pure or nearly pure synthetic, organic dyestuffs or lakes of high color concentration. Toners are sometimes used to bring color mixtures of pigments up to standards of tint (see also **Para Red, Toluidine Red,** etc.).

Transparent White (see **Aluminum Hydrate**).

Turnsole, a blue from seeds of the plant, *Crozophora tinctoria*, indigenous to southern Europe, is an indicator dye like litmus. When freshly squeezed from the seeds, it is red; but when made alkaline, it turns blue. In mediaeval times, small linen cloths were dyed directly with the juice of the seeds and, when dipped in a gum solution, served as a convenient source of the color for manuscript painting. If violet was desired, the cloths were first limed to neutralize the acidity of the seed juice. Turnsole violet was highly esteemed in XIV century Italy (Thompson, *The Materials of Medieval Painting*, pp. 143–144), and was used occasionally to tone azurite.

Tuscan Red is a red iron oxide brightened with one of the more permanent organic pigments like alizarin red.

Tyrian Purple, one of the most important and most costly of the organic coloring matters of the ancients, was prepared from several mollusks (whelks) including *Murex brandaris* and *Purpura haemostoma*, found on the shores of the Mediterranean and the Atlantic coast, including the British Isles. Huge quantities of these mollusks were used for dyeing fabrics in classical times, and on certain shores of the Mediterranean there still remain heaps of the shells about the sites of ancient dye works. The color-producing secretion of the whelk is contained in a little vein or cyst, and when this is broken and squeezed by hand, it issues as a white fluid. Cloths to be dyed are dipped in this fluid and are exposed to strong sunlight which causes the development of the color finally to purplish red or crimson. The hue obtained depends somewhat on the particular species of mollusk and on the extraction process. P. Friedländer, in his experiments on the extraction of purple from *Murex brandaris* collected at Trieste in 1908, obtained only 1.4 grams of the pure dye from 12,000 mollusks. It was he who established the identity of the coloring principle as 6 : 6' dibromoindigotin ('Über den Farbstoff des antiken Purpurs aus murex brandaris,' *Berichte der Deutschen Chemischen Gesellschaft*, XLII [1909], pp. 765–770). The purple color is remarkably stable, resisting alka-

lis, soap, and most acids, and is only destroyed by hot nitric acid or chlorine. It is insoluble in most ordinary organic solvents, except hot aniline and nitrobenzene (Friedländer, *loc. cit.*, p. 768).

Pliny (see Bailey, I, 25–33) describes in some detail the source and method of extraction, and says that the best quality was made at Tyre, probably the reason why it is still called ' Tyrian purple ' (Laurie, *The Pigments and Mediums of the Old Masters*, pp. 47–62). This was the color in the togas of Roman emperors and gave rise to the expression, ' born to the purple.' It was used in the preparation of a purple ink and in dyeing parchments upon which the codices of Byzantium were written. Whelks that yield a purple dye are also found in waters of the British Isles, and they furnished the purple color for some of the early English, Irish, and French manuscripts (see Thompson, *The Materials of Medieval Painting*, p. 156). The color went out of general use about the VIII century, though it may have been used occasionally up into the XII century (Thompson, *loc. cit.*, p. 157).

Ultramarine Blue, artificial (French ultramarine, permanent blue). All the ultramarine used in commerce is made artificially by a furnace process. In chemical composition and structure it is identical with the natural ultramarine which is made from the rare mineral, lapis lazuli (see **Ultramarine Blue, natural**). The chemical composition of the mineral was first established by Désormes and Clément in 1806 (see ' Memoir sur l'Outremer,' *Annales de Chimie* [first series], LVII [1806], pp. 317–326). They showed that it was essentially a compound of soda, silica, alumina, and sulphur, and they predicted, on the basis of the analysis, that artificial production should follow. Already blue masses had been observed in ovens where the Leblanc soda process was being carried out (see Rose, p. 175) and, in 1814, L. N. Vauquelin (' Note sur une couleur bleue artificielle analogue à l'outremer,' *Annales de Chimie* [first series], LXXXIX [1814], pp. 88–91) described a blue substance taken from the hearth of a demolished soda furnace by M. Tessaërt at the glass works of St Gobain, and showed that it was quite similar in composition and properties to ultramarine from lapis lazuli. In November, 1824, the *Société d' Encouragement pour l'Industrie National* offered a prize of 6000 francs for a method for making artificial ultramarine at a cost not to exceed 300 francs per kilogram. The prize was awarded four years later to J. B. Guimet in Toulouse for his method of preparing artificial ultramarine which he asserted he had developed in 1826 and had not published, but had kept a secret. Almost simultaneously and quite independently, Christian Gmelin of Tübingen, and F. A. Köttig of Meissen, perfected processes for the same purpose. Very soon after 1830, factories were established in France and Germany where it came principally to be made, although later it was also manufactured in England, Belgium, and the United States.

Two distinct kinds of ultramarine are made. ' Soda ultramarine ' is made by heating in closed fire clay crucibles in a muffle furnace, a finely ground mixture of China clay, soda ash, coal or wood charcoal, silica, and sulphur. After maintaining

a bright red heat from 12 to 18 hours, the product is cooled, ground, and lixiviated to remove soluble salts, dried and again ground until the proper color and degree of fineness are obtained. With a small amount of sulphur the color is dark blue, but with a high percentage of sulphur it is dark blue with a reddish tinge. Soda ultramarine also contains a high percentage of silica and is sometimes called acid-resisting because it is stable in the presence of alum solutions (important where ultramarine is used in the paper trades). 'Sulphate ultramarine,' which has a greenish tinge (see **Ultramarine Green**) and little covering power, is made by using sodium sulphate (Glauber's salt) in place of soda ash. By washing and roasting with additional sulphur, it may be changed to blue ultramarine (see Bearn, pp. 80–85, and Rose, pp. 173–202). Variations in the process give blue, red, and violet ultramarines in various shades and hues. The chemical synthetic product does not differ from natural ultramarine in composition or chemical properties and it is much purer. Ultramarine is essentially a sodium aluminum silicate which also contains a certain amount of sulphur. F. M. Jaeger says (*Optical Activity and High Temperature Measurements, Part III, Constitution and Structure of Ultramarine* [New York: McGraw-Hill Book Co., 1930], pp. 403–441) that it has no fixed formula and the ratios of the various constituents can change within limits. There appears, however, to be a fixed component in ultramarine with the formula, $Na_8Al_6Si_6O_{24}$, which may take on sodium and sulphur atoms to give ultramarines with formulas ranging from $Na_8Al_6Si_6O_{22}S_4$ to $Na_{10}Al_6Si_6O_{24}S_2$. The cause of the color and differences of color in ultramarines is still more or less a mystery. It appears to be associated with the sulphur present or a combination of sodium and sulphur. When the pigment is decomposed by acids, sulphur and hydrogen sulphide are released and the color is immediately discharged.

Artificial ultramarine, in contrast with natural ultramarine, is finely divided and homogeneous. The particles, which are rounded, are about the same size as Dutch process white lead. The small, individual particles are quite opaque to transmitted light; they are isotropic, and the refractive index is low ($n = 1.50$). The color by reflected light is claimed (see De Wild, p. 20) not to be the pure blue of natural ultramarine but usually to have a purplish tinge which makes it less desirable from the artist's point of view. This blue is stable under all conditions, except in the presence of acids. It is readily decomposed, even by dilute acetic acid, with decoloration of the pigment and evolution of hydrogen sulphide. It is permanent to light and is unaffected by high temperatures. Since it is unaffected by alkalis, it is stable in fresco. Impure ultramarines may contain free sulphur and, hence, cause darkening when mixed with lead and copper pigments. Artificial ultramarine in rich oil films occasionally appears to decolorize and to become gray with age. This phenomenon is sometimes called 'ultramarine sickness' and seems to be caused by an acid condition in the film. Weber points out (p. 113) that it never occurs when white pigments are mixed with the film; this is probably because some whites, like those of lead and zinc, can readily neutralize acid.

Ultramarine is today quite widely used as an artist's pigment, and is known to many as ' French ultramarine,' presumably because of its discovery and long production in France. Just when artificial ultramarine was first used for pictures has not been definitely established, but the date must have been about 1830 or soon after. Laurie says (*New Light on Old Masters*, p. 44) that Turner used it. In color, quality, and brilliance, it was superior to Prussian blue and indigo, which were the only other readily available blue pigments in the first part of the XIX century.

Ultramarine Blue, natural (lapis lazuli). Genuine ultramarine blue pigment is from the semi-precious stone, lapis lazuli, which is a mixture of the blue mineral, lazurite, with calcspar, and iron pyrites. (For a complete mineralogical and crystallographic treatment of lapis lazuli, see W. C. Bröger and H. Bäckström, ' Die Mineralien der Granatgruppe,' *Zeitschrift für Krystallographie und Mineralogie*, XVIII [1890], pp. 209–276.) Various ancient sources have been ascribed to this stone, including Persia, Tibet, and China, but the most reliable information indicates that the lapis lazuli which was brought to Europe in mediaeval times originated in mines which were located in Badakshan, now a province of northeast Afghanistan. The Badakshan mines, lying in a most inaccessible region at the headwaters of the Oxus, on the north side of the Hindu Kush near Firgamu, appear to have been worked very early and possibly they were the source of the lapis lazuli used in Mesopotamia and in classical times. They were visited by Marco Polo in 1271, and were described by Capt. John Wood of the Indian Navy (*A Journey to the Source of the River Oxus* [London, 1872], pp. 169–172), who saw them in 1838. Lapis lazuli was probably an important article of trade over the caravan routes that led to the Mediterranean and thence to Europe, during the Middle Ages. It was probably imported into Italy through Venice, a terminal for Oriental commerce. Its present name, ultramarine, derives from *azurrum ultramarinum* or *azurro oltramarino* which formerly served to distinguish it from azurite which was variously called *azurrum citramarinum, azurro della magnia*, or *azurro dell' Alemagna* (see Merrifield, p. ccxi, and Beckmann, I, 474). Significant, also, is the fact that the blue pigment made from this stone was at one time known in Spain as *atzur d'Acre* (see J. Gudiol, *La Pintura Mig Eval Catalana*; II, *Els Trescentistes* [Barcelona: S. Babra, 1924], p. 89).

Although lapis lazuli was used throughout the East in remote antiquity and classical times for lapidary purposes, there is no evidence, as yet, that it was used for a pigment until some centuries after the beginning of the Christian Era. Lucas (p. 286) finds no evidence for it as a pigment among the ancient Egyptians, although the stone was imported into Egypt as early as predynastic times. It first became a pigment, apparently, in the region of its origin, in Afghanistan, and adjacent countries. Gettens has reported its occurrence in VI and VII century wall paintings in the cave temples at Bāmiyān in Afghanistan. It was also in contemporary wall paintings at Kizil in Chinese Turkestan. Laurie says (' Materials

in Persian Miniatures,' p. 146) that blue from lapis lazuli was used in Byzantine illuminated manuscripts from the VII century on but that the quality of the early blue was poor. Laurie adds (*loc. cit.*, p. 148) that this dull blue was used in Persian miniatures in the XIII and XIV centuries, but that in the XV century it was replaced by fine ultramarine which may have had its source in the East but was refined in Europe and then returned to the East again. In China, however, azurite, not ultramarine, was the chief mineral blue.

Methods for purifying and concentrating ultramarine from the crude lapis lazuli appear to have been developed in the West in the XII and XIII centuries, although the raw material still came from the East. These methods have been handed down in numerous recipes which are quite similar in principle and vary only in details. One of the best is given by Cennino Cennini (see Thompson, *The Craftsman's Handbook*, pp. 36–39), who directs that the powdered mineral be kneaded in a weak lye solution with a paste or dough of wax, pine rosin, linseed oil, and gum mastic. The dough retains the foreign particles (silica, calcite, pyrite, etc.), but the fine particles of blue color settle out in the alkaline water. The first extraction gives the finest and purest color; each successive extraction gives a product less pure until, finally, there is a pale gray-blue called ' ultramarine ash.' The reason for the separation is the preferential wetting and retention of the impurities by the dough mixture. Microscopically, natural ultramarine is characteristic in appearance, and one can quite easily distinguish it from modern artificial ultramarine (see **Ultramarine Blue, artificial**). The particles are clear blue and translucent; their fracture is conchoidal and, when not too finely divided, certain ones with squared corners and others shaped like sharp splinters can be seen. The blue particles are isotropic and have a very low refractive index, $n = 1.50$, lower than dried linseed oil or Canada balsam. Unless it is very highly purified, ultramarine contains colorless, birefracting particles of calcite; occasionally small, golden particles of iron pyrites can be seen by reflected light. Since the refractive index of ultramarine is so low, it served better and was far brighter in tempera than in oil. It has apparently discolored (turned green) in many old paintings because of the yellowing of oil and varnish films that are applied over it.

Natural ultramarine is unaffected by red heat or by alkalis but is decomposed by dilute acids, even acetic acid, with complete loss of color and the discharge of hydrogen sulphide gas (see **Ultramarine Blue, artificial**). This sensitivity to acids may be the cause of the so-called ' ultramarine sickness,' a phenomenon that is occasionally met with in old pictures where areas painted with ultramarine have turned gray-blue. As explained by De Wild (pp. 14–16), this may perhaps be caused by either an acid medium or varnish or by an acid atmosphere. The blue is stable, however, in strong light and many specimens which are several hundred years old show no apparent change in color.

In mediaeval times, natural ultramarine was a costly material; it was in a class with gold as a symbol of luxury and it was frequently specified by the rich

in contracts and commissions for paintings. It was used from Byzantine times through the XVIII century in European paintings and, though it had more frequent literary mention than azurite, it is found less often in old paintings than this latter pigment. Dürer used ultramarine, and in his letters to his patron, Jacob Heller (see W. M. Conway, *Literary Remains of Albrecht Dürer* [Cambridge: University Press, 1889], pp. 66–69), he complains of its cost. De Wild lists (p. 18) several Dutch and Flemish paintings, beginning with the Van Eyck 'St Barbara' (1437, at Antwerp), on which he identified it. He also found it on a Dutch painting dated as late as 1810. It disappeared from the painter's palette soon after that but can still be bought from certain English colormen, and it is claimed that the ultramarine is purified by methods similar to those described in the mediaeval recipes.

Ultramarine Green is nearly identical in composition with ultramarine blue (see **Ultramarine Blue, artificial**) and is produced in a similar way. It is the palest in color of the ultramarines and the most sensitive to acids; otherwise, it is quite similar, physically and chemically, to ultramarine blue. Microscopically, it is heterogeneous; the bright, transparent particles of ultramarine green are mixed with a large proportion of ultramarine blue, as well as colorless particles. Though still listed by a few colormen, it apparently has never been extensively used. It was first prepared by Köttig in Meissen in 1828, but was not manufactured on a commercial scale until 1854–1856 (see Trillich, III, 78).

Ultramarine Violet (ultramarine red) is made by mixing soda ultramarine blue with sal ammoniac and heating for some hours at a temperature of about 150° C. Ultramarine red is prepared in a similar way, except that dry hydrochloric acid gas replaces sal ammoniac. These special ultramarines were developed in Germany mainly in the years between 1870 and 1880 (see Rose, pp. 193–195). Chemically and physically, ultramarine violet is similar to ultramarine blue and usually contains much of it. Not being affected by alkalis, it is one of the very few violets that can be used in fresco painting. In oil technique, it is pale and has poor covering power. It is readily available today in dry powder and in various mediums, including oil.

Ultramarine Yellow, a name sometimes misapplied to **Strontium Yellow.**

Umber (raw umber, burnt umber). Raw umber is a brown earth pigment similar to the ochres and siennas but contains manganese dioxide as well as hydrous ferric oxide. The general run of raw umbers has 45 to 55 per cent iron oxide, 8 to 16 per cent manganese dioxide, silica, alumina, etc. Raw umber is rather widely distributed in nature. One of the best, found on the island of Cyprus, has long been known as Turkey umber. Others are found in England, France, Germany, and America. From the crude lump umber, it is prepared as a pigment by the usual process of grinding and levigation. The best earths have a warm, reddish brown color with a greenish undertone. Microscopically, the pigment is heterogeneous in composition and particle size. It contains much goethite, but the grains of that mineral are finer and darker yellow-brown or more nearly opaque than the

goethite of raw sienna and yellow ochre; there are many orange, yellow, and color-less ones and there is also a small proportion of birefracting material. Umber is durable; it is compatible with other pigments, and is adaptable to all mediums. Poor grades, which contain humus matter, are not so stable and are liable to fade in strong sunlight.

Burnt umber is made by roasting the raw earth at a dull red heat until the desired shade is obtained. The heating changes the ferric hydrate to ferric oxide and the product is redder and warmer than raw umber. Microscopically, the burnt differs little from the raw, except that it is a little redder and more transparent.

The umbers are unaffected by alkalis and by dilute mineral acids. Because of their manganese content, they dry well in oil, and have been used as driers for varnishes. They have high oil absorption, requiring up to 80 per cent to grind, and for this reason oil films pigmented with them have a tendency to become darker with age.

The umbers have been available since earliest times, but Thompson says (*The Materials of Medieval Painting*, pp. 88–89) that they were not found on the early mediaeval palette and they did not come into general use in Europe before the close of the XV century.

Van Dyke Brown (Cassel earth, Cologne earth) is a name commonly used to designate a brown organic pigment which is derived from earthy substances simi-lar to lignite or brown coal. It contains usually over 90 per cent of organic matter, with a small amount of iron, alumina, silica, etc. Most of the raw Van Dyke brown has come from Germany, from places near Cassel and Cologne. Harrison (p. 242) says that the best grades of this pigment are prepared from good, clean peat deposits which have been well carbonized by slow formation and long weath-ering. It is said (Weber, p. 115) that it got its name from ' the famous artist who was partial to the use of brown in his pictures.' It is prepared first by heating to drive off excess moisture, and then by the usual processes for earth pigments. It has a warm, reddish brown shade and, since it is partially transparent in oil, it is used for staining of woods and for glazing in pictures. When seen microscopically, it is heterogeneous in particle size and composition, and the particles seem more opaque and less crystalline than ochres and umbers. When ignited, it burns and leaves a gray ash, and when heated in an ignition tube, tarry vapors are given off. It dissolves in dilute sodium hydroxide to give a deep brown solution. Because of its tarry and bituminous nature, it is a fugitive pigment. It fades on exposure to strong light and develops a cold, gray tone. In oil, however, it is more permanent than in water color. The pigment appears to dissolve in oil or varnish and to stain it; for this reason, it is difficult to isolate and to identify in such mediums.

Little is known about the early use of the lignite colors. Probably they came into use in the late XVII and early XVIII centuries when brown shadows and backgrounds became popular.

Van Eyck Green (see Verdigris).

Venetian Red is an iron oxide (see also Iron Oxide Red) with a brick-red color. Formerly a natural oxide, partially hydrated (see Church, p. 180), today it is obtained by calcining a mixture of copperas (ferrous sulphate) and whiting (calcium carbonate). The product, a finely divided mixture of ferric oxide and calcium sulphate, does not require washing but is simply ground and sieved. Although the best Venetian red may contain as high as 50 per cent ferric oxide, the greater part has 10 to 30 per cent with the rest a mixture of calcium carbonate and calcium sulphate.

Verdigris is specifically the normal acetate or one of the basic acetates of copper but, on occasion, the term is also used to indicate copper carbonate or any of the other blue or green corrosion products which form on copper, brass, or bronze. The verdigris (vert de Grece) of commerce is usually the dibasic acetate, $Cu(C_2H_3O_2)_2 \cdot 2Cu(OH)_2$. It is a greenish blue, crystalline powder with acetic odor. Its preparation was known in ancient times. Theophrastus (p. 225) and, later, Pliny (see Bailey, II, 41–43) tell how to prepare it by exposing copper to the vapors of fermenting grape skins or in closed casks over vinegar. There are numerous mediaeval recipes for its preparation. Production of this material has long centered about Montpellier, France (verdet de Montpellier), and the methods used there differ little from those of ancient times (see Beckman, I, 171–175). The crude verdigris produced by the action of acetic vapors on strips of metallic copper can be lixiviated and the product recrystallized from acetic acid, after which it can be used as a pigment. Well crystallized verdigris particles have the shape of pointed needles. De Wild says (p. 78): ' They are often united in bundles, while the larger pieces show fibrous structure. If, however, the pigment is not recrystallized but ground directly, it is seen in transparent grains.' Verdigris is strongly birefracting ($\alpha = 1.53$; $\beta = 1.56$ [Merwin]), and it is pleochroic, changing from light blue-green to deep green-blue.

This green is the most reactive and unstable of the copper pigments. It is slightly soluble in water and readily soluble in acids. When heated, it decomposes with the escape of acetic acid and water, and leaves a black residue (CuO). Unless locked up with protective coatings, it is a fugitive color; it blackens readily with sulphur-bearing pigments. Under very favorable circumstances, as, for example, where used in the illumination of books and manuscripts which have been kept closed, it has sometimes endured well. Laurie says (New Light on Old Masters, p. 45) that Watteau frequently used a mixture of verdigris and ultramarine for his skies and, in spite of the theoretical incompatibility of these two pigments, there has been no apparent reaction; his skies are as luminous as ever. De Wild (p. 78) found it on several paintings of the Flemish School. Thompson says (The Materials of Medieval Painting, pp. 163–169) that it was a favorite pigment in the early days of oil painting in Italy, particularly in landscape painting, but it was a fugitive color and there are many cases where it has turned dark brown. He says

it was much used by scribes and illuminators of books; in many of these it is well preserved but in others it has eaten into the parchment so that parts painted with it drop out and leave gaps in the page. Laurie states (*The Pigments and Mediums of the Old Masters*, p. 100) that real crystalline verdigris is not found on paintings or manuscripts until the beginning of the XV century but from that time its use continued up to the XIX century. It is now seldom listed by colormen.

A pigment allied with it is transparent copper green. Laurie, in several of his published works (particularly in *The Pigments and Mediums of the Old Masters*, pp. 35–39 and 99–103) has described a peculiar grass-green paint which frequently is found on illuminated manuscripts that date from the VIII through the XIV century. When examined microscopically, it exhibits no discrete crystalline particles of verdigris or other copper salt, yet it tests positively for copper. It is green-stained, pellicular paint. The resinous character of the medium is quite evident from its fracture and brittleness. In dilute hydrochloric acid the color is discharged and it is soluble enough to test for copper. The color is destroyed by dilute alkali and by heat. Laurie believes that this color was produced by combining copper acetate or verdigris with some balsam like Venice turpentine. It is well known that copper and copper salts react readily with resin solutions to form copper resinates, and these solutions become green-stained. Laurie suggests (*op. cit.*, p. 37) that this transparent copper green could have been applied by dilution with turpentine or it could have been dried, ground to a powder, and mixed with gum, or with white of egg, or even emulsified with egg. He says there appear to be no early recipes for the preparation of this green, and it is first mentioned, so far as he knows, by De Mayerne (*MS. Sloane*, 1052) in the XVII century. Further (p. 164), just as it disappeared from illuminated manuscripts in the late XV century, it began to appear in the ' oil ' paintings of the Van Eycks and their followers, and its use continued until about the middle XVI century in Germany and northern Italy. He sometimes terms it ' Van Eyck green ' (see p. 128) because it is found in so many of the paintings of those masters. The color obtained by the direct action of copper salts on pure balsams is blue-green, and Laurie suggests that the warmer hues of the copper green were made by admixture with organic yellow pigment like yellow lake, saffron, or gamboge (see p. 101). In many paintings this color appears to be unaltered and in much its original condition—the result, partially, of the protective influence of the resinous medium.

Verditer (see **Blue Verditer**).

Vermilion (cinnabar, English vermilion, Chinese vermilion) is red mercuric sulphide (HgS). It is found in nature as the mineral, cinnabar, which is the principal ore of the metal, mercury. Although the crushed and ground ore served directly as a pigment for centuries, yet in very early times men learned how to recombine the elements, mercury and sulphur, to form artificial cinnabar or vermilion. Cinnabar was known by the Greeks and Romans, and was mentioned by Pliny, who called it ' minium ' (see Bailey, II, 119–127). The name, minium, later

became fixed to the artificial pigment, red lead. Pliny says that almost the entire Roman supply came from Sisapo in Spain. This source was probably the famous Almaden mines which today are still the world's most important source of mercury. He speaks of its use as a pigment and says that it was costly and its price was fixed by the government. The pigment, vermilion, has been identified numerous times on Pompeian and Roman wall paintings. Lucas makes no mention of it as a pigment in ancient Egypt, and there is some question as to whether or not it was used in Mesopotamia and the Near East. The pigment has been known in China since prehistoric times and it has long been held in high esteem there. It was identified as the red in the fossae of the incisions of the famous Chinese oracle bones (see A. A. Benedetti-Pichler, 'Microchemical Analysis of Pigments,' *Industrial and Engineering Chemistry, Analytical Edition*, IX [1937], pp. 149–152) which date from the Shang epoch in the second millenium B.C. It was used by the Chinese, probably as early as Han times, for making the red ink which is so often seen on cartouches and stamp seals of early Chinese silk and scroll paintings.

Cinnabar is fairly widely distributed in nature and sources are known in England, Europe, China, Japan, California, Mexico, Peru, as well as in Spain. Soon after classical times, artificial cinnabar is noticed. Geber (or Jabir), the VIII–IX century Arabic alchemist, speaks about a red compound formed by the union of sulphur and mercury (see Kopp, IV, 184–188). Recipes for its preparation are common in the Middle Ages. From writings of Cennino Cennini, the vermilion of the Italian painters of the XV century is supposed to have been artificial. He says (see Thompson, *The Craftsman's Handbook*, p. 24): 'A color known as vermilion is red and this color is made by alchemy prepared in a retort.' Even in China they knew very early how to make vermilion by the dry method. They may have been the first to make it artificially, and their knowledge of the process could have been carried to the West by the Moors.

The dry method of preparation was the one used by the ancient alchemists and is used, probably, by the Chinese at the present time. In the Dutch modification of the Chinese method, 100 parts (by weight) of mercury are combined in an iron pan with 20 parts of molten sulphur to form black amorphous mercuric sulphide (ethiops mineral). The black mass is charged into retorts where it is heated, and by sublimation and condensation on earthenware pots or iron cylinders is changed into the red crystalline modification of mercuric sulphide. The product has only to be treated with a strong alkali solution to remove free sulphur, and to be washed and ground under water to prepare it as a pigment. The change from black mercuric sulphide to vermilion is entirely physical. This dry-process vermilion, particularly that produced by the Chinese (Chinese vermilion), is rather coarsely crystalline and slightly violet-red in color.

The wet method has found favor with English, German, and American producers. It was known as early as the XVII century that the red modification of

mercuric sulphide could be made by treating the black sulphide with alkali sulphides (see Kopp, p. 187). Production of vermilion by this method began in the late XVIII century in Germany (see Rose, p. 111). The mercury and sulphur are ground together in the presence of water and, toward the end of the grinding operation, a warm solution of caustic potash is added to complete the transformation. After being stirred for some time, the black mercuric sulphide develops the desired vermilion color. In an improved method, potassium pentasulphide is used in place of caustic potash (see Bearn, p. 119). Vermilion prepared in this way must be washed and dried to be rid of the soluble sulphur compounds.

Chemically and physically, artificial cinnabar does not differ from the natural. There are no optical differences between them, and it is often quite impossible to tell the origin of the vermilion in a paint film. If it is coarse and if the particles appear to be broken fragments rather than single small crystals and if there are inclusions of impurities in the broken fragments, then it may be natural in origin. Impurities in vermilion are no satisfactory criterion of origin, however, since very pure, natural cinnabar frequently occurs in nature. Artificial vermilion, particularly that made by the wet process, is very finely divided and homogeneous; differences in the color of different samples are caused mainly by differences in particle size. The sublimed product from the dry process (*e.g.*, Chinese vermilion) is usually more coarsely crystalline and it has a bluish, carmine-red color. When it is finely ground, the color approaches the orange of wet-process vermilion.

Vermilion is one of the heaviest pigments (sp. gr. = 8.2). It has excellent body and hiding power. It is highly refracting and birefracting ($\epsilon_{Li} = 3.14, \omega_{Li} = 2.81$). Under the microscope, the particles are translucent, deep orange-red by transmitted light. By reflected light at high magnification, the red particles have a certain waxy lustre which seems to be quite characteristic. Many fragments show perfect cleavage.

Vermilion, on the whole, has been a permanent pigment. It is frequently seen on Roman wall paintings, quite unchanged. On many Flemish paintings of the XV century it appears to have retained all of its original brilliance. It is not permanent under all conditions, however, and one peculiar property is that specimens of it are frequently observed to darken when exposed to direct sunlight. This occurs more often where the pigment is used with tempera or water color mediums than with oil. Darkening appears to be a purely physical change, and is thought to be caused by the formation of a metastable black modification of mercuric sulphide (see De Wild, p. 67, and Church, p. 169). Wet-process vermilion is more often observed to darken than the dry-process or the natural vermilion; impurities seem to have some part in the change. The tendency to discolor has caused vermilion to be replaced on the modern artist's palette by cadmium red. When heated, vermilion sublimes at about 580° C. (see Mellor, IV, 944). At higher temperatures it burns with a bluish flame and leaves no appreciable residue. It is insoluble in

alkalis and in concentrated acids but is soluble in aqua regia. Although it is a sulphide, it is so inert that it does not darken white lead when the two are mixed, unless it contains free sulphur or soluble sulphide as an impurity. It has often been used with white lead for flesh tints.

Vermilion has been found on numerous paintings of nearly all periods and countries in the West since classical times. It is a rich color, and Thompson has remarked (*The Materials of Medieval Painting*, p. 106) how its brilliance increased the color intensity of the palette of mediaeval painters. It demanded bright blues, greens, and yellows to go with it and to complement it. In Far Eastern wall paintings these blues and greens were supplied by azurite and malachite.

Vert Emeraude (see **Viridian**).

Vine Black (see also **Charcoal Black** and **Carbon Black**), which is similar to charcoal, is prepared by carbonizing vine twigs or vine wood. (One kind, so-called, is made from wine lees.) The pigment has a blue hue, and gray tints made with white have a bluish tinge (see Weber, p. 24). Other similar vegetable blacks are made from peach stones, cocoanut shells, cork, etc. Such sources of black are mentioned by Cennino Cennini (see Thompson, *The Craftsman's Handbook*, p. 22).

Viridian (*vert emeraude*, Guignet's green, transparent oxide of chromium) is the transparent, bright green, hydrous oxide of chromium and is usually given the formula, $Cr_2O_3 \cdot 2H_2O$. The anhydrous or dull green, opaque oxide of chromium is also used as a pigment (see **Chromium Oxide Green, opaque**). Viridian is prepared today much as it has been for years, by heating to dull red heat a mixture of an alkali chromate with excess boric acid. After completion of the reduction, the charge is raked into vats containing cold water and let stand to hydrate; it is then washed by decantation, ground wet, washed with hot water to free it from soluble salts, and dried (see Bearn, p. 101). The finished product usually contains boric acid, some of which may be chemically combined with the chromium oxide. The color of the hydrous oxide is a deep, cool green of great purity and transparency. It is a desirable pigment because of its excellent tinting strength and its stability in all mediums. It is unaffected by dilute acids and alkalis and by light; strong heat only causes it to change to the opaque, anhydrous oxide. Viridian is characteristic microscopically; the bright green, transparent particles are quite unmistakable and unlike any other pigment. Usually they are fairly large, irregular in size, slightly rounded, and appear to be fairly strongly birefracting in polarized light. H. Wagner and A. Renc (' Chromoxydhydratgrün,' *Farben-Zeitung*, XLI [1936], pp. 821–823) explain the apparent anisotropy to strain in the particles caused by cooling. The refractive index is moderate.

Viridian is classed as a modern pigment. Although the element, chromium, was discovered by Vauquelin in 1797 and the anhydrous green oxide was then known, it was many years later, in 1838 (Church, p. 194, gives the date), that Pannetier, a color maker in Paris, began to make a beautiful transparent chromium green. He and Binet, who took over the process when Pannetier died, manufactured the

product by a secret method for years. Finally, in 1859 Guignet patented a method for making the hydrous oxide by a process which he described (see Guignet, pp. 149–153) as new and unique and which is the reduction of potassium bichromate with boric acid, outlined above. This new green immediately replaced Schweinfurt green (see **Emerald Green**) for printing and other industrial coloring purposes. It must have been shortly after that time that the transparent oxide of chromium was introduced as an artist's pigment. Laurie says (*New Light on Old Masters*, p. 44) that the date is 1862. Messrs Winsor and Newton, Ltd, state (in their catalogue, 1930, p. 20) that it was originally introduced by their house and they say (in a private communication) that this pigment, as well as aureolin, was popularized by Aaron Penley, a water color painter. Church says (p. 195) that the pigment came to be best known in England by the name, viridian, and that it was unfortunate that it came to be called 'vert emeraude' in France and, hence, confused with the poisonous copper aceto-arsenite or Schweinfurt green, known in England as ' emerald green.'

Weld (arzica) is a natural yellow dyestuff, obtained as a liquid or as a dry extract of the herbaceous plant, Dyer's Rocket, *Reseda luteola*, formerly culti-vated in central Europe. The coloring matter is luteolin or tetrahydroxyflavone, $(C_{15}H_{10}O_6)$. It is extracted with aqueous solutions and may be made into lakes of various shades of yellow with different mordants. Although weld extract has lower tinctorial power than some other natural yellow dyes like quercitron (see **Quercitron Lake**), it yields the purest and the fastest shades of all (*Colour Index*, p. 294). Sparingly soluble in hot water and moderately soluble in alcohol, it gives a deep yellow solution with alkalis. Weld has had a long history as a dye and lake pigment, and Thompson says (*The Materials of Medieval Painting*, p. 187) that it is still cultivated in small quantities in Normandy for dyeing silk.

White Bole (see **Bole** and **China Clay**).

White Lead (flake white, Cremnitz white) is the most important of all the lead pigments; it is the basic carbonate of lead, $2PbCO_3 \cdot Pb(OH)_2$, and ordinarily contains about 70 per cent of lead carbonate and 30 per cent of lead hydrate. Although normal lead carbonate occurs in nature as the mineral, cerussite, it has never been important as a source of white pigment. White lead was known in early times and was one of the first artificially prepared pigments. Theophrastus (pp. 223–225), Pliny (see Bailey, II, 75), and Vitruvius (VII, 12) all describe its preparation from metallic lead and vinegar. There are also numerous mediaeval recipes for making it. A large part of the white lead used today is made by the ' Dutch ' or ' stack ' process, which differs little in principle from the method used in classical and mediaeval periods. Metallic lead in the form of strips, ' buckles,' or other shapes is exposed for about three months in clay pots which have a sepa-rate compartment in the bottom containing a weak solution of acetic acid. The pots are placed in tiers in a shed with spent tan bark or manure separating them. When the building is closed, the combined action of the acetic vapors, heat, and carbon

dioxide from the fermenting tan bark, oxygen of the air, and water vapor slowly transform the lead to basic lead carbonate. After being washed, dried, and screened, the product is ground in linseed oil. Various other processes, including the chamber, electrolytic, and precipitation processes, most of which are more rapid than the Dutch, are also used for preparing white lead.

Although white lead can be purchased in a dry powder form, the greater part of it comes on the market ground to a thick paste with 9 to 10 per cent of linseed oil. Since white lead is a poisonous compound if inhaled as a dust or if ingested, grinding and manufacture into paint was long regarded as a hazardous industry and in several countries it was curbed by legislative action. Now, because of improved factory methods, such dangers are no longer attendant. Painters, however, still suffer from ' painters' colic ' or ' plumbism ' if they are careless with it.

White lead is a very finely divided yet a definitely crystalline compound. At 400× magnification, it can be observed to be highly birefracting. Merwin says (p. 514): ' Individual grains seen in several samples were tabular (perhaps twice as broad as thick) and hexagonal in outline.' The refractive index is high, $\omega = 2.09$. It is commonly understood (see Bearn, p. 45) that the lead hydroxide, $Pb(OH)_2$, part of the white lead molecule, is able, partially, to saponify linseed oil and to form with it a lead soap (lead linoleate). This fact has been used to explain why white lead in oil forms such a homogeneous, durable, hard, and non-porous paint film. (White lead films are conspicuously strong, and their strength extends to all mediums.) It is also given as the reason for the apparent increase in transparency of old white lead films (see Eibner, *Malmaterialienkunde*, p. 121) with the striking through of darker underpainting, sometimes called, ' *pentimento.*'

The siccative or drying action of white lead upon oils is another reason for its being so widely used. Pure white lead in oil is favored as an outside white paint because it chalks on weathering (does not check or crack) and leaves a satisfactory surface for repainting. On indoor exposure, however, it has a tendency to yellow, particularly in the dark. It is darkened, even blackened, by contact with sulphide pigments and hydrogen sulphide in the air because of the formation of black lead sulphide. When protected by oil or varnish films, this reaction is very slow and the effect may be negligible. In fact, white lead is commonly seen in paintings where it has been mixed with vermilion (HgS), ultramarine, and other sulphur-bearing pigments for centuries without any sign of incompatibility. With impure pigments that bear free sulphur, however, a darkening effect may be quickly noticed. In water color films, it is often seriously blackened. When heated at a moderate temperature, white lead turns bright yellow because of the formation of massicot (lead monoxide, PbO); higher temperatures melt the massicot and change it to litharge and even further oxidize it to red lead. White lead is readily soluble in dilute mineral acids and in acetic acid with effervescence (CO_2). There is perhaps no question that, so far as general use is concerned, white lead is the most important pigment in the history of Western painting. It is practically the only

white used on easel paintings from remote antiquity to the XIX century. Radiography of old paintings rests to a great extent upon the generous use of white lead in the past: since lead has a high atomic weight, it has a high mass absorption coefficient for Roentgen rays (see De Wild, pp. 92–98). Its first use as a paint pigment must have been very early. It is not mentioned extensively, however, by either Partington or Lucas in their accounts of the materials of the Egyptian and other early civilizations. It must have been used in classical times for painting pictures as well as for cosmetic purposes. It has been identified as a pigment on Fayum portraits (see George L. Stout, ' The Restoration of a Fayum Portrait,' *Technical Studies*, I [1932], p. 86), and was probably known and used as a pigment in the Orient quite as early as in the West. It lies thickly on painted sculpture of Tang times from Tun Huang in Western China. In Europe, hardly an important painting, before the XIX century, is without it. De Wild has listed (pp. 34–39) over 80 paintings in which it occurs.

Although white lead has been used in tempera and in water color, it is not so satisfactory in these mediums as in oil. Today its place in water color has been largely taken by zinc white (Chinese white), and in oil it is meeting serious competition from the titanium pigments. The pigment is sold to the artist under the name, ' flake white.' Cheaper grades are sometimes ' cut ' or adulterated with barite or blanc fixe.

Cremnitz (Kremnitz) white is a special kind of white lead which is prepared by the action of acetic acid and carbon dioxide on litharge. It is now greatly favored by artists because it is considered to be whiter, denser, and more crystalline than ordinary, Dutch process white lead.

Whiting (see **Chalk**).

Woad is a blue dye very similar to indigo (see **Indigo**) which is obtained from the leaves of the woad plant, *Isatis tinctoria*, a herbaceous biennial indigenous to southern Europe. Before the importation of indigo in the XVII century, it was widely cultivated in England and on the Continent for its dye (see J. B. Hurry, *The Woad Plant and its Dye* [London: Oxford University Press, 1930]), which is extracted by a fermentation process similar to that used with indigo. Although the coloring principle of woad was formerly thought to be the same as that of indigo, it is now known to be a distinct substance (see Perkin and Everest, pp. 524–525). Woad blue was apparently used in mediaeval times for a pigment as was indigo (see Thompson, *The Materials of Medieval Painting*, pp. 135–140). It is quite impossible to distinguish between the two when they occur as pigments in old paintings.

Yellow Berries (see **Persian Berries Lake**).

Yellow Lake (see **Quercitron Lake**).

Yellow Ochre (see **Ochre**).

Zinc Green (see **Cobalt Green**).

Zinc White (Chinese white), or zinc oxide (ZnO), has now almost the impor-

tance of white lead as an artist's pigment. Neither zinc oxide nor metallic zinc seem to have been known as individual substances in the ancient world, though certain zinc ores were used in making brass. Zinc was first described as an element by Margraaf, a German chemist, in 1746. Although the use of the oxide, as a substitute for white lead, was first suggested by Courtois of Dijon in 1782 (see Rose, p. 84), more than 50 years passed before it became commercially available. According to Church (p. 134), as early as 1834 a peculiarly dense form of zinc oxide was introduced as a water color pigment by Messrs Winsor and Newton, Ltd, of London, under the name, ' Chinese white ' (see also Winsor and Newton's catalogue, 1930 ed., p. 15). The chief difficulty in the way of its commercial use at that time was its poor drying qualities in linseed oil. In the years 1835–1844, Leclaire in France showed that this difficulty could be overcome by using with the zinc oxide an oil that had been rendered siccative by boiling with pyrolusite (MnO_2), and in 1845 he began, near Paris, to produce zinc oxide on an industrial scale. By 1850, it was regularly made as an oil paint. De Wild says (p. 40) that the first trial orders of such paint, from the firm of Hafkenscheid in Amsterdam, were in 1854.

In the French process of manufacture zinc vapor, from molten metallic zinc, is burned in an oxidizing atmosphere at a temperature of about 950° C., and the fumes of white oxide are collected in a series of chambers. In the American or direct process, zinc ores, principally sphalerite (zinc blend, ZnS), are mixed with coal coke and burned, and the white smoke of zinc oxide is collected in suitable chambers. In either process the occurrence of such impurities as metallic zinc, soot, and other metallic oxides can seriously impair the general quality and whiteness of the product. So-called ' leaded zinc oxides,' which are made by the direct oxidation of lead-bearing zinc ores, contain several per cent of lead sulphate. Dry zinc white comes on the market in various qualities and degrees of whiteness. ' White seal ' and ' green seal ' zinc white contain over 99 per cent zinc oxide; the latter has the better hiding power. ' Red seal ' and ' gold seal ' are understood to be slightly less pure, and ' gray seal ' zinc white contains metallic zinc.

Zinc oxide is a pure, cold white. In the dry state it is lighter and more bulky than white lead. It is non-poisonous but is a mild antiseptic. It requires more oil (18 to 20 per cent) to form a paste than white lead. It has a tendency eventually to dry brittle and to crack. Mixtures of zinc oxide and white lead combine the advantages of both pigments.

As would be expected, since zinc oxide originates as a smoke, it is very finely divided and separate grains are difficult to observe except at high magnifications. Merwin says (p. 506) that the pigment from zinc vapor (French process) has a grain size much less than 1μ in diameter. The refractive index ($\omega = 2.00$ [Merwin]) is about the same as white lead but, unlike the latter, is little birefracting. In ultra-violet light, the oxide appears bright yellow. It is not affected by strong sunlight. It is readily soluble in dilute alkalis. Although it can react with hydro-

gen sulphide to form zinc sulphide, it is not darkened, because zinc sulphide itself is white (see **Lithopone**) and, for this reason, the oxide has been an important pigment for use where industrial atmospheres are prevalent. It is claimed to be a mildew inhibitor for outside paints (see H. A. Gardner, L. P. Hart and G. G. Sward, ' Mildew Prevention; Fourth Report on Investigation with Conclusions and Recommendations,' *Circular no. 475, National Paint, Varnish and Lacquer Association* [January, 1935]). Zinc white, more than some other whites, seems to accelerate the fading of certain coal tar colors that are mixed with it in tints and exposed to strong sunlight. It has been widely used in paintings since the middle XIX century. It continues to be popular for water color under the name, ' Chinese white,' but it is also sold to artists in an oil paste.

Acicular zinc oxide is a special form in which the particles are needle-shaped and crossed and joined in pairs to form X's. It has greater hiding power and whitening strength than ordinary zinc oxide which contains mostly rounded particles.

Zinc Yellow is zinc chromate, $ZnCrO_4$, which is made artificially by adding a hot solution of potassium dichromate to a solution of zinc sulphate. The pigment has a bright, clean, lemon-yellow shade, much like strontium chromate. It lacks the body and strength of lead chromate yellow. Since, however, it is not poisonous and is not darkened by hydrogen sulphide gas, it has found favor for special uses. It is partially soluble in water and this behavior has somewhat limited its use It is also readily soluble in dilute mineral acids and in acetic acid, but is not affected by dilute alkalis. It is not very permanent to light, having a tendency to turn gray-green caused by the formation of chromic oxide. Microscopically, it may be observed to consist of tiny spheroidal grains which have strong bire-fringence. It has only a moderately high refractive index ($n = 1.84$–1.90 [Mer-win]). Little is known about the occurrence of zinc yellow in paintings. It was discovered by Vauquelin in Paris in 1809, but was not produced as a commercial pigment until after 1850 (Trillich, III, 55). Apparently it has only been used as an artist's color in recent years, and for this purpose only in oil and water color mediums (see Weber, p. 133).

Zinnober Green is a term ordinarily synonymous with chrome green (see **Chrome Green**) which is a processed mixture of chrome yellow and Prussian blue. More specifically, it is given to mixtures that are olive in hue.

BIBLIOGRAPHY

Anonymous, *Merck's Index*, 4th ed. (Rahway, N. J.: Merck and Co., 1930).

K. C. Bailey, *The Elder Pliny's Chapters on Chemical Subjects* (London: Edward Arnold and Co., Part I, 1929; Part II, 1932).

NORMAN F. BARNES, 'A Spectrophotometric Study of Artists' Pigments,' *Technical Studies*, VII (1939), pp. 120–138.

J. G. Bearn, *The Chemistry of Paints, Pigments, and Varnishes* (London: Ernest Benn, Ltd, 1923).

John Beckmann, *A History of Inventions, Discoveries, and Origins*, 4th ed., 2 vols (London, 1846).

Ernst Berger, *Beiträge zur Entwicklungsgeschichte der Maltechnik*, 4 vols (Munich: G. D. W. Callwey, 1901–1912).

Godfrey L. Cabot, 'Lamp Black and Carbon Black,' *Eighth International Congress of Applied Chemistry*, XII (1912), pp. 13–31.

M. Chaptal, 'Sur quelques couleurs trouvées à Pompeïa,' *Annales de Chimie*, LXX (1809), pp. 22–31.

A. H. Church, *The Chemistry of Paints and Painting*, 3d ed. (London: Seely, Service and Co., 1901).

F. W. Clarke, 'The Data of Geochemistry,' 5th ed., *Bulletin no. 770, U. S. Geological Survey* (Washington D. C.: Government Printing Office, 1924).

Colour Index, edited by F. M. Rowe (Bradford, Yorkshire: Society of Dyers and Colourists, 1924).

E. J. Dana, *A Textbook of Mineralogy*, 3d ed. by W. E. Ford (New York: John Wiley and Sons, 1922).

Sir Humphrey Davy, 'Some Experiments and Observations on the Colours Used in Painting by the Ancients,' *Philosophical Transactions*, CV (1815), pp. 97–124.

Max Doerner, *The Materials of the Artist and Their Use in Painting*, trans. (New York: Harcourt, Brace and Co., 1934).

A. Eibner, *Entwicklung und Werkstoffe der Wandmalerei* (Munich: B. Heller, 1926). *Malmaterialienkunde als Grundlage der Maltechnik* (Berlin: J. Springer, 1909).

H. A. Gardner, *Paints, Varnishes, Lacquers and Colors*, 8th ed. (Washington, D. C.: Institute of Paint and Varnish Research, 1937).

Rutherford J. Gettens, 'The Materials in the Wall Paintings of Bāmiyān, Afghanistan,' *Technical Studies*, VI (1938), pp. 186–193.
'The Materials in the Wall Paintings from Kizil in Chinese Turkestan,' *Technical Studies*, VI (1938), pp. 281–294.
'Pigments in a Wall Painting from Central China,' *Technical Studies*, VII (1938), pp. 99–105.

Ch.-Er. Guignet, *Fabrications des Couleurs* (Paris, 1888).

Ingo W. D. Hackh, *A Chemical Dictionary* (Philadelphia: P. Blakiston's Son and Co., 1929).

A. W. C. Harrison, *The Manufacture of Lake and Precipitated Pigments* (London: Leonard Hill, Ltd, 1930).

H. Kopp, *Geschichte der Chemie*, 4 vols (Braunschweig, 1843–1847).

R. B. Ladoo, *Non-Metallic Minerals* (New York: McGraw-Hill Book Co., 1925).

E. S. Larsen and H. Berman, 'The Microscopic Determination of the Non-Opaque Minerals,' *Bulletin 848, U. S. Department of the Interior, Geological Survey* (1934).

A. P. Laurie, 'The Identification of Pigments Used in Painting at Different Periods, with a Brief Account of Other Methods of Examining Pictures,' *The Analyst*, LV (1930), pp. 162–179.

'Materials in Persian Miniatures,' *Technical Studies*, III (1935), pp. 146–156.

The Materials of the Painter's Craft (Philadelphia: J. B. Lippincott Co., 1911).

New Light on Old Masters (London: The Sheldon Press, 1935).

The Painter's Methods and Materials (Philadelphia: J. B. Lippincott Co., 1926).

The Pigments and Mediums of the Old Masters (London: Macmillan and Co., Ltd, 1914).

A. Lucas, *Ancient Egyptian Materials and Industries*, 2d ed. (London: Edward Arnold and Co., 1934).

A. Maerz and M. Rea Paul, *A Dictionary of Color* (New York: McGraw-Hill Book Co., 1930).

R. C. Martin, *Glossary of Paint, Varnish, Lacquer and Allied Terms* (St Louis: American Paint Journal Co., 1937).

Joseph Meder, *Die Handzeichnung, ihre Technik und Entwicklung* (Vienna: Anton Schroll and Co., 1919).

J. W. Mellor, *A Comprehensive Treatise on Inorganic and Theoretical Chemistry*, 16 vols (London: Longmans, Green and Co., 1922–1937).

M. P. Merrifield, *Original Treatises on the Arts of Painting*, 2 vols (London: John Murray, 1849. To be reprinted by Dover Publications in 1966).

H. E. Merwin, 'Optical Properties and Theory of Color of Pigments and Paints,' *Proceedings of the American Society for Testing Materials*, XVII (1917), pp. 494–530.

C. Ainsworth Mitchell, *Inks: Their Composition and Manufacture* (Philadelphia: J. B. Lippincott Co., 1937).

J. R. Partington, *Origins and Development of Applied Chemistry* (London: Longmans, Green and Co., 1935).

A. G. Perkin and A. E. Everest, *The Natural Organic Colouring Matters* (London: Longmans, Green and Co., 1918).

W. M. Flinders Petrie, *Medum* (London, 1892); Chap. VIII by W. J. Russell, 'Egyptian Colours,' pp. 44–48.

E. Raehlmann, *Über die Maltechnik der Alten* (Berlin: Georg Reimer, 1910).

Friedrich Rose, *Die Mineralfarben* (Leipzig: Otto Spamer, 1916).

F. C. J. Spurrell, 'Notes on Egyptian Colours,' *The Archaeological Journal*, LII (1895), pp. 222–239.

Theophilus, *An Essay Upon Various Arts*, trans., with notes, by Robert Hendrie (London, 1847).

Theophrastus's History of Stones, trans. by Sir John Hill (London, 1774).

Daniel V. Thompson Jr, *Il Libro dell'Arte, The Craftsman's Handbook of Cennino d'Andrea Cennini*, 2 vols (New Haven: Yale University Press, 1932-1933. Reprinted in 1 volume by Dover Publications, 1954).

The Materials of Medieval Painting (London: George Allen and Unwin, Ltd, 1936).

'Trial Index for Mediaeval Craftsmanship,' *Speculum*, X (1935), pp. 410–431.

Edward Thorpe, *A Dictionary of Applied Chemistry*, 7 vols (London: Longmans, Green and Co., 1921–1927).

Maximilian Toch, *The Chemistry and Technology of Paints*, 3d ed. (New York: D. Van Nostrand Co., 1925).

Paints, Painting and Restoration (New York: D. Van Nostrand Co., 1931).

Heinrich Trillich, *Das Deutsche Farbenbuch*, Parts I–III (Munich: B. Heller, 1923).

Rokuro Uyemura, 'Studies on the Ancient Pigments in Japan,' *Eastern Art*, III (1931), pp. 47–60.

Vitruvius, *The Ten Books on Architecture,* trans. (Cambridge: Harvard University Press, 1926. Reprinted by Dover Publications, 1960).

F. W. Weber, *Artists' Pigments* (New York: D. Van Nostrand Co., 1923).

Mary Elvira Weeks, *The Discovery of the Elements* (Easton, Pa: Mack Printing Co., 1934).

A. M. de Wild, *The Scientific Examination of Pictures*, trans. (London: G. Bell and Sons Ltd, 1929).

SOLVENTS, DILUENTS, AND DETERGENTS

Absolute Alcohol (see **Alcohol**).

Acetone (dimethyl ketone [CH_3COCH_3]). As the most important member of the ketone group of solvents, this has been known since the early XIX century. Formerly it was obtained to a large extent from the dry distillation of calcium acetate which, in its turn, was a by-product of wood distillation. Now acetone comes as a by-product from the fermentation of molasses or corn mash in the production of **n-Butyl Alcohol** and is also made synthetically. The liquid is clear and boils at 56.1°C. The odor is strong and rather sweet. Acetone is completely miscible with water and with most organic liquids. Industrially, it is perhaps the most generally used of the low-boiling solvents because of its solvent strength and its low cost. It dissolves cellulose nitrate, other cellulose derivatives, synthetic resins of the glyceryl phthalate, thio-urea, and vinyl types, the natural soft resins, and certain waxes. Fossil resins dissolve in it to a large extent, and shellac to more than 80 per cent. It is miscible in all proportions with linseed, tung, and polymerized oils.

Since acetone is miscible with water, oils, and most solvents, it makes a good coupling agent for combining immiscible fluids. It is an important ingredient of neutral paint removers because of its action on resins and on linoxyn (oxidized linseed oil). Used in excess with lacquer and varnish films, it may cause them to blush, especially in humid weather; this is from condensation of moisture within the film when rapid evaporation of solvent cools the surface. Acetone is only mildly toxic and is safe to use in well ventilated places, though its vapors are highly flammable. (See L. C. Cooley, 'Acetone,' *Industrial and Engineering Chemistry*, XXIX [1937], pp. 1399–1407.)

Alcohol (Cologne spirits, grain alcohol, ethyl alcohol, ethanol [C_2H_5OH]). The second in the series of monohydric alcohols is inexpensive when obtainable tax-free, yet is the purest and probably the most useful of the organic solvents. It acts readily on almost all natural resins, including shellac, and on many of the synthetic compounds that serve as film materials in painting, but it is comparatively inactive on the drying oils and quite inactive on waxes and aqueous mediums. The liquid is clear and volatile, boiling at 78.3°C.; vapor pressure at 20°C. is 44 mm. Alcohol is miscible in all proportions with water and with most organic liquids and is a solvent for some inorganic substances like sodium hydroxide.

The preparation of alcoholic beverages by fermentation from grains and fruits can be traced to ancient times. A. Lucas (*Ancient Egyptian Materials and Industries* [London: Edward Arnold and Co., 1934], p. 23) says that although the ancient Egyptians made beer and wine, they were not acquainted with the process of distillation and had no distilled spirits. According to him, also, it is the general belief that distilled spirits were not known until the Middle Ages, the first use of them being for the preparation of medicine. E. O. von Lippmann (*Beiträge zur Geschichte der Naturwissenschaften und der Technik* [Berlin: Julius

185

Springer, 1923], pp. 56–126) corroborates this by concluding that alcohol was not the discovery of the Alexandrian or Arabian alchemists, but first became known probably in the XI century and in Italy. He finds the first mention of it in the *Mappae Clavicula*, a MS. of the XII century, and a later one in the MSS of the so-called 'Marcus Graecus' which date from 1250 to 1300. Other Italian writers of the XIII century speak of its medicinal value. Its use spread rapidly after the Great Plague of 1340 (see G. Sarton, *Introduction to the History of Science* [Baltimore: The Williams and Wilkins Co., 1927], I, 533–534; II, 29, 130, 408, 1038–1039). It is said (see Samuel Couling, *The Encyclopaedia Sinica* [London: Oxford University Press, 1917], under 'Wine') that distillation of alcoholic spirits was first introduced into China in the Yuan Dynasty (XIII century).

The name has an Arabic origin, the particle *al* and the word *kohl*, a term used for centuries to designate any fine powder, particularly an eye paint from antimony sulphide. Its application to a volatile liquid, especially the spirit of wine, seems to have been made by Paracelsus in the early XVI century. Before that the terms *aqua ardens* in the Middle Ages and *aqua vitae* in the Renaissance, were commonly given to it.

Although much alcohol is made synthetically, most of that used in industry is still the product of the fermentation of sugar, or of natural carbohydrates which yield sugar, by enzymic action. Cane sugar and beet sugar molasses are the principal sources, but cereals like wheat, barley, and corn, and also potatoes, are likewise important. The Weizmann process for production of butyl alcohol by fermentation of corn starch yields about 10 per cent of ethyl alcohol as a by-product. Alcohol from fermentation has to be concentrated and separated from water and similar impurities by distillation and rectification. This is done in high columnar stills where the vapors condense on baffle plates and are redistilled with progressive enrichment. Industrial alcohol has about 5 per cent of water and can not practically be purified further by distillation because alcohol and water form a constant boiling mixture when the distilled vapors contain 97.2 per cent alcohol by volume.

Synthetic ethyl alcohol, marketed as 'ethanol,' is now made in quantity from ethylene gas, obtained from the cracking of petroleum, or is made from acetylene. This is identical in composition and properties with alcohol derived from fermentation.

Absolute or anhydrous alcohol is ethyl alcohol free from water. This is 200 proof (100 U. S. proof contains 50 per cent alcohol; proof spirit [U. S.] has 42.52 per cent by weight of absolute alcohol in distilled water). The 5 per cent of water left in the alcohol that comes from straight distillation can be removed in order to make absolute alcohol by a special process (Keyes) of azeotropic distillation with benzene or by redistillation over quicklime or over a hydrate-forming salt. Now it is made industrially in large quantities and at a fairly low cost. Absolute alcohol is

preferable as a lacquer solvent because it is miscible with a wider range of solvents than is the usual industrial product and because it is not so likely to cause bloom. Unlike the ordinary alcohol, it is miscible with turpentine and benzene. It is, however, strongly hygroscopic and does not remain anhydrous unless carefully protected from the air.

Alcohol probably came first into use as a paint material for the preparation of spirit varnishes—soft resins in a suitable solvent. The slight literature that exists in connection with the restoration of pictures mentions it as a solvent to be used for the removal of old varnish film. The softening and gelation caused by alcohol vapors on varnish films is the basis of the so-called ' Pettenkofer process ' formerly used for the regeneration of paintings (see Max von Pettenkofer, *Über Ölfarbe und Konservierung der Gemälde-Galerien durch das Regenerationsverfahren* [Braunschweig, 1870]; also Eibner, pp. 449–452). In this process the painting was put in a sealed chamber with alcohol vapors. The solvent vapors coalesced the edges of the cracks of the varnish film, made that film continuous, and gave it added transparency and the appearance of a revarnished surface. Sometimes copaiba balsam was first applied and was driven into the film by the vapors. The assertion is frequently made that alcohol is a strong solvent for oil paint, but the description of the oil paint is not given. Possibly action on immature films or films containing some amount of resin as an admixture have been the basis for this belief, although it remains to be categorically denied.

Ammonia (NH_3) and **Ammonium Hydroxide** (NH_4OH). The colorless gas is very soluble in water. Concentrated ammonia water is 28 to 29 per cent NH_3 and has a specific gravity of 0.90. It is also very soluble in alcohol. It goes out of solution much more rapidly than the fluid evaporates until, in the case of water, the concentration of dissolved ammonia falls to 6.1 per cent. There the evaporation rate is the same for both and the gas can be expelled from the water only by heating. In water the solution is alkaline, and takes the name, ammonium hydroxide. Because of alkalinity, it neutralizes acids and forms ammonium salts. It is a weak alkali, however, and the weakness seems to come from its low ionization. A dilute solution has certain uses because it provides a weak alkali which leaves no residue on evaporation of the water. The presence of the dissolved gas lowers the surface tension of water and allows it more readily to wet surfaces and to penetrate into fabrics or other rough textures. The mild alkali properties enable it to cut thin films of oil and grease. The presence of the dissolved gas in the mixture of water with organic solvents acts rapidly on fatty or greasy materials and can be used occasionally with safety in removal of them from surfaces of paintings. As a rule, however, the water content of such a mixture is dangerous, even if the alkalinity does not threaten the preservation of the linoxyn film.

As ammonium carbonate, a white solid called *spiritus salis urinae*, it was known to the early alchemists. Another name for it was ' spirit of hartshorn,' because it was obtained from the dry distillation of hoofs, bones, and horns. This, in effect, was the only volatile form known up to about the XVIII century. Ammonium

chloride (sal ammoniac or sal ammoniacum), a fixed salt of ammonium, was, however, known to the ancients. The gas (NH_3) was first isolated by Joseph Priestly, English chemist and discoverer of oxygen, in 1774. Until recently, industrial ammonia was a by-product of coal through dry distillation in gas works and coke ovens. Now it is made synthetically from hydrogen and nitrogen.

 Amyl Acetate ($CH_3COOC_5H_{11}$). At one time this ester of acetic acid and amyl alcohol was prepared in large quantities from fusel oil, a residue obtained from the rectification of alcohol. A more uniform product is made synthetically. It is a clear liquid, with a penetrating odor (giving it the common name, banana oil), which is overpowering in high concentrations. The boiling point is 148°C. and the flash point is high, 77°C. In 1882 it was introduced as a solvent for cellulose nitrate and for many years continued to be the leading solvent for that material. Now it is largely replaced by butyl acetate. The amyl acetate is a good solvent for many resins and is miscible with linseed oil. It mixes with water only very slightly. Much of the synthetic product, composed of five isomeric amyl acetates, is sold as Pentacetate. There is no record of experimental data on the action of this long-standing solvent on resin and linoxyn films.

 Amines (see **Solvents, classification**).

 Banana Oil (see **Amyl Acetate**).

 Benzene (benzol) is the simplest of the aromatic series of organic compounds. This is a hydrocarbon with the formula, C_6H_6, and is usually represented as having the ring or cyclic structure shown below. It is a clear, colorless liquid, with a

peculiar odor. It boils at 80° to 81°C., is highly flammable, and, being an unsaturated compound, it burns with a sooty flame. It is miscible with most organic solvents but practically not with water.

 The benzene of commerce is largely obtained by the destructive distillation of coal tar, and the bulk of it comes over in the first or ' light oil ' fraction. This is further fractionated to give the industrial product commonly known as benzol, a mixture of about two thirds benzene with one third toluene and other benzene homologues. Among impurities, it contains thiophene, a sulphur compound, and pyridine. Further fractional distillation of benzol and special chemical treatment to remove impurities, combined with filtration and crystallization below 5.5°C. (its solidifying point) yields the pure benzene.

 The toxicity of its vapor prevents benzene from being widely used in coating and cleaning compounds, though it is an effective solvent for a wide variety of

materials, including some cellulose derivatives. Prolonged exposure to the vapor affects the blood, producing both anaemia and leucopenia, the symptoms being headache and general lassitude, and if exposure is excessive, it leads to delirium and final death (see Hamilton, pp. 156–165).

Benzine (petroleum spirit). This name is now being discarded because of its confusion with benzene, a coal-tar product. It is still given to a volatile petroleum distillate similar to gasoline. At times the word is applied indiscriminately to various petroleum fractions below kerosene.

Benzol is the commercial name for the coal-tar distillate, **Benzene,** containing also toluene and other benzene homologues.

n-**Butyl Acetate** ($CH_3COOC_4H_9$). One of the recent developments of the solvent industry, this ester of butyl alcohol and acetic acid is a clear, stable liquid with strong ethereal odor. When pure, it boils at 126.5°C., but the commercial product is only about 85 per cent pure. Unlike the lower esters, it is not hygroscopic and, hence, does not hydrolyze and become acid. It mixes in all proportions with benzene and many other organic solvents, but is only slightly miscible with water. The solvent action is strong on cellulose nitrate, other cellulose plastics, and synthetic resins. The low rate of evaporation prevents blush and gives a good flow to such mixtures. In the lacquer industry it has largely displaced amyl acetate. The vapors are not toxic. Secondary butyl acetate and isobutyl acetate, prepared from isomers of butyl alcohol, are also available commercially, and their properties are little different from those of the normal acetate.

n-**Butyl Alcohol** (butanol [C_4H_9OH]) may be prepared in four isomeric forms, but the normal alcohol is the most important. The Weizmann process brought it out on a commercial scale during the war of 1914–1918 when it was derived as a by-product of acetone in the fermentation of corn mash by a specially developed bacillus. Somewhat later its value as a lacquer solvent was recognized and its production became the chief purpose of the Weizmann process. It is separated from the other solvents, acetone, ethyl alcohol, higher alcohols, and fatty acids, and is purified by distillation. Little has been done to record experimentally its action on the film materials of artists' paint and varnish. Very limited observations make it seem that the solvent properties of butyl alcohol are somewhat stronger than those of ethyl alcohol.

It is not miscible with water in all proportions but only to the extent of 7.7 per cent at 20°C. and mixes with most organic solvents. It is able, moreover, to promote miscibility in other mixtures like that of benzene, petroleum naphtha, and ethyl alcohol. Commercially, it is said to have a good solvent action on hard copal and on shellac. Its boiling range is 110° to 118°C. It evaporates at a moderate rate, is not hygroscopic, and, since it does not incline towards blush, is a favorite solvent for synthetic lacquers. It is said to be a good solvent for metallo-organic driers like lead and cobalt linoleates, and to have an effective solvent action on linoxyn and other oxidized oil films. The vapors of butyl alcohol are distressing

and have a toxic effect if inhaled for any considerable period. They are com-
bustible but not highly flammable.

Butyl Cellosolve (see **Ethylene Glycol Monobutyl Ether** and **Glycol Ethers**).

Butyl Lactate. This solvent ($CH_3 \cdot CHOH \cdot COO \cdot C_4H_9$), an ester of butyl
alcohol and lactic acid, is very slow to evaporate and, for that reason, has certain
special uses. Herbert E. Ives and W. J. Clarke (' The Use of Polymerized Vinyl
Acetate as an Artist's Medium,' *Technical Studies*, IV [1935], pp. 36–41) suggest
it as a solvent for vinyl acetate when that is used as a painting medium. When
pure, it is colorless, but commercial varieties have a brown tint. It is only slightly
miscible with water (3.4 per cent at 25°C.) but is miscible with most organic
solvents. Toch says (p. 91) that butyl lactate added in small amounts to tur-
pentine acts as a good cleaning agent for old paintings.

Carbon Disulphide (carbon bisulphide [CS_2]). The only important industrial
solvent of this type containing sulphur, this is a volatile liquid which boils at
46.3°C. and is heavy (sp. gr. 1.263). It was discovered in 1796. The commercial
product, made by the direct union of carbon and sulphur at dull red heat, is
slightly yellow in color and has a disagreeable odor caused by impurities of other
organic sulphur compounds. It mixes with most organic solvents but only slightly
with water. The flash point is -20°C.; it is highly flammable and forms explosive
mixtures with air. It can be spontaneously ignited by contact with objects at
150°C.; even contact with a warm steam pipe or electric lamp bulb may be suffi-
cient to cause ignition of the vapor. Because of this, it is about the most dangerous
solvent in commercial use. Its vapors, moreover, are strongly toxic. Although it is
a good solvent for oils, fats, waxes, rubber, and a number of resins, safer materials
are now taking its place.

Carbon Tetrachloride (tetrachlormethane [CCl_4]) may be regarded as meth-
ane, in which all the hydrogen atoms have been replaced by chlorine. Prepared
by the chlorination of carbon disulphide, this is a clear liquid with an odor similar
to that of chloroform, a high specific gravity (1.629), and a boiling point of 77°C.
Because it is non-flammable, it has a unique place among organic solvents and is
miscible with most of them. Solvent action on oils and soft resins is good and it is
frequently mixed with other solvents to cut down the fire hazard. A disadvantage
is that at slightly elevated temperatures it reacts slowly with water to form
hydrochloric acid. At moderate temperatures it is stable to water and to light.

Cellosolve is a trade name for ethylene glycol monoethyl ether, and the name
is used with qualifying adjectives like methyl, butyl, etc., to designate several
other closely related derivatives of ethylene glycol (see **Glycol Ethers**).

Cellosolve Acetate (see **Ethylene Glycol Monoethyl Ether Acetate** and **Glycol
Ethers**).

Chlorinated Hydrocarbons (see **Solvents, classification**).

Chloroform (trichlormethane [$CHCl_3$]), a clear, colorless liquid, with a charac-
teristic sweetish odor, and a boiling point of 61°C., is prepared by the action of

bleaching powder on alcohol or crude acetone. Although rapidly volatile, the vapors can be ignited only with difficulty. Mixed with alcohol, it is a good solvent for cellulose acetate and, alone, is active on most resins, but it has little use commercially. In all proportions it is miscible with most of the organic solvents and with vegetable and mineral oils. When allowed to stand for a long time in the light, it will slowly react with moisture to form hydrochloric acid and phosgene, but if 1 per cent of alcohol is added, its decomposition is hindered. Chloroform was discovered in 1831 by Liebig and Soubeiran, and its use as an anaesthetic in 1848 by an Englishman, Simpson.

Coal-Tar Hydrocarbons (see **Solvents, classification**).

Denatured Alcohol. Addition of poisonous or distasteful material to ethyl alcohol so that it can not be safely used in the concoction of beverages, gives it this name. The Bureau of Internal Revenue, Treasury Department of the United States, in the Appendix to Regulations, no. 3, *Formulae for Completely and Specially Denatured Alcohol*, 1938, specifies the use of such materials as gasoline, aliphatic isoalcohols, methyl isobutyl ketone, and organic hydrogenated materials in three formulas for completely denatured alcohol which can be used without restriction of sale. There are also given many special denaturing formulas employing such materials as methyl alcohol, benzol, ether, pyridine, animal oil, acetone, and others, but such specially denatured alcohol can only be used under close government regulation.

Detergent. Broadly this can be taken to mean any cleansing agent or anything that aids in cleaning. Although soap has long been the common detergent in the past, a large number of special materials has been developed recently for this purpose. The most important is that group of compounds known as the sulphated alcohols. These are sodium sulphuric esters of straight-chain fatty alcohols ranging from eight to eighteen carbon atoms and higher. The cleansing action of any detergent is caused by its ability to wet completely particles of dirt and to disperse or deflocculate them and keep them in suspension so that they can be rinsed away. (See **Surface-Active Agent**; also R. A. Duncan, ' The New Detergents,' *Industrial and Engineering Chemistry*, XXVI [1934], pp. 24–26.)

Diacetone Alcohol. When pure, this keto-alcohol, $(CH_3)_2C(OH)CH_2COCH_3$, is a colorless liquid having a mint-like odor. It is made by the condensation of acetone, and the commercial grade contains some uncondensed acetone and some mesityl oxide. There is no sharp boiling point for diacetone alcohol; it distills between 130° and 180°C., about 85 per cent between 150° and 170°. It may contain a trace of acetic acid, but the acidity should not exceed 0.02 per cent. It is not miscible with the petroleum hydrocarbons but mixes completely with water and with most organic solvents. The low vapor pressure (3.3 mm. Hg at 20°C.) and low evaporation rate make it useful as an ingredient to retard the drying of varnishes, to make them brush more easily, and to prevent blush. General experience with it seems to indicate that its solvent action on dried

varnishes is about like that of ethyl alcohol. It is a good solvent for cellulose acetate. Toch says (p. 91) that diacetone alcohol is one of the most important restoring agents for paintings because of its miscibility with other solvents, its slow evaporation, and its ability to coalesce the crackle on old varnish films.

Dibutyl Phthalate ($C_6H_4[COOC_4H_9]_2$) is the most widely used chemical plasticizer for commercial lacquers. A colorless liquid, it has a boiling point between 200° and 216°C. and a flash point of 160°C. It is made by the direct action of butyl alcohol on phthalic anhydride and has a high degree of stability, being only very slightly volatile. Amounts equalling or exceeding the solids content are used in compounding commercial lacquers. Although the films that contain it remain plastic for a long time, they eventually lose it, with a consequent hardening. Gardner (p. 419) reports experiments in which it was found that a film of 2 parts nitrocellulose and 1 part dibutyl phthalate lost only 0.98 per cent of the plasticizer after baking for 20 hours at 50°C. It is light-stable but yellows very slightly on long standing. On a number of resins, including mastic, it has some solvent action. Other alkyl esters of phthalic acid are used as plasticizers—diethyl phthalate, diamyl phthalate, and dimethyl glycol phthalate.

1,2-Dichlorethane (see **Ethylene Dichloride**).

Diluent. In its broad meaning this is any material added to a paint or varnish to make it thin and easily applied. More specifically with respect to varnishes and lacquers, it is an added liquid which by itself would not serve as a solvent for the film material. As such, it can be put into the mixture only to a limited extent without causing precipitation of the solid. The amount of diluent that is tolerated in combinations of film materials and solvents is called ' the dilution ratio.' No film material can be properly called a ' diluent.' Whether or not a completely volatile fluid is a diluent or a solvent depends entirely on its relation to a particular solid. If the fluid is capable of dispersing all or part of that solid and holding it as so much suspended matter, then that fluid is a solvent for that solid. If it can not do this but is in some degree miscible with a solution formed by another fluid, it is a diluent. Turpentine, for example, is a solvent for mastic resin but is only a diluent to a small extent for solutions of certain synthetic resins. Petroleum naphtha is a solvent for dammar resin but is only a diluent within limited proportions for solutions of mastic.

Dioxane (1,4-dioxane $[O : (CH_2CH_2)_2 : O]$) is a cyclic diether. The boiling point is 101.5°C. and the liquid is colorless and stable, with a faint ethereal odor. It is made by distilling ethylene glycol with sulphuric acid. Completely miscible with water and with most organic solvents, it has itself a high solvent strength for natural and synthetic resins, and also for oils, fats, and waxes. Like ether, it is much used in the extraction of ethereal oils, but since it has a relatively low volatility, it is much more useful in the removal of old surface films, especially those in which a wax or partly dried oil is present. The vapors are explosive, and

there are some indications of toxicity. Oil-soluble dyes dissolve in dioxane, but those which are usually spirit- or water-soluble are only partially affected by it.

Distillate. This name, given to a liquid that is condensed from its vapors, covers most of the organic solvents. In distillation a liquid is purified by being heated to the boiling point, the vapors then being condensed and collected. Fractional distillation is the slow distillation of a mixture of substances and the separate collection of distillates at each boiling point or after definite temperature intervals. The low-boiling fractions are collected first. The distilling range is the recorded thermometer range at which a liquid is distilled. Destructive distillation is the heating with exclusion of air of complex organic matter like wood or coal until it is decomposed or split into a number of liquid and solid substances. Steam distillation is the passage of steam through a liquid whereby the liquid vapor is carried off with the steam and, on condensation, the liquid and water are separated by their immiscibility. Vacuum distillation is done under reduced pressure; it is usually carried out with high-boiling materials which decompose at their atmospheric boiling points. Most organic solvents are distilled in processes of preparation or purification (see **Alcohol, Petroleum Thinner,** and **Turpentine**).

Essential Oil, a volatile oil, with characteristic odor, derived from plants.

Esters (see **Solvents, classification**).

Ether (ethyl ether [$C_2H_5OC_2H_5$]). Since the XVI century this clear, volatile, and highly flammable fluid has been made by the dehydration of ethyl alcohol with sulphuric acid. The solvent action is very wide, including oils, resins, fats, and waxes. High vapor pressure (442 mm. Hg at 20°C.), with danger of explosion, make it hazardous to use as a studio or laboratory solvent. The boiling point is 34.5°C. The vapors are heavy and tend to creep. Because of its rapid evaporation, it has little use as a commercial solvent for lacquer. It is completely miscible with alcohol and with most organic solvents, but with water only to the extent of 7.42 per cent at 20°C. It has some use as an extraction solvent in the analysis of paint samples, and either alone or in mixtures for the removal of resin and wax.

Ethyl Acetate ($CH_3COOC_2H_5$). Action of acetic acid on alcohol forms this ester. It is a colorless liquid, with faint odor, and the pure, anhydrous form boils at 78°C. Being hygroscopic, it reacts with absorbed water by hydrolysis to form acetic acid and alcohol. It is miscible with alcohol and with most organic solvents, but only partially with water. Its acidity and the tendency to cause blush, the result of rapid evaporation, are factors against its use as a solvent.

Ethylene Dichloride (1,2-dichlorethane [CH_2ClCH_2Cl]), a clear, volatile liquid, has an odor somewhat like that of chloroform and boils at 83.5°C. (It may be confused with dichlorethylene, $C_2H_2Cl_2$.) Dutch chemists discovered it in 1795, making it one of the earliest organic compounds to be isolated. Only in recent years, however, has it become commercially available. Direct chlorination of the ethylene gas is the method of manufacture. This is an excellent solvent for oils, fats, and waxes, and for certain resins, but serves only as a diluent for cellulose

derivatives. In its resistance to hydrolysis and oxidation it is outstanding among chlorinated hydrocarbons, and is among the most stable of this series (see G. O. Curme Jr, ' Importance of Olefine Gases and Their Derivatives, III, Ethylene Dichloride,' *Chemical and Metallurgical Engineering*, XXV [1921], pp. 999 ff.). Being hard to ignite, it is used to lower the flash point of solvent mixtures. The vapors are not dangerously toxic but are anaesthetic if breathed in high concentrations.

Ethylene Glycol (glycol [$CH_2OH \cdot CH_2OH$]). This dihydric alcohol is an intermediate between alcohol and glycerine (glycerol). The liquid is colorless, has a sweet taste with no odor, and boils at 197.2°C. It will not mix with hydrocarbons but will mix in all proportions with water, alcohol, and many organic liquids. It is extremely hygroscopic, absorbing approximately twice its weight in water in an atmosphere of room temperature, and 100 per cent relative humidity. This unfits it for the common uses as a softener for mediums and dried films.

Ethylene Glycol Monobutyl Ether (butyl cellosolve [$C_4H_9OCH_2 \cdot CH_2OH$]) has the highest boiling point, 170.6°C., and the lowest evaporation rate of the common **Glycol Ethers**. The solvent action and other properties are similar to those of cellosolve, but it is less volatile.

Ethylene Glycol Monoethyl Ether (cellosolve [$C_2H_5OCH_2 \cdot CH_2OH$]). This is the most important of the glycol ether series, being a colorless, stable liquid, with a mild, fruity odor. It is made synthetically from ethylene gas obtained in the cracking of petroleum. The boiling point is 134.8°C. It is a good solvent for natural and synthetic resins and is characterized by its moderate rate of evaporation (see **Glycol Ethers**). It is used, in small percentages, in lacquers to improve flow qualities and to prevent blush.

Ethylene Glycol Monoethyl Ether Acetate (cellosolve acetate [$C_2H_5OCH_2 \cdot CH_2OOCCH_3$]). This clear liquid is a solvent for most natural and synthetic resins and is miscible with most of the organic solvents. It is distinguished from cellosolve, the closely related ethylene glycol monoethyl ether, by its higher tolerance for petroleum hydrocarbons (see **Glycol Ethers**).

Ethylene Glycol Monomethyl Ether (methyl cellosolve [$CH_3OCH_2 \cdot CH_2OH$]). A member of the series of **Glycol Ethers,** this is miscible with water and with most organic liquids. In many respects it is like the other members of the series, but differs from the rest by being hygroscopic. It is a solvent for essential oils and for natural and synthetic resins. Its boiling point is 124.5°C. and it is the most volatile of the commercially available glycol ethers. As a solvent for certain dyes, it is much used in the preparation of non-aqueous stains for wood and for vegetable and animal fibres.

Gasoline (petrol). Produced chiefly as a motor fuel, this mixture of volatile, aliphatic hydrocarbons is obtained from the distillation or cracking of petroleum. Where rapid evaporation is desired, it is used as a solvent for paint mediums and

is a common cleaning agent. Its volatility and flammability prevent a wide use of it as a paint thinner. The gasoline from American sources contains several hydrocarbons, but chiefly hexane, heptane, and octane. That from Rumanian and Russian sources may have hydrogenated benzene compounds called naphthenes. Being a mixture, gasoline has no definite boiling point but, rather, a boiling range as wide as from 60° to 120°C.

Glycerol (glycerine [$CH_2OH \cdot CHOH \cdot CH_2OH$]), is a trihydric alcohol, clear, syrupy, and with a sweet taste. It was first prepared in 1779 by Scheele through the saponification of olive oil with litharge. Now it is obtained chiefly as a by-product of soap manufacture. It is miscible in all proportions with water, alcohol, and many organic solvents. In the practice of painting it is chiefly used as a moistening and plasticizing agent, particularly for aqueous mediums such as egg white, gelatin, and gum.

Glycol Ethers. This name is given to a series of solvents rather recently developed and sold under the trade name, cellosolve. Besides cellosolve itself, which is ethylene glycol monoethyl ether, there are: methyl cellosolve (ethylene glycol monomethyl ether), butyl cellosolve (ethylene glycol monobutyl ether), and cellosolve acetate (ethylene glycol monoethyl ether acetate). Because of strong solvent action, medium and low volatility, stability, mild odor, and tolerance for aromatic hydrocarbons, the series has had a wide commercial use in the manufacture of coatings from synthetic resins. Since they contain no ester group, they do not develop acidity through hydrolysis. In the treatment of paintings, particularly the removal of old and discolored films of varnish, they are used alone or as ingredients to couple mixtures of hydrocarbons with alcohols or ketones.

Gum Spirits of Turpentine (see **Turpentine**).

Hexane, the colorless, volatile, liquid, aliphatic hydrocarbon (C_6H_{14}), is a normal component of most gasolines, but serves also as a special solvent. It is prepared by careful fractional redistillation of lower petroleum fractions.

Ketones (see **Solvents, classification**).

Methyl Acetate (CH_3COOCH_3). This ester is derived from methyl alcohol and acetic acid, and can be prepared by distilling the former over calcium or sodium acetate in the presence of sulphuric acid. It is also a by-product of wood distillation. The odor faintly resembles that of methyl alcohol, the liquid is clear, boils at 53 to 59°C., and is the most volatile of the ester type of solvents as well as the most active. In this respect it resembles acetone. It mixes with water but is liable to decomposition by hydrolysis, with the formation of acetic acid. The vapors are not strongly toxic but are highly flammable.

Methyl Alcohol (wood alcohol, methanol). This, the simplest member of the alcohol series, has the formula, CH_3OH. Formerly it all came from the dry distillation of vegetable waste, particularly wood. Repeated distillation or special treatment is necessary in order to get a pure product, the chief difficulty being the removal of acetone which is also the product of this dry distillation. That

method has been largely displaced since about 1920 when a way was found for synthesizing methyl alcohol from carbon monoxide and hydrogen. The result is a pure product known as methanol and made more cheaply than that from wood distillation.

When pure, methyl alcohol has an odor about like that of ethyl alcohol. It is a clear liquid and boils at 66°C. As a solvent, it acts about as does ethyl alcohol including solution of shellac. It is the basis of many paint removers and is much used as a denaturant for ethyl alcohol because it does not affect the properties of the latter as a solvent, and it can not be easily separated from it by distillation. The vapors of methyl alcohol are much more poisonous than are those of ethyl alcohol. Unlike the latter, it is oxidized in the system with the formation of formaldehyde and formic acid. The vapor is flammable.

Methyl Cellosolve (see **Ethylene Glycol Monomethyl Ether** and **Glycol Ethers**).

Methyl Ethyl Ketone ($CH_3COC_2H_5$). This solvent is like acetone, except ethyl replaces one methyl group of that compound. Usually made by the dehydrogenation of secondary butyl alcohol, it can also be obtained from wood distillates, though that product contains a considerable amount of acetone. The evaporation is somewhat slower than that of acetone, but the solvent action is about the same as is the odor. It acts well on cellulose acetate. It is a colorless, flammable liquid, boiling at 76.6°C. As a commercial product, it contains methyl acetate and methyl alcohol.

Methyl Isobutyl Ketone (hexone [$(CH_3)_2CHCH_2COCH_3$]). As a medium-boiling ketone, this solvent is useful in mixtures for lacquers and varnishes. Unlike the lower ketones, it is only slightly miscible with water (1.9 per cent). It is colorless and stable, not highly toxic or flammable. The boiling point is 116°C.

Methylated Spirit (see **Denatured Alcohol**).

Methylene Chloride (dichlormethane [CH_2Cl_2]), a clear liquid resembling chloroform, is produced by the chlorination of methane. It is the most volatile of the chlorohydrocarbons and boils at 42°C., but has a very low flammability. It is a strong solvent for oils, resins, rubber, and some cellulose derivatives. Because of its action on linoxyn, it is included in many paint removers. Care is required in handling it because of its volatility, but it is least dangerous physiologically of the chlorohydrocarbons and is stable to light and moisture.

Mineral Spirits (white spirits). As a vague synonym of 'mineral thinner' and 'petroleum thinner,' the term designates a rather wide range of petroleum distillates and has also come to mean a particular kind of thinner suitable for paint and varnish. The solvent is prepared from petroleum bases which may contain naphthenic hydrocarbons and are free from those sulphur and unsaturated hydrocarbons of the olefin series which give an objectionable odor. It boils between 150° and 210°C., but the distillation range varies according to source and refinery. Some distilleries offer various grades with differences in boiling range and flash point.

Mineral Thinner (see **Petroleum Thinner**).

Morpholine is a clear liquid with a musty and ammoniacal odor. The chemical formula is O : $(CH_2CH_2)_2$: NH; the boiling point is 128.9°C. It is miscible in all proportions with water, and dilute solutions boil or evaporate with little change in composition. A constant alkalinity is maintained in the solution and in the distillate. Being mildly alkaline, it forms soaps with fatty acids and so may be used as an emulsifying agent. Since in its structure it is a ring compound, combining an ether and an amine, it is a strong solvent for dyes, waxes, shellac, and for casein. It is one of the few available solvents which has a direct effect on a thoroughly hardened linoxyn film.

Naphtha. In the technical literature on solvents and diluents, there is some confusion about this term. It comes from the Greek, ναφθα, and, in turn, from the Acadian, *naptu* (see R. J. Forbes, ' Petroleum and Bitumen in Antiquity,' *Ambix*, II [1938], p. 76). Originally the word was used for crude petroleum or vapor coming out of the earth in regions of the Near East. Recently it has been applied to the volatile distilled products of petroleum and coal-tar. Petroleum naphtha, distilled in the range, 100° to 160°C., is from paraffin or naphthenic hydrocarbons (see **V. M. and P. Naphtha**). Coal-tar naphtha, a crude distillate, contains chiefly benzene and its homologues. Solvent naphtha is a mixture of toluene, isomeric xylenes, cumene, and other coal-tar hydrocarbons after the separation of benzene from coal-tar naphtha by fractional distillation.

Oil of Spike Lavender, a product similar to turpentine, is obtained by the distillation of spike lavender (*Lavandula spica*). This is different from the lavender oils used in perfumes, for that comes from the dried tops of lavender flowers. Oil of spike is a colorless liquid, boiling between 170° and 200°C., and is less volatile than turpentine. A solvent for soft resins, it is frequently called for in old recipes for spirit varnish. It may have been used more for its odor than for its solvent properties. According to Doerner (p. 122), Rubens used it occasionally, but considered it to be inferior to oil of turpentine.

Oil of Turpentine (see **Turpentine**).

Paint Remover. This name covers a large group of commercial preparations made for the purpose of softening and dissolving paints and varnishes. Most of them are mixtures of organic solvents, with a small amount of paraffin wax which retards evaporation and keeps the solvent itself in contact with the paint for a long time. Ammonia is a common ingredient also. With it are apt to be acetone, methyl alcohol, and benzene. To reduce flammability, chlorinated hydrocarbons like trichlorethylene are added. Many such mixtures are patented. Speed and completion of solution in a paint remover, as in any single solvent, are dependent upon various factors in the paint and on the combination of materials used on it. Oil films thoroughly dried and containing pigment are very slow to dissolve and are strongly resistant to the usual organic solvents. For them the type of paint remover which contains strong alkalis is more effective. Some of these with sodium

hydroxide, potassium hydroxide, or ammonia are made up for use in a paste with sawdust, chalk, starch, or similar bulky materials.

Penetrant is a term used for any one of various sulphated and sulphonated higher fatty acids, alcohols, and esters. When used even in very small amounts, these reduce interfacial tension between liquids and solids. Thereby they increase ease of wetting and penetration (see **Surface-Active Agent**; also B. G. Wilkes and J. N. Wickert, 'Synthetic Aliphatic Penetrants,' *Industrial and Engineering Chemistry*, XXIX [1937], pp. 1234–1239).

Petroleum Ether is a petroleum distillate, chiefly hexane, with a boiling range between 40° and 60°C. Although too volatile for a diluent in paints and lacquers, it is a good extracting agent for soft resins, oils, and waxes.

Petroleum Spirit, a term that may indicate any **Petroleum Thinner**, is used also specifically for a distillate boiling in the range of 60° to 120°C. This is similar to **Benzine** and **Gasoline**.

Petroleum Thinner (benzine, gasoline, mineral spirits, naphtha, petroleum spirits). The name is used for those hydrocarbons obtained from the distillation of crude petroleum and commonly employed with paints and varnishes. They are produced by most of the large oil companies; Gardner lists many of them (see pp. 570–574) and includes data on evaporation rates, distillation ranges, flash points, density, and other properties. The solvent properties of the petroleum thinners vary considerably according to the particular kinds of hydrocarbons they contain, to their structure, molecular weight, and proportions. They are good thinners and solvents for mineral and fatty oils, but hard fats (like tristearin) have limited solubility in them. Resins are poorly dissolved in petroleum thinners containing high percentages of aliphatics but are more soluble in those containing hydrogenated aromatics (naphthenes). Cellulosic compounds and polymerization products like vinyl acetate are generally insoluble. The higher boiling fractions are used as thinners for oil paints, varnishes, wax polishes, and emulsions, and they now displace turpentine for many purposes. They have wide industrial application because of their cheapness.

Although the Babylonians, the Assyrians, and other peoples of the Near East were acquainted with crude petroleum and related substances like asphalt and bitumen obtainable from the regions of the Caspian Sea (Baku), the Dead Sea, and Mesopotamia, there is no sign that they refined it and put it into any preparations of paint and varnish. Even though the art of distillation was perfected in early mediaeval times (see **Alcohol**), no definite mention of a distillate as a painter's material occurs until the XVII century in the MS. of De Mayerne (Berger, III, 108, 188, and 190). Petroleum products did not come into commercial use for paint thinning until the latter part of the XIX century. Heaton says (p. 17) that in 1885 Samuel Banner first introduced petroleum distillate as a solvent for the paint industry under the name, Patent Turpentine (English patent 12,249 of that year). For some time it was regarded as only a cheap substitute, but within the last twenty-five years it has found a more respectable place in the paint and

varnish industry. Great care is being taken to prepare petroleum thinners for specific purposes. Impurities of sulphur compounds, which formerly caused trouble, have been largely eliminated.

Plasticizer. This term has come into use recently to describe any solid or liquid substance added to a film material in order to give that material elasticity and pliancy. More specifically it stands for any one of a series of substances, largely liquids with high boiling point and low volatility, that are used to reduce the inherent brittleness of lacquer and synthetic resin coatings. Ordinary solvents and diluents, even though fairly volatile, may be retained in small quantities as part of the lacquer or varnish film during some weeks or months. With their final escape, however, most organic films become brittle and friable, lose their protective value, and, through the formation of minute crevices, become dull. Linoxyn, the dried film of linseed oil, remains plastic for some years, and that is why it is used as a plasticizer in resin-oil and spirit varnishes, but it, too, eventually changes into a brittle and crumbling state. Lack of permanent flexibility seems to be a shortcoming of most organic films, particularly those made from cellulose derivatives and resin-like polymers. Celluloid is nitrocellulose plasticized with camphor; castor oil also has long been used to plasticize nitrocellulose. The synthetic or chemical plasticizers are mainly esters of high molecular weight, but they include a few amines, ethers, aromatic ketones, and even hydrocarbons. Most of them boil above 250°C. and have a vapor pressure less than 0.1 mm. mercury (see Gardner, pp. 576–578). The various plasticizers of modern industry have been put into two groups: gelatinizing—those which have a solvent or swelling action on the material to be plasticized—and non-gelatinizing—those which have no solvent or swelling action but merely fill intermicellar spaces as water does the pores of a sponge. Probably the best known of these plasticizers are dibutyl phthalate and tricresyl phosphate.

Reagent Solvents are those which are used to dissolve water-insoluble materials by chemical action upon them. Most of them are acids, but some are alkalis. They react with materials to form water-soluble salts. Hydrochloric and nitric acids and sodium hydroxide are examples. Almost without exception none of these reagents can be used directly on artists' paint. Their activity is apt to be violent and destructive.

Restrainer. A word restricted almost entirely to the terminology of picture restoration, it was formerly applied to a solvent which had a low activity on resinous surface films and which was used in combination with a solvent having a high activity. In some cases they were mixed together. In others, they were applied alternately to the film. The theory was that the slow-acting or non-solvent material would serve to dilute and make less concentrated the fast-acting one so that its solvent effect could be controlled. Turpentine and alcohol, the former as the restrainer, were regularly used in this way before a wider variety of solvent materials became available.

Saponin is a glucoside obtained from the soapwort and other plants. It is a white, amorphous powder which forms a solution with water that foams like soap when shaken. It has found some little use in cleaning paintings, and it is thought to be less harmful than soap for this purpose (see Mayer, p. 398). A. Lucas (*Antiques, Their Restoration and Preservation*, 2d ed. [London: Edward Arnold and Co., 1932], pp. 166–167) recommends a 1 per cent aqueous solution of saponin for removing accumulated dirt and smoke from a painting, but cautions that if used in excess the water may penetrate to the canvas and cause damage.

Soap. Commonly the word is used to define the sodium or potassium salt of palmitic or stearic acid. It may be given to the mixed salts of several acids obtained from ordinary fats. Although other metals can form soaps, these are not soluble in water. Alkaline hydrolysis of fats with strong alkalis, producing a soap, is called saponification. A soap is hard if made with soda, soft if made with potash. Sodium carbonate and olive oil make Castile soap.

Occasionally it has been an addition to painting mediums, but the principal use of soap is as a detergent. It can aid in the removal of grease or dirt from paint or fabric. In doing so, it acts partly as an emulsifying or surface-active agent which, by lowering interfacial tension, cuts fatty films and releases and disperses particles of dirt they contain. In part, also, it appears that dirt particles are adsorbed to the surface of colloidal soap particles. In its relation to paint, soap has a number of defects. When put with emulsions, it is said to cause a later darkening of the paint (Doerner, p. 226). Mayer (p. 373) says that when soap is dissolved in water and used as a cleaning agent for paint, a minute quantity of alkali may be produced by hydrolysis and may alter the surface color. He also warns (p. 406) that the oil paint film can be weakened by soap solution, its adhesion destroyed, and a permanent blush left on it. Undoubtedly part of the ill effects of soap solutions on paintings is from the seepage of water into the ground and support.

Historically, soap appears to have been known in classical times and small quantities have been found at Pompeii and other sites dating from the I century A.D. Early treatises on painting frequently mention mixtures of fat and lye for use in the refinement of granular blue pigments, and De Mayerne, in the early XVII century (Berger, IV, 292), has a brief description of the cleaning of a picture with soap and fine ashes, followed by washing with water.

Solvent. This name is given to any of the volatile fluid organic compounds which can, without chemical change, convert a solid or semi-solid organic material into a technically useful solution. Generally such a solution is a mobile liquid capable of application in thin films. The organic substances converted are usually colloidal, oils, waxes, resins, gums, and cellulosic bodies, and are used as varnishes or mediums for paints.

Solvents, classification. A chemical basis serves best to afford an arrangement of the various useful solvents in painting and restoration. Most of them are

definite chemical compounds and the larger part, being compounds of carbon, are organic. Formerly, of course, most of them had a natural origin, but now far the greater number comes from synthetic manufacture. Industrially, the petroleum hydrocarbons form the most important class and have a definite place in the practice of painting. These are aliphatic or paraffin hydrocarbons derived from crude petroleum, a complex mixture containing hydrogen and carbon. Chemically, they are known as straight-chain hydrocarbons because the carbon atoms of each molecule appear to be linked in a line by a single bond. This homologous series of solvents has the general formula, C_nH_{2n+2}. They begin with the simple gas methane, CH_4, and extend to compounds that have thirty or more carbon atoms which are hard waxes. The lower homologues with five to ten carbon atoms are most used as solvents. Chemically, they are not active, but have a good solvent action on fluid oils, fats, bitumen, rubber, and wax, as well as on a few resins such as dammar. They are flammable and form explosive mixtures with air, but are not highly toxic.

Coal-tar hydrocarbons, another class of solvents, are those derived from the destructive distillation of coal-tar, a by-product of coke and coal gas. Aromatic and benzene hydrocarbons are other names given to them. They contain the benzene ring (see **Benzene**) and that material is the simplest member of the group. Toluene and xylene are derivatives. Like the petroleum hydrocarbons, they are hydrophobic but, chemically, are more active because of the three double bonds in the benzene ring. Their general solvent action is stronger and they affect most resins and certain cellulose derivatives, as well as the other materials which the petroleum hydrocarbons dissolve. The coal-tar group is flammable and generally toxic.

Chlorinated hydrocarbons make a further class, those obtained by introducing chlorine into the hydrocarbon molecule. It goes into coal-tar hydrocarbons through the double bond and into petroleum hydrocarbons by replacement of hydrogen. Perhaps the most familiar in this class are carbon tetrachloride, chloroform, and ethylene dichloride. Their solvent power is somewhat stronger than that of the other hydrocarbons. Like them, they are hydrophobic but, unlike them, are nonflammable or of very low flammability. They have, however, injurious physiological effects when used in large quantities. Under ordinary conditions, most of them are stable, but a few decompose and liberate hydrochloric acid in the presence of light or moisture. They have a high specific gravity.

Turpentine hydrocarbons are known almost entirely through the one product familiar in painting practice. Turpentine is a mixture of various aromatic hydrocarbons known as terpenes, and all of them have a ring structure and the empirical formula, $C_{10}H_{16}$. They differ according to internal grouping of the atoms. Composition varies with differences in the species of pine from which the original balsam comes. Turpentine is fairly active chemically because of its unsaturation, and has a moderate solvent action, taking effect on fats, soft resins, and liquid

TABLE I. PHYSICAL PROPERTIES OF ORGANIC SOLVENTS AND DILUENTS[1]

NAME	FORMULA	BOILING POINT OR BOILING RANGE °C.	VAPOR PRESSURE (mm. Hg at 20° C.)	FLASH POINT °F.	SPECIFIC GRAVITY 20/20° C.	MISCIBILITY AT 20° C.[5]	
						In water	Water in
Petroleum ether	—	40–60	—	<0	0.63–0.67	Slight	None
Gasoline	—	60–120	—	<40	0.66–0.68	Slight	None
Petroleum naphtha (petroleum spirits)	—	80–130	—	<40	0.68–0.78	Slight	None
V. M. and P. naphtha	—	100–160	—	20–50	0.74–0.76	Slight	None
Mineral spirits	—	150–200	—	90–100	0.77–0.80	Slight	None
Benzene	C_6H_6	80	118[3]	<5.5	0.878	Slight	None
Toluene	$C_6H_5CH_3$	111	26[3]	44–45	0.866	Slight (0.2)	None
Xylene	$C_6H_4(CH_3)_2$	139	11[3]	80	0.862	Slight (0.05)	None
Tetralin	$C_{10}H_{12}$	205	<1[3]	180	0.972	Slight	None
Turpentine, gum spirits	$C_{10}H_{16}$	150–200	4.4	110	0.868	Slight	None
Turpentine, steam distilled	$C_{10}H_{16}$	150–175	4.4	115	0.857	Slight	None
Dipentene	$CH_3(C_6H_8)C{:}(CH_2)CH_3$	170–200	2[3]	145	0.853	Slight	None
Chloroform	CH_3Cl	61	160	Very high	1.498	Slight	None
Carbon tetrachloride	CCl_4	77	91	Very high	1.629	Slight	None
Ethylene dichloride	$C_2H_4Cl_2$	83.5	65.3	70	1.255	Slight (0.87)	Slight (0.16)
Methyl alcohol	CH_3OH	64.5	98	60	0.792	Complete	Complete
Ethyl alcohol, anhydrous	C_2H_5OH	78.3	44	70	0.791	Complete	Complete
n-Butyl alcohol	C_4H_9OH	117.7	6	115	0.811	Partial (7.7)	Partial (20.1)
Methyl acetate	CH_3COOCH_3	57.1	166	<40	0.908	Partial (24.2)	Partial (8.2)
Ethyl acetate	$CH_3COOC_2H_5$	77.1	65	<40	0.901	Partial (8.7)	Partial (3.3)
n-Butyl acetate	$CH_3COOC_4H_9$	126.3	10	88	0.876	Slight (0.5)	Slight (1.8)

Amyl acetate	$CH_3COOC_5H_{11}$	125–150	9[3]	77	0.870	Slight (2.0)	Slight (2.0)
Butyl lactate	$CH_3CH(OH)COOC_4H_9$	140–200	0.4	159	0.980	Partial (4.0)	Slight (14.5)
Acetone	CH_3COCH_3	56.1	178	15	0.791	Complete	Complete
Methyl ethyl ketone	$CH_3COC_2H_5$	76.6	119[3]	34	0.810	Partial (25.6)	Partial (11.8)
Methyl isobutyl ketone	$(CH_3)_2CHCH_2COCH_3$	116	18	75	0.802	Slight (2.0)	Slight (2.3)
Diacetone alcohol	$(CH_3)_2C(OH)CH_2COCH_3$	167.9	1.5	135	0.936	Complete	Complete
Ether	$C_2H_5OC_2H_5$	34.5	44[2]	−40	0.715	Partial (6.9)	Partial (1.3)
Dioxane	$O{:}(CH_2CH_2)_2{:}O$	101.1	29.5	65	1.034	Complete	Complete
Methyl cellosolve	$CH_3OCH_2CH_2OH$	125	8.0	115	0.966	Complete	Complete
Cellosolve	$C_2H_5OCH_2CH_2OH$	135.1	4.9	130	0.931	Complete	Complete
Butyl cellosolve	$C_4H_9OCH_2CH_2OH$	171.2	1.0	165	0.902	Complete	Complete
Cellosolve acetate	$C_2H_5OCH_2CH_2OOCCH_3$	156.3	1.2	140	0.975	Partial (23.0)	Partial (6.0)
Ethylene glycol	$CH_2OH{\cdot}CH_2OH$	197.2	0.12	240	1.116	Complete	Complete
Glycerol	$CH_2OH{\cdot}CHOH{\cdot}CH_2OH$	290	0[4]	—	1.263	Complete	Complete
Pyridine	C_5H_5N	115.3	—	—	0.982	Complete	Complete
Morpholine	$O{:}(CH_2CH_2)_2{:}NH$	128.9	11.1	100	1.001	Complete	Complete
Triethanolamine	$CH_2CH_2OH{\cdot}CH_2CH_2OH{\cdot}CH_2CH_2OH$ ⎦N	244[2]	0.0001	380	1.126	Complete	Complete
Carbon disulphide	CS_2	46	—	<40	1.263	Slight (<1)	None

[1] These data are from several sources but mainly from a larger table compiled by A. K. Doolittle, 'Lacquer Solvents in Commercial Use,' *Industrial and Engineering Chemistry*, XXVII (1935), pp. 1169–1174. There is a slight disagreement on many of the figures given, but this probably comes from differences in the purity of solvents used by the several investigators. The figures given here are, in most cases, values that are identical or nearly identical in several sources.

[2] At 50 mm.

[3] At 30° C.

[4] Below 27.85° C.

[5] Miscibility with water has to be given in general terms, except in a few instances where figures are available. The figures in parentheses show per cent by weight.

TABLE II. SOLUBILITY OF FILM SUBSTANCES IN ORGANIC SOLVENTS AND DILUENTS[1]

Solvent	Linseed oil (fluid)	Linoxyn (dried linseed oil)	Congo Copal resin	Dammar resin, Batavia	Dammar resin, Singapore	Mastic resin	Sandarac resin	Elemi resin	Rosin (colophony)	Copaiba balsam, Maracaibo	Venice turpentine	Shellac, orange	Gum arabic	Cellulose acetate	Cellulose aceto-butyrate	Ethyl cellulose	Cellulose nitrate	Polyvinyl acetate	Methyl methacrylate polymer	n-Propyl methacrylate polymer	n-Butyl methacrylate polymer	Rubber	Chlorinated rubber	Beeswax	Carnauba wax	Japan wax	Paraffin wax
Petroleum ether			I	S		I	I	I	LS		LS			I	I	I	I	I				S	I	I	SS	S	
Gasoline	S		I	S		I	I	I				I		I	I	I	I	I	I	I	S	S	I				
Petroleum naphtha (petroleum spirits)			I	S		I	I	I		PS				I	I	I	I	I				S	I				
V. M. and P. naphtha			I	S		I	I	I			S			I	I	I	I	I				S	I	SS	SS		
Mineral spirits		I	I	S		I	I	I						I	I	I	I	I				S	I			S	
Benzene	S		I	S		I	I	I	S	S				I	I	I	I	I	S	S	S	S	I				
Toluene		I	I	S		I	I	I			S	I		I	I	I	I	I	S	S	S	S	I			S	
Xylene		I	I	S		S	I	S						I	I	S	I	S	PS	S	S	S	S			S	
Tetralin		I	I	S		S	I	S						I	I	S	I	S				S	S			S	
Turpentine, gum spirits	S		I	S		S	I	LS	S	S	S	I		I	PS	S	I	S	I	I	S	S	S	S	S		S
Turpentine, steam distilled			I	S		LS	I							I	PS	S	I					S		SS	SS	S	
Dipentene	S		I			LS		I				I		I	S			I	S	S	S		I		SS		SS
Chloroform			I	S			I	I	S	S	S			I	I	S	I					S					S
Carbon tetrachloride	S		I		S	LS						PS		I			I		I	S	S		S	S	SS	S	S
Ethylene dichloride	S	PS	SS	S	I	PS	SS	SS			S	SS	I	I	S	S	I	S	S	S	S	S		PS	SS	SS	
Methyl alcohol	I	PS	I	S		S	LS	PS	S		S	S		I	S	S	PS	S	I	I	I	S	S	PS	SS	SS	
Ethyl alcohol, anhydrous	I	PS	SS	PS	PS	S	S	SS	S	S	S	S	S	I	S	S	I	S	I	I	PS		I	SS	SS	I	I

Solvents:

- n-Butyl alcohol
- Methyl acetate
- Ethyl acetate
- n-Butyl acetate
- Amyl acetate
- Butyl lactate
- Acetone
- Methyl ethyl ketone
- Methyl isobutyl ketone
- Diacetone alcohol
- Ether
- Dioxane
- Methyl cellosolve
- Cellosolve
- Butyl cellosolve
- Cellosolve acetate
- Ethylene glycol
- Glycerol
- Pyridine
- Morpholine
- Triethanolamine
- Carbon disulphide

[1] The letters which indicate solubility signify as follows: S = soluble; I = insoluble; LS = largely soluble; PS = partially soluble; SS = slightly soluble. Blanks are left where information is inadequate for a rating. These data are from more than twenty sources—handbooks, tables, and manufacturers' announcements and data sheets. In most instances, the solubility has been determined on lump or powdered raw materials. Although that may be different from the solubility of a film of the same material, in general they are the same. In respect to certain materials, especially the natural ones, there are conflicting data. This no doubt arises from variations in source or age of the material, and, in some cases, in the purity of the solvent. In order to keep this consistent with Table I, all solvents listed there are repeated though adequate data on some of them are sparse.

oils. It is flammable and, although irritating when breathed, is not particularly toxic.

Alcohols contain the hydroxyl group, –OH. Because of this group, they are strongly polar, fairly active chemically, and may be considered as organic bases. The most common member of the group is ethyl alcohol (ethanol), and its homologues carry names with a similar ending—methanol, propanol, and others. The latter, synonyms for methyl and propyl alcohol, get their names usually because they are synthetic products. Lower alcohols are water-miscible in all proportions. They act as solvents on resins and some synthetic materials but poorly on fats, waxes, and true gums. Higher alcohols have low miscibility with water. Vapors of the lower alcohols are flammable and explosive. They irritate the mucous membrane but, with the exception of methyl alcohol, are not toxic.

Esters are considered to be reaction products of organic bases (alcohols) and organic acids. An example is **Ethyl Acetate** derived from ethyl alcohol and acetic acid. As a group they are noticeable for a sweet and rather fruity odor. They are weakly polar and only the lower esters are hydrophyllic; these may hydrolyze back to alcohol and acid. The higher esters, however, are not easily decomposed. Esters of high molecular weight are much used as plasticizers.

Ketones are distinguished by the presence of the carbonyl group, $=CO$. The lower ketones are neutral and highly volatile, and only the lowest are hydrophyllic. The higher members are solids. The most important of the lower ketones is acetone or dimethyl ketone, a strong solvent for natural resins, synthetic resins, or cellulose derivatives, and miscible with most other organic solvents and diluents.

Glycol ethers are derived from the dibasic alcohol, glycol, by replacement of a hydroxyl group with an ether group. The most important of this group, all of which are of fairly recent development, is the so-called ' cellosolve '—ethylene glycol monoethyl ether.

Polyhydric aliphatic alcohols differ from common alcohols in having more than one hydroxyl group. Ethylene glycol or glycol is dihydroxy alcohol and lies between ethyl alcohol and glycerine. This glycerine or glycerol, in turn, is trihydroxy alcohol. These are similar to mono-alcohols in their chemical properties but have higher viscosity and lower volatility. They become more hygroscopic in proportion to the number of hydroxyl groups they contain.

Ethers are organic compounds in which two hydrocarbon radicals are joined by an oxygen atom. Being very slightly polar, they have good solvent action on waxes and fats.

Amines contain the $-NH_2$ group and form derivatives with many organic compounds. A few of these have special uses in connection with organic solvents. The amino derivatives of the polybasic alcohols, particularly triethanolamine, are useful emulsifying agents. Pyridine and morpholine have special uses as solvents for linoxyn, dried linseed oil.

Solvents, evaporation rate. The volatile part of a paint or varnish film is necessary at the time of application and largely escapes or evaporates after the film is spread. This escape is a movement of molecules through the surface and

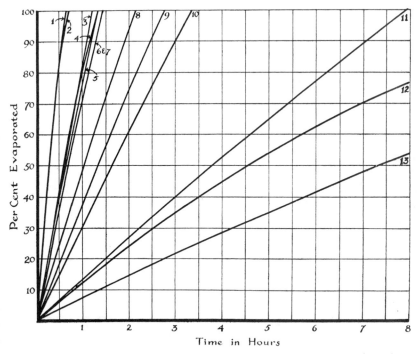

FIGURE I. Evaporation rate curves of fast to intermediate liquids, adapted from those of A. K. Doolittle, 'Lacquer Solvents in Commercial Use,' *Industrial and Engineering Chemistry*, XXVII (1935), p. 1171, fig. 3. According to number, these are as follows:

1. Methyl acetate	7. Methyl ethyl ketone
2. Acetone	8. Ethanol (anhydrous)
3. Benzene	9. Petroleum naphtha
4. Ethylene dichloride	10. Toluene
5. Ethyl acetate	11. *n*-Butyl acetate
6. Methanol (anhydrous)	12. Xylene
13. Amyl acetate (mixed isomers)	

into the surrounding air where they mix with the gaseous components of the air and become part of them. Escaping molecules exert a pressure called ' vapor pressure.' The rate of escape differs greatly in different liquids. To some extent,

this is regulated by outside factors, including temperature, atmospheric pressure, humidity, ventilation, and amount of liquid surface exposed. Internally there are definite factors also—vapor tension, surface tension, latent heat of evaporation,

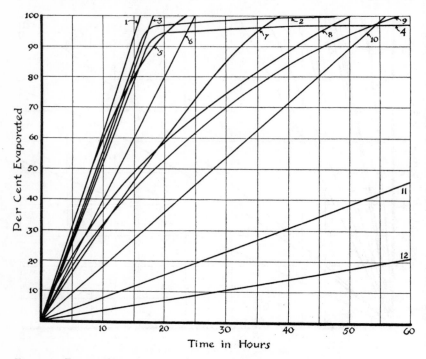

FIGURE 2. Evaporation rate curves of intermediate to slow liquids, adapted from those of A. K. Doolittle, 'Lacquer Solvents in Commercial Use,' *Industrial and Engineering Chemistry*, XXVII (1935), p. 1170, fig. 2. According to number, these are as follows:

1. Methyl cellosolve	7. Cellosolve acetate
2. Steam distilled turpentine	8. V. M. and P. naphtha
3. *n*-Butanol	9. Mineral spirits
4. Gum spirits turpentine	10. Diacetone alcohol
5. Amyl alcohol (mixed isomers)	11. Butyl cellosolve
6. Cellosolve	12. Butyl lactate

specific heat, dissolved impurities, and a few others. Although vapor pressure and evaporation rate are closely related, they are not the same. Vapor pressure is the pressure (expressed in millimeters of mercury) when a liquid and its vapor are in equilibrium in a closed system at a definite temperature. Vapor molecules in air

exert a partial pressure and contribute to the total pressure of the atmosphere they pervade. When the vapor pressure in the air in a closed space above a liquid becomes a maximum, the air is saturated in respect to the liquid. When the temperature of a liquid is raised, its vapor pressure increases and when it equals the pressure of the atmosphere, the liquid boils. Evaporation rate is the rate at which vapor evaporates freely and continuously at the surface of liquid in an open system under a specified set of conditions. These conditions include surface exposed, rate of air-flow over the surface, temperature, and other factors. Unlike vapor pressures, evaporation rates are not readily capable of numerical expression but are best shown by curves like those in figures 1 and 2. The simplest method of reaching these determinations is gravimetric, the loss of weight of a fixed quantity of solvent under fixed conditions being measured at regular intervals (see Gardner, pp. 318–322). Evaporation rates of solvents are not in the same order as their boiling points. Compounds that contain hydroxyl groups evaporate more slowly than compounds of the same boiling point not containing hydroxyl; for example, alcohols evaporate more slowly than their esters of higher boiling point (see Hofmann, p. 135). Chemical structure and types of molecular aggregates are influential.

When solvents are mixed together they behave somewhat inconsistently. If they are members of a homologous series, as would be the case with toluene and xylene, they evaporate at different rates simultaneously and do not affect each other. Certain liquids, however, may form constant evaporating mixtures. The solvent with the higher rate evaporates rapidly until, in a binary mixture, a certain proportion of the two is reached, and from that point on they evaporate together at a constant rate. Such a mixture is apt to occur with dissimilar compounds like that of an alcohol and a hydrocarbon. Hofmann gives the relative proportions of certain constant evaporating mixtures as follows: benzene 47, ethyl acetate 53; toluene 45, ethyl alcohol 55; there are also a few ternary mixtures which strike a constant evaporating level. In the application of varnishes and lacquers, rapidly evaporating solvents and diluents are not usually desired, for they cause chilling at the surface with possible precipitation of moisture and a blush in the film.

Solvents, flammability. When mixed with air, the vapors of most organic solvents, diluents, and thinners are explosive. In general, the degree of flammability of hydrocarbons and compounds of carbon, hydrogen, and oxygen is inversely proportional to the boiling points and the vapor pressures. Those containing sulphur are highly flammable; those with chlorine, much less. Unsaturated compounds are generally more flammable than saturated compounds. The measure of flammability is the flash point—the lowest temperature at which a liquid gives off enough vapor to be ignited. At this temperature the vapor molecules are so concentrated that they can unite with oxygen, and combustion becomes self-propellant. This point is determined by a special test and several types of

apparatus are made for testing. The point is usually designated in degrees Fahrenheit and a liquid is supposed to be flammable when the flash point is below 150°F. Those which flash below 40°F. are exceedingly flammable and dangerous. When solvents are mixed, the flash point of the mixture is not necessarily the average of the points of the components. There may be uneven evaporation or constant boiling mixtures may be formed. A common addition to the flammable solvents is that of carbon tetrachloride, and this, in an adequate quantity, seems to be effective. Ethylene dichloride is used in the same way. The explosive power of solvent vapor depends on temperature and on the proportion of this vapor to the air. The lower explosive limit is the smallest amount of solvent vapor according to volume per cent which will allow the propagation of the flame. An upper explosive limit is reached when the solvent vapor exceeds the quantity which has oxygen enough to keep up a fire. The danger of flammability can be much reduced by careful storage. Frequent inspection of containers to guard against leaks, the use of tin or lead-lined cans for all organic solvents, and metal cases remote from any excess heat, from sparks, or from flame will go a long way to prevent accidents. If film materials conveyed by flammable solvents are sprayed mechanically, there is an attendant fire hazard unless good ventilation is provided. In particular, sparks from motors and from electrical connections have to be guarded against. An open flame should not be used near containers of flammable solvents. It is particularly dangerous to distill or heat organic solvents in a container, especially a glass container, over a free flame. If the container breaks, there is nothing to prevent instantaneous and violent explosion. Such heating, when necessary, should be done over a steam bath or by properly insulated electrical equipment.

Solvents, miscibility. This is the capacity of a fluid to mix with another. Interfacial tension between the molecules seems to be the determining factor. When the difference in tension is small, the two go together easily, but when it is great, the two are drawn into separate layers. In general, solvents that have a similar chemical constitution and properties are miscible with each other. Lower members of a homologous series are more widely miscible than those of higher molecular weight. The greater part of organic solvents is immiscible with water, exceptions being the lower alcohols and ketones. Acetic esters and higher alcohols, butyl and amyl for example, are limited in their ability to mix with water but go well with the hydrocarbons. Acetone is the only solvent which will mix with water in all proportions and with all other organic liquids. Frequently two immiscible fluids can be made to go together by the addition of a small amount of a third. Butyl alcohol, for instance, will make a mixture out of petroleum spirit and ethyl alcohol. Solvents with this capacity are called ' mutual solvents ' or ' coupling agents.'

Solvents, toxicity. Almost any materials used as solvents or diluents in the art of painting are poisonous if taken into the human body in large amounts. There is, however, a great variety among their toxic affects, and the risk of their being drunk as a fluid is slight. The greatest exposure is to their vapors and, in general,

the more volatile among them are the more toxic. Acetone, alcohol, ether, and chloroform are narcotics. They affect the nerve centers causing stupefaction, intoxication, and ultimately anaesthesia. The coal-tar hydrocarbon, benzene or benzol, has a direct physiological effect on blood cells, causing leucopenia and anaemia. Excessive use of this material seems permanently to injure bone marrow where the cells originate. This poisoning can reach an acute stage resulting in death. The National Safety Council has set as a safety limit for the concentration of benzene vapor 100 parts of benzene per 1 million parts of air. Toluene and xylene are less toxic, but relatively impure grades of toluene may contain benzene. The vapors of chlorinated aliphatic hydrocarbons—particularly trichlorethylene, tetrachlorethane, and, to some extent, carbon tetrachloride and ethylene dichloride—affect the central nervous system and damage the liver and kidneys. Petroleum hydrocarbons are far less injurious. Exposure to concentrated vapors of them may produce dizziness and nausea. Carbon disulphide has an effect on the central nervous system. The toxicity of methyl or wood alcohol when taken as a fluid is well known. It injures the central nervous system, but moderate exposure to the vapors has not been shown to be seriously harmful. Most operations in the painting and restoration of pictures do not involve high concentrations of any of these vapors. Spraying of varnishes, particularly on large areas, is an exception, as is the use of a solvent in the removal of such film materials, especially where the operator is working with magnifying lenses and is close to the evaporating surface. In all cases, good ventilation should be provided and work should be stopped immediately at any sign of physical irritation, headache, or drowsiness.

The National Safety Council supplies the following information with regard to the toxicity of some of the common solvents. The figures after the solvent are the maximum allowable concentrations of solvent vapor in parts per million of air.

SOLVENT	CONCENTRATION (p.p.m.)	SOLVENT	CONCENTRATION (p.p.m.)
Amyl acetate	400	Carbon disulphide	15
Butyl acetate	400	Carbon tetrachloride	100
Butyl alcohol	100	Ethylene dichloride	100
Methyl alcohol	100	Ethyl ether	400
Benzene	100	Turpentine (American)	200
Benzol	75	Xylol	200

Spike Oil (see **Oil of Spike Lavender**).

Spirits. Specifically, this term is used for volatile substances dissolved in alcohol, but in older usage it was applied to any distilled volatile liquid. It is still commonly given to ethereal essential oils and distillates—spirits of turpentine, petroleum spirits, Cologne spirits, and wine spirits. Methyl alcohol is still occasionally called ' wood spirits.'

Surface-Active Agent (wetting agent, detergent, penetrant) is a compound which reduces interfacial tension at the boundaries between gases, liquids, and solids; it especially promotes wetting and penetration of liquids into solids and serves as a detergent, emulsifying, and dispersing agent. The oldest type of surface-active agent is a saponified vegetable oil, a soap, but in recent years many special compounds have been developed. These include principally fatty alcohol sulphates and sulphonated higher fatty acid esters, ethers, and amides. The latter compounds have greater adaptability than soaps in respect to the physical conditions under which they are used. They have high wetting power even in low concentration, are stable in dry form and in solution, and are soluble both in water and in organic solutions. They are not precipitated by hardness in water. They are polar compounds and their activity is dependent upon the ability of their molecules to become oriented and adsorbed at an interface (see a series of papers on ' Surface-Active Agents,' *Industrial and Engineering Chemistry*, XXXI [1939], pp. 31–69). Like soap they can be used to remove grime and greasy deposits from paint, but there is always a risk from the action of water and possibly from residues of the agents themselves.

Tetralin (tetrahydronaphthalene $[C_{10}H_{12}]$) is a colorless fluid which boils at 205°C. It is derived from the hydrogenation of naphthalene and is a good solvent for resins, oils, fats, and waxes. Moreover, it is said to have a strong solvent effect on linoxyn, the dried, oxidized film of linseed oil. In paint and varnish removers it is a common ingredient. Discoloration from standing is one of its drawbacks.

Thinner, a solvent or diluent or a mixture of both used to reduce a film material to suitable brushing or spraying consistency. The common thinners for oil paint are turpentine or petroleum distillates. Strictly, a thinner is a **Diluent** but, because the difference between solvent and diluent exists only in relation to particular film-forming solids, this more general term is used for either.

Toluene (toluol, methyl benzene $[C_6H_5 \cdot CH_3]$) is derived from coal-tar by fractional distillation of commercial benzol. A clear, colorless liquid, it resembles **Benzene** but boils at a higher temperature, 110°C., and is less volatile. It is miscible with most other organic solvents and is said to be the most widely used hydrocarbon diluent for commercial cellulose lacquers. For resins and for cellulose ethers, it has a considerable solvent power and a higher dilution ratio than the petroleum hydrocarbons. Its vapor pressure permits rapid drying without blush. It is low in cost and, unlike benzene, is not dangerously toxic. The less pure form of toluene is called toluol.

Toluol is a commercial or industrial grade of **Toluene.**

Tricresyl Phosphate ($[CH_3C_6H_4]_3PO_4$) is generally used as a plasticizer in commercial lacquers, though it is a moderately good solvent for some resins, including mastic. It has a high boiling point, 275° to 280°C., and a high flash point, 230°C. At 25°C. it is 0.2 per cent soluble in water.

Triethanolamine ($[CH_2CH_2OH]_3N$). Though extremely active as a solvent for oils and fats, this is best known to painters and restorers as an emulsifying agent.

It is a straw-colored, viscous liquid, with a faint odor of ammonia, and in some respects it combines the properties of that material and glycerine. It is highly hygroscopic and miscible with water in all proportions. It mixes with alcohol but not with petroleum or coal-tar hydrocarbons. Like ammonia, it combines with acids and acidic materials, forming soaps of low alkalinity with fat. It is less alkaline, however, than ammonia, the pH of a 25 per cent solution being 11.2 at 25°C. Small additions of triethanolamine can produce stable water emulsions of various oils and waxes. Usually the amount of triethanolamine is 2 to 4 per cent of the oil or fat to be emulsified. Casein is colloidally dispersed in water by a 5 to 15 per cent solution of triethanolamine.

Turpentine. The name (*terebinthos* [Gr.], *térébenthine* [Fr.]) was originally applied to the crude exudation or balsam from various species of pine, and is still given to certain kinds like Venice turpentine from the European larch, and Strasbourg turpentine from the European white fir. In the United States, however, the word is commonly used only for the volatile liquid obtained by the destructive distillation of an oleoresin. About two thirds of the world's supply comes from the long-leaf pine that is grown in Georgia and the Carolinas, though part is from other closely related species. A fair amount is from the Maritime pine cultivated along the southwest coast of France. American production began at the close of the XVI century. The French did not start until the middle of the XIX century, but, until recently, their production methods were more efficient. Small amounts of turpentine come from Spain, Greece, and other countries.

In the usual method of collecting the resinous exudate, the tree is chipped near the base, gutters are attached, and the material is caught in earthenware cups. (For details, see T. Hedley Barry, *Natural Varnish Resins* [London: Ernest Benn Ltd, 1932], pp. 145–199.) The crude oleoresin (French) yields 18 per cent turpentine, 75 per cent dry resin, 10 per cent water, and 2 per cent solid impurities. It is put into copper stills together with water in order to effect steam distillation, the water being later separated by gravity. With methods developed during recent years, the yield from the crude material is 15 to 25 per cent by weight. The molten residue is rosin or colophony. Most of the distillate is sold to the paint and varnish trade after a simple purification by redistillation (rectification) under the name, 'pure gum spirits of turpentine,' or 'oil of turpentine.'

The distilled turpentine is a mixture mainly of various and closely related aromatic hydrocarbons known as terpenes, all of which have the empirical formula, $C_{10}H_{16}$. The composition includes α-pinene, β-pinene, dipentene, terpinene, borneol, fenchyl alcohol, limonene, and traces of camphor. The American turpentine is largely α- or dextro-pinene, and the French is β- or laevo-pinene.

When fresh and pure, turpentine is a clear, volatile, flammable liquid which boils in the range of 150 to 180°C. Any marked deviation from this range indicates impurity, and the Federal Specifications Board specifications require that 90

per cent should be distilled over below 170°C. When spread, it should evaporate almost completely, and when poured on clean filter paper should leave no appreciable residue after a half hour. The normally moderate and uniform rate of evaporation makes turpentine a good thinner for paint and varnish, and it seems to give paint a particularly acceptable handling quality under the brush.

The components are active chemically. Being unsaturated compounds, they absorb oxygen and produce non-volatile, resinous substances. Apparently, also, some polymerization reactions take place. These, of course, occur only in the presence of air and are particularly noticeable in a light and warm location. Poorly sealed containers will allow turpentine to thicken into a sticky substance which can not longer be used as a safe thinner for paints. If the distillate is pure, it probably has on paint a thinning action and no other. There has been some belief that through the formation of peroxides it might act as an oxygen carrier and, hence, promote the drying of oil films, but any siccative action of this kind is quite uncertain. Heaton (p. 62) says that there is enough oxidizing action and enough acidity in turpentine to have a destructive effect on fabrics, and he suggests that its use in connection with artists' canvases should be avoided where the maximum durability is essential.

All vegetable and mineral oils in a fluid state are miscible with turpentine, and it dissolves most resins, except those of a fossil origin, and most waxes. It is immiscible with water, but mixes in most proportions with nearly all organic solvents. It is not toxic or narcotic, but prolonged exposure to its vapors may cause headache and sickness, usually temporary, to some persons.

A variety of turpentine, produced chiefly in America, is made by steam distillation of pinewood logs and stumps. After such wood is first reduced to fine chips or powder, there is an initial distillation to extract turpentine and pine oil. The wood is then digested with petroleum spirit to extract the resin. It is said that the yield of turpentine from this source is between four and eight gallons per ton of the wood. Wood turpentine, as it is called, produced on a large industrial scale, is more standardized and uniform than gum spirits. It is similar to the oleoresin product, the main difference being that it contains a greater proportion of dipentene, limonene, and terpinene. In consequence, it has a greater solvent strength. The odor is distinct from that of ordinary turpentine. Except for this, for slightly different physical properties, and for a narrower distillation range, there is not much distinction between it and the turpentine from gum spirits. That made by destructive (dry) distillation of pine wood is an inferior product.

The history of turpentine is a long one. In crude form, at least, it appears to have been known in classical times or earlier. Greek writers tell about a material obtained from coniferous woods and juniper, and Pliny (XV, 7) describes *pissinum*, made by boiling pitch from trees and catching the vapors in a fleece spread over the tops of the vessels. A yellow fluid was wrung out. He also mentions (XVI, 22) a tarry substance from the destructive distillation of coniferous wood, and that

may be the ' pitch from trees.' The distillate, a complex substance containing terpenes, creosote, acetone, and phenolic bodies, is now sometimes called ' tar spirit.' It would have good solvent properties but a doubtful value as a thinner or diluent for resin varnish (see Laurie, *Greek and Roman Methods of Painting* [Cambridge, 1910], pp. 27–33). Other references in Pliny, however (XIV, 25; XVI, 21 and 23; and XXIV, 22), leave little doubt that the distilled volatile component of coniferous wood or of oleoresins was known and used in ancient times. (A more complete discussion may be found in A. Lucas, ' Cedar-Tree Products Employed in Mummification,' *Journal of Egyptian Archaeology*, XVII [1931], pp. 13–21; and Kenneth C. Bailey, *The Elder Pliny's Chapters on Chemical Subjects* [London: Edward Arnold and Co., 1932], II, 238–239.)

In spite of the evidence about the knowledge of turpentine in classical times, there is nothing to indicate that it was used with paints. In the early part of the mediaeval period, however, when the art of distillation had been perfected and when turpentine was a more familiar product, it may well have been common as a painter's material. Leonardo da Vinci in the late renaissance refers to it occasionally, chiefly in connection with the preparation of ' Greek fire.' That there may be confusion in his writings between the crude oleoresin and the spirit is possible, but in one place he definitely speaks about a turpentine of the second distilling (Edward MacCurdy, *The Notebooks of Leonardo da Vinci* [New York: Reynal and Hitchcock, 1938], II, 196). Berger (I, 228n, and III, 160n) says that there is no information about when the distilled product was first used in the art of painting, though he mentions a description made by Marcus Graecus which shows that distillation was familiar in the VIII century. By the XVI century numerous references show that distilled turpentine was a regular ingredient of varnishes (Charles L. Eastlake, *Materials for a History of Oil Painting*, 2 vols [London, 1847–1869], I, 291, 301, and 313; Berger, IV, 191, 193).

V. M. and P. Naphtha (Varnish Makers and Painters Naphtha) is a petroleum distillate with a boiling range, 100° to 160°C., between those of gasoline and kerosene. It is a common turpentine substitute and is widely used as a diluent and thinner for oil paint. (See also **Petroleum Thinner.**)

Water. This, the common solvent or diluent for aqueous mediums, glues, gums, egg white, casein, and others, the diluent for emulsions, like yolk of egg, the solvent for dyes and for inorganic salts, is without doubt the most generally used of any single material in the arts. Chemically, it is considered to be inert and stable. Most substances that are dissolved in it can be recovered in their original state after evaporation. To a small extent, however, it does dissociate, forming H^+ and OH^- ions, and these ions are capable of entering into a type of chemical reaction called hydrolysis or hydrolytic dissociation. Many organic materials, the lower organic esters like ethyl acetate, for example, are readily hydrolyzed by water with the formation of some acetic acid. Moreover, water serves as a catalyst for many chemical reactions, and the effects of many gases depend on at

least a trace of moisture. Changes in the chemical nature of lime plaster in the process of fresco painting require water.

Water has a higher heat capacity than any solid or than any other liquid at ordinary temperatures and pressures. In other words, more heat is required to raise the temperature of a given mass of water by a given amount than for any other substance. Water has also the highest latent heat of fusion (80 calories) and vaporization (536 calories). Heat conduction is less than that of metals but is higher than that of other liquids and non-metallic solids. Its maximum density is at 4°C. It expands when cooled beyond this point to zero and further on solidification. Surface tension, 73 dynes, is higher than that of any other liquid except mercury. Because of this many surfaces are hard to wet with water.

In relation to the various film materials and adhesives used in the art of painting, water may have a solvent action, a swelling action, or practically no action at all. The waxes and resins are little affected by it. Certain materials like the true gums, egg white, and fish glue are soluble in cold water; the water causes complete dispersion (peptization) of the material into particles of colloidal dimensions. Skin and bone glues and, also, starches are swelled by cold water to form hydrogels. Moderate heat is required to convert these gels to a fluid condition.

Natural impurities common in water may be contributing causes of deterioration of paint materials in which water is an original component. All ground waters contain various gases and salts. The gases are chiefly those of the air—oxygen, nitrogen, and carbon dioxide. The salts are chiefly sulphates and carbonates of calcium, magnesium, and iron. These cause what is called ' hardness ' in water. In addition, there is apt to be organic matter, algae and bacteria. Formerly works on painting techniques frequently called for distilled water in formulas and for mixing aqueous paints. Today many municipal supplies, particularly in the eastern seaboard of the United States, are comparatively free from injurious impurities and distilled water is not necessary. When, however, the local supply is not good, distilled water, now easily available, had better be used in connection with important work.

Wetting Agent, any material which lowers the interfacial tension between liquids and solids, and serves thus to aid in wetting a surface (see **Surface-Active Agent**).

White Spirits (see **Mineral Spirits**).

Xylene (xylol) is dimethyl benzene ($C_6H_4(CH_3)_2$). The commercial product, xylol, is a mixture of three isomeric xylenes, chiefly meta-xylene. Like benzene and toluene, it is a clear liquid derived from the destructive distillation of coal tar and fractional distillation of the ' light oil.' Less volatile than toluene, it boils at 139°C., and its lower volatility favors it as a diluent for brushing lacquers. It is not so dangerous a toxic as benzene.

BIBLIOGRAPHY

Anonymous, 'Final Report of the Committee on Benzol,' *Bulletin of the National Safety Council* (Chicago, 1926).

W. M. Bayliss, *Principles of General Physiology*, 3d ed. (New York: Longmans, Green and Co., 1924). Chapter VIII, 'Water, Its Properties and Functions.'

Ernst Berger, *Beiträge zur Entwicklungsgeschichte der Maltechnik*, 4 vols (Munich: G. D. W. Callwey, 1901–1912).

Ethel Browning, *Toxicity of Industrial Organic Solvents* (New York: Chemical Publishing Co., 1937).

Max Doerner, *The Materials of the Artist and Their Use in Painting*, trans. (New York: Harcourt, Brace and Co., 1934).

A. K. Doolittle, 'Lacquer Solvents in Commercial Use,' *Industrial and Engineering Chemistry*, XXVII (1935), 1169–1179.

T. H. Durrans, *Solvents*, 3d ed. (New York: D. Van Nostrand Co., 1933).

A. Eibner, *Malmaterialienkunde als Grundlage der Maltechnik* (Berlin: Julius Springer, 1909).

H. A. Gardner, *Physical and Chemical Examination of Paints, Varnishes, Lacquers and Colors*, 9th ed. (Washington, D. C.: Institute of Paint and Varnish Research, 1939).

Alice Hamilton, *Industrial Toxicology* (New York: Harper and Brothers, 1934).

Noel Heaton, *Volatile Solvents and Thinners* (London: Ernest Benn Ltd, 1925).

H. E. Hofmann, 'Evaporation Rates of Organic Solvents,' *Industrial and Engineering Chemistry*, XXIV (1932), pp. 135–140.

Otto Jordan, *The Technology of Solvents*, trans. (New York: Chemical Publishing Co., 1938).

K. B. Lehmann and F. Flury, *Toxikologie und Hygiene der technischen Lösungsmittel* (Berlin: Julius Springer, 1938).

Ralph Mayer, *The Artist's Handbook of Materials and Techniques* (New York: The Viking Press, 1940).

Ibert Mellan, *Industrial Solvents* (New York: Reinhold Publishing Corp., 1939).

Maximilian Toch, *Paint, Paintings and Restoration* (New York: D. Van Nostrand Co., 1931).

SUPPORTS

Academy Board and **Canvas Board.** The so-called 'mill boards,' 'academy boards,' and 'canvas boards' for several decades have been supplied for the use of amateurs and students. The term 'mill board' is generic for any strong, hard-pressed, flexible pasteboard made from rope, yarn, or other cheap fibres. C. Roberson and Company, Ltd, estimate that mill board was developed at the end of the XVIII century and their records show that it was in existence when the firm was founded in 1819. It appears in the Winsor and Newton Company, Ltd, lists of 1841.

Academy board is simply a mill board which is given a surface in preparation for painting, primarily oil painting. It is made of paper containing chalk and size and has a face of pale gray or white ground usually of a lead, oil, and chalk mixture. In some cases the face is given a rough texture by having a piece of paper laid on and pulled off again while the ground is still wet. Reeves and Son, Ltd, and Winsor and Newton Company, Ltd, London, first listed this board in 1850. The records of George Rowney and Company, Ltd, London, carry it back as far as 1852. When it reached the continent can not be stated exactly. The old firm of Lefranc in Paris, founded in 1775, has no records concerning it. It was manufactured in America by E. H. and A. C. Friedrichs Company, New York, in 1868.

Canvas board, a paper board with primed canvas fastened to one face, was put on the market by George Rowney and Company, Ltd, in 1878. It appears in the records of Reeves and Son, Ltd, and of Winsor and Newton Company, Ltd, in 1884. C. Roberson and Company, Ltd, think that it was introduced between 1875 and 1880. 'Russel board,' a type of canvas board in which the cloth is turned back and fastened over the edge, has been sold for over fifty years by F. Weber Company, Philadelphia. In 1887, Rowney introduced what they called Rushmore boards, a paper board having a surface grained in imitation of canvas. (This information has been compiled from personal correspondence with several of the older artists' supply dealers in England, the Continent, and this country.)

Aluminum. The element aluminum is a white, soft, malleable, and ductile metal. Its particular property is its lightness; it has only about one third the weight of the common metals. Although not readily attacked by acids, particularly by organic acids, it is rapidly corroded by alkalis. It has marked resistance to atmospheric corrosion. The aluminum metal cap on the Washington Monument, made in 1884, still reflects sunlight from its exposed surfaces. Under certain atmospheric conditions, even brightly polished aluminum becomes frosted with time because of the formation of a thin oxide coating.

Although compounds of aluminum were known as early as classical times, it was not until 1825 that the Danish chemist, H. C. Oersted, became the first to isolate this metal. Aluminum was available in small quantities for the next half century but at prices comparable to those of the noble metals; it did not come into commercial use until after 1886 when Charles Martin Hall discovered the process that led to large-scale production. Although ingot aluminum was produced as

early as 1893, the making of sheet metal did not assume large proportions until about a decade later.

Aluminum is prepared by the electrolysis of the mineral bauxite ($Al_2O_3 \cdot 2H_2O$) in a fused bath of cryolite. For this reason, the commercial product is of high purity. Sheet aluminum is obtained by either hot or cold rolling. Modern alloys of aluminum have a wide range of hardness and working properties.

Because of its very recent commercial history, few paintings are done on this metal. Its light weight, however, has suggested its use as a paint support and as a new support for the transfer of old paintings. Previous use in the automobile body industry shows that it gives a suitable surface for the application of paint. Highly polished or ' bright-finish ' aluminum is too smooth for satisfactory coating. ' Gray plate,' which is made by putting the aluminum through rolls that are covered with a coating of aluminum metal particles and aluminum oxide, has a better ' tooth.' It can be sand-blasted or roughened in other ways to give a rougher surface. Gray oxide coatings that are adherent and protective may be applied chemically (see Edwards, Frary, and Jeffries, II, 471) and electrochemically. L. McCulloch has published a method for giving aluminum a dead-white finish. The aluminum is boiled for some time in a mixture of lime and calcium sulphate; the coating formed is fine-grained, is adherent, and does not separate from the metal on bending.

Artificial Building Boards. In recent years a number of artificial building boards have been developed and are coming into extensive use in house construction and in remodeling. Although some of these may be considered as lumber or plaster substitutes, others have specific purposes. They may all be divided into three categories:

> 1. Fibre building boards
>> a. Homogeneous type (either porous or compact)
>> b. Laminated type
> 2. Mineral building boards
>> a. Asbestos with cement
>> b. Paper liner with gypsum core
> 3. Composite board (wood core with paper liner)

Low-grade vegetable fibres are largely used for the manufacture of the fibre boards. They may be wood-pulp, bagasse (crushed sugar cane residue), straw, corn-stalk, or sawmill waste. The porous, homogeneous fibre boards are made primarily for heat-insulating purposes, but that made from bagasse is also used for interior wall finishing. The laminated type, made by joining several sheets of thin cardboard with an adhesive, is used for wall boards almost entirely. Water resistance is produced in most boards by incorporating rosin size before forming and, in addition to this internal sizing, many boards have applied to them paints, gums, oils, or waxes to further increase water resistance. Both starch and water-glass are used as adhesives in making laminated boards. Frequently, both sides are

finished with a 'liner,' a sheet of paper of better quality than the fibre in the interior.

One type of fibre building board has aroused a considerable interest among painters of the present. It is of the compact, homogeneous type and is made by the so-called 'Masonite process' from wood chips of the long-leaf yellow pine. The wood fibres are torn apart by exploding the chips with high-pressure steam. The natural wood lignins are used to cement the wood fibres together again on large plattens with the aid of heat and pressure. The finished fibre board, which is chestnut brown in color, has one smooth side and one rough side; this is caused by imprints of the wire screen on which the board is formed. The rough side may be coated with a gesso ground or it may be primed with a white paint. The wire mesh imprint gives the surface a texture somewhat similar to that of coarse canvas. The Masonite product is hard and dense; it does not bend or warp easily. It is prepared in sheets four feet wide and up to twelve feet in length and from one eighth to one half inch thick. Three general types of the Masonite product are available: a thick, porous board for insulation purposes, a semi-hard board, and a hard or 'tempered' board.

Artificial building boards have one advantage: they are homogeneous in physical properties in all directions. They have no grain and, hence, are not subject to unidirectional shrinking and swelling. In large sheets, unless properly supported, they are liable to twist and to warp from their own weight.

Besides the artificial fibre boards, there are two types of wall board that are made almost entirely of inorganic or mineral materials. The first of these is made chiefly from asbestos and Portland cement in varying proportions. A little sulphite pulp for binding purposes and some pigment may be added. These asbestos boards are hard and dense. Weight and brittleness are their chief disadvantages; they are liable to fracture much like glass. When secured to a wall or properly re-enforced, however, they offer an excellent surface for the direct application of paint. The second type is made with a gypsum filler and a paper liner. This is a plaster substitute; it is fragile, easily broken, and, unless carefully supported and held at the edges, it can not be carried about and handled. It is of little use as a paint support unless it has been previously secured to a wall.

A third general class of artificial building board is a composition board made with a core of thin wood laths (frequently redwood) which are held together edge to edge with sodium silicate cement and a paper liner on both sides. On the outside they are similar in appearance to the laminated fibre boards. Boards of this type have little to recommend them for painting purposes.

Asbestos is a magnesium calcium silicate mineral which occurs in various combinations as white, grayish masses of long, compact, silky fibres, flax-like and readily separated. (See also **Artificial Building Boards.**)

Ash (*Fraxinus*). The European ash (*F. excelsior*) is a wood which grows widely from England to Asia. The American white ash (*F. americana*) is a little

coarser in texture but is otherwise similar. It is a tough, close-grained hard-wood. The heart-wood is light brown and the sap-wood is nearly white. The wood is ring-porous and annual rings are very distinct. In tangential section the rings produce marked elliptical or parabolic figures. The rays are fine and not conspicuous. The so-called ' mountain ash ' (*Pyrus*) belongs to an entirely different family. Ash has not been extensively used as a support for paintings (see also **Wood**).

Beech (*Fagus*). The beech usually found in panel paintings of the West is *Fagus sylvatica*, one of the common forest trees of temperate Europe. *Fagus americana* is very like it. The wood is not remarkable for either strength or durability but has been much used in mill-work and turnery. It is heavy and fairly straight-grained, and is diffuse-porous though the pores are small. Annual rings are not distinct. The color, particularly that of the heart-wood, is reddish to reddish brown. On quarter-sawed surfaces the rays are conspicuous as dark flakes from one sixteenth to one eighth inch in height. Only a few paintings of the German school are reported to be on beech.

Birch (*Betula*). This genus of tree is widely distributed over the northern hemisphere. The white birch (*B. alba*) is the species most commonly used in Europe. (It is not to be confused with the paper birch [*B. Papyracea*] of North America.) The yellow birch (*B. lutea*) and the sweet birch (*B. lenta*) are the species most valued for timber in America. Birch is moderately strong and does not warp badly. Heart-wood is reddish brown in color. The texture is close and compact; the pores are diffuse and very small and for this reason the annual rings are not conspicuous. The rays appear on quarter-sawed surfaces as very small, reddish brown flakes. Birch is often stained to imitate mahogany. It has been little used in panel painting (see also **Wood**).

Brass, as the term is now used, is an alloy of copper and zinc. The proportion of the two metals may vary within fairly wide limits, but ordinary brass is about 2 parts copper and 1 part zinc. In its older use, the term was applied to the alloys of copper and tin, now known as bronze. The brass spoken of in the Bible was probably bronze and so, also, was much of the brass of later times until the distinction between zinc and tin became clearly recognized. Copper-zinc alloys were known in Roman times. They were manufactured in England in the XVI century. Although it is probable that brass was used as a support for painting, along with other metals (see also **Metals** and, particularly, **Copper**), no available evidence for such use appears.

Canvas is, literally, a coarse cloth made from cotton, hemp or flax. This definition serves well enough to describe the traditional fabric used as a paint support in Europe (see also **Fabrics**), though hemp fibre is rarely found in such objects. The word ' canvas ' has now a number of meanings. It may be used for artists' canvas or for a picture painted on canvas.

Cedar (*Cedrus*). Under the name ' cedar ' is included a number of woods from different genera, some of which are not conifers, and the name has been applied

rather indiscriminately to woods having a certain fragrant odor characteristic of the true cedars. The cedar of Lebanon (*Cedrus Libani*), one of the important woods of history, was used widely in Egypt and the Near East. No true cedar is indigenous to Europe. The wood is generally reddish brown and light in weight, but has a coarse and spongy texture; it is easy to work but is liable to shrink and warp. The annual rings are clearly marked. According to available records, it was one of the woods used for the support of mummy portraits made in the Fayûm district between the I century B.C. and the VI century A.D. It had occasional use in the panels of European painting.

Chestnut (*Castanea*). The sweet chestnut (*C. vulgaris*) is commonly known in Europe. A similar tree (*C. dentata*), before a recent blight, flourished in America. Chestnut resembles oak and it is mainly the indistinctness of the medullary rays that differentiates it from that wood. It is a soft, light wood, comparatively free from warping and shrinking. It is ring-porous and hence the annual rings are easily distinguishable. Spring-wood vessels (pores) are large and generally arranged in double or triple rows; summer-wood vessels are very small and can scarcely be observed with the naked eye. Because of the large pores, plain-sawed chestnut has a conspicuous figure. It is subject to attack by worms. Chestnut was much used for painted panels, particularly in Italy (see also **Wood**).

Clay is perhaps the oldest of plastering materials. Although one of the poorest, it has endured surprisingly well as a paint support in certain instances. The essential components of clay are the hydrous silicates of aluminum which are widely distributed on the earth's surface. These may be associated with other substances or impurities to a greater or less extent. Clay absorbs water readily and becomes plastic, a property which has made it pre-eminently useful in the ceramic arts.

Cloth (see also **Fabrics**). Although this term might have become general for the woven stuff that is used, in various kinds, as a support for paint, ' canvas ' or ' fabric ' are more apt to be applied to it. The word ' cloth ' is frequently used, however, in this general sense. More specifically it is used to define a kind of weave: simple cloth, in which warp threads and weft threads pass over and under each other alternately; and, among others, compound cloth in which there are multiple warps or wefts, or both, one warp and one weft being of cloth weave.

Copper. The chemical element, copper, is a yellowish red, soft metal. It is ductile and malleable and, hence, is easily rolled into thin sheets or plates. It is prepared by the reduction of sulphide, oxide, and carbonate ores. Most of the copper that now appears in the market is electrolytically refined; its purity generally runs better than 99.9 per cent. The electrolytic refining of this metal was first carried out on an industrial scale in 1869 at Pembrey, Wales.

Freshly-worked copper has a luster and takes a bright polish but it is soon tarnished when exposed to the air. Under indoor conditions, it is stable for centuries and the tarnish remains very superficial. Exposed out-of-doors, it

gradually acquires a thin, green patina composed of the basic salts of copper. These are formed as a result of the corrosive action of atmospheric carbon dioxide and sulphur dioxide. The patina may last for centuries, under these conditions, even when the metal is in sheet form. When it is buried in the ground, however, corrosion is fairly rapid, particularly if the metal comes into contact with saline waters. Although copper is not acted upon quickly by dilute mineral acids, since it is below hydrogen in the electromotive series, it is acted upon by acids under oxidizing conditions. Some organic acids, like acetic acid, corrode it slowly. The fatty oils and fats also attack copper slowly but the action does not bear any simple relation to the acid content of the oil. C. W. Volney (Mellor, *Comprehensive Treatise*, III, p. 102) found that several natural fatty oils, including linseed oil when in contact with copper, dissolved fairly large proportions of the metal. Individual oils have different effects on the copper surface: some leave it bright; others tarnish it. The oil itself turns green. It has been observed that spirit-resin varnishes in contact with copper or brass turn green (' green drip '). Painting on a copper panel has been observed to have a green-stained, oil-resin film between the metal and white ground. This indicates a slow chemical reaction between the copper and the oil or resin while the latter was still plastic or semi-fluid.

Known in prehistoric times, having a continuous history which is much involved with that of bronze (a copper-tin alloy), copper itself was not much used as a support for paint until it became cheap and plentiful in sheet form. That was probably in the XVI century (see also **Metals**). At about that time, also, its use for intaglio printing began to be exploited and it has since been the principal plate material of etchers and engravers.

By the XVII century mention of the use of copper as a paint support had got into the literature. The voluminous MSS of De Mayerne (Berger, IV, 416) include a reference to painting with oil on copper and other metals. The Spaniard, Palomino, writing in 1724 (*Museo Pictorico*, II, 44; see Berger, IV, 83) says that copper panels are to be grounded with the same oil preparation as that used for panels of wood. He points out, also, that the smooth surface of the metal will not give a good bond unless it is first rubbed with garlic.

Cotton is the seed hair of the cotton plant (*Gossypium*); it consists of a single hair-like cell which, when fully ripe, is flattened and twisted. The length of the cotton fibre varies from 2 to 5.6 cm. and the diameter from 0.0163 to 0.0215 mm. The walls are thick and the lumen or central canal is broad, giving the fibre the appearance of a collapsed, twisted tube (see figure 2, p. 231). Cotton is over 90 per cent cellulose and is one of the most important sources of that material.

Like wool and linen, cotton was being made into clothing in prehistoric times. It has been for thousands of years the staple fabric of the Orient. The plant grows generally in tropical and sub-tropical regions, more than half the world's normal supply coming from the United States. It is also grown in British India, Egypt, Russia, and Brazil. Sea Island cottons, grown on islands off the southeastern

coast of the United States, are the best in quality; Egyptian cotton is next. Cotton fibres, being nearly pure cellulose, are readily affected by acids and by moderately strong oxidizing agents but alkali hypochlorites, in dilute solutions and at ordinary temperatures, have little effect on them. In spite of its long history, cotton has been used comparatively little as a support for paint until recent times (*cf.*, **Linen**). Particularly in the XX century has it been made into a commercially prepared canvas. As yet it has not acquired the reputation for permanence that linen has.

Cradle is the term applied to a wood structure fixed to the back of a panel painting to prevent it from warping with changes of humidity. It consists of narrow wood strips having slots and being joined with glue to the back of the panel parallel to its grain. Transverse strips ride freely in the slots and, if conditions are favorable, keep the panel flat but do not interfere with the normal expansion and contraction, across the grain of the wood, with changing humidity conditions. (For illustrations, see Thompson, *Tempera Painting*, pp. 11–12, and De Wild, p. 90. See also **Wood, deterioration and treatment**.)

Esparto or **Esparto Grass** (*Stipa tenacissima*) is a kind of spear grass used, particularly in England, for the manufacture of paper (see also **Paper**). The plant has long leaves in which the fibres are strong and flexible. To produce a pulp from the grass, it is boiled in a solution of caustic soda.

Fabrics. As supports for painting, fabrics may be considered according to the weave and also according to the thread and to the origin of the fibres. Animal fibres (see **Fibrous Substances**) may be divided into those which come from animal hairs (see **Wool**) and those which come from insects, *i.e.*, the silk worm (see also **Silk**). The animal fibres may be identified by their continuous cylindrical structure as seen under the microscope, by chemical identification of their protein content, and by their characteristic odor when burned.

Among the vegetable fibres are three general categories. Vegetable hairs include cotton—seed hairs from various species of *Gossypium*—fibres of 'cotton trees,' Bombax cottons, vegetable silks, seed hairs of *Asclepiadaceae*, etc. The second group is made up of bast fibres from the stems of dicotyledonous plants. Further division of this group would begin with flax and flax-like fibres, hemp, Gambo hemp, sunn hemp, and yercum fibre. After these come the Bohmeria fibres, ramie, and China grass. Next come jute and jute-like fibres, then the coarse bast fibres, and, finally, basts, including linden and other woody materials. The third group includes fibre bundles of monocotyledonous plants. First are leaf fibres, including Manilla, pita, sisal, Mauritius hemp, New Zealand flax, bowstring hemp, and esparto. Next are stem fibres such as tillandsia, fruit fibres such as coir, and, finally, paper-making fibres—straw, esparto, bamboo, wood, paper-mulberry, etc. Out of the large range of these categories only a few fibres have a marked place among the paint supports that have been used or are used now. These are the animal fibre, silk, the bast fibre, flax, and the seed hair, cotton.

The first step in converting fibres into cloth is, of course, the removal of inter-cellular matter (see also **Linen**), leaving relatively pure fibres. These are carded, combed, drawn out and spun to the correct size. After spinning, single ends are put together, in such number as will make the size of thread required, and are twisted together in a direction opposite from that of the spinning. The reversal of direction keeps the twist from kinking. When wound, the twists are ready for weaving.

FIGURE 1. Simple weaves of fabric are shown in the drawings taken from figures 1, 2, and 3 in 'A Classification of Hand-Loom Fabrics,' *The Pennsylvania Museum Bulletin* (Philadelphia), XX (November 1924), page 27, by Nancy Andrews Reath. At the left is a simple cloth, each warp thread (vertical) passing under one and over one weft thread; in the center is a simple cord in which the warp threads (vertical) are much smaller than the weft threads; at the right is a simple twill in which a warp thread passes under one and over three of the weft threads.

Hand-weaving is a simple and familiar process. One set of threads, the warp, is strung parallel on a frame and another set, the weft, is carried, by a shuttle, in and out among the warp threads to make the fabric. The different ways in which the two intersect are differences in weave. According to the descriptions of these different ways, as given by Nancy Andrews Reath (pp. 8 ff.), those that usually appear in painting supports can be defined as follows: (1) simple cloth, in which warp threads and weft threads pass over and under each other alternately (ribbed cloth or cord, in which one set of threads is heavier than the other, seems to have had no appreciable use in painting); (2) simple twill, in which regularly recurrent warp threads pass in echelon over and under the weft threads two or more at a time, producing diagonal ribs or stepped patterns.

The history of fabrics as painting supports (see also **Linen** and **Cotton**) can be traced back at least as far as the XII dynasty (2000–1788) in Egypt (a small painted fragment, linen, of this time is in the Royal Ontario Museum of Archae-

ology, Toronto), and the practice must have preceded that by many centuries. Examples of it are found in Egypt dating from the early years of the Christian era. A few scrolls from Chinese Turkestan (see Sir Aurel Stein, *Serindia* [Oxford: Clarendon Press, 1921]) are from the Six Dynasties (265–581 A.D.). In the Far East fabric was used with steady continuity by painters and, although important paintings in Europe do not mark its employment so regularly, there is no reason to suppose that it was ever abandoned. Pliny (XXXV, 51) remarks that the Emperor Nero ordered a colossal portrait of himself, 120 feet in length, to be painted on canvas. The icon, the altarpiece, and walls of churches took precedence in Christian painting, but linen and some silk were probably always used for painted banners and for other purposes. In the third book of Eraclius, *De Coloribus et Artibus Romanorum*, chap. XXVI, are directions for preparing linen that is to be painted on (Merrifield, I, 230). This was written in the XII or XIII century. Cennino Cennini about 200 years later gives a similar but far more explicit instruction (Thompson, pp. 103–104).

With the decline of painters' work on altarpieces and with pictures acquiring larger scale, during the Renaissance, fabric or canvas was more and more used. It is today the principal support for paintings executed in the oil medium. The usual practice is to stretch the fabric on frames to which it is attached by tacks at the outer edges. Most modern frames, called stretchers, are so mortised at the corners that they can be slightly extended in outside dimension, and the fabric tightened, by means of small wedges, called ' keys,' inserted in the joint. Such a stretcher is not much seen before the XIX century. Earlier than that, also, it was the common practice to stretch the fabric before it was sized or had a ground film applied. Now artists' canvas is bought in pieces or rolls ready for painting. In consequence, these latter canvases show a ground film where they run over the edges of the stretchers. In older paintings the fabric is apt to show no coating at the edge. Usually linen or cotton has been used alone but there was an old, and very sound, practice of using it over wooden panels. It was glued directly to the wood and had a gesso ground laid over it. Probably this originated in Egypt and it was much followed in Italy during the XIII to XV centuries. Occasionally it has been combined with paper into a double support, the paper being used actually in place of a ground film.

Fabrics, conservation and treatment. The deterioration of fabrics is largely that of the cellulose which, except for silk, chiefly composes them (see **Fibrous Substances**). To some extent this is an inevitable consequence of exposure to a normal atmosphere. It has been found, however, that cellulose itself is extremely resistant. Probably the principal deterioration of artists' canvas comes either from materials that are added in the paint structures or from conditions that could be avoided in the environment of a picture. Oil in the ground or applied at the reverse of a fabric is one cause of its weakening. Not only does the oil film embrittle the whole structure; it also tends by its own oxidation to increase that of

the fibre and to change it to oxycellulose. Glues or pastes used in priming encourage the growth of mold and micro-organisms which will attack and destroy the fabric. They can be kept from growing by conditions in the rooms where paintings are put. Darkness and dampness (a relative humidity of 65 per cent or more) are all that such organisms need to start their development in a normal room temperature. Spores are almost sure to be present.

Treatment of the fabrics used for paint supports may include attempts at disinfection to remove active micro-organisms. Such treatment is usually made with thymol vapor or formaldehyde applied either in solution or in closed chambers. By far the most usual treatment, however, is that known as 'relining.' The aim of this is to strengthen the fabric structurally. It is a process of backing the old canvas with a new one, a film of adhesive material being used to attach the two. In general, this treatment has been applied for at least 200 years. In its application usually a light facing is attached to the paint and often this is held on a stretching frame. The old canvas being removed from its stretcher, it is carefully cleaned and smoothed on the reverse side. A new canvas is selected, stretched, and sized or impregnated. The old canvas is sized or impregnated also, enough of the adhesive material being left to form a bond. The two surfaces are then set together and the adhesion is established usually with heat and pressure.

Until the late years of the XIX century, the principal adhesive for the relining process was glue. It was sometimes used in emulsions with oils or varnishes. Then wax and a mixture of wax with a small amount of resin came into use and has sometimes been called the 'Dutch process' of relining. Wax has found much favor. The general technique is not very different but impregnation of the old fabric is more certain and the sealing power against dampness is, of course, far greater than that of glue. Glue also suffers from its tendency to augment the growth of mold.

Mounting instead of relining has occasionally been done for European paintings on fabric. In this treatment the principle is much the same but a rigid panel instead of another fabric is used at the back of the old support. For the most part, the wax type of adhesive is used, and the development of this and of artificial boards has greatly encouraged adoption of the method for use with small paintings. In the East, of course, mounting has been practiced for many centuries and is used for paintings on silk or paper. It is done largely with paste as an adhesive.

Fibrous Substances. Fibres are special structural components of animal and vegetable origin which are utilized in textile, paper, cordage, and brush manufacture. Only one important fibre, asbestos, is of mineral origin; it is no special structural component like the animal and vegetable fibres but is an unusual crystalline form of a mineral substance.

Animal fibres are composed of nitrogenous colloids like the albumins, fibrins, and gelatins and they are of highly complex constitution. Unlike the vegetable or cellulose fibres, they are resolved and finally dissolved by alkalis whereas the

former are quite resistant to that agent. Animal fibres are mainly restricted to the making of textiles. The number used is relatively small and may be divided into two kinds. One is the epidermal hair of animals of which the wool from sheep is the most important. Particularly characteristic of animal hairs are the tiny scales which completely surround the shaft. These are embedded in an epidermal layer over a cortex or fibre layer. A medulla or pithy center may or may not be present.

FIGURE 2. Three types of fibres, adapted from photomicrographs at 100 diameters, in *Chemistry of Pulp and Paper Making*, by Edwin Sutermeister, 2d ed. (New York: John Wiley and Sons, Inc., 1929), Plates 1, 2, and 6: at *a* a drawing showing a group of cotton fibres; at *b* a group of linen fibres; and at *c* a group of paper mulberry fibres.

Animal hairs are very long as compared with most vegetable fibres. The identification of a fibre as a hair is simple because of the scales, but the identification of hair as to its source is rather difficult. Among the hairs of textile importance there are slight individual differences which allow at least a partial identification of the source; the quantitative measurements of diameter and scale size are of great aid in verification of qualitative observations as to the shape of scale and kind of medulla. Silk is another kind of animal fibre. True silk is the continuous filament that forms the cocoon of the *Bombyx mori*, the worm that feeds on the leaves of the mulberry tree. The silk fibre is, in reality, a double fibre bound together with sericin or silk glue. The two individual fibres are separated by boiling in soap and water which dissolves the sericin. Tussah or wild silk is the secretion of wild silk worms; it is difficult to decolorize and, hence, is usually dyed a dark color.

The vegetable fibres are numerous and diversified in characteristics. They are colloidal bodies made from cellulose and derivatives of cellulose. In all the higher forms of plant life the living cells consist essentially of protoplasm sur-

rounded by a wall of cellulose. In the woody structure of these higher plants, where cell growth has ceased, the cells become cemented together with a substance called lignin. This lignin, which is somewhat similar to cellulose and is generally spoken of as one substance, is in all probability made up of several closely related substances. It is the substance that is removed chemically in preparing cellulose for paper. The woody tissue of plants is made up of cells which exhibit great diversity of form, size, and markings. The paper maker is interested in the true wood fibres or libriform cells, and in the tracheids. The wood fibres characteristic of deciduous trees or hard-woods are elongated cells with strongly thickened walls; they are variable in length in different woods, ranging from 0.14 mm. to 2.0 mm. and in all cases they are the longest elements present. The woody tissue of coniferous trees consists almost entirely of tracheids which are elongated, tapering cells, more or less lignified and characterized by bordered pits or discoid markings. These pits are so constant in number and mode of distribution that they may be used as distinguishing characteristics for some woods. The tracheids of coniferous woods are considerably longer than the wood fibres of hard-woods, frequently reaching a length of 4 or 5 mm. This is one of the reasons that spruce wood is so valuable for making sulphite pulp.

Bast fibres are those fibre bundles found in the inner bark of various plants. They are held together by incrusting materials and by partial identity of their cell walls. Some kind of chemical or mechanical treatment is necessary to separate them. The commonest method is that of retting. The bast tissues of dicotyledonous annuals furnish such staple materials as flax, hemp, ramie, and jute. The walls of bast fibres are generally of considerable thickness and the central canal varies greatly in different species. The fibres are characterized by irregular thickenings of the walls at intervals to give joints or nodes.

In the seed hairs, like cotton, the fibres are individual cells or units. Although they occur as complex aggregates they are not cemented together as are wood or bast fibres. This is the reason that cotton is such a valuable source of fibre and cellulose.

Fir (*Picea* and *Abies*). The name of this wood now correctly includes the spruces (*Picea*) as well as the true firs (*Abies*) and is also frequently applied as a general term for all of the true conifers (*Abietineae*). In northern Europe the Norway spruce (*P. excelsa*) is the most important timber species but in southern Europe the silver fir (*A. pectinata*) is an important rival. This tree appears to be the true *Abies* of the Latin writers. It is abundant in most of the mountain ranges of southern Europe. The wood is inferior to *P. excelsa* but is soft and easily worked. The wood structure of the spruces and firs is similar to the pines except that the resin ducts are smaller, more scattered, and less distinct. Woods from various firs have no doubt been used rather extensively in the panel paintings of Europe. It is little mentioned in the records but there perhaps it has been often confused with pine.

Gesso, in its restricted meaning, the white priming or ground made from burnt gypsum (plaster of Paris) and glue, which was used by the Italian painters for preparing wooden panels or other supports for painting and gilding. Today the term is often applied to grounds made from almost any white inert or pigment like whiting or zinc oxide (see p. 115). Properly prepared gesso is hard and can be finished to an ivory-like surface with a proper absorbency for paint. It has been used on carved wooden moldings which were to be gilded and decorated because it was easier than the wood itself to carve delicately and to prepare for gilding (see Thompson, *The Materials of Medieval Painting*, p. 31). Gesso sets more slowly than plaster of Paris but is harder, more strongly adhesive, and can be smoothed more satisfactorily. Modern painters and picture framers prefer to use whiting or gypsum mixed with zinc oxide in place of straight gypsum or plaster of Paris because this addition gives gesso a greater bulking and hiding power; fewer coats are required. Such formulas call for about equal measures (equal parts by volume) of pigment (gypsum, whiting, zinc oxide, or mixture) and glue solution (1 part of glue to 15 parts of water by weight).

Glass is a super-cooled liquid made by the fusion of soda, lime, and silica in varying proportions. Other metal oxides, such as those of lead, barium, potassium, and iron, may enter into its composition. Although glass was known in Egypt as early as 3500 B.C., cast plate glass was not made until the latter part of the XVIII century. G. W. Morey ('A Half Century of Glass . . .,' p. 943) says, ' . . . during all these centuries only one type of glass was known, soda-lime-silica glass, modified, of course, by the very considerable amount of impurities that crude manufacturing methods made unavoidable.' Hackh's *Chemical Dictionary* says that glass is an amorphous, hard, brittle, often transparent material consisting of a mixture of the silicates of some of the alkali metals, the alkaline earth metals, and the heavy metals, and that it is obtained by the solidification of a fused mass containing:

a. SiO_2 as quartz, flint pebbles or siliceous sand; this can be replaced by B_2O_3, Al_2O_3 or Mn_2O_3.

b. Na_2O or K_2O as carbonate or sulphate.

c. CaO as limestone or marble; this may be replaced by PbO, MgO, ZnO or BaO. The constituents *a*, *b*, and *c* are finely powdered, well mixed and heated to 1000–1100° C.; on cooling to 890° C. the pasty glass is worked by blowing, drawing, casting, or fusing piece to piece and now annealed by slow cooling or reheating and cooling. The composition of glass varies between $(K, Na)_2O$, $(Ca, Pb)O$, $6 SiO_2$ and $5(K, Na)_2O$, $7(Ca, Pb)O$, $36 SiO_2$.

It is well known that glass was used for windows in Roman times. N. H. J. Westlake (I, 4) cites several examples of window glass from Pompeii and other Roman sites. Hot glass was probably both cast and blown at that time. Because

of obvious shortcomings, glass has never been an important support for paintings, although the large and rigid flat surfaces it offers must have suggested its use. It has, however, been made a support for miniatures and for decorated clock faces. The smoothness of its surface has presented a certain difficulty in the application of paint. Painting on glass or painted glass may be of different kinds: the application of a pigment with a medium, in the ordinary sense, or the kind that is commonly called ' stained glass ' where vitrifiable pigments are applied and fired in. J. D. LeCouteur (p. 1) contends that the expression ' stained glass,' so often applied to colored glass whether mediaeval or modern, is misleading and erroneous. It should be ' painted glass.' He goes on to say, however, that the method, discovered in the XIV century, whereby glass was colored yellow by painting with a silver solution and refiring, produces a glass that may properly be called 'stained.' Painting and gilding on glass appear to have been frequently done in the Renaissance. In Thompson's translation of Cennino Cennini, *Il Libro dell' Arte*, there is shown a diptych with panels of gilded and painted glass and Cennino Cennini describes (pp. 111–113 of this translation) a method for gilding on glass and scratching in designs with a needle. Leonardo da Vinci made a suggestion (see W. Ostwald, p. 137) that paintings be made directly on glass and seen through it so that there would be no diffusion of light from the surface of the paint. The suggestion may have been acted on; paintings done in this way have survived from somewhat later times. For the most part, they are of provincial origin, and doubtless large numbers have been lost entirely.

Although glass is generally considered to be a stable material, it is subject to internal changes and decay which depend upon environment. There is some tendency to crystallization or ' devitrification ' on the part of the super-cooled liquid alkali silicates from which it is made, and this causes glass to become more brittle with age. Ancient glass, which has long been buried in the soil, exhibits a dull surface with well known iridescence. The cause is said to be the action of moisture, oxygen, and carbonic acid in the atmosphere. They dissolve the alkali from the glass and leave silicic acid in the form of minute scales that produce iridescence by interference. In ancient glasses there was often an excess of alkali over and above the proportion required to combine with the silica present. The excess is soluble in water and attracts moisture and carbon dioxide from the atmosphere. There have been seen ancient glazes on pottery where practically all the alkali has been leached out by ground waters to leave only a residue of porous silica or silica hydrate. Potash glasses, like Venetian glass, are liable to become moist (' sweating glass ') because of the hygroscopic nature of the potassium carbonate that is formed in the initial stages of decay. The silica does not reach a powdery condition, for it is dissolved by the moist alkali. It may become opalescent but not iridescent. These are, however, extreme cases of deterioration. A glass that still retains its paint film has probably changed little in the course of centuries, except to become more brittle.

Glass Fabric. Molten glass can be blown or drawn into fine fibres which can be woven into fabrics. Although such fabric is used chiefly for electrical insulation, it is also made into finer stuffs. Its use as a support for paintings has been suggested and small quantities, glass fabric with a prepared ground, have been marketed by artists' supply houses. Because of its inorganic nature and, hence, its resistance to mildew and other agents of organic decay, it may be good for special purposes. The fabric has high gloss and sheen, is harsh to the touch, is not elastic, and is brittle when sized with glue. Glass fibre is marketed under the trade name, 'Fiberglas,' by the Owens-Corning Fiberglas Corporation.

Gum Wood, red gum, and satin walnut are names given to the *Liquidambar styraciflua*, a tree indigenous to North America. Species from other genera, however, may be called ' gum wood.' The wood from *L. styraciflua* is medium hard, is easily worked, and has no important variations in structure. The heart-wood is reddish brown and the sap-wood, pinkish white. The pronounced figure in tangential and radial sections is caused by dark streaks that are distinct from the annual rings. The pores are small and rings are not easily noticeable in sections, either cross or longitudinal. Medullary rays are quite clearly marked in strictly radial sections. The wood is strongly inclined to shrink and warp.

Gypsum Cement. Plaster of Paris is not the only cement or plastering material made from gypsum. When gypsum is burned at a higher temperature than that used in making plaster of Paris, it loses all, or nearly all, its water of crystallization and the product has poor setting qualities. If, however, this product is dipped in certain salt solutions, such as alum, borax, cream of tartar, etc., and is again calcined, a very useful cement, slower to set and more easily worked than plaster of Paris, is obtained. These highly calcined gypsum products are known under various proprietary and traditional names, such as Keene's cement, Martin's cement, and Parian cement.

Hemp is derived from the bast fibres of the stem of *Cannabis sativa*. It has been used for centuries in the making of ropes and sailcloth, and the finer varieties have been spun into yarns and woven into textiles. It probably originated in India but will grow almost anywhere, and commercial varieties include Russian, Italian, Chinese, and Arabian hemp fibres. In a few cases, chiefly during the XIX and XX centuries, hemp cloth has been used as a support for paintings.

Hydraulic Cement is any cement that hardens by chemical combination with water, but the term is usually restricted to that kind which is obtained by burning a mixture of lime and clay and pulverizing the resulting clinkers, and which, ordinarily, goes by the name, Portland cement (see **Portland Cement**). Pozzolanic cements also come within this classification (see **Pozzolana**).

Iron. Since mediaeval times iron has had first place among the metals. Its properties and method of preparation are familiar. Although for purposes of armor-making it was beaten into thin sheets quite early, it probably was not rolled into sheets to any great extent before the middle of the XVI century. Its tendency

to oxidize or to rust is also well known. Although the art of coating copper vessels with tin reached a high standard in Roman times (E. S. Hedges, p. 207), the practice of coating sheet iron with tin (tin plate) was not general before the XVII century. The coating of iron with zinc (galvanizing) probably dates from experiments of Melouin in 1741 (see Hedges, *loc. cit.*). Sheet iron and tin plate appear to have been used only to a limited extent as a support for paintings. It may be seen more frequently, however, as a support for miniatures, coats of arms, and signs. Cennino Cennini's painting on iron with oil (ed. Thompson, p. 57) is probably not painting of an iron panel but painted design on an iron object.

Ivory. For commercial purposes the tusks of the walrus, the hippopotamus, and other animals are considered to be ivory but that, in its strict sense, means the material of the tusk of an elephant. This is a tooth and the two tusks are the upper incisors. They grow during the life of the animal, forming themselves out of phosphates and similar substances. Structurally, they lie in layers, the one inside being the last produced. Ivory is very dense; its pores are close and compact and they are filled with a gelatinous solution. Arcs of slightly different color show in cross sections of the tusk. These arcs intersect to make lozenge-shaped spaces in which lie innumerable minute tubes closely placed and radiating outward in all directions. The marking in cross sections is characteristic and is often used to distinguish ivory from materials used for its imitation. Most ivory comes from Africa but some is Asiatic and a certain amount is still derived from the remains of prehistoric animals in Siberia. Unlike bone, ivory can be worked immediately.

This has made it a favorite material for carving from neolithic times. It was cut and fashioned and often stained long before it came into use as a support for paint. Lucas (p. 310) reports that in ancient Egypt it was used as a ground for writing. By the days of Greek ascendancy it was evidently a common practice to paint on ivory, for Pliny (XXXV, 149) mentions it quite definitely in that connection. It is probable that the practice continued, though mention of it is rare. Theophilus (chap. CX) speaks of ornamenting ivory with gold leaf, and Pierre Lebrun, *Recueil des Essaies des Merveilles de la Peinture*, 1635, chap. XXXVII (Merrifield, II, 820–821) says, ' Ivory must be washed with the liquid which is found under horse dung, for the colors can not be applied without this secret and invention.'

Ivory, cut into thin slices, has been much used as a support for miniature painting. It became popular in England and France for that purpose in the XVIII century because it was the most suitable material for painting with transparent colors. Sometimes curved slices of ivory were flattened out by hydraulic pressure, making unusually large sheets. Some of these, however, have curled and cracked with age (see *Encyclopaedia Britannica*, 14th ed., on Miniature Painting).

Jute is derived from several species of *Corchorus*, especially in India and China, where it has been cultivated for centuries. It was first introduced into Europe in the latter part of the XVIII century. The commercial fibre is 4 to 8 feet long but

the ultimate fibre is only 1 to 5 mm. long, and has a large lumen and thin walls. The tensile strength and wearing qualities are poor. The fibre contains much lignin and has not good keeping quality. It is made into sackcloth and as such has found occasional use as a paint support.

Larch (*Larix*). The common larch (*L. europaea*), a conifer, is a native of Europe and Asia. The North American representatives, *L. laricina* (tamarack) and *L. occidentalis*, are similar. The wood is coarse in texture and tough but, unless carefully seasoned, it is liable to warp and bend; it is heavy and straight-grained. The color of the heart-wood is russet to reddish brown. The annual rings are distinct. In longitudinal section there are no characteristic figure or ray markings. Although it is a tree well known in Europe, records do not show that it was extensively used in panel painting except for a small number by the German schools.

Leather (see also **Parchment**). This material is made from the skins of various animals. These are prepared by a process known as ' tanning ' and are so rendered flexible and imputrescible. (Raw skins, being subject to bacteriological as well as chemical disintegration, readily putrefy.) The chief ingredient of tanning substances is tannin or tannic acid, secreted by various parts of a large number of plants, and these are usually classified as *Pyrogallols*, including chestnut, oak, sumach, and others, and *Catechols*, including hemlock, mangrove, larch, birch, and others. Oak-bark (*Quercus robur*) and Vaolnia (*Quercus aegilops*) contain both types and, because of the blend, produce excellent leathers. The fibres of the plants are crushed and are then leached by infusion with water to produce a tan liquor. (Under modern methods of manufacture this liquor is then tested for its tannin content and for its acidity.) The skins or hides are cleaned and softened and have the hair and the scarf skin or epidermis removed. The latter process is usually one of liming and scraping. Lime, so used, is removed by washing the skins in weak acid solutions. After that they are hung in successively different strengths of tan liquor. When tanning and drying are finished, the leather is usually treated with oils and is pared and smoothed, a process known as ' currying.'

Although the tanning of leather is a craft which appears to be very old, the product has never been in great favor as a support for paint. The reasons for this are obvious and are both technical and economic. Leather did, however, figure among the properties of interior decoration as well as for personal adornment and for numerous accessories of dress and equipment. Paint was used frequently in the designs laid on such objects. Painted leather harness is often found and a Roman parade shield covered with leather on which are painted representations has been discovered at Dura-Europos in Syria. Stamping and gilding leather was an old craft in the Venetian lagoon and work of this order spread into other regions of Europe. The Mediterranean basin seems to have remained the principal source, however, of European leather in the middle ages, much of it coming from the countries of the Moors and Saracens in Africa, or from Cordova, or Marseilles.

Mrs Merrifield points out (I, cxi) that Eraclius described painting on plain leather stretched on a panel and that Marco Rizzi is said to have painted on kid skins. As late as the XVII century there is written evidence for a survival of this practice. The MSS of De Mayerne (Berger, IV, 211) refer to a color for painting leather and also to a ground for painting on leather (Berger, IV, 277).

Lime Plaster (see also **Plaster**). Since prehistoric times lime has been one of the most important plastering materials. Pure lime itself or ' neat ' lime is not used except for very thin surface washes and then it is usually mixed with salt, glue, or casein. In thick layers, neat lime shrinks and cracks. To avoid this, it is mixed with sand, finely crushed stone (frequently marble), or fibrous, organic matter. Magnesia (MgO) is a frequent impurity in limes, and the so-called ' magnesia limes ' are derived from dolomitic limestones. Cowper (p. 16) says that Italian limes contain up to 40 per cent magnesia. Magnesia limes slake more slowly than high calcium limes. They expand less on slaking and shrink less on drying and they set more slowly. A high magnesia lime is not considered a good lime.

Lime is calcium oxide (CaO). It is prepared by heating one of the various forms of calcium carbonate ($CaCO_3$), limestone, marble, or chalk until nearly all of the carbon dioxide is driven off, $CaCO_3 \rightleftharpoons CaO + CO_2 \uparrow$. When freshly prepared, the product is called ' quicklime ' or ' caustic lime,' for it readily combines with water and decomposes organic matter. When quicklime is exposed to the air for some time, it becomes air-slaked for the above reaction is reversible and the lime combines with atmospheric carbon dioxide and returns to calcium carbonate. When water is added to quicklime, the two combine vigorously with the liberation of much heat. The product formed, calcium hydrate, is the slaked lime so important in the preparation of mortar, $CaO + H_2O \rightarrow Ca(OH)_2$. In fine mortars and plasters it is essential that lime in this hydrated condition should be thoroughly seasoned, even over a period of months, before it is used. Calcium hydrate combines with atmospheric carbon dioxide to form calcium carbonate, $Ca(OH)_2 + CO_2 \rightarrow CaCO_3 + H_2O$. This last reaction is essential to the setting of mortar.

There are two stages in the setting of lime plaster. The first is the drying out of the water and the second is the subsequent hardening by chemical action between the calcium hydrate and the carbon dioxide of the air, resulting in the formation of calcium carbonate and the liberation of a further quantity of water which evaporates. To the formation of a coherent mass of crystals of calcium carbonate—practically limestone—is, then, attributed generally the strength of old plaster. This process of carbonation is excessively slow and generally incomplete. Minute traces of quicklime were found in the pure lime plaster on the walls of the palace at Knossos, in Crete, which had been exposed freely to the atmosphere for about 3500 years; and free lime is found in the plaster used in the Pyramids. In 1911 it was reported that free lime was present in most of the samples of mortar taken from St Paul's Cathedral, London, and as much as 20 per cent

was found in one specimen taken from the core of a main pier. Various investigators have observed that little absorption of atmospheric carbon dioxide takes place until mortar is fairly dry, but not completely dry. The process of carbonation is greatly accelerated by subsequent periodic wetting of the mortar. The useful penetration of atmospheric carbon dioxide is but one twenty-fifth inch in interior plaster work.

Lime-Wood (*Tilia*). The general name, *Tilia europaea*, or European lime or linden, includes several well marked sub-species which are found growing quite generally over northern Europe. The American bass-wood (*Tilia americana*) is similar. The lime sometimes acquires great size and is valuable as a timber tree. The wood is soft and light and is one of the ' white-woods ' of commerce. The annual rings are only fairly distinct, even though the pores are very small and diffusely distributed. In longitudinal section neither the figure nor the ray is conspicuous. The color is generally light, often a mellow, creamy brown. Linden has been reported as the wood in a fairly large number of panel paintings of the German schools. Pliny (XVI, 30) mentions it and describes the tree as growing in the mountain valleys of Italy.

Linen is made from fibres (see **Fabrics** and **Fibrous Substances**) of the flax plant (*Linum usitatissimum*) which yield about 8 per cent of these fibres. They are ultimately 6 to 60 mm. long and 0.012 to 0.026 mm. wide. The cellulose content is between 70 and 80 per cent. The fibres are obtained from the green bark by rotting or retting, cleaning, and bleaching. They are very tough, can be bleached white, and take, more readily than cotton, a variety of colors by dyeing. Microscopically, linen fibre may be distinguished from cotton, with which it is most likely to be confused, by the fact that it shows joint-like cross markings and does not twist, whereas the cotton fibre shows no cross markings and does have twists (see figure 2, p. 231).

Specimens of linen have been found in the villages of the Lake Dwellers and in other prehistoric remains. The wrappings of most of the Egyptian mummies are of linen, and fine linens have been made from ancient times. Linen has been woven successfully in America only in the coarser forms of crash and toweling. Scotland, Ireland, and Belgium produce the finest linens of commerce today, and Russia, the largest amount of flax. So common has this material been as a paint support that it is almost a synonym for canvas, the usual name for a fabric that is painted.

Mahogany. There are two principal varieties of this wood—West Indies (*Swietenia mahagoni*); East coast, tropical America (*Swietenia macrophylla*)—and both, among others, are indigenous to tropical parts of America. The former is harder and darker than the latter, and is a richer red in color. In both varieties the heart-wood is reddish brown and darkens on exposure to light. The sap-wood is narrow, and ranges from light brown to white. The growth layers are practically homogeneous in character, with little variation in pore size, and they are marked by very thin, light-colored lines. These are the chief marking device, taking the

form of soft, irregular lines in tangential section and straight lines in quarter-sawed section. The most distinctive feature is the appearance of the various markings in reflected light; almost all of them appear relatively lighter or darker than adjacent areas, depending upon the source of the light. As a paint support, mahogany has been considerably used since the tropical regions of America were opened to commerce and it is a favorite material for cradles and other accessory supports. It is said to have been used as a furniture wood in the early part of the XVIII century. The timbers of several other species of wood are used and known as mahogany, and those of the West African *Khaya senegalensis* are known as African mahogany (see A. Koehler, ' The Identification of True Mahogany, Certain So-Called Mahoganies, and Some Common Substitutes,' *Bulletin No. 1050, U. S. Department of Agriculture*, 1922).

Maple (*Acer*). The common maple of Europe (*A. campestri*) is not an important timber tree and it appears that the wood is seldom used for painted panels. In America the sugar or hard maple (*A. saccharinum*) furnishes timber of economic importance. The sugar maple is hard, does not readily warp or shrink, and has superior working qualities. The heart-wood of the hard maple is a light reddish brown; it has no conspicuous figure, and is diffuse-porous, the pores being very small. The annual rings are, however, fairly distinct. Rays are conspicuous as fine dashes in quarter-sawed surfaces and are similar to those in beech.

Metals. Metals have never been used extensively as supports for paint. In ancient times they were probably too highly valued for other purposes and were not available in large sheets or panels. Sheets for armor and such uses had to be beaten out laboriously by hand; methods for rolling metals were not developed before the middle of the XVI century. Metal-rolling mills driven by water-power were in use in Europe in the first part of the XVIII century but steam-power for this purpose, with a subsequent large-scale production, did not come into general use before the latter part of the same century.

The great difficulty with metal of any kind as a support for paint, at the present day, is a flexibility greater than that of the paint, ground, and surface films of the design itself. The value of a support is the strength and firmness it supplies for those films. To make metal sufficiently rigid is to make it so heavy that it becomes practically unmanageable. Expansion of metal with heat has been argued against it, but since the highest coefficient of thermal expansion for any of the commonly used metals is that of aluminum, given at 24×10^{-6}, and that for oak is 54.4×10^{-6} with other common woods all above 32×10^{-6}, that objection does not hold comparatively. The real objection to it lies in its tendency to be bent, dented, or flexed.

Below are listed some of the physical properties of the metals generally used. (These are taken from *Smithsonian Tables*, Vol. LXIII, 1914, and from *Handbook of Chemistry and Physics*, 20th ed. [Cleveland: Chemical Rubber Publishing Co., 1934]. For other properties, see **Aluminum, Copper,** and **Iron.**)

	Relative Hardness of the Elements	Coefficient of Thermal Expansion * (Approximate)	Specific Gravity
Copper	3.0	14×10^{-6}	8.9
Brass (66 Cu, 34 Zn)	—	19×10^{-6}	8.4
Iron	4.5	12×10^{-6}	7.8
Aluminum	2.9	24×10^{-6}	2.7

* The increase in length per unit length (measured at 0° C.) per degree centigrade.

Mortar (see also **Plaster**) is a building material prepared by mixing lime, plaster of Paris or hydraulic cement with water and with sand and fibrous materials, giving a mixture which sets by hydration or carbonation. It is used in masonry and in plaster. The term ' mortar ' is ordinarily restricted to the mixture of the components of plaster while they are still in the plastic condition after the addition of water. The term is also applied to any one of these mixtures when used as a cementing or bonding material for stone and bricks.

Mulberry or **Paper Mulberry**. The fibres of the paper mulberry (*Broussonetia papyrifera*) are used by the Chinese and Japanese in the preparation of certain special papers (see also **Paper**). They are separated from the inner bark of the tree by scraping, soaking, and maceration in water, and they may be purified still further by boiling in weak alkaline solutions. As used in Oriental papers, the fibres are generally unbroken. They are long and slender and they vary in length from 6 to 20 mm., with an average width of 0.030 mm. They are nearly transparent under the microscope and show transverse jointings as well as longitudinal striae. The central canal generally shows as a well defined line and the ends are sometimes blunt and rounded, sometimes fringed (see also **Fibrous Substances**).

Oak (*Quercus*). The principal European species of oak are *Q. pedunculata* and *Q. sessiliflora*; the two principal species in North America are the white oak (*Q. alba*) and red oak (*Q. borealis*). Oak is a hard wood, grayish brown in the heart-wood and white in the sap-wood. The red oak varieties have a reddish tinge in the heart-wood. The figure is produced by the strongly marked annual rings in tangential section and consists of straight lines, irregular curves, and parabolas. In quartered section the figure is produced chiefly by the large medullary rays which appear as more or less continuous ' flakes ' across the grain of the wood. The annual rings are very distinct in end surfaces, with marked segregation of very large pores at the beginning of each year's growth and very minute pores in the denser, outer portions. The rays are also strongly marked, being of two types —large (regular and conspicuous) and very small. The size and distribution of the large rays make it easy to distinguish oaks from all other woods. Most oak-wood

contains tannin. In European panel paintings, particularly of the Flemish school oak was much used (see also **Wood**).

Olive-Wood (*Olea*). This genus includes about 20 species widely scattered chiefly over the Old World from the basin of the Mediterranean to South Africa. Among them, the common olive tree (*O. europaea*) is most important. Although it grows to no great height, it frequently develops trunks large enough for timber. The wood, which is hard and close-grained, is valued by cabinet makers and by wood-turners; it is yellow or light, greenish brown in hue but is often veined with a darker tint. It may be polished to give a smooth marble-like surface similar to that of boxwood. The pores are scarce and obscure. It is known that a few Italian paintings were made on olive-wood panels.

Panel (see also **Wood**) is a word generally used to describe all movable or easel paintings that are not executed on a support of fabric. At times, however, it is used even more broadly to designate all paintings not done on walls, as, ' the panel painting of the Italian Renaissance.' Technically, panels are understood usually to be supports of wood.

Paper. The papers used in the fine arts are commonly made from cotton or linen but the Far East and the classical world have been used to coarser plant materials like mulberry and papyrus. When any such fibres are separated by macerating the plant or other source into a pulp and then are disposed in a thin, compact web, dried in a sheet, and pressed flat, the product is some class of paper. The chief material of all paper is cellulose, the pure plant substance which forms the cell walls, and this, regardless of its source, is made up of carbon, hydrogen, and oxygen, present in the same proportions (see also **Fibrous Substances**). Classes of paper can be distinguished most conveniently for study according to the sources of the fibre, though in industry it is a frequent practice to classify papers according to their particular uses. H. N. Lee has made a convenient arrangement of paper-making fibres: (1) the cotton group, including cotton, linen, ramie, hemp, and perhaps paper mulberry; (2) the wood-pulp group including the two distinct classes—(*a*) ground wood or mechanical wood-pulp, the entire wood substance reduced to a fibrous form, and (*b*) chemical wood-pulp in which intercellular matter has been considerably dissolved away leaving a much purer cellulose; (3) the grass group, including esparto and bamboos; and (4) the rope group, a kind used only for rough paper in localities of the Far East.

Although cellulose remains the same, the characteristics of the different groups of fibres vary to a great extent. Cotton fibre has a natural full length of 20 to 40 mm.; linen runs usually from 25 to 30 mm. and has a less uniform diameter than cotton. Paper mulberry fibre shows great variation in width and has a natural full length of about 15 mm. Wood-pulp fibre is much shorter, its natural full length being about 3 mm. It can be seen that the longer fibre makes a stronger paper, and it has also been suggested that the fibres of the cotton group contain a much purer cellulose than those from wood or grass. The latter are more apt to

deteriorate because they are more easily hydrolyzed and oxidized. Certainly experience with papers has shown that, in general, those made from cotton-group fibres are far more stable as to color and consistency than those as yet made from the wood-pulp group.

Besides the fibres themselves or any impurities that go with them, paper may contain other materials added for the purpose of giving it certain kinds of surface properties. Loading materials, chiefly China clay, are used mainly in the manu-facture of the coated or glossy papers required for some kinds of printing. Sizing materials are more common and are apt to appear in western products of the present day except in blotting and filter papers. Glue and starch used for sizing seem to have only a slightly harmful effect. They are apt to increase a tendency towards the development of mold and micro-organisms. Rosin, on the other hand, is definitely a bad addition to paper fibre, for in a fairly short time it be-comes dark and brittle.

The most serious and rapid breakdown of paper probably takes place in these added materials, if the fibre itself is pure. Fibrous cellulose is naturally very inert and resistant but it has a number of points where it is vulnerable. It de-composes at $250°$ C. and the products are complex and numerous. Evidently it is able to withstand effects of atmospheric oxygen to a large extent. It is even resistant to the action of weak oxidizing agents and bleaching solutions. This resistance has a definite limit, however, and when the strength of the solut'on becomes too great, destruction takes place. The products are chiefly oxalic and carbonic acids and there are left, also, the residues known as oxycelluloses. These vary according to the oxidizing agent, its strength and temperature, and according to hydrolytic reactions that occur at the same time. In all cases, they are weak, friable substances and no means are known for converting them back into cellu-lose. Pure cellulose is attacked by dilute acids and produces either dextrins and dextrose, soluble substances, or insoluble materials called hydrocelluloses. The effect of micro-organisms on cellulose is well known; bacterial fermentation is the means by which it is digested. And it has been noticed that many such organisms are able to develop and to decompose cellulose in a free supply of air. Mold is an enemy of paper and is doubtless responsible for much of its discoloration. The brown spots or 'foxing' so familiar in old books, prints, and drawings are ap-parently stains caused by the decomposition of mold and micro-organisms. It seems probable, however, that mold itself is little apt to grow on pure cellulose and that its first nourishment at least comes from added materials, chiefly animal glue and casein.

The ancient papyrus was made directly from the paper reed, *Cyperus papyrus* of Linnaeus. This was cut into long strips and those from the center of the plant were found to be the broadest and the most valuable. The strips were laid out, so that they crossed at right angles, on boards and were soaked in water (tradi-tionally that of the Nile). After soaking, the web formed by the crossed strips

was hammered flat and was dried in the sun. The method is peculiar to papyrus. Paper, as usually defined, is made from the separated fibres reduced to a pulp and felted into sheets in which the direction and arrangement of the fibres have no relation to what they were in the plant. In its natural condition plant fibre is associated with intercellular matters of a glutinous, resinous, or siliceous character and the removal of these is the first step in producing a workable pulp.

The pulp for Chinese paper came largely from the inner bark of the bamboo and the paper mulberry tree. Hemp was used, cotton and linen rags were sometimes added, and occasionally refuse silk may have been put in, though alone it would not have been suitable. There is a coarse Chinese paper made of straw but this is used as a wrapping.

Soon after paper-making had come into Europe, it was found that a fine pulp could be made with relative ease from old rags of cotton and linen, for the cloth had already gone through a process that had cleared the fibres of most extraneous materials. Rag papers are still the finest support of the paper kind to be had for paintings and similar works of art. In modern manufacture, the rags that come to the mill are dusted, sorted, cut into small pieces, and boiled in an alkaline solution under low steam pressure during six to twelve hours. They are then washed and are ' broken ' in a machine that contains a roll and a steel plate so arranged that they tease out the fibres, destroying the textile nature of the material and reducing it to a pulp. The pulp is then given a chlorine bleach. After that comes beating which makes it absorbent and felted in its structure. When paper is made by hand, it is formed from the wet pulp on a wire screen that is the size of the sheet and has a removable frame, the deckel. The pulp is shaken out on the screen, and when the sheet is formed, it is laid out on a felt. A number of them are piled and pressed and then are dried. Such a method is little different from that described by Hans Sachs, cobbler-poet of Nürnberg, in a German book of trades, 1568 (translation from Hunter, *Paper-Making*, etc., p. 22):

> Rags are brought into my mill
> Where much water turns the wheel,
> They are cut and torn and shredded,
> To the pulp is water added;
> Then the sheets twixt felts must lie
> While I wring them in my press.
> Lastly, hang them up to dry
> Snow-white in glossy loveliness.

When practically dry, the paper is separated from the felts and taken to lofts where the individual sheets are spread out. Paper at this stage is called ' water leaf ' or ' rough ' and is highly absorbent, but is used directly by some for water color painting. To overcome the absorbency, the paper is put through a sizing bath, and is again dried and pressed (rolled) to give the desired finish; cold pressed (C.P.) is paper of medium absorbency, and hot pressed (H.P.) is denser and has

a smooth, almost glazed surface. Several materials have been used for screens in the shallow sieve that collects and felts paper fibres. In a few instances, the bottom has been made of cloth. Fine reeds were generally the material used in the Far East. In the West paper has been formed usually on wire screens, and papers made on such a screen usually show, especially when held to the light, a faint pattern of the screen which is called a ' wire mark.' The marks are caused by the tendency of the pulp to settle more between the wires than over them and so their positions are faintly marked by an alternation in densities. Special characteristics in the wire marks sometimes give a clue to the time and origin of the paper.

Water-marks, probably suggested by the screen marks or wire marks impressed in paper during hand manufacture, are the initials, names, seals, or symbols marked in Occidental paper by the same means. They are made by wires which are set into the screen on which the sheet is formed. The wet pulp settles out more thinly along the lines of the design made by these wires and the design shows as somewhat more translucent than the sheet around it. Oriental papers have no water-marks, nor have those of Arabian and European manufacture before the end of the XIII century. They first appear in the product of either the mills of Bologna, 1285, or the mills of Fabriano in 1293 and 1294. Since then they have been common and the history of them occupies many volumes (see Briquet, in particular). In the XIV century they are characterized by simple designs and large wires. For a short time (1307–1320) in Fabriano the maker's full name was used, but the mills then went back to simple initials until the XVI century. By 1545 the date of manufacture began to be added to the full name of the maker. Until about 1790 they were usually called ' paper-marks.'

When paper is made by machine, the wet pulp flows out on a moving, endless mold of fine wire cloth. It is beaten, strained, cleaned, and carried to a screen of brass cloth supported by tube rolls. This is forty to fifty feet long. As thin pulp it goes over suction boxes and through rolls. Then, as paper, it is passed on felts through other rolls that take out moisture and over heated cylinders for further drying. The better papers are ' tub-sized' with gelatin or animal glue, containing alum, after they leave the drying cylinders.

The preparation of pulp from materials other than rags is somewhat more complicated. When raw fibre is taken for paper-making, it is necessary to remove as much as possible of intercellular material (see also **Fibrous Substances**). In the case of esparto the grass is boiled at a high temperature, and for three or four hours, in a strong solution of caustic soda. A steam pressure of thirty to forty pounds per square inch is usually maintained. The fibres are drained, washed, and bleached, intercellular matter being largely digested by the caustic soda. Roots and other impurities are taken out of the pulp. A method similar to this is used for straw.

Mechanical wood-pulp is little more than sawdust matted into sheets. For chemical pulp three methods of preparation have to be distinguished: the soda process, the sulphate process, and the sulphite process. The soda process is used

principally for poplar, birch, and similar hard-woods. In its general lines it is not very different from that used for esparto and straw. (A full description is given by Sutermeister, pp. 106 ff.) Wood that is to be made into pulp by any of the three chemical processes is first cut into logs eight to twelve inches in diameter and four feet long; these are reduced to chips each under an inch in size. The sulphate process is essentially alkaline, and the chips go into a soda bath. The lost alkali, however, is made up in this method by sodium sulphate instead of soda ash. The sulphite process is acid. In this treatment of the chipped wood, intercellular matter is decomposed by boiling at high temperatures in the presence of sulphurous acid. Magnesia or lime is added and the steam pressure is 90 to 150 pounds per square inch. Sulphite pulp has strong and hard fibres whereas the soda pulps are comparatively soft and mellow.

Paper, conservation and treatment. It has been noticed (see also **Paper**) that pure cellulose fibre is the most resistant and permanent part of paper. This is affected only by very high temperatures, by acids, alkalis, strong bleaching solutions (mainly oxidizing agents) and a few other means of destruction most of them very rare under normal housing conditions. Added materials in paper are apt to cause general discoloration, brittleness, and an aggravation of mold or bacterial growth. To prevent autoxidation of a resin, for instance, is impossible by any methods known, but many other ill effects on paper can be prevented or kept safely down by general care in the mounting, exhibition, and storage of such objects. High humidity is to be avoided and dry, well-aired storage is indispensable. Similar conditions must be maintained for exhibition. Bad mounting has been responsible for much loss and many blemishes in paper objects. Drawings, prints, or water colors, if they have good care, are given mats, usually of the ' window ' type, and made of rag pulp. They are attached to the mats only by small hinges of adhesive at the upper corners, are kept, with slip papers for protection, in light, dry boxes, and, when exhibited, are put under glass.

Certain types of treatment for paper have a value that is largely preventive. They are to stop any tendency toward deterioration that may have been observed. Fumigation is one of these and is done largely to destroy any mold or bacterial growth or to kill spores before they develop. Thymol has been much used for this purpose and so has formaldehyde. Another preventive treatment is removal of paper from mounting boards that tend to discolor or embrittle it. Restorative treatment is also frequent. Removal of grease spots or of dirt can usually be done with organic solvents. Removal of water stains or foxed marks— discoloration of the fibre itself—is more difficult and less certain, but there are now established methods for it. In all methods oxygen is the active agent. It has been employed as a vapor, the evaporation from a plaster block saturated with hydrogen peroxide and placed with the paper in a sealed chamber being enough to effect bleaching. As a rule, however, the paper is immersed in a bath of bleaching solution followed by a neutralizing bath and careful washing. One

process (Keck, *loc. cit.*) has for its bleach very dilute sodium hypochlorite and hydrochloric acid in a practically neutral mixture. Free chlorine is evolved from this. Hypochlorous acid, formed by the action of chlorine on water, oxidizes the organic coloring substances that make up the stains. Besides this, of course, there is a wide range of operations in the mending and repair of paper.

Paper, history in painting. The history of paper as a support for drawings and paintings is, to a large extent, the history of the development of paper itself. The oldest papyrus now preserved is Egyptian and has on it the accounts of King Asa (3580–3536 B.C.). The manufacture of this ancient forerunner of paper was probably carried on largely in the delta of the Nile, but the use of it became common all through the Mediterranean region and reached to imperial Rome. The plant from which it was made came to be grown rather widely—in Syria, Arabia, India, Nubia, and as far west as Sicily. By the X century A.D. paper had displaced it.

The Chinese, using plant fibre reduced to pulp, were making paper certainly in the II century A.D and may have started the practice even before the Christian era. Introduction of the manufacture to the West is usually dated from a Chinese attack on Samarkand, 721. Arabs held the place and, according to tradition, learned the art of paper-making from Chinese prisoners taken at that time. Karabacek (p. xxi) says that the dissemination of paper through the West began with the establishment of the second paper factory at Bagdad in 794–795 under the reign of Harun Al-Rashid. He lists (p. 245) items 917 and 918 in the collection of the Archduke Rainer, two letters on paper of about 800. A large number of Arabic MSS on paper dated in the IX century are still preserved. The Arabs practiced and spread the craft for some centuries. Apparently linen fibre was principally used in their product, but other materials, raw cotton or rags, were sometimes added in small amounts. This eastern-made paper of the middle ages was strong and glossy and it contained no water-marks. Coming through Greece it got to be known as *charta bombycina*, or *charta*, or even *papyrus*.

By 1100 paper was being manufactured at Morocco. In 1102, King Roger of Sicily made a deed on paper that is still preserved. The first manufacture in Europe was by Moorish workmen located largely at Xativa, Valencia, and Toledo. France had a paper mill at Hérault in 1189, Italy had mills at Montefano and at Fabriano in 1276, Germany, one at Cologne in 1320 and another at Nürnberg in 1390. Italy's first great center of manufacture was Fabriano and it was here that the first known water-marks were made in 1293 and 1294. Paper was used in England as early at least as the first years of the XIV century. A MS. in the British Museum (Add. 31, 223), a register of the hustings court of Lyme Regis, is on paper and the entries begin in 1309. This paper is like that made in Spain. There is no record of English manufacture before the XVI century but probably there were mills before then.

Until the XVIII century practically all European paper was made from rags. A publication of a ' Society of Gentlemen,' London, 1716, Essay VI, suggests

using raw hemp for the pulp, and René Antoine Ferchault de Réaumur suggested to the French Royal Academy (November 15, 1719) that wood or plant fibres would be suitable for the purpose. This suggestion was carried further by Dr Jacob Christian Schäffer (1718–1790), a citizen of Regensburg, who wrote a six-volume treatise on the subject. It was well into the XIX century, however, when wood-pulp was used on any extensive scale for paper-making. The paper machine was invented in France in 1798 by Louis Robert and was developed there and in England during the early years of the next century.

Through all of its history paper has been used primarily as a writing material, but probably parallel to that has been its employment as a support for drawing and for painting. It stands with silk and linen in the scroll paintings of China and Japan. An early mention of it in connection with the arts of Europe occurs in the MS. of the monk, Theophilus (XI–XII century), where there is a reference to '. . . Greek parchment, which is made from linen cloth' (1, XXIV). By the time of Cennino Cennini, paper was a regular material in the workshop of the painter. He speaks of its use for drawing (chaps X and XII), about methods for tinting it (chaps XV, XVI, XVIII, and others), and of how to make tracing papers (chaps XXIII–XXVI). From this time, c 1400, it had an established place in the making of European works of art. Those preserved from the Renaissance are largely prints or drawings but some paintings are found, notably a head attributed to Memling and now in the Louvre, 2028A. This is a sketch in color on paper that is tinted red-orange. It is probably from the development of such sketches and of drawings with added color that paper came to be used so extensively in the XIX century as a support for the so-called ' water color ' painting. Besides its use independently, paper has now and then been made a part of a more rigid, composite support. The small cardboard panels (see also **Artificial Building Boards** and **Academy Board**) are really made of paper-pulp, but aside from these, sheet paper is frequently combined with wood or with cloth. A number of such constructions can be found dating from the XVI century in Europe.

Papyrus (see also **Paper**). This ancient writing material was made from the strips of a reed, *Cyperus papyrus*. They were crossed on boards and then were soaked, hammered, and dried.

Parchment (see also **Leather**). The distinction between parchment and vellum is a difficult one to draw. According to some authors (for example, Johnston, p. 173) vellum is a name which belongs to calfskin only, but is generally given to any moderately good skin that is used for writing or painting. At times 'vellum' is made to designate what is more exactly called ' uterine vellum '—the delicate skins of new-born or still-born calves, kids, or lambs. Practically, it is impossible to maintain the distinction in any general description of these materials; one term can conveniently be made to apply to both, for the materials are similar and the preparation is the same. The skins best for use are those of calves, sheep and lambs, goats and kids. They are prepared by washing, liming, unhairing, and scraping;

then follows a second washing after which the skins are stretched on frames, are scraped again, pared, dusted with chalk, and rubbed with pumice. The resulting skin is very pale in tone, being smooth and nearly white (if a good piece) on the surface that was the original flesh side, and somewhat rougher and more yellow on the surface that was the original hair side.

Skins were used as writing materials in ancient times by Near Eastern peoples, Persians, Phoenicians, Jews, and Ionian Greeks. The word 'parchment' comes from Pergamum. The story is that the Ptolemies, envious of the growth of the Pergamene library, refused to export papyrus. Thrown back to the use of skins for writing purposes, Eumenes II (197–158 B.C.), king of Pergamum, was responsible for developments in their manufacture. It appears certain that at about this time preparation was enough improved so that both sides could be used. This made possible the construction of a codex. Illumination of MSS is a practice that must be almost as old as writing itself, and in Europe such painting on parchment forms an important part of the history of the art. Pliny (XXXV, 67 and 68) speaks of paintings on wood and on parchment, and this may be taken to mean a kind of painting not connected with MS. illumination. By the II century A.D. parchment was probably coming into Europe. In a short time its use was well established and the skins available were thin and firm and had a delicate texture. It seems quite evident that in the later middle ages and in the Renaissance the painters who illuminated MSS thought of no other support. Even in the XVII century there are numerous references to it by De Mayerne (see particularly Berger, pp. 175, 177, and 216).

Pine (*Pinus*). Although the genus, *Pinus*, includes many species, the name 'pine' is often applied to species of other genera, especially to some of the firs. Modern botanists, however, reserve the name for the spruces and silver firs of the genera *Picea* and *Abies*. The needles of the true pines grow in clusters or tufts from a membranous sheath whereas in the firs the needles are placed singly on the shoots. The red pine (*P. sylvestris*), also known as the Baltic pine or Scotch fir, is the most important timber conifer of Europe. It is found as far south as Italy and Spain but prefers more northerly latitudes. The stone pine (*P. Pinea*) is an important timber tree of Italy; the wood is soft, fine-grained, and easily worked. In America the white pine (*P. strobus*) furnishes valuable, white, soft, and even-grained lumber. Other valued American pines are the southern yellow pine (*P. mitis*) and western yellow pine (*P. ponderosa*), both hard pines. The pine woods are characterized by a resinous odor and the presence of resin ducts which may often be seen, even without a lens. The chief structural component of pine wood, as with other coniferous woods, is the tracheid with its bordered pits. The heartwood is usually light orange to reddish brown; the sap-wood is lighter in color. Pines are divided into two general groups, according to structure: soft and hard. In the soft pines, like the American white pine (*P. strobus*), the wood is relatively light in color and the annual rings are not particularly distinct, for there is slight

difference in the density between spring- and summer-wood. There is practically no figure or stripe in longitudinal section. The hard-wood group, comprising the yellow or pitch pines, is distinguished usually by deeper color, pronounced annual rings and by a stronger odor of the resin. Quarter-sawed, hard pine has a striped appearance. Pine wood, in general, is durable, does not warp badly, and is straight-grained. According to the records, pine was widely used in European panel painting, but in these records the term ' pine ' probably includes woods from many other conifers.

Plaster is the term given to the surface material, of a wall or building, which has been applied as a plastic mass made by mixing certain dry materials with water and letting the mass set by drying, carbonation, or hydration. The term ' plaster ' is broadly applied to its three stages: the dry powder, the plastic mass, or the hardened surface. Although plaster may be made from various materials, modern usage confines the term to interior surfaces only. Many materials have been used in making it; all employ water for reducing the dry components to a plastic state. The active or setting components of plaster are commonly clay which sets by drying, lime which sets by carbonation, and gypsum and pozzolana which set by hydration. Inert materials, like sand and finely crushed stone, and fibrous binders, like hair, straw, and jute, are important ingredients in plaster. Sand and other inert materials are necessary in preparing thick coats of lime plaster since neat lime plaster shrinks and contracts on drying. This shrinkage is almost entirely prevented by the sand grains when these grains are in contact with each other. Very fine sand does not allow a proper distribution of the lime, since the pores are too small to be filled properly with the particles of lime hydrate. Clay plasters usually contain inert materials and fibrous binders to prevent undue shrinking. Gypsum and pozzolanic plasters are not so dependent upon these fillers for shrinkage prevention and binding but may have them added for economy. Plaster, since earliest times, has served as a support for painting and decoration. The pigment may be incorporated directly in the wet plaster, as in true fresco, or it may be applied to the dried plaster surface with an organic binding medium, as in fresco secco.

The wall upon which plaster is laid must be specially prepared for the reception and retention of the plastic material. A creviced structure through which the plaster is forced and keyed was, in early times, built up with reeds and saplings joined to joists with cords; wooden laths, either split or sawn, have been used for hundreds of years; metal and wire lathing are now common. The durability of plaster work very often depends upon the sturdiness of the foundation. A brick and masonry surface is frequently rough and porous enough for the direct application of plaster, provided the joints have been thoroughly raked out. It is essential that the surface be not dry and porous because then water is sucked from the plastic mass and poor setting results. The shrinkage and ultimate decay of wood and other organic materials used as supports are often the beginning of

the deterioration of plasters. When plaster in put on, the wall, whether of stone, brick, or slate, is first thoroughly wetted with lime or baryta water. One or more coats of rough plaster are then laid on. These are allowed to set, and the rough plaster is wetted with distilled or lime water before the final coat, one eighth to one quarter inch in thickness, is applied. In the Greek method there were three steps. The first coats were often composed of slaked lime with rough sand, pounded brick, or tile, and sometimes even straw, flax, or cotton. While this rough plaster was still damp, the second coats of lime and river sand were laid on. The third step was the application of the final coats. These were three and each was allowed to dry. The plaster was composed of lime and fine marble dust. The surface obtained by this process was so smooth and hard that it could be polished.

Paleolithic man undoubtedly knew of burning and slaking lime and, from the abundant deposits of limestone and gypsum, made plasters that have lasted through the centuries. In Egypt a clay plaster is found, dating from the prehistoric period. Two principal kinds were employed: the first, very coarse, of Nile alluvium with generally a small amount of carbonate of lime and occasionally gypsum. Being unburnt, this had no binding properties. The second, which is still used as a finishing coat to sun-dried brick, consisted of a natural mixture of clay and limestone. Preparatory to painting, these rough surfaces were usually covered with a gypsum plaster, an exception being found at El-Amârna where paint was applied directly to the first layers. Though there was plenty of lime in ancient Egypt, gypsum seems to have been used almost exclusively for covering temple interiors and exteriors preparatory to painting. A theory has been advanced that gypsum was used because of a scarcity of fuel, for it requires a far lower temperature for burning than lime. Analyses of plaster from the pyramid of Cheops show 82 per cent calcium sulphate and about 10 per cent calcium carbonate. The Egyptians used plaster for coating brick and wood and for covering mummy cases which were subsequently painted. Herodotus speaks of burnt gypsum and other ancient sources, notably Vitruvius and Pliny, tell of the use of both lime and gypsum plaster.

There is a difference of opinion as to whether the fresco paintings at Knossos, Crete (1500 B.C.), are true fresco or secco. It would be the earliest example of true fresco. The ground plaster for the palace wall paintings has three layers: the first is very coarse; the second is a relatively refined plaster; and the final coat is a fine lime plaster without any intermixture of sand or marble dust. The lime had probably remained slaked for a long period before being used. As the Egyptians used fresco secco on their gypsum plaster grounds, it seems probable that the paintings at Knossos were done in this same method, in spite of having been executed on a lime plaster. A few centuries later, at Mycenae, a fine, white lime stucco is found. The Greeks used plaster very liberally to cover both the interiors and exteriors of temples and public buildings, for flooring pavements, and for covering statues. The plaster coatings were then painted, though a pavement

where the plaster has been stained with pigment during the slaking process is found in several temples. The thickness of plaster walls in ancient times was much greater than now. The Greeks employed a method of beating the stucco with an implement called a *baculi* until the texture became so close and fine that it resembled marble.

Cowper (p. 4) says that there was much plaster work in Rome and that it was the common external finish for private houses. Examples of the decorative modelled stucco of Rome and Pompeii are well known. Vitruvius (II and VII) gives explicit working instructions for the choice and use of lime, sand, pozzolana, and other materials for mortar and plaster, and he gives, also, details for the application of fine six-coat marble dust and lime plaster on reed laths for internal decorative work. The old Roman wall paintings seem to have been executed on a very smooth plaster. The pigment has probably been preserved because of the wax film used for protection. In mediaeval times the art of making fine lime and hydraulic mortars was lost, although poor lime mortars continued to be used. In the Renaissance, however, interest in the ancient arts of decorative plaster and stucco work was revived. Cowper (p. 5) says that Vitruvius was still accepted as the authority on plaster.

Linen stiffened with plaster was used for decorating purposes in Egypt, and Cennini, writing in 1437, speaks of fine linen soaked in glue and plaster and laid on wood as a painting ground. Canvas and plaster were in general use in Great Britain up to about 1850.

Wall paintings recovered from Central Asia by Stein, and dated from the end of the III century A.D. to the X century or slightly later, show supporting walls of a mud plaster containing, in some instances, an admixture of fibre or coarse straw. The mud surface has been smoothed and a coat of whitewash applied over it. The thickness of the slabs is from one and a half to two inches. Plaster and decorated plaster work reached a high development in Asia Minor; Persian, Moorish, and Saracen work, however, depended mainly on gypsum.

Painted plaster has been found in excavations in both the American continents, in Asia, and in the Near East. Lime and gypsum plasters and Portland cement are used today much as they were by the ancients. Modern mural painting, in either true fresco or tempera, follows the same rules established centuries ago.

Plaster, deterioration and treatment. Clay plasters are perhaps the weakest, lime and gypsum are stronger and pozzolanic plasters are the strongest. In the drying-out and shrinking process they are subject to cracking in the order named. This defect is counteracted by the proper proportion of filler and binder. Plaster is subject, also, to slight stresses from thermal expansion and contraction. Walls may suffer disfigurement through large settling cracks which run from corner to corner. These are caused by movement of the building after the plaster has set and are not necessarily defects in the plaster itself. Except for the pozzolanic types, plasters are seriously affected by continued or alternate exposure to water,

with the result that they bulge and crack. If plasters contain soluble salt impuri-
ties, such as calcium chloride or magnesium sulphate, they may effloresce with
changing humidity conditions. This may happen if sea sand or estuary sand is
used in the preparation. ' Pitting ' or the appearance of small conical holes in the
surface of plaster is often the result of improper slaking in the preparation of the
mortar. After the plaster has set and hardened, unslaked particles of lime slowly
become air-slaked; they increase in volume and drop from the surface, leaving
tiny craters.

In the treatment of deteriorated or broken plaster, one of the first steps is to
provide a proper support if that is lacking. When plaster surfaces are not too
badly broken and disintegrated they can be repaired and filled up with materials
similar to those from which the plaster was originally made. Lime plaster can be
filled with fresh lime mortar or with plaster of Paris. When plaster is in bad
condition, A. Lucas (p. 185) recommends consolidation with melted paraffin wax.
Artificial resins and lacquers are finding a limited use for this purpose.

Plaster of Paris is the hemihydrated sulphate of calcium, $2CaSO_4 \cdot H_2O$, and
is made by heating finely ground gypsum at a temperature around $145°$ C. When
mixed into a paste with water, it regains its water lost on heating and sets rapidly
to a moderately hard solid. If gypsum is heated to $200°$ C., all the crystal water
is expelled and the product will combine with water and set only very slowly.
The theoretical quantity of water necessary to set the plaster is about 18 per
cent of its weight, but, in practice, from 30 to 35 per cent is generally used. To
cut down the setting time glue, vegetable gums, or other colloidal matter are
added as retarders. Plaster of Paris expands slightly on setting and, hence, is
valuable for making casts and reproductions. The surface of set plaster of Paris
is not suitable for the application of paint because of its high absorbency. By
dipping plaster casts in melted wax, paraffin, or stearin, or by the application of
these in solvents, the pores are filled and the surface is made smooth so that dirt
will not adhere and the articles may be washed. Mixed with glue, plaster of Paris
sets to a much harder material which can be sanded and given an ivory-like
surface suitable as a ground for painting (see **Gesso** and **Stucco**).

Plywood and **Veneer**. Within recent years plywood has become an important
material in building construction. That now used is made from ' rotary ' veneer
cut in thin sheets from a log of wood. Three and sometimes five or seven sheets
of the ply are glued together with the grain of each extending in a direction at
right angles to that of the adjacent sheet. Plywood can be recognized not only by
the laminations at the edge, but also by the wavy grain of the surface, particularly
in coniferous woods where alternate wide bands of spring- and summer-wood are
exposed by the rotary cutting of the log. Large sheets up to 8×15 feet in dimen-
sion are now available. Frequently, the 'core' or middle ply is thicker and of
cheaper wood than the surface plies. For furniture and interior paneling, the
surface ply may be of an expensive hard-wood like walnut or gum-wood, sliced or

sawed. Coniferous woods are used throughout, however, for the cheaper ply-woods. Animal glue is perhaps the most extensively used adhesive in making ply-wood but fish glues, casein, blood albumin, and, in special cases, sodium silicate and artificial resin plastics may be used. Obviously, the strength, durability of the adhesion of the plies, and behavior to moisture and water depend largely on the character of the adhesive.

Plywood has certain advantages over ordinary lumber. The plywood panel is stronger, in some respects, than a single board of the same thickness. Large ply-wood panels are not likely to check, shrink, and warp so much as solid pieces of the same size. They do not suffer so much from the grain characteristics of a solid piece of wood. This is important since tensile strength, compression strength, binding strength, and stiffness along the grain of the wood are twenty times more than that across the grain. The main shortcoming of plywood is the liability to failure of the adhesive between the plies. There are many poorly made plywoods that come apart, layer by layer, after a short time. When made, however, with synthetic resins, hot hide glue, blood albumin, or lime-casein adhesives and when special care is taken in the selection of the woods, they are very durable and lasting supports.

Poplar (*Populus*). Wood from trees of this genus are light in color and light in weight. In Europe that of the white poplar (*P. canescens*) and the Lombardy poplar (*P. fastigiata*) are the principal sources of timber poplar. Poplar wood is soft, weak, fine-grained and fine-textured. It is diffuse-porous and the pores are very small. The annual rings are fairly well defined but the rays are very fine and are not visible without a lens. Poplar was frequently used in the Italian schools for panel painting. Although poplar is sometimes known in the trade as ' white-wood ' this name is also used for the so-called yellow or tulip poplar (*Liriodendron tulipifera*). Tulip poplar is frequently used when panel construction is called for today. It is stronger and tougher than ordinary poplar; it is fine-grained and fine-textured. The annual rings are indistinct and there is little or no figure in longi-tudinal section. The heart-wood is frequently yellowish green but it may be streaked both white and black. The wood is diffuse-porous and the rays are fine.

Portland Cement is entirely an artificial product but it represents the most important branch of the modern cement industry. It is a hydraulic cement ob-tained by burning a mixture of lime and clay and pulverizing the resulting clinker. The clinker thus produced is mixed with 2 per cent gypsum and ground to 200 mesh. The product is a greenish gray powder that consists of basic calcium sili-cates, calcium aluminates, and calcium ferrites. When mixed with water it solidifies into artificial rock. It derives its name from its similarity to Portland stone.

Pozzolana is a cement derived from volcanic ash. Deposits of it are found in Italy, near Naples (Pozzuoli), in the islands of the Grecian archipelago, and in Germany on the Rhine. They are easily decomposable silicates which have re-

sulted from the action of volcanic fires and need no further treatment than fine grinding and mixing with lime. Pozzolanic cements are slow in hardening but have a considerable ultimate strength. They have been used since the time of the Romans who were well acquainted with their properties. The term ' pozzolanic ' has become broadened in its use to apply to those materials which may not be cementitious but which will combine with hydrated lime at ordinary temperatures in the presence of water to form stable, insoluble compounds of cementitious value. Artificial pozzolanic materials may be derived from pounded bricks and tiles, burnt clay, or granulated blast-furnace slag. Pozzolanic cements are very similar to Portland cement in chemical composition; both set by the formation of calcium aluminum silicates of complex chemical structure.

Ramie, Rhea, or **China Grass** are names given to a plant of the nettle family, *Boehmeria nivea*, which grows wild within 36 degrees of the equator and has been cultivated in China, Assam, and Java for centuries. The bast fibre has been successfully cleaned only by hand and can not be spun so easily as wool or cotton. In China it is made into grass cloth by hand, but is not manufactured by machinery anywhere. It has more than three times the tensile strength of linen or cotton, has a very pure color, a good luster, fineness, and resistance to climatic conditions.

Relining Canvas is used in the backing of an old painting on fabric. A new piece of fabric, the relining, is attached to the reverse side of the old by means of an adhesive (see also **Fabrics, conservation and treatment**). The purpose is usually to strengthen the support, but at times this treatment is applied where the ground film has become loosened from the old fabric.

Silk is the natural product of certain moths. There are four or five main groups of these, some cultivated and some wild. In external appearance silk is a solid thread resembling a glass rod, but the fibre is really composed of three layers surrounding a tube (see also **Fibrous Substances**). The tube is filled with a fatty matter which helps to preserve flexibility. No textile fibre has a larger proportion of waste than silk. The fibre is a double filament and, prior to boiling off or degumming in a hot solution of soap, it is harsh and relatively lacking in luster. In the degumming about 30 per cent of the weight is lost. The microscope shows the double filament irregularly coated with masses of sericin, but after boiling off it appears as a shining, cylindrical, solid rod. Strong acids dissolve silk but weak acids, such as tartaric and acetic, are absorbed and improve the luster. Dilute alkalis do not affect it so much as they do wool, but hot concentrated solutions rapidly dissolve it. Ammonia dissolves the sericin but attacks the fibroin very slowly. Silk has great absorptive power for dyestuffs. The general method of weighting silk is by means of solutions of metallic compounds, especially tin. This results in a great loss in strength, especially upon exposure to sunlight.

The most striking physical property of silk is its luster. It is a highly absorbent fibre and readily becomes impregnated or wetted with water. It stands a higher temperature than wool without receiving injury. It can be heated to 110° C.

without decomposition but at 170° C. it is rapidly disintegrated. It readily absorbs dilute acids and in so doing increases in luster. Luster is diminished by dilute alkalis, however. Ammonia and soaps have no effect beyond dissolving the silk glue or sericin. Silk absorbs metallic salts, particularly those of tin, and this behavior is made use of in the weighting of silk.

It is generally accepted that the silk industry originated in China. J. M. Matthews (*Textile Fibers*, p. 242) says that historically it dates back to about 2700 B.C. Tradition has it that in early history the cultivation of the silkworms and the preparation of the fibres were strictly guarded secrets known only to the Chinese royal family. Gradually the industry spread throughout China but that civilization monopolized it for about 3000 years. In the early period of the Christian era sericulture was introduced into Japan. The Arabs acquired a knowledge of the silk industry in the VIII century and it spread under Moorish influence to Spain, Sicily, and the African coast. In the XII century sericulture was practiced in Italy, and in the XIII century, in France, but it did not become important there until the reign of Louis XIV.

There is little evidence of silk as a paint support in Europe but it is common in the Far East and its history, traced in the paintings found, carries it back to T'ang times (618–907). Probably before and certainly since then it has been the chief material on which was executed the series of great scroll paintings made in China and Japan. Painted silk was probably not often pictorial in the practice of European workshops, though Cennino Cennini speaks of using linen or silk as if the two were co-ordinate (ed. Thompson, p. 103).

Stone. The three general types of stone, based on method of formation, are: sedimentary, igneous, and metamorphic. Sedimentary rock varies, in its mechanical structure, according to the degree of consolidation or compactness and according to the materials of which it is composed. One of its most characteristic features is a stratified structure because of its origin in sediments of eroded material that has been deposited under water in horizontal layers. Since it is stratified, sedimentary rock cleaves readily; slates and shales are good examples. The principal types are: sandstone, shale, limestone, and gypsum. Sandstone is composed of grains of sand, varying from microscopic to large grain, and bound by a cementing medium such as silica, alumina, carbonate of lime, or oxide of iron. The color, depending on the amount of iron, varies widely—cream, red, blue, etc. The grains of sand may be composed of mineral quartz, granite, basalt, limestone, etc. Shale is a soft, brittle rock, actually compact mud, silt, or clay. Limestone is a dense, compact rock composed mostly of carbonate of lime. It is porous and is often filled with shells or fossils. Gypsum, called alabaster in England, is hydrated sulphate of lime, deposited by precipitation from sea water. As a rock, gypsum is soft, usually fine-grained, and readily cleaved.

Igneous, or primary, rocks are formed by solidification of molten masses from within the earth. They are coarse- or fine-grained, depending upon the rate of

cooling. They do not contain fossils or stratification but are sometimes made more or less of mixtures of crystalline materials, fine or coarse. The most important component minerals are feldspar, quartz, pyroxene, and hornblende. Granite is most representative of the class. Other igneous rocks are diorite, basalt, etc.

Metamorphic rocks are sedimentary or igneous rocks changed in character by mechanical movement of the earth's crust, by the chemical action of liquids and gases, or by heat. They are highly crystalline, with a parallel structure at times closely resembling stratification. The principal types are gneiss, mica-schist, quartzite, slate, and marble. Gneisses are rocks containing feldspar, quartz, and mica, with parallel or laminated structure. Mica-schist is a friable, slaty rock containing quartz and mica, often dotted with common red garnets. Quartzite is sandstone so firmly cemented by silica that fractures take place through the quartz grains instead of around them. Slate rock originates from fine-grained, sedimentary rocks; it is closely related to shale, and is sometimes called argillite with reference to its origin from clay. Marble is the name given to the metamorphic condition of sedimentary rocks formed by lime deposits such as limestone and chalk. Generally, marks of bedding, fossils, etc., are effaced and the material is converted into crystalline grains of calcite. Dolomite marble is composed of a double carbonate of lime and magnesia in crystalline and granular masses. Pure marble is white. The figures and coloring of ornamental varieties are caused by impurities; the reds and yellows result from oxide of iron and the neutral tones from organic matter. Marble is hard, compact, and takes a good polish.

The use of stone as a paint support is largely architectural. That much of stone, both flat and sculptured, carried paint in classical times is a commonplace of history and it is to be supposed that much of the technical writing about how to paint on stone had this end in view. By the XVI century in Europe, however, it is found to carry occasional independent compositions. Perhaps the painter most devoted to it was Alessandro Turchi, the Italian (1582-c 1648), but northern painters used it also.

Stretcher. This is a frame, usually rectangular in shape and made of wood, over which a fabric is pulled and held taut for purposes of painting. Thompson (*Tempera Painting*, pp. 15–17) describes the use of stretchers in preparing canvas. (See also figure 6, p. 286, and p. 312.)

Stucco is a term that has been loosely and broadly applied to a variety of materials used in the plastic state for the covering of walls, for the preparation of decorative details on buildings, and for the making of figures and reliefs. The term is often used synonymously with lime plaster. It has been given to gypsum and to pozzolanic materials, particularly when these are in figures and reliefs. It is sometimes given to plaster of Paris that has been hardened by something like lime water. Modern, technical use generally confines it to a plaster for exterior walls or other external surfaces of any building or structure. Here it is used

without regard to the composition of the material, but in connection with its location and purpose. Modern stucco often consists of small stones bound with Portland cement. Occasionally the term is applied to surfaces prepared from an inorganic filler and animal glue, in which case it is practically synonymous with the term ' gesso ' when that is used in the broadest sense.

Support, a term used to designate the physical structure which holds or carries the ground or paint film of a painting. Panels, canvases, walls, and any of the flat expanses on which paintings can be made, fall under this heading.

Sycamore is the name of a wood which is identified with three species of tree: (1) *Ficus sycomorus*, a species of fig tree common in Egypt, Syria, and elsewhere, was widely used for general purposes in ancient Egypt. Lucas (p. 387) notes that it was used in the construction of coffins. (2) *Acer pseudoplatanus* has no connection with the *Ficus sycomorus*, but is a large species of maple common in England and on the Continent. (3) *Platanus occidentalis* is the North American button-wood or plane tree. The name ' sycamore ' has been applied erroneously to both of these. In the latter the heart-wood is reddish brown in varying degrees and is often not clearly defined from the sap-wood, for the pores are diffusely placed. The wood is heavy, lock-grained, and has a tendency to warp unless properly seasoned. There is a distinct demarcation between the spring-wood and the summer-wood although the pores are diffusely placed. The rays are nearly all broad, dark, and conspicuous and many are more than twice as broad as the average pore. The sycamore fig was undoubtedly used as a support for painting in many of the Egyptian mummy portraits from the Fayûm district.

Terra-Cotta is a term applied to baked clay products and these may vary widely in composition. In modern, technical usage ' terra-cotta ' means those clay products used for structural, decorative work that can not be formed by machinery. In sculpture, particularly of the Italian Renaissance, it made a surface that was usually painted. It seems not to have furnished a support, however, for independent designs.

Twill, a weave of fabric in which a series of regularly recurrent warp threads pass in echelon over and under the weft threads, one after another and two or more at a time, producing diagonal ribs or stepped patterns (figure 1, p. 228).

Vellum (see also **Parchment**), a fine kind of parchment made, according to some definitions, from calfskin; according to others it is from the skins of new-born or still-born calves, kids, or lambs. Generally it is applied to any moderately good skin that is used for writing or painting.

Walnut (*Juglans*) is a wood derived principally from two species of the genus. The European walnut (*J. regia*) ranges from England to the Far East. That imported from the Caucasus (Circassian) has always been the finest in quality. The heart-wood is fawn-colored and numerous dark brown or black streaks are present; these streaks determine the figure of the wood. It is heavy and straight-grained. Although the spring-wood pores are large and clearly visible, it is not a distinctly

ring-porous wood. In tangential section the pores appear as well defined grooves but the rays are not very distinct. The American or black walnut is darker, more uniform in color, and not so prominently figured as the European variety; it is more distinctly ring-porous than European walnut. Most of the pores contain glistening tyloses. The rays are fine and inconspicuous. The wood is comparatively free from warping and has good gluing qualities. Walnut was used to a minor extent by all the important European schools in panel painting.

White-Wood is a name given to woods from various species of the poplar. It is also frequently applied to tulip poplar and to bass-wood (see also **Poplar**).

Willow (*Salix*). The European willow (*S. alba*) furnishes a soft, light, fine-grained wood similar in color and texture to poplar. The American black willow (*S. nigra*) is similar except that the heart-wood is reddish brown. One of the most outstanding properties of willow-wood is that it does not split easily. The wood is diffuse-porous but annual rings are distinctly visible. It has no distinct figure in longitudinal section. Although the records do not show that willow was in any way extensively used in panel painting in Europe, its valuable properties must have suggested it for that purpose.

Wood. Woods differ in many respects. Some of their characteristics can be recognized by the unaided eye but others are so fine that they can only be studied or recognized with the microscope. Dr Eloise Gerry of the Forest Products Laboratory, Madison, Wisconsin, has discussed the terms used in describing woods, the distinguishing characteristics which make the differentiation of various woods and the identification of species possible. The following is an abridgment of Dr Gerry's discussion of terms. First are characteristics common to woods of the north temperate zone:

1. *Heart-wood and Sap-wood.* The interior wood of mature trees is usually darker in color than that lying near the surface. The dark part is heart-wood, the region where active growth has stopped. In the outer sap-wood, growth is still active. Trees with characteristically colored heart-wood are black walnut, cherry, oak, and red cedar. In some trees, however, there is little or no difference in color between heart-wood and sap-wood.

2. *Annual rings.* The cross section of a tree trunk shows a ring structure. These rings represent seasonal growth and are called ' annual rings.' Each spring wood formation begins and it continues until some time in late summer.

3. *Spring-wood.* The cells formed at the beginning of the growing season have the largest cavities and the thinnest walls. They make up the spring-wood which is the softer, lighter-colored part of the annual ring.

4. *Summer-wood.* The cells formed during the latter part of the growing season have smaller cavities and thicker walls. The summer-wood is generally heavier, darker in color, harder, stronger, and less porous than spring-wood. One layer of spring-wood and one of summer-wood together constitute a year's growth or annual ring.

5. *Rays* (medullary rays). These may be observed as radiating lines in the cross section of a tree. The rays serve the tree for purposes of conduction and storage. They are particularly conspicuous in oak, beech, and button-wood. The ways in which logs are cut up are described with reference to their relation to the position of the rays and also to the rings. Quarter-sawed, edge-grained, or radially-cut lumber is sawed parallel with the rays. Plain-sawed, flat-grained, or tangentially-cut lumber is sawed at right angles to the rays.

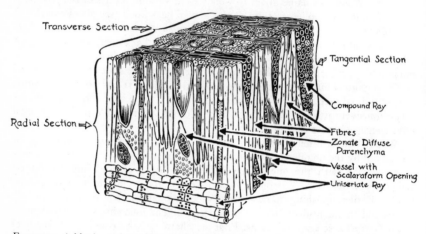

FIGURE 3. A block section of beech-wood, at about 200 diameters, adapted from figure 12, page 39, of 'Technology of New York State Timbers,' *Technical Publication no. 18*, New York State College of Forestry (Syracuse University, 1926), by C. C. Forsaith.

Apart from these characteristics, all woods may be divided into two main groups: hard-woods and soft-woods or conifers. The two classes differ in structure and not in the literal meaning of the terms, ' hard ' and ' soft.'

1. *Hard-woods* are structurally more complex than soft-woods. They all have a certain type of cell, larger than the others, which is called a ' pore ' or ' vessel'. The pores are specialized for sap conduction and have open ends. They are fused together, end to end, and, when not closed by tylosis, they aid in the drying of a wood or in impregnating it with a preservative. Hard-woods are subdivided into two groups, based upon the arrangement of the pores. The first is ring-porous hard-wood, *e.g.*, oak, ash, elm. These have comparatively large spring-wood pores which are generally visible to the naked eye. On the end grain of a log the pores form distinct rings and there is a marked difference between the size of the spring-wood pores and those of summer-wood. The second group comprises the diffuse porous hard-woods, *e.g.*, maple, black walnut, yellow poplar. The pores,

though larger than the other cells, are not so conspicuous as in the ring-porous group. There is only a gradual, not a marked, decrease in size from the spring-wood to the summer-wood pores. Tylosis is the name given to froth-like growths which fill the pores of certain hard-woods. A. Koehler (*Guidebook*, etc., p. 5) says, ' These are formed by ingrowths from neighboring cells and fill the pores

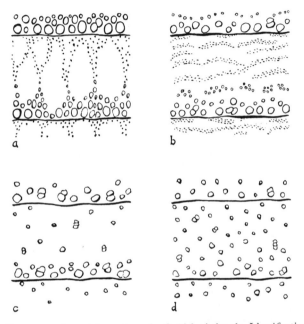

a b

c d

FIGURE 4. Diagrams adapted from those in *Guidebook for the Identification of Woods Used for Ties and Timbers*, by Àrthur Koehler (Washington, D. C.: Government Printing Office, 1917). These are from figures 3 to 6. At *a* is shown a cross section of ring-porous wood with a radial arrangement of pores in the summer-wood; at *b* a similar section with a wavy, tangential arrangement of the summer-wood pores; at *c* a ring-porous wood without any definite arrangement of the pores in the summer-wood; and at *d* a diffuse-porous wood.

more or less like so many toy balloons crowded into an air shaft.' Parenchyma cells make up the light-colored tissue that can be seen between the pores of hard-woods. The distribution of the parenchyma is useful in identifying woods.

2. *Soft-woods* or conifers have no pores, *i.e.*, specialized cells of the type distinguishing the hard-woods. Instead, they have fibre-like cells (tracheids) with closed ends. Not all the soft-woods are actually very soft. These woods come

from needle- or scale-leaved trees, nearly all of which bear cones and have un-covered seeds. Annual rings are clearly defined in soft-woods. Scattered among the tracheids of some soft-woods and absent in others are minute spaces which contain pitch and these are known as ' resin passages.' The presence or absence of resin passages in soft-woods is not such a distinguishing characteristic as the ring and diffuse porosity of hard-woods.

A great deal of chemical research has been done on the composition of wood. The bulk of the wood fibre is cellulose, a compound of carbon, hydrogen, and oxy-gen, belonging to that great class of organic materials known as the carbohydrates. The formula is expressed empirically as $(C_6H_{10}O_5)_n$ where n is supposed to have a value, roughly, of the magnitude of 5000. Besides the cellulose, there is a material called lignin, a cementing substance which holds the cellulosic wood cells together. With cellulose, it forms ligno-cellulose. There are, also, various minor components: resins, tannins, essential oils, wood sugars, and waxes.

Wood substance is a typical elastic jelly. It is not soluble in ordinary organic solvents. It is quite inert to the petroleum hydrocarbons, but it is swollen by water and the lower alcohols, ketones and esters. It is also swollen by contact with the vapors of these liquids. Not all the swelling manifests itself in exterior dimensional changes of the wood; much of the swelling is absorbed in plastic deformation within the wood structure.

Several properties of a physical nature make wood generally useful for pur-poses of art and architecture, and it has certain physical properties which may be regarded as shortcomings. Compared with many other materials that may be used for paint supports, wood is a light material. It has limitations as to width of single boards, but the ease with which it may be worked, joined, and glued allows construction of fairly large, flat surfaces and panels. Woods vary in texture con-siderably. Many of the conifers are fine-textured, because they have no pores, and there is not much difference in density between the spring-wood and summer-wood. Woods like oak which have large wood vessels are spoken of as coarse-grained or textured woods.

The structure of wood is cellular, not labyrinthine. From one half to three quarters of dry wood is air space. The structure is nearly like that of the honey-comb in which there is no communication between cells. The air enclosed in wood is mostly enclosed within the tracheids and wood cells and not between the cells. There is not complete isolation between the tracheids of soft-wood because their walls are penetrated by small pits (bordered pits) covered by membranes, which are microscopic openings about 0.00002 mm. in diameter.

Wood readily absorbs or gives up water (moisture) and, consequently, it is subject to shrinking and swelling. This change in dimension with changing mois-ture content may be considered a shortcoming. There are three forms of water in wood: (1) the water that is in chemical combination with carbon to form the cellulosic material, (2) the water that is absorbed by the cell walls, and (3) the

water that is free in the cell cavities. Water in chemical combination is a constant thing and has no effect on the swelling and shrinking of wood. Also, that which is free in the cell cavities, like sap in growing wood, or which is taken up in resoaking, has no direct effect. It is the water absorbed by the cell walls themselves that has a pronounced effect upon the thickness of the walls of the wood cells. It is the water absorbed by the cell walls that is the important factor bearing upon the shrinking and swelling of wood. When green wood has become thoroughly dry, it still contains a certain amount of moisture, but the amount varies with that in the surrounding air. In an atmosphere saturated with water vapor the cell walls can take up 20 to 30 per cent of moisture (based on the dry weight of the wood) while the fibre cavities are still empty. This percentage varies with the species. The condition when the cell walls are saturated with water vapor is called the ' fibre saturation point.' Under normal atmospheric conditions (60–70 per cent relative humidity) air-dried wood contains about 12 per cent by weight of water. Data on the relationship of average moisture content of wood to relative humidity of the atmosphere are given in *Technical Note No. F-13, Forest Products Laboratory* (Madison, Wis.), as follows:

Relative Humidity of Atmosphere (Per Cent)	Average Moisture Content of Wood (Per Cent)
20	5.0
25	5.8
30	6.6
35	7.4
40	8.2
45	9.1
50	10.0
55	10.9
60	11.9
65	13.0
70	14.3
75	15.7
80	17.5
85	19.5
90	22.2
95	25.6

Wood does not shrink equally in all directions. There is practically no longitudinal shrinkage or expansion. Change in dimension, caused by change in moisture content, is all transverse and, in general, the tangential decrease is about twice as great as the radial. This explains why logs of wood crack radially on drying. Forsaith (p. 114) says that, in general, a loss of 1 per cent by weight in air-dried timber will cause a radial shrinkage of about 0.2 of 1 per cent and a tangential shrinkage of 0.3 of 1 per cent.

Species of woods differ considerably in the ratio of their radial and tangential shrinkages on drying. In the case of mahogany, birch, and black walnut, these differences are relatively slight, and hence these woods are not prone to crack extensively on drying. On the other hand, the differences between the radial and tangential shrinkages of beech, maple, and oak are large and these woods crack

FIGURE 5. Relations of quarter-sawed and plain-sawed boards, adapted from figure 1, page 8, a drawing in 'The Identification of Furniture Woods,' *Miscellaneous Circular no. 66* (Washington, D. C.: Government Printing Office, 1926), by Arthur Koehler. At the left is a quarter-sawed (radial) board; in the center the log with annual rings showing at the end grain; and at the right a plain-sawed (tangential) board.

radially on drying. Since wood shrinks more tangentially than radially, quarter-sawed lumber shrinks less in width and more in thickness than plain-sawed lumber. When pieces of quarter-sawed and plain-sawed lumber are placed edge to edge in the same panel, one may become thinner than the other with change in moisture content. Plain-sawed lumber, also, has a tendency to cup, since the center side is more nearly radially cut than the outside. A. Koehler ('Shrinking and Swelling of Wood,' pp. 18–20) has published tables giving figures which permit the comparison of radial and tangential shrinkages of a great many species of wood. Werthan and Haslam have shown that the expansion of summer-wood is often greater than the over-all expansion of the wood. Their data indicate that

summer-wood expands so much that the forces are greater than those of the swelling of spring-wood, with a result that the spring-wood is often compressed. Paint does not chip and flake from spring-wood so quickly as it does from summer-wood, which indicates that there is less mechanical movement in the spring-wood. Its natural expansion is balanced by the compression effects exerted upon it by summer-wood.

It is difficult to find published data which give the linear increase in the swelling of wood with change in the moisture content of wood. S. T. C. Stillwell, of the British Forest Products Laboratory, supplies the information (private communication) that a quarter-sawed oak panel 1 foot in width, increases 0.023 inch for each increase in moisture content of 1 per cent. A tangentially-sawed panel of the same width gains 0.038 inch. These movements were measured over a range corresponding to relative humidity conditions of from 20 per cent to 80 per cent. This laboratory has also made some measurements on the expansion and shrinkage of old panel paintings with changes in relative humidity. Their graphs show that certain painted panels may change in width across the grain as much as 1.5 per cent to 2 per cent in a range of relative humidity varying from 40 to 80 per cent.

Wood, deterioration and treatment. The decay of wood is always caused by an external, living organism. All such organisms need for their growth food, water, air, and warmth. In general, they belong to the mass of dependent plants known as fungi and, so far as they infest wood, may be considered in three classes: bacteria—unicellular organisms the action of which is still imperfectly understood, though it appears that some of them may be destructive to wood tissues; ascomycetes—chromogenetic fungi known as sap stains and having only a slight influence on the strength of wood; and basidiomycetes, the highest class of fungi and the most destructive to wood. These are made up structurally of many branching, hollow tubes arranged loosely like mold or crowded into cushions. The tubes grow principally in length. They may be formed into fruit-bodies, plate-like, bracket-like, or flat, and assuming a variety of shapes. The characteristics of some of the principal basidiomycetes that live on wood can be shown in a tabular form (this is condensed from the table by Prof. Percy Groom in ' Dry Rot in Wood,' pp. 6 and 7).

An understanding of the conditions of growth carries with it sufficient indication of how to prevent that growth. Many of the fungi that cause dry rot will attack sound wood. This is particularly true of the *Coniophora puteana (cerebella)*. Inoculation occurs from a microscopic spore, and thin films of such materials as wax would help to prevent this from getting lodged in the surface. None of the fungi will live without an ample supply of water vapor, or without fresh air. Extreme and prolonged dampness is therefore to be avoided and occasional fumigation with thymol or some of the stronger gases would tend to kill any active or dormant growth.

The result of attacks of dry rot may be more or less severe and treatment of the wood which has decayed will have to be carried out according to the requirements of particular cases. In all cases where wood has been attacked by fungi some has been used for their nourishment and the structure is weakened. With this weakening the wood becomes more red in color and more brittle, loses its characteristic odor, gives a dull sound when struck, shrinks, and often warps. It may or may not have visible fungus on the surface but in advanced cases will show cross-shakes and cup-shakes—fractures running at right angles to the grain, with, in the latter, a curling into concave flakes between the fractures.

Name	Surface Growth *	Comments
Merulius lacrymans (domesticus)	White to gray strings sometimes as thick as a lead pencil; brittle when dry; auxiliary growth in dense sheets with large bracket-like and scalloped fruit-bodies.	Little moisture needed; rot runs through and causes cross-shakes.
Polyporus vaporarius (group)	White strings and auxiliary growths, never colored, with fruit-bodies in thin sheets, all white.	Members of this group need more water than the *Merulius lacrymans*.
Coniophora puteana (*cerebella*)	Slender strings becoming red-brown, and fruit-bodies yellow to olive-brown, sheet-like and with minute pimples.	Needs much moisture; rot incomplete, often without cross-shakes.
Paxillus pannoides (*Acheruntius*)	Very slender, yellow to brownish yellow; fruit-bodies shell or fan-shaped, surface yellow to brown and with radiating gills.	Takes much moisture; wood when attacked first takes on a characteristic yellow color.
Lenzites saepiara and *L. abietina*	No strings; occasional sheets or cushions, tan in color; fruit-bodies from wood cracks are yellow to umber with radiating gills.	Demands much moisture; fungus remains inside and resists death from desiccation; external wood may remain intact except for cross-shakes and cup-shakes.
Polyporus destructor	No strings or other growths on surface; bracket-shaped fruit-bodies, white to gray.	Demands much moisture; decay internal.

* Since, in the study of conservation of works of art, identification of species is not needed as a rule, the descriptions of Professor Groom are much abridged here. He points out that fruit-bodies in particular have various shapes within species.

The so-called 'worms' which destroy wood are the larvae of beetles of the order *Coleoptera*. In this large order only one group needs to be much considered in relation to objects of art. This is made up of the furniture beetles (*Anobiidae*), insects which inhabit seasoned wood. The larvae of the Anobiid beetles are usually one tenth to one third inch long, are somewhat cylindrical and elongated in shape, and are brownish in color. When full-grown, or developed as 'worms,' they are curved and wrinkled, have three pairs of legs and strong, biting jaws. The entire life history of them is not known in all its points, but it is certain that, although the

cycle from egg to beetle may be prolonged to two years or more, it usually lasts only a year. These larvae infest both coniferous and hard-wood objects and may invade heart-wood as well as sap-wood.

The common furniture beetle is the *Anobium punctatum*. It is small (1/10 to 1/4 inch) and is reddish brown to dark brown in color. The insects usually emerge in June or July, leaving their pupal beds or cells in the wood at that time. Frequently they are found crawling on walls and ceilings. They pair then and the females lay their eggs in cracks and crevices of wood. The young larvae bore in, going first at right angles and then along the grain. As they grow, they work towards the surface and gnaw out a small cell which serves as a pupal bed. From this the beetle emerges. The largest of the furniture beetles is the *Xestobium rufovillosum* or death watch beetle. It is one fourth to one third inch long and brown in color. Its pupation occurs in the spring as does that of the *Anobium* but the beetles do not emerge until autumn or even as late as the following spring. It is comparatively rare and its traces distinguish it from the *Anobium:* the exit holes are larger and the dust is in coarse pellets. Two other kinds of beetles that infest furniture are so rare as not to have acquired popular names. They are the *Ernobius Mollis* and the *Ptilinus Pectinicronis*.

It appears that the Anobiids prefer old wood, possibly because of chemical changes that improve it as food, or because of the presence of micro-organisms, or simply because it offers better places for egg-laying. In panel paintings the tunnels made by larvae not only bring about a general weakening of the support, but also establish areas of particular weakness where the paint is apt to collapse and be entirely lost. The ground and paint film offer no food and it is often found that the larvae run their tunnels directly beneath them. Pupal beds are made there and beetles emerge through the paint, leaving behind them tubular openings next the ground and completely hidden. These empty tunnels afford no resistance to the general shrinkage of the panel and when that occurs, the paint above them ' buckles ' or ' tents ' and frequently flakes off entirely. The presence of such tunnels in a painted panel is indicated by buckled films, by marked or thread-like cracks following, usually, the grain of the wood, by visible exit holes, or by a lack of resonance if the tunnels are sufficiently numerous. In many instances there are but slight indications on the painted surface; probing the panel from the reverse will give some evidence about the general state of the wood. Where ground and paint films are thin and uniform, a radiograph may show the location of tunneled wood, but as a rule the density contrast of pigments is so great as to conceal that in the support.

The activities of the termite (*reticulitermes flavipes*) are similar to those of the beetle. It appears, however, that prevention or elimination of them is less a matter for individual objects than for structural changes in buildings. (This is explained by Morgan Marshall in ' The Termite Menace,' *Technical Studies*, IV [1936], pp. 129 ff.)

Much the larger part of wood treatment as it has to do with the art of painting is restorative. In the preparation of panels there are only the familiar processes of joining members or of adding cleats, dowels, or splines to such joins. For purposes of restoration, or to prevent or arrest the deterioration of wood, fumigation is often employed. As a rule, the object is placed in an air-tight chamber and there exposed to the fumes of a nature toxic to larvae and usually to fungi. Such fumigants are carbon disulphide, carbon tetrachloride, formaldehyde, ethylene dichloride, and ethylene oxide, among others. Where wooden objects are stored or exhibited in tight cases repellants like paradichlorobenzene are often kept with them.

The treatment of weakened wood by impregnation is a method as yet little used for panel paintings. Where it has been used, wax or a combination of waxes and resins is made the impregnating material. This is forced into the wood by heat or is carried in by absorption when dissolved in a solvent. In most instances, such treatment is effective rather in sealing the wood structure and in making the outside more firm than in actually strengthening it, for the depth of penetration is not great and the cavities in wood cells are rarely reached. Thorough impregnation could only take place with immersion of the panel in the dissolved material or with keeping it at a temperature above the melting point of the impregnating material for somewhat prolonged periods. Either of these carries with it a risk to the paint structure, which has kept it from being generally adopted.

Various types of accessory supports have been attached to wood panels in an effort to strengthen them or to keep them in an even plane. The most simple are cleats or braces either glued to the reverse or mortised in. Occasionally a solid, checked-out lattice of new wood has been glued on. This has the disadvantage of putting the panel under great restraint and with the expansion and contraction that is inevitable from changes of atmospheric humidity, the panel itself is apt to check or crack. The attachment called a ' cradle ' is designed to prevent this. It is composed of longitudinal members set at intervals in the same direction as the grain and glued in place. On the edge of these members, next the panel, notches of uniform size are cut so that another member, transverse, can slide in them. These transverse members are not attached and the cradle as a whole is expected to leave the panel free to expand and contract without warping. Although effective in many cases, the cradle must have favorable conditions or it, too, becomes fixed by cramping and endangers the panel as does a lattice.

For any accessory support to be effective, the wood of the panel must be strong enough to carry it. When the wood is much weakened by worms or by dry rot, another type of treatment is necessary. Removal of the weakened wood and replacement with a luting material is possible where deterioration is confined to limited areas. If the panel is largely honeycombed by worm tunnels or desiccated by fungi, the painting will probably have to be rebacked or transferred. In the

rebacking process the original panel is cut down to a thickness of one eighth inch or less and this is attached to a new panel, usually three to five ply and with a middle core made up of a number of strips. In the process of transfer, the wood is entirely removed and the ground may or may not be left.

Wood, history in painting. In western civilizations the use of wood as a paint support can well be supposed to have reached into the earliest practice of the art. Painted wood sculptures exist from the time of the Old Kingdom in Egypt, as early as the IV Dynasty (2900–2750 B.C.), and by the Middle Kingdom (2160–1788 B.C.) sarcophagi with painted representations are known. Duell draws attention to the practice of easel painting in the VI dynasty, and by the time of the mummy portraits, executed largely in the Fayûm during the early centuries of the Christian era, wood is found as a regular, independent support for pictorial designs. The kinds employed for this purpose were, according to available data, sycamore (undoubtedly the sycamore fig [*Ficus sycomorus*]), cypress, cedar, and pine. The cedar, cypress, and pine were all foreign importations but are listed by Lucas as found in other Egyptian objects made of wood. The sycamore fig was native. Practically nothing survives in the way of painting on wooden supports from classical times, though a set of parade shields, pine and covered with representations, have been found by a Yale University expedition at Dura-Europos in Syria. They are of Roman origin, somewhat before 256 A.D. Pliny (XXXV, 77) says that Pamphilos, IV B.C., taught his pupils to paint on panels of boxwood, and such a support must have been common for the portable pictures of antiquity. Except for the fine craft of lacquer painting which was generally exercised on objects of wood, the Far East was not given to its use as a support for painted designs. A possible exception is the set of the doors, carrying representations of religious scenes, of the Tamamushi shrine in the Kondo of the Horyuji monastery at Nara, Japan, dating from the VI or VII century. It is evident, however, that by the XVI century, and probably for a long time before that, panel painting was a common practice in India, and Coomaraswamy has brought together a number of references to show this.

A summary made from the catalogues of the Munich and Vienna museums, with a few items from the catalogue of the National Gallery, London, shows the following distribution of woods in the panels of 1100 European paintings from the time of the early Renaissance:

Beech—German, 11.
Cedar—Flemish, 1; Italian, 4. (Total, 5)
Chestnut—German, 1; Italian, 28. (Total, 29)
Fir—Flemish, 2; German, 4. (Total, 6)
Larch—German, 3.
Linden—Flemish, 3; German, 85; Italian, 8. (Total, 96)
Mahogany—Flemish, 2.
Oak—English, 2; Flemish, 560; French, 13; German, 80; Italian, 18. (Total, 673)
Olive—Italian, 4.

Pine—Flemish, 2; German, 131; Italian, 15. (Total, 148)
Poplar—Flemish, 1; German, 10; Italian, 110. (Total, 121)
Walnut—Flemish, 3; French, 2; German, 4; Italian, 3. (Total, 12)

A further comment on the panels used in European painting is made by Eibner in his *Tafelmalerei* (pp. 78 ff.). For the XV and XVI centuries he says that Italian painters used poplar, walnut, chestnut, cypress, pear, mountain ash, maple, pine, cedar, and willow; that the French used oak; that the painters of the Netherlands used oak, mahogany, linden, cedar, maple, pear, and poplar; that the Dutch used linden, red beech, fir, spruce, alder, and Swiss pine; and that the English used oak, spruce, fir, and pine.

The joining of pieces to make a wood panel is described by many of the early treatises on painting; such a description is in the *Schedula diversarum artium* of the monk Theophilus (early XII century) and is given by Laurie (*Materials*, etc., p. 158, from MS. chap. XVII). It calls for making a glue from cheese-casein, with quicklime to dissolve it. Similar directions are found in the famous *Libro dell' Arte*, the Craftsman's Handbook of Cennino Cennini (early XV century; ed. Thompson, p. 68).

From very early times other materials, like cloth, leather, and (later) paper, were combined with wood to make a compound support for paint. Structures of this kind are found in Egyptian mummy cases where linen with gesso over wood forms the support of paint and gold. A Roman parade shield of the II century A.D., found at Dura-Europos, is made of plywood covered with leather on which the painting is executed. In European panel painting, particularly in Italy, the practice of applying cloth over the wood was common before 1400, and is specifically described by Cennino Cennini (ed. Thompson, p. 70). He directs the use of old thin linen cloth that is cut or torn into strips, soaked in a good size (*i.e.*, a glue made from goat or sheep parchment), and spread over the panel.

During the Renaissance in Europe cloth supports came to be more common, particularly for larger compositions, but wood continued in use and is still frequently employed by painters.

Wood-Pulp (see also **Paper**). In the early stages of making paper, cardboard, and certain building boards, logs are cut, chipped, and reduced to a fibrous mass. This is usually done either by grinding and soaking, which produces mechanical pulp, or by chipping and decomposing intercellular materials in the raw wood through the action of alkaline or acid additions to the water used for cooking. The latter produces chemical pulp.

Wool (see also **Fabrics** and **Fibrous Substances**) was probably the first fibre spun by man. It is the epidermal hair of lambs and sheep, and consists of a protein called keratin. Although the best and greatest quantity of it comes from sheep, some comes from the angora goat, the cashmere goat, the camel, alpaca, llama, and other animals. The use of cloths made from this fibre for support of paint and paintings has been negligible.

BIBLIOGRAPHY

Fred H. Andrews, O.B.E., 'Central Asian Wall-Paintings,' *Indian Art and Letters*, VIII (1934), pp. 1–21.

Anonymous, *Cleaning and Restoration of Museum Exhibits, Third Report* (London: H. M. Stationery Office, 1926).

Anonymous, *Some Notes on Atmospheric Humidity in Relation to Works of Art* (London: The Courtauld Institute of Art, 1934). Pp. 48.

Victor Bauer-Bolton, 'Zur Frage der Konservierung der Tafelmalerei,' *Museumskunde*, V (1933), pp. 95–112, and 'La Conservation des Peintures de Chevalet—les Supports et les Fondes,' *Mouseion*, XXIII–XXIV (1933), pp. 68–91.

Ernst Berger, *Beiträge zur Entwicklungsgeschichte der Maltechnik*, 4 vols. (Munich: G. D. W. Callwey, 1901–1912).

R. M. Boehm, 'The Masonite Process,' *Industrial and Engineering Chemistry*, XXII (1930), pp. 493–497.

Charles Moïse Briquet, *Les Filigranes* (Paris: A. Picard and Son, 1907).

J.-F. Cellerier, 'Traitment d'une Statue en Bois contre l'Action des Parasites,' *Mouseion*, XVII–XVIII (1932), pp. 128–131.

A. H. Church, *The Chemistry of Paints and Painting* (London: Seeley and Co., 1901).

Ananda K. Coomaraswamy, 'The Technique and Theory of Indian Painting,' *Technical Studies*, III (1934), pp. 59–89.

A. D. Cowper, 'Lime and Lime Mortars,' *Special Report No. 9, Department of Scientific and Industrial Research* (London: His Majesty's Stationary Office, 1927).

C. F. Cross and E. J. Bevan, *A Textbook of Paper-Making* (London: E. & F. N. Spon, 1907).

Max Doerner, *The Materials of the Artist and Their Use in Painting*, trans. (New York: Harcourt, Brace and Co., 1934).

Prentice Duell, 'Evidence for Easel Painting in Ancient Egypt,' *Technical Studies*, VIII (1940), pp. 175–192.

J. D. Edwards, F. C. Frary and Z. Jeffries, *The Aluminum Industry*, 2 vols. (New York: McGraw-Hill Book Co., 1930).

A. Eibner, *Entwicklung und Werkstoffe der Tafelmalerei* (Munich: B. Heller, 1928). *Entwicklung und Werkstoffe der Wandmalerei* (Munich: B. Heller, 1926).

Encyclopaedia Britannica, 11th and 14th editions.

C. C. Forsaith, 'The Technology of New York State Timbers,' *Technical Publication no. 18, New York State College of Forestry* (Syracuse University, 1926).

Eloise Gerry, 'The Structure of Wood,' *Lecture Note, U. S. Forest Products Laboratory* (Madison, Wisconsin, June, 1929).

A. L. Goodale, *Chronology of Steel* (Cleveland: Penton Publishing Co., 1931).

Percy Groom and others, 'Dry Rot in Wood,' *Bulletin no. 1, Forest Products Research* (London: His Majesty's Stationery Office, 1928).

J. H. Haslam and S. Werthan, 'Studies in the Painting of Wood, I. Influence of Wood Structure on Paint Behavior,' *Industrial and Engineering Chemistry*, XXIII (1931), pp. 226–233.

E. S. Hedges, *Protective Films on Metals* (New York: D. Van Nostrand Co., 1933).

H. O. Hofman, *Metallurgy of Copper* (New York: McGraw-Hill Book Co., 1914).

A. L. Howard, *Timbers of the World* (London: The Macmillan Co., 1920).

Dard Hunter, *Paper-Making Through Eighteen Centuries* (New York: William Edwin Rudge, 1930).

F. Hamilton Jackson, *Mural Painting* (London: Sands and Co., 1904).

K. Jex-Blake and E. Sellers, *The Elder Pliny's Chapters on the History of Art* (London: Macmillan and Co., Ltd, 1896).

Edward Johnston, *Writing and Illuminating and Lettering*, 12th ed. (London: Sir Isaac Pitman and Sons, Ltd, 1922).

Joseph Karabecek, *Papyrus Erzherzog Rainer, Führer durch die Ausstellung* (Vienna, 1894).

Katalog der Älteren Pinakothek zu München (Munich, 1925).

Katalog der Gemäldegalerie (Vienna: Kunsthistorisches Museum, 1928).

Sheldon Keck, 'A Method of Cleaning Prints,' *Technical Studies*, V (1936), pp. 117–126.

J. A. Knowles, 'Processes a·d Methods of Medieval Glass Painting,' *Journal of the Society of Glass Technology for 1922*, pp. 255–274.

Arthur Koehler, *Guidebook for the Identification of Woods Used for Ties and Timbers* (Washington, D. C.: Government Printing Office, 1917).

'The Shrinking and Swelling of Wood,' *Bulletin, Forest Products Laboratory* (Madison, Wisconsin, July, 1931).

A. P. Laurie, *The Materials of the Painter's Craft* (Philadelphia: J. B. Lippincott Co., 1911).

The Painter's Methods and Materials (Philadelphia: J. B. Lippincott, 1926).

J. D. LeCouteur, *English Medieval Painted Glass* (London: The Macmillan Co., 1926).

H. N. Lee, 'Established Methods for Examination of Paper,' *Technical Studies*, IV (1935), pp. 3–14.

A. Lucas, *Ancient Egyptian Materials and Industries*, 2d ed., revised (London: Edward Arnold and Co., 1934).

Harry Miller Lydenberg and John Archer, *The Care and Repair of Books* (New York: The R. R. Bowker Co., 1931).

J. Merritt Matthews, *The Textile Fibers* (New York: John Wiley and Sons, 1924).

Leon McCulloch, 'Lime Process for Coating Aluminum,' *Transactions of the Electrochemical Society*, LVI (1929), pp. 41–44.

J. W. Mellor, *Comprehensive Treatise on Inorganic and Theoretical Chemistry* (London: Longmans, Green and Co., 1923).

M. P. Merrifield, *Original Treatises on the Arts of Painting*, 2 vols (London: John Murray, 1849. To be reprinted by Dover Publications in 1966).

William Millar, *Plastering, Plain and Decorative* (London: B. T. Batsford, 1897).

G. W. Morey, 'A Half Century of Progress in the Glass Industry,' *Industrial and Engineering Chemistry*, XVIII (1926), pp. 943–945.

'The Corrosion of Glass Surfaces,' *ibid.*, XVII (1925), pp. 389–392.

J. W. Munro, 'Beetles Injurious to Timber,' *Bulletin no. 9, Forestry Commission* (London: His Majesty's Stationery Office, reprinted 1930).

Kenneth P. Oakley, 'Woods Used by the Ancient Egyptians,' *Analyst*, LVII (1932), pp. 158–159.

Wilhelm Ostwald, 'Iconoscopic Studies,' *Technical Studies*, IV (1935), pp. 135–144.

J. R. Partington, *Origins and Development of Applied Chemistry* (London: Longmans, Green and Co., 1935).

L. V. Pirsson, *Rocks and Rock Minerals* (New York: John Wiley and Sons, 1908).

H. J. Plenderleith, 'La Conservation des Estampes, Dessins et Manuscrits,' *Mouseion*, XXIX–XXX (1935), pp. 81–104.

 The Preservation of Antiquities (London: The Museums Association, 1934).

F. Rathgen, *Die Konservierung von Altertumsfunden* (Berlin: Walter de Gruyter, 1926).

Nancy Andrews Reath, 'The Weaves of Hand-Loom Fabrics,' *The Pennsylvania Museum Bulletin* (Philadelphia), XX (November 1924).

Helmut Ruhemann, 'La Technique de la Conservation des Tableaux,' *Mouseion*, XV (1931), pp. 14–22.

B. W. Scribner and F. T. Carson, 'Study of Fiber Wall Boards for Developing Specification Standards,' *Paper Trade Journal* (September 26, 1929), pp. 61–68.

Shorter Oxford English Dictionary.

Alfred J. Stamm and L. A. Hansen, 'Minimizing Wood Shrinkage and Swelling,' *Industrial and Engineering Chemistry*, XXVII (1935), pp. 1480–1484.

William Suhr, 'A Built-Up Panel for Blistered Paintings on Wood,' *Technical Studies*, I (1932), pp. 29–34.

Edwin Sutermeister, *Chemistry of Pulp and Paper-Making* (New York: John Wiley and Sons, 1929).

Theophilus, *An Essay upon Various Arts* (translated, with notes, by Robert Hendrie, London: J. Murray, 1847).

Daniel V. Thompson Jr, 'The De Clarea of the So-Called "Anonymus Bernensis," ' *Technical Studies*, I (1932), pp. 8–19 and 69–81.

 Il Libro dell'Arte, The Craftsman's Handbook of Cennino d'Andrea Cennini, 2 vols (New Haven: Yale University Press, 1932-1933. Reprinted in 1 vol. by Dover Publications, 1954).

Daniel V. Thompson Jr and George Heard Hamilton, *De Arte Illuminandi* (New Haven: Yale University Press, 1933).

T. R. Truax, 'The Gluing of Wood,' *Department of Agriculture, Bulletin no. 1500* (Washington, D. C.: Government Printing Office, 1929).

C. G. Weber, 'Fiber Building Boards,' *Industrial and Engineering Chemistry*, XXVII (1935), pp. 896–898.

C. G. Weber, F. T. Carson and L. W. Snyder, 'Properties of Fiber Building Boards,' *Miscellaneous Publication, Bureau of Standards, no. 132* (Washington, D. C.: Government Printing Office, 1931).

N. H. J. Westlake, *A History of Design in Painted Glass* (London: James Parker and Co., 1881).

A. Martin De Wild, *The Scientific Examination of Pictures*, trans. (London: G. Bell and Sons, Ltd, 1929).

TOOLS AND EQUIPMENT

Agate, a hard, semi-precious stone out of which burnishers for gold leaf are now commonly made. The word is often used to mean burnisher.

Alembic. Like the oil press and other articles of equipment for the preparation of mediums, the alembic, a glass vessel with neck bent downwards, for distillation, is occasionally seen in studio interiors of the XV century and shortly after. A painting of St Luke of the school of Massys, in the National Gallery, London (no. 3902), shows a small alembic on a shelf along with other containers. Leonardo da Vinci mentions it a few times in his notebooks, largely with respect to the distillation of turpentine.

Amassette (see also **Slice** and figure 24). This name, obviously French,in origin and probably restricted to that locality of Europe, has been used to define a scraper made out of horn. This, like the slice, was for piling and collecting paint on the grinding slab. It is mentioned in the Brussels MS. of 1635 by Pierre le Brun (Merrifield, II, 770 and n.).

Anatomical Figure. Interest in anatomy on the part of painters brought about extensive study by means of dissection, and later, as a more convenient means of information for students, various kinds of casts and models were made to show the positions of muscles and bones. Although occupation with this study began in the XV century, widespread study of anatomy was a development of the XVI century. Various drawings and paintings of academies in the late XVI century particularly show students and teachers at the work of dissection and drawing. Skeletons and skulls are common models and, more rarely, casts or models of muscles.

Atomizer. When certain types of drawings require to be fixed in order to prevent their chafing they are sprayed with a resin dissolved in a suitable organic solvent. The common means for making such a spray is a pair of small metal tubes placed at right angles to each other so that a stream of air from the larger blows across an open end of the smaller, the other end of the smaller tube being in the resin solution. A spray of the diluted resin is thus thrown out. There are many variations of the construction of this simple tool. Most artists still blow these by mouth rather than with a pump or bulb. Historically, the atomizer is probably fairly recent in the arts. As late as the XVII century, large drawings used as cartoons were dipped into a bath of fixative (Meder, p. 191).

Basin Slant. The porcelain palette with inverse, wedge-shaped depressions for water color painting is frequently made in the form of a disk which sits like a lid on a basin for water (figure 26, *b*). In this lid the depressions are on radial lines and a hole is put in the center where a brush can be dipped in the water beneath. Some manufacturers add a separate and removable cup which fits into the central opening.

Beaker. A glass container for measuring quantities of fluid is now practically without consideration amongst artists' colormen. Beakers are commonly seen, however, in paintings of artists' studios from the XV to XVIII centuries.

Blender or **Softener,** a fairly large, round brush, with the end flat rather than domed, and made regularly of badger hair. It is used, dry, to grade or soften edges, particularly in oil painting (see **Brush** and figure 1, *h*).

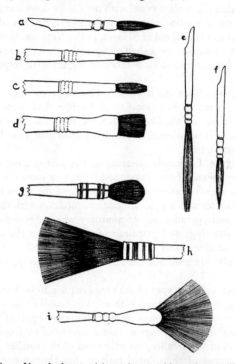

FIGURE I. A selection of brush shapes: (*a*) a pointed sable set in a quill; (*b*) the same in a metal ferrule; (*c*) a slightly flat sable with a straight edge; (*d*) a square end sable flatter than *c*. These three shapes are common in both sable and bristle brushes and many others are made as variations on them. At *e* is a very long sable with a flat end, called a 'striper'; *f*, with a somewhat longer hair than *a*, is called a 'writer'; both are set in quills. Heavier brushes are: (*g*) a mop of camel hair with a wired quill mounting similar to the brush called a 'dabber'; (*h*) a blender or softener made of badger hair, round, and mounted with wire; (*i*) a very thin, flat brush, called a 'fan,' set in a metal ferrule and made of sable or bristle.

Breathing Tube. A small tube made of paper, cane, or occasionally of metal, about half an inch in diameter and six or more inches long, has as its principal purpose the moistening of the bole ground before gold leaf is laid in manuscript illumination. The breath, blown through it gently, carries enough moisture to

make the bole adhesive. A simple instrument of this kind may have had long use in the past, but it was not much referred to before the time of modern writing on methods (see Johnston, p. 154).

Bristle, the material, usually hog hair, made into heavier brushes.

Brush. Some kind of fibrous tuft used for holding and spreading paint seems to be quite as old as the art itself. The brushes chiefly used in the West by the artists of the present are of two general types: the bristle of hog hair and the sable or other fine hair. Many different materials are actually used. For auxiliary work in painting, that is, for blenders, for the so-called 'fan,' for stencilling, or for varnishing, badger, horsehair, camel hair, and others are added to the two principal types (figure 1). The East has known a still greater variety of materials for brush making (figure 2). Ancient Egypt held largely to one tool of this kind—plant fibres as they occurred in a reed which was macerated at the end to separate them and produce a suitable tuft. China and Japan have had brushes made regularly of deer, fox, and numerous hairs of wild animals, and for certain purposes have had brushes made of feathers or of human hair.

During the past 200 years or more the craft of brush making has been carried on as a special activity outside of the artist's studio. Whether the brushes are of bristle or of a fine hair, the mounting is much the same for those used directly in the practice of painting. The hairs are cut and sorted, and thorough cleaning with sterilization is usually part of this preliminary process. The hair itself has to be kept aligned because it is important in brush making that the tip of the brush be made up of the natural tips of the hairs that are in it. These are the outer ends, called the 'flag' or 'split' ends, whereas the root end of the hair, called the butt, is usually cut off. Brushes which do not have the flag ends as their tips are brittle and can not be controlled for fine work. During manufacture the hairs are straightened, sorted, and cut according to the length and size the brush is to have. They are then shaken together in small metal cylinders called 'cannons,' and shaped by hand to the form desired. The tufts so made are tied. After this, they are mounted, usually in metal ferrules, with a cement such as rubber, pitch, or synthetic composition. Quills also are used still to a very large extent for the mounting of smaller brushes such as the sable or the so-called 'camel hair.'

It seems commonly agreed that the best of the fine, soft brushes are those made from what is called 'red' sable. This is the hair of the kolinsky, an animal which may be any of several species of Asiatic minks, and the name is from the Russian for *Kola*, a district in northeastern Russia where these animals are found. The pelt is reddish yellow in color, and the tail supplies the hair used for brush making. The so-called 'camel hair,' also used for small, soft brushes, is, in the modern production of these tools, actually the hair from a squirrel. The best of this comes from Siberia and Russia, and the color ranges from red through gray to black. Fitch brushes have also been used as a fair substitute for sable. Probably the fine brush described by Cennino Cennini (C. LXIIII) was rather rare, even in his day. This was made

of miniver, or ermine, and some of the quality of the brush must have been lost by the trimming that he suggests, with scissors (Thompson, pp. 40–41). The regular brush for modern oil painting, because it is stiff enough to draw out a fairly heavy and paste-like mixture, is made of hog hair, usually bleached white.

In the Far East, brushes are commonly mounted in bamboo and have somewhat more specialized selection according to use than is common in the West. The hairs of deer and wolf will be combined, for example, into a brush for certain kinds

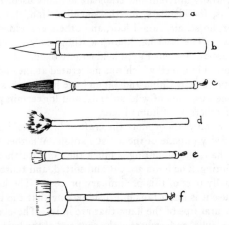

FIGURE 2. A few of the Chinese brushes described and illustrated by Sickman: (*a*) a small brush of deer hair made for drawing and having two reducing collars, the smaller one a silver tube; (*b*) a plain, pointed brush of pure goat hair with the usual bamboo handle; (*c*) a goat hair brush set in an enlarging holder of ivory attached to a handle of bamboo which carries a loop for hanging—a brush for large ink painting or for inscriptions; (*d*) a brush of chicken feathers pressed open; (*e*) a stub brush with an enlarging holder of horn; (*f*) a wide, flat brush set in a brass frame or ferrule attached to a bamboo handle—used for removing charcoal or powder.

of writing and painting. A particular brush of deer hair is made for marking such details as the veins of a leaf. A brush for inscriptions is made of two parts rabbit and eight parts goat hair. With a few exceptions, these are pointed in shape.

The soft or fine brush used by western painters is ordinarily pointed, except for a few that have blunt ends and for such special brushes as dabbers, stripers, mops, fans, and wash brushes. Shapes of the bristle brushes, however, have a large number and variety. The ferrule in which the hairs are mounted may be round in section, slightly flattened, or very flat and thin. The flat brush is probably the more usual in the modern practice of oil painting. The shapes of the ends and the differences in the length of the hair make up a various range of brushes that are

offered by artists' colormen. The sizes are indicated by number and commonly run from 0 to 12, the last being about an inch across at the end of the ferrule. Fine sable and camel hair brushes, when mounted in metal ferrules, are numbered in a similar series. Those mounted in quills have the size indicated by the source of the quill, as lark, crow, duck, goose, or swan. These, with intermediate entries, give a series of eleven or twelve sizes.

Although minor changes and greater standardization have come with specialized brush manufacture, brushes themselves as implements for painting are probably not far different from those that were made and used by prehistoric man. The Egyptian brush of reed fibre is an exception to the general rule of East or West, for animal hair tied to a stick or set in a reed or quill has been the typical primitive brush. In the British Museum is a short brush made of woolen yarn bound with fine thread to a small reed handle. It was found at Oxyrhynchus in Egypt among objects of the Roman period and, although it is shown with painters' materials, it may not have been typical of any brushes used for pictorial work. From the same site and in the same collection is an unusual brush of the simplest possible design, being only a very small bundle of coarse, black hair bound through the middle to leave the ends free. Berger (I and II, p. 172) assumes, largely on the interpretation of literary evidence, that the Greeks and Romans used bristle for their larger brushes, and that finer work was done with a soft hair. By the time of the so-called 'Mt Athos' MS., reflecting methods of the XI and XII centuries in the region of Greece, it is clear that many kinds of hair were used—pig, bristle, ox, and ass. Cennino Cennini, representing largely the methods of the XIV century, speaks of small, fine brushes of miniver, mounted in quills, and large brushes made of the bristles of a white hog, bound in a bundle around a stick handle. These two types, doubtless with great variations in the kinds of hair used, seem to have prevailed throughout Renaissance and early modern painting. Until metal ferrules came into use, probably in the early part of the XIX century, the fine brush had a quill mounting and was always round in section. Paintings of artists' studios through the XVIII century still show the heavy and the light brushes as round in section, although a flat brush could have been made out of bristles and without a metal ferrule.

Brush Case. As manufactured for the modern painter, this is a long box of metal with a sliding top, usually of enamelled or plated metal, and with a handle. Its purpose is to hold brushes for travelling or for out-of-door sketching and to prevent their being unduly worn or frayed. Some cases have a partition to which the brushes are fastened by means of an elastic band. Those for oil-color brushes are about 14 inches long and often more than 2 inches in diameter. The water color cases are smaller and may be either round or oval in cross section.

Brush Cleaner. Pans or vats of various sizes and shapes to hold oil or turpentine (see figure 3) have been in use for many years as receptacles for cleaning paint brushes or to prevent their drying out. Clips are often arranged above a pan so

that the brush handle will be caught there and the hairs kept immersed in the fluid. Such a cleaner was advertised in the catalogue of Winsor and Newton for 1863.

Burnisher. An instrument of hard stone (figure 4) has been used from remote antiquity for polishing the leaf or foil of gold or other metals. To be burnished, the leaf has to be laid by what is now called 'water gilding' over a layer of amorphous earth or bole mixed with size. The usual stone for modern burnishers is agate, and it is produced by manufacturers in a number of shapes suitable for fine

FIGURE 3. Brush cleaners or washers as sold for the modern practice of oil painting: (*a*) a circular base carrying a beaker of oil or turpentine above which is a metal clip for holding brush handles; (*b*) a rectangular container for the turpentine or oil, open at the top, into which fits a frame (*b'*), which is open at both top and bottom and contains a wire grating. When the grating is submerged, the brush is dragged across it in the fluid.

illuminations and for heavier, broader work. Haematite, a stone recommended for burnishers by Cennino Cennini (C. CXXXV, Thompson, p. 82), is still somewhat used in branches of the gilding trade. Various other stones were common in the Middle Ages and Renaissance, including sapphires, emeralds, and rubies. Fine burnishers were frequently made from the teeth of animals, and a pointed, hook-shaped burnisher of agate is still referred to as a dog tooth. A detail of a wall painting from the Egyptian tomb of Nebamen and Ipuky (Thebes, no. 181) shows one of the artisans in the scene using a burnisher while another is stamping designs in the gold. The date of this is *c* 1380 B.C. A MS. of the XIII century A.D., *De Coloribus et Artibus Romanorum* (Merrifield, I, 220), describes making burnishers from haematite, a method which includes smoothing on a grindstone, tile, and whetstone, followed by polishing on a plate of lead, on the hairy side of a cowskin, and afterwards on poplar wood. The teeth of animals are said to have been polished in the same way.

Burnishing Slab, a flat piece of hard material put under parchment when gold leaf used in illuminations is being burnished. Johnston (p. 153), in his discussion of modern methods of writing and illuminating, suggests a flat piece of vulcanite, celluloid, or metal for this purpose.

Cabinet. The painter's cabinet as made today is a chest of drawers, ordinarily low and not more than two feet square, with the top free for palette, oil cups, or other accessories. This article of furniture is largely for oil painting, tubes of color being kept in the drawers. Water color cabinets and others made for drafting have, however, been advertised since early in the XIX century. A small cabinet for illumination and missal painting is mentioned in the catalogue of Winsor and Newton for 1863 and another for heraldic blazoning in their catalogue of 1864. A desk-like object of walnut, very small in size, is seen in the Victoria and Albert

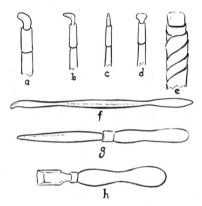

FIGURE 4. Burnishers. The upper row has a number of shapes for use on gold leaf. These are adapted from drawings in Thompson, *The Practice of Tempera Painting*, p. 67. Usually such burnishers are of agate. One (*e*) is represented as made of haematite, and *a* is made of flint; *f* is a copper plate burnisher of steel; *g* and *h* are also steel and are used for the burnishing of copper plates in the engraving process.

Museum, London, where it is described as a miniature painter's cabinet and is believed to have been used by Richard Crosse, an English painter of 1742 to 1810. Berger (I and II, p. 186) quotes a remark of Varro which seems to indicate that painters of classical antiquity kept boxes or large cases in which the various colors were arranged in compartments (see figure 15, *a* and *b*). Those representations which remain, however, of painters' workrooms during the Middle Ages and the Renaissance have no furniture which resembles the painter's cabinet as that is known today. By the XVII century a few signs of it begin to appear, as in 'A Painter's Studio' by Gonzales Coques (Flemish, d. 1684), in Schwerin. Here a large box, like a small trunk or chest, is shown open in the middle of the floor. The upper part is divided into compartments. One of these holds brushes, another a large flask, and another smaller, bottle-necked containers. Below these compartments, the contents of some of which are not visible, is a set of drawers.

Cabinet Saucer (see **Saucer**).

Camel Hair, a term inaccurately applied to a fine-haired brush, usually a small, pointed one but also a large wash brush. This hair is from a squirrel native to Russia and Siberia (see **Brush**).

Camera Lucida. A prism is used in this instrument to deflect the rays of light from an object and to throw the image of this object onto a paper where it can be traced. Meder (p. 214) mentions it as a modern instrument. It is illustrated in the catalogue of C. Roberson for about 1848. Perhaps its chief contemporary use is as an accessory to microscopes. With it drawings can be made from the magnified field.

Camera Obscura. This differs from the camera lucida in being a more direct and simple though more awkward apparatus. One type was, in effect, a large box in which the artist sat and executed drawings (figure 5). In another, the image or view was conveyed through a small hole in which a double convex lens was placed so that it threw this image on translucent paper or on ground glass. Here, of course, the image is seen inverted. According to Meder (p. 550), the camera obscura was invented by Erasmus Reinhold of Wittenberg in 1540. Certain improvements were made by Porta in 1558, and it was made into a transportable unit by Hook in 1679. Probably it was little used after the camera lucida had been perfected.

Canvas Pliers. For stretching canvas over the stretching frame, painters frequently use pliers or pincers made with a wide nose, corrugated in order to hold well on the edge of the fabric (figure 6, *b*). This tool is common in studios but seems to have had only a rather recent use. It is mentioned in catalogues of 1889 and times since then. It is not noticed earlier or referred to in earlier literature on painting practice.

Cast. Models in the form of plaster casts have been for many centuries a regular part of the studio furnishings of painters and of painting academies. At what point the cast came in to supplant the antique statue or fragment is not clear, for most of the evidence about the use of such material is found in paintings and drawings where a distinction between the two can not be made. The earliest of these to be noticed are paintings of the XVI century, among them a 'Portrait of an Artist,' attributed to Lorenzo Lotto and in a private collection in London. In this a number of fragmentary figures, probably stone sculptures, are seen with other working materials. By the XVII century casts are commonly represented in studios and frequently students are shown drawing from them. Works by Ryckaert, Eglon van der Neer, and Gottfried Schalcken contain this type of subject as does, later, the work of Chardin.

Cauterium. Whether or not encaustic painting as practiced by the ancients was a method which involved the use of melted wax and heated instruments, some of the tools found in the equipment of ancient painters and mentioned in the literature were of a type which might well have been used in this way. One of

these was the *cauterium*, a kind of spatula of metal, with a rounded end. It may have resembled those in figure 23, *c* and *d*. Many of the Fayûm portraits show in their conformation the marks of a blade of this sort and have somewhat the look of modern oil paint that is spread with a palette knife.

Cestrum. Like the *cauterium*, this was a metal spatula used for painting in ancient times. It was, however, different in shape, being pointed and more like a stylus. Eastlake (I, 154) gives as synonyms for it, *viriculum* and *rhabdion*. Pliny (XXXV, 149) mentions the *cestrum* and, from the context, it appears that this must have been an instrument that was usually heated.

FIGURE 5. Two types of camera obscura—drawings adapted from illustrations in Meder. At the left (p. 550, fig. 256) is a cross section of an early construction in which the image falling through the lens is reflected by the mirror (*a*) onto a drawing glass or tracing surface (*b*). At the right is a French camera obscura of the second half of the XVIII century (p. 551, fig. 257). This is a large box in which the draughtsman sits, closing the door behind him. The image enters at the side opposite that shown here, through a lens in the small box at the top. From there it is deflected by the glass (*a*) onto the drawing surface (*b*). At *c* is the seat for the draughtsman. Heavy metal straps at the side of the box are to hold poles by which it is carried.

Chalk. The regular black chalk used for drawing is a natural deposit, a slaty, soft, earthy material, very rich in carbon. In Europe it is found mainly in Thuringia, parts of France, and Andalusia (Meder, p. 109). Other colors, chiefly a range of earth reds, are common in practice and are available in the stocks of artists' colormen. The white chalk used for drawing—to be distinguished from the white chalk that is an inert used for grounds—probably has included a number of different materials such as sticks of gypsum or steatite (soapstone). As now prepared for the market, the various colors of drawing chalk are put up in small sticks or as

pencils. Their use goes back to the earliest antiquity of the art, and they were very common during the Renaissance. Cennino Cennini (C. XXXIIII, Thompson, p. 20) speaks of a certain black stone from Piedmont soft enough to be sharpened with a penknife, very black, and good for drawing. Meder (p. 122) says that Leonardo da Vinci was the first to use chalk throughout for a complete and finished drawing.

FIGURE 6. Equipment for use with painters' canvas. At *a* is shown a corner section of the common stretching frame. These pieces, made so that they can fit together to a mortised and mitred corner, form a complete frame by a combination of four and are sold as single pieces of various lengths by artists' colormen. They are usually of pine and are about 1 × 3 inches in section. At *b* is a type of pincer or plier used for stretching canvas over such a frame. The fabric is gripped between the two broad jaws and the spur beneath serves as a fulcrum, acting against the edge of the stretcher frame.

Channel Edge Support. This name is given arbitrarily to a wooden channel occasionally seen attached to the end grain edges of thin panels in paintings of the studios particularly of Dutch artists of the XVII century. One is found in a work attributed to Rembrandt, 'The Painter in his Studio,' formerly in a private collection in England (*Burlington Magazine*, CCCLXXII [1925], p. 264). This channel was undoubtedly fitted without nails or screws over the end grain in order to hold the panel itself flat while the painter was working on it and before it could be supported in the frame. Painters of this period who chose to work on wood often had panels that were thin, less than ¼ inch or 6 mm., and these were in danger of warping or even of splitting while still in the studio.

Charcoal. Like chalk, this universal drawing material has probably been used from primitive times. (See figure 7, *d*.) The kind usually favored is made from the willow twig, and the description of its manufacture by the painter himself is adequately given by the early XV century writer, Cennino Cennini (C. XXXIII, Thompson, p. 19). According to this, a dry willow stick is cut into slips as long as the palm of the hand and then split or divided like match sticks and these done up in bundles. The bundles are put into a baking dish and left in a baker's oven overnight. The coals should then be quite black and, if they are too much roasted, will break easily in the hand. Far Eastern painters are reported to have used charcoal for preliminary outlines, particularly in ink painting on paper (Bowie, p. 32).

Claude Lorraine Glass. For reflecting a landscape in miniature, a black convex glass was said to have been developed and used by the painter whose name it

carries. Since it was not a silvered mirror, much of the detail of a landscape was merged together by the relatively weak reflection, and convexity brought a large scene down to a very small area. Sketches and drawings were done from the reflections in the glass. It was much used in the XVII and XVIII centuries and is still occasionally seen in the studios of painters and etchers. Mrs Merrifield (cxxv) reports that an eminent Italian painter of the XIX century spoke of

FIGURE 7. Tools for use with charcoal and crayon: (*a*) a crayon holder of modern type, so made that the jaws at either end are tightened by a sliding ring and grip the crayon between them; (*b*) a similar holder as shown in a drawing by Bouchardon (Meder, p. 118, fig. 45); (*c*) a lead pencil, apparently a holder for a metallic stylus, described by Konrad Gesner in 1565 (Meder, p. 140, fig. 50); (*d*) willow twigs set in a lump of clay for burning into charcoal by the method described in the Mt Athos MS. (Meder, p. 102, fig. 42).

having a black mirror once owned by Bamboccio in which the subject was reflected exactly like a Flemish landscape. It was said to have gone from Bamboccio to Gaspar Poussin and on to others.

Cloths. The common paint cloth or paint rag of the modern studio has probably come in largely with the development of broad-scale oil painting. Frequently they are called palette cloths, and J. S. Templeton in *The Guide to Oil Painting* (London, 1845) speaks of using old linen in order to avoid lint. De Mayerne, writing in the XVII century (MS., p. 90; Berger, IV, 261), speaks of holding paint cloths with the little finger of the left hand and of using them to squeeze out and clean the paint brushes. A cloth for ordinary cleaning purposes must have been used from very early times. Pliny, however (XXXV, 103), tells how Protogenes got the effect of foam on a dog's mouth by throwing his paint-soaked sponge at the picture.

Compass, the usual drawing instrument for circles (figure 9). This probably became a painter's tool during antiquity. It is made of two straight legs, usually pointed at the tip and hinged at the other end. Meder (p. 187) says that it was

certainly known in Pompeian times. Cennini (C. CXL, Thompson, p. 85) speaks of using compasses for incising the outlines of haloes in the burnished gold of panels. Modern usage often refers to this instrument in the plural as a pair of compasses.

Copper Point. Though less common than that of silver, the point or stylus of copper as a drawing instrument to be used on a prepared surface has had occasional mention in the history of the art. It is said to have a tendency to turn slightly yellowish as it corrodes on standing. This might depend on the kind of atmosphere to which it was exposed. A codex in Montpellier (see Meder, p. 74) mentions the use of a copper point.

Crayon, a small stick for drawing, composed usually of pigment in an oil or wax. It is smooth and is ordinarily used on paper. Certain crayons of modern manufacture contain water-soluble dyes and are prepared in an aqueous medium. Drawings made with these are afterwards washed over with a brush and water to extend the tones made by the crayon marks. The use of crayons in Europe evidently began in Italy in the middle of the XVI century (Meder, p. 108). Marks of such a drawing instrument are found in the work of Tintoretto, the Bassani, and others. They appear in German drawings of the XVI century and are common in Europe by the XVII century. One type of crayon was made in the XVII century by dipping and cooking charcoal in linseed oil.

Crayon Holder. Made as a removable handle for short pieces of charcoal, chalk, or crayon, this is usually a tube split at both ends and fitted with sliding rings (figure 7). Into the split part the round chalk or crayon can be placed and held tightly by the rings slid over the split metal. The common crayon holder is of brass and is from 4 to 6 inches long, with or without a wooden center. It is advertised by most dealers in artists' materials but probably had a greater use in times when the pencil as known today had not yet been devised. Paintings of the XVI century frequently show it in the hands of artists and draughtsmen, and by the XVIII century it is found with fair regularity in studio interiors. According to Meder (p. 185), an earlier form of the holder was a split reed, and the metal tube was introduced only in the XVI century. Catalogues of artists' materials in the XIX century list it normally under the name of 'portcrayon.'

Cushion. In the process of applying gold leaf, this extremely thin material has to be laid out where it can be flattened and frequently be cut. Squares of the gold are usually dropped from the books, in which modern leaf is put up for the market, onto a gilder's cushion (figure 12, *a*). The typical cushion is made over a rectangular panel of wood, five or six inches wide and eight to ten inches long. A thin padding is placed over this. Stretched across the pad and pulled tightly over the edge of the wood a piece of soft calfskin is tacked rough side up. Around three sides of this cushion a shield four or five inches high is fastened, made ordinarily of parchment or of heavy paper. This is to prevent draughts of air from disturbing the gold leaf. The calfskin needs to contain as little oil as possible, and it is frequently powdered over with haematite or red ochre to prevent the leaf from sticking. Some form of

cushion must have been in use since ancient times when the application of gold in leaf form began. The one described by Cennino Cennini in the early XV century (C. CXXXIIII, Thompson, p. 81) is like that in common use today, the padding in his case being made with 'shearings.'

Dabber, a large, round brush, regularly of camel hair (see **Brush** and figure 1).

Desk. This piece of furniture as a particular equipment of the artist is largely confined to the use of scribes, illuminators, illustrators, miniature painters, and draughtsmen. The varieties of its forms are innumerable and, according to the evidence of old paintings and illuminations, follow the changing styles of furniture in general. Johnston (pp. 49–51) describes in some amount of detail a simple desk to be made for illuminating and lettering from a drawing board hinged to the edge of a table and elevated to the height required by a round tin set under it. On this board (figure 8) the paper is held by tape or string at the top, and by a kind of pocket made from heavy paper or vellum fastened across the lower part. Under this is a light pad of blotting paper. He says that Eastern scribes use a pad made of fur.

Dipper, a small cup for medium or diluent, made to be clipped onto the edge of a palette. This is of metal, usually with an opening smaller than the body of the cup, and frequently is equipped with hinged lids. In Renaissance paintings in which an artist is represented at work, the container for such liquids is usually shown as a kind of cup hung over the peg of an easel or in a similar position. The dipper, or small container, attached to the palette, is probably of fairly recent origin. A pair of them is seen in a work of the school of the XVIII century in the Bonnat collection at Bayonne. This is a drawing, said to be a portrait of Boucher. The artist is shown with a large, oval palette on which is clipped a double oil cup or dipper of the kind now commonly sold.

Divider, an instrument like a pair of compasses (figure 9) used for comparing and laying off dimensions (see **Compass**). The proportional divider has a movable axis point and is scaled so that the opposite ends can be kept at a certain ratio.

Draughting Instruments. These are used more by architectural and engineering designers than by painters, but sets of such instruments are frequently listed with the supplies of artists' colormen. They usually include pencil and pen compasses, ruling pens, and dividers.

Easel. A light frame made to hold a painting in a vertical or nearly vertical position is probably the most universal article of furniture in the workrooms of painters and certainly is one of the oldest (figure 10). The simplest design is an arrangement of three legs so that two stand forward in a parallel position and have pegs or other rests where the painting can be held up. The third leg swings back, and its position determines the angle at which the painting stands. Although subject to many variations in details of its construction, such a three-legged easel with pegs for the picture is a standard type and is somewhat different from another that is now prevalent. This other has usually been called a 'studio easel.'

It is heavier and more complicated (figure 11). The base is broad and rides on four casters or small wheels, one of which is usually adjustable in height. From the base rise posts firmly fixed, into which a sliding frame is slotted. This frame carries the painting in a shelf that has a wooden rail at its front. The top of the painting is held by another sliding member which comes down over its edge and is fastened with a set screw. The narrow shelf or rail is usually moved up and down by means of a worm gear operated by a crank. Another adjustment permits the painting to be tilted forward, also by means of the crank. Modifications of this as of the simple three-legged type are innumerable, and some easels have been made which combine the aspects of the two.

FIGURE 8. The desk of a scribe, according to Johnston (p. 50), is a drawing board to which a piece of stout paper or vellum is fastened with thumb tacks. Under this is a writing pad usually made of blotting paper. The tape or string around the top of the board holds the writing paper in place.

There seems to be no historical limit to the simpler easel. It is manufactured and sold now and probably has been the property of the painter since separate and portable pictures were first made. It is found in studios as these are shown in the works of the Renaissance and until quite recent times. Often, in the easels represented, a rest board is laid across the pegs, and these pegs vary in shape and in ornamentation. The swinging leg is hinged in different ways and the top is finished in a variety of shapes. Far more complicated means for holding pictures are, however, occasionally illustrated during the Renaissance and later times. One striking example is also the earliest instance known of the representation of an easel. This is in a relief on the wall of the mastaba of Mereruka (see Prentice Duell). It is an upright pair of posts which Duell considers to have been fixed in a base to permit the entire frame to be moved. The painting was supported on notched members which swung forward at right angles to the post or swung back out of the way if other such members at a different height were needed. Pliny (XXXV, 81) says that when Apelles went to call on Protogenes, he found a solitary old woman keeping watch over a large panel that was placed on an easel.

The studio easel, as described above and as shown by artists' colormen of the present, was devised and largely developed during the XIX century. The earliest, said to have been of French manufacture, had worm gears made of wood.

Eraser. Probably the common means of removing marks of charcoal, chalk, or graphite from paper or parchment has been, until a century ago, with crumbs or pellets of soft bread. Feathers as brushes are mentioned in connection with charcoal; soft leather like chamois skin has been used extensively in the past; and Cennino Cennini (C. XII, Thompson, p. 8) speaks of making erasures in silver-point drawing, also with bread-crumbs. In the MSS of Jehan le Begue (Merrifield, I, 63) an alum paste is suggested to be used for erasures in drawing. Abrasives such as pumice and cuttlefish bones, as well as metal scrapers, served this same purpose. Rubber seems to have become an eraser for drawings in the latter part of the XVIII century (Meder, pp. 190–191). It was then very expensive and evidently so hard that it was apt to scratch the paper. A manual on miniature painting, written by Constant-Viguier and published in 1839, warns against this. Indian rubber in different shapes and sizes is listed in the catalogue of C. Roberson and Company in about 1840. It was then sold by the pound. Methods of plasticizing crude rubber and of introducing various grades of abrasives have given to erasers now available on the market a very wide range of cleansing properties from soft, pliable materials to others which act almost like sand-paper.

Fan Brush, a soft brush of fan shape, very flat, and set in a metal ferrule. It is made in either sable or bristle and is used for special finishing, as of foliage or hair, in oil painting (see **Brush** and figure 1, *i*).

Finder, a device usually made by the painter himself for locating the area of his composition in a natural landscape. It is merely an aperture of the size and shape required, cut out of a thin cardboard or similar material. Occasionally cross lines of thread or wire run through the center. (See also **Sight Measure.**)

Folio (see **Portfolio**).

Gallipot, a small cylindrical vessel made of porcelain and used for holding diluent or medium. The name has now gone out of use in catalogues of artists' colormen, but appears in those of Winsor and Newton for 1868 and 1870.

Gilder's Knife, a steel-bladed knife, fairly heavy, only a little flexible, and about eight inches long (figure 12, *b*). This is used for cutting gold leaf into pieces smaller than those in which it is regularly sold. Cutting is done on the cushion after the leaf has been thoroughly flattened.

Glass Frame or **Tracing Apparatus.** One method of drawing much in use during the Renaissance was in effect a tracing of the person or object represented, on a frame which was placed between the draughtsman and his subject. The frame contained a sheet of glass and evidently some kind of soft crayon was used on it. Dürer illustrated this method with woodcuts and in one of these a fixed position for the draughtsman's eye is shown (figure 27). Squaring the area of the glass with lines is indicated by him in other representations. Meder (p. 467) says that Holbein, Clouet, and Ottavio Leoni used an apparatus of this sort. It appears that paper could be placed over the tracing which was on the glass, and the drawing could be worked up from that.

Gold Point (see also **Silver Point**). To what extent a wire or point of gold has been used in the practice of drawing is a matter of some doubt. Enough has been said about it, however, to indicate that it may have had at least occasional employment along with the very common silver point as an instrument to be used over a slightly abrasive ground. Meder (p. 81) mentions it, and a modern writer on drawing (Harold Speed, *The Practice and Science of Drawing* [Philadelphia: J. B. Lippincott Co., 1925], p. 275) says that gold point gives a warmer line than silver, but can be used in much the same way on paper that has been treated with Chinese white (zinc oxide).

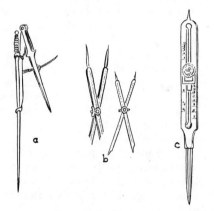

FIGURE 9. Compasses and dividers: (*a*) a type of compass with a lead stylus as shown by Dürer (from Meder, p. 77, fig. 29); (*b*) two sketches of proportional dividers as shown in the MSS of Leonardo da Vinci (from Meder, p. 188, fig. 68); (*c*) a proportional divider, closed, of modern manufacture. This opens to an x-shape on the screw near the center and can be set for the proportional relations desired.

Graphite Pencil. This, usually called a 'lead' pencil, is the common implement for casual writing and for a great deal of drawing in modern times. It is made almost entirely of pure graphite held together by firing at high temperatures, with some addition of clay. Such pencils are now commonly sold as wooden sticks with the so-called 'lead' in the center, or the leads are put in a permanent holder where they can be moved in position as they wear down.

Lead itself was certainly used in the same way as other metals (see **Silver Point** in particular), and the confusion of names makes it difficult to know at what time graphite came in to take its place. R. Borghini, writing in 1586 (*Il Riposo in cui della Pittura e della Scultura si Favella*, Florence, p. 139), describes the use of a *piombino* which may be graphite instead of lead. Meder (pp. 140–141) quotes Johann Mathesius (1564) with regard to a new writing instrument of

mineral origin and for use on paper. This, as judged by the context, might be graphite. It was not until the XVIII century, however, that anything like the graphite pencil as that is now known had come into regular use as a drawing instrument.

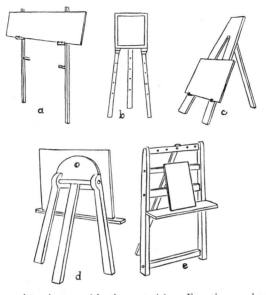

Figure 10. Painters' easels as used in the past: (*a*) an Egyptian easel represented in a tomb relief of the Old Kingdom (from a reconstruction by Prentice Duell (VIII, 181, fig. 4); (*b*) an easel in a Roman tomb relief (from Berger, I and II, 175, fig. 33); (*c*) an easel in a Pompeian wall painting of a pygmy's studio (from Berger, I and II, 174, fig. 31); (*d*) an easel of the XVII century, shown in a painting by Rembrandt, 'The Painter's Studio,' in the Art Gallery, Glasgow; (*e*) an easel in a French miniature painting of the XV century (from Berger, III, 231, fig. 16).

Grinding Slab, a flat piece, usually of glass or stone, on which color is ground from a coarse to a finely divided state, frequently with the medium that is to bind it as paint (figure 13). Materials for this purpose available on the market today are usually of glass and are small in size. They are used little, except by tempera painters or by illuminators who are working with colors not previously prepared. Many catalogues of artists' materials do not even list these small slabs amongst their supplies. Machine grinding and preparation of artists' paint, a development which has taken place largely since 1825, have slowly removed from the studio the grinding equipment which was invariable in its furnishing before that.

Probably many different hard stones were adopted by painters for this purpose, but porphyry seems to have been a favorite since the Middle Ages. Thompson (*The Practice of Tempera Painting*, pp. 88–89) says that porphyry or granite are still the best materials for slabs and mullers but that glass is a simple substitute. This or marble has to be resurfaced when it gets smooth and that can be done with moderately fine emery powder, wetted, and ground between muller and slab. Sir Aurel Stein (*Serindia*, I, 772) reports the discovery at Tun Huang in Chinese Turkestan of a wooden block which he thought had been used as a grinding slab. It was D-shaped in section, and one end and the adjacent side still had wrappings of linen. On it was thick, black paint. A second similar block was found in the same site. No mention has appeared in the technical literature of the color-grinding methods used by ancient Egyptians, but it can be assumed that the hard mineral pigments, particularly the well known Egyptian blue, must have been ground on a slab or in a mortar. One indication of such a utensil is seen in the British Museum. It is a piece of dark stone about seven inches across, rather flat on the bottom, rounded at the edges, circular in plan, and less than half as thick as its diameter. The top has a shallow, saucer-shaped depression. This seems to be Egyptian and is something between a mortar and a grinding slab. Little is known about other ancient practices of preparing paints, but an anecdote by Pliny (XXXV, 85) suggests that in the studio of Apelles there were boys who ground the colors. By the early Middle Ages in Europe, the fairly standard equipment of the painter's work-room appears to have been a heavy slab mounted on a heavy block. The MS. of Theophilus speaks of it, as does that of Eraclius (see Laurie, *The Painter's Methods and Materials*, pp. 25 and 27). Cennino Cennini mentions porphyry (C. XLII, Thompson, p. 25) and so does the author of the much later Brussels MS. in 1635 (Merrifield, II, 770). By the XVII century there are many representations of the grinding tables or blocks, usually with circular or polygonal, heavy slabs.

The hand-grinding of colors undoubtedly continued long after fairly large-scale commercial manufacture was developed, and some amount of it is still done by artists' colormen or by painters themselves. In the early XIX century, a form of hand-operated color mill was developed, and shortly after that a larger mill with stones propelled by hand, horse, or steam power. The common modern mill is operated by a motor and is of rotating cylinders. Water colors, as first manufactured for sale, were usually in small, hard cakes which, like the Far Eastern ink stick, had to be ground with water on a small slab in order to bring the color out into the fluid. Such grinding material and equipment were sold commonly after the middle of the century and, although little mentioned or advertised, can still be bought.

Hog Hair, the name formerly applied to the heavier artists' brush, now usually referred to as bristle (see **Brush**).

Holder (see **Crayon Holder**).

Inkpot. Primarily the property of scribes, the inkpot, ink-horn, or inkstand, simply a vessel for holding fluid ink, was doubtless also a regular part of the furnishings of the painter's studio, even in those times when writing was com-

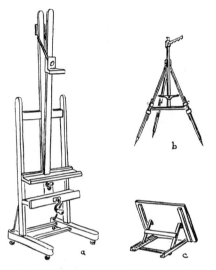

FIGURE 11. Modern easels: (*a*) the studio type with screw adjustment of height and of tilt; (*b*) a folding easel for sketching; (*c*) a tilt board or table easel.

paratively rare. As illustrated in Renaissance painting, the inkpot is apt to be either a kind of well like the modern ink-well or a simple, cylindrical vial with a flange at the top. The latter is perhaps slightly more common. It frequently appears on the desk of St Luke, set into a board at the edge (figure 14, *a*), the flange or lip of the vial catching on the wood, and the main part going through a hole. As a rule, a number of vials, probably for different colored inks, are seen together. Classical scribes, it appears, were in the habit of using inkstands or inkpots, and many of these in bronze and terra-cotta and in various shapes are still preserved. At the Niya site in Chinese Turkestan were found oval, trough-shaped pieces of horn which Stein thought to be probably inkstands (*Serindia*, I, 225 and 256).

Kolinsky, the name usually given to the hair from which the fine sable brushes are made. Furriers apply the name to the red sable or tartar sable or any of several Asiatic minks. The tail is used for brush making and that of the *Putorius sibiricus* is said to be the most favored for this purpose.

Lay Figure, a mechanical figure of human shape, usually of natural size and covered with a knitted fabric. The armature is jointed, even to the fingers, and can be put into postures like those taken in life. Such a complex mechanism has been used for the arrangement of draperies for study purposes and has had a wide utility in professional portrait painting because it permitted the artist to work on costume without a sitting. The lay figure probably superseded models and manikins, and it is doubtful if its use was at all general before the XVIII century. It is listed in the catalogues of artists' colormen in the early XIX century and is still occasionally seen.

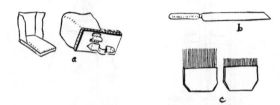

Figure 12. Parts of a gilder's equipment (after Thompson, *The Practice of Tempera Painting*, pp. 56 and 57): (*a*) the cushion of leather with a shield of parchment or paper and straps underneath for holding; (*b*) a knife for cutting the leaf on the cushion; (*c*) tips of fine hair in different lengths used for picking up the leaf. (These are out of scale, the size of the cushion being represented as too small for the others.)

Lead Point. Lead is among the various soft metals which, drawn over an abrasive ground, produce a distinguishable and clean mark (figure 7, *c*). Its place in the recorded history of drawing is vague because of the natural confusion of this metal with silver and its later confusion with the graphite pencil which, almost from the beginning, was called a 'lead' pencil.

Mahlstick or Maulstick, a light stick or rod of wood, with a soft leather-covered ball at one end; it is to rest and support the painting hand. The ball rests against a part of the easel, or at times against a part of the painting. The opposite end is held by the hand which holds the palette, and the working hand is rested on the stick itself. The sticks made commercially are usually of hard wood or bamboo, jointed with brass ferrules to give them a length of four feet. Early catalogues of artists' supplies speak of this as a rest stick, and it still carries that name. It was probably not much used before the time of oil paintings on a large scale and does not appear to be mentioned or referred to in the Mediaeval and Renaissance treatises on painting. A few instances of it appear in representations of artists made during the XVI century and it has a regular place in the hands of the painters as they are shown in works of the XVII century and later.

Manikin, a jointed figure of human shape but with only a general resemblance to the human form, used by painters as models, particularly for arrangement of costume and drapery. The manikin, as manufactured and sold today, is different from the lay figure in having a much more mechanical appearance, being of wood and openly jointed. There is no distinction of sex and no description of muscles or of any superficial refinements of form. The modern commercially made manikin for painters is of wood and varies in size from a height of about a foot to more than five feet.

Although collections of ancient art show many jointed figures, particularly those of small scale, there is no definite indication that these were ever used as manikins. Meder (pp. 551 ff.) speaks of the use of manikins and refers to a wooden female figure, carefully carved and so jointed that it was obviously used as a manikin, made in the XVI century and now at Innsbruck. Another is shown in a drawing by Adrian van Ostade. Michael Sweerts, active in the second quarter of the XVII century, made many paintings of studio interiors. One in the Cook collection (Richmond, England) shows a student making a copy. Around him is an assembly of paraphernalia, including what seems to be a life-size manikin.

Metal Point. The stylus of metal (figure 25) was a common tool for drawing and for writing in ancient times, and the discovery that a metal point drawn over an abrasive surface left a fine line, must have been made centuries before any historical evidence appears for its general use. Drawing with a point of silver or of lead, copper, or gold depends upon a surface which has been constructed in such a way that it will abrade away and hold a small deposit of such a metal when that is moved over it. A great variety of means has been found for producing surfaces of this kind on wooden panels to be used for practice by apprentices, or on parchment or paper for the work of their masters. Chalk and calcined bone bound with a weak size and coated over such a surface were among the many in common use. Some of the metals, particularly silver and copper, leave a mark that grows darker with time as the abraded grains of the metal corrode. It is probable that the overwhelming reference to silver point in descriptive literature gives it slightly too great a prominence. Frequently there is no distinction among metals and drawing with any one of them is referred to as silver point.

Miniver, a hair formerly used in brush making. The word has been connected with the ermine, but apparently referred also to other plain white furs used in trimmings of ceremonial costumes. Cennino Cennini (C. LXIIII, Thompson, p. 20) says, 'In our profession we have to use two kinds of brushes: minever brushes, and hog's-bristle brushes.'

Mirror. Commonly employed by etchers in order to have a reflected image of the model or landscape and so to avoid transposition in the final print from the plate, the mirror is also used extensively by painters. It has the value of giving a kind of distance and isolation to the work when a painting in progress is studied

in this mirror image. Probably such reflecting surfaces have been useful to painters since they were first invented. Leonardo da Vinci (*Treatise on Painting*, Rigaud translation, C. 350, p. 150) says that a mirror is useful in reflecting the object that is being painted in a position for comparison with the painting itself. Both then have a flat appearance, 'an even superficies.'

Figure 13. Grinding implements: (*a*) mortar and pestles of alabaster from a late classical find (Berger, I and II, 215, fig. 47); (*b*) a table with slab and probably a jug of oil, in a French miniature of the XV century (from Berger, III, 231, fig. 16); (*c*) stone slab and muller set on a wooden block as shown in a painting by G. Dow, 'An Old Painter' (private collection, London).

Model. Objects used by draughtsmen and painters to serve as models from which to work are, of course, innumerable, and any object in a room or studio could become such a model. Certain kinds of objects, however, have been taken up so regularly and so exclusively for this purpose that it is possible to consider them as furniture of the painter. (Among these are inanimate figures; see **Cast, Anatomical Figure, Lay Figure,** and **Manikin.**) Renaissance literature on painting indicates that before that time hills, mountains, grottoes, and similar features in the landscape were drawn from rocks which could be studied at close range or set on a worktable. It appears, also, that foliage may have been described by repeating small areas drawn from branches brought indoors. From the Renaissance on, direct representation of small objects has continued, and painters' studios are represented as containing a variety of fabrics, costumes, armor, and similar things clearly to be used as models. A more affected type of small model, made and sold as such, seems to be a device of the XIX century. By 1870 the catalogue of Winsor and Newton advertises J. D. Harding's 'Drawing Models.' These were architectural blocks made up in cubic shapes, for, as the catalogue puts it, the cube was the unit and basis of all solid and rectangular figures, including

architectural construction. Somewhat earlier than that, the catalogue of Rowney and Company had listed and itemized what were known as Rustic Models. Among these were a Dutch windmill, gates, pumps, stiles, railings, wells, cottages, water-wheels, boat-houses, and castles, 'carefully studied from Nature, for the use of sketching classes.'

Mop, a large, round brush, usually of camel hair (see figure 1, *g*).

Mortar, a grinding vessel of cup shape, often made of hard stone (see **Grinding Slab** and figure 13, *a*).

Muller, the moving part of the usual device for grinding color, of which the grinding slab itself is the fixed and lower part (figure 13). Generally the muller is a stone rounded at the top and at the bottom completely flattened so that it has full contact with the grinding slab. The top is curved to fit the hand. Probably, in most cases the material of the muller was the same as that of the stone because any difference in hardness would have resulted in undue wear on the softer; but the Brussels MS. of 1635 (Merrifield, II, 770) mentions a muller of flint or whetstone to be used on a porphyry slab. As hand-grinding of colors has gone out of practice, the large slab and heavy stone muller are now very rarely seen. Occasional grinding of small quantities of pigment is usually done on a ground glass slab with a glass muller.

Needle, the name usually given to the fine-pointed steel instrument used in etching and in dry-point on copper plates.

Oil Cup (see **Dipper**).

Painting Knife (see **Palette Knife**).

Palette. This word, perhaps as much used as the name of any utensil connected with the art of painting, has a figurative as well as literal meaning. By the former, it denotes arrangements of color, mixtures and assortments of pigment, or the scheme of tone relations in a given work or in the work of a painter or school. Literally, in its present use, it has to do with the surface on which a painter lays out and mixes his colors before applying them to the painting itself. As a rule, the palette is an object that can be carried in the hand, but many painters prefer to use the top of a painting cabinet or table which can be brought into a position conveniently near to the easel. Such a mixing surface is said to have been preferred by Whistler and by other painters of recent times. It is seen also in an ancient studio, that of a pygmy in a Pompeian wall painting (Berger, I and II, 174, fig. 31). For the most part, however, the palette is a thin slab of material made in such a way that it can be held securely in one hand and provide a fair amount of area in which plastic paint can be placed in lumps or mixed together with medium or diluent.

The standard material for palettes during many centuries has been hardwood, cherry and walnut having been particular favorites. Other materials, however, are not uncommon—porcelain or enamelled ware, often with cups or slants in them for water color glass, and aluminum for decorating or for wax painting. At

present, three shapes of palette are usual (figure 17): the oval, the oblong or rectangular, and the studio or arm palette. The two former are from nine to sixteen inches long and from six to twelve inches wide. The oval palette has a thumb hole set not far from the center, and the edge is cut out in an irregular curve so that the fingers can grasp the edge of the palette. The oblong palette has three right angles, and the thumb hole is set fairly near the fourth corner which is cut out in a curve suitably shaped for a grip. The studio or arm palette is larger than the other two types, and varies from about twenty to nearly thirty inches in length and from about fourteen to about eighteen in width. The thumb hole is

FIGURE 14. Containers for ink: (*a*) ink or color pots set in holes of a board at the edge of a scribe's desk, as shown in a painting of the German school, 'St Luke,' Castle Rohoncz, Hungary; (*b*) an inkwell and stopper in a 'Portrait of a Young Painter,' by H. Burgkmair, late XV century, from a private collection in Berlin; (*c*) a pen case and ink bottle to be carried on a scribe's belt (from Meder, p. 62, fig. 26).

set well back from the edge, and that edge which is held towards the painter is cut out to fit around the elbow. This palette in particular is of a varying thickness from one half to three quarters inch at the thumb hole side to about an eighth inch at the opposite. This provides greater strength where the strain is greater and gives a certain weight to the end which is shorter, allowing a balance to the whole. Although these are the standard shapes commercially produced, there are doubtless variations according to the taste and invention of painters for whom the standard product is not quite suitable.

In the past such variations of shape are too numerous for a specific record. They are indicated by the paintings of studio interiors and by a few actual palettes that have survived. The time at which a slab of wood for disposing and mixing colors may first have been used is impossible of statement. There has probably been some confusion between slabs used for mixing and those used for the grinding of colors. It has been suggested, for instance, that the Egyptians had a palette as early as predynastic times, but it appears that this was a piece of slate on which face paint was ground. Berger (I and II, 27) saw a wooden palette in an Egyptian painting which represents a painter at work. He does not, however, consider this

to have been at all usual, for other representations seem to indicate that Egyptian painting was done with fluid paint carried in small pots. The same author draws attention to a reference in the Mt Athos MS., a painter's handbook supposed to reflect practices of the XI century and later, in which is mentioned a palette with a hole for the thumb of the left hand. By the XV century (figure 16), paintings of St Luke had begun to show him holding what is evidently a wooden palette. The shapes of the palettes in these paintings are widely varied, usually oblong however, and with thumb holes differently placed. The corners are apt to be cut in complex curves. In an engraving from a self-portrait by Jacopo Bassano, there

FIGURE 15. Paint boxes: (*a*) a box, evidently containing paints in small jars, shown in a representation of a woman painter in a Pompeian wall painting (from Berger, I and II, 175, fig. 32); (*b*) a bronze box with a sliding cover and hinged lattice lids under that, containing irregular lumps of pigment and found in the tomb of a late classical Gallo-Roman painter at St Médard-des-Prés (from Berger, I and II, 214, fig. 46); (*c*) a modern sketch box for oil painting with a palette, metal hooks in the top for holding canvas or academy board, and compartments below for brushes, tubes, and bottles.

is shown a paddle-shaped palette having three straight sides and a fourth extended to form a handle. This shape seems to have continued, though it is rarely seen, for it appears again in a palette formerly used by Sir Joshua Reynolds and now shown as exhibit no. 332 in the Royal Academy, London. During the XVI century oval palettes seem to have come more into use and are common in the XVII and after. Perhaps a transitional shape is that seen (figure 17, *b*) in the drawing by Peter Breughel the Elder, 'A Painter in his Studio,' Bayonne, where an oval with one straight side is seen. A similar palette, oval but cut off straight at the thumb hole, is held by Gerard Dow in his self-portrait at the Cheltenham Municipal Art Gallery.

Palette Cup (see **Dipper**).

Palette Knife. A spatula, usually smaller and slightly more flexible than the kind used for domestic and laboratory purposes, serves to mix the oil paint in modern practice (figure 23). When the paint is worked to the consistency required, it can then be piled on the palette. As prepared for the artists' trade, palette knives

of steel are presented in a variety of shapes. The straight blade or simple spatula usually has a slightly wider shoulder than handle and tapers to a rounded tip. The length varies from about $2\frac{1}{2}$ to 6 inches. A trowel shape with offset blade is frequently longer. Broader blades with a longer shank having slightly tapered edges or diamond or triangular shapes are sometimes called 'painting knives.'

FIGURE 16. Some shapes of painters' palettes in the past: (*a*) a long-handled palette in a French miniature of the XV century (from Berger, III, 231, fig. 16); (*b*) a small palette shown in a 'St Luke' attributed to Wolgemut (late XV century) in the *Germanisches Museum*, Nuremberg; (*c*) a palette from a 'St Luke' attributed to Heinrich Dünwegge (*c* 1500–1523) and in the *Landes-Museum*, Münster; (*d*) a paddle-shaped palette, shown in an engraving from a self-portrait by Jacopo Bassano; (*e*) a small palette seen in a 'St Luke' attributed to Colin de Cotter (late XV century) and in Vieure near Moulins; (*f*) a XVII century palette seen in a studio representation (Vyvyan Sale, Christie, 1935) by David Ryckaert (Flemish, XVII century); (*g*) a palette of Sir Joshua Reynolds, now exhibited in the Royal Academy, London (no. 332); (*h*) the palette in a work attributed to Quentin Matsys (*c* 1500) and called 'Quentin Matsys Painting the Portrait of His Mother,' in a private collection in England; (*i*) one of the three palettes in the painting by D. Ryckaert, referred to above.

In the earlier centuries of oil painting the knife used by the painter for scraping the grinding slab or for transferring paint to the palette seems to have been of a different kind. Probably a slice was the most common tool for this purpose (figure 24). Where any kind of knife in connection with the grinding and preparation of paint is seen in the studio paintings of the XV to the XVII century, it has a heavy blade and the appearance of an ordinary stiff knife of moderate size.

By the XVIII century, however, this had somewhat changed. An engraving from a self-portrait by Hogarth shows a palette knife of the spatula type. In 'A Painter's Studio' attributed to François Boucher, in a private collection in Paris, a broad spatula kind of knife is seen beside the grinding slab. A dagger-shaped tool, much like the so-called 'painting knife,' can be noticed in the thumb hole of

FIGURE 17. Modern shapes of the painter's palette: (*a*) a rectangular palette with a block for grip near the thumb hole, used by John Constable and now exhibited at the Royal Academy, London (no. 330); (*b*) this shape is seen as early as the XVI century in the work of Pieter Breughel the Elder (particularly in a drawing, 'A Painter in his Studio,' Bayonne) and later in the work of G. Dow, 'Portrait of the Painter' (Cheltenham Municipal Art Gallery). Contrary to the custom in those seen in figure 16, where the thumb hole is either in a kind of handle near the middle or is in the upper part, in these more recent types of palette, the thumb hole is placed nearer the center of one edge or slightly below the center, leaving the upper edge of the palette for distribution and mixing of paint. This is a slight change, and the palette shapes throughout the Middle Ages and Renaissance seem to have been very numerous. At *c* is a standard modern palette, generally rectangular in outline; at *d* is the oval palette; and at *e* the so-called 'arm' palette.

the palette lying on the floor in Turner's 'Watteau in his Studio' in the Tate Gallery. When artists' colormen began to list palette knives, there were two or three materials used for them. C. Roberson and Company mention steel, ivory, and iron in a catalogue of about 1840, and the same materials are mentioned in

the catalogue of Winsor and Newton for 1870. Ivory palette knives or spatulas are still available but are now little used.

Pantograph. Operating on a kind of steelyard relation of scale, this is an instrument by means of which copies in larger or smaller size can be made by a process of tracing over the work to be copied (figure 18). The usual construction is of four strips of wood set as overlapping sides of a square, the position of which, from the worker, is with one corner towards the bottom of the page. A downward projection of the upper left strip is fixed in place, the lower corner of the square is moved over the work to be copied, and a downward projection of the upper right strip marks the enlarged copy. The scale of the enlargement can be changed by adjusting the relations of the overlapping strips. The pantograph does not appear among the catalogues of Winsor and Newton, artists' colormen, until the year 1892, and has not been found in other catalogues before that. Its age, however, is much greater than this. Meder (pp. 189–190) says that it was described by Scheiner in 1635.

Pen. In present-day usage, this word has been attached almost entirely to a metal instrument for writing or drawing that has been developed largely since the middle of the XVIII century. Recent usage, however, has not yet established itself in the history of art, particularly of writing and illuminating, where the word refers principally to the pen made of a quill, though it may also have to do with a reed or with a metal slip. Very possibly, the reed has the greatest antiquity, the hollow joints of bamboo or tubular stock of coarse marsh grass (*calamus*) having been used by Greek and Near Eastern writers from Roman times. And the reed or cane pen is probably the most easily made (figure 19). According to the description given by Johnston (pp. 51–54), it should be cut from a stalk about 8 inches long, one end of which is tapered obliquely and shaved back to the hard, outer shell. The nib or writing edge is then cut across squarely and is slitted longitudinally for about $\frac{3}{4}$ inch. To retain ink in the pen a thin strip of metal the width of the nib and about 2 inches long is bent into the reed in an S-shape and sprung up under the nib. Besides its use in the classical world, the reed pen undoubtedly had a common employment, particularly for large writing, throughout the Middle Ages and the Renaissance. It was known in Egypt. In a bronze pen case from Oxyrhynchus, thought to be of Roman times and now in the British Museum, are two reed pens cut in the way just described. In the Far East a number of examples from the III to the IX century was found at Niya, at Lou-Lan, at Mīrān in the Tārīm Basin, and at Tun Huang. The pens found at Mīrān were accompanied by written records and were of wood and of reed; those from Tun Huang were roughly cut from the twigs of tamerisk. Although they are little used today, reeds ready cut are available from a few artists' colormen. They are of bamboo or what is called 'Indian reed.'

The common pen, however, from classical times until very recently has been the quill. Although one of the earliest specific allusions to the quill is said to have

been made by St Isidor of Seville in the VII century, it was probably used for many centuries before that. In the West the quills of the goose and the turkey seem to have been most taken for the manufacture of pens, and Johnston (pp. 54–60) recommends a wing feather quill from a turkey as strong and suitable for ordinary writing. According to his directions, the barbs are first stripped from the

FIGURE 18. A pantograph, an instrument for making enlargements or reductions in scale of drawings: (*a*) that described by Christ. Scheiner in 1635 (from Meder, p. 189, fig. 69); *b* and *c* are modern pantographs produced commercially; *d* is a French one of the XVIII century (from Meder, p. 189, fig. 70).

shaft and then this shaft is cut and pared at the larger end which is to be used for the nib. The extreme tip is cut off on a slab and a slightly oblique, chisel-shaped nib is left. As with the reed, modern scribes have found that a thin strip of spring metal looped into the shaft and under the nib will hold a fair quantity of ink. Meder (p. 34) considers that the pen has been the drawing instrument of greatest use in Europe since the time of Early Christian art, and the history of its use as summarized by him includes much of the drawing of the Renaissance and most of the great names through the XVIII century.

Pens of metal, although they dominate the writing means of modern times, are by no means modern in origin. Among writing instruments exhibited in the British Museum is a bronze pen found in the Tiber at Rome, in its shape much the same as the steel pen of today. Another found at Pompeii is in the Naples Museum. There seems to have been little use of metal for writing purposes during

FIGURE 19. Diagrams showing the cutting of pens from quill and reed (largely adapted from Benson and Carey, pp. 42–48). In the upper row is shown the general sequence of cutting a quill, including the position of the metal spring for holding ink; in the middle row, the cutting of a reed, including the angles given to the nib; and at the bottom, a series of steel pens used for lettering.

the Middle Ages or the Renaissance or in any general sense until the XIX century. Samuel Harrison in Birmingham, England, made a steel pen in 1780 but such devices were not on the market until about 1803 when it is known that they were sold in London. These pens were in a tubular shape, so formed that the edges made the slit, and the nib was cut and tapered as was that of the quill. Machine-made pens did not appear until about 1822, and James Parry is said to have been the first manufacturer of the steel slip pen. When pen making was established as an industry, the material used was rolled sheets of cast steel made from Swedish charcoal iron. Suitable strips were cut from the sheets and these were annealed, pickled, and rolled to a thickness of about 1/160 inch. From the ribbons of thin steel the pen blanks were punched, annealed again, and were tempered, scoured,

and polished. Stainless steel is now frequently used for non-corroding qualities. A few other materials have appeared in the history of pen making—tortoise shell and glass—but they have never had great use as drawing instruments.

Pen Case. This minor piece of equipment seems to have had no currency during the last century or more, and was probably limited, for the most part, to the time when the scribe was a special and somewhat itinerant craftsman. The case proper was a long, usually tubular, container made frequently of leather or of horn and attached with thongs to the scribe's belt where it hung along with the ink-horn (figure 14, c). During the later Renaissance, painters evidently took up this kind of case for carrying brushes, and artists' colormen still show boxes of a similar size, ordinarily of metal, in which brushes can be carried along with other sketching materials.

Pestle, an elongated piece of hard material, usually stone, for grinding pigments or other materials in a mortar.

Poona Brush. This name indicated a shape and utility of brush rather than any particular hair. It was ordinarily a rather small implement of bristle, sometimes of badger, and was blunt-ended and round in cross section. It appears in catalogues of artists' colormen chiefly during the middle of the XIX century. As shown there, it was mounted in a quill and bound around with thread. Probably the stencilling brush has largely taken its place.

Portcrayon or **Porte-Crayon** (see **Crayon Holder**).

Portfolio, a protecting and carrying cover for drawings and similar works on paper. It is usually made with two sheets of board, covered and hinged at one of the long sides. The other three sides are provided with tapes for tying the portfolio shut, and flaps are sometimes attached for protecting the edges of the contents.

Pounce Bag, any loosely meshed cloth through which a colored powder could sift, has been used over pricked drawings as a means of transferring these to another surface. This has been done for duplication of drawings or for the transfer of the design to a ground suitable for painting. The antiquity of the method is indefinite. Stein (*Serindia*, I, 484) found what he considered to be a pounce bag at Mirān Fort, occupied by Tibetans at the end of the VIII and during all of the IX centuries A.D. This was a felt pad stitched around the edge and filled with powdered charcoal. He thought it might have been used for transferring designs to fabrics before painting or embroidering.

Pouncing Apparatus (see **Tracing Apparatus**).

Press, Oil. Before the time when oils were regularly prepared and sold by apothecaries, the oil press and similar heavy equipment for preparing and cooking this medium were the usual properties of the artist's studio. Little is left to show what the oil press may have been. Laurie (*The Painter's Methods and Materials*, p. 25) translates a comment from the MS. of Theophilus, *c* 1200, to the effect that this was merely a press made primarily for other purposes. In this description,

linseed, which has been dried over the fire and ground to a powder, is heated with water, wrapped in linen, and put into such a press as was used for extracting the oil of olives, of walnuts, or of the poppy.

Proportional Divider (see **Compass, Divider,** and figure 9, *c*).

Punch or **Stamp.** During the centuries when painters were occupied with making altarpieces that had backgrounds of gold leaf, there was a varying but general use of small instruments for stamping figures in the haloes and other details that were described in the gold. Few references to the nature of these instruments occur in contemporary literature. Thompson (*The Practice of Tempera Painting*, p. 69) suggests that a variety of punches could be made with brass rods as the shafts, the ornaments to be filed or incised at one end.

Quill, the tube or barrel of a feather; this has had much use in painters' tools (see **Brush, Pen,** and figures 1 and 19).

FIGURE 20. The ruling pen: (*a*) as seen from the side, showing the general shape of the blades; (*b*) a compass with a ruling pen, showing the slot between the two blades of the latter.

Rack. Small strips of ivory or wood, cut with short, semi-circular grooves in the upper edge, have been used as a place to lay brushes during painting, particularly of water color and miniatures. The purpose is to hold the fine tip of the brush away from the work-table and to keep it from rolling. These no longer appear in catalogues but were frequent in the middle of the XIX century and probably had been used for an indefinite time before then.

Reducing Glass, a double concave lens which diminishes the appearance of size in objects viewed through it; often used by painters as an artificial means of getting a distant point of observation of their work.

Rest Stick (see **Mahlstick**).

Ruling Pen. Developed evidently during modern times as an instrument of precise draughting, this differs from the typical pen made from reed, quill, or steel. Instead of being a section of tubular shape, tapered to a point or nib, it has two parallel sides and the drawing edge is between the ends of these (figure 20). The width of the line described is regulated by their distance apart, and this is adjusted by a small set screw. A variety of sizes is manufactured. Most ruling pens are straight, but a curved pen for particular purposes is available, and ruling pen attachments for compasses are now the usual means of drawing circles with ink.

Sable, the hair of one of a number of Siberian minks, used in the making of fine brushes. Sables are ordinarily prepared as round brushes, fairly long, and with a tapered point (see also **Brush**).

Saucer. In modern use the saucer is a porcelain disk with a rounded depression in the top for holding thin paint, usually washes in water color painting and architectural rendering. In size, saucers range from one inch to nearly four inches in diameter. They are made with covers and, in the type ordinarily used by architects, are constructed so that one saucer forms the cover for another in a tier of five or six.

Scraper. Some kind of blade has perhaps always been used for smoothing paint or grounds, and it is impossible to indicate the varieties of such a tool. Eastlake (I, 375) says that a wooden or horn scraper called *stecca* was used during the Renaissance to spread the first coat of gesso on a wooden panel. In the modern application of gesso, Thompson (*The Practice of Tempera Painting*, p. 30) describes scrapers for dry gesso to be made from steel strips or from the blades of carpenters' planes. For scraping paint, smoothing, or removing it in the process of painting, curved knives with a point have been made and listed by dealers in artists' supplies. Also for this purpose, Solomon (p. 74) recommends a 'wire plush mat' which can be bought in lengths at tool shops.

Screen Frame. As a means of laying off the area of a subject in squares corresponding to those marked on the paper where the draughtsman was to work, a screen containing a series of wires so set as to form the squares has occasionally been used. It is illustrated in woodcuts by Dürer and is to be compared to the glass frame or tracing machine as one of the devices for getting sight proportions common in the practice of the XVI century and later (see also **Glass Frame** and **Tracing Apparatus**). At times a combination of the glass and screen frames seems to have been made.

Shade and **Shelter.** When landscape painting reached a point at which much of the finished work was done out-of-doors, weather conditions began to be met by the construction of various shades or shelters for the use of the painter. One of these, common today, is the so-called 'sketching umbrella.' This is a folding device. The canopy cloth is on a collapsible frame of small steel ribs; the stalk is in two or three parts, with removable joints. Such umbrellas have a diameter of about $3\frac{1}{2}$ feet. The stalk is fitted with a steel spike at the end so that it can be set firmly in the ground. Probably the use of a shade or screen of some kind has been common in studios for a long time. A rather strange Oriental umbrella is seen attached to easels in a number of paintings by Gerard Dow, particularly a portrait of the artist, signed, and bearing the date of 1652, in the Czernin collection, Vienna. During the XIX century, and perhaps earlier, small tents were used by painters and some of them were regularly sold by artists' colormen. They appear in catalogues between 1870 and 1890.

Shell. From earliest times shells of clams and mussels have evidently been favorite containers for paint mixtures. Prentice Duell says that shells were the forerunners of the palettes of the Egyptian painters. They are frequently mentioned in the technical literature on painting for the Middle Ages and the Renaissance, and are seen as appurtenances in the painting rooms that are represented in pictures as late as the XVII century. Small mussel shells are used still for the so-called 'shell gold,' powder gold in an aqueous medium, as it is prepared in France.

Sight Measure. Developed from the simple finder or window, which is an opening cut into a piece of cardboard, the sight measure is made to establish certain relations and measurements in the rectangles formed by such an opening (figure 21). The purpose of the finder is to select out of the field of vision those isolated areas which are to be the subject for representation. The sight measure has the same purpose. It is a thin metal window, usually painted dead black, and with a sliding adjustment fixed automatically at 10 units of width and running to about 30 in length. As the slide is moved away from the end, a window is opened, the measure of which, with respect to the width of the slide, is indicated by a scale marked at the edge of the opening. The sight measure has probably not been much used as a standard piece of equipment, but appeared in the catalogues of artists' colormen towards the end of the XIX century.

Silver Point (see also **Metal Point**). This has undoubtedly been the most common of the metal points used for drawing. In all of these the principle is the same. The support, usually parchment or paper, is coated with a thin ground of material that has an abrasive character: calcined bone, chalk, fine pumice, or, more recently, zinc white. Usually these grounds are held by an aqueous medium like glue size and are very lean in their structure. When the silver point is drawn over a ground like this, fine particles of the metal are taken off and left in the line that has been described. It is a pale gray mark which in time corrodes slightly to a darker value and a warmer tone. Probably the use of such a point developed from the stylus which was a common instrument for writing or scratching on tablets of various materials in ancient times. Certainly the silver point and various other points were well established in use in the Middle Ages and, although the graphite pencil has largely displaced them in recent centuries, the silver point particularly is still favored by a few draughtsmen. In *The Practice of Tempera Painting* (pp. 44–45), Thompson suggests silver point for modern drawing on papers tinted with zinc white and other colors, and he speaks of an easily made point of silver wire set into a propelling pencil holder.

Sketching Easel (see also **Easel**). Designed primarily as a light, folding, and easily portable unit for holding a canvas or panel in out-of-door painting (figure 11, *b*), this type of easel has a number of different styles. All those advertised by artists' colormen, however, are made with three legs, adjustable in height and hinged from a small block where they come together at the top. Some have cross

pieces which can be fastened in place; many have tilting devices to allow the canvas to be tipped forward at the top; others are fitted with sliding trays that can be adjusted at different heights. The wood of such easels has to be light but well seasoned and carefully selected; it is usually a light hardwood. When closed, most easels are about 30 to 36 inches long and open to a height of 5 or 6 feet.

In a sense, this is the same as the traditional three-legged easel used during the Middle Ages and the Renaissance. In a drawing by Jan Asselijn (1610–1652), 'Dutch Painters in Rome,' a regular easel with pegs is seen in use by a landscape painter. On it is a large canvas. Another of the figures is sitting on the ground, evidently drawing on a board. When out-of-door sketching became a widespread practice for amateurs, the number and variety of sketching easels increased. One model even supplied a combination in a single mechanism of sketching seat and easel together, and this in 1849 was described as '. . . the most convenient and pleasant apparatus ever introduced for the Lady Sketcher.' Such combinations were still shown in 1889, but the models now offered are less complicated in design.

Sketching Frame, a light, wooden, rectangular frame or panel made for holding water color paper. It is provided with strips that go along the edges and are held in place with metal clips. Usually the paper is wetted, stretched over the frame, and held in place by the strips and side clips. These frames are rectangular, as produced for the market, and vary in size from 6 to 20 inches.

Sketching Stool, a light, portable stool with collapsible frame of wood or metal, used for out-of-door sketching.

Sketching Tent (see **Shade** and **Shelter**).

Sketching Umbrella (see also **Shade** and **Shelter**), an umbrella with a diameter of about 3½ feet, made with a staff or stalk in two or three parts that can be fitted together to a length of 6 or 7 feet. The upper end of the staff has a set screw so that the canopy can be adjusted at different angles. The lower end tapers to a metal spike that can be set into the ground.

Slab (see **Grinding Slab**), a flat stone or glass used for the grinding of pigments, the word is applied, also, to a porcelain tile with small wells used in tempera painting, illumination, and similar fine work. These slabs are different from tiles and slants only in minor details (see also **Tile**).

Slant (see also **Tile**), a porcelain container, usually for a number of colors, made with depressions in the upper side (figure 26). The typical slant has three or six inversely wedge-shaped divisions and is rectangular in its general outline. The depressions are rectangular in plan and taper down from the level of the surface to a depth of a quarter inch or more. There are other shapes which are circular, the deeper part of the depression being towards the center.

Slice, a tool with a blade of metal or wood, used principally as a scraper (figure 24). Although the word has been applied to various kinds of spatulas, it is usually intended to indicate one with a scraping edge at right angles to the handle like that of the putty knife. Thompson (*The Practice of Tempera Painting*, p. 37)

speaks of a wooden slice or slip of hardwood with tapered, straight edge for spreading a heavy gesso on panels. He translates as 'slice,' a *steccha di legnio* mentioned by Cennini (*The Craftsman's Handbook*, p. 21). This was used to scrape up color from the grinding slab.

Softener (see **Blender**).

Spatula, a blade, usually of flexible metal, used in painting largely to mix, spread, and transfer a somewhat thick paste of oil color (see also **Palette Knife** and figure 23). The use of the spatula probably has a very long history in this art but tools of such a general kind are little referred to in the literature.

FIGURE 21. A sight measure with an adjustable slide to be used as a finder, principally in landscape painting. The aperture is set to the proportions of the support to be used for a particular work. This was shown in the catalogue of Winsor and Newton for 1889 and for a few years following.

Sponge (see also **Cloths**). This, as a cleaning and wiping material, has probably been used in painting from ancient times. It is referred to as part of the painter's equipment by Pliny the Elder, and Cennino Cennini (Thompson, p. 99) speaks of a little piece of soft sponge for spreading varnish. At present it is used largely with water color for thinning washes on paper. Brushes, so-called, made of small bits of sponge and mounted in handles, are supplied by some artists' colormen. They are for picking out highlights.

Stamp (see **Punch**).

Stencil, a cut-out pattern, usually from a thin metal or cardboard sheet, and so made that paint can be put into the areas left open when the stencil itself is held tightly against the surface on which the paint pattern is to be applied. This is used largely for repeating abstract elements in interior decoration. Books of stencils are regularly sold by artists' colormen. A form of stencil permitting more flexible treatment is made with a silk screen on which a ground of gesso-like composition takes the place of the paper or metal of the ordinary stencil. In this type the paint in an oil medium is pressed through the fine silk gauze which covers the more open part.

Stencilling Brush, a short, stiff brush, usually round in section and flat across the end. It is made of bristle and is intended for use in pressing the paint into the cut-out part of a stencil.

Stretcher. Though properly part of the support of a painting rather than a tool in its manufacture, this device at times has been also a piece of equipment

and not a permanent part of the finished picture. In earlier days of painting on canvas, provisional stretchers were used to which the linen was laced while it was in the studio. Such arrangements are evident in many paintings, particularly of the Dutch school during the XVII century. One of these in the Hermitage collection, 'The Painter in his Studio,' by Peter Codde (Amsterdam, *c* 1600–1678), shows the canvas attached by a heavy cord with pins or pegs at the edges of the stretcher pieces. A space of about 6 inches was left between the linen and the wooden stretching frame. In the XVIII century evidently the practice of attaching the canvas to the stretcher by tacks was usual before the painting began rather than after, and such practice has continued to the present. In the XVIII century, also, or perhaps in the early XIX, stretchers with keys, small wedges which could be tapped up at the corners to extend the outside dimensions and make the canvas more taut, were introduced. Later in the XIX century and prevalent still came the stretcher with mitred corners and with double keys at the corners (figure 6, *a*). These were made commercially with a rather complex mortised fitting so that a piece of any length could be used universally with any other pieces, the mitred ends being all the same. In the restoration of paintings for the process of relining, a heavy provisional stretcher is common, being much larger than the outer dimensions of the painting and allowing for manipulation of the edges during this process. After the painting is relined, these edges are cut back to a suitable space for stretching.

Striper, a flat brush of moderate size and with a very long, fine hair of sable or of squirrel. This is used largely in industrial rather than in pictorial painting (see **Brush** and figure 1, *e*).

Studio. The work-room of a painter, which now commonly goes by the name, studio, has had a varied history and has undergone changes of character with the different centuries during which it can be seen in painted representations. At present it is apt to be a rather large room with high ceilings and high sidelight, preferably on the north, and including some amount of ceiling light. Sloping, large windows are frequently used for this purpose. Generally it is a place of simple furnishing, rather bare, and aimed almost entirely at utility. This rather specialized type of work-room was developed in the latter part of the XIX century. J. S. Templeton, in *The Guide to Oil Painting*, 3d ed. (London, 1845), speaks of the painting room '. . . which is sometimes affectedly styled a Studio, or Atelier,' as a room of ordinary and moderate dimensions, and the fashion of that time, seen in paintings of the period, indicates that it was a rather sumptuous apartment. Turner's painting, 'Watteau in his Studio,' in the Tate Gallery, represents a rich, salon-like interior, somewhat confused in its appointments, with a number of pictures and a clutter of draperies and small objects. This type of room is commonly seen in the studio interiors of the XVIII century. During the XVII, particularly in the north of Europe, two types of studio are found. One is a normal interior of a house, a room like a drawing room; the other is plainly a rough work-

shop type of interior, frequently barn-like, often in disrepair, and sometimes shown as having only an earthen floor. In the XV and XVI centuries, a normal kind of room interior seems to have been the working place of the painter.

FIGURE 22. Stumps or soft instruments to be used with chalks or powders: (*a*) an elaborate one, shown in the catalogue of Winsor and Newton for 1870, with a curved handle and a whalebone foot that carried a leather cover; (*b*) a French stump of chamois, of about 1740 (from Meder, p. 185, fig. 65); (*c*) a modern leather stump; (*d*) a small instrument of the same type as the stump but made of paper only and called a 'tortillon.'

Stump and **Tortillon.** This is a piece of leather, felt, or paper, tightly rolled into the shape of a small stick and tapered at one or both ends (figure 22). It is used for softening edges and smoothing tones in drawings that are made with chalk, pencil, charcoal, crayon, or any material that can be moved about by light abrasion after it is applied. The tortillon is made only of paper, according to the usage of the word by artists' colormen, and is relatively small, 3 to 5 inches long. The paper may be gray or white. The stump may also be of paper, usually gray, and somewhat softer than the tortillon. It is also made and sold in yellow leather and, occasionally, has been made of cork. The stump is usually pointed at both ends and comes in a variety of sizes which run according to number, the largest being somewhat less than an inch in diameter. Felt stumps are still softer and have about the same sizes as the leather ones. The simple cylindrical stick shape with the conical-pointed ends is the only one offered by modern manufacturers. In the catalogue of Winsor and Newton for 1870, there was shown, however, a more elaborate shape, a kind of fine trowel-like instrument with a handle of whalebone and an elastic foot. This was covered with leather and allowed for a fine line to be drawn with its edge. Cork stumps were also listed at

this time by a number of manufacturers. The leather ones were either white or yellow, and paper was in use for this purpose at least as early as 1846. Meder (p. 185) suggests that the stump was a normal development of rolling pieces of

FIGURE 23. Spatulas and palette knives: (*a*) a group of palette knives typical of those in use at present; (*b*) painting knives, also modern; (*c*) a bronze spatula in the Naples Museum (from Berger, I and II, 264, fig. 54); (*d*) a bronze spatula of Pompeian origin, also in the Naples Museum (from Berger, I and II, 266, fig. 56).

leather in order to get a fine point on them, and says that soft paper stumps were in use as early as the XVIII century. In the Victoria and Albert Museum, London, is the work-box of a pastel painter, Mrs Elizabeth Cay (1770–1831). She had been a pupil of the Scottish miniature painter, Archibald Skirving (1749–1819). The box contains small bottles of relatively pale pigment in powder form, apparently tints from mixture with white, and with them a set of leather stumps in various sizes. The indication is that the pastel in the case of this painter was taken as a powder rather than as a stick and was applied entirely by means of stumps.

Stylus or **Style,** a metal point, usually rather blunt and not a cutting point, used for various accessory work in connection with painting: for making lightly ruled lines, for locating points, and for incising on gold ground. This is an ancient instrument and one of general utility outside of the arts. It was a frequent means for common writing in classical times when it was employed on tablets of blackened wax or on pieces of broken pottery. In European painting there are many and various uses to which it has been put; it is mentioned in connection with incised ornament on gold, with the marking of outlines in wet plaster during fresco painting, and with light ruling on parchment or paper. The distinction between the entirely mechanical stylus and the metal point of silver or copper used for drawing is sometimes hard to make. (See also **Metal Point** and **Silver Point.**)

Table Easel (see also **Easel**), a small rack or stand usually of hardwood and of very light and compact construction, made and sold under this name, particularly during the middle of the XIX century. The catalogue of Winsor and Newton for 1849 shows such an easel in three sizes. At about this same time, Reeves and Son had a small folding easel which could go into a pocket. It was of walnut, about 12 x 16 inches opened, and with two or three angles of adjustment. A somewhat heavier easel of this type is still available (figure 11, *c*).

Figure 24. Scrapers for paint: (*a*) a slice or stucco spatula of the type used for grounds, this one made of bronze and in the Naples Museum (from Berger, I and II, 264, fig. 54); (*b*) a wooden slice (from an illustration in Thompson, *The Practice of Tempera Painting*, p. 37); (*c*) a knife used for laying grounds (from the MS. of De Mayerne, Berger, IV, 102, fig. 2).

Tablet. The drawing tablet of modern use is a sheaf of papers, always fastened with an adhesive at one or more edges, and backed by stiff paper board. It is made in a great variety of sizes and of many different papers. Its name doubtless comes from the actual tablet of wood commonly used for drawing during the Middle Ages and until the XV or XVI century in Europe. These, according to descriptions of Renaissance writers, were used largely by apprentices, though Meder (p. 165) says that before this they had been used by both masters and pupils. They were usually coated with a white ground like gesso. Drawings were made on them with metal points or with charcoal as studies and for practice. With slight abrasion, the drawing could be effaced.

Tile (see also **Slant**). This name has been given to a variety of porcelain containers used largely in water color painting, wash drawing, miniature, and tempera painting (figure 26). The tile is usually a block of porcelain containing in its upper face a number of depressions, wedge-shaped or round, the former generally carrying the name, slant. Some tiles have both, that is, rounded depressions and slanting or wedge-shaped ones. Small tiles are about 2½ x 4 inches and larger ones, containing 20 and more wells, are about 4 x 8 inches. In the early part of the XIX century, the tiles were called saucers and, in some cases, particularly in the XVIII

century equipment of the water color painter, they were accompanied actually by very small saucers or independent dishes of porcelain. Containers of this kind, that is, divided dishes, are well known in the Far East and, as a kind of painting slab, were familiar articles of equipment in the ancient world. The British Museum has a number of such divided dishes that are Egyptian in origin, one of alabaster with a pedestal, and another with divisions on radii and inner circles in its generally circular shape, is of terra-cotta. A pan, circular in outline and rather flat, with a partition across the center, is occasionally seen in representations of studios in the XVII and XVIII centuries.

FIGURE 25. Three shapes of stylus or metal point (from Meder, p. 77, fig. 29): (*a*) the silver point of Hans Kranach; (*b*) the silver point of Hans Baldung; (*c*) the silver point of Jan Mabuse. These are instruments shown in paintings by those masters.

Tip, a gilder's instrument used for lifting the leaf from the cushion and laying it upon the bole (figure 12, *c*). It is made of camel hair, usually set between paper cards, and varying in length. The thickness of the brush is hardly more than that of two or three hairs. The tip is placed over the leaf that is to be taken up, having first been made very slightly adherent by being rubbed on something that is a little oily. Most gilders rub it across their heads. The technical literature of the Middle Ages and the Renaissance makes no reference to such an instrument as the gilder's tip, but does speak of other means for lifting and handling gold leaf. The necessity for a tip came in with the much thinner gold that is used now.

Tool. This word is here applied miscellaneously to any implements used by the painter. During the XIX century and somewhat earlier, it was given to the brush alone. Brushes are frequently listed in old catalogues as painting tools.

Tortillon (see **Stump** and figure 22, *d*).

Tracing Apparatus. It appears that this was first described in any adequate detail by Leonardo da Vinci, and the descriptions are found in his *Notebooks* (II, 253–254; *MS.*, 2038, *Bib. Nat.*, 24r). The machine was later described and illustrated by Dürer (see Meder, p. 466, and figs 204 and 206). The principle of such a device lies in tracing the visual image as this is intercepted on a pane of glass (figure 27). It shows on such a glass only when it is described by some instrument like a wax crayon, piece of soap, or a similar soft and fatty marking material. When highly developed, this tracing machine was so made that squared

cross lines of wire were placed behind the glass so that the outlines traced there could be transferred to paper which had a similar linear screen.

The word, 'tracing machine,' or 'tracing apparatus,' has also been applied to a glass plate so arranged that a mirror beneath it throws the light through the glass. Over the glass is placed a drawing and over that the thin or tracing paper on which such drawing is to be followed. Transmission of the light through the paper clarifies the details and makes the tracing operation a relatively easy one.

FIGURE 26. Tiles and slants: (*a*) an ancient container of crystal, found in a late classical tomb at St Médard-des-Prés and containing gold powder mixed with a gum-like substance (from Berger, I and II, 214, fig. 46); (*b*) a circular slant, with cup and basin; (*c*) a divided slant tile; (*d*) a tile or slab, with cover; (*e*) a slant and well tile.

Tube. Both oil paint and water color are now largely put on the market in collapsible metal tubes with screw caps (figure 28). These are made of tin, as other metals are apt to have a slightly deteriorating effect on pigments or even on mediums. A variety of sizes among these tubes is now available. Certain pigments, usually white, are put up in pound tubes and many in half pound. The smallest tube in ordinary use is 2 inches long by about $\frac{1}{2}$ inch in diameter. Three- and 4-inch tubes of the same diameter are common. There is a double 4-inch tube about $\frac{3}{4}$ inches in diameter, and a studio tube which is somewhat larger. The smallest size is used mainly for water colors. The development of collapsible tubes as containers for color occurred largely during the middle years of the XIX century. Somewhat earlier than this there had been rigid metal tubes with pistons into which oil colors were put and which could be refilled at the colorman's. Small bladders were a common container for commercially sold oil paints in the early part of that century, also, and these bladders of paint are listed along with collapsible metal tubes in the catalogue of C. Roberson and Company for about 1840. Tubed water colors were slow to displace those put up in cakes or in pans, but had appeared in the trade by 1850.

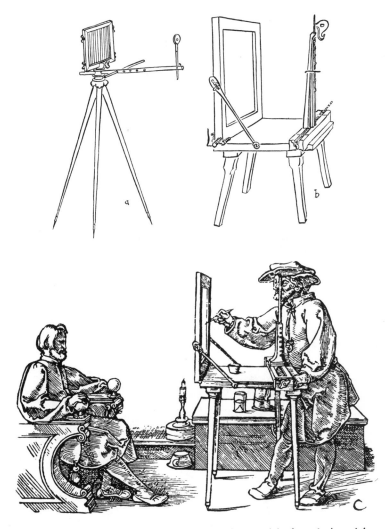

FIGURE 27. Tracing apparatus or glass frame: (*a*) that designed by Fried. Christ. Müller in 1776 (from Meder, p. 547, fig. 253a); (*b*) that shown in a sketch by Dürer of 1514 and said to be an exact representation according to the description by Leonardo (from Meder, p. 546, fig. 253); (*c*) an illustration of the use of the apparatus sketched in *b* (from a woodcut by Dürer).

Wash Brush. This, also called a 'sky brush,' is usually made of camel hair and is a fairly large tool set in a moderately flat metal ferrule and shaped round at the end. It is used for applying broad areas or washes of water color (see **Brush**).

FIGURE 28. Containers for oil paint: (*a*) the skin or bladder in which the mixed and ground paint was kept, with a tack-like piece of bone used to puncture the skin; (*b*) the firm metal tube with a piston filled and refilled with oil paint; (*c*) the collapsible metal tube in common use today.

Whisk, a mediaeval tool of the illuminator used for beating up egg white as a medium. It appears to have been a wooden stick with a flat, thin, circular loop at one side, this being also of wood. It is illustrated and described by Thompson in 'The *De Clarea* of the So-Called "Anonymus Bernensis"' (*Technical Studies*, I [1932], pp. 13 and 17).

BIBLIOGRAPHY

John Howard Benson and Arthur Graham Carey, *The Elements of Lettering* (Newport, Rhode Island: John Stevens, 1940).

Encyclopaedia Britannica, 11th edition.

Ernst Berger, *Beiträge zur Entwicklungsgeschichte der Maltechnik*, 4 vols (Munich, 1901-1912).

Henry P. Bowie, *On the Laws of Japanese Painting* (San Francisco: Paul Elder and Co., 1911. Reprinted by Dover Publications, 1952).

Cennino Cennini, Thompson edition.

Prentice Duell, 'Evidence for Easel Painting in Ancient Egypt,' *Technical Studies*, VIII (1940), pp. 175-192.

Charles L. Eastlake, *Materials for a History of Oil Painting*, 2 vols (London, 1847-1869. Reprinted by Dover Publications, 1960).

K. Jex-Blake and E. Sellers, *The Elder Pliny's Chapters on the History of Art* (London: MacMillan and Co., Ltd, 1896).

Edward Johnston, *Writing and Illuminating and Lettering*, 2d ed. revised (London: J. Hogg, 1908).

A. P. Laurie, *The Materials of the Painter's Craft* (Philadelphia: J. B. Lippincott Co., 1911).

The Painter's Methods and Materials (Philadelphia: J. B. Lippincott Co., 1926).

Leonardo da Vinci, MacCurdy and Rigaud translations.

Edward MacCurdy, *The Notebooks of Leonardo da Vinci*, 2 vols (New York: Reynal and Hitchcock, 1938).

Joseph Meder, *Die Handzeichnung: ihre Technik und Entwicklung* (Vienna: Anton Schroll and Co., 1923).

M. P. Merrifield, *Original Treatises on the Arts of Painting*, 2 vols (London: John Murray, 1849. To be reprinted by Dover Publications in 1966).

Reeves and Son, Ltd, miscellaneous catalogues.

John Francis Rigaud, *Leonardo da Vinci, A Treatise on Painting* (London: George Bell and Sons, 1906).

C. Roberson and Company, Ltd, miscellaneous catalogues.

George Rowney and Company, Ltd, miscellaneous catalogues.

Laurence Sickman, 'Some Chinese Brushes,' *Technical Studies*, VIII (1939), pp. 61-71.

Solomon J. Solomon, *The Practice of Oil Painting* (Philadelphia: J. B. Lippincott Co., 1910).

Sir Mark Aurel Stein, *Innermost Asia*, 3 vols (Oxford: Clarendon Press, 1928).

Serindia, 5 vols (Oxford: Clarendon Press, 1921).

Daniel V. Thompson Jr, *Il Libro dell'Arte, The Craftsman's Handbook of Cennino d'Andrea Cennini*, 2 vols (New Haven: Yale University Press, 1932-1933. Reprinted in 1 volume by Dover Publications, 1954).

The Practice of Tempera Painting (New Haven: Yale University Press, 1936. Reprinted by Dover Publications, 1962).

Winsor and Newton, Ltd, miscellaneous catalogues.

GLOSSARY

The definitions of the few terms which follow here are added to the general data on painting materials in order to clarify somewhat further technical words used in the foregoing text. Most of those not defined here will be readily located in a dictionary. The definitions given may not completely explain the meanings of all the terms, but it is hoped that they may be of some help. They are taken, with a little modification, from standard reference works in the various branches of science.

Å, a symbol for Ångström unit which is a measure of length, usually of the wavelength of light. 1 Å $= 10^{-7}$ millimeters or 10^{-10} meter or $0.000,000,0001$ meter; 10 Å $= 1$ millimicron (mμ).

A.S.T.M., American Society for Testing Materials.

Acicular, needle-like or slender in shape.

Acid, a chemical compound which contains hydrogen as a positive radical and in solution gives hydrogen ions (H$^+$); it neutralizes bases, yielding a salt and water; *e.g.*, HCl (hydrochloric acid), H$_2$SO$_4$ (sulphuric acid), and CH$_3$COOH (acetic acid).

Acid Number or Value, a measure for free fatty acid in animal and vegetable fats; expressed as the number of milligrams of potassium hydroxide required to neutralize the free fatty acids in one gram of the fat.

Acid Salt, a compound derived from an acid and a base in which only part of the hydrogen of the acid is replaced by a basic radical; *e.g.*, an acid carbonate, NaHCO$_3$ (sodium bicarbonate), or an acid phosphate, NaH$_2$PO$_4$ (sodium dihydrogen phosphate).

Aliphatic, belonging to or derived from fat; belonging to that group of organic compounds having an open- or straight-chain structure as opposed to a ring or cyclic structure (see **Aromatic**). The aliphatic compounds include not only the fatty acids and derivatives of the paraffin hydrocarbons but also unsaturated compounds of the ethylene and acetylene series; *e.g.*, butane, CH$_3$CH$_2$CH$_2$CH$_3$; ethylene, H$_2$C $=$ CH$_2$; and acetylene, HC \equiv CH.

Alkali, essentially the hydroxides of the metals, lithium, sodium, potassium, rubidium, and caesium, but also the carbonates of these metals and of ammonia; *e.g.*, NaOH (sodium hydroxide) and K$_2$CO$_3$ (potassium carbonate).

Alum, ordinarily the double sulphate of aluminum and potassium, K$_2$SO$_4$·Al$_2$(SO$_4$)$_3$·24H$_2$O; also the generic name for other double sulphates of monovalent and trivalent metals which are isomorphous in crystalline form and contain 24 molecules of water of crystallization, like ammonium alum and chrome alum.

Amorphous, a term applied to materials which apparently do not have crystalline form; unorganized; without definite form; structureless.

Amphoteric, said of a substance that has both acid and basic properties; *e.g.*, aluminum hydroxide, Al(OH)$_3$.

Anhydrous, said of a compound which is without or has lost water, in particular, its water of crystallization.

Anisotropic, having different physical properties in different directions, like crystals; as regards the transmission of light, a substance which is doubly refracting (see **Isotropic**).

Aqueous, containing water; watery; **Aqueous Solution,** one in which water is the solvent.

Aromatic, belonging to or derived from that series of organic compounds, many of which are odorous, having a closed-chain or ring structure of the benzene type (see **Benzene**) as opposed to the aliphatic (see **Aliphatic**) and alicyclic or saturated ring compounds; *e.g.*,

phenol

alizarin

Atom, the smallest subdivision of a chemical element which remains unchanged in chemical reactions; composed of electrons, protons, and other structural units.

Atomic Weight, the number which indicates the relative weight of an element as compared to hydrogen (1.008) or oxygen (16.000).

Autoxidation, a complex type of slow oxidation at ordinary temperatures by oxygen of the atmosphere.

Base, (1) a compound which yields hydroxyl (OH⁻) ions in aqueous solution; a compound which reacts with an acid to form a salt and water; an alkali; *e.g.,* NaOH (sodium hydroxide) and Ca(OH)₂ (calcium hydroxide); (2) an ·inert material upon which a dye is struck in the manufacture of a lake pigment.

Basic Salt, a compound derived from an acid and a base in which not all of the hydroxyl radical of the base has been replaced by an acid radical; *e.g.,* white lead, $2PbCO_3 \cdot Pb(OH)_2$.

Binary Compound, a compound that consists of only two elements; *e.g.,* KCl (potassium chloride) and Fe_2O_3 (ferric oxide).

Birefracting, doubly refracting; a characteristic of transparent anisotropic crystals.

Birefringence, the strength of the double refraction of a material. **Birefringent,** doubly refracting.

Blanch, (1) to make white; (2) a pale, misty cast that comes over a film of varnish or paint; it can be used, in distinction to blush and bloom, as a name for the change which comes in old films when a solvent has been put on them and has evaporated, leaving a milky look, usually irregular in distribution

Bleeding, the property of a color in a dried paint film to diffuse and spread away from the layer in which it is applied to other paint or varnish layers.

Bloom, the white or cloudy appearance of the surface of aged varnish films, caused by the presence of minute cracks. or pores which diffuse light. Such a film has a faint bluish cast; it is not milky white like a blanched film.

Blush, the white appearance or turbidity that sometimes develops in lacquer or varnish films almost directly after they are applied. The phenomenon usually occurs only in humid weather. It is caused by rapid evaporation of solvents, which produces cooling at the surface and which, in turn, causes condensation of moisture within the

film. The effect on light is like that in an emulsion. Blush is distinct from blanch and bloom, which affect films previously dried.

Boiling point (b.p.), the temperature at which a liquid boils; the temperature at which the vapor pressure of the liquid reaches the pressure of the surrounding atmosphere. (The b.p. of water at normal atmospheric pressure is 212° F., 100° C.)

Calcareous, containing calcium; said of compounds such as calcium carbonate or limestone.

Carbohydrate, a type of organic compound containing carbon, hydrogen, and oxygen, the latter two in the proportion of water; *e.g.,* sucrose, $C_{12}H_{22}O_{11}$, or cellulose $(C_6H_{10}O_5)_n$.

Catalyst, a substance which increases the rate of a chemical reaction but is itself unchanged at the end of the reaction. Some catalysts are merely contact agents acting mechanically, but others appear actually to take a direct part in the chemical reactions they accelerate, forming unstable intermediate compounds from which the catalyst is regenerated as they are decomposed.

Caustic Soda, sodium hydroxide (NaOH), usually an impure form or technical grade.

Cellulose, a carbohydrate, $(C_6H_{10}O_5)_n$, which is the main structural ingredient of plant and woody tissue; hence, also, the principal constituent of wood, fabric from plant fibres, and paper. It is almost pure in absorbent cotton and filter paper. Cellulosic plant cells in woody tissue are cemented together with another plant material called 'lignin' and, hence, wood is sometimes called 'ligno-cellulose.'

Chemical Compound, a substance in which the molecules consist of unlike atoms and in which constituents can not be separated by physical or mechanical means. In a chemical compound the constituent elements are combined in definite proportions by weight. In a physical mixture, on the other hand, there is no fixed relationship among the components.

Chemical Element, a substance which can not be decomposed by ordinary types of chemical change or made by chemical union of other substances; matter which consists of atoms of one type. There are at least 92 possible elements, from hydrogen, the lightest, to uranium, the heaviest, but of these only 90 are known. About a third of all the elements are comprised in the

common classes of paint materials. These are listed with their symbols.

Aluminum	Al
Antimony	Sb
Arsenic	As
Barium	Ba
Cadmium	Cd
Carbon	C
Chromium	Cr
Cobalt	Co
Copper	Cu
Gold	Au
Hydrogen	H
Iron	Fe
Lead	Pb
Manganese	Mn
Mercury	Hg
Molybdenum	Mo
Nitrogen	N
Oxygen	O
Phosphorus	P
Potassium	K
Selenium	Se
Silicon	Si
Sodium	Na
Strontium	Sr
Sulphur	S
Tin	Sn
Titanium	Ti
Zinc	Zn

Chemically Pure (c.p.), of the highest grade but not necessarily 100 per cent pure; sometimes applied to commercial pigments to describe a grade free from extender or added inert pigment; *e.g.*, c.p. cadmium sulphide.

Chromophore, a structural arrangement of atoms which endows dyes and other related organic compounds with color; *e.g.*, the quinoid structure in dyes.

Colloid, a state of subdivision of matter which consists either of single, large molecules (proteins, organic polymers, etc.) or of aggregates of smaller molecules (colloidal gold, sulphur, etc.). There are eight recognized classes of colloids: *solid sols* (solid in solid) such as alloys; *suspensions* (solid in liquid) such as paint; *smokes* (solid in gas) such as carbon smoke and zinc oxide smoke; *gels* (liquid in solid) such as glue gel and fruit jelly; *emulsions* (liquid in liquid) such as milk; *fogs* (liquid in gas) such as clouds or visible steam; *solid foams* (gas in solid) such as sponge rubber or pumice; *foams* (gas in liquid) such as soap lather. The colloidal particles are called the disperse phase and the surrounding medium, the continuous or external phase.

Compound (see **Chemical Compound**).

Conchoidal Fracture, the type of fracture in which the broken edge of a material has shell-shaped depressions and elevations. This fracture is often shown in amorphous or vitreous substances like glass, cold asphalt, and resins.

Condensation, in organic chemistry, a process in which molecules of the same or different substances combine to form molecules of greater molecular weight, accompanied usually by the loss of water; *e.g.*, phenol-formaldehyde condensation to form bakelite; the transformation from gaseous to liquid state, as steam to water.

Consistency, the viscosity or fluidity of a liquid or paste; the resistance of a product to deformation or flow.

Co-precipitate, an intimate combination of substances which are precipitated simultaneously in one chemical reaction; *e.g.*, ZnS (zinc sulphide) + $BaSO_4$ (barium sulphate) to form lithopone.

Coupling Agent, a solvent which will cause two immiscible liquids to mix; *e.g.*, the addition of butyl alcohol to effect the mixing of petroleum spirit and ethyl alcohol.

Covering Power, the extent to which a certain volume of paint will spread on a surface in normal thickness, usually expressed in square feet per gallon.

Cryptocrystalline, very finely crystalline, microcrystalline.

Crystal, a form of matter in which atoms or molecules regularly aggregate by forces of molecular affinity; it is a solid with a definite internal structure and an external form enclosed by a number of symmetrically arranged plane faces. The granular texture of solids is caused by the irregular massing of crystal aggregates. Crystals are usually classified in six systems: *isometric* or *cubic*, in which the crystal axes are of equal length and at right angles to each other (sodium chloride, $NaCl$); *tetragonal*, in which the three axes are at right angles to each other but one is of unequal length (nickel sulphate, $NiSO_4 \cdot 6H_2O$); *rhombic* or *orthorhombic*, in which there are three unequal axes all at right angles to each other (barium sulphate, $BaSO_4$); *monoclinic*, in which the three axes are of unequal length, two at right angles to each other and a third at right angles to one but inclined with reference to the others (gypsum, $CaSO_4 \cdot 2H_2O$);

triclinic, in which all axes are of unequal length and all inclined toward each other (copper sulphate, $CuSO_4 \cdot 5H_2O$); *hexagonal*, in which three equal axes in the same plane intersect at angles of 60° and a fourth is at right angles to all of these (quartz, SiO_2).

Deliquescence, the property of certain substances to become moist or liquid when exposed to the air; as sodium hydroxide and calcium chloride. It is a property of solid substances whose hydrates have lower aqueous vapor tension than the air.

Density, the weight of matter per unit volume of a substance; it is conveniently expressed as the number of grams per cubic centimeter (see **Specific Gravity**).

Dicotyledon, having two cotyledons; a plant whose seed develops two leaves on germinating, as the bean seed.

Diffraction, the bending of light as it strikes the edge of an opaque body.

Double Bond, in chemistry, a method of representing a certain type of unsaturation in organic compounds where two single valence bonds connect two atoms, as in $H_2C = CH_2$; same as ethylenic linkage. The position of the double bond in the carbon-to-carbon chain is a point of activity in the molecule (see **Unsaturated**).

Efflorescence, the property of certain substances, particularly crystalline salt hydrates, to lose water when exposed to the air and to crumble to a powder (*e.g.*, washing soda, $Na_2CO_3 \cdot 10H_2O$); a property of solid substances in which hydrates have greater aqueous vapor tension than the air.

Element (see **Chemical Element**).

Empirical Formula, in chemistry, a formula which shows the number and variety of atoms in a molecule but does not indicate the way in which the atoms are linked together; *e.g.*, the empirical formula of verdigris [$Cu(C_2H_3O_2)_2 \cdot 2Cu(OH)_2$] is $Cu_3C_4H_{10}O_8$ (see **Structural Formula**).

Emulsifying Agent, a material which reduces interfacial tension between immiscible liquids to aid in the formation of an emulsion, as soap.

Enzyme, a catalytic substance produced by living cells which has a specific action in causing the decomposition or synthesis of compounds into new ones; *e.g.*, the yeast enzyme, zymase, which splits sugar into alcohol and carbon dioxide.

Essential Oil, one of a group of volatile oils of characteristic odors, distinguished from the fatty oils by their volatility, non-greasiness, and non-saponifying properties. They fall into two main classes: (1) those existing in plants as such, the odoriferous constituents of leaves, flowers, or woods like oil of turpentine, peppermint, and lemon; and (2) those developed from plant constituents by enzymic action or heat, like oil of bitter almonds and creosote oil, respectively. Essential oils may include as constituents hydrocarbons like pinene, alcohols like menthol, phenols like thymol, aldehydes like geranial, ketones like camphor, acids like hydrocyanic acid, and esters like methyl benzoate.

Ester, an organic compound formed from an alcohol and an organic acid by elimination of water; hence, sometimes the name 'ethereal salt'; *e.g.*, ethyl acetate ($CH_3COOC_2H_5$), formed by the action of acetic acid upon ethyl alcohol.

Esterfication, the formation of an ester from an alcohol and an organic acid, with the aid of dehydrating or catalytic agents.

Ethylenic Linkage, in organic compounds, an unsaturated linkage or double bond, as contained in the substance, ethylene, $H_2C = CH_2$ (see **Double Bond**).

Fat, a solid or liquid oil consisting of the glyceryl esters of the higher fatty acids, as tristearin (stearin) which is contained in beef fat, and tripalmitin, contained in vegetable fats and oils such as palm oil.

Fibril, a small fibre or filament.

Film, a thin, usually continuous layer or skin of any substance. It may be more or less homogeneous in structure like a varnish film or heterogeneous like a paint film.

Flash Point, the lowest temperature, under specified conditions, at which the vapors of a liquid can be momentarily ignited; a constant for many organic liquids.

Fluorescence, a kind of luminescence which is the property of certain substances of absorbing light of one wave-length and emitting or radiating it as another wave-length, usually greater. It is thought to be caused by the return of electrons displaced by the exciting radiation to a more stable position. Fluorescence radiation is the immediate result of, and takes place only during, the absorption of radiation from some other source. Ultra-violet light and x-rays are the most commonly used exciting radiations for producing fluorescence.

Fraction, in distillation, those liquids which distill at a certain temperature or temperature range. **Fractionate,** to separate into

parts, as liquids of a certain boiling point or boiling range, by distillation.

Fungicide, an agent which destroys fungi; as mercuric chloride or Bordeaux mixture.

Fungus, a cryptogamous plant, destitute of chlorophyll, deriving nourishment wholly or chiefly from organic compounds; included are bacteria, molds, rusts, smuts, and mushrooms.

Gel, a jelly; same as jell; the colloidal suspension of a liquid in a solid; the solid phase of a colloidal system as opposed to the sol, or liquid, phase; a colloidal system in which matter is dispersed in a solid dispersion medium and in which the particles of the disperse phase are at a standstill in contradistinction to those in a sol (see **Sol**) where they are in motion.

Glyceride, an ester derived from the tribasic alcohol, glycerol. The animal and vegetable fats and oils are mainly triglycerides of the higher fatty acids, as linolein.

Grain is the longitudinal arrangement of fibres or particles in wood, stone, leather or a fabricated substance; it may be the plane of cleavage along which a material can be split into two or more parts. In substances that have grain, physical properties such as moisture absorption, heat conduction, and thermal expansion are likely to be different with the grain than they are across it. Tensile strength, flexure breaking strength, and compressibility may also be affected by the direction of the grain. Materials with grain may be said to be heterogeneous in physical properties.

Ground, the film or stratum in a painting which lies between the support and the paint or design proper. The materials in the ground, paint, and surface layers have many points of identity, but can be considered separately because they represent different structural units in a picture. All contain, except in true fresco and in some gypsum grounds, a film material, or adhesive, or binding medium. This occurs alone in a surface film and often in a priming and acts as a vehicle or carrier of inert pigment particles in the paint film and usually in the ground. The ground is a mechanical preparation on which the design of the picture is executed. The surface film is likewise mechanical and often is not applied by the artist himself. Differences in the function and in the treatment of these three parts of a painting make it expedient to consider them separately.

Hiding Power, the capacity of a paint to obscure or hide the surface on which it is applied; the degree of opacity in a paint or pigment.

Homologous Series, a series of compounds, the members of which differ in composition by a constant amount and in which physical constants change uniformly; *e.g.*, the paraffin series of hydrocarbons, the members of which differ regularly by the addition of $(-CH_2)$ but have each the general formula, C_nH_{2n+2}.

Hydrocarbon, any compound consisting of hydrogen and carbon, as benzene, C_6H_6.

Hydrolysis, (1) a decomposition reaction involving water; (2) the partial reversal of a neutralization or condensation reaction. **Hydrolyze,** to cause hydrolysis.

Hydrophobic, a substance which does not absorb or is not wetted by water.

Hydrophyllic, a substance which absorbs or is wetted by water.

Hydrous, containing water, as opposed to anhydrous. **Hydrous Salt,** a salt containing water of crystallization, as gypsum, $CaSO_4 \cdot 2H_2O$.

Hygroscopic, a substance which absorbs moisture from the atmosphere, as calcium chloride or sodium hydroxide.

Inclusion, a foreign body, gaseous, liquid, or solid, usually of minute size, enclosed in a mineral or other body.

Infra-Red, the invisible part of the spectrum between radio waves and the red portion of the visible spectrum, consisting chiefly of thermal rays; the wave-length region between 0.03 centimeter and 8000 Å units.

Inorganic, not organic; pertaining to chemicals or substances which do not contain the element, carbon; designating or composed of matter other than animal or vegetable. **Inorganic acid,** same as mineral acid; a compound of hydrogen with a non-metal other than carbon, or an acid radical containing no carbon; *e.g.*, HCl (hydrochloric acid), HNO_3 (nitric acid), and H_2SO_4 (sulphuric acid).

Interface, the boundary between two phases; *e.g.*, the boundary between the dispersed phase and the continuous phase in an emulsion of immiscible liquids.

Interfacial Tension, the forces that orient molecules and keep them together at the boundary of a phase; the surface tension of a liquid/liquid boundary surface.

Iodine Number or **Value,** the amount of iodine absorbed by a fat or oil under speci-

fied conditions; the amount of iodine in grams as iodine monochloride (Hübl solution) or iodine trichloride (Wijs solution) absorbed by 100 grams of the oil or fat; the measure of unsaturation of an oil or fat.

Ion, an electrically charged atom, radical, or molecule; a positively charged ion is a cation; *e.g.*, Na^+; a negatively charged ion is an anion; *e.g.*, Cl^-.

Ionization, electrolytic dissociation; the breaking up of molecules into two or more oppositely charged ions; a phenomenon that happens when polar compounds like inorganic acids, bases, and salts are dissolved in water, as $NaCl \rightarrow Na^+ + Cl^-$.

Isomer, any compound having the same number and kinds of atoms as another but differing in molecular arrangement as well as in chemical and physical properties; having the same empirical but different structural formula; *e.g.*, butane, $CH_3CH_2CH_2CH_3$, and isomeric butane, $CH_3CH(CH_3)CH_3$.

Isotropic, having the same physical properties in every direction (*cf.*, **Anisotropic**).

Laminated, made up in thin plates, scales, layers, or plies, as mica or plywood.

Levigate, to reduce a substance to a powder by grinding in water, followed by fractional sedimentation in order to separate the coarser from the finer particles.

Lignin, the cellulose-related material which lines the vegetable cells of wood; it acts as a cement for the cells and imparts rigidity to woody substance. **Ligno-Cellulose,** any of several closely related substances constituting the essential part of woody tissue.

Lixiviate, to extract and separate a soluble substance from its mixture with insoluble matter; to leach.

Lumen, the bore or inside passage of a small tube, vessel, or duct.

Lye, a solution of sodium or potassium hydroxide or the alkaline solution (potassium carbonate) obtained in leaching wood ashes.

Melting Point (m.p.), the temperature at which a crystalline solid changes to a liquid.

Micelle, a unit structure built up from complex molecules in colloids. It may have crystalline properties and is capable of increase or diminution in size without change in chemical nature. The cellulose micelle, for example, is a bundle of parallel chains composed of polymeric molecules derived from the simple unit, $C_6H_{10}O_5$.

Micron, μ, or mu, a unit of length equal to one millionth part of a meter or one thousandth part of a millimeter.

Micro-organism, any minute animal or plant visible only through a microscope, as a bacterium.

Mildew, any whitish or spotted discoloration caused by parasitic fungi like mold on cloth, leather, or other vegetable matter (see **Mold**).

Mineral, any inorganic or fossilized organic substance found in nature. Minerals differ from rocks in that they have definite chemical composition and usually definite crystal structure. Their composition can generally be expressed by a chemical formula.

Mineral Acid, inorganic acid, as hydrochloric, nitric, or sulphuric acids.

Miscibility, the property of certain liquids to mix with each other in all proportions, as alcohol and water.

Mold (mould), a variety of fungus growth, usually filamentous, which grows on damp vegetable material (see **Fungus**).

Molecular Weight, the relative mass of a molecule referred to the mass of the hydrogen atom. It is calculated by adding the atomic weights of all the elements and their multiples indicated in the chemical formula; *e.g.*, molecular weight of water, H_2O, is 18.016, which is the sum of the atomic weights of two atoms of hydrogen (at. wt, 1.008) plus that of one atom of oxygen (at. wt, 16).

Molecule, the chemical combination of two or more like or unlike atoms. It is the smallest quantity of matter that can exist in the free state and retain all the properties of the original substance.

Monomer, the simple unpolymerized form of a compound, having low molecular weight as distinguished from the dimer or polymer (see **Polymer**).

Mutual Solvent, that which acts as a common solvent or coupling agent; that which brings about the miscibility of substances not otherwise miscible with each other; *e.g.*, the action of acetone in producing a mixture of certain oils with water (see **Coupling Agent**).

Neutralization, in chemistry, the process of combining an acid with a base (hydroxide or alkali) in proportions to form a salt and water, leaving no excess of free acid (hydrogen ions, H^+) or base (hydroxyl ions, OH^-); the opposite of hydrolysis. The end point of neutralization is shown by indicators like litmus or phenolphthalein or by measurement of electrical conductivity.

Normal Salt, a salt in which all the hydrogen atoms of the acid have been replaced by a

metal, or all the hydroxyl radicals of a base have been replaced by an acid radical; *e.g.*, sodium carbonate, Na_2CO_3, normal salt, and sodium bicarbonate, $NaHCO_3$, acid salt.

Occlusion, the adhesion of a finely dispersed substance to larger solid particles or their retention inside a solid mass.

Organic Acid, a compound containing one or more carboxyl radicals, — COOH. A monobasic acid contains a single carboxyl group; *e.g.*, acetic acid CH_3COOH; a dibasic acid contains two carboxyl groups; *e.g.*, oxalic acid, $(COOH)_2$, etc.

Oxidation, the act of combining with oxygen or any electronegative element or radical, as the addition of oxygen, chlorine, or sulphur; increasing the positive valence of an atom or ion by loss of electrons; *e.g.*, $Fe^{++} - 1$ electron $\rightarrow Fe^{+++}$.

Oxycellulose, oxidized cellulose, a degradation product of cellulose formed by natural oxidation or by bleaching processes.

Paint Film, a thin, continuous layer of medium and pigment combined.

Particle Size, the average diameter of particles, as those of pigments or of colloids, usually expressed in microns (μ).

Paste, in general, a glutinous or other tenacious substance used as an adhesive; in paint technology, a thick, putty-like mixture of medium (usually oil) and pigment.

pH, a measure of acidity, neutrality, or alkalinity in aqueous solutions; the symbol for the logarithm of the reciprocal of the hydrogen ion concentration; $pH = \log 1/C_{H^+}$. Solutions with pH 1–6 are acid, pH 7 are perfectly neutral, and pH 8–14 are alkaline. pH is measured electrometrically or colorimetrically with the use of indicators.

Phase, any homogeneous substance, either solid, liquid, or gaseous, that exists as a distinct and mechanically separate portion in a heterogeneous system, as in an emulsion; any homogeneous parts of a system that are separated from one another by definite physical boundaries.

Pleochroism, a change in color exhibited by certain optically biaxial colored crystals when rotated in polarized transmitted light. If only two extremes of hue are observed, the substance is said to be dichroic; if three, trichroic.

Polarized Light is that in which the light waves vibrate unilaterally, parallel to each other in the same plane, elipse or circle, whereas in non-polarized light the waves vibrate in a number of planes. Light may be plane polarized by reflection or refraction at non-metallic surfaces or by transmission through crystals showing double refraction.

Polyhydric Alcohol, an alcohol that contains more than one hydroxyl group, as glycerol, $(CH_2OH)_2CHOH$.

Polymer, in organic chemistry, a compound formed by the combination of two or more molecules of the same substance to produce a new compound with the same empirical formula but with higher molecular weight. The polymerization process is usually accompanied by a change in state (as liquid to solid) and a transfer of energy. A polymerized substance is often named with the prefix, poly-; *e.g.*, polyvinyl acetate.

Precipitate, the deposit of an insoluble substance in a solution after the addition of a chemical or precipitating agent or on evaporation, cooling, or electrolysis. Precipitation takes place in a solution when conditions are such that the solution contains more of the component than is required for saturation and there is an excess of the component to be thrown out of the solution.

Priming, in painting construction, a thin, continuous layer between the ground and the paint film, sometimes confused with 'ground.' A priming layer may consist of pigment in medium but is usually medium alone.

Protein, one of a group of nitrogenous organic compounds of high molecular weight that occurs in vegetable and animal matter. Examples of protein-containing substances are animal glue and egg albumen.

Pyrogenetic, produced of or by heat; made by a furnace process.

Radiography, photography with x-rays.

Rectification, the redistillation of a liquid for the purpose of purification.

Reduction, the act of depriving of oxygen or any electronegative element or radical; increasing the negative valence of an atom or ion by addition of electrons; *e.g.*, $Fe^{+++} + 1$ electron $\rightarrow Fe^{++}$; opposite of oxidation but both reactions take place concurrently.

Refraction, the bending or deflection of light rays when passing from one transparent medium to another of different density.

Refractive Index, the ratio of the velocity of light in a certain medium compared with its velocity in air under the same conditions; it is expressed as the ratio of the sine of the incident angle of light to the sine of the

angle of refraction; $n = \sin i/\sin r$. The refractive index (n) of water is 1.33; gypsum, 1.52; zinc oxide, 2.00.

Roentgen Rays, same as x-rays (see X-Rays); a form of radiant energy discovered by Wilhelm Konrad Röntgen in 1895.

Salt, one of the group of substances that results from the reaction between acids and bases; the product, in addition to water, formed by the neutralization of an acid by a base; *e.g.*, sodium chloride (common salt) formed by the action of hydrochloric acid on sodium hydroxide.

Saponification, the conversion of an ester into an alcohol and an acid by hydrolysis or into an alcohol and an acid salt by means of an alkali. It is the process by which soap is made by action of alkali on vegetable or animal fats and oils.

Saponification Number or **Value,** the quantity of potassium hydroxide (in milligrams) required to saponify one gram of fat or oil; the measure of the amount of true fat or fatty acid in a substance.

Saturation, the complete satisfaction of the valence bonds in a molecule; also the complete or maximum absorption of a substance by a solvent.

Single Bond, a single linkage or valency between atoms.

Slake, (1) to slack or loosen; (2) the addition of water to quicklime to form calcium hydroxide.

Sol, a colloidal solution or the liquid phase of a colloidal solution; a colloidal system in which matter is dispersed in a liquid dispersion medium and in which the dispersed particles show independent movement, as Brownian movement (see **Gel**).

Solution, the combination of a solid, liquid, or gaseous substance (called the ' solute ') and a liquid (called the ' solvent ') to form a homogeneous mixture from which the dissolved substance can be recovered unchanged by evaporation and crystallization or by other physical processes.

Specific Gravity, the ratio of the density of a substance to the density of some other substance chosen as standard. In the case of solids and liquids, the standard is usually water and, if metric units are selected, specific gravity is equal to the density (grams per cubic centimeter); *e.g.*, s.g. of water is 1.00; gypsum, 1.36; vermilion, 8.09.

Spectrum, a variously colored band of light showing in succession the rainbow colors or isolated lines or bands of color when light is refracted by a prism or diffracted by a grating.

Spectrogram, a photographic plate, film, or print on which a spectrum is recorded, together with a comparison spectrum.

Stria, a minute groove or channel or a narrow line or band, as of color; one of a series of parallel lines or grooves.

Structural Formula, a representation on a plane surface of the atomic arrangement of a molecule, as that of benzene:

Sublimate, a solid substance which, on heating, passes into the vapor state and, on cooling, returns to the solid state without passing through the liquid state in either direction; *e.g.*, mercuric chloride, iodine, and red mercuric sulphide.

Supernatant Liquid, the liquid standing above a sediment or precipitate.

Surface Film, the thin, transparent film, usually of varnish, spread as a protective coating over the surface of a painting.

Surface Tension, the contractile surface force of a liquid by which it tends to assume a spherical form and to present the least possible surface; its value is measured in dynes on an instrument called a tensiometer.

Tack or **Tackiness,** stickiness, as the condition of a surface of partially dried varnish.

Technically Pure (t.p.), pure enough for technical or industrial uses but not pure enough for analytical or pharmaceutical purposes.

Temper, to mix in proper proportions; to compound or blend; to soften or mollify; to combine with a liquid medium; to make a paint or to make a material brushable; to harden, as of metals, by heating and rapid cooling.

Thermoplastic, capable of being softened and made to flow by heat and pressure; a term commonly applied to artificial resins and plastics which are resoftened by heating.

Thermosetting, a term applied to artificial resins and plastics which are molded and

set by heat and pressure but which do not return to the plastic state on reheating.

Tincture, a dilute extract of a drug or chemical, usually a plant principle in alcohol.

Tinting Strength, the ability of a coloring material like dye or pigment to impart color; same as 'tinctorial power.'

Tooth, the roughened or absorbent quality of a surface which favors the application and adhesion of paint coatings.

Top Tone (or Mass Tone), the full strength and color of a pigment or paint when viewed by reflected light (see also **Undertone**).

Tufa, a sedimentary rock composed of silica or calcium carbonate deposited from waters of lakes, rivers, and springs.

Ultra-Violet (or Ultra-Violet Rays), that portion of the invisible spectrum that lies beyond the violet or on the shorter wavelength side of the visible spectrum; that portion of the light spectrum between 4000 Å units and 120 Å units.

Undertone, the color of a pigment or paint when viewed by transmitted light or when spread thinly over, or mixed with, much white.

Unsaturated, (1) designating an organic compound having double or triple bonds or linkages between carbon atoms; e.g., ethylene, $H_2C = CH_2$, or acetylene, $HC \equiv CH$; (2) said of a solution which is capable of dissolving more solute.

U.S.P., letters commonly affixed to the name of a material indicating that it conforms in grade to the specifications of the United States Pharmacopoeia and that it is approved for use in medicinal preparations; it does not necessarily mean, however, that the material is chemically pure.

Valence, a value or number which expresses the capacity of an atom to combine with other atoms in definite proportions; it is measured with the combining capacity of hydrogen taken as a unit; e.g., chlorine in HCl (hydrochloric acid) is monovalent; oxygen in H_2O (water) is divalent; and carbon in CH_4 (methane) is tetravalent.

Vapor Pressure, the pressure at which a liquid and its vapor are in equilibrium at a definite temperature. If the v.p. reaches the prevailing atmospheric pressure (1 atmosphere), the liquid boils. V.p. is usually expressed in millimeters of mercury; e.g., v.p. at 20° C. for water is 17.5 mm.; for alcohol, 44 mm.; and for acetone, 178 mm.

Viscosity, the internal friction of a fluid which influences its rate of flow or causes it to exhibit slight resistance to change of form; the state of being glutinous or sticky or resistant to flow.

Volatile, designating a substance that evaporates rapidly.

Water of Crystallization (Water of Hydration), water that is combined with certain crystalline salts in definite proportions by weight and which may be completely removed by heating; e.g., $CaSO_4 \cdot 2H_2O$ (calcium sulphate dihydrate) and $CuSO_4 \cdot 5H_2O$ (copper sulphate pentahydrate).

X-Rays, a group of invisible light rays of extremely short wave-length, ranging from 0.06 to 20 Ångstrom units, produced in an exhausted tube (called an 'x-ray tube') by fast-moving cathode rays impinging upon a metal surface.

Supports - plaster p. 250
Pigments : gypsum
levigation - p. 145
toxicity - p. 211